Toward
a Global
Middle Ages

Toward a Global Middle Ages

ENCOUNTERING THE WORLD
THROUGH ILLUMINATED MANUSCRIPTS

Edited by **BRYAN C. KEENE**

THE J. PAUL GETTY MUSEUM LOS ANGELES

With contributions by

Suzanne Conklin Akbari

Sussan Babaie

Roland Betancourt

Jerry Brotton

Jill Caskey

Kristen Collins

Morgan Conger

Michelle H. Craig

Mark Cruse

James Cuno

Eyob Derillo

J. Sören Edgren

Elizabeth A. Eisenberg

Tushara Bindu Gude

Byron Ellsworth Hamann

Melanie Holcomb

Kaiqi Hua

Alexandra Kaczenski

Bryan C. Keene

Rheagan Eric Martin

Sylvie L. Merian

Asa Simon Mittman

Megan E. O'Neil

Alka Patel

Pamela A. Patton

Alex J. West

Contents

Foreword

The tradition of illuminating manuscripts bound into books first flourished among the Abrahamic faiths of Judaism, Christianity, and Islam, ranging from the Middle East to North and East Africa and Europe during the long Middle Ages, about 500–1500 of the Common Era (CE). This codex culture took its place alongside the rich, and in some cases older, traditions of writing on "paper" that could be stored, bound, rolled, or folded that originated in Egypt and later emerged as far afield as India and Central and East Asia (independently, a similar practice of codex creation appears during this time among the Maya of Central America, and later in the Andes). Indeed, the period once referred to as the Dark Ages would perhaps better be called the Illuminated Ages, given both the stunning array of decorated books that were produced during this time and the breadth of knowledge contained within their pages.

The acquisition of the Ludwig Collection by the Getty in 1983 made it possible for us to present a range of highly important illuminated manuscripts from the principal European schools of book decoration and production during the High Medieval and Renaissance period (ca. 800–1600), in addition to significant examples from major centers of the Byzantine world, historic Armenia, Tunisia, Safavid Isfahan (Iran), and the colonial Andes. In the decades since then, the Manuscripts Department has continued to expand the scope of the collection, acquiring a number of works that throw light on the active interconnections that characterized the medieval world, including sacred texts from Coptic Egypt and Ethiopia, and most recently, the Rothschild Pentateuch, the most remarkable northern European Hebrew manuscript from the High Middle Ages.

I wish to thank Thomas Kren, senior curator emeritus; Elizabeth Morrison, senior curator of manuscripts; and Kristen Collins, curator of manuscripts, for their commitment to broadening the remit of the collection and its exhibition program. I also commend Bryan C. Keene, associate curator of manuscripts, for conceiving exhibitions, publications, and public programs that situate the history of the book in a global context, none more so than this publication, which expands the framework of the medieval world beyond Europe and the Mediterranean to the Americas, Africa, Asia, and Austronesia.

Toward a Global Middle Ages reminds us that the peoples of medieval Europe were not isolated but engaged dynamically with neighboring cultures, through trade, diplomacy, cultural exchange, and much else, and that we in museums and the discipline of art history generally must incorporate more expansive and inclusive perspectives into our presentations and narratives. The authors of this volume meet that challenge admirably by re-examining a period in history that is weighted with Eurocentrism and, in some cases, colonialism. Our colleagues in Getty Publications, Kara Kirk, Karen Levine, Ruth Evans Lane, Kurt Hauser, Amita Molloy, and Nina Damavandi, also deserve thanks and acknowledgment for their expert stewardship of this project.

Timothy Potts
Director
The J. Paul Getty Museum

Acknowledgments

The pages of this book chart a journey into our shared global past, and the following individuals have accompanied, guided, or rescued me on this venture.

Elizabeth Morrison, senior curator of manuscripts at the Getty, has witnessed, reviewed, edited, and made recommendations for no less than three versions of the present publication, a process that began in 2013. I am grateful for her support and encouragement, and for her challenge to me to broaden the scope at each stage. With Kristen Collins, curator of manuscripts, I have had the pleasure of conceiving exhibitions and courses that address a global Middle Ages. Our collaboration began during the run of her seminal exhibition *Icons from Sinai* (2006), and expanded when we began mapping the presence of çintamani-design fabrics in the Getty manuscripts collection, a project that led us to consider pilgrimage and trade routes together with Nancy Turner, conservator of manuscripts. To Kristen and Nancy, I am grateful for conversations that always return to close looking at the objects and lively discussions. To Nancy, I am also indebted for hours of instruction regarding the materials and science of manuscripts. The current and former staff in the Manuscripts Department at the Getty have been essential interlocutors during the many phases of this project; they include assistant curators Larisa Grollemond and Christine Sciacca; curatorial assistants Alexandra Kaczenski, Rheagan Eric Martin, and Erene Morcos; graduate interns Abby Kornfeld, Megan McNamee, Melanie Simpson, and Katherine Sedovic; undergraduate interns Michelle Prestholt and Isabel Diaz-Brady; senior staff assistant Andrea Hawken; and volunteers Kristin Brisbois, Stefanie Difrancesco, Scott Hornbuckle, Lindsey Gant, Calvin Kaleel, Bethany Lamonde, and Elizabeth Sandoval. Single-handedly, Morgan Conger masterfully managed the organization of drafts and image logs, but more importantly, she has read every essay assiduously (in addition to a mountain of additional bibliography) while also keeping me accountable for the goal of presenting a more inclusive view of the medieval world. Thank you.

My sincerest gratitude and thanks are due to each of the contributors to the volume for shaping this inclusive vision of the Middle Ages: Suzanne Conklin Akbari, Sussan Babaie, Roland Betancourt, Jerry Brotton, Jill Caskey, Kristen Collins, Morgan Conger, Michelle H. Craig, Mark Cruse, James Cuno, Eyob Derillo, J. Sören Edgren, Elizabeth A. Eisenberg, Tushara Bindu Gude, Byron Ellsworth Hamann, Melanie Holcomb, Kaiqi Hua, Alexandra Kaczenski, Rheagan Eric Martin, Sylvie L. Merian, Asa Simon Mittman, Megan E. O'Neil, Alka Patel, Pamela A. Patton, and Alex J. West. I am grateful also for the input and direction given at the Getty by Timothy Potts, director, and Richard Rand, associate director for collections.

The exhibition *Traversing the Globe through Illuminated Manuscripts* (2016) and the accompanying symposium and study days at the Getty provided the inspiration for the present volume, as did the exhibition *Pathways to Paradise: Medieval India and Europe* (2018). I learned a great deal from the generous knowledge sharing of colleagues at the Getty, especially Stephanie Schrader, Jane Bassett, Anne-Lise Desmas, Quincy Houghton, and a cohort of creative minds, including BJ Farrar, Elie Glyn, Michael Mitchell, Mark Mitton, and Alexandra Mosher; Clarissa Esguerra, Tushara Bindu Gude, Linda Komaroff, the late Julie Romain, Naoko Takahatake, and Sharon Takedo at the Los Angeles County Museum of Art; Carol Togneri and Melody Rodari (formerly) at the Norton Simon Museum; Vanessa Wilkie at the Huntington Library; Genie Guerard, David Hirsch, and Octavio Olvera at the UCLA Library Special Collections; and Suzanne Blier (Harvard University), Heather Bodamo (University of California, Santa Barbara), Elizabeth Boone (Tulane University), Gabrielle Bychowski (Case Western Reserve University), Gudrun Bühl (Dumbarton Oaks), Stephen Campbell (Johns Hopkins University), Joanna Cannon (Courtauld Institute of Art), Helen Evans (The Metropolitan Museum of Art), Jessica Goldberg (UCLA), Sarah Guérin and Nicholas Herman (University of Pennsylvania), Dorothy Kim (Brandeis University), John

Lukavic (Denver Art Museum), John McQuillen (Morgan Library), Kirstin Noreen (Loyola Marymount University), Dagmar Riedel (Columbia University), David Simonowitz (Pepperdine University), and Pamela Troyer (Metropolitan State University of Denver).

Another guiding light has been Cynthia Colburn (Pepperdine University), whose friendship and vision I cherish; I am grateful that she encouraged me from our first meeting to think globally and with compassion. Geraldine Heng (University of Texas at Austin) has been part of the vanguard of the global and racial turns in medieval studies, and I thank her and Lynn Ramey for being patient guides along my own journey. I thank Christina Normore (Northwestern University) for sharing early drafts of her edited volume on the global turn in medieval art history (2018). The group of scholars with whom I presented at the 2017 conference "Bibliography among the Disciplines" provided important feedback on many of the ideas developed in this book. These individuals include Daniela Bleichmar (University of Southern California); Hwisang Cho (Xavier University); Devin Fitzgerald (Harvard University); A. Mitchell Fraas (University of Pennsylvania); Florence Hsia, Robin Rider, and Caitlin Tyler-Richards (University of Wisconsin, Madison); Ben Nourse (University of Denver); and Rachel Stein (Columbia University). My sincerest thanks are also due to the Very Reverend Dr. Robert Willis, Dean of Canterbury, and Fletcher Banner for their unmatched generosity and friendship.

At Getty Publications, I thank Karen Levine, editor in chief, and Ruth Evans Lane, editor, for their constant sense of direction and for nudging me to always venture further afield. Sincerest thanks are due to Lindsey Westbrook for boldly traversing the nuances of copyediting this book. I thank Nina Damavandi for adroitly ordering images from all the world, Amita Molloy for carefully overseeing the book's production, and Kurt Hauser for its truly wondrous and thoughtful design.

To my fellow life voyagers—Christine Spier, Shereen and Eric Catanzaro and little Ravenna, Dominic Del Brocco and Nicholas Riippa, Alec McPike, Brittany and Daniele Corbucci and family, and Maeve Morales-O'Donnell—we know the way.

Above all, I am grateful to the patience, encouragement, and support of my family—especially to my parents, Rosemarie and Kenneth, for instilling in me the love of language and travel. I am also thankful for the wisdom of my grandparents, Lorraine (†) and Samuel (†) Magnolia and Virginia and Laurence Keene, as well as Elaine and Douglas Hoffman. To my siblings, Samuel and Kendra, and to Audrey, Jack, and Cameron, thank you for always making me smile. Thanks are also due to David, Merrick, and Leland Siebenaler, for joining us on this family journey.

And especially to Dr. Mark Mark Keene—thank you for your intrepid sense of adventure and unfailing love. You are my light. I dedicate this book to Alexander Jaxon and Éowyn Arya, and to all those who venture into the world with open hearts and minds.

Bryan C. Keene
Associate Curator of Manuscripts
The J. Paul Getty Museum

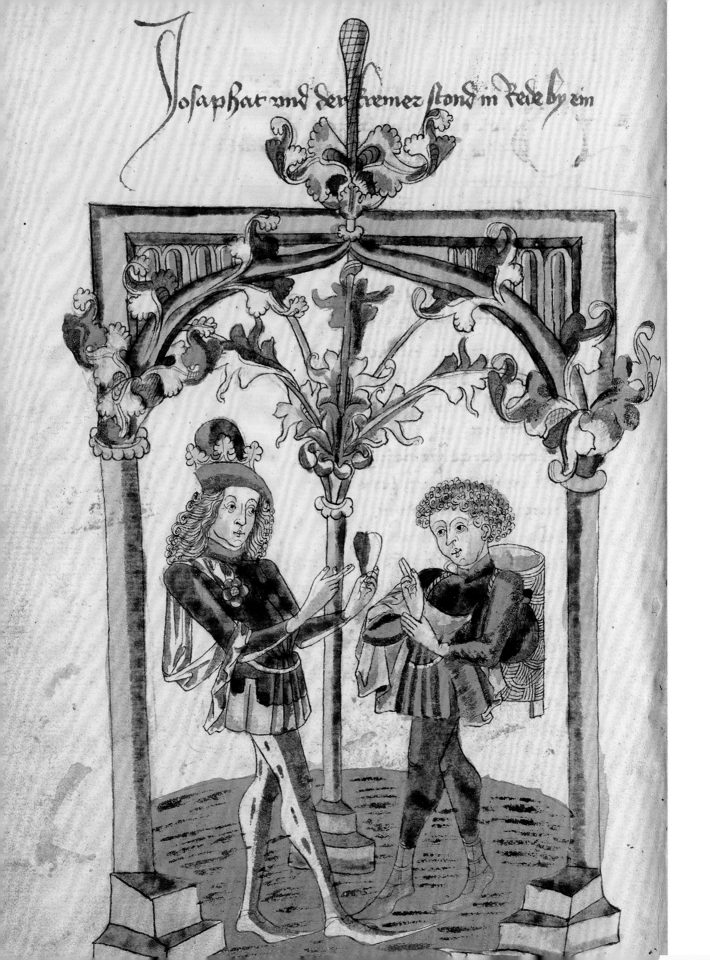

Prologue

BRYAN C. KEENE

In the land of India, the prince Josaphat lived in isolation for many years in the royal palace, until one day when he witnessed illness, old age, and death for the first time. After meditating beneath a tree and encountering a Christian monk, Josaphat chose to renounce worldly pleasures and convert to Christianity. Rudolf von Ems (1200–1254) was one in a long line of writers in the Common Era (CE) to recount this tale,[1] which might be traced as far back as John of Damascus (seventh century, Syria) and later to Yahya ibn Khalid (ninth century, Bactria), Euthymius of Athos (eleventh century, Georgia and Greece), and Gui de Cambrai (twelfth century, France), and later still to Rashid al-Din Hamadani (thirteenth century, Persia), Jacobus of Voragine (thirteenth century, Italy), and even Marco Polo (fourteenth century, Italy).[2] The Latin name Josaphat ultimately derives from the Sanskrit word *bodhisattva*, an enlightened follower of the Buddha who helps others reach Nirvana (release from cycles of desire and suffering). Stories from the life of the Buddha reached Mediterranean audiences through a lengthy process of linguistic and geographic translation—*Budhasaf* in Arabic, *Iodasaph* in Georgian, and *Ioasaph* in Greek—as vignettes from the life of the Indian "enlightened one" became part of the Christian hagiography of Saint Josaphat and his spiritual mentor, Saint Barlaam. Numerous illustrated copies of texts by some of the above writers have survived, including the 1469 version of Rudolf von Ems's text from Hagenau, France, illustrated by a follower of Hans Schilling (fig. prologue.1). A thirteenth-century copy in Greek perhaps produced in Constantinople (now in the library at the Holy Monastery of Iviron on Mount Athos, Greece) contains French translations of the text in the margins, added at an uncertain point in the past but likely indicative of the kinds of encounters a pilgrim or traveler might have with a manuscript (fig. prologue.2).[3] A manuscript from 1553 in Ge'ez, the official language of historical kingdoms and courts in Ethiopia, preserves the tale of Yěwâsěf, as the protagonist was called. The author's preface mirrors the account of Gregory Jeretz (the Presbyter), a twelfth-century Armenian chronicler, suggesting additional pathways by which the Christianized account of the Buddha's life commingled throughout Byzantium and its former commonwealth.[4]

The connection between shared events from the life of Saint Josaphat and the historical Buddha (Shakyamuni) was only realized in the sixteenth century by the Portuguese humanist Diogo do Couto (ca. 1542–1616), and serious study of the Buddha-Josaphat connections emerged only in the nineteenth century. The long history of this textual tradition of the life of Saint Josaphat now encompasses accounts in Armenian, Dutch, English, French, Ge'ez, German, Greek, Hebrew, Icelandic, Italian, Latin, Polish, Spanish, Syriac, Tagalog, and Yiddish.

Amid this linguistic commingling are also Arabic and Persian chronicles that locate the Buddha within local and regional histories of Islam or of the world. During the reign of Shahrukh Mirza (r. 1405–47), son of Timur (Tamerlane), the historian Hafiz-i Abru (d. 1430) chronicled the history of the world up to the present reign of the Timurids. One section of the *Majma al-Tavarikh* (Compendium of Histories) includes the story of Shakyamuni Buddha, who the author recounts rose from the dead and appeared to his followers (fig. prologue.3). This narrative detail is not found in Indian sources but can be located in certain Chinese texts. The writer may have conflated Christ's death and resurrection with the Buddha's posthumous manifestations.[5] The prism of hues worn by a group of devotees contrasts with the stark, tomb-like structure, or stupa, surrounding the reclining Buddha—sculpted versions of which could have been encountered at the time at

Prologue.1. *Josaphat Speaking to the Merchant Barlaam about the Precious Gem in Barlaam and Josaphat* by Rudolf von Ems, follower of Hans Schilling (artist), Hagenau, Alsace, France (formerly Germany), 1469. Los Angeles, The J. Paul Getty Museum, Ms. Ludwig XV 9 (83.MR.179), fol. 43v

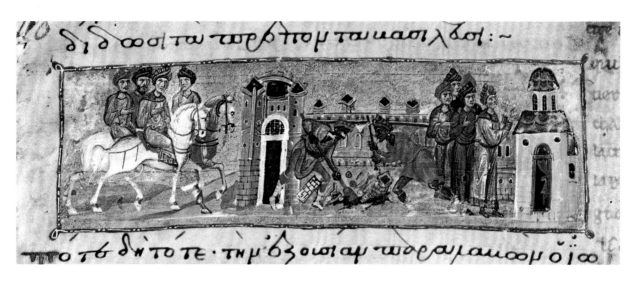

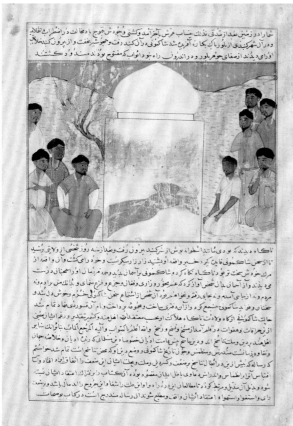

Prologue.2. *Ioasaph Burns the Idols and Builds a Church* from a facsimile of *Barlaam and Ioasaph* (Greek with French translations, possibly Constantinople, early thirteenth century. Mount Athos, Greece, Holy Monastery of Iviron, Codex 463), fol. 110r. Los Angeles, Getty Research Institute, 83-B9662

Prologue.3. *The Appearance of Shakyamuni (the Buddha) after His Death*, leaf from a manuscript of the *Majma al-Tavarikh* (Compendium of Chronicles) by Hafiz-i Abru, Herat, Afghanistan, 1425 CE / AH 828. Los Angeles County Museum of Art, The Nasli M. Heeramaneck Collection, gift of Joan Palevsky, M.73.5.412

various sites within Timurid territory, including present-day Tajikistan, Uzbekistan, and Afghanistan.

The roadways and waterways that led to the translation and reinterpretation of the Buddha story into Central Asia and Europe are similar to those pathways that helped Buddhism spread into South and East Asia (Buddhism arrived in Sri Lanka by the third century BCE, in China in the third century CE, and Korea and Japan by the fourth and fifth centuries, respectively). In these regions one finds a long history of texts and images about the Buddha, and about bodhisattvas such as Avalokitesvara, among many others, who is called Guanyin in China or Quán Thế Âm in Vietnam, for example. Palm-leaf manuscripts emerged in India and Southeast Asia, whereas the handscroll developed as a primary format for Buddhist painted or printed sutras throughout East Asia. A pair of sutra (scripture) covers from the reign of the Yongle Emperor (Zhu Di) of Ming China (r. 1403–24) once preserved part of an edition of the 108 volumes of a Tibetan Buddhist text produced in Beijing (fig. prologue.4). Surviving manuscripts from the reign of the Yongle and Xuande Emperor (Zhy Zhanji; r. 1426–35), some of which were enclosed by such lacquered boards, may have featured block-print illustrations, while others were lavishly decorated with costly materials and golden calligraphy.[6] At the center of both covers is the flaming jewel that represents the Buddha, his teaching, and the monastic community. This particular symbol of an auspicious gem appears as a gift from Saint Barlaam to Saint Josaphat in the text discussed at the beginning of this prologue (see fig. prologue.1).

Interestingly, a tale about disavowing and renouncing worldliness is precisely one that traversed the globe and connected vast geographies through local interpretation and expression.

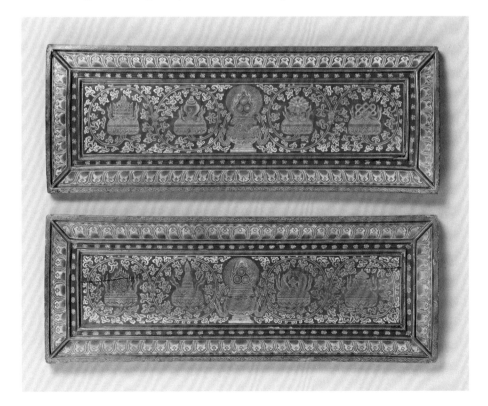

Prologue.4. Sutra covers with the *Eight Buddhist Treasures*, China (Ming dynasty), Yongle period, 1403–24. New York, The Metropolitan Museum of Art, gift of Florence and Herbert Irving, 2015.5001.52a,b

The opening example in this prologue is from Europe, a familiar starting point for those interested in the Middle Ages. But Europe occupies a small corner of the globe, and as the story of the Buddha-Josaphat demonstrates, there are numerous ways in which communities were connected in the premodern world. *Toward a Global Middle Ages: Encountering the World through Illuminated Manuscripts* addresses decorated books—bound, folded, or rolled with painted or printed embellishment—produced across the Earth during the period traditionally known as the Middle Ages, or medieval era. Through essays and case studies, the authors have expanded the often Eurocentric historiography, chronology, and geography of this vast field of study to include objects, individuals, narratives, and materials from Africa, Asia, and the Americas—an approach that follows and critiques the recent scholarly turn known as the global Middle Ages. The present publication is intended for all who are interested in engaging in a dialogue about how books (broadly defined) and other textual objects contributed to world-making strategies from about 500 to 1500.

1 Haug 1997.
2 Lopez and McCracken 2014. For Gui de Cambrai's version, see McCracken 2014.
3 I am grateful to the fathers of the Holy Monastery of Iviron for allowing me to study Codex 463. See Hilsdale 2017.
4 See Colin 2008.
5 Canby 1993a, 299–310.

6 For art of the Yongle period, see Watt and Leidy 2005. On April 3, 2018, Sotheby's in Hong Kong sold two sets of five *leporello* (accordion-fold) albums from the *Prajñāpāramitā* (Perfection of Wisdom, vols. 61–65 and 226–30), written and illuminated in gold ink on indigo-colored goat-brain paper (lot 101). The manuscripts were produced during the reign of the Xuande Emperor.

Introduction: Manuscripts and Their Outlook on the World

BRYAN C. KEENE

Illuminated manuscripts and illustrated or decorated books—like today's museums, libraries, and archives—preserve a rich array of information about how people have perceived the world, its many cultures, and everyone's place in it.[1] Images and texts within handmade and painted book arts reveal ideas about globality, including notions of geography, race, religion, gender, trade, and travel. In the case of graphic or epigraphic arts (inscriptions), the written words or pictograms themselves can reveal aspects of linguistic, regional, religious, and cultural identity or difference, as well as contact and assimilation.

In a text by Nizami Ganjavi (1141–1209) called the *Haft Paikar* (The Seven Portraits), the Sasanian prince Bahram Gur (r. 420–38) pays daily visits to princesses from different regions in color-coded pavilions (fig. introduction.1): India on Saturday (black), Byzantium on Sunday (yellow), Tartars of Rum (Turkmenistan) on Monday (green), Slovenia on Tuesday (red), the Maghreb on Wednesday (turquoise), China on Thursday (sandalwood), and Iran on Friday (white).[2] The world-making strategy presented in this manuscript reveals more about a major book-producing center—Shiraz in present-day Iran—and about the male gaze in the history of art than it does about the ruling women whom the work describes and depicts (from Byzantium, the Rum, Slovenia, and so forth). This example is one of many that demonstrates how the real and imagined worlds of artists, writers, travelers, and many others come to life in stunning and at times surprising ways on the pages of medieval books. These highly prized objects are prisms through which to glimpse and study the world, its peoples, different belief systems, and an interconnected global history of humanity.

In the premodern era, a complex nexus of land and sea routes connected the remarkably mobile Afro-Eurasian peoples, many of whom were far more aware of the world beyond their doorsteps than one might realize. A significant number of

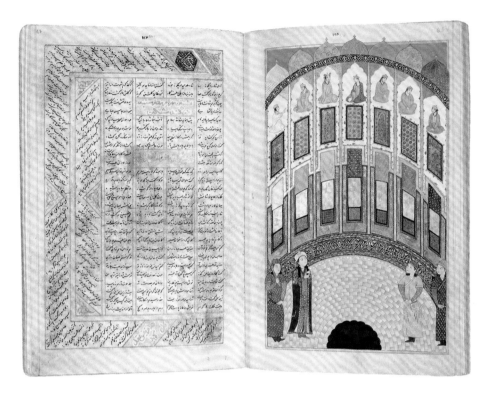

Introduction.1. *Bahram Gur in the Hall of Seven Images* in the *Khamsa* (Quintet) of Nizami, Shiraz, Iran, 1410 CE / AH 812. Lisbon, Portugal, Calouste Gulbenkian Museum, inv. L.A. 161, fol. 66v

individuals ventured to foreign lands as pilgrims, merchants, ambassadors, soldiers, or in some cases as curious travelers. Countless groups, however, did not have the means to travel, due to either economic inequalities or the potential risks associated with movement away from one's home. And it is a grim reality that many people were forced to migrate as political or religious refugees, or to be violently and inhumanely subjugated to slavery. All of these realities complicate the task of de-centering history, which is often written from the vantage point of the elite. Discussions about classes of people or races as historical witnesses also demand that historians of all fields provide plural accounts and allow multiple voices to speak for themselves.[3]

A few discrete examples of travel attest to connections beyond hemispheric Afro-Eurasia during the Middle Ages, at times recorded in texts and in other instances passed down as oral history.[4] These moments when people from nearly every continent in the premodern world interacted include ventures to North America by Greenlanders or Icelanders, and Polynesian voyages to coastal South America. Movement throughout the greater Pacific Ocean and across the Americas also resulted in contact between diverse communities, as attested to by the field of linguistics. The history of a connected world is therefore not merely a "modern" phenomenon.

> "If you don't know you have a history, it can be hard to believe you have a future." —*Hidden Histories*, Historiska Museet, Stockholm[5]

Toward a Global Middle Ages: Encountering the World through Illuminated Manuscripts is organized into four sections: the first section provides an introduction to a "global Middle Ages," followed by a look at the intermediality of "the book," then a range of examinations of identity-making strategies or polemics, and finally a section devoted to exploring transregional itineraries. Each section includes thematic essays concerned with a particular region or cultural nexus, as well as shorter case studies. One goal of this publication is to interrogate the terms "medieval" (or "Middle Ages"), "global," and "book(s)" as understood within the constructs of historic time, academic

periodization, and museum curatorial practice from a specific place on the Earth. The twenty-six authors—book historians specializing in art, literature, cartography, religion, and luxury objects—emphasize moments of encounter, exchange, and exploration by considering networks rather than boundaries, connectivity rather than isolation, geographic centers as well as peripheral regions, and a world of cross-cultural artistic interaction. A range of macro- and micro-historical perspectives emerges—approaches that Emmanuel Le Roy Ladurie characterized as "parachutists" versus "truffle hunters," respectively.

The idea of a global past in relation to bibliographic history or manuscript cultures, as understood in this publication, refers to three kinds of decorated textual objects: first, those whose contents visualize or conceptualize the world(s), real and imagined, through a combination of text and image; second, those that embed, encase, or enshrine foreign materials or ideas within the pages or bindings (engendering discussions of hybridity or of a more complex local identity, which is always intertwined with borrowings from other worlds); and third, those that physically traversed boundaries with their owners. The authors in this publication propose an array of models for reassessing "the book," which will include bound, folded, and rolled textual objects—codices, scrolls, amulets, screenfolds, and so forth—on parchment, paper, and palm leaves that are handwritten or printed, but always, for our aims, containing decoration (which also includes alphabetic adornments or calligraphic embellishments).[6]

The current scholarly approach toward a global Middle Ages critiques Eurocentric narratives and periodization, and interrogates the applicability of terms like "medieval" or the "Middle Ages" to other parts of the globe or to other moments in history, either diachronically in deep time or synchronically (at times, in the latter, following the approach of micro- or local history).[7] These endeavors have seldom addressed the global role that book arts played in forging transregional connections and in actively shaping cross-cultural contacts.[8] One notable exception is the field of book conservation—conservators have been at the vanguard of

discovering the material entanglements of a networked medieval world.[9] Getty manuscripts conservator Nancy Turner's work (at times in collaboration with scientists from the Getty Conservation Institute) has deepened our knowledge of materials, techniques, and trade from across the Mediterranean world to Ethiopia and Peru;[10] Stella Panayotova and Paola Ricciardi have also expanded the global scope of medieval manuscript studies through a conference and a two-volume publication that encompass the Islamicate world and East Asia, as well as the Mediterranean.[11] The underpinning of the turn toward a global Middle Ages is to (re)write histories of the medieval past—from about the sixth through the sixteenth century, with variation on dating as will be explained below—to more accurately reveal the diversity and complex connectivity of the period. Attempts to redefine the institutionalized division of subjects, geographies, languages, literatures, and materials of a global Middle Ages respond to various theoretical and disciplinary approaches, including comparative and travel literature,[12] world history,[13] global art history,[14] religious studies,[15] Mediterranean studies,[16] postcolonial discourse,[17] network theory,[18] Southern theory,[19] and materiality,[20] among others.[21]

A global Middle Ages cannot imply a total world system, which is often a tenet of globalization, because the period under consideration primarily witnessed intra-hemispheric contact (with the few exceptions mentioned earlier). The French concept of *mondialisation*, which can be translated as world-making or worlding, is sometimes seen as a response to the belief that globalization is a modern phenomenon.[22] *Mondialisation* approaches to the past often emerge as micro- or small-world histories.[23] Attempts to define macro or hemispheric models or circuits for the medieval world include Janet Abu-Lughod's important study and map of the "Eight Circuits of the Old World," which Monica Green has redrawn to include sub-Saharan Africa.[24] I would argue that these systems can be remapped in a variety of ways, not least to include Greenlander or Icelander voyages to North America (as recorded in the *Vinland Sagas*), or the reciprocal journeys between East Asia, Africa, and island Southeast Asia

in the Indian Ocean world, but also to incorporate transcontinental movement in the Americas or transpacific migrations in greater Australasia.[25] Andre Gunder Frank's Sinocentric account of "Major Circum-Global Trade Routes" provides a helpful counterpoint to Abu-Lughod.[26] In James Belich's words, "A global approach need not be universal, but it should cross boundaries of discipline, time, and space."[27] Thus "global" can mean looking at larger, rounded world networks or contact zones hemispherically as opposed to encompassing the entire globe, or can describe projects that include the entire Earth in contact or through comparative studies (the study of code-switching in linguistics could provide greater insights into medieval literacy and scribal culture in multilingual contexts, for example). As my colleague Kristen Collins has said, "global" is a methodology of inclusion. The objects in the present volume are especially well suited to disciplinary crossovers, because the study of book arts attracts specialists in art, history, literature, linguistics, religion, cartography, trade, and so forth whose chronological scopes vary greatly.

The turn to a global Middle Ages furthermore challenges assumptions about a singular teleology or linear trajectory for Europe toward modernity, while such scholarly endeavors simultaneously provincialize Europe, to borrow Dipesh Chakrabarty's phrase.[28] A prevailing aim of this turn has been to destabilize, deconstruct, decolonize, and de-orientalize the lingering Eurocentrism of the broader medieval field. Following the 2017 alt-right and white supremacist protests at the University of Virginia in Charlottesville, medievalists are more actively attempting to dismantle the propaganda and pernicious racism of the popularly imagined white Middle Ages. It is important to remember that any use of the terms "medieval" or "Middle Ages" is inherently Eurocentric, given the long historiography of this period that emerged in the nineteenth century and the colonial or imperialist foundations of the discipline of medieval studies and its subfields. Some have insisted on referring specifically to the *European* Middle Ages when discussing comparative chronologies in other regions,[29] and in a similar way, the term "global" is at times applied when referring to the geographic reaches of a dynasty or empire (the global Tang and Song dynasties or the global Islamicate world of Afro-Eurasia, for example). Finally, Alexander Murray has asked, "Should the Middle Ages Be Abolished?"[30] One plausible alternative to these various models is to speak of Afro-Eurasia and the Americas along hemispheric lines pre-1492; another possibility is to look to climate and disease studies for alternate "global" methodologies.[31] This publication touches on these matters.

The modalities and demographics of Afro-Eurasian manuscript cultures of the so-called global Middle Ages share the goal of encoding and preserving knowledge, and of translating the past in the present moment, thereby granting future potentiality to the text-image. This aim has also been identified in studies that counter logocentrism—that is, an emphasis on words, or what Stephen Greenblatt has called a "literall [*sic*] advantage," to denote European sensibilities of superiority when encountering perceptively illiterate peoples.[32] For example, Elizabeth Boone has termed "alternate literacies" in relation to pre-Columbian and Mesoamerican epigraphic forms of communication that did not strive to represent speech but did record information in graphic form (penned, painted, or sculpted).[33] Bodily adornment (tattooing, painted patterning, amulets, talismans) and oral traditions could expand the scope of this publication further afield into places around the globe where writing was not the primary form of expressing identity or recording the past (or where such accounts have not survived). A few attempts have been made throughout this publication to consider these perspectives. By advocating for methodologies that acknowledge alternate forms of literacy and chronology, or that uncover the global in the local, as editor I affirm the words of Peter Linehan and Janet Nelson: "Many partial worlds emerge as one medieval world."[34] In order to think globally, a bit of cognitive, cartographic, and chronological remapping is in order. Following is a brief look at how the medieval is often constructed in scholarship of Europe, Byzantium, the Islamicate world, greater Asia, Africa, the Americas, and Australasia.

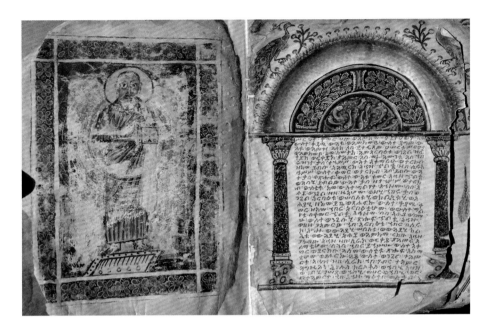

Introduction.2. *An Evangelist* and a decorated text page in the Garima Gospels, Abba Garima Monastery, Ethiopia, sixth century. Tigray region, Ethiopia, Abba Garima Monastery, Abba Garima 2, fols. 1v–2

Introduction.3. *Christ Enthroned with Four Monks* in the Rabbula Gospels, Monastery of Saint John of Zagba, Syria, sixth century. Florence, Italy, Biblioteca Medicea Laurenziana, Cod. Plut. I, 56, fol. 14a

Decentering the European Middle Ages

One of the great challenges of telling a global history is determining its chronological and geographic scope. The Middle Ages, for example, has sometimes been described as a thousand-year period, centered largely on the Judeo-Christian communities of the historic Roman Empire—East (Byzantium) and West (Latin kingdoms and the Holy Roman Empire)—in present-day Europe, Western Asia, and the Mediterranean Basin from about the fourth through the mid-fifteenth century.[35] This period is bookended, so to speak, by the advent of the codex among the Christian communities of Afro-Eurasia (with such early surviving examples as the Cotton Genesis, perhaps from Egypt,[36] the Garima Gospels of Ethiopia (fig. introduction.2), the Rabbula Gospels of Syria (fig. introduction.3), or the Etchmiadzin Gospels of Armenia), and the introduction of printing in Europe. The rubrics of "Rome to Renaissance" or "Constantine to the fall of Constantinople (1453)" or "parchment to paper and print" usually describe the so-called medieval millennium, but as we have just seen with the selection of Late Antique or so-called Early Christian Gospel books, locations in present-day Europe were among a larger network of book-producing centers that included Byzantium and territories under its influence, or regions with a shared but varied adoption of Christianity.

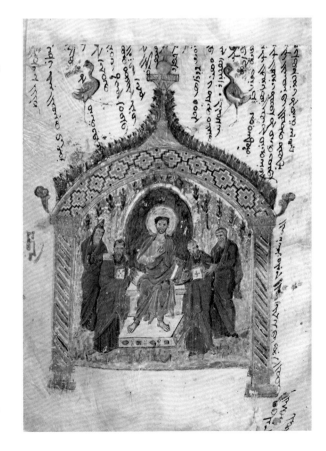

Introduction.4. Inner back cover silk doublure of the Lindau Gospels, tenth century, possibly Syria. New York, The Morgan Library & Museum, Purchased by J. Pierpont Morgan (1837–1913) in 1901, Ms. M1

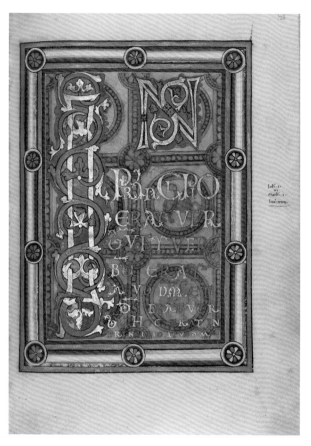

Introduction.5. Decorated incipit page in a Gospel book, Helmarshausen, Germany, 1120–40. Los Angeles, The J. Paul Getty Museum, Ms. Ludwig II 3 (83.MB.67), fol. 128

The binding of the Lindau Gospels, a Carolingian masterpiece, unites the local and the global. The back cover (late eighth century) may have been made in Salzburg, while nearly one hundred years later, the court workshops of Charles the Bald (r. 875–77) in West Francia produced the front cover, composed of a gold relief of the crucified Christ and gems evocative of the gates of heavenly Jerusalem described in the book of Revelation. The two inner covers were, at an unknown date, lined with silks from Byzantium and possibly Syria (datable to the ninth or tenth century) (fig. introduction.4). Several of the decorative pages feature intricately rendered designs inspired by textiles, a common feature of manuscripts from this period (from Central Europe to Northern India alike). In a twelfth-century Gospel book

from Helmarshausen, Germany, the combination of luminous gold and silver letters against a background painted to resemble purple patterned silk would have visually transported the reader of the manuscript back to imperial Rome, when the grandest manuscripts were written on parchment dyed or painted with (or to resemble) costly Tyrian purple, a pigment made from the murex sea snail native to the Levantine coast of the Mediterranean (fig. introduction.5). The geometric and animal designs on the textiles also evoke the luxurious garments worn in Byzantium, which were highly desired by Western Europeans (as diplomatic gifts or smuggled commodities), and which often covered manuscripts or were transformed into delicate veils to shroud precious illuminations.

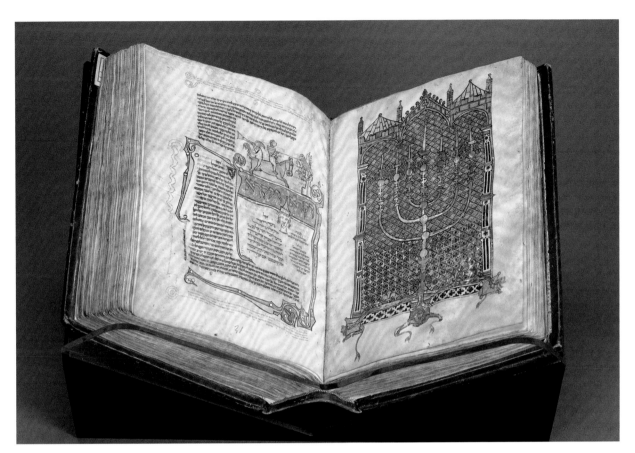

Introduction.6. *A Menorah* and *Monkey-Knights on Horseback* in the Rothschild Pentateuch, France and/or Germany, 1296. Los Angeles, The J. Paul Getty Museum, Ms. 116 (2018.43), fols. 226v–227

A truly global account of the Middle Ages must also acknowledge the place and contribution of Jewish communities within the Mediterranean and beyond (in Egypt, Yemen, or greater Central Asia, for example),[37] even as Christian communities at times persecuted their Jewish neighbors and held prejudices against them as "strangers within."[38] The Rothschild Pentateuch (fig. introduction.6) is a rare survivor from the High Middle Ages. Colophons record the date of 1296 and the patron Joseph ben Joseph Martel, as well as the scribes Elijah ben Meshullam, who wrote the main text, and Elijah ben Jehiel, the micrographer (the term for a calligrapher of minute scripts, sometimes forming abstract designs). The main portions preserve the text of the Torah (the five books of Moses—Genesis, Exodus, Leviticus, Numbers, and Deuteronomy), the inner margins contain Aramaic translations, and the outer margins feature commentary by Rabbi Schlomo Itzhaki (Rashi) (1040–1105). The visual program resembles Gothic painting of the period, but beyond stylistic splendor, it is important to remember that the manuscript was created at a moment when Jewish communities were being expelled from England, marginalized by legal codes in the Kingdom of Aragón (Spain), and forced to publicly identify themselves by dress in Central Europe. In the fifteenth century, the manuscript was in northern Italy, where the most celebrated Jewish scribe-artist, Joel ben Simeon (active second half of the fifteenth century), added a scene of Moses addressing the Israelites (see fig. IV.7). This later painting testifies to the eventful lives of medieval manuscripts and the changing role of Jewish scribe-artists.

As mentioned earlier, the chronological scope of *Toward a Global Middle Ages* ranges from about the sixth to the sixteenth century, while many of the authors have focused their essays on the pivotal twelfth through fifteenth century, when contact increased between communities in Afro-Eurasia prior to large-scale transatlantic encounters with peoples in the Americas (see the timeline in this volume by Morgan Conger).

Betwixt and Between: Worlds of Byzantium

Despite shared ancient, classical, and Christian heritage and territory, as well as diplomatic links between the Greek-speaking Byzantine "East" and Latin-speaking European communities in the "West," Byzantium has too often held a tenuous place within "the medieval," precisely due to the artificial boundaries imposed by scholars or the flawed notion of timelessness in Byzantine art (a fate that also befalls discussions of what is sometimes termed art for Orthodox traditions).[39] The 2016 Dumbarton Oaks Byzantine Studies Symposium, "Worlds of Byzantium," reevaluated cosmopolitan and imperial approaches to Byzantine history, which highlight the always international and intersectional character of those individuals who ruled from, looked to, traversed, or battled over the Hellespont.[40] This theme will be explored throughout this publication.

Libraries from the monastic communities on Mount Athos (Greece) to Mount Sinai (Egypt) today preserve hidden histories of Byzantine painting and textual diversity, as demonstrated by the *Barlaam and Ioasaph* manuscript in Greek with French glosses discussed in the prologue (see fig. prologue.2). An opening inscription in that particular manuscript reveals the fluidity of geographic thinking at the time: "A story profitable for the soul from the innermost country of the Ethiopians, called of the Indians." In 2010, the manuscript holdings of Saint Catherine's Monastery at Mount Sinai (fig. introduction.7) were newly catalogued under four broadly defined categories: Greek and Latin texts; the Syriac, Christian Palestinian Aramaic, and Arabic manuscripts; the Georgian, Caucasian Albanian, and Armenian codices; and the Slavonic books.[41]

In addition to the networks that can be mapped through the manuscript culture of libraries, silk weaving in Byzantium provides another history that shares much with book production. During the reign of Emperor Justinian (r. 527–65), sericulture was likely introduced to Byzantium through imported silkworm eggs from China or central Asia. Constantinople and its environs became one of the great silk weaving centers between Europe and Asia, and women in particular played an important role in the development and success of the industry there.[42] Silk was so precious in the eastern Roman Empire—as well as throughout the Mediterranean, the Middle East, the Indian subcontinent, and East Asia—that it was not only worn as an elite status symbol but also used to enshroud reliquaries, altars, and manuscripts. The binding of a Gospel book produced in the imperial workshops of Constantinople or Nicaea (present-day Turkey) consists of crimson-purple silk wrapped around wooden boards. The reader would have lifted a blue or purple silk veil to reveal the radiant miniature icon (devotional image) (fig. introduction.8). These trade connections link Byzantium not only with Central and East Asia but also with Western Europe, as illuminators often emulated Byzantine and other "Eastern" silk patterns on the purple-painted pages in manuscripts, as discussed above.

The Islamicate Worlds of Afro-Eurasia

Beyond Europe and the Mediterranean worlds of Byzantium, the term "medieval" has been applied with far less consensus or acceptance. Islamicists often contend with the notion of a so-called golden age that began shortly after the religion's inception in the seventh century and lasted until the sixteenth century or early modern period.[43] Thomas Bauer proposes that a global Middle Ages should emphasize the shared intellectual histories of the Greco-Roman-Persianate world when addressing Islamicate societies, rather than applying "medieval" to the history of early Islam.[44] Geographically, the Islamicate world engaged a vast territory, from the Iberian Peninsula and large swaths of Africa (coastal and interior) and throughout Central, Eastern, and Southern Asia (including India), and at times also encapsulated Christian and Jewish communities (in Armenia

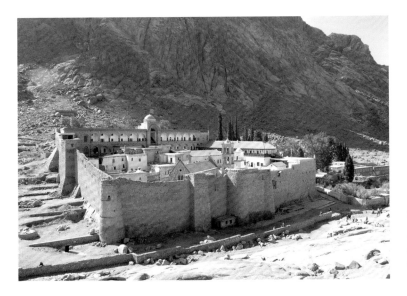

Introduction.7. Saint Catherine's Monastery, Sinai, Egypt

Introduction.8. *The Ascension* in a Gospel book, Nicaea or Nicomedia, Byzantium (present-day Turkey), early and late thirteenth century. Los Angeles, The J. Paul Getty Museum, Ms. Ludwig II 5 (83.MB.69), fol. 188

Introduction.9. Folio from the Blue Qur'an, North Africa (Tunisia?), ninth–tenth century CE / third–fourth century AH. Los Angeles County Museum of Art, The Nasli M. Heeramaneck Collection, gift of Joan Palevsky, M.86.196

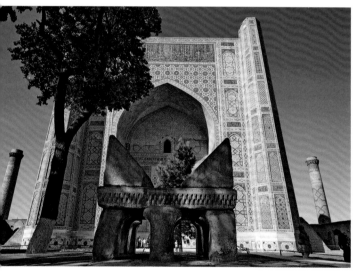

Introduction.10. Monumental Qur'an stand in the courtyard of the Bibi-Khanym Mosque, Samarkand, Uzbekistan, early fifteenth century CE / early ninth century AH.

or Egypt, for example, as elsewhere).[45] Multiculturalism has often loomed large over studies of the Iberian Peninsula in the Middle Ages, sometimes under the rubric of *convivencia* (coexistence) or more recently as *coincidencia* (coincidence), since Christians, Jews, Muslims, Africans, Arabs, and others lived in frequent exchange networks. We must also remember that the Arab, Persian, and Turkic empires of the same centuries—the Abbasids, Ghurids, Seljuqs, Timurids, and Safavids included— were astonishingly diverse.[46]

From the Horn of Africa to the greater Maghreb (and into Andalusia in the southern Iberian Peninsula), there is a long history of manuscript production for and by the *'Ahl al-Kitab* (people of the book), that is, the Abrahamic faiths of Judaism, Christianity, and Islam (see figs. I.1, II.4, 8.1, 8.2, IV.5, IV.8, 19.1, 19.2). One of the most famous early manuscripts from North Africa is the Blue Qur'an, probably made in Kairouan, Tunisia (perhaps for the Great Mosque), which was under Fatimid control around 900–950. Scholars have also assigned the now dispersed pages to Umayyad Spain, Kalbid Sicily, or Abbasid Iraq (fig. introduction.9).[47] The manuscript was likely colored with indigo dye rather than being submerged

in a liquid bath, as Jonathan Bloom has demonstrated,[48] and this process of simulating deep hues of blue, purple, or scarlet finds manifestations in Late Antique and Carolingian Europe, Byzantium, and South and East Asia (India and Korea, among other sites) (see figs. introduction.19, 7.1, 7.3, 7.4). It should be noted that women in the Maghreb played an important role in the establishment of mosques as sites of learning and writing. For example, the Qarawiyyin mosque in Fez was founded by Fatima al-Firhi (ca. 800–880), and her sister, Maryam al-Firhi, sponsored the al-Andalus mosque in Fez in 859.

Illuminated and oral Quranic cultures reveal the globality of the Islamicate world, similar to the discussion of Gospel books above. For example, in Samarqand, Uzbekistan, two of Shahrukh's children, Baysunghur (d. 1433) and Ulugh Beg (d. 1449), were respectively responsible for commissioning one of the largest Qur'ans ever produced in Islamic lands and a monumental lectern to support it (fig. introduction.10).[49] Although the manuscript was later tragically dispersed, the stone stand still dominates the courtyard of the Bibi-Khanym Mosque in Samarkand, originally constructed during Timur's reign. When we turn our attention to the African continent, it will be useful to consider Rudolph Ware's framework of the "Walking Qur'an,"[50] a methodological approach for examining embodied knowledge and Islamic education systems specifically in West Africa but with practical applications for the vast world of Islam, from al-Andalus to Guangzhou in China.

The combined Greco-Roman and Arabo-Persian heritage of the Islamicate world catalyzed a quest for the study, copying, and transmission of knowledge across time and space.[51] An Arabic copy of *De materia medica* (On Medicinal Material) by Dioscorides (first century CE), produced in 1224 CE / AH 621 possibly in Baghdad, Iraq, or northern Jazira, Syria, contains a section about the panacea-elixir *theriac* (fig. introduction.11).[52] Images of plants throughout the manuscript's pages followed Byzantine prototypes, combined with an interest in figural and architectural motifs common in art under the Abbasid Caliphate (750–1258). Descriptions in the manuscript of plants like terebinth, anise, rhubarb, and saffron allow the reader to mentally plot points on a map that would range from the Canary Islands and Morocco to Egypt and India.[53] The contents of a book as a map is a theme carried across this publication by several authors.

One of the great cartographic achievements of the twelfth century was the *Kitab nuzhat al-mushtāq fi'khtirāq al-āfāq* (The Book of Entertainment for He Who Longs to Travel the World), compiled by the Arab geographer Muhammad al-Idrisi (1099–1165) as an imperial commission of a silver tablet (measuring about twelve by five feet)—and eventually a book—for Roger II of Sicily (1095–1154).[54] Al-Idrisi followed Ptolemy's division of the world into seven climate zones and mapped an

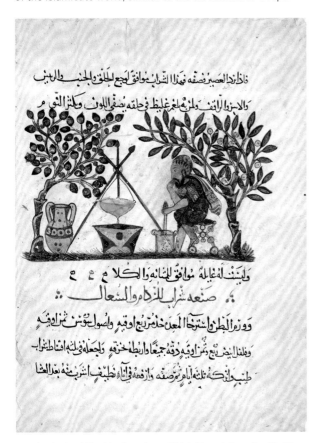

Introduction.11. *A Physician Preparing an Elixir* in *De materia medica* (On Medicinal Material) of Dioscorides, possibly Baghdad, Iraq, or northern Jazira, Syria, 1224 CE / AH 621. New York, The Metropolitan Museum of Art, Rogers Fund, 1913.152.6

Introduction.12. *Map of the World* in *Kitab nuzhat al-mushtāq fi'khtirāq al-āfāq* (The Book of Entertainment for He Who Longs to Travel the World) by Muhammad al-Idrisi, Maghreb (Morocco), late thirteenth or early fourteenth century CE / late eighth or early ninth century AH. Paris, Bibliothèque nationale de France, Ms. Arabe 2221, fols. 3v–4

Introduction.13. *Map of the World-Universe* in *Ajā'ib al-makhlūqāt wa gharā'ib al-mawjūdāt* (The Wonders of Creation and the Oddities of Existence) by Zakariya al-Qazwini, Istanbul, 1553 CE / AH 960. Washington, DC, The Library of Congress, Near East Section, African and Middle Eastern Division, 104

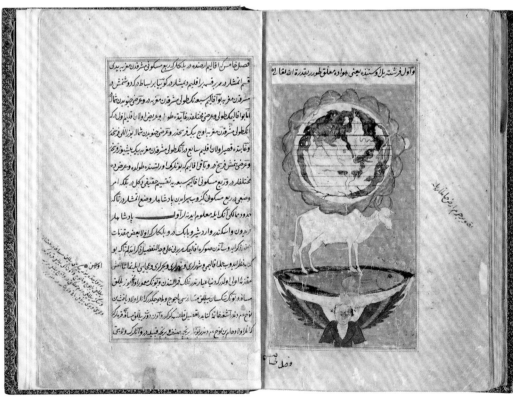

impressive picture of the earth in seventy sectional itineraries covering Eurasia and North Africa. A copy of the text from the late thirteenth or early fourteenth century, likely produced in the Maghreb (Morocco), is the earliest illustrated example to survive (fig. introduction.12). The full world map at the beginning of the manuscript is oriented south-to-north, and thus Eurasia and the Mediterranean are toward the bottom of the page while Africa and India are toward the top. Numerous islands are identified in the Atlantic, and all habitable land lies within 180 of the 360 degrees of the world's longitude (from Spain, Morocco, and Britain in the West to China, Java, and Ceylon in the East).[55] Reorienting our view of the world is often a useful exercise in considering new global perspectives.

Another astronomer-geographer whose writings, like those of al-Idrisi, enjoyed a long life in circulation was Zakariya al-Qazwini (1202–1283). In addition to his chronicle on the life of Saladin (1137–1193), he wrote the cosmographic text *Ajā'ib al-makhlūqāt wa gharā'ib al-mawjūdāt* (The Wonders of Creation and the Oddities of Existence), which discussed all astral phenomena, including weather, planetary movements, star charts, angels, and so forth. His world map was also oriented to the south, but it rests on an ox standing on a fish in a bowl of water held by an angel (fig. introduction.13).

The spiritual and metaphysical subtext of this image is that all knowledge is built upon previous traditions, ultimately reflecting the divine. As Persis Berlekamp has demonstrated, later editions of al-Qazwini's text—like the copy from Azerbaijan under consideration—incorporated passages about and images of talismans to increase the efficacy and protective power of the text-image relationship.[56]

Book Arts, Oral Traditions, and Material Networks across Africa

The written word represents a rich form of communication, memory, and art in Africa. The continent also has a legacy of oral tradition. The libraries at Timbuktu, Mali, for example, preserve manuscripts from about the late thirteenth century to the twentieth century, written in Arabic and local African languages (fig. introduction.14). Many of these codices identify the scribe, the proofreader, and the vocalizer (who would have added diacritical marks and other notation to indicate how a text should be recited).[57] This range of names effectively expands our knowledge of individuals and professions that contributed to Africa's rich textual history. Ibn Battuta (1304–1368/69) from Morocco wrote a firsthand account of his travels through Western and trans-Saharan Africa, the Middle East, and China; his contemporary al-Nuwayri

Introduction.14. Medieval manuscripts from Mali, Niger, Ethiopia, Sudan, and Nigeria at the home of Abdel Kader Haidara, director of the Bibliothèque Mama Haidara De Manuscripts, Timbuktu, Mali.

Introduction.15. Codex Leningradensis, Aaron ben Moses ben Asher (scribe), Cairo, Egypt, 1008–9. St. Petersburg, Russian National Library, Firkovich Collection, Hebr. II. B, 19a, fol. 476v

(1279–1333) penned the encyclopedic text *Nihayat al-arab fī funūn al-adab* (The Ultimate Ambition in the Arts of Erudition) in an attempt to record all knowledge that had come down to the people of Mamluk Egypt (r. 1250–1517), with references to places and products from as far away as the Indo-Malaysian archipelago.[58] Manuscripts therefore represent a rich tradition of artistic expression and intellectual preservation in Africa.[59] Similarly, the role of griots, or historian-storyteller-poets, must be acknowledged in the transmission of culture and history across West Africa. The most famous example is the epic of Sundiata Keita (ca. 1217–1255) of Mali, whose rule was attested to in the writings of Ibn Battuta and Ibn Khaldun (1332–1406).[60] Indeed, as Suzanne Blier has suggested, Africa was a key center in the long Middle Ages, as demonstrated not only by the impact of gold distribution by Mansa Musa (ca. 1280–ca. 1337) or the powerful image of the Ife king in local and global contexts, but also in an elastic context that allows us to see movement in multiple directions, from Mamluk Egypt to Ghana and northern Nigeria,

through archaeological finds in ceramics, or through the lens of the Black Death and slavery in relation to sub-Saharan Africa and greater Eurasia.[61] Furthermore, François-Xavier Fauvelle's book *Le Rhinocéros d'or* (2013) presents a history of medieval Africa constructed from written and oral accounts of the continent, beginning with a look at narratives about the Swahili coast of East Africa by the eighth-century Chinese writer Du Huan (*Jingxingji* or "The Account of My Voyages") or references on a stele recounting the voyages of Zheng He (1371–1433).[62] Museum exhibitions are also deepening our understanding about connections between African communities and the world, as in *Le Maroc médiéval: un empire de l'Afrique à l'Espagne* (Medieval Morocco: An Empire from Africa to Spain; Musée du Louvre, Paris, 2014);[63] *World on the Horizon: Swahili Arts across the Indian Ocean* (Krannert Art Museum, Champaign, Illinois, 2017);[64] and *Caravans of Gold, Fragments in Time: Art, Culture, and Exchange across Medieval Saharan Africa* (Block Museum of Art, Evanston, Illinois, 2019), to name a few.

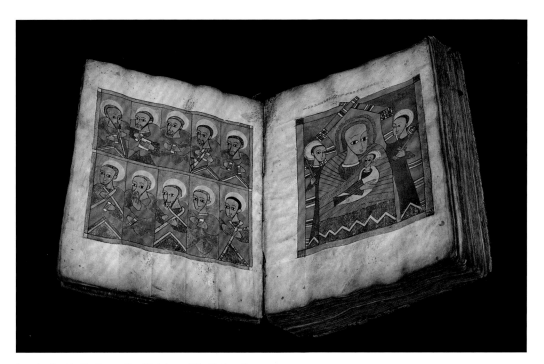

Introduction.16. *The Seventy-Two Disciples* and *The Virgin and Child with the Archangels Michael and Gabriel* in a Gospel book, Gunda Gundé Monastery, Ethiopia, 1480–1520. Los Angeles, The J. Paul Getty Museum, Ms. 105 (2010.17), fols. 9v–10

Trans-Saharan and Sahel Africa—from the Maghreb and Mali to Egypt and Ethiopia—were always connected to the worlds described in the sections above (Western and Central Europe, Byzantium, and the Islamicate world),[65] from the Roman or early Christian period of the fourth century well into the fourteenth century, when waves of plague took a toll on human life there,[66] and beyond into the colonial period.[67] A closer look at societies within the continent reveals empires and city-states whose economies were always trans-local and interdependent, as well as engaged in global networks. The written records of this medieval past—representative of the diffusion of the three Abrahamic religions (Judaism, Christianity, and Islam) throughout the continent—are preserved in libraries at Timbuktu, in mosques such as the one in Qairawan (Tunisia), for which the Blue Qur'an may have been produced, in monasteries like Abba Garima (Ethiopia), or in synagogue *genizot* (storage areas for worn-out or discarded Hebrew writings), as in Cairo (Fustat). Some of the earliest hand-stamped objects—talismans and amulets in Arabic—date to the ninth

century in Egypt, and this practice appears to have continued there until about 1430.[68] In addition, the oldest complete manuscript of the Hebrew Bible was written and decorated by Aaron ben Moses ben Asher in Cairo in 1008–9 (fig. introduction.15).[69] The micrographic Hebrew script constitutes a major development in manuscript layout and organization of the period, and the geometric patterns and so-called carpet pages (which imitate or emulate prayer rugs or carpets) reveal connections to Islamic art of the Fatimad Caliphate (909–1171) in the region.[70] Without the famous Cairo *genizah* (a storeroom of medieval Jewish texts), our knowledge of the medieval Mediterranean Basin would be far more limited in terms of the cost and time of travel or the intricacies of trade.[71]

In the highlands of Ethiopia, a late fifteenth-century Gospel book from the Gunda Gundé monastery contains a sequence of serial representations of prophets from the Hebrew Bible, the apostles (including the biblical Philip the Deacon, who converted a eunuch of Empress Candace of Ethiopia), and the seventy-two disciples sent out by Christ (fig. introduction.16).[72]

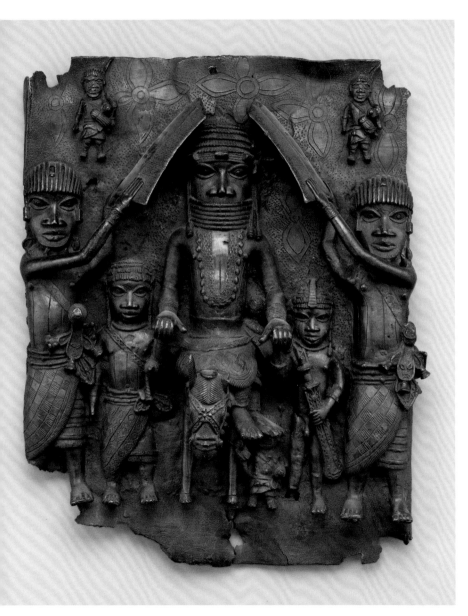

Introduction.17. Plaque with an equestrian Oba and attendants, Edo peoples, Kingdom of Benin, Nigeria, 1550–1680. New York, The Metropolitan Museum of Art, The Michael C. Rockefeller Memorial Collection, Gift of Nelson A. Rockefeller, 1965, 1978.412.309

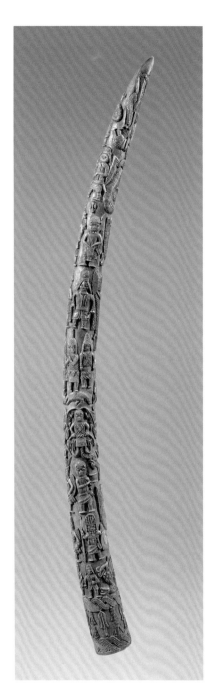

Introduction.18. Altar tusk, probably commissioned by Oba Osemwende, Edo peoples, Kingdom of Benin, Nigeria, early nineteenth century. Los Angeles, Fowler Museum at UCLA, X65.9129

Following this set of images, the Virgin Mary sits enthroned as Queen of Heaven, holding the baby Jesus, between two militant archangels. This iconic image can be connected to the court of Emperor Zar'a Ya'qob (r. 1434–68) and Empress Eleni (d. 1522), whose patronage championed the visual tradition of Mary flanked by archangels at a time when Italian artists were traveling to and working in Ethiopia, including Nicolò Brancaleon (ca. 1460–after 1526). Such manuscript genealogies connected rulers and monks to an even earlier period when individuals from the Judeo-Christian tradition interacted with this region on the Horn of Africa (King Solomon, for example, was said to have received spices and rarities from the Queen of Sheba, who was believed to rule over Ethiopia).

Beyond the pages of manuscripts, the more than nine hundred brass plaques and hundreds of sculptures from the palace of the Oba (or king) in Benin City, Nigeria, produced from the thirteenth century onward, provide a wealth of historical information about the Kingdom of Benin's relationship with greater Africa, Europe, and the Indian Ocean world (fig. introduction.17). They are also powerful reminders of the long shadow of colonialism, as more than two thousand of the Benin bronzes can be found in seven museums alone: in the United Kingdom (700 in the British Museum; 327 in the Pitt Rivers Museum at Oxford), Germany (580 in the Ethnological Museum of Berlin; 196 in the Museum of Ethnology in Hamburg; 182 in the Museum of Ethnology in Dresden), Austria (200 in the Weltmuseum in Vienna), and the United States (163 in the Metropolitan Museum of Art in New York).[73] Some scholars have suggested that the format of the plaques may have been inspired by European manuscripts, and indeed their arrangement in pairs on columns leading to the throne room of the Oba served ceremonial, political, and commemorative functions.[74] Numerous panels show the Oba or his representatives in the presence of other African or European peoples, particularly the Portuguese, and bronze heads or ivory masks of Iyobas (queen mothers) attest to the status of ruling women in West Africa. These plaques chronicle the history of the kingdoms of the Oba and Iyoba, from medieval to modern times.

Sub-Saharan Africa was also intricately enmeshed in far-afield trade relationships and in actively recording historic time. The luxury objects that survive from the many cultures that make up the tropical and coastal regions—such as carved ivory tusks of the Edo peoples (fig. introduction.18) or the Luba *lukasa* (memory aids)—demonstrate what scholars have termed heterochronicity, or different modes of articulating, measuring, or documenting historic time.[75] What we might call the material worlds of medieval Africa consisted of gold and ivory, among others, exported transcontinentally and throughout the Mediterranean and Indian Ocean realms, in addition to textiles and ceramic vessels imported from as far away as Portugal or China. Pottery sherds found on the island of Kilwa in Tanzania along the Swahili coast or at the Great Zimbabwe, the largest collection of ruins south of the Sahara (see fig. IV.10), link Eastern Africa to the Chinese imperial workshops of Jingdezhen; and a Ming coin discovered on Manda Island in Kenya provides another tantalizing glimpse of the future potential for writing all of Africa into premodern history, especially since manuscripts in a range of languages from the continent—as in the *Kitab al-Sulwa* (Kilwa Chronicles)—and oral accounts attest to these links, exchanges, and blendings of culture and materials.

Manuscript and Textual Communities of Greater Asia
Often described as the crossroads of Europe and Asia, historic Armenia and the Armenian kingdom of Cilicia (founded in 1198) held tenuous but important places between the many empires or polities of the medieval world, to which manuscripts often attest. The Etchmiadzin Gospels, for example, is a composite manuscript whose four opening illuminations on two older, inserted leaves and the ivory plaques on the covers were likely produced in the sixth century, while the rest of the manuscript was produced in 989 at the monastery of Bgheno-Noravank in Siwnik', Armenia.[76] The depiction of the three Magi on one of the pages (and again on one of the ivory plaques of the binding) follows conventions from late Roman and Byzantine art for clothing foreign or "Eastern" figures, like Scythians and Sasanian Persians.[77] Elsewhere in this volume,

greater Armenia will be addressed by way of manuscripts created during Mongol (twelfth to thirteenth century) or Safavid rule (sixteenth to seventeenth century), demonstrating the shifting geography of what we might call medieval Armenia.

Turning to South Asia, scholars referring to medieval India and neighboring regions generally address a span of time from the eighth through the eighteenth century, that is, from the Chola Empire to the colonial period. The Delhi Sultanate (1206–1526) has been seen as one of the most formative periods of artistic, literary, and book production prior to Mughal rule (1526–1857). For textual communities, India's bibliographic history has sometimes been divided into Vedic, Buddhist, Muslim, and Christian periods.[78] The history of the subcontinent is at times framed by points of contact with the many cultures of Asia and the broader Indian Ocean nexus.

In a thirteenth-century Nepalese *Pancharaksha* (Five Protective Charms) manuscript, the seated Buddha Shakyamuni makes a gesture of charity or compassion with his proper right hand (fig. introduction.19). The çintamani design of three orbs or dots can be seen in the background of the pages, as well as on the cloth that extends from the Buddha's throne. The concept of this wish-granting or protective jewel originated in Hindu and Buddhist sacred texts, but eventually the motif became a favorite pattern on luxury textiles throughout East Asia, the Persian Empire, the Islamicate world, and Europe. Pictorial depictions of the design appear in Buddhist paintings from Dunhuang to Tibet, Bihar, and elsewhere; representations in sculpture can be found on the Sasanian tombs at Naqsh-e Rustam, northwest of Persepolis, Iran; and the textile pattern was represented on garments of holy figures

Introduction.19. Buddha Shakyamuni (top), Goddess Mahasitavati (middle), and Goddess Mahasahasrapramardini (bottom), folios from a *Pancharaksha* (Five Protective Charms), Nepal, early thirteenth century. Los Angeles County Museum of Art, From the Nasli and Alice Heeramaneck Collection, Museum Associates Purchase, M.72.1.25a–c

Introduction.20. *Mandala of Mahavira* in a *Kalpasūtra* (Book of Sacred Precepts), Gujarat, India, sixteenth century. Pasadena, California, Norton Simon Museum, Gift of Narendra and Rita Parson, P.2006.03 .70; .74

Introduction.21. *Krishna Uproots the Parijata Tree*, folio from a *Bhagavata Purana* (Ancient Stories of the Lord), Delhi region or Rajasthan, India, 1525–50. Los Angeles County Museum of Art, From the Nasli and Alice Heeramaneck Collection, Museum Associates Purchase, M.72.1.26

in European art as early as the ninth century in the Book of Kells.[79] The borders around the *Pancharaksha* scenes are closely related to cotton and silk textiles from India and the Islamicate world, specifically in Persia.

For members of the Svetambara Jain religion, one of the oldest belief systems in India, the most sacred text is the *Kalpasūtra* (Book of Sacred Precepts), which records the lives and legends of the twenty-four Jina-Tirthankaras (conquerors or liberators), who have achieved liberation from the endless chain of birth and rebirth. Every year during Paryushana—an eight-day festival when the laity of the Jain religion vow to temporarily fast and study sacred texts—the white-clad Jain monks read aloud passages from the text. Multicolored and

sometimes beautifully patterned silk veils once covered each of the more than one hundred paintings in a *Kalpasūtra* manuscript from Gujarat, providing an additional haptic quality of revealing and concealing the venerated images (fig. introduction.20). Indo-Egyptian and Indian Ocean trade networks contributed to the spread of sericulture across vast distances, as we saw with Byzantium above. As Ina Baghdiantz McCabe has demonstrated, Armenian silk weavers worked for wealthy merchants in regulating the sericulture trade along the many Silk Roads.[80]

Early Hindu manuscript painting from the pre-Mughal period is rare, but several pages from a copy of the *Bhagavata Purana* (Ancient Stories of the Lord)—a central text for Vaishnavas (those who believe in the supremacy of Vishnu, or

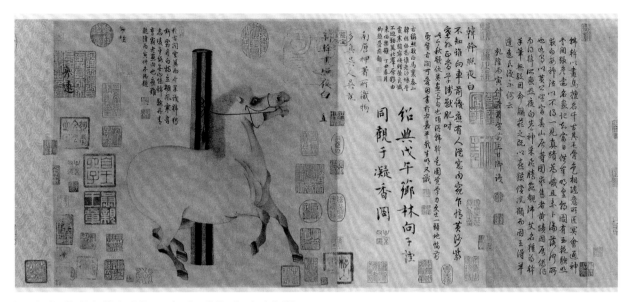

Introduction.22. *Night-Shining White* on a handscroll, Han Gan (artist), China (Tang dynasty), 750. New York, The Metropolitan Museum of Art, Purchase, the Dillon Fund Gift, 1977, 1977.78

Krishna)—survive from about 1525–50 (fig. introduction.21). Unlike earlier Hindu book arts that followed the format of Jain or Buddhist palm-leaf manuscripts, the *Bhagavata Purana* consisted of a new format, with text on the verso of the page and illustrations on the recto.[81] Produced in Rajasthan, an area known for its large Jain population, this Hindu manuscript once consisted of more than two hundred illustrations whose style was prized by the Mughals. The tradition for illustrated manuscripts in India is also rich in examples made for communities of Christians (from the first centuries CE), Muslims (from the eighth century CE), and Sikhs (a tradition that emerged in the second half of the fifteenth century CE).[82]

In East Asia—specifically China, Japan, and Korea—manuscripts and printed materials are ideologically treated together in what has sometimes been called a medieval period.[83] Printing during the Tang dynasty (founded 618) represents a hallmark in world history,[84] as in the famous portrait of Night-Shining White, the preeminent horse of Emperor Xuanzong (r. 712–56), painted by Han Gan (ca. 706–783) (fig. introduction.22). Horses contributed to long-distance trade, specifically in luxury commodities during the Tang dynasty. The handscroll—on paper, silk, or cotton—constitutes an important format for the recording of text and image in East Asia,

and the legacy of such objects can be seen through evidence of use and ownership (Han Gan's painting, for example, features seals from Tang, Song, and Qing emperors, as well as members of their courts, Ming officials, and Japanese envoys).[85] The Library Cave at Dunhuang, sealed around 1000, preserved a rich array of visual and philosophical traditions through scrolls and other textual objects, including texts written or printed in Chinese, Old Uygur (Old Turkic), Tibetan, Tangut (a Tibeto-Burman language), and Hebrew (fig. introduction.23). A fragment from the Buddhist text of the *Daśakarmapathāvadānamālā* (Garland of Legends Pertaining to the Ten Courses of Action, fig. introduction.24) was written in the Uygur script and followed the palm-leaf format typical of South and Southeast Asian books. The history of the book and of trade along the Silk Roads is enriched by the preservation of manuscripts at Dunhuang.

The centuries from the Tang and Song to the Ming dynasties (the Ming founded in 1368) in China, or from the Heian and Kamakura periods (794–1185; 1185–1333) to the early Muromachi in Japan (1333–1573), or Unified Silla to the start of the Choson (Joseon) period in Korea (ca. 668–1392), were moments of considerable movement along the roadways and waterways of commerce, known collectively as the Silk Roads,

Introduction.23. Mogao Caves
16–17 (Library Cave), Dunhuang,
Gansu province, China, 862 (sealed
around 1000). Photo courtesy of
Dunhuang Academy

Introduction.24. *Monks in Prayer,
Encircled by a Serpent and a
Sinner in Flames* in *Daśakarmapa-
thāvadānamālā* (Garland of Leg-
ends Pertaining to the Ten Courses
of Action), Dunhuang, Gansu
province, China, tenth century.
New Jersey, Princeton University
East Asian Library Dunhuang and
Turfan Collection, the Gest Collec-
tion, PEALD 6r

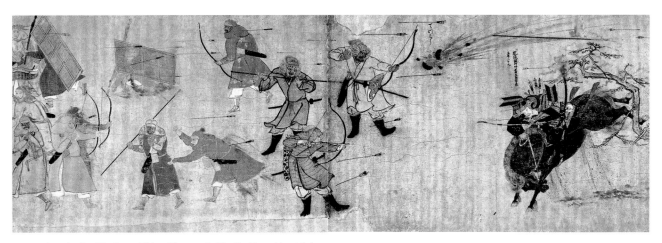

Introduction.25. *Samurai Takezai Suenaga Fighting the Mongol Army during the Battle of Brun'ei in 1274* on a scroll of the *Mōko shūrai ekotoba* (Illustrated Account of the Mongol Invasion), Japan, 1293. Tokyo, Imperial Palace, Museum of the Imperial Collection

from the Pacific to the Atlantic.[86] The flowering of painting and book creation during the Northern Song dynasty in China, beginning in 960 and ending around 1279, has been termed a renaissance.[87] The thirteenth century saw the emergence of the Mongols and the movements of their successors (Chagatai Khanate, Golden Horde, Ilkhanate, and the Yuan dynasty) across Eurasia into the following century, effectively ending the renaissance just mentioned. The *Mōko shūrai ekotoba* (Illustrated Account of the Mongol Invasion, fig. introduction.25) handscrolls record the Mongol invasions of Japan, with a famous standoff between the invading archers and bombardiers with samurai Takezaki Suenaga (1246–1314).[88] To the west, the Mongol presence reached into central Asia or Europe, as visualized in numerous illuminated manuscripts (see fig. 15.2).

Worlds Together, Worlds Apart: The Americas in a Medieval Framework

The term "medieval" has not been easily applied to the Americas or many parts of Oceania and Australasia, regions that developed largely independently of the interwoven socioeconomic nexus of greater Afro-Eurasia.[89] For Mesoamerica, the period of about 900 to 1521 is rarely discussed under the rubric of "medieval" but more traditionally as Postclassic, whereas the chronology of the Central Andes from 600 to

1532 is referred to as Middle Horizon (600–1000), Late Intermediate Period (1000–1470), and Late Horizon (1470–1532).[90] The endpoints of these civilizations are marked by conquest and destruction. An attempt will be made in this volume to include these seemingly distant cultures under the rubric of "worlds together, worlds apart."[91] The fortuitous survival rate of Afro-Eurasian manuscripts (with the exception of tropical regions) contrasts greatly with the limited number of codices from the Americas prior to the centuries of genocide and hegemony (of conversion or subjugation through institutionalized slavery), a reminder of the sinister effects of cultural destruction in the wake of transatlantic travel.

The Aztec, Maya, Inca, Mississippian, and other Amerindian peoples were connected by commerce and through a network of rivers, coastal routes, and overland roadways (likely used for religious functions; for example, processions and pilgrimages). Many Mesoamerican and Andean societies had rich literary traditions, some of which were written, decorated, and bound in codices or screenfold books at a time before contact with Europeans, and which continued to be produced long after, often with a mixing of Amerindian and European motifs and ideas.

The most prized objects of Mexico's indigenous elite Aztec rulers were remarkably catalogued in the Codex Mendoza, most likely created for Don Antonio de Mendoza

(1495–1552), the first viceroy of New Spain around 1542 (fig. introduction.26).[92] The contents of the manuscript provide a cautionary tale about Spanish colonial rule: beyond the brightly colored paintings of turquoise, feathers, skins, and textiles, or the descriptions of the multiethnic societies of Mexico and Central America, there is a history of conquest and exploitation—first, those of the Mexica rulers (*tlatoani*) described in the text, and then through the subtext of history, whereby the Aztec themselves were conquered by the Spanish. The roughly contemporaneous Codex Tepetlaoztoc (Codex Kingsborough, 1554) portrays some of the more gruesome realities of Spanish rule, such as Hernán Cortés (1485–1547) ordering four Nahua nobles to be burned alive.[93] Life for indigenous peoples in the contact zones of the Americas was fragile and precarious.

Among the earliest illustrated accounts of Inca and Spanish colonial Peru are texts written by the Spanish (Basque) Mercedarian friar Martín de Murúa (ca. 1525–ca. 1618). Murúa intended to educate the Hapsburg monarchy in Madrid about the so-called New World Andean civilization. The artists paid careful attention to the multicolored textiles of the Inca rulers through thirty-four full-page watercolor illustrations (see fig. II.7). In several instances throughout the manuscripts, the artists embellished weaponry and garment accessories with silver, which coincidentally was a major export product to European courts from the mining city of Potosí near La Plata (Sucre, Bolivia), a city named after the Spanish word for the precious metal. Arriving in Europe, Inquisitorial censors redacted passages from Murúa's text that even hinted at failed missionary attempts in the Southern Hemisphere.[94] An illustrated chronicle written from the perspective of Felipe Guaman Poma de Ayala (ca. 1535–after 1616), a Quechua nobleman, cast Murúa as brutal and covetous, and depicted him beating a female weaver (fig. introduction.27)—a valuable lesson on the multiple perspectives of historical voice and an important lens into the violent history of misogyny and the male gaze (evoked above with the example of Bahram Gur).

Petroglyphs, pictographs, and painted cave or rock art made by indigenous North American peoples span the period of the Middle Ages, with examples predating and postdating this moment of historic time. Archaeo- and ethnoastronomers have advanced global connections between a supernova that occurred in 1054 (SN 1054, the Crab Nebula) and North Amerindian petroglyphs and cave paintings, as well as texts that may describe the same fantastic cosmic event from Japan (the diary of Fujiwara no Teika [1162–1241]), China (in the *Lidai mingchen zouyi* (Memorials and Disputations of Famous Officials throughout the Ages [ca. 1416]), Iraq (the writings of Ibn Butlan [1038–75]), and Central Europe (including an illustrated copy of the *Historia septem sapientum* [The Seven Wise Masters], decorated by the same follower of Hans Schilling in Hagenau discussed in the prologue [see prologue.1]).[95] The Shoshone-Bannock peoples of Idaho's Snake River Valley, for example, may have carved a similar event into the so-called Map Rock and surrounding basalt deposits (fig. introduction.28).[96] Indigenous perspectives about glyphic arts emphasize that native cultures are not stagnant, and that cultural memory and oral tradition can help connect the present with the deep history of the past.[97] These artifacts—manuscripts and petroglyphs—are sites of local expression that require interpretation based on a particular cultural context, notwithstanding the possible global connections that emerge. There is much potential to expand this kind of study within the framework of the global Middle Ages, as long as we are willing to think creatively and expansively about the remit of our fields of study.

Carved amuletic pendants and painted earthenware vessels from across the Plains, the Southeast Woodlands, and along the Pacific and Atlantic coasts preserve decorations of signs and symbols, which connect to a complex array of beliefs and traditions that are as diverse as the groups who lived across this hemisphere.[98] The rattlesnake design on a shell pendant from a mound on Chickamauga Creek in Tennessee, for example, is both local and transregional, with links to other Mississippian sites, including the great city of Cahokia (fig. introduction.29).[99] Integrating the corpus

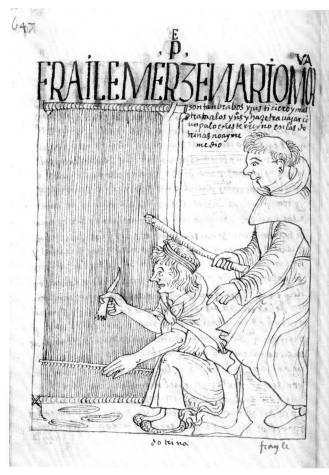

Introduction.26. *Tribute from the Provinces to the Spanish Empire* in the Codex Mendoza, possibly Francisco Gualpuyogualcal and Juan Gonzalez (artists), Nahua and Spanish culture, Mexico City, 1542. Oxford, Bodleian Library, Ms. Arch. Selden A. 1, fol. 46

Introduction.27. *Martín de Murúa Beating a Female Weaver* in *Nueva crónica y buen gobierno* (New Chronicle and Good Government) by Felipe Guaman Poma de Ayala, Peru, 1615/1616. Copenhagen, Denmark, Det Kongelige Bibliotek, GKS 2232 4º, fol. 661

Introduction.28. Map Rock petroglyph, Shoshone-Bannock People, Givens Hot Springs, Canyon County, southwestern Idaho, 1054. Photo: Kenneth D. and Rosemarie Ann Keene

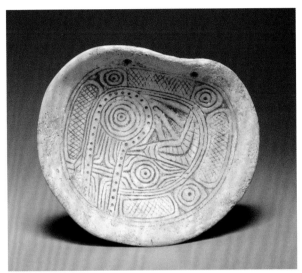

Introduction.29. Pendant with serpent design, Mississippian, Tennessee, thirteenth–fourteenth century. New York, The Metropolitan Museum of Art, The Michael C. Rockefeller Memorial Collection, Bequest of Nelson A. Rockefeller, 1979, 1979.206.446

of visual material mentioned briefly in this section into the framework of a global Middle Ages might be possible if we follow the approaches of anthropologists, archaeoastronomers, climate scientists, linguists, historians of agriculture and disease, or the sociological approach advocated by Raewyn Connell's Southern theory (that is, social thought *from* societies in the Southern Hemisphere).[100]

A Sea of Islands: Australasian and Pacific Networks in the Tropics

Relatively few premodern books survive from tropical Africa and Australasia due to climate change, volcanic eruptions, and the susceptibility of organic materials to decay in such conditions.[101] An 1157 Javanese translation of the *Mahābhārata* (The Great Tale of the Bhārata Dynasty), known as the *Bharatayuddha*, is a rare early example of a decorated palm-leaf manuscript from Indonesia.[102] The oldest datable manuscript in the Austronesian dialect of Malay, for example, is the *Nītisārasamuccaya* (Compendium of the Essence of Policy,

also known as the Tanjung Tanah, see fig. 5.1), a legal text with Sanskrit passages also from Jambi, Sumatra (western Indonesia), where it is housed. The text is written on mulberry bark paper, which was radiocarbon dated to about 1345–77. Travel throughout the Pacific and Indian Oceans was extensive during the period covered by the present publication, not only between communities and empires of East and Southeast Asia but also between Australia, New Zealand, Melanesia, Micronesia, and Polynesia.[103] These Australasian networks—in a "sea of islands"[104]—are best conveyed in epic poems (*kakawin*) such as the Javanese text of the *Deśawarṇana* (The Depiction of the Districts), written in 1365 by Mpu Prapañca (active fourteenth century). The Buddhist monk-author describes the vastness of the Hindu-Javanese Majapahit kingdom, including perhaps the earliest reference to New Guinea.[105] The Chinese text *Yingya shenglan* (The Overall Survey of the Ocean Shores) provides a reciprocal account of this kingdom's domain within a global context. It was written as early as 1416 by Ma Huan (ca. 1380–1460), a Muslim-Chinese interpreter who accompanied Zheng He (1371–1433) on his voyages, and it describes the vastness of the connecting seas

from Champa (Vietnam) to Calicut (India) to Mecca (Arabian Peninsula, present-day Saudi Arabia).[106]

For many of the cultures that constitute the island nations of the Pacific, oral tradition remains one of the strongest links to deep historic time, if one considers time unbound by constraints from beyond the diverse ocean realm. Descriptions of the life of Vanuatu chief Roy Mata, who united several island tribes in the thirteenth and fourteenth centuries, helped archaeologists to tentatively locate the ruler's tomb.[107] In New Zealand, the ancestors of the present-day Māori arrived on the islands around 1100, and some of the earliest surviving objects are stone carvings and wooden drums and boxes that visualize aspects of Māori history that would have been transmitted orally for generations. A *papa hou* (votive or treasure box, fig. introduction.30) from as early as 1500 (to around 1800) depicts the story of creation, scenes that would have been carefully carved using a *whao* (a chisel or scriber—a poignant linguistic association between sculpting and writing). Such objects were worn as adornment and could also serve an amuletic function. Across the vast Pacific, linguistic analysis of the relationship between local words for sweet potato, for

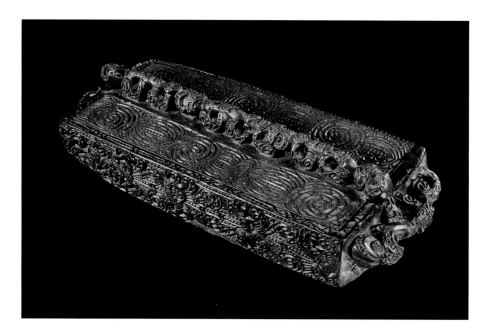

Introduction.30. *Papa hou* (treasure box), Northland, New Zealand, 1500–1800. Wellington, The Museum of New Zealand, Te Papa Tongarewa, WE000864

example, and ethnobotanical studies of the genetic strands of the plant suggest a promising hypothesis for contact between people in the tropical Americas and Australasia during the medieval period (beginning around 1000–1100).[108] Trade in spices, gems, flora, and fauna provide further insights into the global reach of materials from the Indian Ocean world, island Southeast Asia, and greater Australasia.[109] An enticing example is the appearance of four cockatoos—known to live throughout Indonesia east of Java or New Guinea—in a copy of *De arte venandi cum avibus* (On the Art of Hunting with Birds), datable to the last years of the reign of the Holy Roman emperor Frederick II (r. 1194–1250).[110] The avian specimens provide a cautionary tale of how the possibilities of a global Middle Ages can be distorted, as evidenced by social media posts and online news outlets that sensationalize the connections between medieval Europe and Australia without nuancing the numerous island civilizations that contributed to long-distance global trade throughout the premodern world. We should recall that parrots and peacocks are described in Pliny the Elder (first century) and Isidore of Seville (seventh century) as coming from India or parts of Africa, respectively, and that these birds found their places in manuscripts of the Greek *Physiologus* (from the second century onward) and the Latin bestiary (from the twelfth century onward). The colorfully plumed birds are also discussed in the thirteenth-century Yuan Chinese treatise with Arabic source material called the *Huihui yaofang* (Prescriptions of the Hui [Uygur]), and in the Yuan book *Yinshan zhengyao* (Essential Knowledge for Feasting and Drinking) by Hu Sihui (active 1314–30).

Ornithological migration, trade, and gift giving reveal much about an interconnected world. The "medieval tropics" were always intimately part of the medieval world.[111]

> "The field of medieval studies speaks to the urgencies of the present while looking at the past." —Geraldine Heng[112]

The above discussions advocate that future studies of a global Middle Ages should include every corner of the globe, whether or not a place is connected to large- or small-world systems and whether or not artistic or written records survive. Keeping in mind the challenges of periodization and of writing global and inclusive histories, this book offers the reader tools, methodologies, and frameworks for interrogating or testing the idea of a global Middle Ages. The aim is to emphasize the polycentric and multivocal entanglements of a world without a center through the vestiges of written and illustrated arts. There are certainly other approaches for addressing the vast chronological and geographic scope covered by this volume, and for addressing other forms of writing or oral tradition. I welcome continuing this dialogue across disciplinary lines, and I am committed to advocating for greater inclusion and diversity of perspectives.

Author's note: My interest in a global Middle Ages, before I knew the full weight of this field, was sparked in 2006 when I worked as a museum educator at the J. Paul Getty Museum and consulted the following texts when planning a course called "East/West Connections in the Getty Collection": Kaplan 1985; Mellinkoff 1993; Brotton 1997; Mack 2002; Hess, Komaroff, and Saliba 2004; Jardine and Brotton 2005; Monnas 2008. My initial thoughts on the subject were published in Keene 2016 and Keene and Conger 2018.

1 Evans and Marr 2006.
2 Chelkowski 1975.
3 For discussions of the concept of race in the Middle Ages, see T. Hahn 2001, 1–37; Lomperis 2001, 147–64; Rubiés 2009; G. Heng 2011a, 258–74, 275–93; G. Heng 2015, 358–66; Mittman 2015, 6–51; Whitaker 2015, 3–11; Whitaker 2016; D. Kim 2016; Lomuto 2016; "Race, Racism and the Middle Ages" series 2017.3
4 See Beecroft 2016, 17–28.
5 I am grateful to Kristen Collins for journeying with me to Stockholm to research global connections in book arts and portable objects. For the quote, see https://stomouseio .wordpress.com/2015/11/18 /sweden-history-museum -hidden-histories-lgbtq-at-the -swedish-history-museum -wednesdays-1100-2000/.
6 For global book history, see Burlingham and Whiteman 2001; Eliot and Rose 2007; Vallet, Aube, and Kouamé 2013; Watts 2012. For discussions of manuscript cultures of the European Middle Ages, see Schleif and Schier 2016; Wallis and Wisnovsky 2016; Johnston and Van Dussen 2015; Bromilow 2013; Kelly and Thompson 2005. For global book cultures, see Alfonso and Decter 2015;

Helman-Wazny 2014; J. Kim 2013. For spices and pigments, see Lopez and Raymond 1990; Cannuyer 1992; Halkiu 2017.
7 The following journals are dedicated to producing volumes dedicated to a global Middle Ages: *The Medieval Globe* and *Medieval Worlds Institute for Medieval Research*. For scholarship on the global Middle Ages, including theories of hybridity, see Linehan and Nelson 2001; Winks and Ruiz 2005; Hourihane 2007; Institut du Monde Arabe 2008; Weiss and Salih 2009; Canepa 2010, 7–29; Caskey, Cohen, and Safran 2011; A. Walker 2012, 183–96; Bagnoli and Gerry 2011; Schüppel 2014, 48–63; Heng and Ramey 2014, 389–94; G. Heng 2014, 234–53; Borgolte 2014; McClure 2015; Moore 2016, 80–92; Burke 2016; Keene 2016; Normore 2017; Keene and Conger 2018; Holmes and Standen 2018. For theoretical (re)considerations of the global turn and periodization of ancient art, see Alcock, Egri, and Frakes 2016; Colburn 2016, 1–11. For a critique of global art history, see Pollock 2014, 9–23; Mukherji 2014, 151–55; Mattos 2014, 259–64; Holmes and Standen 2015, 106–17.
8 *Crossroads: Traveling through the Middle Ages* (2017) at the Allard Pierson Museum, Amsterdam, was an admirable example of a museum exhibition presenting a holistic view of medieval Mediterranean movements of people, objects, and ideas.
9 *Care and Conservation of Manuscripts* is a series of proceedings from the international seminars on book preservation held at the University of Copenhagen (edited by Gillian Fellows-Jensen, Peter Springborg, and Matthew James Driscoll).

10 See Turner 1998; Turner et al. 2001; Turner, Phipps, and Trentleman 2008; Turner and Trentleman 2009; Turner and Schmidt Patterson 2017; Turner 2018.
11 For a combination of art history and technical art history related to global book arts of the medieval period, see Panayotova and Ricciardi 2018.
12 Higgins 1997; Rubiés 2002; Euben 2006; Khair 2006; Mancall 2006; Kinoshita 2007, 61–75; Touati 2010; Porter 2012; Kinoshita 2017, 223–46.
13 Oxford's World History series includes Findley 2005; Lockard 2009; Austen 2010; Liu 2010; Golden 2011; Alpers 2014. See also Gunn 2003; Nortrup 2005; Sassen 2006; Boucheron 2009; Howard 2012; Marks 2015.
14 Elkins 2002; Summers 2003; Carrier 2008; Zijlmans and van Damme 2008; Bell 2010; P. Wood 2013; Casid and D'Souza 2014; Gludovatz, Noth, and Rees 2015.
15 Franklin 2014; Trivellato, Halevi, and Antunes 2014.
16 Braudel 1949; Braudel 1978, 243–61; Buchthal 1983; Hoffman 2007; Abulafia 2013.
17 Biddick 1998; J. Cohen 2000; Holsinger 2002, 1195–227; Utz and Swan 2004; Kabir and Williams 2005; Davis and Altschul 2009; Lampart-Weissig 2010; Stahuljak 2010, 255–74; Richards and Omidvar 2014; Warren 2014, 281–91.
18 Preiser-Kapeller's work in this area is vast and important. Of particular note are "Complexities and Networks in the Medieval Mediterranean and Near East (COMMED)" and "Mapping MEDieval CONflicts: A Digital Approach towards Political Dynamics in the Pre-Modern Period" (see http://oeaw.academia.edu /JohannesPreiserKapeller). See also Preiser-Kapeller and Mitsiou 2011; Pomeranz 2012,

245–69; DaCosta Kaufmann, Dossin, and Joyeux-Prunel 2015.
19 Connell 2007.
20 See Kinoshita 2004, 165–76; Riello and Gerritsen 2016. To take just one example—the color blue—see *Afrique bleue: Les routes de l'indigo* 2000; Petrossian and Roussel 2006; Balfour-Paul 2010; Legrand 2012; Blondeau 2014.
21 There are currently at least a half dozen art history graduate programs dedicated to the study of the global Middle Ages, at institutions in Europe such as Oxford University, Cambridge University, the University of Edinburgh, Heidelberg University, and the University of Zurich, as well as programs in North America, including Stanford University, the entire University of California network, the University of Pennsylvania, the University of Texas at Austin, and elsewhere. Faculty at the University of Toronto and Guangzhou Academy of Fine Arts in China partnered to develop graduate seminars in "Global and Postglobal Perspective on Medieval Art and Art History" as part of the Getty Foundation's Connecting Art Histories initiative. A faculty research group at the University of Sydney is dedicated to the global Middle Ages. The University of California initiated the working group "The Middle Ages in the Wider World" in 2017. Interdisciplinary conferences have been convened at some of the aforementioned institutions (in 2007 at the University of Texas, in 2009 at Oxford, in 2019 at the University of Pennsylvania) as well as at several other universities and museums (in 2015 at Northwestern University and in 2016 at the Getty Museum, for example). Annual gatherings such as the

Medieval Academy of America, Leeds Medieval Congress, the Medieval Association of the Pacific, the Renaissance Society of America, and others have included numerous sessions on premodern globality in the last half decade alone.

22 For one approach to "worlding" (with related bibliography), see Kinoshita 2009, 39–52.

23 To provide just two examples, see Ginsburg 1989; Brooks 2008. See also Sindbæk 2007, 59–74.

24 Abu-Lughod 1989; M. Green 2017.

25 The *Vinland Sagas* include the *Grœnlendinga saga* (Greenland-ers' Saga), which is contained within the Codex Flateyensis (Copenhagen, Royal Library, MS Gks 1005), and *Eiríks saga rauða* (Eirik the Red's Saga), which is found in manuscripts in Reykjavík (Stofnun Árna Magnússonar Institute for Icelandic Studies, MS AM 544 4to and MS AM 557 4to). See G. Heng 2018, 257–86.

26 Frank 1998.

27 Belich 2016, 93.

28 Chakrabarty 2000.

29 MacEachern 2016, 90–103.

30 A. Murray 2004, 1–22.

31 The leading voice in the fields of climate and disease history is Monica Green, professor of medicine and health at Arizona State University.

32 Greenblatt 1991, 9.

33 Boone 1994, 3–26.

34 Linehan and Nelson 2001, 2.

35 For overviews of Christianity in the Middle Ages, see Swanson 2015; Rubin and Simons 2009; Beihammer et al. 2008; Noble and Smith 2008. For overviews of Byzantine Christianity, see Geanakoplos 1966; Goss 1986.

36 Lowden 1992, 40–53.

37 Epstein and Lachter 2015.

38 Myers and McMichael 2004.

39 For Byzantium's marginaliza-tion, see Nelson 1996, 3–11; Peers 2010, 77–113; Boeck

2015. For critical responses to the presentation of African art in museums, see Vogel 2004, 653–85; Berzock and Clarke 2011.

40 For "Worlds of Byzantium" program and abstracts, see https://www.doaks.org /research/byzantine /scholarly-activities /worlds-of-byzantium /program-and-abstracts. For multicultural studies of Byzantium, see Blöndal 1978; Evans and Ratliff 2012; Ödekan, Necipoğlu, and Akyürek 2013; Boeck 2015.

41 Mango, Mango, and Brunner 2011.

42 Fulghum 2001–2; Jacoby 2004, 197–240.

43 Ettinghausen, Grabar, and Blair 1987; Atiyeh 1995; Blair and Bloom 1996.

44 See http://www.faz.net /aktuell/feuilleton/debatten /warum-man-sich-vom-begriff -mittelalter-verabschieden -sollte-15750694.html.

45 Prezbindowski 2012.

46 For an overview of these empires or cultures, see Gordon 2007; Starr 2013. Habibi (2012) presented on *farang/farangi* in Persian painting at the University of Edinburgh in 2012.

47 The literature on this manuscript is vast. For a relevant discussion of the issues of dating and the place of creation, see Evans and Ratliff 2012, 275–76, n. 192 entry by Linda Komaroff; Bloom 2015, 196–218. Marcus Fraser has argued that the manuscript was produced in Cordoba, and his essay "Origins and Modifications in the Blue Qur'an and other Early Islamic Manuscripts" will be published as part of the proceedings of the conference "Manuscripts in the Making: Art and Science," held December 8–10, 2016, at Cambridge University.

48 Bloom 2015.

49 Farhad and Rettig 2016, 223, nos. 28–29, entry by Farhad.

50 Ware 2014.

51 See Casagrande-Kim, Thrope, and Ukeles 2018.

52 For this manuscript tradition, see Weitzmann 1971, 40. See also Guesdon and Grabar 2008; Kerner 2010, 25–40; Rogers 2010, 41–48; Touwaide 2016, 13–38.

53 M. Collins 2000.

54 Muhammad al-Idrisi's full name was Abu Abdullah Muhammad al-Idrisi al-Qurtubi al-Hasani as-Sabti. See Brotton 2012, 54–81; Pryor 2013, 155–82; Burgersdijk et al. 2015.

55 Park 2012, 82–86; Stevenson 2012, 26–33.

56 Berlekamp 2011, 119–50, 158–59.

57 See El Hamel, ibn Abi Bakr al-Sidiq, and Al-Walati 2002.

58 Al-Nuwayri, trans. Muhanna 2016.

59 Krätli and Lydon 2011.

60 See Niane 2006.

61 Suzanne Blier, remarks delivered at "Manuscripts in a Global Context: A Sympo-sium," at the J. Paul Getty Museum, Los Angeles, April 16–17, 2016.

62 Fauvelle 2014.

63 Lintz et al. 2014.

64 Meier and Purpura 2018. The exhibition was also presented at the National Museum of African Art, Smithsonian Institution, Washington, DC (2018), and at the Fowler Museum, Los Angeles (2018).

65 D. Ross 1994, 1–36; Pouwels 2002; Reese 2004; Haour 2007; Krätli and Lydon 2011; Burns, Jensen, and Clarke 2014; Davis and Johnson 2015; Wynne-Jones and Fleisher 2015; MacEachern 2016, 90–103; Halkiu 2017.

66 M. Green 2014.

67 Harvard University hosted a symposium on February 5, 2015, called "Medieval/Africa: The Trans-Saharan World, 500–1700."

68 See Schaefer 2006.

69 Eckher 2004, 150, no. 60; Stern 2017.

70 See Kogman-Appel 2011.

71 Goldberg 2012 is an essential reference for Jewish, Christian, and Muslim trade relations during the Middle Ages.

72 The Gunda Gundé monastery preserved the art of illumination through a prolific scriptorium. The monastery's remote hillside location protected it from a series of military-religious incursions by Somali-Abyssinian Muslim rulers in the sixteenth century.

73 See K. Brown 2018; Gunsch 2018; Effros and Lai 2018.

74 Ben Amos and Rubin 1983; Visonà, Poynor, and Cole 2007; Plankensteiner 2010; Halkiu 2017.

75 DaCosta Kaufmann and Pilliod 2005; Moxey 2013.

76 Der Nersessian 1933, 327–60.

77 Durand, Rapti, and Giovannoni 2007, 108–9, n. 33, entry by Vigen Ghazaryan.

78 Patel and Kumar 2001.

79 For the çintamani pattern in Mediterranean art, see Folda 2007; Folda 2016; Keene and Conger 2018.

80 Baghdiantz McCabe 1999.

81 Pal 1993, 134–39, 143–45.

82 Patel 2016.

83 For a history of writing and manuscript culture in China, see Hayot et al. 2008. For medieval Japan, see T. Hakubutsukan 1957. For medieval Korea, see Lee and Leidy 2013. For the interconnected histories of greater Asia, see Singh and Dhar 2014.

84 For a discussion of Chinese-European relations under the Jesuits, see Reed 2011; Johns 2016.

85 Buckley Ebrey 2008, 80–81; N. Hakubutsukan 2010, 64–65, 298, cat. no. 26.

86 For a gripping account of the history of the Silk Roads, see Frankopan 2015.

87 Gernet 1982; *Heilbrunn Timeline of Art History* 2000–ongoing.

88 Kunamoto 2001.

89 Enterline 2004; United States Department of Energy, Brookhaven National Library 2013.

90 See Davis and Altschul 2009, 1–24. The University of Illinois at Urbana-Champaign hosted the symposium "The Medieval Americas: Violence, Religion and Cultural Exchange before Columbus" on April 3, 2015. The following papers were delivered: Lisa Lucero, "Setting the Stage for the Medieval Maya: Climate Change, Urban Diaspora, and a New Regime"; William Walker, "Religion, Weather and Climate during the Medieval Warm Period and Little Ice Age in the North American Southwest"; Michael Mathiowetz, "Reassessing Models of Climate Change and Social Transformation in the Pueblo World: The Rise of Casas Grandes in the Depopulation of the Four Corners Region in the Southwest"; Christine Van Pool, "Reviving the Old and Grabbing the New: The Mesoamerican Transformation of the North American Southwest"; Timothy Pauketat, "The Fifth Wind: Post-Classic Mesoamerican Inspiration in the Medieval Mississippian World"; Kristin DeLucia, "Style and the Production of History: Aztec Pottery and the Materialization of a Toltec Legacy"; Margaret Brown Vega, "Violence, Religion, and Expansion in Medieval Times: The Southern Chimú Empire, 11th–15th Centuries AD"; Geoffrey McCafferty, "Blood of the Gods: Chocolate as Sacrament in Medieval Mexico and Central America."

91 Guha 2002; Tignor et al. 2013.

92 Richter 2017, 99–109.

93 London, British Museum, AOA Am 2006-Drg13964.

94 Adorno 2008, 95–124.

95 Other examples of North American petroglyphs are in the Ancestral Pueblo sites at Chaco Canyon in New Mexico.

96 W. Miller 1955a; W. Miller 1955b; Lewis 1998, 51–182; Krupp 2015, 33.

97 See McCleary 2016.

98 See Berlo and Phillips 2015.

99 Alt and Pauketat 2015.

100 For climate studies related to the Ancestral Pueblo people, see Benson, Petersen, and Stein 2007. For Southern theory, see Connell 2007.

101 See Lowe and Pittari 2014, 35–46.

102 See A. Kumar 1996, 25–27.

103 P. Smith 2009, 1–24; Matisoo-Smith 2017, 209–25.

104 Waddell, Naidu, and Hau'ofa 1993.

105 Van der Meij 2017.

106 Iguchi 2017.

107 Trau 2012, 4–11.

108 Roullier et al. 2013, 2205–10.

109 See James McHugh's work on materials traded in the Indian Ocean world, including McHugh 2014, 2013, 2012a, 2012b, 2011a, 2011b.

110 The manuscript is Cod. Ms. Pal. Lat. 1071, Vatican City, Biblioteca Apostolica Vaticana (fols. 18v, 20, 20v, 26v). See https://digi.vatlib.it/view /MSS_Pal.lat.1071; Dalton et al. 2018.

111 West 2017.

112 Comment made at the 53rd International Congress on Medieval Studies in the session "Whiteness in Medieval Studies 2.0."

A Timeline for a Global Middle Ages: Linear Time and Modes of Remembering the Past

MORGAN CONGER

Disciplinary, material, and geographic divisions pose challenges for presenting inclusive, diverse, and global histories.[1] Moreover, thematic approaches to a region or religion must contend with periodization.[2] The goal of this timeline is to traverse spatial and temporal boundaries and to provide a chronological structure that complements and contextualizes objects—across time and in time—that are presented in this volume.[3] Book arts and graphic objects of all formats from around the globe are foregrounded, some of the earliest of which, in this context, were produced in Ethiopia, China, and Central America.

Although the following timeline presents a linear chronology, historic time can be conceived and/or recorded in other ways.[4] The Yoruba culture of Nigeria and Benin, for example, measured time in conjunction with solar and lunar cycles;[5] Aboriginal populations in Australia perceived time neither linearly nor cyclically but as a fluid continuum known as *tjukurpa* time, or "dream time";[6] Lakota tribes of the Great Plains created calendrical *waniyetu wówapi* (winter counts) documenting time annually from first snow to first snow as a way to observe community histories;[7] and Inca peoples living in the Central Andes recorded calendrical and economic information using *quipus* (knotted string devices)[8] and *tukapas* (monumental tapestries) (see fig. II.8).[9] While the goal of this timeline is to present a global survey of book arts that acknowledges heterochronicity, the inclusion of every time measurement system operating within a global framework is far too ambitious to incorporate here. This timeline therefore attempts to provide a chronological overview of the textual communities considered throughout the publication, which is otherwise arranged thematically, while also demonstrating the porosity of geography and different temporalities.

The dates that follow are presented in two formats: first, the Gregorian calendar, followed when appropriate by the Islamic calendar with dates indicated as AH (the Anno Hegirae, which denotes the Prophet Muhammad's migration from Mecca to Medina [*al-Hijra*] in 622 CE).[10] When AH dates are provided, the Gregorian dates are abbreviated as BCE (Before the Common Era) or CE (Common Era).[11] The life dates of individuals, when known, have been provided throughout the publication; regal dates are abbreviated as (r.); the dates of dynasties have also been indicated when they are relevant and potentially helpful to the reader.

— Morgan Conger is senior staff assistant and former curatorial research volunteer in the Manuscripts Department at the J. Paul Getty Museum.

1 These challenges are addressed in Le Goff 2017; M. Sullivan 1967; Hillenbrand 1999; Stokstad 2004; Luttikhuizen and Verkerk 2006; Davies et al. 2011; Belich et al. 2016.

2 Blier 2008, 14–19; Tignor et al. 2013.

3 Several online resources with robust timelines are available, including the Metropolitan Museum of Art's Heilbrunn Timeline of Art History (http://www.metmuseum.org /toah/); Qantara: Mediterranean Heritage (http://www .qantara-med.org); the David Collection (https://www .davidmus.dk/en/collections /islamic); and the British Museum (https:// britishmuseum.withgoogle .com). For a review of the Heilbrunn Timeline, see Hohensee 2018.

4 Shryock and Smail 2011; Lucas 2005; De Landa 1997; Reingold and Dershowitz 2017; Ahuja and Hill 2017, 208; Hamann 2016a.

5 Blier 2012a, 206–7, 209–11; Drewal, Pemberton, and Abiodun 1989, 13–43; Lawal 2012, 222–23.

6 On *tjukurpa* time, see D. James 2015; Isaacs 2009. On Australian Aboriginal astronomy, see Norris and Hamacher 2015, 2215–22.

7 Greene and Thornton 2007.

8 Pillsbury 2017, 33–43. For decoding Incan *quipus*, see Medrano and Urton 2017, 1223.

9 Urton 2007, 245–68.

10 Hillenbrand 1999, 9.

11 See Reingold and Dershowitz 2017.

100 BCE to 399 CE

50 BCE–50 CE
North Gateway of the Great Stupa, Sanchi, Madhya Pradesh, India (fig. 20.3)

4th century
Teotihuacan-style ceramic vessel, Tikal, Guatemala (fig. 9.6)

500 CE

6th century
Garima Gospels, Abba Garima Monastery, Ethiopia (fig. introduction.2)

6th century
Rabbula Gospels, Monastery of Saint John of Zagba, Syria (fig. introduction.3)

6th century
Ashburnham Pentateuch, perhaps produced in Rome or possibly North Africa or Syria (fig. I.1)

500–700
Wooden writing tablets, Byzantine Egypt (fig. II.4)

600 CE (1st century AH)

650–800
Maya codex-style vessels, northern Peten (Guatemala) or southern Campeche (Mexico) (figs. 9.4a–b, 9.5, 9.7a–b)

700 CE (2nd century AH)

8th century
Stockholm Codex Aureus, Southumbria, Canterbury, England (fig. IV.3)

ca. 700
Star maps (north circumpolar region and the god of lightning), Dunhuang, Gansu Province, China (Tang dynasty) (fig. II.3)

750
Han Gan's *Night-Shining White*, China (Tang dynasty) (fig. introduction.22)

755–800
Vase of the 11 Gods, Naranjo, Guatemala (fig. 9.8)

800 CE (3rd century AH)

9th century CE / 3rd century AH
Bowl found in the Belitung shipwreck, Iraq (probably Basra) (fig. 18.2b)

9th century CE / 3rd century AH
Qur'an, North Africa (Tunisia?) (fig. IV.4)

9th–10th century CE / 3rd–4th century AH
Folio from the Blue Qur'an, North Africa (Tunisia?) (fig. introduction.9)

825–50
Bowl found in the Belitung shipwreck, Gongxian, Henan province, China (Tang dynasty) (fig. 18.2a)

862
Mogao Caves 16–17 (Library Cave), Dunhuang, Gansu Province, China (fig. introduction.23)

900 CE (4th century AH)

10th century
Daśakarmapathāvadānamālā (Garland of Legends Pertaining to the Ten Courses of Action), Dunhuang, Gansu Province, China (fig. introduction.24)

10th century
Life of Samuel of Kalamoun, Fayum (possibly), Egypt (fig. epilogue.1)

10th century
Lindau Gospels, silk doublure, possibly Syria (fig. introduction.4)

10th century
Paris Psalter, Constantinople (fig. 12.4)

945
Beatus map in an *Apocalypse*, San Salvador de Taibara, Spain (fig. 4.3)

10th–14th century
Pottery sherds, Zhejiang, Longquan area, China; found in Kilwa, Tanzania (fig. IV.10)

Late 10th or early 11th century
Gospels of Otto III, Reichenau Abbey, Germany (fig. III.2)

1000 CE (5th century AH)
ca. 1000
Menologion (Service Book) *of Basil II*, Constantinople (figs. 12.1, 12.3)

First quarter of 11th century
Bowl depicting a running hare, Egypt (fig. epilogue.2)

1008–9
Codex Leningradensis, Cairo, Egypt (fig. introduction.15)

1017–25
Psalter of Basil II, Constantinople (fig. 12.2)

1020–50 CE / 410–41 AH
Kitāb Gharāʾib al-funūn wa-mulaḥ al-ʿuyūn (The Book of Curiosities of the Sciences and Marvels for the Eyes), Egypt (fig. 1.3)

1025
Prajñāpāramitā (The Perfection of Wisdom), Bihar, India (fig. 20.4)

1054
Map Rock petroglyph, Shoshone-Bannock Tribes, Givens Hot Springs, Canyon County, southwestern Idaho (fig. introduction.28)

1075
T-O map from *Etymologies* by Isidore of Seville, St. Augustine's Abbey, Canterbury, England (fig. 6.1)

1075–1100
Manuscript covers with scenes from the Buddha's life, Bihar, India (fig. 20.1)

1100 CE (6th century AH)
12th century
Saddharma-pundarika (Lotus Sutra), China (Song dynasty) (fig. 7.1)

12th century
Frontispiece for the *Saddharma-pundarika* (Lotus Sutra), China (Song dynasty) (fig. 7.2)

12th century
Liber Floridus (Book of Flowers), northern France or Flanders (Hainaut) (fig. 4.2)

Early 12th century
T-O map, Cambridgeshire, Thorney Abbey, England (fig. 6.2)

1120–40
Gospel book, Helmarshausen, Germany (fig. introduction.5)

1143
Black and White Wrestlers, Cappella Palatina, Palermo, Italy (fig. 14.4)

1149 CE / AH 544
Al-shifa bi ta'arif huquq al-Mustafa (The Rights of the Prophet), Morocco (fig. 19.1)

1150
Mūlasarvāstivāda-nikaya-vinaya Sūtra (Collection of Monastic Codes of the Mūlasarvāstivāda) from Jingoji Temple, Japan (Heian period) (fig. 7.4)

1170s

Stammheim Missal, Hildesheim, Germany (fig. 13.1)

1175

Mahaprajñāpāramitā Sūtra (Great Wisdom Sutra), Japan (Heian period) (fig. 7.5)

1200 CE (7th century AH)

Early 13th century

Pancharaksha (Five Protective Charms), Nepal (fig. introduction.19)

Early 13th century

Barlaam and Ioasaph, possibly Constantinople (fig. prologue.2)

13th–14th century

Pendant with serpent design, Mississippian, Tennessee (fig. introduction.29)

13th–14th century

Dresden Codex, Yucatán Peninsula, Mexico (figs. 3.1, 9.2, 9.3a)

Early and late 13th century

Gospel book, Nicaea or Nicomedia, Byzantium (present-day Turkey) (fig. introduction.8)

1224 CE / AH 621

De materia medica (On Medicinal Material) of Dioscorides, possibly Baghdad, Iraq, or northern Jazira, Syria (fig. introduction.11)

1237 CE / AH 634

Maqāmāt al-Harīrī (The Assemblies of al-Hariri), Baghdad, Iraq (fig. III.1)

1240s–1250

Shah ʿAbbas Bible, northern France (Paris) (figs. 10.1, 10.2)

1270s

Breviary, Paris (transferred to Italy in 1296) (fig. 18.1)

1277 or after

Bestiary, Thérouanne (Flanders), present-day France (fig. III.3)

1290–1310

Fueros de Aragón (Feudal Customs of Aragón) or *Vidal Mayor*, Huesca, northern Spain (figs. 13.3, 14.1, 14.2, 14.3)

1293

Mōko shūrai ekotoba (Illustrated Account of the Mongol Invasion), Japan (fig. introduction.25)

1296

Rothschild Pentateuch, France and/or Germany (fig. introduction.6)

Late 13th or early 14th century CE / late 8th or early 9th century AH

Map of the World in *Kitab nuzhat al-mushtāq fiʾkhtirāq al-āfāq* (The Book of Entertainment for He Who Longs to Travel the World) by Muhammad al-Idrisi, Maghreb (Morocco) (fig. introduction.12)

1300 CE (8th century AH)

14th century

Pentaglot Psalter, Nile Delta, Egypt (fig. IV.5)

1300s

The Romance of Alexander the Great, Trebizond, Turkey (fig. IV.1)

1300

Leipzig Mahzor, Worms, Germany (fig. 21.3)

1314 CE / AH 713

Jami' al-tawarikh (Compendium of Chronicles), Herat, Afghanistan (fig. 15.3)

1330s CE / AH 730s

Great Mongol Shahnama (Book of Kings), Tabriz, Azerbaijan (fig. III.5)

1340

Saddharma-pundarika (Lotus Sutra), Korea (Koryô dynasty) (fig. 7.3)

1345-77

Nītisārasamuccaya (Compendium of the Essence of Policy), Kerinci residency of Jambi, Sumatra (fig. 5.1)

1353

Vitae beatae Hedwigis (The Life of the Blessed Hedwig), Silesia (Poland) (fig. 15.2)

1370-80

Kalpasūtra (Book of Sacred Precepts) and *Kālakāchāryakathā* (Stories of the Teacher Kalaka), Gujarat (?), India (fig. 2.2)

1375

Catalan atlas, Majorca, Spain (fig. II.1)

1386

Gospel book, Kʻajberunikʻ Lake Van region, Armenian kingdom (present-day Turkey) (fig. III.6)

Late 14th-early 15th century

Gospel book, Amhara region, Ethiopia (fig. 4.1)

Late 14th-15th century CE / late 8th-9th century AH

Hamzanama (Adventures of Hamza), Delhi region, India (fig. 2.3)

1400 CE (9th century AH)

Early 15th century CE / early 9th century AH

Monumental Qur'an stand in the courtyard of the Bibi-Khanym Mosque, Samarkand, Uzbekistan (fig. introduction.10)

15th century

Rothschild Pentateuch, later addition in Italy (fig. IV.7)

15th-16th century CE / 9th-10th century AH

Talismanic shirt, India (fig. II.6)

1404-24

Sutra covers with the *Eight Buddhist Treasures*, China (Ming dynasty), Yongle period (fig. prologue.4)

1410 CE / AH 812

Khamsa (Quintet) of Nizami, Shiraz, Iran (fig. introduction.1)

1410

Livre du Grant Kaam (The Book of the Great Khan) by Marco Polo, Tournai, Belgium (figs. 16.3, 16.4)

1410

Le Livre des merveilles du monde (The Book of the Marvels of the World) by Marco Polo, Paris (figs. 16.1, 16.2)

1420 CE / AH 822

Iskandarnama (Book of Alexander), Gujarat (?), India (fig. 2.1)

1425 CE / AH 828

Majma al-Tavarikh (Compendium of Chronicles) by Hafiz-i Abru, Herat, Afghanistan (fig. prologue.3)

1430-40

Book of hours by the Master of Sir John Fastolf, France or England (fig. 22.1)

1440-50 CE / 843-53 AH

Iskandarnama (Book of Alexander) of Ahmadi, Edirne Palace, Ottoman Turkey (fig. IV.2)

1444 CE / 847-48 AH

Shahnama (Book of Kings) of Abu'l-Qasim Ferdowsi, Shiraz, Iran (fig. III.8)

1450

Rothschild-Weill Mahzor, Italy (fig. 21.2)

1450-70 CE / 853-74 AH

Chandayana (Romance of Laurik and Lady Chandaini) folio, Delhi or Jaunpur, India (fig. 2.5)

1450–96

Hebrew Bible, Spain, Portugal, and North Africa (fig. IV.8)

1450–1500 CE / 853–905 AH

Qur'an case, Nasrid Emirate of Granada, Spain (fig. III.7)

1460

Ashkenazi Haggadah, Germany (Ulm) (fig. 21.1)

1464

Roman de Gillion de Trazegnies (Romance of Gillion de Trazegnies), Antwerp, Belgium (fig. 13.5)

1467–72

Histoire de Charles Martel (History of Charles Martel), Bruges, Belgium (figs. 13.4, 17.2)

1469

Barlaam and Josaphat, Hagenau, Alsace, France (formerly Germany) (fig. prologue.1)

1469

Prayer Book of Charles the Bold, Ghent, Belgium (fig. 17.3)

1470s–80s

Hours of Engelbert II of Nassau, Ghent, Belgium (fig. IV.9)

ca. 1470

Copy of Korean Kangnido Map of 1402, Korea, Choson (Joseon) period (fig. 1.4)

1480–90

Book of hours illuminated by Georges Trubert, Provence, France (fig. 17.1)

1480–1520

Gospel book, Gunda Gundé Monastery, Ethiopia (fig. introduction.16)

1490

Illustrated *Vita Christi* (Life of Christ) with devotional supplements, East Anglia, England (fig. 13.2)

1490–1530

Ivory pyx, Sierra Leone (fig. II.5)

1495–1505 CE / 900–910 AH

Ni'matnama (Book of Pleasures), Mandu, Madhya Pradesh, India (fig. 2.6)

1500 CE (10th century AH)

16th century

Kalpasūtra (Book of Sacred Precepts), Gujarat, India (fig. introduction.20)

16th century

Relación de las Cosas de Yucatán (Narrative of the Things of Yucatán), Mexico (fig. 9.1)

16th century CE / 10th century AH

Shetima Kawo Qur'an, Nigeria (fig. 19.2)

1500–1800

Papa hou (treasure box), Northland, New Zealand (fig. introduction.30)

1500

Devasano Pado Kalpasūtra (Book of Sacred Precepts from the Devasano Pado Temple) and *Kālakāchāryakathā* (Stories of the Teacher Kalaka), Gujarat (probably Patan), India (fig. 2.4)

1501 CE (?) / AH 906 (?)

Shahnama (Book of Kings) folio, Jaunpur (?), India (fig. 2.7)

1513 CE / 919 AH

Piri Reis world map, Istanbul (fig. 1.2)

1516

Portolan chart, Vesconte Maggiolo, Naples, Italy (fig. 1.1)

Before 1521

Codex Bodley, Mexico (fig. 3.2)

1637–38
Silk doublure in a Gospel book, New Julfa (Isfahan), Iran
(fig. II.10)

ca. 1650 CE / AH 1060
A Young Man Holding a Cup, Iran (fig. 10.4)

1652
Hymnal, Constantinople (fig. 11.4)

1678
Armenian Hymnal, Constantinople (fig. 11.1)

1700 CE (12th century AH)
18th century
Awdä Nägäst (Cycle of Kings), Ethiopia (fig. 8.2)

1750
Missal, Yovan Ēsibits'i (fig. 11.6)

1750
Magic recipe book, Ethiopia (fig. 8.1)

1770
Pancharaksha (The Five Protective Charms), Chakrabahal,
Nepal (fig. 20.2)

1800 CE (13th century AH)
Early 19th century
Altar tusk, Edo peoples, Kingdom of Benin, Nigeria
(fig. introduction.18)

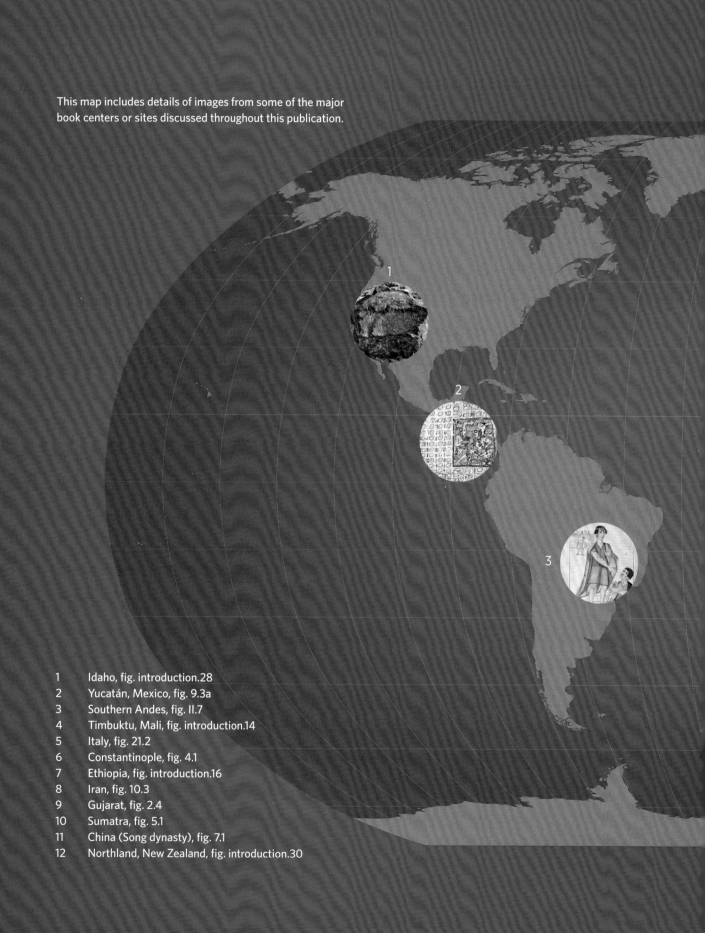

This map includes details of images from some of the major book centers or sites discussed throughout this publication.

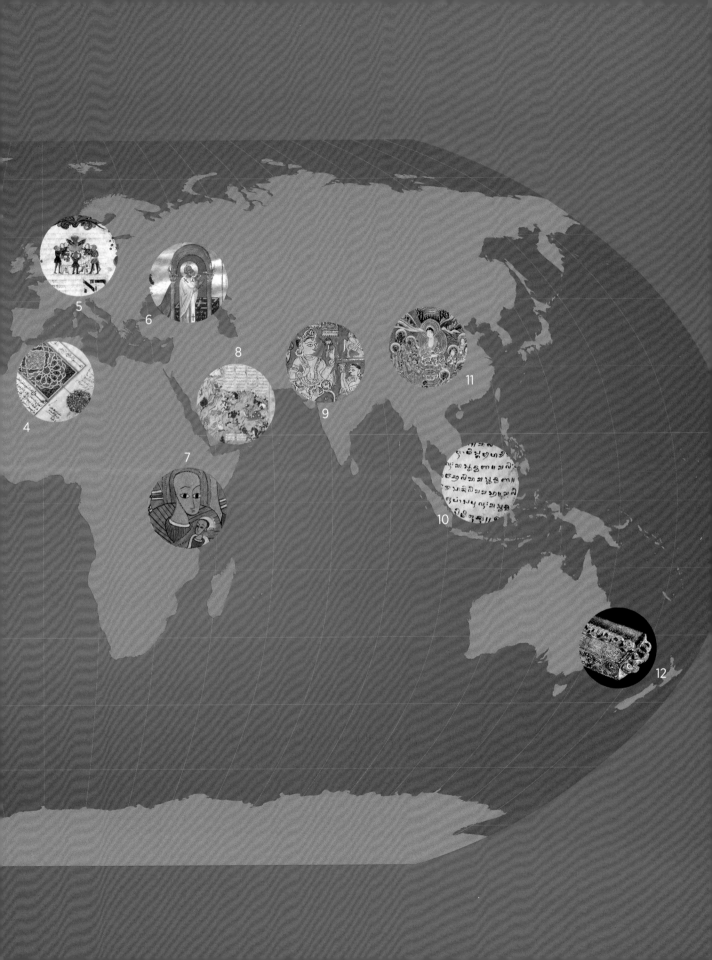

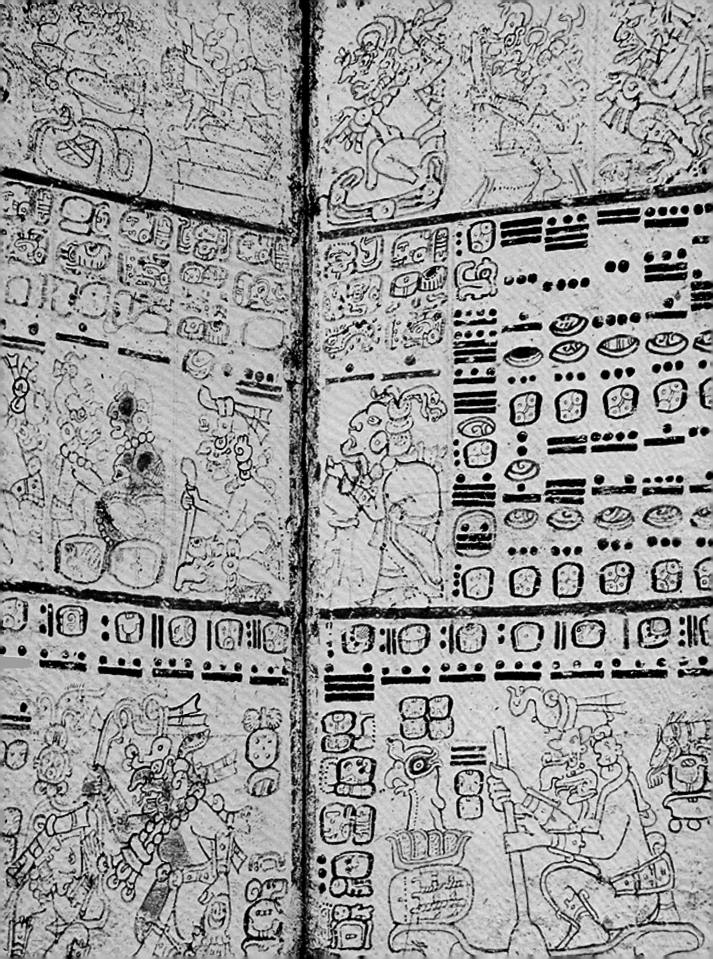

BRYAN C. KEENE

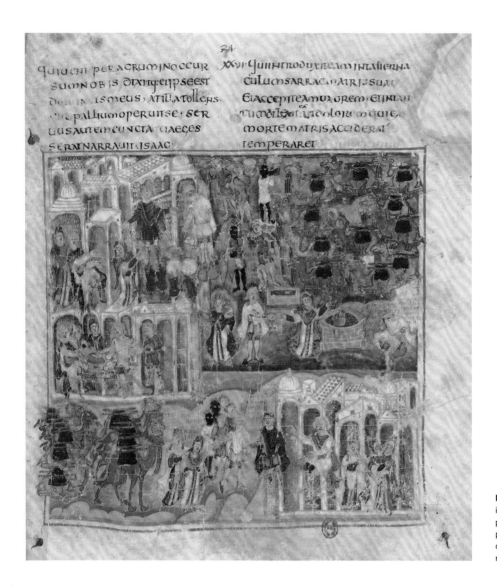

I.1. *The Story of Rebecca and Eliezer* in the Ashburnham Pentateuch, perhaps produced in Rome or possibly North Africa or Syria, sixth century. Paris, Bibliothèque nationale de France, NAL 2334, fol. 21

The story of Rebecca and Eliezer in the fifth- and sixth-century Ashburnham Pentateuch (fig. I.1), perhaps produced in Rome but possibly in North Africa or Syria, visualizes trade communities and ideas about racial or cultural groups of the greater Mediterranean Basin from the perspective of a Latin-speaking Christian.[1] The manuscripts discussed throughout this volume emphasize transmission, translation, and circulation of transregional narratives, visuals, and accounts of great local and cultural significance from various points on the globe. The focus on illustrated or decorated text objects can only provide a partial view of the long period under consideration, especially because only a fraction of codices, scrolls, and so forth received such text-image embellishment, and fewer still survive. Each of the contributors has striven to demonstrate the porosity of boundaries—territorial and disciplinary alike[2]— but it is also important to acknowledge the continuing need to

dismantle Eurocentrism or Western-centrism in regard to the constructs of linear time, literacy and textuality, and world-making strategies (often falling under the rubrics of empire, nation, religion, or a vague sense of "culture"). Additionally, several of the authors have attempted to expose the colonial constructs of "center" and "canon" embedded in the collecting history (provenance) of the objects under consideration.

In this section, Jerry Brotton's essay explores the propositions and hypotheses for world-making afforded by the medieval mapmaker's craft from Iberia to Korea. World maps and the writing of history always reveal a view of the Earth from the perspective of a particular time and place. Alka Patel's essay assesses the historiography—or writing of history—of the concept of "medieval India" by examining the range of painterly styles in book arts prior to the Mughal period. Relatedly, Byron Ellsworth Hamann's essay challenges the historiography of a medieval framework for Mesoamerica by considering taxonomies of "the book." Continuing with a reevaluation of the field of medieval studies, Suzanne Conklin Akbari's essay addresses the movable location of Ethiopia on European maps of the Middle Ages and within academic disciplines today. Citing the disproportionately low survival rate of manuscripts—textual and decorated—in tropical parts of the world, Alex J. West nevertheless argues for the inclusion of what he calls the "medieval tropics" in broader scholarly discourse. And finally, Asa Simon Mittman's case study advocates that a reevaluation of T-O maps provides hope for crossing disciplinary borders in medieval studies. The most common expression of the sphericity of the Earth in Europe during the Middle Ages was the T-O system, in which the known landmasses were arranged within the letter *O* separated by lines that form the letter *T*, with Asia generally representing the largest portion (usually above) and Europe and Africa sharing roughly equal segments (below).

Each of the following sections in this volume begins with a brief essay that addresses a particular theme and its applicability to a range of objects that complement those discussed by the authors. The map on pp. 44–45 highlights the major centers of book use and production discussed throughout

this publication. Several contributors also refer to important archaeological sites where portable objects have been found (some of which feature texts as inscriptions), such as the Helgö hoard in Sweden; the pottery sherds from Kilwa, Tanzania (see fig. IV.10); the Kilwa coins found at Arnhem Land in Australia; and the Belitung shipwreck near Indonesia (see fig. 18.2a).[3] Cave Hoq on the island of Socotra in Yemen is a prime location for considering connected worlds in a global Middle Ages, due to the rich variety of drawings and epigraphy there—in Indian (Brahmi) and South Arabian languages, as well as in Aksumite, Greek, and Palmyrene Aramaic—that reveals the complex trade networks that crisscrossed the Indian Ocean from about the second century BCE until the thirteenth century CE. I invite the reader on a journey from monastic sites in the Kathmandu Valley of Nepal to courtly centers in Europe, from printing sites in imperial China to the scriptoria of Ethiopia and the temples of the Yucatán.

1 See Verkerk 2004.
2 Territorial and disciplinary boundaries level out in the digital sphere as numerous institutions around the world make their manuscript holdings available to the world. A few notable examples include the British Library collections (European, Islamic, Asian, and African); the West African Manuscripts Database (http://amirmideast.blogspot.com/2012/05/west-african-arabic-manuscript-database.html); the Bibliothèque nationale de France's Gallica virtual map of medieval place names and manuscript images (http://beta.biblissima.fr/fr/desc-map); the Digital Vatican (https://digi.vatlib.it/); and the numerous partners with iiiF (http://iiif.io/community/groups/manuscripts/).

3 One should also recall the Byzantine and Central Asian silks found in Viking ship burials in Norway; Byzantine silks found in Nara, Japan; a Byzantine lamp found in Thailand; or the Chinese coins found in Kenya and Ethiopia. See Strauch 2012.

World Views and the Map Makers' Craft

JERRY BROTTON

Weltanschauung is usually translated from the German as "worldview," based on its combination of *Welt* (world) with *Anschauung* (view), which derives from the Middle High German verb *schouwen* (to look at or to see). It has been adopted by various strands of modern philosophy and psychoanalysis to mean a comprehensive conception or theory of the world and humanity's place within it. The concept of Weltanschauung obviously has geographic as well as philosophical significance, and is an attractive approach to use when understanding the motivations behind the creation of world maps, including those from the Middle Ages. A worldview creates the conditions for the construction of a map of the world, but the world map in turn gives shape and definition to a culture's view of the world. As much as the premodern mapmaker acts on their physical observations of the Earth, the choice of orientation, centers, margins, and toponymy, and even the use of raw materials (such as vellum, ink, or compasses), will be shaped by their Weltanschauung.[1] This is one of the many reasons why maps from the medieval and early modern periods remain such fascinating and vital documents for scholars working in disciplines across the humanities and social sciences.

The Weltanschauung of the Genoese Vesconte Maggiolo (1478–1530) and his portolan chart made in Naples in May 1516 is particularly significant when considered within the context of this publication (fig. 1.1). With its focus on worlds within books and that other vexed contemporary term, "the global," this publication's inclusion of Maggiolo's beautiful and enigmatic chart requires the audience to question many assumptions about the period and culture from which it emerges. Maggiolo was a mapmaker whose extant charts and maps show us that the traditional distinctions between the Middle Ages and the Renaissance are of little use in understanding his worldviews, especially as depicted in this chart.[2]

We are used to thinking of the cartography of the Middle Ages as being local, executed exclusively in manuscript, highly

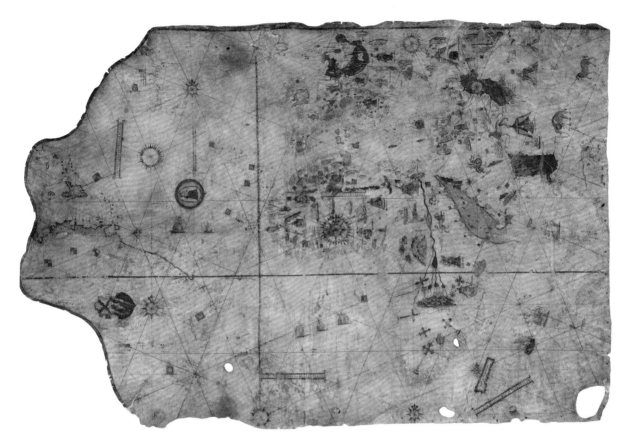

1.1. Portolan chart, Vesconte Maggiolo, Naples, Italy, 1516. San Marino, California, The Huntington Library, HM 427

decorative, and shaped by religious imperatives and motifs. This is in sharp contrast to Renaissance mapping, which is assumed to be international in scope, breaking with theological imperatives, embracing mass reproducible print, and pursuing disinterested scientific techniques of projection and measurement. Very few of these distinctions are meaningful when examining Maggiolo's world chart.[3] Drawn on parchment in black and red ink using Gothic script, the chart relies on the tradition of navigational maps known as portolans (from the Italian *portolano*, "relating to ports or harbors") used by pilots and merchants in the Mediterranean starting in the twelfth century. It is decorated with fantastic imaginary beasts like unicorns and dragons, as well as semi-mythical kings enthroned in pavilions. One of its most distinctive features is the large medallion of the Virgin and Child floating off the west coast of Africa in the Atlantic. All of these features are characteristic of medieval manuscript maps and charts: the exquisite illumination on vellum, the seamless mix of realism with exotic fantasies of faraway lands, and the presiding role of religion in the representation of a world fashioned in the image of a Christian God. The geographic outline of Maggiolo's chart fuses the classical assumptions found in Claudius Ptolemy's *Geography* (ca. 150 CE), with its *ecumene*, or "living space," centered on the Mediterranean and concentrating on

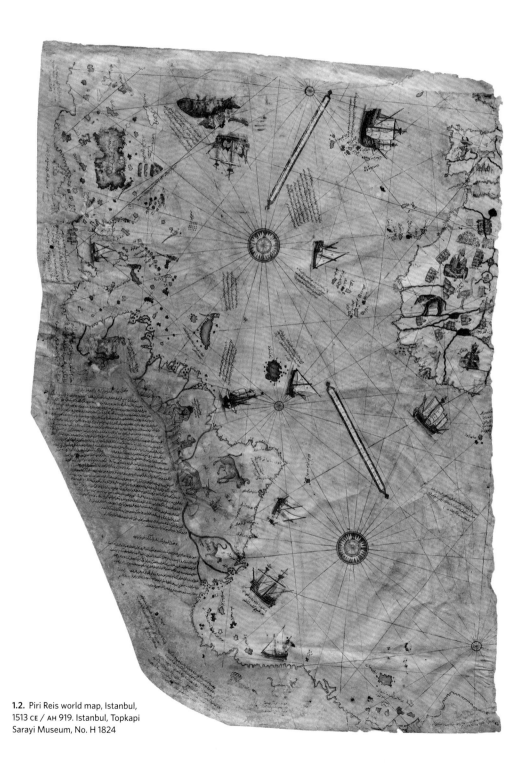

1.2. Piri Reis world map, Istanbul,
1513 CE / AH 919. Istanbul, Topkapi
Sarayi Museum, No. H 1824

the tripartite division of Europe, Africa, and Asia, stretching as far east as Alexander the Great's travels into India.

In all these respects, the chart looks like many fifteenth-century portolan charts of the Mediterranean of the kind used by pilots since at least the fourteenth century. Nevertheless, other features of Maggiolo's chart appear far more quint-essentially "Renaissance." Across its surface can be found ten compass roses, each composed of a standard thirty-two rhumb line network (navigational arcs crossing all meridians of longitude at the same angle). These, along with the four scale bars, were used in tandem with a compass by pilots to orient themselves and navigate across open seas. The vertical latitude scale bar running from north to south through the Atlantic is numbered from 40 degrees S to 67 degrees N, broadly in line with Ptolemy's latitudinal estimates of the known world.

Such classical estimations were being radically revised as a consequence of what seems to be the most striking innovation within Maggiolo's chart, namely the recent discoveries to the west in the Caribbean and the Americas, and to the south and east with the circumnavigation of Southern Africa and the opening of the sea route to India. Spanish and Portuguese encounters in the Americas following the first voyage of Christopher Columbus (1451–1506) in 1492 are carefully recorded to the west, with the outline of South America's northern coastline just beginning to emerge. Portuguese exploration and commercial settlement is also highlighted throughout West Africa, the Cape of Good Hope, and India following the voyages of Bartholomeu Dias (1488), Vasco da Gama (1497–99), and Pedro Alvares Cabral (1500), with the stone crosses or *padrãos* in Southern Africa the most visible symbols of this expansion. Maggiolo's career as part of a mapmaking dynasty that moved between Genoa and Naples enabled him to assimilate news not just of the maritime culture of the Mediterranean but also of the Iberian discoveries in the Atlantic and down the coast of Africa.

Distinctions between the Middle Ages and the Renaissance have little meaning when examining the Maggiolo chart. Such divisions have been imposed retrospectively,

primarily by nineteenth-century European scholarship, which cast a long shadow over the twentieth century and still exerts some sway over the popular imagination today. Not only is the contrast unhelpful, but it also limits our understanding of the geographic connections that took place throughout this period, and which stretched well beyond the boundaries of Christian Europe. Just three years before Maggiolo completed his chart, another was being made on the other side of the Mediterranean from what would seem to be a very different worldview. In 1513, the Ottoman admiral and mapmaker known as Piri Reis (d. 1553) drew his famous world map that survives in a fragment on which Iberia, Northwest Africa, the Brazilian coast, and the Caribbean look remarkably similar to their depictions in Maggiolo's chart (fig. 1.2). Apart from being written in Ottoman Turkish script, the shape and orientation of this map (if extant) would seem to emanate from a very similar worldview. It also contains similar compass roses and scale bars, while also mingling its scientific elements with more mythical and fanciful assumptions. The cities, rulers, flora, and fauna of Northwest Africa are shown in colorful detail, and although the Ottoman map has no presiding religious authority like Maggiolo's, it shares the preoccupation of medieval Christian *mappae mundi* with its depiction of monstrous races in the so-called New World and mythic scenes such as the story of Saint Brendan, shown in the top left-hand corner.

Piri Reis's depiction of the geography of the Americas is particularly striking because it is even more accurate than Maggiolo's. The Caribbean islands are rendered with remarkable detail and are in line with Columbus's earliest discoveries. They are so close to Columbus's conception of what he discovered that they even reproduce some of his mistakes: to modern eyes, Hispaniola (labeled "Izle despanya") requires 90-degree rotation, though its orientation on Piri Reis's map suggests that it reiterates Columbus's assumption that the island was Japan (or "Cipangu"). The extensive legend on the bottom left emphasizes that a significant amount of exchange of cartographic information about the Spanish exploits in the Americas took place in the Mediterranean between Christians

like Maggiolo and Muslims like Piri Reis, who also shared a common classical intellectual heritage when composing their maps. The Ottoman pilot boasted that his map "was able to show twice the number of things contained in the maps of our day," having "made use of new maps of the Chinese and the Indian Seas which no one in the Ottoman lands had hitherto seen or known."[4] He continued:

> No such map exists in our age. Your humble servant is its author and brought it into being. It is based mainly on twenty charts and *mappa mundi*, one of which is drawn in the time of Alexander the Great, and is known to the Arabs as *dja'grafiye*. This map is the result of comparisons with eight such *dja'grafiye* maps, one Arab map of India, four new Portuguese maps drawn according to the geometrical methods of India and China, and also the map of the western lands drawn by Columbus.[5]

The implication of these claims requires revisions to the established understanding of the global circulation of texts and ideas at this time. To begin with, they place the Ottomans at the center, not the periphery, of a global world picture that looked westward to assimilate Iberian texts about the discoveries in the New World, including Columbus's; eastward to incorporate Arabic, Indian, and Chinese charts and scientific methods; and backward over time to draw on Ptolemy's *Geography* (or *dja'grafiye*, as Piri Reis calls it). The rediscovery of Ptolemy's classical text in Byzantium in the fourteenth century had transformed subsequent European mapmaking, but it also had a long and distinguished tradition of study and translation in the Arab world, and in 1465 it was translated into Arabic by Georges Amirutzes (1400–1470) for the Ottoman sultan Mehmed II (r. 1444–46; 1451–81).[6]

A decade after making his world map, Piri Reis created another extraordinary cartographic artifact, the *Kitab-i Bahriye* (Book of the Sea). This atlas was first produced in 1521 with 130 chapters and more than a hundred maps focusing on the Mediterranean, with a revised version made in 1526 with 210 charts representing a more global range. It shares many affinities with a 1512 sea atlas produced by Maggiolo, not least their shared geographic knowledge. In the stylized language characteristic of Ottoman texts of the period, Piri Reis outlines his extensive understanding of the latest Portuguese discoveries, including Dias's circumnavigation of the Cape of Good Hope in 1488:

> He was the man who found the land of the Abyssinians and the Cape of Good Hope.
>
> For what they call *Kavu Bono Ispiranse* is what we refer to *Umiz Burnu*.
>
> They sought this place mile by mile and discovered it in the ninth year [1488].
>
> This place is the beginning of the route to India and this is why they made it their goal to find it.
>
> Every year they advanced a thousand miles. At the farthest place they reached, they set up a marker [*padrão*] and returned.[7]

In addition to revealing his earlier knowledge of Columbus's voyages in his 1513 world map, here Piri Reis exhibits a deeply informed awareness of both the cartographic and the geopolitical dimensions of late fifteenth-century Portuguese seaborne expansion throughout Africa and the Indian Ocean. Writing about Hormuz in the Persian Gulf, he states that "the Portuguese have reached this place and they have a built a fort," from where they "collect tolls from ships that pass."[8] Hormuz had fallen to the Portuguese in 1507 as part of a wider plan to prevent Muslim trade in the Persian Gulf and the Red Sea, which inexorably led to conflict with the Ottomans and Persians.

As Catholics clashed with Sunni and Shia Muslims over control of commercial routes across the Indian Ocean as far as China, there was an inevitable exchange of knowledge, notwithstanding adversarial differences. Writing about the Portuguese trade in Chinese porcelain, Piri Reis observes in passing, "I asked these Portuguese about this land of China."[9] His comment encapsulates the global dimension of the circulation of knowledge at this time. Oral and manuscript geographic information

1.3. World map from *Kitāb Gharā'ib al-funūn wa-mulaḥ al-ʿuyūn* (The Book of Curiosities of the Sciences and Marvels for the Eyes), Egypt, 1020–50 CE / 410–41 AH. Oxford, Bodleian Library, Ms. Arab c.90

circulated among followers of the Abrahamic religions. Such competitive exchanges often took place in relative discursive silence and can only be discerned by following the movement of material objects and artifacts like textiles, porcelain, and of course maps, charts, and globes.[10] In some cases the clashes between cultures like the Portuguese and the Ottomans captured in texts like Piri Reis's *Kitab-i Bahriye* also disclose almost in parentheses that despite such conflict, exchange also took place at a global level, stretching from depictions of the Americas in the west to accounts of China to the east.

Maggiolo and Piri Reis probably never knew of each other's maps, but the affinities between their cartographic world pictures can be traced back to even older traditions of world mapping centered on the Mediterranean, including those that emerged from the Arabic world. One of the most remarkable examples to have come to light in recent years is the anonymous Fatimid Egyptian treatise on the cosmos, *Kitāb Gharā'ib al-funūn wa-mulaḥ al-ʿuyūn* (The Book of Curiosities of the Sciences and Marvels for the Eyes), written between 1020 and 1050 (fig. 1.3). Since its discovery and acquisition by the Bodleian Library in 2002, this extraordinary forty-eight-page manuscript has transformed scholarly understanding of the medieval Arabic cartography, and has been the subject of intense debate and research.

The text is divided into *maqālahs* (two parts), one describing the heavens and astrological divination, the other the Earth and its climate, and contains sixteen maps, including two of the whole world. The anonymous author quotes cosmological descriptions from the Qur'an in explaining to the book's patron that he chose "to write a volume encompassing the principles of the raised-up roof [the sky] and the laid-down bed [the Earth] . . . that will reveal to you their intricate and difficult aspects." Celestial knowledge mainly "eludes humans" because "the Exalted Creator has unique knowledge of His mysteries," but "revealed to Idrīs, may the Peace of God be upon him, the secret knowledge of the celestial bodies."[11] Idrīs, identified as the Greco-Egyptian deity Hermes Trismegistus, is just one of the many syncretic examples of how Islamic cosmology fashioned itself through careful comparison of Persian, Greek, and Indian intellectual traditions, from the names of the stars and the planets to the overwhelming influence of Ptolemy's *Geography* that appears in the manuscript's second part. Its later sections on marvelous creatures and fantastical humans read like something out of Pliny, while the apocalyptic accounts of discord, wars, killings, fires, and epidemics at the conjunction of certain planets and comets is a further amplification of medieval Arabic immersion in Ptolemy's astrological writings.

Although frustratingly little is currently known about the book's provenance or authorship, the rectangular world map in the second book provides a striking example of how Arabic learning bridged the gulf between the Hellenic culture that gave rise to Ptolemy's *Geography* ca. 150 CE and its reappearance in Byzantium in the late thirteenth century. What immediately strikes the viewer when looking at the map is its orientation: south is at the top, with Mecca and the Arabian Peninsula displayed with particular prominence. This was typical of Islamic mapmaking of the time, and was due to how finding the direction (known as *qibla*, or "sacred direction") and distance to Mecca preoccupied those communities that had converted to Islam in its early period of territorial expansion beyond Arabia in the eighth century. Most lived directly north of Mecca, leading them to regard the *qibla* as due south,

and thus to place this cardinal direction at the top of their maps, as is the case here.

The worldview represented here is defined implicitly by its theology, with Mecca (a golden horseshoe shape above the red Yemeni Hadramawt mountain range), Medina, Sana'a, and Muscat in the Arabian Peninsula both prominent, with Europe reduced to the Muslim-controlled Iberian Peninsula of Andalusia, and the sources of the Nile, or "Mountains of the Moon," dominating the map's apex. But as with the Maggiolo and Piri Reis maps, this one mixes science with myth: in the top right corner is one of the earliest recorded scale bars found on any map, while in the bottom left-hand corner is a depiction of the great wall built along the Caucasus Mountains by Alexander the Great to hold back the monstrous races of Gog and Magog that feature in both the Bible and the Qur'an.

The map and the manuscript within which it is found have transformed scholarly understanding of Islamic geography. The map's coastlines and toponymy suggest clear visual affinities with Christian Mediterranean portolan traditions, while also drawing on even older Muslim mapping traditions dating back as far as ninth-century Baghdad and the mathematical geography commissioned by its Abbasid caliphs. It shows how the Abrahamic faiths that emerged from the Mediterranean in the Middle Ages possessed global visions that shared many common visual, mathematical, and commercial features. If these visions were not necessarily representations of "globalization" as we understand it today in terms of economic imperatives, they were certainly representations of various facets of "globalism" in terms of depicting the whole Earth driven by various religious, political, commercial, and intellectual forces, but which produced surprisingly similar world maps.[12]

One final world map suggests just how far these imperatives reached across the global Middle Ages. In 1402, the Korean neo-Confucian scholar, diplomat, and poet Kwŏn Kŭn (1352–1409) created a world map known as the "Kangnido," a Korean abbreviation of its full title, translated as "map of integrated lands and regions and of historical countries and capitals." The map was subsequently lost, though several copies, including the one pictured in figure 1.4, were made later. It

1.4. Copy of Korean Kangnido Map of 1402, Korea (Choson [Joseon] period),
ca. 1470. Kyoto, Japan, Ryokuku University Library

is the earliest known East Asian map of the whole world, and the first to depict the new Korean Goryeo Empire (top right) as well as Europe (in the upper left-hand corner). As Kwŏn Kŭn's text at the bottom explains, this is a world dominated by the Chinese Ming dynasty at its center, with a vastly inflated Korea to its right, which appears three times the size of Japan (at bottom right), which is actually larger. The rest of the world is peripheral: India almost completely disappears, although Europe and Africa are shown in surprising detail, considering there is no evidence for the spread of Greco-Roman geographic knowledge as far as Korea. At the top, the landmass stretches to infinity, suggesting that its maker believed, like many Chinese mapmakers, that the heavens were round, but the Earth was square and flat.

Korea was often seen as the easternmost point known to Ptolemy, and is where Maggiolo and Piri Reis's geographic knowledge ended. It is a striking inversion to see a Korean map showing Europe as the limit of its own cartographic awareness. Several features immediately strike a Western viewer. The first is that the map is oriented with north at the top. Although this looks strikingly modern to Western eyes, the northern orientation comes from archaic Chinese imperial traditions. The emperor always faced south, looking down on his subjects, who faced north looking "up" at him. The Chinese for "back" is synonymous with "north" phonetically and graphically because the emperor's back is always turned to the north on the assumption that the south is the cardinal direction from which warm winds and sun bring agricultural plenty. So, although the Kangnido map puts north at the top, south is the most important direction. The second striking feature is that Africa is shown as circumnavigable more than eighty years before Dias rounded the Cape of Good Hope (1488). This indicates that Chinese information on East Africa and even the cape had reached Korea decades before the early Portuguese voyages breached the boundaries of Ptolemy's Hellenic world picture, which only stretched as far south as Libya. Finally, Europe is shown in remarkable detail considering the apparent limits of Korean knowledge of "barbarian" lands beyond East Asia. The Mediterranean and Iberia

are shown in reasonable outline, and there are approximately a hundred place names in Europe, including Constantinople and even Germany, spelled phonetically as "A-lei-man-i-a." It is tempting to believe that the tiny rectangle at the edge of Europe represents the British Isles, but it is more likely the Azores, the westernmost limit of Ptolemy's geography.

This Korean cartographic worldview is shaped by several forces. The first is the geopolitical reality of Korea's powerful neighbor, Ming China, and Japan, which are both shown as dominating the map to the exclusion of all other powers. The second is geomancy, known in Korea as *p'sungu* (wind and rain, or shapes and forces) and better known in Chinese as *feng shui*. This involves understanding nature's mountains and rivers as channeling the Earth's energy and where best to site cities, monasteries, even graves. The Kangnido map shows the Korean peninsula covered in rivers and mountains running like veins across its surface (a suitably geomantic analogy in which the health of the Earth and that of the human body were often compared). But what drove this map's creation more than anything was the belief system that underpinned it: Confucianism. With its emphasis on stability driven by the "health" of the body politic, Kwŏn Kŭn's neo-Confucian beliefs can be found in his text at the bottom of the map, and they suffuse its geopolitics and geomancy. This map is described as "nicely organised and well worth admiration," from which anyone "can indeed know the world without going out of his or her door! By looking at maps one can know terrestrial distances and get help in the work of government."[13] Why go off traveling, asks this Confucian map, when the world can be consulted and understood from the comfort and security of your own home, and can even help you in civic life? Where Maggiolo, Piri Reis, and the anonymous maker of the world map in *Kitāb Gharā'ib al-funūn wa-mulaḥ al-ʿuyūn* accept the dangerous vicissitudes of travel (from the Old French *travail*, to labor or toil in painful effort), the Kangnido map abandons the dangerous margins of faraway travel composed of monsters for a more serene and irenic armchair geography.

The idea of the world, even a worldview, is common to many human communities, including prehistoric and nomadic

peoples.[14] Throughout history these communities have expressed very different ideas of the world and how it should be represented. Nowhere are these differences more pronounced than in the Middle Ages, when scholars from North Africa to Korea produced strikingly similar world maps driven by very different imperatives. The routes by which information and ideas were transmitted in manuscript form between cultures remains an area of exciting but also challenging research, simply because of the specialized nature of the linguistics and the archival work required, and it is one that still lacks the methodological precision often used in studying the transmission of printed texts. Nevertheless, it remains an important challenge if scholars from outside Europe, including those from Africa, Asia, and the Americas, are to enlarge our understanding of the Middle Ages within a truly global worldview.

— Jerry Brotton is a professor of Renaissance studies at Queen Mary University of London.

1 Recent research has also shown that such cartographic "world pictures" are not exclusively created by men. On women's contributions to the history of cartography from the thirteenth century, see van den Hoonard 2013.
2 On Maggiolo, see Grosjean 1979.
3 For a survey of the map, see Caraci 1937, 37–54; Skelton 1962, 308–11.
4 Oktel 1988, 43.
5 Quoted in Özdemir 1992, 60–61.
6 See Raby 1987, 296–318; Pinto 2016.
7 Oktel 1988, 97–99.
8 Oktel 1988, 165.
9 Oktel 1988, 141.
10 On this revisionist account of the permeability of the conceptual and geographic borders between east and west in the Renaissance, see Brotton and Jardine 2000.
11 Rapoport and Savage-Smith 2014, 332.
12 For a detailed account of the distinctions between these different conceptions of the global from the classical to the modern period, see Cosgrove 2001.
13 Quoted in Ledyard 1994, 245.
14 For examples of prehistoric petroglyphs categorized as maps, see C. D. Smith 1987, 54–101. For a discussion of cartographic worldviews focusing on nomadic and "indigenous" communities in African, Native American, Eurasian, Australasian, and Pacific cultures, see the essays in Woodward and Lewis 1998.

2

Stories and Pictures from All the World: South Asian Book Arts from the Twelfth to the Sixteenth Century

ALKA PATEL

Exploring illustrated manuscripts from Northern South Asia datable to the twelfth through the sixteenth century provides several valuable opportunities. It brings welcome focus to the centuries prior to the establishment of the Mughal Empire (1526–44, 1555–1858), which, although a seminal time frame, has only begun to receive sustained scholarly attention in the last two decades.[1] Equally important, however, are opportunities for historiographical and methodological reflections on the concept of the "medieval," and the place of the Object in historical inquiry.

This essay begins with an overview of the application of the "medieval" rubric to the early second millennium CE in South Asia, the shifting meanings of the term, and the conceptual alternatives for this temporal classification that emerged throughout the twentieth century. Such an overview throws into high relief the conundrum facing investigators of this time frame of South Asia's history, namely the apparent necessity as well as the artifice of slicing time along the razor's edge of scholarly expertise. South Asian illustrated book production is replete with exemplars that transcend regional and linguistic specializations, urging not only scholarly collaboration across disciplinary partitions but also the fashioning of more inclusive analytical frameworks.

While historiographical reflection is instrumental in rethinking the prevailing approaches to twelfth- through sixteenth-century illustrated book production in South Asia, it is critical to go beyond interrogation. A greater emphasis on and inclusion of material culture—specifically illustrated manuscripts—as historical evidence enables investigation outside of royal and courtly cultural activity, providing a valuable entrée into mercantile circles of patronage and spheres of circulation.[2] Here, then, is a singular opportunity not only to expose the tacit but operational, secondary, and illustrative status of the Object, writ large, in the composing of South Asia's history but also to recuperate the Object's historical and historiographical power.

Emergence of the "Medieval" in South Asia

Tracing the coalescence of the medieval rubric within historiography on the Indic cultural sphere, beginning in the early nineteenth century, reveals the selective application of European Enlightenment principles to this materially and epistemologically unfamiliar world.[3] The process also allows us to consider what the medieval elucidates and what it occludes in scholarly application to South Asia's history.

At the outset, it should be noted that material culture virtually never played a decisive role in the administrative or intellectual structuring of the South Asian past. Since early nineteenth-century European engagement with the region, it was the proto-discipline of *history* in its various forms, more than any other European Enlightenment-era framework, that was deployed to organize the region's temporalities. Thus, the present essay's aim of emphasizing and using the evidentiary value of the Object ensues from largely uncharted historiographical territory, further underscoring the necessity and timeliness of the effort.

The British East India Company's administrators of the early nineteenth century had both intellectual and pragmatic interests in South Asia's past, gathering knowledge primarily for administrative purposes, and at times also intellectual interests. It was during these early years of British presence that the temporal category of the medieval took hold as an organizing touchstone for South Asian history. The British affinity with larger European historiography meant that European periodization was roughly transposed into temporal divisions for South Asia. This transposition included the connotations of decline that accompanied the medieval in the European context: just as Europe had seen the disintegration of the Roman and Carolingian Empires and the ensuing "Dark Ages" or medieval period, South Asia supposedly also entered a precipitous decline after the demise of the Gupta Empire of the mid-fourth through late sixth century CE.[4]

Simultaneous with the temporal parceling of South Asia's history were the nineteenth-century studies of South Asian religions, themselves the inevitable results of Europe's engagement with its own, changing perception of religion, and this integral yet varied cultural practice's role in its past and post-Enlightenment present. These entwined endeavors of temporal and religious categorization proceeded under the auspices of ruling India more effectively, receiving further impetus by accruing the dual legitimacies of administrative and academic imprimaturs.

For British administrators and scholars, the lack of familiarity with the cultural and epistemological landscape of South Asia led to distinguishing the region from European historical and intellectual processes. The increasing divergence between religion, science, and theories of government taking hold in post-Enlightenment Europe was deemed inapplicable to the historical and cultural unknown of this other side of the world. Much that Europe had left behind as "primitive" was considered still prevalent in South Asia. Religious fervor, for example, was considered endemic to the natives of this new world, which was still to be understood and domesticated. Indeed, religious categorization came to have a quasi-scientific, diagnostic status by the latter half of the nineteenth century, serving as a taxonomic tool for the administrative needs of the East India Company.[5]

South Asia's own historical realities were, by default, woven into this religio-temporal classification, which was increasingly becoming the exclusive lens for understanding the region's past. In the twelfth century, precisely when Europe was supposedly in the throes of the medieval, the subcontinent saw the establishment of a politically ascendant Islam in North India, with the Ghurid campaigns of the 1190s. Muslim mercantile communities had been embedded within larger polities throughout the subcontinent since the seventh and eighth centuries.[6] But as of the late twelfth and early thirteenth centuries, confessionally Muslim politico-military elites originating beyond the putative northwestern frontiers of the Indic world established bases of power throughout Northern India, eventually forming sultanates, or distinct and competing polities of varying stability and longevity. The influx of these new political actors also meant the importation of Persianizing political cultures and protocols of kingship by the Ghurids.[7]

The prevailing British administrative and intellectual frameworks of the nineteenth and twentieth centuries, themselves inflected by European Enlightenment ideas of history and religion, gathered and reductively ordered the multiple historical processes of South Asia's late twelfth through fifteenth century. The processes were not just collectively interpreted in political terms but also—perhaps primarily—cast as decisive *religious*, and thus civilizational, shifts. From the earliest Western-language histories on South Asia's past, then, the "medieval" fell neatly in line with the "Islamic," combining temporal and religious taxonomies that have thrown long shadows, even structuring later historiographical trends in the analysis of this temporal span in South Asia.

The rise of Indian nationalism in the early twentieth century and the continued reading of India's past for larger political aims—this time, independence from colonial rule—prompted substitution of religious nomenclature with seemingly more neutral terms such as ancient, medieval, and modern. However, closer scrutiny of this tripartite division reveals that, though the labeled veneers changed, little beneath them was dislodged or altered. The elision of "medieval" and "Islamic" continued in force. One important change, however, was the full-fledged association of the medieval with a narrative of political and cultural decline, a parallel already posited in the European context.[8]

Furthermore, the European and colonial idea of history considered political fragmentation as a lesser developmental stage in society, which inexorably cleaved toward great imperial formations. Prior to the rise of the Mughals in the early sixteenth century, South Asia's political fragmentation into small, Muslim-ruled sultanates reinforced the synonymous relationship between "medieval" and "decline." Indeed, such a teleological perception of the past was further reinforced during the early twentieth century, fueled by the nationalist anxiety that sought in the *past* the unified and independent India of the *future*.[9]

By the 1930s through the 1950s, in an ambit of increasingly diverse nationalist interests, no less in the thrall of a burgeoning Cold War between communism and capitalism,

Indian Marxist historians coined the term "Sultanate" as another handle for the span of centuries dubbed "medieval." The period of multiple sultanates prior to the Mughal Empire arrested the attention of many Indian Marxist historians not so much for the teleology of imperial formation or nationhood but rather as a basic analytical framework. "Sultanate" functioned as a discernibly Marxist formulation—not to be found prior to the 1930s—wherein scholarly attention was concentrated on the predominantly *Muslim* political elites of the twelfth through the fifteenth century as the principal economic and cultural actors.[10] In its broad contours, the framework inherited from this early twentieth-century scholarship is still operative today.[11]

The outcome of the historiographical vagaries of the twentieth century in the current scholarly landscape is the formulation of "medieval-Sultanate-Islamic," which is frequently deployed in the use of *one* of these terms, while subsuming all three in application. However, such a tripartite formulation requires caution. With its emphasis on the political ascendancy of Islam in South Asia—the central axis around which the various historiographies treated above have cohered—the framework privileges *Northern* India as the initiator of momentous processes of historical change. It must be noted, however, that the southern reaches of the subcontinent underwent independent historical developments; in fact, it was not until well into the fourteenth century that Muslim-ruled polities or sultanates emerged in the south.[12] Therefore "medieval" as well as "Sultanate" both demand a geographically nuanced application within South Asia, bearing in mind the differing politico-cultural realities of north and south.

Illustrated Books of the Fourteenth through the Sixteenth Century in Northern India

Within Northern India, scholarship on the medieval has relied heavily on textual sources composed at Delhi. Admittedly, the concentration of royally commissioned court chronicles and histories in Delhi and its vicinity likely means that little in comparison survives from other localities. Nevertheless, such a limited gaze has resulted in a center-periphery perception of

these centuries overall, wherein Delhi serves as the political *and* cultural motor of the subcontinent, from which that antiquated idea of "influence" radiated in all directions.[13] This is far from the vista presented to us by the Object, here specifically illustrated book production. Indeed, the use of the Object as an additional and integral primary source is a methodological necessity, precisely *because* it considerably complicates—or, more optimistically, enriches—not only how we define the medieval in South Asia but also how we deploy the concept in the study of the centuries gathered within it.

An overview of medieval South Asian or pre-Mughal illustrated manuscripts, such as is possible here, provides two significant expansions of the perspectives gleaned from the primarily textual evidence of courtly chronicles marshaled for the writing of the history of these centuries. First and foremost, it is noteworthy that book illustrations furnish extensive indices of artistic patronage, consumption, and other cultural activities among prominent non-royal actors, particularly lesser nobles and prosperous merchants.[14] Many illustrated books produced in the North Indian sultanates bear colophons naming sultans as patrons (discussed below). Other important surviving works, however, bear the hallmarks of more commercial production in non-royal workshops, especially those with localized stylistic interpretations of "archaic elements of fourteenth-century Mamluk and Inju styles" (that is, of the Mamluk Mediterranean [r. 1250–1517] and the Inju [Injuids] of Persia [1335–57]). The painting styles just mentioned derived from manuscripts imported to the subcontinent via its extensive Indian Ocean connections with the Mediterranean, the Red Sea, and the Persian Gulf.[15] But it must be noted that true access to the non-royal echelons of cultural activity necessitates the fording of scholarly divides, especially the seemingly strict boundaries between Islamic and non-Islamic book production.[16]

Second, illustrated book production corroborates the conclusions put forth in studies of contemporaneous South Asian architecture.[17] Like buildings, manuscript illustrations call for contextualization within independent, regionally localized aesthetic and technical practices. A fundamental reality

about books and their illustrations is that, while in some ways they are inherently mobile, they are by no means placeless. These works had a point of origin, a context in which they were made, where their impetuses converged and from whence, once finished, they subsequently traveled. Although some regional traditions had varying degrees of dialogue with Delhi's artistic production, they responded to and were the visible results of the specific political, economic, and cultural circumstances of their respective geographic milieus. We can glean much, then, from locating and mapping, to the best of our current abilities, the places of origin of even a few sample manuscripts, as carried out below.

The illustrated *Iskandarnama* (Book of Alexander, fig. 2.1) provides an apt entrée into this overview of pre-Mughal (pre-1526) illustrated book production. The original work was likely of mercantile patronage in the Gujarat sultanate (r. 1407–1573) with its capital at Ahmedabad in present-day India. Despite indications of cropping and placement on another paper support, the illustrations are datable to ca. 1420 or perhaps earlier, particularly based on their affinities with Mamluk painting and the latter's spatial conventions. Such a connection is plausible due to the commercial linkages between Gujarat's ports and those of the Eastern Mediterranean. While no actual manuscripts from the Mamluk Mediterranean have been found in Gujarat, the commerce in many commodities—ranging from textiles to stone to woodcarving—could also have included illustrated works on paper.[18]

In contrast with the Mamluk antecedents, however, visual references to peacocks and plantain trees help determine this manuscript's place of origin as India. Furthermore, the figural types stylistically link the illustrations also to contemporaneous Western Indian Jain manuscripts, particularly the latter's depictions of Sahi kings (fig. 2.2). Although the principal male and female protagonists of Jain manuscript illustrations are distinguishable by their characteristic projecting farther eyes, the "foreign" Sahi kings were likely based on the figural types of Eastern Mediterranean manuscripts.[19] Intriguingly, then, the painters working on manuscripts for non-royal and most likely mercantile patrons—consumers of either Persianate

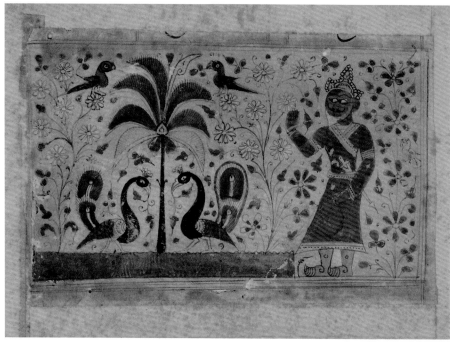

2.1. *Iskandarnama* (Book of Alexander) folio, Gujarat (?), India, 1420 CE / AH 822. Ahmedabad, India, N.C. Mehta Collection, NCM nos. 6–7

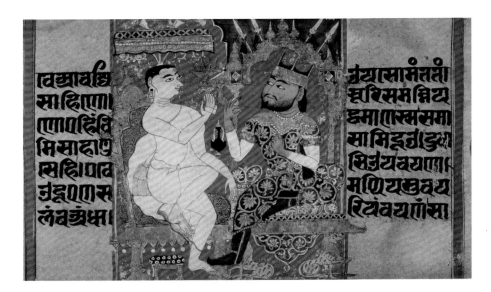

literature or Jain religious texts—relied on some overlapping figural conventions originating in very different geographic and cultural milieus.

At approximately the same time as Gujarat's *Iskandarnama*, illustrated book production in the Delhi region also encompassed a great diversity of styles and iconographies. Indeed, adaptations of the archaic Mamluk figural type are also to be found in the so-called Berlin *Hamzanama* (Adventures of Hamza, fig. 2.3), generally attributed to the Delhi region during the late fourteenth to the fifteenth century.[20] But this folio tellingly juxtaposes two stylistic and iconographic registers: the one above, eliding the pre-Islamic and Islamic eras in the *Persian* world of the mythical hero Hamza, probably a composite of at least two historical personages of the seventh and ninth centuries, and his companions meeting the Sasanian emperor Khosrow I Anushiruwān (r. 531–79); the one below, a register just as unabashed in its *Indian* visual and cultural references, with the decidedly South Asian figural type of the buxom, long-haired women acrobats and musicians.[21]

Again, the commonality of figural types and even iconographies is documentable across linguistic cultures as well as religious ambits. A discernible dialogue between the female

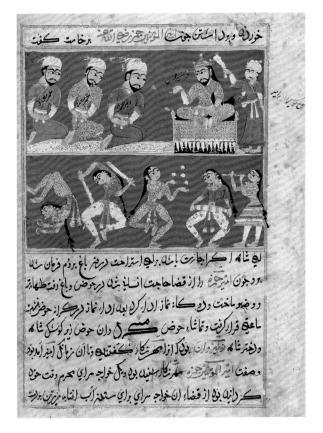

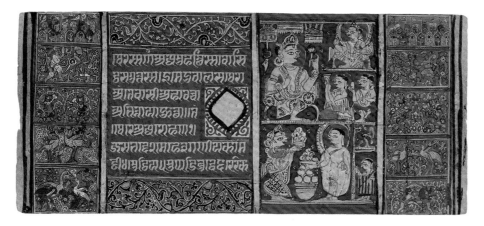

2.4. *A Monk Is Greeted at the Gate of the Coronation Hall* in the *Devasano Pado Kalpasūtra* (Book of Sacred Precepts from the Devasano Pado Temple) and *Kālakachāryakathā* (Stories of the Teacher Kalaka), Gujarat (probably Patan), India, 1500. Zurich, Museum Reitberg, Gift of Nanni and Balthazar Reinhart, RVI 2239, folio 148

2.5. *Chandayana* (Romance of Laurik and Lady Chandaini) folio, Delhi or Jaunpur, India, 1450–70 CE / 853–74 AH. Berlin, Staatsbibliothek Preussicher Kulturbesitz, Orientabteilung, MS.or.fol.3014

figural type of the *Hamzanama* and the female figures in Jain book illustrations hints at the work of skilled painters across genres (fig. 2.4). Such an observation is further plausible with a view to the expanded iconographies of Jain book illustrations of the fifteenth century and afterward. Unlike their earlier counterparts, these illustrations were unabashed in their use of arabesques and other recognizably Persianate border illuminations. Perhaps even more noteworthy was the incorporation of small vignettes—serving as secondary illustrations in smaller frames—coming directly out of Persianate courtly culture, including scenes of hunting, horsemanship, military processions, and various flora and fauna, all seemingly unrelated to the folio's principal iconography. Artists apparently shared styles and iconographies transcending Islamic and non-Islamic religious and literary illustrated manuscripts.

While the two Persianate manuscripts discussed above have elicited some scholarly consensus on their places of manufacture, opinion is split regarding the places of origin of others. Some have attributed works like the Berlin *Chandayana* (Romance of Laurik and Lady Chandaini, fig. 2.5) to Delhi, though others assign it to the easterly Jaunpur sultanate (r. 1394–1479).[22] Regardless of the ultimate attribution and despite the work's fascinatingly hybrid literary origins,[23] it is important to emphasize that the style of the *Chandayana* illustrations is emphatically in dialogue with Jain manuscript illustration. The figures are notable in the characteristic sharp features and projecting farther eyes, both traits also found in the stylistically rather conservative visual lexicon of Jain manuscript illustration.

2.6. *Ni'matnama* (Book of Pleasures) folio, Mandu, Madhya Pradesh, India, 1495–1505 CE / 900–910 AH. London, The British Library, India Office Library, IO Islamic 149/ETHE 2775

2.7. *Shahnama* (Book of Kings) folio, Jaunpur (?), India, 1501 (?) CE / AH 906 (?). New York Public Library, Spencer Collection Indo-Pers. Ms. I

The Mandu sultanate (r. 1392–1562) furnishes the best documented corpus of manuscripts, given the availability of several colophons among the surviving works (fig. 2.6).[24] They date to the late fifteenth and early sixteenth centuries, and are surprisingly coherent in their stylistic sources, perhaps because of their royal patronage. Despite Mandu's landlocked location, the political rise of the sultanate throughout the fifteenth century brought embassies from Timurid lands, which would have been among the primary conduits for the arrival of Herati as well as Shirazi illustrated manuscripts there.[25] Nevertheless, the prominent references to the local Indian cultural milieu should also be noted, particularly in the female figures.

While some of these definitely emerge from a Persianate context, the stylistic and sartorial conventions for others are adaptations of Indic prototypes.

A sixteenth-century *Shahnama* (Book of Kings, fig. 2.7) manuscript has the advantage of a colophon dating the work and locating its place of origin near Jaunpur, though it seems to have been made for a non-royal patron.[26] Again, the later Timurid visual references are undeniable. But we must return to the Berlin *Chandayana*, whose origins have been proposed as in *either* Delhi or here. The stylistic parallels with Jain manuscript illustration are also notable here, in the three-quarter view and the projecting eyes of the figures. The

بيك ترك روى أهنين برش
بشر و در أمدجو شير دمان
جوانا د دشمن درماز ابكنز
خود ولى ديداكخان كرديني

كريكبا ريزنخناز يك بس
بدنيا نا دش زماني أمان
بنم شنيدش عالبد مغز
تهكردن همانا كردن زبني

تا وزن برتنش نا باد ر
جهان شفتيرلاه بر شيرد
اينى كردزا زكردنكنان
بنجيد وبرلا يمجكخله خوانت

جوشمابرشجو شيمابار
كزان شيرشرشر برلودكرد
زدازترد مهزييجيزيتان
اينجشدن كردد رحك رانت

بتارك برلاورد روماهنين
فون لا برا فلد برتكشت
مخم جون درانشير دزلد د
دولا كهمي بخت انت دلبي

يكى ترك شسنه زبولاجين
ان ادمدجوكه روان
بجنك شيرا ز تكبيد ده
دولى نجى اندشعلان

حبال يكى تبخ زهرا بما ن
نوى دشمزايخانزار ه
وليكن شيرش دراراو
دولى نجي اندشعلان

كسندى جوزاك لن زلى بار
كطفل ازدنينا ريدامد يكى
بالهان ترك دسنا كشت
سعبد برخيمتيزينبوزريان

2.8. *Iskandar Defeats the Russians in Battle*, folio from the *Sharafnama* (Book of Honor) of Sultan Nasiruddin Nusrat Shah, Bengal (Bangladesh and India), 1531–32 CE / AH 938. London, The British Library, Or 13836 f.59r

angularity of the *Chandayana* figures does not echo the area's Jain manuscript illustration, however, thus favoring a Delhi origin for this manuscript. We should note nonetheless that, like Delhi, Jaunpur also domiciled a variety of patrons and preferences.

Finally, a manuscript of the *Sharafnama* (Book of Honor, fig. 2.8)—referring to the first part of the *Iskandarnama* composed by the twelfth-century poet Nizami (1141–1209)—is dated by colophon to 1531–32. The work was commissioned by Sultan Nasiruddin Nusrat Shah (r. 1519–38) of the far eastern sultanate of Bengal (r. 1352–1576), centered at the city of Gaur. As was the case with several examples before, belonging to various points of origin within Northern India, here we see the local interpretation of styles from the Persianate world conveyed in what have been termed "Shirazi manuscripts in commercial production."[27]

After the above overview of Northern India during the centuries defined as "medieval" and also "Sultanate," the question posed at the start of this essay still remains to be answered: How does the Object—and specifically manuscript production—require rethinking our approaches, mainly constructed by historians reliant on *textual* sources? One initial and perhaps obvious answer would be the decentering of Delhi as the radiating locus of cultural production. Having traced the "medieval" in South Asian historiography is useful here. For while the emphasis on Delhi may appear justified by the preponderance of textual sources surviving there, one cannot help but hearken back to that early twentieth-century nationalist anxiety of projecting the future nation onto a fragmented past. The Object, by contrast, focuses the gaze on a very different cultural landscape for the "medieval." The variety and independence of styles, with Delhi as one among many regional cultures, necessitates that we examine each of these localities as a center in its own right, rather than as a subordinate outpost falling into a cultural and geographic hierarchy.

Incorporating manuscript illustration as integral to our apprehension requires a second and perhaps more abiding adjustment of "medieval" and "Sultanate"—namely, the ability to expand the analytical gaze beyond a Persianate political elite. This shift has further consequences particularly for that Marxist-originated term "Sultanate." In contrast to historians' main resource of official chronicles with known royal patrons and authors, very few literary works with illustrations have surviving colophons, and even fewer specify royal patrons. The majority of illustrated books were, to borrow Robert Skelton's term, "commercial" productions and likely circulated among a mercantile or other non-royal clientele. Analysis of these non-elite manuscripts not only broadens our understanding of the goings-on in the South Asian "medieval" at large, beyond the realm of the sultans and their immediate courtiers, but also gives us a true entrée into the fluidity of styles and iconographies that the artists relied upon and, by extension, that their patrons consumed.

In the end, a true integration of the Object into frameworks of analysis for the "medieval" and the "Sultanate" complicates both of these terms with the wide array of cultural production. It is necessary to interrogate, then, the very viability of a monolithic nomenclature for the enormous variety in cultural production during this span of almost three centuries, in terms of political and religious affiliations as well as stylistic variation. It is the hope of this essay that the object talks back (as it were) by generating its own avenues of inquiry and taking its rightful place in the writing of the grand narrative of history.

— Alka Patel is a professor of art history at the University of California, Irvine.

1 Recent studies include Patel 2004; Merklinger 2005; Lambah and Patel 2006; Hasan 2007; Brac de la Perrière 2008; Flood 2009, esp. chapters 3–6; Allan 2013.

2 Within studies of South Asian history, the need for "a corrective to the scholarship focused inveterately on histories of elite groups" has been articulated principally by scholars of the eighteenth century, or early modern period. Indeed, the inclusion of the present essay within a volume on the medieval from a global perspective certainly holds out the hope that a traditionally marginal field such as South Asia can finally impact other regional historiographies. See Chaturvedi 2014, 309–10.

3 Although equally significant in hindsight, the indigenous Indic perceptions, divisions, and characterizations of time in discrete eras are not treated here, given the present-day inheritance of and reliance on Western intellectual frameworks. But for studies of premodern indigenous historiographies in India, see especially the still magisterial reference work by C. H. Philips (1961), which brings together overviews of history writing in Indic vernaculars and the lesser known Portuguese, Dutch, French, and Danish historiographies on South Asia.

4 Ali 2014, 384–85.

5 See Gottschalk 2013, 23–33. The narrower purposes of this essay prevent a full disaggregation of these intimately intertwined cultural and epistemological practices, so that Gottschalk's detailed study of just such questions in his larger work are all the more important.

6 For a gathering of the textual and material sources and mapping of the known Muslim mercantile communities throughout South Asia, prior to the late twelfth-century Ghurid campaigns, see Willis 1985; Chakravarti 2008; Patel 2004; Patel 2008; Patel 2010.

7 See especially Patel 2006, as well as the larger volume in which the essay appears; it treats the varying degrees of dialogue between the localized art and architectural cultures of South Asian sultanates with the larger Persianate world. See also below in main text.

8 See Ali 2014, 392–95.

9 Mukhia (1976, esp. 174) traces the seemingly inescapable drive toward larger and all-encompassing political formations and cultural identities even into late sixteenth-century Mughal historiography, which was mirrored in the British colonial view of world history. See also Ali 2014.

10 See especially S. Kumar 2007, 21–35, for an overview of this historiography, beginning with the early twentieth-century Indian Marxists through the post-independence Aligarh school, as well as more recent analyses.

11 As pointed out by Daud Ali (2014, 403–7), another more recent and broader temporal framework to be applied to the period is "early modern," which seeks to situate the Mughal Empire both globally and in the longue durée, looking back to its immediately preceding centuries, as well as looking forward toward incipient colonialism.

12 On "historical developments," see Ali 2014, 386.

13 See esp. S. Kumar 2007, 89–92. The author pointedly notes the "Delhi-centered" nature of the court chronicles, especially of the thirteenth and fourteenth centuries, and the resulting difficulties for the modern historian in accessing other sites of political power and cultural activity.

14 The phenomenon of extensive non-royal patronage is traceable in later Mughal-era illustrated book production as well. See Patel 2017, 142, 146–53.

15 See esp. Skelton 1978; Losty 1982, 40–41; Brac de la Perrière 2008, 54–56; Brac de la Perrière 2009.

16 See Brac de la Perrière 2008.

17 See Lambah and Patel 2006, wherein the cultural and political variety of primarily the northern sultanates is in full view.

18 See esp. Brac de la Perrière 2008, 67; Brac de la Perrière 2009.

19 Khandalavala and Chandra 1969, 10–14.

20 Brac de la Perrière 2008, 70.

21 The Hamzanama, both in its meta-epic form and in this specific iteration, highlights the distinctiveness of Persian literary production in India, a vast corpus dating from the beginning of the twelfth century (and perhaps earlier) and continuing unabated at least through the twentieth century. In contrast to greater Iran, where the Shahnama's preeminence was unquestioned, the Persianizing cultural ethos of India instead seemed to prefer the Hamzanama, probably even actively participating in the final form of the compilation; in fact, portions of the work were set within South Asia itself, such as the hero's adventures in Sarandib, or Sri Lanka. See further Pritchett 2012.

22 Losty 1982, 42–43; Brac de la Perrière 2008, 69–70.

23 The Chandayana composition originated in the fourteenth century in North-Central India, originally composed by a certain Maulana Daud in the Avadhi dialect of the area. See Losty 1982, 52–53. For a recent treatment of varying Chandayana manuscripts, see Adamjee 2017, 134–35.

24 Titley 1964; Titley 2005.

25 Titley 1964.

26 Goswamy 1983.

27 Skelton 1978, 139.

3

The Middle Ages, Middle America, and the Book

BYRON ELLSWORTH HAMANN

How do the pre-Hispanic cultures of Middle America (the Maya, the Mixtecs, the Aztecs, and many others) connect to the idea of a global Middle Ages?[1] And what does it mean to describe certain Middle American artifacts as medieval "books"?

We could start to answer the first question by thinking, contrastively, about the category of "early modern." When studying the two-plus centuries after 1492, "early modernity" has become a productive framework for global connected histories linking the Americas to Europe, Africa, and Asia. "Early modern" is useful, in part, because it displaces an older, Eurocentric framework of Renaissance and Reformation.[2] But what should we call the thousand years of the world's history before 1492, before the "New World" became inextricably connected to the "Old"?

One argument in support of a "medieval Mesoamerica" would rely on coevality.[3] If a comparative medieval horizon makes sense in Afro-Eurasia for, say, the eleventh century, why should the eleventh-century Americas be ignored simply because they had not yet been subjected to Europe's expansionist violence? Indeed, Felipe Fernández-Armesto, Robert Bartlett, and David Abulafia have all argued that the frontier conquests begun by Europeans in the eleventh century (south into the Mediterranean, east to the Holy Land, west into the Atlantic) were precursors to transoceanic European expansions in the fifteenth century (down the coast of Africa, to the Indian Ocean beyond, and across the Atlantic to the Americas).[4] Looking backward from that era of early modern globalizations provided the title to Pál Kelemen's two volumes on (pre-Hispanic) medieval American art in 1943: "One of the most significant events at the close of the Middle Ages of Europe was the discovery of America. This same event marks the end of medieval American civilization."[5]

An alternative argument for a medieval Mesoamerica focuses on social-structural parallels between the New and Old Worlds. This was the premise for the 2015 symposium

"The Medieval Americas: Violence, Religion, and Cultural Exchange before Columbus." Organizer Timothy Pauketat framed the conference as follows: "Just two centuries after the fall of Rome in Europe, the great city of Teotihuacan in Central Mexico had, for all intents and purposes, dissolved. Its dissolution was followed, sooner or later, by the end of various Classic Maya counterparts to the east. Diaspora, reformation, upheaval, and revival followed. . . . The 10th through 13th centuries CE . . . was a period when cultural expansion and increasing civic disorder seemed to go hand in hand."[6]

Yet the medieval-ness of Middle America in the millennium before 1492 is not only a question of temporal coevality or structural similarity. The shadow of the medieval has been in the background of Mesoamericanist imaginations for more than a century.

Today, Mesoamerican chronology is divided into three main periods: Formative (1500 BCE–300 CE), Classic (300–900 CE), and Postclassic (900–1520 CE).[7] This neat division of time has a complex history, but its roots lie in imagining the Maya as a "classical" civilization. In 1913, Sylvanus G. Morley began his essay "Archaeological Research at the Ruins of Chichen Itza" by describing the Maya as "the Greeks of the New World." The period from the third to the sixth century, he explained, "has been called 'The Golden Age of the Maya,' since, in so far as sculpture is concerned, it is best comparable with the classic period of Greek art."[8] A few years later, Roger Fry extended Morley's classicizing analogies forward in time, contrasting the earlier (Greco-)Maya with the later (Romano-)Aztecs: "The Aztecs had everything to learn from the Maya, and they never rose to the level of their predecessors. The relation is, in fact, curiously like that of Rome to Greece."[9]

But Old World / Mesoamerican analogies did not end with classical comparisons. Fourteenth-century Italian historians had created a three-part model for European history, in which an idealized "classical" age was followed by a "medieval" era of decline, followed in turn by a triumphal, "modern" renaissance.[10] Inspired by this chronological drama, Morley argued that the Maya were struck by "universal calamity" at the end of the sixth century, perhaps caused by "barbarian pressure from the south, east, and west." A "transitional period" then began, but those dark ages (three centuries long) in turn gave birth to a Yucatec "Maya Renaissance."[11]

Yet despite this early—and enduring—trope of the Greeks of the New World (and their collapse), naming a whole period of pre-Hispanic history as "Classic" didn't take place until the 1940s. Morley himself, in his 1946 book *The Ancient Maya*, used the Egyptianizing periodizations he created three decades before: Pre-Maya (3000? BCE–317 CE), Old Empire (317–987 CE), and New Empire (987–1697 CE).[12] Alfred V. Kidder seems to have been the first person to formally name the "Classic period," in a book published (like Morley's *The Ancient Maya*) in 1946. Kidder likened his Classic period to ancient Greece, and followed it with a "Late period" involving "incursions of barbarian tribes." In the same publication, Kidder also described the "Formative Maya" as preceding the Classic Maya.[13] A year later, Edwin M. Shook and A. Ledyard Smith both wrote of "Classic" and "Postclassic" periods in their 1947 reports on the archaeology of highland Guatemala.[14] The "Preclassic" appears in Shook's Guatemala report for 1948.[15] By 1952, "Classic" and "Postclassic" were adopted for the Honduran site of Copan, and their spread across Mesoamerica is probably due to George W. Brainerd's 1956 revision of Morley's *The Ancient Maya*, which renamed the principal epochs of Maya history as Preclassic/Formative, Classic, Postclassic, and Colonial.[16] A little more than a decade later, the new system was firmly in place. In 1969, George Kubler asserted that

the concept of a classic epoch in ancient American cultural history is no older than the neo-evolutionary developmental schemes imposed about 1950 on the entire fabric of American antiquity. The designation as "classic" for events roughly between 200 B.C. and A.D. 800 quickly found universal acceptance. Its general use testifies not alone to the convenience of the idea, but also to the plausibility of a parallel with the ancient Mediterranean. Here as there, an era of unprecedented attainments gave way to a medieval age which began with disintegrating societies.[17]

In sum, the concept of a medieval Mesoamerica is useful, at least in part, because it draws attention to the Europeanizing framework that already shapes our divisions of the pre-Hispanic past.

At the same time, staging a dialogue between text artifacts created in (say) the Yucatán before 1500 with text artifacts created in (say) Castile before 1500 reveals a number of points of comparison between those disconnected histories—histories brought together by conquest, in compatible and incompatible ways, over the course of the sixteenth century. The rest of this essay therefore shifts from periodizations to objects, and comparatively explores three key formats for Middle American text artifacts: the screenfold (handheld, or at least hand-holdable in scale), the paper map (handheld and desktop), and the cloth *lienzo* (tabletop, floor, or wall display).

We will begin with a basic question: What was a "book" in indigenous Mesoamerica?

Instruments of Seeing

We can approach this issue through M. T. Clanchy's work on medieval England. In a charming essay from 1980/81, Clanchy takes the reader on a tour of medieval church treasuries. He reveals that spine-bound books were stored therein with a host of other memory objects. Our own archiving practices have ripped those treasuries asunder, "divided by modern conservators between museums (for objects), libraries (for books), and archives (for documents)."[18] But in the medieval past, "archives" housed many different kinds of artifacts, only some of which were books:

> The first medieval archives were therefore the special places, the *secretarium* or *archiva*, where valuables of all sorts were kept. . . . Such archives did not just contain writings but all sorts of memory-retaining objects. On looking into such an archive the viewer would have seen not shelves of filing boxes containing papers but something more exotic: bones of the saints encased in gold, Gospel books studded with gems, charters and seals wrapped in Asiatic silks, finger rings, knives symbolizing conveyances, and so on.[19]

Similarly, when thinking about "books" in Mesoamerica, written-on artifacts need to be placed within a broader conceptual-material category: not memory objects, as in England, but "instruments of seeing." Mesoamerican writing—recording elite genealogies and accounts of the creation of the world, or tables describing the movements of Venus and Mars, or divinatory charts that allowed glimpses into the past or the future—enabled readers to see across space and time. That power was shared with other artifacts used by Mesoamericans to enhance their vision, such as mirrors and crystals (and even technologies adopted from the Europeans, such as eyeglasses and magnetic compasses). The conceptual connection of writing to other kinds of seeing instruments often took physical form. It is no accident that Mesoamerican books were varnished, or their gessoed pages polished: this turned them into reflective, mirror-like planes. The design of cloth *lienzos*—such as the *Lienzo de Tlaxcala*, to be discussed shortly—also worked to turn cloth and pigment surfaces into metaphorical mirrors. Links between writing and other visionary media can be found linguistically as well. Early modern Aztecs used the metaphor "book, mirror" to refer to sign systems in general, including the maize kernels cast in divination and the prophetic cries of animals. Twentieth-century Quiché Maya used *il'bal re*, literally "instrument of seeing," to refer to the crystals and coral seeds used in divination, as well as eyeglasses, binoculars, and telescopes. Their sixteenth-century ancestors used *il'bal re* to refer to the *Popol Vuh*, a hieroglyphic "Book of Council."[20]

But since this is a brief essay, my own micro-exhibition of artifacts contains no obsidian mirrors, no maize kernels, no ceramic vessels filled with mercury. I instead focus on objects of skin, paper, and cloth. Together, their written-on surfaces provide a micro-history of the instruments of seeing that most closely conform to Old World books. In order to keep questions of the medieval at play, these examples are chosen (as with my discussion of Clanchy's memory objects) to create thematic dialogues across the Atlantic.

Screenfolds / Scribal Practice

People in Mesoamerica were making screenfold books since at least the Classic period. They are shown on Maya ceramics, and their decomposed remains have been excavated from Maya tombs.[21] The dozen pre-Hispanic screenfolds that survive today date to the Postclassic period.[22] In format, they are made of long strips of gessoed paper or deerskin up to 27 centimeters in height and 1,350 centimeters in length, folded like an accordion for compact storage. Their structure meant that screenfold books could be extended to show all of their contents at once, or manipulated by clever readers to bring pages from different sections side by side for comparison.[23]

Now housed in museums and libraries in Europe and Mexico, Mesoamerica's screenfolds are usually divided into three groups. Maya scribes created the Dresden Codex (fig. 3.1), the Madrid Codex (or Tro-Cortesianus), the Paris Codex, and the Maya Codex of Mexico (formerly Grolier Codex).[24] The subject matter of these screenfolds is divinatory and astronomical. Five screenfolds, probably painted in and around the modern state of Puebla, form the "Borgia group": the Codex Borgia, the Codex Vaticanus B, the Codex Cospi, the Codex Fejérváry-Mayer, and the Codex Laud. Their contents, like those of the Maya screenfolds, are divinatory and astronomical—and there is fascinating evidence for direct connections between these two scribal traditions.[25] Finally, the largest surviving corpus of screenfold books comes from a region of Southern Mexico called the Mixteca. Three are pre-Hispanic: the Codex Colombino-Becker (or Alfonso Caso), the Codex (Zouche-)Nuttall, and the Codex Vienna (or Vindobonensis). A fourth, the Codex Bodley (fig. 3.2), seems to have been painted in the 1520s, just as the Europeans began to invade Mesoamerica. Three other Mixtec screenfolds were created later in the sixteenth century: the Codex Becker II, the Codex Egerton (or Sanchez Solís), and the Codex Selden (or Añute).[26]

Because so few pre-Hispanic screenfolds survive (especially when compared to the thousands of books from medieval Europe), using these objects to reconstruct scribal practice is challenging—although excavated murals and artifacts from the Classic Maya site of Xultun provide fascinating new data.[27] As is common with manuscript cultures worldwide, Mesoamerican scribes would sometimes copy older manuscripts onto newer surfaces, or resurface old screenfolds and reuse them to write new histories. The Mixtec Codex Selden provides the most famous example of this kind of palimpsesting. The genealogical images we see today were painted around 1560, and are read vertically (from bottom to top). But these images were painted over an older manuscript with a horizontal reading order (left to right), and new imaging technologies have allowed glimpses into what remains of this earlier painted layer.[28] Mesoamerican scribes would also (like the medieval creators of cartularies) compile the contents of several separate manuscripts into a single volume.[29] This seems to explain the multiple, disconnected narratives brought together, anthology style, on the "reverse" side of the Mixtec Codex Nuttall.[30]

Mesoamericans would also update copies of an older manuscript by adding new material, parallel to the revisions of French royal history in the different retellings of the *Grandes chroniques de France* (Great Chronicles of France).[31] The Maya Madrid Codex and Dresden Codex, for example, both contain astronomical tables describing the heavens during different centuries. The Madrid Codex has tables from the tenth and the fifteenth centuries; the Dresden Codex has tables from the eighth to the tenth century, and from the fourteenth to the fifteenth century as well.[32] These variously dated contents may provide evidence for the archiving and consultation of Maya astronomical almanacs across hundreds of years. For example, figure 3.1 shows pages 42 to 45 of the Dresden. The central section of hieroglyphs running across the latter three pages refers to the movement of Mars. Four full-bodied personifications of the planet can be seen to the right, descending from sky bands. To the left, a long-lipped, head-only glyph for Mars appears above the first column of bar-and-dot numbers on 43. The first five numbers in that column form a "long round" date, read top to bottom as 9.19.8.15.0 (dots have a value of 1, bars a value of 5, and a shell 0). These are followed by the day 3 Lamat (in the 260-day ritual calendar), then a "ring number" of 17.12, and finally another ritual calendar date,

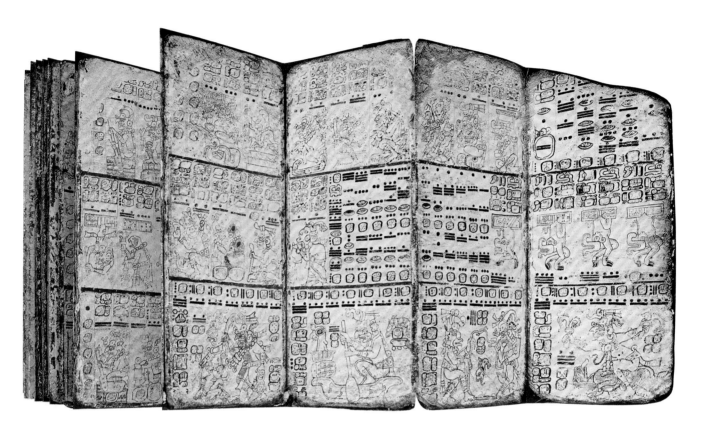

3.1. Facsimile of Dresden Codex (Yucatán Peninsula, Mexico, thirteenth-fourteenth century. Dresden, Germany, Saxon State Library, Mscr.Dresd. R 310), pp. 42–45. Los Angeles, Getty Research Institute, 2645-271

day 4 Ahau. Further calculation with these numbers produces the "long count" date of 9.19.7.15.8, which corresponds to the Gregorian year 818. However, the mathematical-celestial information that follows (including a "recalibrating correction") led Victoria R. Bricker and Harvey M. Bricker to suggest "either ca. A.D. 1250 or ca. A.D. 1350 as the period for which the current version of the table was constructed."[33]

A third parallel in scribal practice is unfinished business. Like the creators of the twelfth-century Winchester Bible, the thirteenth-century Douce Apocalypse, or the

fourteenth-century Prato Haggadah, Mesoamerican scribes did not always complete their books.[34] The last pages of the obverse of the Mixtec Codex Bodley, for example, are only half filled in with genealogical information (see fig. 3.2). The lower two registers are blank, and are followed by two additional folded pages with no writing at all. Nevertheless, these unfinished pages help us to date the manuscript. The last man shown on page 19 is Lord 4 Deer. He faces right, seated on the geometrically patterned frieze that is the place sign of his kingdom, Black Town (*Ñuu Tnoo*) or Tilantongo. His name

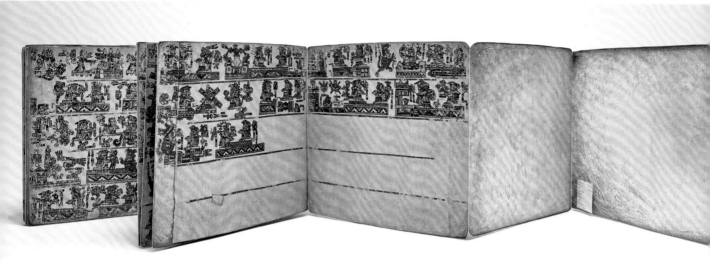

3.2. Facsimile of Codex Bodley (Mexico, ca. 1521. Oxford, Bodleian Library, Ms. Mex. d.1), pp. 19–20 and two blank pages. Los Angeles, Getty Research Institute, 93-B3709

(four dots and the antlered head of a deer) is drawn behind him, and in front of him is his wife, Lady 11 Serpent. Lord 4 Deer was named in 1579 as having been the ruler of Black Town when Hernán Cortés (1485–1547) arrived in Mesoamerica in 1519.[35] The genealogical history on this side of the Codex Bodley was no doubt meant to be updated, continued into the future as new heirs were born to Lord 4 Deer and Lady 11 Serpent. But apparently those plans were disrupted, perhaps by invasion or plague.[36]

None of which is to say that the painting of screenfolds ended with the Europeans. As mentioned above, three other Mixtec screenfolds date from post-Hispanic decades of the sixteenth century, as do all of our surviving screenfolds from Aztec Central Mexico, such as the Codex Borbonicus and the Codex Boturini.[37]

Maps / Archaeology

A second format for Mesoamerican writing was the painted-on-paper map. Although no pre-Hispanic examples survive, this does not mean that maps were post-contact inventions.

Cortés mentions several maps (now lost) made for him by indigenous people, and these suggest an already-existing tradition of mapmaking.[38] But the absence of medieval/pre-Hispanic maps means that my discussion must (as with the Codex Bodley) transition to early modernity.

Perhaps the most famous collection of sixteenth-century Mesoamerican maps are the sixty-nine created as part of King Philip II's *relaciones geográficas* surveys of the New World (1577–86). Philip II (r. 1556–98) also organized parallel *relaciones topográficas* surveys within Iberia (1575–81), a contemporaneous Old World project to which we will return.[39] Although printed questionnaires for the New World surveys requested maps from everywhere, those that were created mostly came from Mesoamerica, probably because mapmaking was accidentally compatible with the region's pre-Hispanic traditions. (In contrast, only one map was submitted from Peru.)[40] Indigenous Mesoamericans also created paper maps for their own purposes across three centuries of Spanish rule. Hundreds survive today in Mexico City's Archivo General de la Nación, many produced as legal evidence for land

claims.[41] But regardless of why they were made, indigenous maps from viceregal Mesoamerica tend to combine pre-Hispanic and European styles and materials.

Figure 3.3 shows a map created just northeast of Mexico City. It is desktop-scale in format, with several sheets of paper glued together to create a surface 61 by 145 centimeters. Probably dating to 1580, it was included as part of the *relación geográfica* for Tequizistlan. Various towns are inked on its surface, their cross-topped churches accompanied by mills, marketplaces, and town halls. These settlements are connected by irrigation canals and roads, the latter marked with the curved hoofmarks of horses (pre-Hispanic pathways, in contrast, were marked with human footprints). Natural features are also included: rivers, fields, and lobed hills marked "cerro." The largest of these is actually named—"great hill called Tenan"—and is further labeled with a description of how the hill *sounded*: "In this ravine is heard a great noise like water." Called Cerro Gordo (Big Hill) today, its sixteenth-century Nahuatl name translates as "mother." In other words, this was a sacred mountain.[42] It rises to the north of the Classic-period city of Teotihuacan, an archaeological site also shown on the map (just under the label for east, "oriente," near the center of the upper edge). Nine pyramids outline a rectangular space. Most are depicted as small triangles, but the ones to the north and east are larger, and represent Teotihuacan's Pyramid of the Moon and Pyramid of the Sun. The area outlined by these inked monuments is labeled "oracle of Moctezuma."

Like the medieval Europeans described in Charles Homer Haskins's *The Renaissance of the Twelfth Century* (1927), Erwin Panofsky's *Renaissance and Renascences in Western Art* (1960), and Michael Camille's *The Gothic Idol* (1989), indigenous peoples in pre-Hispanic Mesoamerica were intrigued by the ruins and remains of previous civilizations.[43] One of the Classic murals at Teotihuacan itself may depict a Formative-period greenstone sculpture; the Classic Maya also collected and reworked Formative greenstone artifacts.[44] From objects excavated in Mexico City, we know that the Postclassic Aztecs collected antiquities from ruined cities (Teotihuacan, Tula, Xochicalco) and brought them back to their capital to be buried as offerings or used as models for new, archaizing

3.3. *Relación geográfica* (geographical survey) map showing Teotihuacan, Mexico, probably 1580. Seville, Spain, Archivo General de Indias, Mapas y Planos Mexico-17

works of art.[45] The Aztecs also visited ruined sites to leave offerings and perform ceremonies. The alphabetic text that accompanies the Tequizistlan map claims that every twenty days "the priests of Moctezuma lord of Mexico would come, with the said Moctezuma, to offer sacrifices" before Teotihuacan's stone images. Those images, and the pyramids they stood upon, are also described in detail.[46]

Teotihuacan's ruined buildings and sculptures are not the only archaeological descriptions provided by respondents to the *relaciones geográficas* surveys. There are dozens of other examples from throughout Spanish America. In some ways, this archaeological sensitivity is surprising. Unlike the request for maps, a request for information about ancient remains was not included in the lists of questions printed for the New World. In contrast, a question about "the remains of ancient buildings, epitaphs, and inscriptions, and antiquities" does appear in the *relaciones topográficas* guidelines being circulated at the very same time *within* Spain.[47]

Yet despite this transatlantic difference in questionnaires, the results provided for those questionnaires in both Spain and Spanish America are, where antiquities are concerned, strikingly parallel. Respondents on both sides of the Atlantic described ruined buildings, strange statues, and ancient texts. These antiquarian answers allow us to think comparatively about a shared interest in archaeology on the part of both Native Americans and Europeans. When Europeans arrived in the Americas, they encountered not only ancient ruins but also Native Americans already interested in those ruins and their meaning. The pages of the transatlantic *relaciones* allow us to see how independent traditions of archaeological interpretation, developed in medieval Europe and pre-Hispanic Mesoamerica, were brought together in dialogue during the sixteenth century.

Lienzos / Crusade

A third format for Mesoamerican writing was the *lienzo*: a large sheet of cotton cloth, painted with narratives of migration and genealogy amid a landscape of place signs. As with paper maps, no pre-Hispanic examples are known. Created in Central Mexico, Puebla, Guerrero, Veracruz, Michoacán, and Oaxaca, around sixty survive from the sixteenth and early seventeenth centuries, and another sixty to seventy from the seventeenth and eighteenth centuries.[48]

Figure 3.4 shows four scenes from a *lienzo* created around 1552 in the town of Tlaxcala, one valley to the east of Mexico City and Teotihuacan. The Tlaxcalans had been pre-Hispanic enemies of the Aztecs, and successfully resisted incorporation into the Aztec Empire. When Cortés and his soldiers arrived, the Tlaxcalans saw an opportunity to defeat their ancient foes, and so formed an alliance with the strangers from across the ocean. The *Lienzo de Tlaxcala* tells how the Tlaxcalans destroyed the Aztec Empire (with some help from the Europeans), and then went on to conquer other lands beyond the limits of Aztec imperial space.

The original *lienzo* was 500 centimeters tall and 250 centimeters wide. A large scene at the top represented the political structure of Tlaxcala ca. 1552; the rest of the cloth below (divided into a seven-by-thirteen grid of rectangular cells) went back in time to 1519, and showed how the Tlaxcalans conquered Central Mexico (1519–23, rows 1 to 8), followed by West Mexico (1529–31, rows 8 to 12) and Guatemala and El Salvador (1524, rows 12 to 13).[49] The *lienzo* was commissioned in preparation for a transatlantic Tlaxcalan embassy to Charles V (r. 1519–58) of Spain. The ambassadors finally left in 1562, but we do not know if they brought the painted cloth with them. Three centuries later, during the French occupation of Mexico in the 1860s, the carefully preserved *lienzo* was taken for copying to Mexico City. There it was lost, and so the reconstruction shown here is from lithographs based on the copy.

Most of the cells with conquest scenes, like those in figure 3.4, are divided into two parts. The Tlaxcalan and European soldiers charge from the left, and enemy warriors defend their communities on the right. An alphabetic label above indicates where the battle is taking place. Over and over again, these scenes of conquest include a mounted European soldier trampling mutilated indigenous bodies. Federico Navarrete argues that this may

Colotlan.

Colhuacan.

Quetzaltenaco.

Tecpan atitlan.

3.4. *Lienzo de Tlaxcala* (Canvas of Tlaxcala), Central Mexico, 1552. www.mesolore.org, row 11, cells 70 and 71; and row 12, cells 77 and 78

be a reference to the divine participation of Saint James "Moorkiller" (Santiago Matamoros) transformed into "Indiankiller" (Mataindios) during the "Conquest of Mexico."[50] The Tlaxcalans who painted this *lienzo* proclaimed themselves to be good Catholics in many of its scenes, so it would have made sense for them to depict divine Christian aid on the battlefield.

Are these violent scenes of Santiago evidence that medieval crusading imagery was imported to Mexico? For medieval Europeans, crusades were not limited to the Holy Land: they could also be waged elsewhere, such as in Muslim Spain.[51] The appearance of "medieval" iconography on the *lienzo* would also be in keeping with one tradition of New World periodization. Several scholars have placed "medieval"

America *not* in the pre-Hispanic centuries following Classic-period collapse but in the decades after the Europeans arrived. In 1966, George Kubler mapped the Old World's classical, medieval, and modern eras onto the New World's pre-Hispanic, colonial, and modern history.[52] In 1984, Luis Weckmann published his two-volume *La herencia medieval de México* (The Medieval Heritage of Mexico), which looked at how "medieval" European practices were imported to New Spain.[53] Five years later, Louise Burkhart's *The Slippery Earth* often referred to "medieval" European ideas in sixteenth-century Mexico.[54]

But iconographically speaking, the image of Saint James Moorkiller is quite rare in the Middle Ages. Scenes of warfare are of course common in medieval manuscripts from both

Europe and the Islamic world.[55] But this particular form of military iconography didn't become popular in European art until the late 1400s, probably in connection with warfare against Muslim Granada and the expansion of the Ottoman Empire.[56] And so it is a different medieval connection that interests me in these painted scenes. The flanks of seven of the *lienzo*'s charging horses (such as in cell 70 at Colotlan, cell 77 at Quetzaltena[n]co, and cell 78 at Tecpanatitlan) are branded with a circle divided in half, the upper half divided again. This design has weighty symbolic implications. It references medieval T-O maps of the Old World (showing Europe, Africa, and Asia).[57]

Why would horses on the *lienzo* be branded with an image symbolizing the world? If (as Navarrete argues) many of these steeds and their riders refer to Santiago as a warrior-saint, perhaps the branded message concerns the global pretensions of Catholic crusade, and the Tlaxcalans' vision of themselves as Catholic crusaders. The very top of the *lienzo* shows the coat of arms of Charles V, king of Spain and Holy Roman emperor. This shield is flanked by the Pillars of Hercules and Charles's motto: PLVS VLTRA (Further Beyond). Significantly, the geography of conquest depicted on the *lienzo* goes well beyond the limits of the former Aztec Empire: the Aztecs did not conquer as far north as West Mexico or as far south as El Salvador.[58] The *lienzo*, then, presents the Tlaxcalans as world conquerors, going "Further Beyond" the imperial limits of medieval Mesoamerica—and thus expanding the world-ruling self-image of their Renaissance Catholic monarch, Charles V.

The idea of the medieval has long been, and continues to be, a productive medium and mediator for thinking about the connections of Middle American studies and the Western tradition. The Mesoamerican medieval raises issues of historiography and periodization, and also the possibilities of imagining comparative—if not connected—coeval histories. The medieval is of course an alien category in Middle America, imported and applied from across the Atlantic. But alien imported categories can still be generative. T-O maps painted on the Tlaxcalan world-in-a-*lienzo* ca. 1552 create a fractal global vision, encompassing seven Old Worlds within a cartography of the Further Beyond—a cartography meant by its Tlaxcalan creators to be sent east across the Atlantic, sailing back to the Pillars of Hercules.

— Byron Ellsworth Hamann is an associate professor of Latin American and Iberian art history at Ohio State University.

1 The term "Mesoamerica" (encompassing the present-day nation-states of Mexico, Guatemala, Belize, Honduras, and El Salvador) did not become popular until the second half of the twentieth century, after it was used in the title of an influential essay by Kirchhoff (1943) (English translation Kirchhoff 1952). "Mesoamerica" displaced "Middle America," which had been used since the late nineteenth century (Bowditch 1904, 9–10; Morley 1930, 2, 28n4, 34, 409). Tulane University's Middle American Research Institute was founded in 1924.

2 Goldstone 1998; Bentley 2007; Fasolt 2012. On connected histories, see Subrahmanyam 1997.

3 Hamann 2016b.

4 Fernández-Armesto 1987; Bartlett 1993; Abulafia 2008.

5 Kelemen 1969, 1:1.

6 See Hamann 2019.

7 On the fatal flaws of "Current Era" or "Common Era" labels, see Hamann 2016a.

8 Morley 1913, 63, 65. The same year, Herbert Spinden also argued that "Maya art furnishes upon examination many analogies to the early products of the classic Mediterranean lands," making various Maya-Greek comparisons throughout his work A Study of Maya Art. Spinden 1913, 15, see also 11, 36, 131–32, 160, 239; O'Neil 2012, 44–45.

9 Fry 1918, 156.

10 McLaughlin 1988. This three-stage model was also applied to India's history (Inden 2000).

11 Morley 1913, 65, 73.

12 Morley 1946, table III; Morley 1917. "Pre-Maya" was not part of Morley's original Old Kingdom / New Kingdom division of time.

13 Kidder 1946, 3–4, 9.

14 Shook 1947, 180, 182; A. L.

15 Smith 1947, 186.

16 Shook 1948, 215.

17 Longyear 1952, 10; Morley 1956, 42–43. The earliest chronology chart divided into Preclassic, Classic, and Postclassic that I have found is in de Borhegyi 1951, 173.

18 Kubler 1969, 46–47; see also Kubler 1977, 37.

19 Clanchy 1980/81, 122.

20 Clanchy 1980/81, 121–22.

21 Hamann 2013, 530–31.

22 Velásquez García 2009; Chase and Chase 2005; Carter and Dobereiner 2016. Thanks to Scott R. Hutson for helping me round up this archaeological herd of articles (as Mixtec codex scholar Nancy Troike would say).

23 In 2001, two fragments from a divinatory screenfold were discovered in San Bartolo Yautepec, recycled as the leather cover for a book of Gregorian chants (van Doesburg and Urcid 2017).

24 Byland and Pohl 1994, 9; Hamann 2004; Just 2004.

25 Vail 2006; see also the essay by Megan O'Neil in part 2 of this volume.

26 On the provenience of the Borgia group manuscripts, see Boone 2007, 213–30. On interactions, see Hernández and Vail 2010; Lacadena 2010.

27 M. E. Smith 1973; Boone 2000, 87–105.

28 Rossi, Saturno, and Hurst 2015.

29 M. E. Smith 1994; Snijders, Zaman, and Howell 2016; Carruthers, Chai-Elsholz, and Silec 2011.

30 D. Walker 1971.

31 http://www.mesolore.org /tutorials/learn/4 /Introduction-to-the-Codex -Nuttall/25/Contents-of-the -Codex-Nuttall-Obverse.

32 Hedeman 1991. Thanks to Karl Whittington, Lisa Iacobellis, and Elizabeth M. Sandoval for their help with European examples in this section.

33 Vail 2006, 503, 506.

34 Bricker and Bricker 1986;

35 Bricker and Bricker 1992, 83.

36 C. Donovan 1993, 6, 16, 18, 59; Morgan 2006, 9, 21, 31–32, 56, 61, 65, 68, 81–88, 99–102; Centeno and Stavisky 2013, 161–84. See also Calkins 1978.

37 del Paso y Troncoso 1905, 73.

38 Jansen and Pérez Jiménez 2005, 30, 72–73.

39 Boone 2007, 5–6, 88–96.

40 Cortés describes these maps as painted on cloth: in other words, they were what we now call lienzos. See "Lienzos/ Crusade," below (Mundy 1998, 197, 228).

41 Mundy 1996, xviii, 2–3.

42 Mundy 2008, 144–59.

43 Leibsohn 1995; Leibsohn 1996; Mundy 1996, 181–209.

44 Tobriner 1972.

45 Haskins 1927; Panofsky 1960; Camille 1989.

46 A. Miller 1973, 154–55; Schele and Miller 1986, 150–51, 163; Proskouriakoff 1968; Rich et al. 2012.

47 Umberger 1987; Umberger 2016.

48 del Paso y Troncoso 1979, 222.

49 Hamann 2017.

50 Johnson 2015; König 1993; Boone 2007, 125–61.

51 Hamann 2013. For an interactive reconstruction of the full lienzo, see http://www.mesolore.org /viewer/view/2/Lienzo-de -Tlaxcala.

52 Navarrete 2006.

53 MacKay 1988.

54 Kubler 1966.

55 Weckmann 1984.

56 Burkhart 1989, 3, 20, 22, 25, 26, 29, 30, 35, 44, 47, 57, 63, 93, 100, 120, 144, 153, 159, 171.

57 See the case study by Kristen Collins and Bryan C. Keene, as well as the case study by Kaiqi Hua, in part 3 of this volume.

58 La Orden Miracle 1971; Hidalgo Ogáyar 1991; Navarrete 2008; Quinn 2011.

59 See the case study by Asa Simon Mittman in part 1 of this volume.

60 http://www.mesolore.org /atlas; contrast the geographic scope of Aztec tribute provinces from the Matrícula de Tributos with the geographic scope of conquests in the Lienzo de Tlaxcala.

4

Where Is Medieval Ethiopia? Mapping Ethiopic Studies within Medieval Studies

SUZANNE CONKLIN AKBARI

Where or how does the study of Ethiopian literature, history, and culture fit within the framework of the discipline of medieval studies? In this essay, I attempt to locate Ethiopia, first in terms of medieval representations—that is, how it was seen through Western eyes—and second in terms of how the study of medieval Ethiopia might contribute meaningfully to the discipline of medieval studies, which is often represented as being concerned primarily with Latin Christian Europe. The place of medieval Ethiopia might be conceived within the overarching framework of a "global" Middle Ages, or it might be conceived in a way that draws upon the methodologies of Mediterranean studies, with a focus on connectivity and regional identities.[1] Either approach must be situated in the context of the long history of Western representations of Ethiopia, which drew upon religious and racial constructions of identity to imagine a people who were at once remote and monstrous, deformed by the heat of the sun, and yet situated at the very heart of an alluring fantasy of Judeo-Christian identity.[2]

Addressing the role of medieval Ethiopia unsettles the very paradigm that underlies the conception of the "medieval period" as the time between the fall of Rome in the West in the fifth century and the fall of Constantinople in the East in the fifteenth century. While this genealogy follows imperial history centered on the Roman Empire, it also lines up geographic concepts with religious identities, identifying the Middle Ages as the period lying between the advent of Christian Rome in the age of Saint Augustine (354–430), and the fall of Christian Constantinople (the eastern capital of the Roman Empire) in 1453 in the age of the Ottomans. Through this periodization, West is opposed to East, Christendom to the world of Islam, Europe to Asia. This set of assumptions lies invisibly behind the discipline of medieval studies.

Incorporating medieval Ethiopia into the story problematizes this easy genealogy of the field, not only in geographic terms but also with regard to confessional, that is religious, identities. If Ethiopia was a Christian nation long before

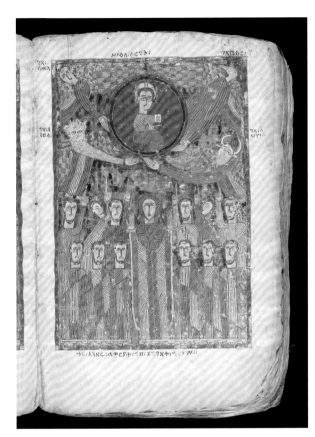

4.1. *The Ascension* in a Gospel book, Amhara region, Ethiopia, late fourteenth–early fifteenth century. New York, The Metropolitan Museum of Art, Rogers Fund, 1998.66, fol. 16

or are they outsiders? And how might their status affect our sense of what kind of people are (or should be) attracted to the discipline of medieval studies?[3] In the Latin kingdom of Jerusalem (founded in 1099 after the First Crusade and lasting until 1291), what did the presence of Ethiopian monks signify to the Frankish settlers who laid claim to the Holy City in both spiritual and political terms? The following pages begin to address these questions, first focusing on medieval European Christian representations of Ethiopia, and then turning briefly to the role of medieval Ethiopia within the discipline of medieval studies.

Locating Ethiopia: The View from Europe

For medieval readers, Ethiopia was at once an exotic, distant location and a place at the crux of salvation history. Ethiopian identity was associated with such figures as the Queen of Sheba, beloved by Solomon and thought to be the sensuous focus of the Song of Songs; the Magi, one of whom was thought to come from that southeastern region; the convert described in Acts 8:26–40, who was a court official in the service of Queen Candace of Ethiopia; and the enigmatic Prester John, whose homeland was at first identified as India, but who by the end of the Middle Ages was placed by mapmakers in East Africa.[4] These various figures situate Ethiopia not only as a key reference point within salvation history but also as a repeated point of reference whose essential identity remains the same throughout time.

In order to begin to unpack this view of an essential Ethiopia, it is helpful to begin by examining the medieval Western view of Ethiopia in space—that is, on medieval world maps. Medieval world maps are often highly schematic or diagrammatic, as in the simple T-O map found in an eleventh-century manuscript included in a copy of the *Etymologies* by Isidore of Seville (560–636, see fig. 6.1), which is oriented toward the East and shows the three known continents of Asia, Europe, and Africa. Other medieval world maps retain this basic T-O structure while flowering into an expanded symbolic geography, as seen on the world map included in Lambert of Saint Omer's early twelfth-century *Liber Floridus* (Book of Flowers,

Rome, and if its manuscript culture—from the Amhara and Tigray regions and beyond (fig. 4.1)—continued far beyond the Middle Ages to the present day, what does this do to our accepted norms of periodization? And what does it offer to those of us who seek to rethink the unspoken assumptions of our discipline of medieval studies? How does the history of repeated contact between Rome and Ethiopia, first in antiquity with the Kingdom of Aksum (founded in 100 CE), and then in the course of fourteenth- and fifteenth-century monastic missions from Ethiopia to Rome, inflect our sense of the field? Are these Ethiopians part of the story of the medieval past,

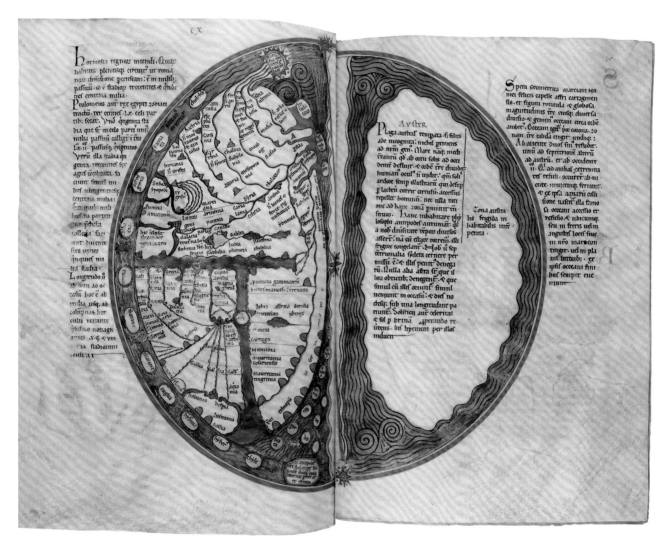

4.2. Zonal world map, *Liber Floridus* (Book of Flowers) of Lambert of Saint Omer, northern France or Flanders (Hainaut), twelfth century. Wolfenbüttel, Germany, Herzog August Bibliothek, Ms. Cod. Guelf. I, Gud. Lat. I, fols. 69v–70

fig. 4.2), which survives in a later twelfth-century copy. The T-O form persists, but it is energized by the elaborate water courses that permeate the territory arising from the four rivers flowing out of Paradise (the Garden of Eden) and augmented by islands that surround the main landmass. In addition, Lambert includes a fourth continent to the south, which according to the map rubric is "unknown to the sons of Adam due to the great heat." This enigmatic space is juxtaposed with Ethiopia, immediately across the equator that runs from top to bottom, in the gutter separating the pages. Ethiopia is thus proximate to the unknown fourth continent, and yet utterly cut off from it.

The location of Ethiopia on medieval maps—like that of India—is both variable and multiple.[5] There are several Indias and several Ethiopias; there is an Ethiopian India, sometimes located in Asia, sometimes in Eastern Africa. Encyclopedists such as Isidore of Seville and Bartholomaeus Anglicus (before 1203–1272) similarly describe two or even three territories of Ethiopia, one located at the very limit of habitable land in the hot south. In doing this, they are repeating and elaborating accounts of the region from antiquity, most importantly the *Historia naturalis* (Natural History) of Pliny the Elder (first century CE), but also earlier Greek accounts (including Homer and Herodotus) that allude to the burning climate of Ethiopia. At the bottom, or extreme southwest, of the world map in the *Liber Floridus*, we find the "terra ethiopium"; above it, to the south, is the "deserta ethiopie"; and farther up (in the area that, on the T-O map, would be Asia), "saba ethiopie." Finally, separating the "desert Ethiopia" from "Saba Ethiopia" is the "locus draconii," the place of dragons.

We can contextualize the labels on Lambert's map by referring to what the encyclopedists say. Isidore of Seville, writing in the seventh century, states in one chapter of his *Etymologies* that there are two Ethiopias, one to the west and one (he says) "around the rising place of the sun [circa ortum solis]" (14.5.16).[6] Elsewhere Isidore says that there are three races of Ethiopians, one of which (the "Indi") lives in the east (9.2.128). Moreover, says Isidore, beyond the two parts of Ethiopia lies a fourth part of the world that "is unknown to

us due to the heat of the sun [solis ardore incognita nobis est]" (14.5.17). This, says Isidore, is where the Antipodes can be found. This description is in keeping with Lambert's map, which cuts off the mysterious fourth continent that is located beyond the equator, but also provides for a fourth landmass extending out from the basic T-O form in the north—above the equator—which is where the stretched-out regions of "the land of Ethiopia" and "desert Ethiopia" appear. The third "race" of Ethiopians described by Isidore, whom he calls the "Indi," corresponds to the land that Lambert identifies as "Saba Ethiopia," situated among the lands of India and, by the name "Saba," associated with the legendary biblical Queen of Sheba. Isidore's encyclopedic account is similar to those of later writers, such as the thirteenth-century Vincent of Beauvais (1184–1264) and Bartholomaeus Anglicus; Vincent, like Isidore, says that there are two Ethiopias but three "races" of Ethiopians; Bartholomaeus says that there are actually three lands of Ethiopia.

Other maps include similarly variable and multiple images of Ethiopia, such as a map from the late eighth or early ninth century that appears with Isidore's *De rerum natura* (On the Nature of Things) in the Biblioteca Apostolica Vaticana (Vat. Lat. MS 6018, fols. 63v–64r). This south-oriented map includes two labels for Ethiopia, "libya Ethiopia" and "deserta ethiopie," with the latter appearing where we would expect to find Asia in the T-O map framework. The map included in a tenth-century manuscript of the *Apocalypse* by Beatus of Liébana (ca. 730–ca. 800) (fig. 4.3), like the Wolfenbüttel *Liber Floridus* map described above, includes a mysterious fourth continent labeled with a rubric that identifies it as inaccessible to the biblical sons of Noah and, just above the equator, in large letters, the rubric "ETIOPIA." This early world map from the popular Beatus manuscript tradition is highly schematic, participating in a symbolic geography that is significantly different from that of the early twelfth century, when Lambert worked. The maps share, however, an apocalyptic vision that makes space for an enigmatic fourth continent that is cut off from the present world but remains a perpetually immanent site of transformation and renewal.

Later maps from Northern and Central Europe treat Ethiopia differently depending upon the specific aims of the mapmaker. For example, the map of the world printed at Magdeburg in 1597 in the *Itinerarium Sacrae Scripturae* (Itinerary of Sacred Scripture) by Heinrich Bünting (1545–1606) draws upon the tripartite structure of the T-O map but recasts those three parts as the three leaves of a clover, with a fourth landmass—America—in the corner, just emerging into view (Los Angeles, Getty Research Institute, 44-2). Here, the apocalyptic fourth continent featured by Beatus in the tenth century, and by Lambert in the twelfth, is replaced by a different geographic horizon, one that is not cut off but rather the desirable object of conquest and exploration. Ethiopia does appear, however, on a late fifteenth-century T-O world map from Lübeck (ca. 1486–88; San Marino, Huntington Library HM 83, fols. 6v-7), in two places: horizontally, along and just above the line of the Nile that separates Asia from Africa, and vertically, up above in Asia, labeled as "Ethiopia superior."[7] The multiple Ethiopias of Pliny and the medieval world maps persist here, as they do in the Fra Mauro map (1457–59; Venice, Biblioteca Nazionale Marciana). South-oriented, it depicts Africa as a large continent at the upper right, featuring "Ethyopia Australis" and "Ethyopia Occidentalis," that is, Southern Ethiopia and Western Ethiopia, as well as more discursive rubrics that refer to a wide range of political and geographic features of the region. These late medieval examples are similar to the earlier ones in that they include multiple Ethiopias, but different in that they replace qualitative distinctions such as "desert Ethiopia" and "Saba Ethiopia" with distinctions that identify the different Ethiopias primarily in terms of the cardinal directions.

World maps such as the Hereford world map (ca. 1300) also label the location of Ethiopia, but they do so in conjunction with another feature of the torrid south—that is, the monstrous races, which are depicted along the southern region on the Hereford map very similarly to the way they are on the earlier Psalter map (after 1262; London, The British Library Additional MS 28681, fol. 9r). Each of the monstrous races appears enclosed in its own individual little box of monstrosity, signaling diversity and multiplicity. A close-up view of these boxed-in monstrous forms can be found in a Bestiary from 1277 or after, which includes a four-eyed Ethiopian archer along with other marvels of humanity produced by the torrid climate of the extreme south (Antipode; Scinopode; coastal Ethiopian; Psalmlarus) and additional monstrous forms on the facing page (Trococite; A Headless Man with Eyes on His Shoulders; A Headless Man with a Face on His Chest; A Man with a Large Under Lip) (Los Angeles, Getty Ms. Ludwig XV 4, fols. 118v–119; see also fig. III.3). For people living in Western Christian Europe, Ethiopia was a crucial concept for thinking with, not just in theological or eschatological terms but also in scientific and medical terms. Natural philosophers such as Albertus Magnus (ca. 1200–1280) used the figure of the Ethiopian—burned black, they thought, by the rays of the sun—as a kind of test case or limit case for climate theory. The dry heat of the region produced certain physiological qualities, so that (Albertus posited) within a few generations, a white northerner living in Ethiopia would have black descendants. This construct (with many variations) was key to the climate theory that underlay most medieval conceptions of racial difference and bodily diversity, and which continued to inform early conceptions of racial difference in the New World well into the early modern period.[8] The monstrous races are thus intelligible in both scientific and theological terms: they are not only a manifestation of the natural laws that govern climate and physiology but also a visible witness to the power of God to create what he wills, when he wills, and to produce marvels.

In theological terms, Ethiopia was understood as a place of special grace and apocalyptic expectation. In the Hebrew Bible, the story of Solomon and Sheba was interpreted in terms of a mystical union that brought the earthly Jerusalem into contact with the southern riches of Ethiopia; in the Acts of the Apostles, the queen of Ethiopia, named Candace, is identified as the ruler of the Ethiopian eunuch who converts to Christianity. Apocryphal stories of the Magi, seen in a twelfth-century Beatus manuscript from San Petro de Cardeña (1175–85; New York, The Metropolitan Museum of

4.3. Beatus map in an *Apocalypse*, San Salvador de Taibara, Spain, 945. New York, The Morgan Library & Museum, Purchased by J. P. Morgan (1867–1943) in 1919, MS M. 644, fols. 33v–34

Art, 1991.232.1), also associate one of the three wise men with Ethiopia, in a reassertion of the fundamentally tripartite division of the world found in the medieval world maps and medieval encyclopedias.[9] These texts divide the world into three parts—Asia, Africa, and Europe—to correspond to the three sons of Noah: Shem is associated with Asia, the biggest part; Ham, the outcast, with Africa; and Japheth, the youngest, with Europe. The three Magi recapitulate the sons of Noah, but while the sons of Noah are scattered outward into the wide world after the Flood, their descendants populating each of the three continents, the three Magi come inward toward the sacred center of the nativity. On this Beatus manuscript page, a depiction of the Virgin and Child with the Magi, to the right,

is integrated within a larger genealogy laid out in a series of linked circles, plus the familiar form of the T-O world map at the top left. Note that the T-O map includes not just the names of the three continents but also the three sons of Noah as a visible reminder of the Old Testament prefiguration of the three Magi, seen at right. The economy of type and antitype is expressed in terms of word and image, with the names of the sons of Noah foreshadowing the vivid human forms of the three Magi.

Depictions of the Magi vary in how they present the ethnic origins of each of the three kings. Some, such as the Beatus image mentioned above and as in a book of hours from Naples (1460s; Los Angeles, The J. Paul Getty Museum, Ms.

4.4. *The Adoration of the Magi* and border with *The Queen of Sheba before King Solomon* in the Prayer Book of Cardinal Albrecht of Brandenburg, Simon Bening, Bruges, Belgium, 1525–30. Los Angeles, The J. Paul Getty Museum, Ms. Ludwig IX 19 (83.ML.115), fols. 36v–37

Ludwig IX 12), show exotic dress but only moderate differences of physiognomy, while others, as in the Prayer Book of Cardinal Albrecht of Brandenburg illuminated by Simon Bening (ca. 1483–1561), show bodily diversity more vividly, with black skin (fig. 4.4). Like the Ethiopian magus, depictions of the Queen of Sheba also vary in how they portray ethnicity. While there was a rich medieval commentary tradition on the Song of Songs that interpreted the allegory of the beautiful and black bride in historical terms, as the Ethiopian Queen of

Sheba, pictorial depictions of the encounter of Solomon and Sheba often show the queen as fair-skinned, as in the page by Simon Bening that faces his image of the Magi.[10] The queen is attended by two other women, her attendance on Solomon and offering of gifts appearing as a counterpart to the offerings of the three Magi. To put it another way, a chain of typological prefigurations links various moments in salvation history, with each one of them rooted in an essential notion of Ethiopian identity. In one typological relationship, the sons of

Noah prefigure, and are fulfilled in, the three Magi. In a second typological relationship, the encounter of Solomon and Sheba, and the tribute offered by the Ethiopian queen to the king of Israel, is fulfilled in the tribute offered by the Ethiopian magus to the newborn king of the new Israel.

The presence of Ethiopian identity as a key point of reference in salvation history was not limited to explicit citations from the Bible and apocrypha, such as Solomon and Sheba, the three Magi, and the Ethiopian convert described in the Acts of the Apostles. It also appears in what we might call the "secular" strands within salvation history, where typological relationships continue to be central. These include the legend of Alexander the Great, which for medieval Europeans (especially in the twelfth century) was central to crusading ideologies, and the fantasy of Prester John, the mythical king of a remote region who would, one day, come to the rescue of the crusader armies in the Holy Land. As on the medieval maps we have seen, the Alexander romances also use Ethiopia as a way to name the geographic limit case, the remote place of extremes. The Pillars of Hercules, marking the borders of the known world, are said to be located in this region, and the exotic queen of the Ethiopians, Candace, has an encounter with Alexander the Great. In some versions, but not all, their relation is an amorous one. The erotic encounter of Alexander and Candace found in the twelfth-century *Roman de toute chevalerie* (Romance of All Chivalry) by Thomas of Kent bears a startling resemblance to the Ethiopian narrative of the early fourteenth-century *Kebra Nagast* (The Glory of Kings), which centers on the relationship of Solomon and the queen of Ethiopia.[11]

Several Alexander narratives explicitly associate Candace with the Queen of Sheba, following an account by Josephus (37–ca. 100 CE) that identifies her as the ruler of Ethiopia; moreover, the name appears in the Acts of the Apostles (8:27) to refer to the ruler of the Ethiopian eunuch who converts to Christianity. This intertwined lineage of encounters with Ethiopians—first, in the biblical account of Solomon, also recounted in Josephus's history; second, in the Acts of the Apostles and commentaries on it; and, finally, in the many

versions of the Alexander romance—served to provide an image of Ethiopia that was paradoxically ancient and novel, with each encounter repeating a narrative of spiritual and material exchange. The legend of Prester John, popular from the mid-twelfth century, lent additional force to this view of Ethiopia. By the late fourteenth century, maps stopped labeling Prester John's Land in the region of India, and instead began to place it in East Africa, drawing upon the legends of Candace and the so-called white Ethiopians under her rule to develop a new locus of abundant wealth and apocalyptic expectation. For example, the Catalan atlas composed by Abraham Cresques before 1380 (see fig. II.1) places "the land of Prester John" ("la tera de preste iohana") between "the city of Nubia" ("civitatem nubia") and the equatorial meridian of Meroe ("meroem").

The Meaning of "Medieval Ethiopia"

Having provided an overview of medieval European representations of Ethiopia, I now turn to the subject of "medieval Ethiopia." What does the term "medieval" mean when applied to this region of the world as the subject of study in itself, as opposed to when we consider it as the object of the medieval Western gaze? Ethiopia has long served as a fixed, unchanging, essentialized point of reference within salvation history, refracted across a wide range of textual and visual witnesses. In the effort to conceive of a more global medieval studies, it is crucial that scholarship focusing on Ethiopian literature, history, and culture not fall prey to the same essentializing tendency. To use the phrase "medieval Ethiopia" is to make a number of assumptions, not just about place but also about temporality or periodization. In what sense can we speak of "medieval Ethiopia"? Or, to ask the same question in more general terms, can we talk about a period called "the Middle Ages" when we talk about other regions of the world? Is there a "medieval India"? A "medieval Japan"? Or is "the medieval" by definition a Eurocentric construct? These questions require us to think about periodization, and the implicit assumptions that inform such efforts at periodization. For example, is the "Islamic world" fundamentally "medieval," as the media

sometimes suggest, awaiting its own "Reformation"? The term "medieval" carries with it a whole range of assumptions, some of which unthinkingly inform our disciplinary perspectives. Focusing on "medieval Ethiopia" provides an opportunity to think about a second challenge presented by the field we call medieval studies—that is, *where* is the Middle Ages? In other words, there is undoubtedly a temporal dimension to our thinking about "the medieval," but there is also a geographic dimension intricately intertwined with that spatial logic. Is the domain of the discipline of medieval studies fundamentally rooted in Latin Christian Europe, or does it have a wider remit? If we try to expand our view of the Middle Ages as being more than just Latin Christian Europe, how can we do so in a rational and fruitful way?

In order to approach this question, it is necessary to have some sense of what we mean by "Europe." The construct of Europe as a geopolitical entity did not exist during the Middle Ages, though the term "Europe" does appear on medieval world maps, marking one of the three known continents of Asia, Africa, and Europe, taking up one-quarter of the T-O map. Beyond this almost geometric awareness of Europe, the concept is largely invisible. Instead, the organizational principles were the empire—especially the Holy Roman Empire, patterned on the glories of Rome, and echoed in the succession of national powers that explicitly defined themselves relative both to Rome and to its successor empire under Charlemagne.

We might be forgiven for assuming that the discipline of medieval studies has always been rooted in the study of Latin Christian Europe, but in fact there has long been a focus on adjacent regions. For example, the foundation of the University of Toronto's Centre for Medieval Studies, announced in the pages of *Speculum* in 1963, listed faculty members in Arabic and Persian history and literature as well as in Latin and Western vernacular languages.[12] The focus on "cross currents and variations" highlighted here was an explicit part of the Toronto mandate from the outset, perhaps distinguishing it from the Latin Christian European heritage that grounded, equally explicitly, the mandate of Toronto's Pontifical Institute

of Mediaeval Studies and the undergraduate program in Mediaeval Studies at the University of Saint Michael's College—all three of these located on the same campus. The broader mandate of Toronto's Centre was in this respect different from that of other centers for medieval studies such as those founded at Catholic University, the University of Notre Dame, and Fordham University, where the confessional affiliation inflected the ways in which the discipline of medieval studies was formulated. This brief look at these North American institutional histories suggests that, while an attentiveness to ethnic, racial, and confessional diversity is in part driven by the political and social concerns of our own time, the definition of the discipline a half century ago was already more capacious than we might expect.

Recent work in the field of medieval studies has sought to conceive of our research and teaching in broader, more inclusive terms. Some have tried to redefine the discipline in expansive ways, as a "global" medieval studies; others talk about "worlding" medieval studies—that is, reconceiving the discipline in ways that are consistent with the fields of world history or world literature.[13] These approaches share a tendency to elide local and regional differences in the service of a bigger picture of the global Middle Ages—the inevitable problem that arises when an effort to see the whole forest makes it impossible to see the trees. Another difficulty arises with regard to periodization: If we want to talk about "medieval Japan" or "medieval India," what period are we talking about? These chronologies vary widely, depending upon whether we simply choose a chronological frame of reference (that is, comparing the events and phenomena of the year 1150 in England to those in India or in Japan), or whether we choose our points of comparison based on related phenomena. Do the Middle Ages happen at the same time in every place? And if not, what assumptions govern our identification of "the medieval"? For the study of "medieval Japan," for example, an understanding of samurai culture in terms of "feudalism" or even "chivalry" has often driven the comparison.

In this context, the place—both temporal and spatial—of "medieval Ethiopia" is a vexed one. Some valuable work on

the material culture of Ethiopia is explicitly couched as a privileged window into the "medieval" past, not just of that particular region but more generally. It is undoubtedly true that certain practices, including scribal manuscript culture and the skilled craftsmanship of the stone churches found in highland Ethiopia, have continued uninterrupted over a long period of time. For a scholar who wants to learn about medieval manuscript practices as they were conducted in France, England, or Germany during the Middle Ages, their only recourse—other than looking at surviving manuscripts and analyzing the economic records of those who worked as scribes—is to go to a place where there is a living manuscript culture, such as Ethiopia, and observe those communities in action.[14] This is good and valuable work, and yet it cannot be right to see a culture as though it is frozen in time, ignoring the legacy of repeated waves of colonialism (Portuguese, Italian, English) that have washed through the region. We must not imagine that, by looking at Ethiopia, we can catch a glimpse of "our" own medieval past, and by "our," I mean not only the normative Western subject (as a default, raced as "white") but also the various communities that might identify in different ways with the region—in terms of religious, racial, or ethnic identities.

To raise these concerns is not to suggest that we should not study medieval Ethiopia. On the contrary, the region has a rich and dynamic history, with the Aksumite kingdom serving in late antiquity and the early Middle Ages as a crucial trading hub that linked the Roman-controlled trade in the Mediterranean with India and the wider South Asian region.[15] The kingdom became Christian in the fourth century, coining the very earliest currency that survives with a cross on it. Ethiopia was a center of early monasticism, and the earliest illuminated gospels that we have today are two manuscripts—the Garima Gospels (see fig. introduction.2)—that were written in the Aksumite kingdom of Ethiopia. One has been carbon dated to the late fourth to mid-sixth century (390–570, Garima 2), and one from the mid-sixth to mid-seventh century (530–660, Garima 1).[16] With the rise of Islam on the Arabian Peninsula, the power of the Christian Aksumite kingdom became

increasingly curtailed; it remained, however, a dynamic cross-roads in confessional, cultural, and social terms.[17]

Over the last few years, cultural heritage archives such as museums and libraries have begun to highlight their holdings of Ethiopian manuscripts. In the United Kingdom, these efforts have taken place in the context of the 150th anniversary of the so-called Abyssinian Expedition of 1868: at that time, the British army set out to rescue hostages held by the Ethiopian emperor Tewodros II (ca. 1818–1868), a campaign that ended with the capture, looting, and burning of the fortified capital of Maqdala. Many objects—manuscripts, liturgical items, icons—were sold at auction and are now held by cultural institutions, including the British Museum (and the British Library), Oxford's Bodleian Library, the Cambridge University Library, Kensington Museum (now the Victoria & Albert Museum), and several others. In some cases, these exhibitions have drawn sharp criticism and calls for reparations, as in the case of the Victoria & Albert exhibition *Maqdala 1868*, which explicitly considered the circumstances under which these items came into the collection. In other cases, the exhibitions have set aside the history of the acquisitions, focusing instead on the scribal cultures that produced the manuscripts (in the case of the British Library) or on the contemporary connections of the Ethiopian and Eritrean diaspora in England to the cultural patrimony now held in British institutions (in the case of the Bodleian). Other exhibitions have sought to place Ethiopian manuscripts in their comparative context, as in the Getty's 2016 presentation *Traversing the Globe through Illuminated Manuscripts*, and the Art Gallery of Ontario's 2018 display of Ethiopian manuscripts and art objects in the context of the Thomson Collection of boxwood and ivories. These shows contrast with the British examples not only in the very different political history (and circumstances of acquisition) that underlies their presentation but also in the way they seek to place Ethiopian manuscripts and art in conversation with objects associated with the European Middle Ages. The successful efforts to maximize public outreach in concert with the scholarly study of Ethiopian manuscripts and art objects, especially evident in the Bodleian show, is highly promising

and suggests new ways to link our study of the interconnected premodern past to our contemporary societies.[18]

This short essay provides an extremely brief overview of medieval Ethiopia—a relatively brief overview of the history of medieval Western representations of Ethiopia, and an even briefer view of the actual medieval history of Ethiopia, with a host of caveats regarding what we might mean by the phrase "medieval Ethiopia." Yet the region is of vital importance to the field of medieval studies in three ways: first, in terms of our paradigm of the premodern past; second, in terms of how Western fantasies of Ethiopia, Africa, and blackness itself have shaped modern assumptions, both popular and scholarly; and third, in terms of how those assumptions have given out signals, often subtle, concerning who belongs in the field and who might not. By considering more fully the place of medieval Ethiopia in the history of early Christian societies, in terms of economic and cultural history, and in the context of manuscript studies, we can significantly widen our sense of the premodern past, bringing to light new histories of connectivity, regional circulation, and exchange. This aspect is closely related to work that has been done over the last decade or so in medieval Mediterranean studies, expanding that work outward toward the Silk Roads and the Red Sea region. The second reason we should turn to "medieval Ethiopia" is in order to come to grips with the way this Western fantasy has shaped our own point of view. By looking at how medieval Westerners imagined Ethiopia—on maps, in images, in texts—we might cast some light on the preconceptions and assumptions that inform our own imaginings of Ethiopia in the twenty-first century. Finally, by centering Ethiopia in our account of the medieval past, we allow ourselves, if only for a moment, to put the margins at the center and the center at the margins, and explore how the world looks from this reconfigured vantage point. If this effort opens up the doors to a renewal of our discipline by making it easier for other voices to enter, we will all be enriched.

— Suzanne Conklin Akbari is professor of English and medieval studies and director of the Centre for Medieval Studies at the University of Toronto.

1 On the potential and the limitations of situating medieval studies relative to both Mediterranean studies and global studies approaches, including world literature, see Akbari 2017, 2–17.

2 On "the extent to which our own disciplinary structures [in medieval studies] participate in the building of conceptual boundaries that limit and exclude participation by those who bring ethnic, racial, and other diversity to the table," see Akbari et al. 2017, 1501–53.

3 For a moving personal reflection on these boundaries, see Otaño Gracia 2018.

4 For a detailed overview of references to Ethiopia and Ethiopians in medieval Latin texts, see von den Brincken 1973, 262–87; on Prester John, see also 382–412.

5 For a more detailed account of Ethiopia on medieval maps and in encyclopedias, see Akbari 2009, 68–72, and in the context of medieval climate theory, 40–46.

6 Citations of Isidore of Seville, *Etymologies*, are parenthetical, by book and chapter number, taken from Lindsay 1989.

7 For images from this manuscript, see the Digital Scriptorium Database: http://dpg.lib.berkeley.edu /webdb/dsheh/heh_brf? Description=&CallNumber =HM+83.

8 On premodern conceptions of race, especially with regard to the effect of climate on bodily diversity, see Akbari 2009, 140–54, 159–63. On blackness in medieval iconography, see the foundational study of Devisse 1979; G. Heng 2018, 181–256.

9 Other folios from this manuscript can be found in the following institutions: Madrid, Museo Arqueológico Nacional; Madrid, Francisco de Zabálburu y Basabe Library; and Gerona, Museu Diocesà.

10 On the exegesis of blackness in the Song of Songs, see Holsinger 1998, 156–85.

11 On the representation of Ethiopia in the *Roman de toute chevalerie* (Romance of All Chivalry), see Akbari 2009, 95–102. The erotic encounter of Alexander and Candace, queen of Ethiopia, emphasizes the queen's wealth and ingenuity in terms that are startlingly similar to the encounter of Solomon and Makeda, queen of Ethiopia, in the Ge'ez-language national origin epic *Kebra Nagast* (The Glory of Kings), which survives in an early fourteenth-century version of the text, but undoubtedly reflects earlier versions of the narrative. On the *Kebra Nagast* and its relation to other versions of the Solomon and Sheba account, see Belcher 2009, 441–59; on the modern reception of the *Kebra Nagast*, see Belcher 2010, 239–57. See also Kotar 2011, 157–76.

12 "The intention of the Centre is to make available to students various approaches to the Middle Ages in programs of studies not available in existing departments. The purpose of the Center is the training of scholars who know the Middle Ages in depth as well as in breadth. The courses of study will freely cross limits of traditional disciplines and departments, but they will be limited to the Middle Ages. By concentrating on a single period, the student will be able to acquire in some depth the basic linguistic and technical skills necessary for teaching and research in mediaeval studies; these include palaeography, diplomatics, and vernacular languages, in which the Center is strong. He will also be able to read widely in the period. His research will follow the material of his subject in order to gain a better understanding of the cross currents and variations in the cultures, interests, and beliefs of the Middle Ages." See "Graduate Centre for Mediaeval Studies: University of Toronto" 1963, 678–81.

13 For example, see G. Heng 2013, 413–29; Kinoshita 2008, 371–85.

14 Winslow 2015.

15 See Eyob Derillo's case study in part 2 of this volume.

16 McKenzie and Watson 2016.

17 See Michelle H. Craig's case study in part 4 of this volume.

18 On the dispersal of the objects looted at Maqdala, see Shinn and Ofcansky 2013, 48. On the Victoria & Albert show, *Maqdala 1868*, see https:// www.theguardian.com /artanddesign/2018/apr/03 /looted-ethiopian-treasures -in-uk-return-loan-victoria -albert-museum. On the British Library show, *African Scribes: Manuscript Culture of Ethiopia*, see http://blogs.bl .uk/asian-and-african/2018 /02/african-scribes -manuscript-culture-of -ethiopia.html. On the Bodleian event, which included both an academic study day, "Introducing Manuscripts from Ethiopia and Eritrea," and a "family-friendly" event, "Ethiopian and Eritrean Ge'ez Manuscripts Discovery Day," see https://www.classics .ox.ac.uk/event/introducing -manuscripts-from-ethiopia -and-eritrea; https://www .classics.ox.ac.uk/event /ethiopian-and-eritrean-geez -manuscripts-discovery-day. On the Getty show, *Traversing the Globe through Illuminated Manuscripts*, see http://www .getty.edu/art/exhibitions /globe/.

Manuscripts and the Medieval Tropics

ALEX J. WEST

Scholars of the Middle Ages frequently work with texts written on perishable materials, including parchment in much of Europe and the Mediterranean, birch bark in Russia[1] and Central Asia, bamboo and paper in East Asia, and palm leaves in India and Southeast Asia. However, environmental differences across Afro-Eurasia mean that such manuscripts are not always preserved with the same frequency. In some parts of the medieval world, no texts were written at all; in others, texts are known to have been produced, but they have not survived to the present day or are known only from recent copies. Naturally, these problems are particularly acute in humid tropical climates, and this meteorological condition biases the medieval historical record in favor of societies in temperate climes.

The oldest inscriptions in the Austronesian language of Malay, for example, date from the late seventh century CE. The oldest *manuscript* in Malay, though, is the *Nītisārasamuccaya* (Compendium of the Essence of Policy, fig. 5.1), or Tanjung Tanah manuscript, from Kerinci, Sumatra, which has been radiocarbon dated to the late fourteenth century. It was stored above a hearth, safe from insects and humidity.[2] Studies of medieval Southeast Asian history consequently rely on inscriptions and on postmedieval manuscripts. A similar issue has affected the survival of textiles, only a small number of which survive from the Middle Ages. Some extant cloths from the Southeast Asian island of Timor bear evidence of long-distance trade, with designs derived from Gujarati (Indian) trade cloths (*patola*), reminding us of how much we have lost to heat and humidity.[3]

How can one create a complete picture of a *global* Middle Ages when many of the surviving Southeast Asian and tropical African manuscripts are postmedieval? Should scholars of the "medieval" tropics focus exclusively on "legitimately" medieval objects—bronzes, inscriptions, reliefs, ethnohistoric texts written outside the tropics—or should they include later texts about earlier phenomena and risk collapsing tropical histories into one undivided whole?

5.1. *Nītisārasamuccaya* (Compendium of the Essence of Policy), also known as the Tanjung Tanah, Kerinci residency of Jambi, Sumatra, radiocarbon dated to 1345–77. Village of Tanjung Tanah, Sumatra

In this essay, I will look at several challenges in the study of manuscript material from or about medieval tropical Asia. First I will discuss a "medieval" Javanese reference to New Guinea to show the limits of what we can learn from the manuscript record. I will then look at a brief Arabic text from a fourteenth-century Egyptian encyclopedia, the problems with which are typical of ethnohistoric material. The final example will look at the evolution of depictions of Java in medieval European manuscripts. My conclusion will suggest the need to coordinate and test philological conclusions with archaeological and ethnographic evidence.

Medieval New Guinea?

New Guinea is an enormous and diverse island. It is home to more languages than any comparably sized section of the Earth's surface, broken up into dozens of primary language families. European colonialism, restricted almost entirely to the coasts, only began toward the end of the nineteenth century, and the populous highland valleys were not known to the outside world until the 1930s. The island has no tradition

of writing, and oral history is limited in reach; anything that happened in New Guinea more than a couple of centuries ago is known through linguistics and archaeology. There are few European accounts from the "Age of Discovery," and those that exist are cursory and discuss only the coasts.

New Guinea's western coasts abut numerous islands of historical significance, however. The inhabitants of some of these islands were literate in Malay by the time Portuguese explorers arrived in the early sixteenth century, as evidenced by a letter sent to the king (sultan) of Portugal in 1521 by Sultan Abu Hayat of Ternate (aged seven at the time of writing; r. 1529–33).[4] Parts of Western New Guinea were linked politically to the Islamic Moluccan sultanates of Ternate and Tidore in the fifteenth century.[5] These states' economies centered on the international clove trade, in which people from New Guinea were surely involved.

But what can be shown to represent this "medieval" Papuan history? There are no manuscripts, nor are there many sculptures or bronze objects.[6] Art in New Guinea is dominated by wooden sculpture. While plenty of wooden objects survive from temperate medieval Eurasia, no examples of the wooden sculpture of medieval New Guinea have come down to us. Can one assume that modern sculpture is representative of earlier tradition? This is a risky proposition: New Guinea is *not* an unchanged primeval land. Displaying a Papuan carving made in the twentieth century by a specific artist as representative of medieval tradition would be as peculiar as using David Hockney's oeuvre to showcase medieval English painting.

That does not mean that New Guinea vanished from the world in the Middle Ages. Nonetheless, it is not referred to in any text until the fourteenth century. A name for part of the island appears in an Old Javanese *kakawin* (long narrative poem) known as the *Deśawarṇana* (Description of the Districts) written by Mpu Prapañca in 1365. The full text of this stanza (canto 14, stanza 5) reads:

> Taking them island by island: Makasar, Butun, and Banggawi,
> Kunir, Galiyahu and Salaya, Sumba, Solot, and Muwar,
> As well as Waṇḍan, Ambwan, Maloko, and Wwanin,

Seran and Timur as the main ones among the various islands that remember their duty.[7]

Prapañca claims that these places were vassals of the Javanese kingdom of Majapahit (1293–1520s). Most of them have been identified with places in Eastern Indonesia: Maloko is surely modern Maluku; Waṇḍan must be Banda; and Ambwan must be Ambon. After these names comes Wwanin, which has been identified with the Onin Peninsula on the west coast of New Guinea.

Onin is home to an aromatic that seems to have become popular in Java in the fourteenth century: massoy, the bark of the tree *Cryptocarya massoy*.[8] The word *masui* ("massoy") occurs in other early Indonesian texts, including the Old Sundanese epic poem *Bujangga Manik* (named for the titular character) and the Malay history *Hikayat Raja-raja Pasai* (Chronicle of the Kings of Pasai). *Cryptocarya massoy* only grows well in this part of New Guinea, so a reference to massoy can be considered a reference to Onin and vice versa. The earliest description of how massoy was *used*, though, is in Miguel Roxa de Brito's 1581–82 report on Seram and New Guinea. Massoy (*massoya*), he says, was popular among "the Javanese, who value it as a medicine. [They] grind it and rub their bodies with it, as an ointment, even when in good health; and they spend a lot of money on it each year."[9]

There must also have been trade in bird-of-paradise plumes by the end of the fifteenth century, as they appear to have been mentioned by the Venetian Niccolò de' Conti (ca. 1395–1469), who traveled to Java and Sumatra in the 1430s. He noted that the skins of "footless birds" were used as head ornaments in "Big Java."[10] A possible earlier reference to Eastern Indonesian birds, perhaps birds of paradise, is found in the ninth-century Old Javanese *kakawin Rāmāyaṇa* (Story of Rama), which uses the term *swari*, apparently related to Malay *kesuari* (cassowary). However, it is difficult to connect these words to New Guinea, let alone a species or locale there.

These may be the earliest references to the world's second-largest island. But they come with a significant caveat: the manuscripts we are relying on are in many cases more recent than the fifteenth century. The best-known manuscript of the *Deśawarṇana* was taken from Lombok during the Dutch conquest of the island in 1895 and dates to around the same time. Indeed, the only Indonesian manuscript conclusively dated to before the sixteenth century is the *Nītisārasamuccaya* discussed above.[11]

New Guinea's manuscript record is thus extremely flimsy, and the island is an extreme case in terms of the limits of the manuscript record. The same or similar problems, though, are present in studying Java and Sumatra themselves, in spite of the epigraphic and archaeological data from the islands testifying to the presence of sophisticated, literate kingdoms before the colonial period. The paucity of the Indonesian manuscript record means that historians have tended to supplement these texts with sources written by foreign authors. These ethnohistoric sources have the advantage that they are often genuine medieval manuscripts, as with the many fourteenth-century manuscripts detailing the travels of Marco Polo (1254–1324) and Odoric of Pordenone (1286–1331). These sources have other problems, however: most of the writers never visited the regions they describe; the place names they use often have tortuous textual histories that make accurate identification difficult; and many regions are described chiefly in terms of their natural products (sandalwood, camphor, and so forth).

To give a flavor of these problems, I will take an example from an encyclopedic text in Arabic, *Nihayat al-arab fī funūn al-adab* (The Ultimate Ambition in the Arts of Erudition), written in the early fourteenth century by Shihāb al-Dīn Ahmad b. ʿAbd al-Wahhāb al-Nuwayri (1279–1333).[12]

"The most noble of all the resins"
The two million words and thirty-three volumes of al-Nuwayri's *Nihayat al-arab fī funūn al-adab* attempted to account for everything in the world known to Mamluk Egypt. This included a small selection of natural products from the Indonesian archipelago, and among these was a forest product from Sumatra and Borneo called camphor (ultimately from Malay *kapur*), which al-Nuwayri calls "the most noble of

all the resins." Camphor is a waxy white substance that people across Afro-Eurasia used to put in their food and medicine, and the most celebrated and important kind came from Barus, a port in Northern Sumatra near the present-day town of Sibolga. This Barus camphor was derived from the wood of *Dryobalanops aromatica*, a tall forest tree.[13] This is what al-Nuwayri says about camphor:

> There are certain places where camphor is typically found. Among them is Fanṣūr, which is an island that is seven hundred *farsakhs* in perimeter and is known as the Land of Gold. The camphor that comes from there is the finest of all types. Another place that camphor is found is Arbashīr, and also al-Zābaj. The camphor from there is the worst kind.[14]

The toponyms are a jumble. Fanṣūr is clear enough: it was the Arabic name for Barus, and may be related to Pansur or Pancur, a modern place name in the area.[15] The Land of Gold, meanwhile, is an old name for Southeast Asia as a whole; this phrase is not in any way synonymous with Barus. The name Arbashīr is unclear, though context suggests that it was located in Southeast Asia. The final place name is also troublesome, as al-Zābaj (الزابج) refers to Śrīvijaya (or its successors), a kingdom *also* on the island of Sumatra; by al-Nuwayri's day Śrīvijaya was no longer a major power, but residual knowledge of it remained in the West.[16]

Al-Nuwayri never visited Southeast Asia, nor did many other Middle Eastern geographers or encyclopedists. Their information was resolutely secondhand, and many later medieval Arabic texts on the area simply repeated the claims of earlier sources. A common claim, repeated by al-Nuwayri, was that groves of camphor trees were frequented by tigers, making camphor collection uncommonly dangerous.[17] This was an old trope in Arabic literature and not the product of serious study. Such passages are typical of the ethnohistoric sources: repeating claims about natural products from hazily recalled and sometimes unidentifiable places in the tropics.

The "Two Javas" Problem in Italian Renaissance Literature and the Fra Mauro *Mappa Mundi*

Such hand-me-downs are hardly unique to the Middle Eastern sources. Both Chinese and European medieval texts on Southeast Asia are replete with similar passages. Here I will discuss a problem in the historical geography of Indonesia taken from medieval European maps and manuscripts, in which the island of Java was misplaced on maps, confused with other islands, and given incorrect names based on copying errors. This "Two Javas" problem was only resolved in the sixteenth century, and it shows the limitations of using the texts as authoritative sources on medieval Southeast Asia.

Java began to appear in European travelers' accounts in the early fourteenth century, with the first manuscripts recounting the travels of Marco Polo and Odoric of Pordenone. Polo's account gave the name *Iaua* to two different islands, almost certainly Java and Sumatra; the former was "big" Java (*grant ille de iaua*) and the latter was "smaller" (*menour*) Java. (Sumatra is in fact several times larger than Java.)

Copying errors meant that by the middle of the fourteenth century Java was known as Iana, and this is the form (ILLA IANA) that appears on the Catalan atlas of Abraham Cresques (1375, see fig. II.1), the first attempt to depict Java in European cartography.[18] Cresques distinguished Sumatra with the name TRAPOBANA, derived from classical Taprobana (Ταπροβανᾶ) as found in Ptolemy's *Geographia*, recently reintroduced to Western Europe by Byzantine Greeks. This Taprobana usually referred to Sri Lanka and perhaps came from the Sanskrit *tāmraparṇī* (copper leaved). Odoric's *Sumoltra* (or, as in British Library Royal MS 19 DI, f.141r, *symolua*) for Sumatra does not appear to have caught on.

The next Western European traveler to visit the region and leave an account was Niccolò de' Conti, who sailed around the Indian Ocean with his Egyptian wife and children in the 1430s. Like some other fifteenth-century Christian travelers,[19] he lived as a Muslim, and when he returned to Italy in 1444 he was made to recount his travels to the Florentine humanist Poggio Bracciolini (1380–1459) by Pope Nicholas V (r. 1447–55) as penance. Conti's travels were thus preserved in

book IV of Bracciolini's *De varietate fortunæ* (The Vicissitudes of Fortune, 1448).[20]

It is hard to tell how well Bracciolini's text replicates Conti's knowledge, but it appears that Bracciolini introduced a number of classical toponyms into Conti's account, including Taprobana (referring to both Sri Lanka *and* Sumatra). The account of Java—labeled Iaua and deliberately emended by some copyists to Iana, in spite of the legibility of Bracciolini's humanist minuscule—was garbled again: *two* Javas appear, one big and one small. This time, though, Java was the "small" one and an unidentified island (Borneo, perhaps?) was the "big" one.

Niccolò de' Conti was also an informant on the Fra Mauro *mappa mundi*, a map of the world completed in Venice in 1459.[21] The map is annotated in vernacular Venetian, and this may be why the toponyms appear more accurate than Bracciolini's. Instead of Iaua, the map has GIAVA, and again there are two of them, "ixola giava minō" (the little one) and "Giaua maȝor" (the big one). The latter may represent Borneo, but it is hard to tell.

These European texts are authentic medieval manuscripts, and this makes them comparatively rare in the manuscript record on tropical Asia. But their geographic ambiguity means that they cannot be used to form conclusions about individual islands in the Middle Ages. It matters a great deal whether an account refers to Java or Borneo, and the confusion severely limits these texts' use as authoritative sources on early Indonesia (or elsewhere in the tropics).

The Medieval Tropics?

Does the absence of a contemporary written record exclude a place from consideration as part of the "global Middle Ages"? If the objective is to better understand the world before the Columbian Exchange, then I would argue instead that the methodology has to broaden: the triangulation of archaeology, ethnography, historical linguistics, oral history, and ethnohistory must be brought in to complement traditional philological scholarship.[22] This approach often treats the tropics as more akin to nonliterate pre-Columbian South America than to the highly literate societies of Egypt or China. This unfortunate (or prejudiced) parallel is evoked not because people in the tropics were not literate: we know that they were in many areas. We must nevertheless accept the fact that many manuscripts have not survived and that philological scholarship is not sufficient to understand medieval tropical societies. If a wider range of methods is not adopted, then our image of the medieval world will always be restricted to what was written down *and preserved*, and that introduces a bias toward the temperate—and perhaps also toward the European, the white, and the colonial.

— Alex J. West is a doctoral candidate at the University of Leiden.

1 See Schaeken 2012.
2 Kozok (2016) is a complete study of this text.
3 Several of these early textiles have been radiocarbon dated. See Barnes and Kahlenberg 2010, 38.
4 This is the next oldest Malay manuscript, after the *Nītisārasamuccaya*. See Gallop 1994, 123.
5 Andaya (1993) is the most complete account of early Maluku ("the Moluccas") in English.
6 Although see Ellen 2003, 71, for archaeological evidence of medieval trade from Western New Guinea.
7 From Pigeaud's 1960 transcription (the English translation is from Robson 1995):
 ikaṅ saka sanūṣanūṣa makhasar butun/ baṅgawī
 kunir ggaliyahu mwaṅ i salaya sūmba solot/ muar
 muwah tikhaṅ i waṇḍan ambwan āthawā maloko wwanin
 ri seran i timūr makādiniṅ aṅeka nūṣātutur.
8 Swadling (1997) has a concise description of this trade.
9 Taken from the translation by Gelpke 1994, 133.
10 Taken from lines 299–302 of the critical edition of the text by Guéret-Laferté 2004, 116–17.
11 This problem is not exclusive to Indonesia; the published text of the Hindi *Mahābhārata* composed by Vishnudas in 1435 relies on a single manuscript witness written in 1863 (see Bangha 2014).
12 Recently translated by Elias Muhanna; see al-Nuwayri 2016.
13 R. Donkin (1999) is a complete historical geography of the substance.
14 Al-Nuwayri 2016, 207.
15 For a history of Barus, see Drakard 1990.
16 See Wolters 1970.
17 See Donkin 1999, 122.
18 See for example National Library of Sweden M.304, p. 146, and British Library Royal MS 19 DI, f.122r, for manuscript examples of the same error.
19 Both Afansy Nikitin (d. 1472) and Ludovico di Varthema (ca. 1470–1517) traveled as Muslims within a few decades of Conti's travels.
20 See Guéret-Laferté 2004 for the full list of variants.
21 See Falchetta 2006.
22 For a case of "triangulation" in Oceania, see Kirch 2017; Kirch 1989. For the testing of ethnohistoric sources with archaeological data in South America, see Besom 2009.

Mapping Global Middle Ages

ASA SIMON MITTMAN

In order to understand what a "global Middle Ages" might be, we need to define "global" in and in relation to the "Middle Ages." To do so, I turn to medieval (Christian) maps. Their construction of the world—like most, maybe all, others—was founded on inclusion and exclusion. In seeking to construct a global Middle Ages, the authors in this volume are therefore working not only against scholarly traditions of periodization but also against indigenous medieval ideas, against autochthonous ideologies. "Global Middle Ages" is a term that is gaining increasing currency as part of a welcome and much-overdue effort to acknowledge in teaching and research that the Middle Ages can encompass more geography than present-day Europe, more religions than Latin and Byzantine Christianity, and more humanity than whiteness. But what this term might mean is dependent on the lens we bring to the period, the geography, the people, and the material we study.

The map on pages 44–45, like all maps, was designed in a time and place. As the cartographic theorist Denis Wood reminds us, "There is nothing natural about [any] map. It is a cultural artifact, an accumulation of choices made among choices every one of which reveals a value."[1] *This* map is the Robinson Projection Map, designed in 1963 for Rand McNally, which still uses it. The National Geographic Society, by contrast, favors an older, less overtly distorted projection. These choices matter, since we understand our vast globe not through direct observation—even the most well-traveled individuals only see infinitesimally thin ribbons and minuscule dots on the globe's surface—but through the maps by which we reduce and distort it. The maps we design determine what stories we tell about the world and our place therein. To know *what* global Middle Ages we are talking about, we have to think about the maps that construct that world. As Jeremy Black says, "The map is *constitutive* of a certain form of reality, not merely a representation of it."[2]

Modern maps would be alien to medieval peoples. Their globe was quite different from ours. The most common medieval image of the globe is the T-O map (fig. 6.1). It is easy to dismiss these. They in no way convey to us the world as we know it. However, they are thick with information and ideology. This English example—from Isidore's *Etymologies*, a text describing a divine plan behind the apparent chaos of our world—is a suitable subject for investigation.

This map contains few elements. In total, seven lines, three words (sixteen letters), six punctuation marks (fifteen dots), two accent marks, and one pinprick. Other medieval maps contain thousands of elements, but this little T-O speaks volumes about a medieval worldview. A quick orientation: three landmasses attested in the Bible and described in Isidore's text. East is on top, owing to the value Christians placed on Asia as the site of both Terrestrial Paradise and of the events of the Bible. The vertical Mediterranean divides Europe and Africa. The rivers are likewise divisionary: the Nile divides Africa from Asia; and the Tanais, or Don, divides Europe from Asia. The midpoint of the map is a pinprick from the mapmaker's compass. The notion that God drew the circle of the world with a compass is an Anglo-Saxon innovation, and reminds us that the image of God above many medieval maps is as much a human construct as the maps he sits atop.[3] The pinprick might imply the holy perfection of the city of Jerusalem, seen as the spiritual and literal center of the world, rooted in passages from Psalms and Ezekiel, and interpreted by Jerome and others. That it is in the middle of the confluence of three bodies of water should not trouble us, as a more complex T-O map shows (fig. 6.2). This manuscript is a *computus* with several texts, charts, diagrams, and maps. There, Jerusalem again stands in the waters at the center, marked with a cross in a circle and labeled in majuscule letters, "HIERUSALEM." This location is a spiritual idea, granted geographic force through the power of the map.

6.1. T-O map from *Etymologies* by Isidore of Seville, St. Augustine's Abbey, Canterbury, England, 1075. London, The British Library, Royal MS 6.C.1, fol. 108v

6.2. T-O map, Cambridgeshire, Thorney Abbey, England, early twelfth century. Oxford, St. John's College, MS 17, fol. 6r

The smooth geometry of the lines of the T-O map makes plain that this is conceptual mapmaking. Nobody believed these landmasses and waters were bounded by straight edges, any more than we believe the Mississippi is blue, as it appears on our maps. The three circular rings around the land are similarly abstract. The first delineates the boundary between land and water. From there to the next circle is the great ocean wrapped around the *ecumene*, the inhabitable world. What, then, is bound by the final circle? *Everything else*. A number of diagrams of the celestial spheres survive, often with zonal maps at their center. These set the Earth in the center of a series of concentric spheres containing water, air, fire, the moon, the sun and planets, the stars, and, finally, the "prime mover," that is, God. As on these diagrams, the little T-O map describes the entire geocentric universe. That is: a global Middle Ages.

So: Jerusalem at the center, the three landmasses and three interior bodies of water, the ocean, and the rest of the universe. The texts—"Asia," "Europa," "Africa"—seem straightforwardly descriptive, but the punctuation is *most interesting*. Those *puncti* are oddly used. The two dots before each word would "mark either a full or a medial pause," and therefore suggest that there was text before each, some previous clause.[4] The three at the end should signal an even more complete stop. This punctuation suggests that each of these words acts as a complete sentence, a complete thought, embedded within a larger discourse. And, of course, they are. They contain within them all a reader knows about each region.

This is a map constructing a divided world, a global Middle Ages riven by crisp boundaries. Such a view of the world might appear, to those of us in medieval studies, as in the wider world, all too familiar in our present moment. The old truce that we seemed to have reached in recent decades, where we all at least paid lip service to notions of diversity, equity, and access, has crumbled, and left many of us reeling. The "Unite the Right" rally in Charlottesville, Virginia, on August 12, 2017, was a signal moment in American culture, when the marchers' tragicomic tiki torches burned the truce

to ashes.[5] The marchers were, in essence, attempting to reinscribe the T-O map's clear, straight black lines, eroded over time, that separate Europe from Asia and Africa. The fascist marchers in Charlottesville and those who sympathize with them are participating in one of the oldest of human impulses, to define themselves through the exclusion of others, to puff themselves up by attempting to stomp others down, to raise their sense of self-worth through the insult of, denunciation of, and outright assault on and murder of other individuals and groups. Reduced to its barest essence, their message is: groups of people should be *separate* from one another.

Indeed, the lines, the words, and the dots on the map all *separate* elements from one another. What hope, then, for a more positive medieval vision of a united globe? This volume contains essays that all suggest connection, communication, collaboration, and *contact*. On the map, there is one way to find this: the great ocean bounds and binds it all together, and the outer circle reminds us that our space is finite. We may divide ourselves from one another constantly, building borders, boundaries, and walls, but we cannot get away from one another. There are only so many places to go, this little map reminds us. We had better get used to one another.

— Asa Simon Mittman is professor and chair of art and art history at California State University, Chico.

1 D. Wood 2010, 108.
2 Jeremy Black 1997, 21. Emphasis in original.
3 Marer-Banasik 1995, 26.
4 Reimer 2015.
5 For more on the event and its connection to medieval studies and monstrosity, see Mittman and Hensel 2018. See also P. Sturtevant 2017, as well as many other posts in this excellent series.

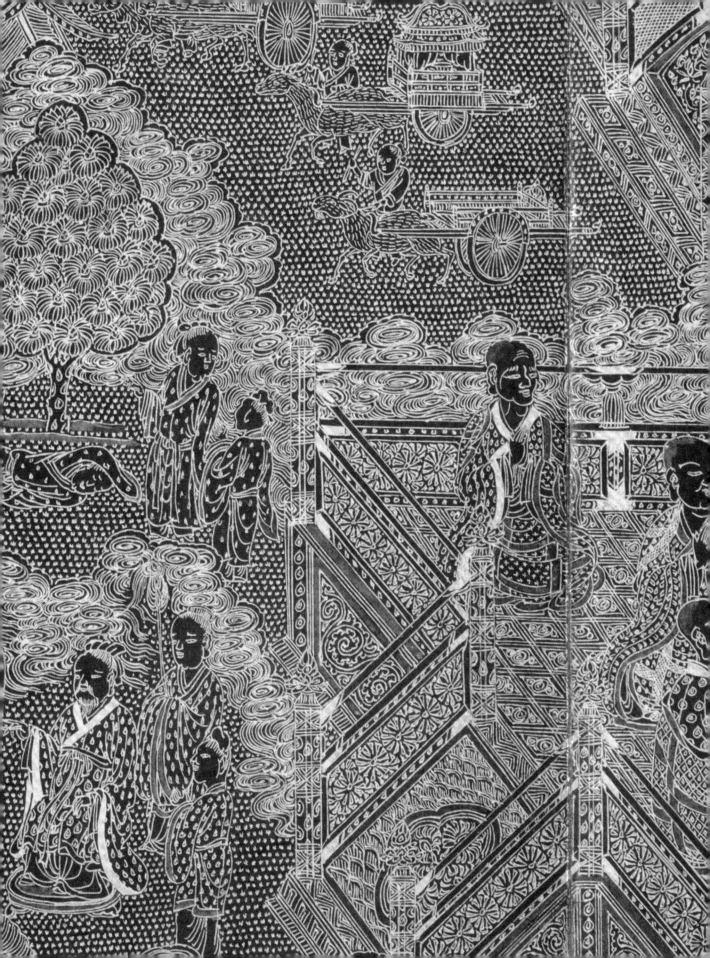

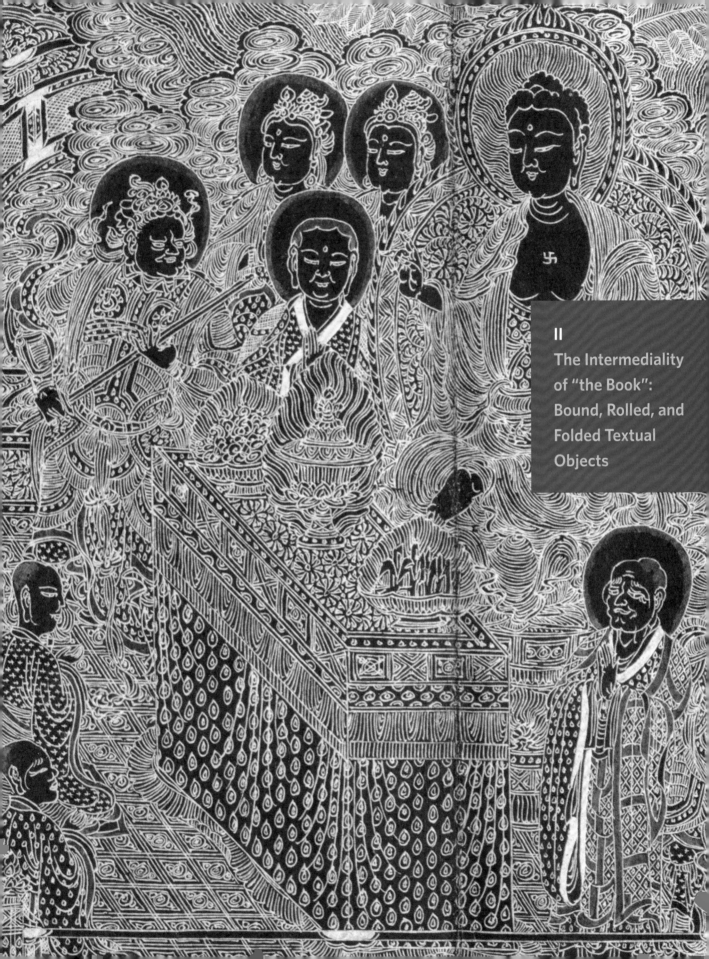

II
The Intermediality
of "the Book":
Bound, Rolled, and
Folded Textual
Objects

II. The Intermediality of "the book": Bound, Rolled, and Folded Textual Objects

BRYAN C. KEENE

In the fourteenth century, illuminated atlases flourished in the Mediterranean world, with versions by Pietro Vesconte (1318, 1321), Perrino Vesconte (1321), and Abraham Cresques (1375) among them.[1] Arguably the most famous of these is the Catalan atlas attributed to the Catalonian Jewish Cresques family (fig. II.1). The scholarship on this particular folding map is wide-ranging, and some attempts have been made to identify the cartographer's visual sources from a variety of portable objects produced and traded across Asia—from Byzantium, Central Asian Muslim kingdoms, and Uygur and Chinese courts.[2] Astronomical and astrological diagrams open the atlas, and the easternmost extreme includes references to Marco Polo (1254–1324), Kublai Khan (r. 1260–94), and islands of spices and gems surrounding Korea, Japan, Indonesia (Sumatra and Java), and greater Southeast Asia. Painted on parchment sheets and decorated with gold leaf and vibrant colors, the atlas has much in common with medieval manuscripts, especially if one considers the intertextual references to other written sources.

II.1. Catalan atlas, Abraham Cresques, Majorca, Spain, 1375. Paris, Bibliothèque nationale de France, Ms. Espagnol 30

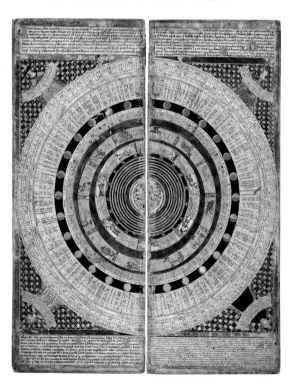

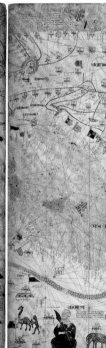

Around 1600 in Zurich, gold- and silversmith Abraham Gessner (1552–1613) engraved the continents known to him—Europe, Africa, Asia, the Americas, and a Terra Australis (Land of the South)—onto several remarkable silver vessels in the form of a double cup, with each detail from printed atlases by Abraham Ortelius (1527–1598), Petrus Plancius (1552–1622), and others carefully rendered (fig. II.2).[3] The vessel by Gessner is supported by Atlas (the Titan who held up the cosmic spheres) and topped by a celestial globe (an astral diagram with Earth at its center). The use of a burin or chisel to remove the metal from the surface of the silver is the same technique used to create Ortelius's copperplate cosmographies. The connection between books and luxury arts (or books as luxury arts) persisted as the art of mapmaking continued to develop with each global voyage.

The essays in this section address the theme of intermediality of "the book"—that is, the relationship between books, broadly defined to include bound, rolled, and folded textual objects written or embellished by hand (including printed examples with metal-leaf decoration), and other media or visual traditions.

Textual Communities in East Asia, East Africa, and the Americas
J. Sören Edgren's essay traces the phenomenon of indigo-dyed illuminated Buddhist sutras in China, Korea, and Japan, with a discussion of the commingling of religious or philosophical traditions there. Examining the contents of the Library Cave at Dunhuang provides useful extensions for Edgren's analysis of the relationship between scrolls and other text-bearing objects. A Daoist scroll dating to the Tang dynasty (618–906) comprises the earliest surviving complete map of the night sky as seen from the Northern Hemisphere (fig. II.3). In Daoist cosmology, the vital energy of the planetary and astral universe (qi) emerged from the void of infinite potential (Dao) and is brought into balance by the complementary forces of yin and yang. This object connects to ancient Chinese scientific and

II.2. Globe cup, Abraham Gessner, Zurich, 1600. Los Angeles County Museum of Art, William Randolph Hearst Collection, 51.13.9a–b

religious teachings, but also relates to a pictorial tradition of representing celestial phenomena at one of the key centers for the preservation of Buddhist texts along the Silk Roads.[4]

The history of East Africa affords numerous opportunities to consider premodern globality and cross-media relationships, especially when examining the legacy of local traditions together with the Hellenistic, Roman, Byzantine, and Islamic history of the area. For example, the early history of monasticism can be traced through surviving sacred sites and manuscript culture in Egypt. Wooden writing tablets from Cairo (500–700, fig. II.4) establish a link between Late Antique and medieval scribal training practices, as wax filled the recesses of the boards to create a reusable writing surface. Book arts also directly contributed to the history of Western and Southern Africa during periods of European colonization. A Sapi-Portuguese ivory pyx (a container for the consecrated host or Eucharist in Christian ceremonies of the Mass) from Sierra Leone features scenes from the life of Christ, which can be directly compared with printed books from Europe, such as those in books of hours by Thielman Kerver or Philippe Pigouchet (fig. II.5).[5] These remarkable objects provide insights into the trade relations of the dominant world economies of the Portuguese and the West African cultures of the Kissi, Mende, Sherbro, and others, but should not overshadow the brutal slave trade taking place at the time.

In this section, Eyob Derillo provides a case study on global connections between talismanic manuscript practices in Ethiopia and the greater Afro-Indian Ocean world. A talismanic shirt from fifteenth- or sixteenth-century Sultanate India demonstrates the porosity of geographic or national boundaries at one extreme of this region of the premodern world (fig. II.6). Covered with all 114 *surahs* from the Qur'an, in addition to magic squares and astrological signs, the cotton shirt's inscriptions relate paleographically to Indian manuscripts, while the object itself can be linked with similar apotropaic vestments from West Africa to the Ottoman, Safavid, and Mughal Empires. Similar wearable texts or textual adornments—such as amulets (of paper, parchment, metal, ceramic, or textile), girdle books,[6] or woven bands of

II.3. Star maps (north circumpolar region and the god of lightning) and detail, Dunhuang, Gansu Province, China (Tang dynasty), 700. London, The British Library, Stein 3326

II.4. Wooden writing tablets, Byzantine Egypt, 500–700. New York, The Metropolitan Museum of Art, Rogers Fund, 1914, 14.2.4a–d

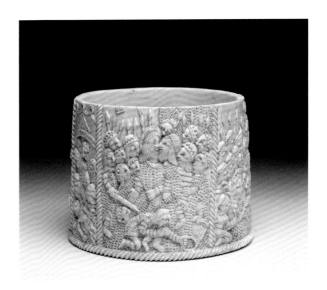

II.5. Ivory pyx with scenes from the life of Christ, Sierra Leone, 1490–1530. Baltimore, The Walters Art Museum, 71.108

II.6. Talismanic shirt, India, fifteenth-sixteenth century CE / ninth-tenth century AH. New York, The Metropolitan Museum of Art, Given by Col. F. G. G. Bailey, 1998.199

calligraphy—transcend borders and also serve to expand our notion of "the book" in Afro-Eurasia.

When incorporating the Americas within a medieval framework, it is important to remember the concept of heterochronicity—that is, different methods for recording time and history. Megan E. O'Neil considers the role of Maya codices and ceramic objects in forging transregional identities in Mesoamerica, and as tools for deciphering the fragmentary glyphic past so violently destroyed by Spanish conquistadors. Worlds away, down the Pacific seaboard, in *Historia general del Piru* (1616, fig. II.7), the artist Martín de Murúa represented the Inca ruler Tupac Inca Yupanqui consulting a *quipucamayoc*, a recorder keeper or accountant in the Inca Empire. The quipu (*khipu*, or "knot" in Quechua) was a system of knots and cords whose color, width, and placement communicated historical data. The text that accompanies several of these images attests to this unique form of recording time (of censuses and tributes), but also reveals censorship by Spanish imperial editors to conceal failed missionary attempts in the Andean world.[7] Writing a global history must include these forms of literacy and timekeeping in order to balance the otherwise absent indigenous perspectives silenced by conquest.

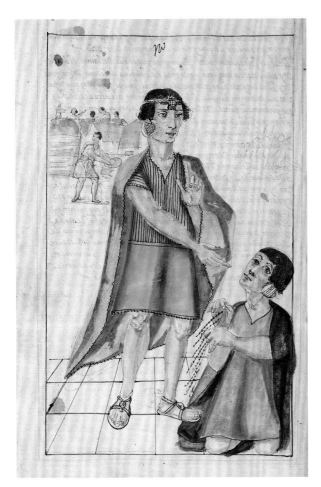

II.7. *Tupac Inca Yupanqui and a Quipucamayoc* in *Historia general del Piru* (General History of Peru) by Martín de Murúa, Southern Andes, South America, 1616. Los Angeles, The J. Paul Getty Museum, Ms. Ludwig XIII 16 (83.MP.159), fol. 51v

Silk Roadways and Silver Waterways

Some manuscripts traveled great distances in the premodern world, together with other precious materials, often becoming bystanders of imperial or colonial ambitions.[8] Large and deluxe decorated copies of the Qur'an produced in the great book-producing city of Shiraz were often presented as diplomatic gifts to the Ottoman court. Facing pages from a dispersed Qur'an include a notation that Sultan Selim II (r. 1566–74) sent the manuscript as a bequest to the mosque in Edirne, Turkey (fig. II.8).[9] By reassessing the influence, or lack thereof, that a French thirteenth-century manuscript had at the court of Shah 'Abbas I of Persia (r. 1588–1629), Sussan Babaie draws attention to the various modalities of book arts, scriptoria, and gift exchange that characterized sixteenth- and seventeenth-century European-Safavid relationships.

A codex that serves as a counterpoint to Babaie's argument is an album (1587–1612) compiled by Johann Joachim Prack von Asch during his time as a military attaché of the Holy Roman emperor Rudolf II (r. 1576–1612) at the Ottoman court at Istanbul (fig. II.9). The book is composed of many types of Ottoman paper, including gold-flecked colored sheets, marbled pages, floral patterns, and the three-dot çintamani design, the influence of which has been seen on book arts and textiles from Ireland to India.

Motifs and their meanings change over time. In her essay, Sylvie L. Merian demonstrates the importance of interrogating every aspect of an object's materiality and cultural context when attempting to outline a global history of, in our case, books and textual arts. During the reign of the Safavid ruler Shah 'Abbas I, a community of Armenian Christians were forcibly transplanted from their homeland in Julfa (medieval Armenia; the present-day Nakhchivan Autonomous Republic) to the outskirts of Isfahan, the shah's capital. There they produced high-quality silk for court use and for worldwide export. The inner covers of the manuscript pictured in figure II.10 retain their original patterned-silk linings, which effectively serve as historical witnesses of imperial ambitions and economic prosperity during the Ottoman-Safavid War (1603–18). Two illuminations in the same manuscript show

II.8. Illuminated facing pages from a dispersed manuscript of the Qur'an, Shiraz, Iran, 1550–75 CE / tenth century AH. Los Angeles County Museum of Art, Bequest of Edwin Binney, 3rd, Turkish Collection, AC1999.158.1 and M.2010.54.1

II.9. *Coat of Arms* and *Ship Sailing* in *Liber amicorum* (Book of Friends) of Johann Joachim Prack von Asch, Istanbul, 1587–1612. Los Angeles, Getty Research Institute, 2013.M.24, fols. 285v–286

II.10. Silk doublure in a Gospel book, New Julfa (Isfahan), Iran, 1637–38. Los Angeles, The J. Paul Getty Museum, Ms. Ludwig I 14 (83.MA.63)

the Old Testament rulers David and Solomon dressed in the purple omophoria of historical Byzantine rulers. Here costume serves a memory function to link the present to the past, while the silk of the bindings acts as a witness to transatlantic and Eurasian trade at a time when Incan silver, European manuscripts, and Armenian textiles traversed empires.

1 Brentjes 2012, 135–46.
2 Brentjes 2008, 181–201.
3 Levkoff 2008, no. 50.
4 Little and Eichman 2000, 142–43. See also Bonnet-Bidaud, Praderie, and Whitfield 2009.
5 Massing 2007, 64–75.
6 Keene 2012.
7 Cummins and Anderson 2008; Salomon and Peters 2009, 101–26; Cohen and Glover 2014; Urton 2017, 1–20. Urton also presented his research at the Getty Research Institute on June 8, 2017, in a talk titled "Can We Decipher the Inka Khipus—and If So, Will We Know How to Interpret the Texts?"
8 Dunlop 2016, 228–391.
9 Uluç 2011, 144–45, 263.

7

Buddhist Illuminated Manuscripts in East Asia

J. SÖREN EDGREN

The topic of this essay—Buddhist illuminated manuscripts, a specific facet of Buddhist manuscripts in East Asia—is intended to provide an entrée to a "global Middle Ages." Indeed, the period covered by these manuscripts coincides with what we might call the later medieval period, that is, the four and a half centuries before the advent of printing in Europe (from around 1000 to ca. 1450). It includes the Song and Yuan dynasties (960–1279, 1280–1368) as well as the early Ming period (1368–1644) in China; the Heian and Kamakura periods (794–1185, 1185–1333) as well as the early Muromachi period (1333–1573) in Japan; and the Koryo (Goryeo) (918–1392) and early Choson (Joseon) (1392–1910) periods in Korea.

It is not my intention to make a direct comparison with Western illuminated manuscripts, which have a firm place in Western bibliography and art history, but since we encounter Islamic "illuminated manuscripts" referred to by analogy,[1] it seems permissible to do the same for East Asian Buddhist "illuminated manuscripts."[2] Generally, these Buddhist manuscripts are written with gold and/or silver ink on dark indigo-dyed paper and have drawn frontispiece illustrations in gold and/or silver ink. Although not exclusively religious, the early European illuminated manuscript texts often represented the dominant religious tradition, which is also true for their Islamic and Buddhist counterparts.

By one Western scholar's definition, "illumination" is a general term meaning "decorated by hand, whether in formal, floral or historiated style, in gold and/or silver and/or coloured paint. It is used of initial letters, single words, first lines or opening pages of (usually very early) printed books; but much more often of manuscripts."[3] In this essay, I prefer not to merely equate illumination with illustration, as some writers do, although I acknowledge the etymological association and the occasional need to be more inclusive. Indeed, the use of gold and/or silver ink is a key feature of illuminated manuscripts. Any references to visual images or pictorial matter

should be taken as incidental to my bibliographical aim of making this aspect of East Asian book history and manuscript culture better known, and not as art historical pronouncements.

The introduction of East Asian manuscripts and imprints here in the context of a "global Middle Ages" notwithstanding, I am not aware of any "globalization" (according to the popular usage of the term) of books and manuscripts in earlier periods. To be sure, there was plenty of interaction and mutual exchange regarding books in discrete regions of the globe—for example, in the area of Europe extending to the Mediterranean Basin, or in the East Asian countries of China, Korea, and Japan—but there was no direct exchange of what we might call book culture between the regions of Europe and East Asia. This lack of knowledge is despite the influence of trade via the so-called Silk Roads and Indian Ocean world, or the influence of religion from the Indian subcontinent. The case of paper and its diffusion westward after a millennium of use as a writing material in East Asia is an important but indirect influence.[4] I am, therefore, describing the rather exclusive activity of a somewhat monolithic culture of "material texts" that received little or no outside influence until the latter half of the nineteenth century. The idea of a "global context" for manuscripts, as addressed in this essay, considers the functions of manuscripts in different parts of the world at the same periods, an approach that provides a basis for a comparative, or "global," history of the book.

Generally speaking, pictorial (especially narrative) illustration played a minor role in Chinese secular book history before the sixteenth century, which may be attributed to traditional Confucian modesty and to a strain of intellectual conservatism favoring text above all else. Plants in *materia medica* (medicinal) books, pictures of bronze vessel collections, and reconstructions of Confucian ritual paraphernalia are the sorts of static images appearing in early Chinese books.[5] The same is true for Korea. Only in Japan, with its highly developed decorative sense and narrative tradition, did secular book illustration play a major role. On the other hand, early Buddhist book illustration fulfilled the need to explain and tell stories.[6] Although I will refer to different Buddhist

illustration and book genres, including printed examples, it is only the manuscripts written with gold and/or silver ink on dark indigo-dyed paper that truly represent the "Buddhist illuminated manuscripts" of my title.

Early Chinese Buddhist manuscripts, following their Indian models, were not illustrated. Buddhism arrived in China over land routes from India in the first centuries of the Common Era, but because the texts of Buddhism were written in Sanskrit and Pali, it took a concerted effort and many years of translation before a sufficient body of texts in Chinese was available with which to promote the spread of Buddhism in China. The first Buddhist texts from India were plainly written on palm leaves and oblong sheets of birch bark arranged horizontally and fastened by a cord threaded through a hole pierced in a stack of leaves in a format known as *pothi*. An imported eighth-century text on palm leaves from India was among the finds at Dunhuang, the desert outpost and repository of more than thirty thousand Chinese manuscripts and a small number of early printed specimens. One of 423 leaves of a surprisingly complete seventh-century manuscript of *Vinayavastu* (Rules of Monastic Discipline) of the Mūlasarvāstivādins (Buddhist monastic order) written in Sanskrit on birch bark typifies the plain, unillustrated type (London, The British Library, Or. 11878 A).[7] A palm leaf from the *Prajñāpāramitā* (Perfection of Wisdom) represents an elegant Indian illuminated manuscript in the *pothi* format from the twelfth century (London, The British Library, Or. 6902), by which time illustrated Indian sutras were not uncommon.[8]

Paper was invented in China around 100 BCE, and it was already being used for manuscript copying when the first Buddhist texts became available in China. Therefore, Chinese Buddhists never had to use natural plant surfaces for writing, as in India, nor did they have to use animal skins, as in Europe. The later illustration of Buddhist sutras in China appears to have developed independently of India, although there may have been influences from other religious manuscript traditions encountered through Central Asia.

Around the seventh or eighth century in China, gold or silver ink was used to copy sutras on dark indigo-dyed

paper. Examples of this type are two Chinese fragments of an unidentified Tang dynasty (618–907) sutra found at Dunhuang in Gansu province and written with gold ink (London, The British Library, Or. 8210 / S. 5720);[9] a Japanese fragment of the *Avatamsaka Sūtra* (Garland Sutra) in silver ink on indigo paper from the mid-eighth century (Nigatsu-dō, Tōdai-ji, Nara, Japan);[10] and a mid-eighth century Korean fragment of an *Avatamsaka Sūtra* with gold and silver ink on reddish-purple paper (Seoul, Hoam Art Museum),[11] which shows how quickly this manuscript custom began to spread in East Asia. These early manuscripts written with gold and silver ink are clearly precursors of the types of illuminated manuscripts under consideration here. In addition to indigo dyes, which provided the most common contrasting background for the East Asian gold and silver illuminated Buddhist sutras, natural paper of ivory hue, reddish-purple paper, and reddish-brown paper (dyed from umber) were also used. Here we should note the use of gold or silver border lines above and below text, as well as the common format of seventeen characters per column, which was something of a standard for Buddhist sutras. Furthermore, the use of such precious metals for transcribing and/or decorating texts, often commissioned by wealthy donors, doubtless added to their value and amounted to a form of veneration.

The earliest extant Buddhist manuscripts on paper were bound as scrolls and were in use no later than the fourth century CE. Scrolls were formed by pasting oblong sheets of paper horizontally, end over end, from right to left according to the order of written text, and by rolling them tightly with or without a wooden rod attached at the end. The characteristic Chinese script was written vertically in columns arranged from right to left, and this practice was also observed in Korea and Japan for secular as well as religious texts. By vertically folding uniform sections of a scroll, it was possible to form an upright rectangular volume with double-page openings that afforded random access to any part of the text. Some scholars

attribute this form to the direct influence of the imported *pothi* format described above, but I consider the influence, at best, conceptual. It seems much more likely that the "foldable" nature of paper logically presented itself to early users of scroll manuscripts. Therefore, I feel I cannot emphasize too strongly the significance of the use of true paper in China and East Asia as the principal material of early bookmaking. The resulting book form is called the pleated binding, also known as accordion or concertina binding from its appearance, and it came into use by the early Tang dynasty. The archaistic use of these two bookbinding forms has been common for Buddhist books in East Asia. Indeed, the modern Chinese name for the pleated binding is "sutra-folded binding." Either form can accommodate a horizontal frontispiece illustration of varying length at the opening of the volume.

The fact that xylographic (woodblock) printing of Buddhist texts in East Asia began as early as the eighth century,[12] and coincided with the beginnings of illuminated manuscripts there, certainly influenced the development of Buddhist illustrated manuscripts, but the influence was unevenly distributed in China, Korea, and Japan. Korea and Japan experimented with the printing of a few Buddhist charms in the mid-eighth century, but they printed nothing more until the beginning and the end of the eleventh century respectively, approximately two hundred fifty to three hundred years later. During that long period, the two countries produced Buddhist illuminated manuscripts based on the Chinese model. On the other hand, in China multiple copies of illustrated printed sutras competed with the handwritten illuminated manuscripts, resulting in a low survival rate for the manuscripts. Nevertheless, non-illustrated sutra copying continued to thrive. Here we can observe that two important Chinese inventions—namely paper (at the beginning of the Common Era), which influenced the productivity of Buddhist manuscripts, and printing (in the early medieval period)—had

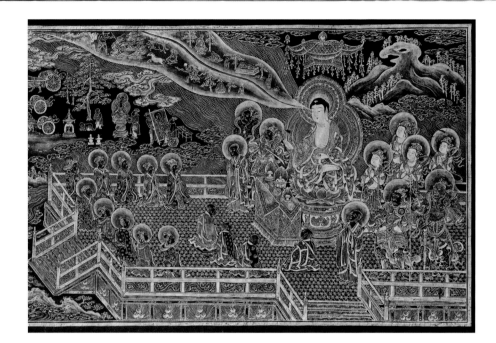

7.1. Frontispiece, detail of the *Saddharma-pundarika* (Lotus Sutra), China (Song dynasty), twelfth century. The Cleveland Museum of Art, John L. Severance Fund, 1970.64

a rather disruptive impact on a smooth and uniform development of illuminated Buddhist manuscripts within East Asia.

The best example of the triumph of illustrated printed sutras is the *Vajracchedika-Prajñāpāramitā Sūtra* (Diamond Sutra), dated 868 and renowned as the earliest complete printed book in the world (London, The British Library, Or. 8210/p.2).[13] It was discovered at Dunhuang. The impressive woodcut frontispiece shows Shakyamuni Buddha seated on a lotus throne behind an altar table, surrounded by disciples and heavenly figures. Throughout the Song period, at least a half dozen different editions of the Tripitaka, or Buddhist canon, were published, each consisting of five thousand to six thousand volumes. With one exception, they contained no frontispiece illustrations. However, at the same time, hundreds if not thousands of lavishly illustrated individual Buddhist sutras were published privately or by Buddhist institutions, and they overwhelmed the production and exclusivity of illuminated manuscripts. I suggest that this hyperactive Buddhist printing in the Song period actually co-opted the development of illuminated manuscripts there,

and only a small number of those produced have survived. Recent archaeology has recovered a few fine examples, notably in Suzhou (located in southeastern Jiangsu province of East China) and Wenzhou (located in southeastern Zhejiang province). The Suzhou example of the *Saddharma-pundarika Sūtra* (Lotus Sutra) from the Ruiguangsi Pagoda is dated to the early tenth century, and another Northern Song illuminated manuscript of the same text is dated 1044.[14] In the latter manuscript, there is the use of flesh color, probably from orpiment, for some faces and limbs, in addition to gold and silver used for the drawing of the figures. The decorative border is another distinctive characteristic. Several eleventh-century manuscripts were found in the Huiguang Pagoda in Wenzhou, including some with gold and silver text written on indigo-dyed paper and natural paper. Some of the covers and wrappers of the volumes have elaborate line decorations in gold ink.[15] The frontispiece of another Song illuminated manuscript of the Lotus Sutra from the following century (fig. 7.1)[16] demonstrates that these concentrated fine-line drawings were laborious to produce.

The Lotus Sutra was one of the most frequently printed and copied illustrated Buddhist texts of the early period.[17] This doubtless was due to its vast popularity, but also to the narrative form of its content, so well suited to illustration. Privately published editions of the Lotus Sutra typically displayed a different frontispiece illustration in each volume. For example, the frontispiece for *juan* (chapter) 7, the final chapter and volume of an important Song printed edition,[18] gives the name of the artist, Wang Yi (active in the twelfth century CE), in a cartouche on the left side (fig. 7.2). The names of block cutters, and occasionally artists and calligraphers, can be found in Song and Yuan editions of Buddhist works. The names of scribes also appeared in Buddhist manuscripts of the period. It is commonly thought that the printed borders derive from the custom of using strips of decorative textile or stamped paper around the mounting of early votive prints, some of which were found at Dunhuang. This example displays a repetition of the Buddhist ritual implement called *vajra*, and

other auspicious Buddhist objects, as well as floral patterns, incorporated into the designs.

During the Heian period—whose nearly four hundred years span from the late Tang dynasty to the late Song—numerous Japanese Buddhist scholars and pilgrims are known to have traveled in China, where they often studied the Chinese language and Buddhism with learned Chinese monks and received gifts of books and acquired many others, which they brought back to Japan. A similar interaction between Buddhists in China and Korea took place. This practice grew and continued well into the fourteenth century and was another source of the circulation of books and manuscripts in East Asia. The Heian period bridged the age of manuscripts and the time of the mature emergence of printed texts in China. Monk Chōnen (938–1016), who traveled to China from 983 to 986, brought back to Japan the entire *Kaibaozang Tripitaka* (Buddhist scriptures, completed in 983), the first printed edition of the Buddhist canon. Partly owing to the enduring

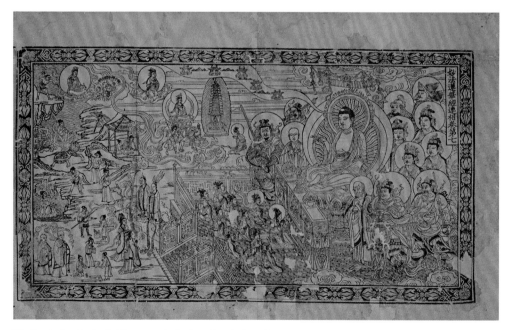

7.2. Frontispiece for the *Saddharma-pundarika* (Lotus Sutra), China (Song dynasty), twelfth century. Taipei, Taiwan, National Palace Museum

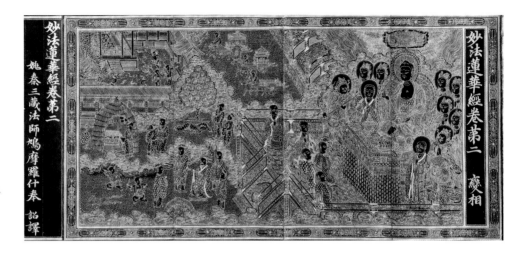

妙法蓮華經卷第二
姚秦三藏法師鳩摩羅什奉
詔譯

妙法蓮華經卷第二
慶相

7.3. Illustrated manuscript of the *Saddharma-pundarika* (Lotus Sutra), Korea (Koryô dynasty), 1340. New York, The Metropolitan Museum of Art Collection, Purchase, Lila Acheson Wallace Gift, 1994.207

popular belief in Buddhism in Japan, and to the continuity of Buddhist practice there, it has been possible to preserve Buddhist books, documents, and artifacts imported from China and Korea to a greater degree than in the two countries of their origin. It should be remembered that the Korean peninsula provided a natural conduit for cultural transfer from China to Japan.

In Korea the culture of the Koryo period (until the end of the fourteenth century) was dominated by Buddhism. The so-called *Tripitaka Koreana* was first published around 1087, but the entire set of woodblocks was destroyed by fire after the Mongol invasion of 1231. New woodblocks for the second edition of the Tripitaka were cut between 1236 and 1251, and it is this set of more than eighty thousand large woodblocks, engraved on both sides, that is monumentally preserved at the Haeinsa Temple in Korea. During this period, many Buddhist illuminated manuscripts were also produced with finely drawn frontispiece illustrations.[19] The overall quality of the calligraphy and of the materials used was excellent, as in *kwŏn* (chapter) 2 of a Lotus Sutra volume, dated 1340 (fig. 7.3).[20] Beginning in the fifteenth century, however, Buddhism in Korea had to coexist with ascendant Confucian doctrines.

The last century of the Song was a time when printed books began to predominate in China, and afterward printed books became common among the imports to Japan. A unique copy of the *Fanwangjing pusajie* (J. *Bonmōkyō bosatsukai*; Brahma's Net Sutra), printed in 1248 in Kyoto by the Japanese monk Tankai, offers an interesting example. Tankai was a disciple of Monk Shunjō (1167–1228), who had founded Sen'yūji Temple in Kyoto, where he initiated significant printing projects. Shunjō previously had been to China from 1199 to 1211 and, after wide travels, had brought back many books. *Fanwangjing pusajie* is a large-character Japanese woodblock facsimile edition with a magnificent woodcut frontispiece, based on an early Song edition imported to Kyoto by Tankai in 1244, when he returned from six years in the Song Empire. The book was published in 1248 at Sen'yūji, where Tankai had deposited the Song edition a mere four years earlier, and if not for an informative printer's colophon, all these particular circumstances would not be known.[21] Since the original Song edition is not extant, this Japanese facsimile edition provides its only trace.

Thus far we have noted the similarities between the Buddhist illuminated manuscript products of China and Korea. In Japan, however, despite retaining calligraphic style and format from the Chinese models initially, the execution of frontispiece illustrations rapidly evolved to reflect Japanese taste and style. Furthermore, the production of Japanese Buddhist illuminated manuscripts took place on a much larger scale than in China and Korea. This is especially true of the twelfth

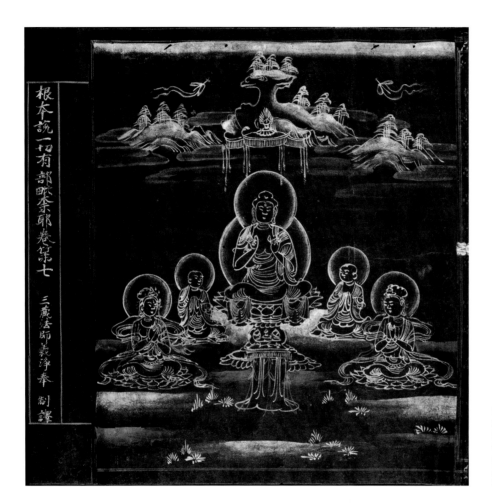

根本説一切有部毗奈耶卷第七

三藏法師義淨奉 制譯

7.4. *Mūlasarvāstivāda-nikaya-vinaya Sūtra* (Collection of Monastic Codes of the Mūlasarvāstivāda) from Jingoji Temple, Japan (Heian period), 1150. Princeton, New Jersey, Princeton University Art Museum, 106

century of the Heian period, when three Japanese manuscript Tripitaka editions were undertaken in the absence of a Japanese printed Buddhist canon.

In the middle of the twelfth century, the retired emperor Toba (r. 1107–23) sponsored a set of sutras that was deposited at the Jingoji Temple near Kyoto. The total number of scrolls produced is disputed, but they were largely extant at the temple in the eighteenth century. Only 2,317 scrolls are there today, as they were gradually dispersed, especially in the Meiji period (1868–1911), and scrolls from the Jingoji manuscript Tripitaka can be found in collections around the world. Here, we illustrate *kan* (chapter) 7 of the

Mūlasarvāstivāda-nikaya-vinaya Sūtra (Collection of Monastic Codes of the Mūlasarvāstivāda) (fig. 7.4).[22] Despite the free-style brushwork of the frontispiece, the compositions were rather uniform in this Buddhist canon. The distinctive Jingoji seal impression is on the second column of text and out of sight in this image.

About the same time, another set of sutras in scroll form, known as the *Arakawa Tripitaka*, was established near Kyoto, of which 3,575 scrolls are extant today. Later in the century, in Northern Japan near Sendai, the *Chūsonji Tripitaka* (Issaikyō) was completed and deposited by a branch of the Fujiwara family. In the late sixteenth century, 4,296 volumes

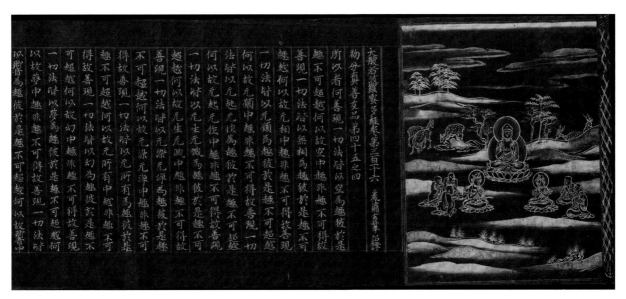

7.5. *Mahaprajñāpāramitā Sūtra* (Great Wisdom Sutra), Japan (Heian period), 1175. New York, The Metropolitan Museum of Art, Dr. and Mrs. Roger G. Gerry Collection, Bequest of Dr. and Mrs. Roger G. Gerry, 2002.447.1

were removed to the Kongōbuji Temple at Mount Kōya in the west, and some of the more than two thousand scrolls formerly kept at Chūsonji Temple have been dispersed. These sutra illustrations, created over three generations, are known for variation of style and composition and for the contrasting use of gold and silver pigments.[23] Here we illustrate an example of the *Mahaprajñāpāramitā Sūtra* (Great Wisdom Sutra) (1175, fig. 7.5). Not all of the twelfth-century manuscript Tripitaka scrolls had frontispiece illustrations, but those that did number in the thousands. Additionally, privately commissioned illuminated sutras were abundant. In the Japanese frontispiece illustrations, secular images often appeared in the foreground, and stylized floral patterns in gold and silver ink called *karakusa* (Chinese grasses) or *hōsōge* (precious Buddha flowers) were painted on the outside square cover sections, and were thus visible when the scrolls were completely rolled up.[24] This was a common feature for these scrolls, as was the presence of pairs of elegant, engraved gilt brass knobs, or rollers.

The influence of Chinese Buddhist illuminated manuscripts extended to other contiguous regions. A rare surviving twelfth-century example of the Lotus Sutra from the northwestern Xixia kingdom (1038–1227), with a frontispiece illustration and Xixia script in gold ink on blue paper, is held in Paris at the Musée Guimet (inv. MG 17624).[25] The influence also extended beyond Buddhism, if we consider that the appropriation of aspects of Buddhist ritual and practice by religious Daoism in the fifteenth century included texts in gold ink on indigo-dyed paper.[26] Interestingly, there is even a unique example of early Arabic writing in gold on blue-dyed parchment known as the Blue Qur'an.[27] These examples provide glimpses beyond East Asia into the potential networks, influences, or comparative studies afforded by considering a global Middle Ages.

— J. Sören Edgren is former director of the Chinese Rare Books Project at Princeton University.

1 See for example Stchoukine 1971. Suarez and Woudhuysen (2010, 813), has an entry for "illuminated manuscript, Muslim."

2 This subject was addressed in the broadest sense by Pal and Meech-Pekarik (1988).

3 J. Carter 1992, 119.

4 Despite a clear history of the transmission of paper technology, there is no concrete evidence for Chinese xylographic printing and its derived print culture having directly influenced the rise of printing in fifteenth-century Europe. Tsien (1985, 293–319) confirms the former and speculates on the likelihood of the latter.

5 Weitz 2015, 49–69.

6 See J. Murray 1994, 136–37, for Buddhist sutras. Kohara (1991, 247–66) compares Chinese and Japanese (emaki) secular paintings.

7 Illustrated in Zwalf 1985, 47, and described as no. 46 (Or. 11878 A) on p. 52. Also described and illustrated in Losty 1982, 29–30.

8 Illustrated and described as no. 62 in Zwalf 1985, 58–59.

9 Wood and Barnard 2010, 39.

10 Rosenfield and Shimada 1970, 20–21. After a temple fire in 1667, some fragments of this sutra were dispersed and are now found in many collections.

11 Pal and Meech-Pekarik 1988, 244, 261–62.

12 Tsien 1985, 146–72.

13 Wood and Barnard 2010, 6–9, 42–55.

14 Suzhou Museum 2006, 159–64; National Library of China 2008, vol. 4, 148–49.

15 Wenzhou Museum 2010, 208–55.

16 Introduced in Cleveland Museum of Art 1980, xxxi–xxxiii, 64–65. A very similar example described as mid-thirteenth-century Japanese is in the Spencer Collection of the New York Public Library. See Sorimachi 1978, 12–13. Keyes (2006, 44–45) disputes the dating. Although this question needs further study, we are clearly dealing with a Chinese prototype.

17 Tanabe 1988. The Lotus Sutra consists of seven (or eight) juan (K. kwŏn, J. kan), the chapter-like division of traditional Chinese books.

18 Huang (2011, 147–63) analyzes the design and iconography common to these Lotus Sutra frontispiece illustrations.

19 This subject is carefully surveyed by Pak (1987, 357–74).

20 Illustrated and described in J. Smith 1998, 171–73, 436–40.

21 Sorimachi 1978, 73–75.

22 See Mote and Chu 1989, 59–65.

23 Rosenfield et al. 1973, 79–81.

24 Pal and Meech-Pekarik 1988, 277–78, illustration on fig. 116. The rectangular covers of Korean pleated binding volumes also were elaborately decorated with gold and silver patterns.

25 See http://www.artres.com /C.aspx?VP3=ViewBox& VBID=2UN365FJRBB99 (click image for larger view).

26 A manuscript volume of gold ink on indigo paper dated 1470 is illustrated and described in Little and Eichman (2000, 233–36).

27 For a description and illustrations of two leaves recently exhibited, see Evans and Ratliff 2012, 275–76. Bloom (2015, 196–218) provides a detailed study of this work.

Traveling Medicine: Medieval Ethiopian Amulet Scrolls and Practitioners' Handbooks

EYOB DERILLO

Amulets, written on organic material or cast in metal, have been worn or carried by peoples of Afro-Eurasia for millennia.[1] This practice remains strong in the northern highlands of Ethiopia, specifically in the regions of Amhara and Tigray, where, historically, amulets have been believed to bring health, protect infants, ward off the evil eye, and visualize the invisible spiritual world of angels and demons.[2] The textual material of amuletic scrolls and magico-medical manuscripts on parchment, paper, and wood survive in greatest quantity from the sixteenth to the nineteenth century—that is, from the late medieval (Solomonic) to the modern period in Ethiopia's history. As we will see, the decoration on these objects likely refers to earlier precedents, both local and global.

The Empire of Aksum dominated the competitive landscape of trade and territorial power in Eastern Africa and the Indian Ocean realm from 100 to 940 CE. The centuries that followed—the long Middle Ages of Ethiopian history (up to the eighteenth century)—saw increased contacts between Ethiopia and the world. Amulets and apotropaic arts constitute, perhaps more than other objects, a global phenomenon with very powerful local resonance. This essay will consider the relationships between the so-called magical recipe books and magic scrolls, with the goal of providing a better understanding of the relationship between practitioner and client, and offering insights into premodern health and medicine practices from the Horn of Africa. Drawing upon little-studied material from the British Library, this brief chapter will examine two Ethiopian texts for healing, which were mostly written in Ge'ez (classic Ethiopic, the most spoken of the Afro-Asiatic languages that commingled in the region under consideration) with other portions, including tracts on magic, medicine, divination, and charms, written in Amharic.

A multidisciplinary approach to these materials has the potential to provide new comparative perspectives for other, better known magico-religious traditions of Central and South Asia, such as the talismanic shirt (see fig. II.6) or painted Yantras from India, and elsewhere in Africa, as in Islamicate and Coptic Egypt. The peoples of Ethiopia were long connected with other cultural groups from Eastern Africa, the Mediterranean, Central Asia, and greater Africa (trans-Saharan, Sahel, and sub-Saharan alike). This global context helps to explain the many sources of inspiration and influence on magico-medicine texts. Although historians of medicine have begun to include Africa in studies of the Bubonic (Justinian) plague—the most famous outbreak of which occurred in the fourteenth century as the Black Death—there is still much potential for examining portable, amuletic, or talismanic texts within these studies.[3]

The word "magic" drives from the Greek *magikē*, that is, an act pertaining to the magi, who were members of the Zoroastrian priestly caste specifically authorized to perform sacred rituals, royal sacrifices, interpretations of dreams and astrological phenomena, and funeral rites. The *Oxford English Dictionary* defines "magic" as "the use of ritual activities or observances which are intended to influence the course of events or to manipulate the natural world, usually involving the use of an occult or secret body of knowledge; sorcery, witchcraft."[4] There is in fact no direct definition for the word "magic" in Ethiopia, but the Ge'ez words used to describe what might be referred to as magic, based on the above definition, are *asmat* (used in prayers to invoke the names of God or of angels) and *saray* (a word used to express an action, like sorcery or casting spells, charms, or enchantments, but which could also apply to the use of an herbal drug to cure illness). While the term *asmat* is held by the Ethiopian Orthodox Church to be lawful because it calls for the assistance of God, the word *saray*, by contrast, indicates unlawful practices that involve evil spirits.[5]

I use the term "amulet scroll," rather than the frequently used "magic scroll," to avoid becoming mired in cultural presuppositions about belief and superstition. According to Ethiopian tradition, the origin of magic, astronomy, spells, and talismans was first revealed to the prophet Enoch by God. The Book of Enoch is therefore a primary source for any study of Ethiopian amulet scrolls, especially since it is only preserved in its entirety in Ge'ez (with fragments in Aramaic among the Dead Sea Scrolls and a few additional portions in Greek or Latin sources).[6] Amulet scrolls and magical recipe books are a striking and distinctive form of Ethiopian Christian material culture. Getachew Haile has demonstrated that the Bible, the hagiography of Ethiopian saints, and homilies of the archangels and literary works like the *Miracles of the Virgin Mary* were major sources for healing texts.[7] Throughout Ethiopia, *däbtäras*, or practitioners of magic, were scribes and clerics who supplemented their income by producing scrolls and practicing traditional medicine. Highly portable objects, scrolls were generally kept in leather cases or cylindrical ones—like an especially fine silver example preserved in the British Library (Or. 12859)—but they could also be hung in the home or worn around the neck, depending on their size. Scrolls were not simply highly personalized objects, as we will see, but valuable as well.

The pages of one personally annotated magical recipe book from 1750 (fig. 8.1) are adorned with talismans and geometric images that would have served as models for making amulet scrolls. These devices were accompanied by prayers for undoing spells and charms, and the drawings focus on the image of the eye, providing a defense against the evil eye and the dark arts. Traditionally, amulet scrolls contained a select range of depictions often derived from manuscripts, including

8.1. Magic recipe book, Ethiopia, 1750. London, British Library, Or. 11390

8.2. *Awdä Nägäst* (Cycle of Kings), Ethiopia, eighteenth century. London, British Library, Add. Ms. 16247

images of saints, guardian angels, archangels, abstract talismanic designs, or events from the lives of important mystical figures like King Solomon, Alexander the Great, and Saint Sueyous (a fourth-century Christian martyr who is venerated by the Ethiopian Orthodox Church).[8] A common motif on such scrolls, and in manuscripts and sculptural arts, is an eight-pointed star with a human face in the center and four arms (vertical and horizontal). The same form is also found in Kabbalistic Judaism and in Islamic art, attesting to the multivalence of meaning embedded within amuletic imagery.[9] The majority of the mystical names for angels, demons, or spirits

found in Ethiopian sources are of Hebrew or Babylonian origin, and it is likely that these names emerged from local Cushitic beliefs combined with early Christian teachings in the region. This rich syncretic heritage is a key characteristic of Ethiopian Orthodox belief.

The *Awdä Nägäst* (Cycle of Kings) is a treatise, probably composed in the fifteenth century, consisting of circular tables (*'awd*) used for divination and fortune-telling. Manuscripts with this text are astrological, numerological, and geographic in scope and content. The basis of the fortune-telling is a sixteen-sector schema named after lakes or rivers (*bahr*) in Ethiopia (for example Tana and Zway). The drawings are always oriented with the same divisions, the only difference being the lettering (in alphabetical order) of the segments. Each diagram can be deciphered—regarding a question about

a situation or ailment—through the corresponding texts that follow the tables (fig. 8.2). The numerical values are assigned to a character of the Ethiopian alphabet and the values of the characters of the name of the person are added up with the name of his or her mother and the year. This calculation is used to select the appropriate chart from which to discern the subject's fortune.

The *Awdä Nägäst* is little known outside of Ethiopia, historically and in the present. The Ethiopian Orthodox Church has banned the text, since the practices it contains are deemed outside the approved disciplines of the faith. Thus, although amuletic scrolls—their imagery and the contents— comprise a synthesis of regional and transregional practices, certain practitioners' handbooks, like the *Awdä Nägäst*, can be better understood as manifestations of local traditions.

To date, research on amuletic scrolls and practitioners' handbooks has primarily (but not exclusively) been framed from the point of view of iconology. And yet several questions arise in relation to the scholarly turn of the global Middle Ages: Can we trace broader regional connections between imagery on scrolls and in manuscripts (or in relation to paintings in architectural contexts)? Given the extensive quotations of style and motifs from early Near Eastern (or Central Asian) Hebrew, Syriac, and Islamic magico-religious imagery, there appears to be much potential to incorporate the large corpus of Ethiopian material into studies on trade, travel, disease, pilgrimage, and other phenomena of movement. In short, this particular aspect of Ethiopian material and visual culture is fertile for future avenues of research that can incorporate it into larger, global fields of study.

— Eyob Derillo is curator of Ethiopian manuscripts at the British Library.

1 See Ryder 2000–; Al-Saleh 2000–.
2 The scholarship on Ethiopian magic is still very much in its infancy. The most widely cited works are Strelcyn (1955) and Mercier (1979). See also Littmann 1904; Budge 1929; Windmuller-Luna 2000–.
3 For global studies of premodern disease, see Selassie 2011, 36–61; M. Green 2014.
4 http://www.oed.com/view /Entry/112186?rskey= iF7tZf&result=1, accessed July 12, 2018.
5 See Budge 1929.
6 Budge 1935.
7 Haile 1978.
8 Burtea 2007.
9 See Mercier 1979; Mercier 1997.

9

The Painter's Line on Paper and Clay: Maya Codices and Codex-Style Vessels from the Seventh to the Sixteenth Century

MEGAN E. O'NEIL

This essay considers the roles and perceptions of books and related media, both among the Late Classic and Postclassic Maya, and in sixteenth-century Yucatán, after Spaniards invaded the Maya region. Examining the significance of books in these three eras, this essay explores the power attributed to books, the social and performative nature of their production and use, and their roles in intercultural exchange, both between the Maya and Central Mexican cultures in pre-Hispanic times and between the Maya and Europeans in the sixteenth century. By comparing Maya book practices to those in the rest of the world during the long Middle Ages—before the Maya were in contact with Europeans—and by addressing the encounter of Maya and European book cultures after the Spanish invasion, this essay connects to the volume's broader themes.

Yet the concept of the book first must be expanded for the Maya in the Late Classic period, for ceramic vessels were other portable items used to preserve and share information and tell stories. Books and vessels were both interactive media, requiring users to turn the page or rotate the vessel to follow the narrative. Maya bark-paper screenfold books could hold longer narratives than vases, and their pages could be folded in varying ways to connect different narratives held within, and vessels were more than books, for they were also containers for holding and serving food and drink. Both were used in dynamic ritual performances and in social gatherings, perhaps at the same time. Indeed, during a short period (650–800) in northern Peten (Guatemala) and southern Campeche (Mexico), Maya ceramic artists made explicit the relationship between books and vessels by creating ceramic vessels that emulated bark-paper books in appearance and even shape. The relationship between the two media required a transformation of forms, materials, and techniques that may be considered analogous to the kinds of transformations enacted when artists translate images and texts from another culture into their own idiom. Artists creatively played with

materials and styles to create new forms in these intercultural and intermedial translations and transformations.

Books as Loci for Collaboration and Conflict in Sixteenth-Century Yucatán

Before contact, both the Maya and the Spanish greatly valued books and writing. Although both cultures had low literacy rates, both used books to preserve and share knowledge, and books were vital guides for ritual practice. Furthermore, for the Maya and for the Europeans, books could be sacred: some were anointed, encased in valuable materials, and buried in tombs. In addition, in both cultures, books were important vehicles for intercultural exchange, and were copied within cultures and translated across cultures and languages.

After the Spanish invaded the Yucatán and friars established evangelization missions, books (among other items) came to be essential touchstones in an intercultural web of contacts—both collaborative and conflictual—between Spanish clergy and Maya and other indigenous nobles.[1] One aspect of intercultural exchange was the use of books to teach Latin letters, Castilian Spanish, and Catholic doctrine, as well as the writing of the Yucatec Maya language in Latin letters.[2] Painted images—such as murals—and performances were other media the Spaniards used to teach Catholicism; these were especially needed because of low literacy rates in both Spain and the Maya region.

At the same time, Spanish friars in sixteenth-century Yucatán scorned Maya hieroglyphic codices as containers for idolatry, seizing and burning them in extirpation campaigns and *auto-da-fé* (act of faith) rites of the Spanish Inquisition, which included public penance, even execution. In an infamous rite in Mani (Yucatán) in 1562, thousands of deity effigies and more than twenty books were burned under the authority of Fray Diego de Landa (1524–1579).[3] There clearly was an understanding that the Maya considered books potent and kept sacred knowledge in them. This message was perhaps especially salient to friars, who attributed great power to the Bible, whose words, images, and even material substrate were deemed potent in medieval Europe and later. Because

the Maya used books to follow ritual calendars and practices, the Spanish clergy described Maya codices as "books of the devil" and thought that destroying codices could cure idolatry.[4] Moreover, they punished scribes for writing in the Maya script. Yet Landa's zealous extirpation and conversion efforts involved not only the destruction of books but also the recording of information about Maya culture and writing. Landa worked with Gaspar Antonio Chi (ca. 1531–1610), a Maya scribe, to record what Landa thought was a Maya alphabet (fig. 9.1).[5] Although it actually was a syllabary, and its creation thus was the result of cultural misunderstanding, this document played a crucial role in the decipherment of Maya hieroglyphs centuries later.[6]

Maya priests and scribes responded to Spanish authority and oppression by hiding books and deity effigies and obscuring the religious knowledge they contained. One tactic was to write in Latin letters. They produced books called *Chilam Balam*, which were written in Yucatec Maya in Latin letters and allowed scribes to preserve knowledge while hiding it from the Spaniards. Some may have partially copied hieroglyphic codices,[7] and the scribes also added Christian content, metaphors, and riddles to obscure the traditional knowledge and religious practices.[8] The formats also were new: instead of making bark-paper screenfolds, they used sheets of European paper and bound them in the style of many contemporaneous European books. The *Chilam Balam* books were thus a form of intercultural translation; however, they were made not to understand the foreign culture but to defy its authority and preserve indigenous knowledge.

Maya scribes in colonial Yucatán also continued to write in hieroglyphs. John Chuchiak describes their "graphic pluralism" as a form of resistance to Spanish authority.[9] Writing in both Latin letters and hieroglyphs, scribes worked creatively to resist, adapt, and create new identities within the political and social systems formed in the wake of the Spanish invasion. Nevertheless, the continued efforts to root out idolatry and destroy Maya religious practices and writing tragically led to the extinction of Maya hieroglyphic writing during the colonial period.

9.1. Maya syllables recorded by Gaspar Antonio Chi in Diego de Landa's *Relación de las Cosas de Yucatán* (Narrative of the Things of Yucatán), Mexico, sixteenth century, 45r

Postclassic Maya Painted Bark-Paper Codices

Not all pre-Hispanic Maya books were destroyed. Three of the four extant Maya books made their way into European collections after the Spanish invasion and are named after the European cities—Dresden, Madrid, and Paris—whose libraries hold them today. The fourth, allegedly discovered in a cave in Chiapas ca. 1965, was initially named after the Grolier Club in New York, where it was first publicly exhibited in 1971, and is now in Mexico's Biblioteca Nacional de Antropología, and its name has been changed to Códice Maya de México, or Maya

Codex of Mexico (hereafter CMM).[10] These four codices were painted in the Postclassic (1000–1521) period. The CMM was made in the eleventh or twelfth century,[11] and the Dresden, Madrid, and Paris codices were painted in the fourteenth and fifteenth centuries. The Dresden and Madrid codices appear to have been copied from older codices, possibly from the Late Classic period, and thus may give insight into books from that period.[12]

The content of the Postclassic codices is religious and astronomical and related to divination and ritual performance. The artists used the painted page to preserve and share information about humans in relation to animals; supernatural entities of corn, rain, and other forces of nature; and extraterrestrial beings such as the sun, moon, and Venus. They also functioned as aids in following ritual calendars (fig. 9.2).[13] The books were consulted regarding good days for planting and for counsel in divination, based on the potential positive or negative outcome of performing an action on a certain day. In addition, they recount and portray the actions of deities at the beginning of time; such actions would be repeated as part of world renewal rites, another way these books functioned as prescriptions for ritual practice.

Maya codices were intended not for private, personal reading but for dynamic ritual use by groups. Multiple scribes worked on each codex: five to eight scribes painted the Dresden Codex, and nine worked on the Madrid Codex (or Tro-Cortesianus).[14] Furthermore, there is evidence that books were viewed by multiple individuals at once. Indeed, a 1596 idolatry case in Calotmul (Yucatán) recorded a cleansing or blessing ceremony of hieroglyphic codices in which priests placed the books on sacred leaves, surrounded the books with effigies of the creator god Itzamna, and made offerings of copal incense, food, drinks, and greenstones.[15] One of the concerns the friars had with Maya books was that they encouraged Maya people to continue practicing traditional rites according to calendars in the books.

All four codices are painted on *amate* paper made from the inner bark of different species of trees of the genus *Ficus* (wild fig), in the mulberry (*Moraceae*) family.[16] Each is a long

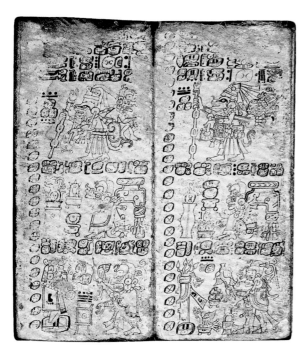

9.2. Facsimile of Dresden Codex (Yucatán, Mexico, thirteenth–fourteenth century. Dresden, Germany, Saxon State Library, Mscr.Dresd.R.310), p. 25. Los Angeles, Getty Research Institute, 2645-271

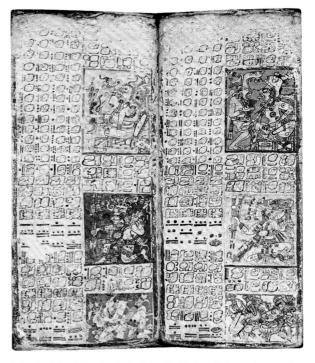

9.3a. Facsimile of Dresden Codex (Yucatán, Mexico, thirteenth–fourteenth century. Dresden, Germany, Saxon State Library, Mscr.Dresd.R.310), p. 49. Los Angeles, Getty Research Institute, 2645-271

9.3b. Drawing of name of "chak ["great" or "red"] xiw(i)-tei" from p. 49 of the Dresden Codex (9.3a) by Maeve O'Donnell Morales (based on Taube and Bade 1991, fig. 1)

strip of bark paper, folded accordion or screenfold style.[17] The pages generally have a ratio of 2:1, about twice as tall as wide, with each page measuring 9 to 12 centimeters in width.[18] The bark paper was covered with stucco,[19] and then painted with pens made of bird quills or reeds and brushes made of hair or fur attached to bone, reed, or bamboo tubes.[20] Scribes used organic and inorganic colorants, including vegetal carbon black (from burned wood), iron-bearing minerals (like hematite, at times mixed with kaolin clay), and Maya blue.[21] The painters mapped out the pages with red frames after the stucco application. For the Madrid Codex, David Buti et al. showed that artists first outlined images in black and then filled in the red and blue colors; they also noted that the composition of the pigments in the Madrid Codex matches that used in contemporaneous Maya mural paintings.[22] This may indicate that the book and mural painters were the same, or that they worked together or shared materials.

There is evidence that the Madrid Codex was made in northeast Yucatán but was copied from earlier sources from the southern lowlands, where the Late Classic Maya civilization had primarily flourished. Yucatec morphology in the inscriptions indicates that the scribes were Yucatec Maya speakers, but there are grammatical features from Eastern Ch'olan languages that are interpreted as the result of scribes copying earlier codices from the southern lowlands.[23] Other evidence for copying portions of codices is the fact that sections of distinct codices are cognates of each other. (In the study of Mesoamerican codices, "cognate" is an adjective and a noun referring to similar passages in different works that appear to derive from the same source or similar sources.) For example, Anthony Aveni has shown that there are fifteen pairs of numerically cognate almanacs in the Dresden and Madrid codices.[24] Books were thus transmitters of information from one document to the next, from the past to the present and future, and from one group of scribes to another.

Pre-Hispanic Maya books also contain information that clearly results from cross-cultural exchange with Central Mexican cultures, and books may have been an important medium for such exchanges. The sections of Maya codices

with 584-day Venus cycles are cognates with sections of the Codex Borgia and others of the Borgia group, which originated in Central Mexico, likely in the Puebla-Tlaxcala region (fig. 9.3a).[25] For example, the Dresden Codex has tables tracking the movements of the planet Venus composed of images of Venus manifestations, such as Venus as morning star. Associated inscriptions give auguries of the outcomes of performing rites on certain days. Some deities have names from Nahuatl, the language of the Aztec or Mexica Empire, but are written in Maya script. For example, one figure in the Dresden Codex is named "tawiskal(a)," most certainly a transcription of Tlahuizcalpantecuhtli, a Mexica Venus deity; another is "chak ["great" or "red"] xiw(i)-tei," which Karl Taube and Bonnie Bade have linked to the Mexica fire deity Xiuhtecuhtli (fig. 9.3b).[26] These cognates, however, are not exact copies; they have been translated and transformed. The images are mostly in Maya style with Maya characteristics. Karl Taube and Bonnie Bade demonstrate that the figure labeled "tawiskal" is a Maya-style howler monkey artisan and does not look like the Mexican Tlahuizcalpantecuhtli.[27] The Maya thus took some features of the Central Mexican Venus tables and transformed them to make them their own. These intercultural cognates, translations, and transformations are in some ways analogous to the translations and transformations in which Maya scribes participated under Spanish rule in the sixteenth century, although the reasons for this intercultural exchange were vastly different.

Books likely were one of the media through which information and artistic styles traveled (along with people carrying them), but other materials and objects traveled, too. Indeed, Maya blue was used at the Templo Mayor of Tenochtitlan in Central Mexico. Gold and turquoise mosaic ear flares, made of materials from both lower Central America and the American Southwest or Northern Mexico, were discovered in a Late Postclassic burial at the Maya site of Santa Rita Corozal (Belize), and there is evidence of Aztec merchants in Mayapan (Yucatán, Mexico).[28] Furthermore, the murals at Santa Rita Corozal and Tulum (Quintana Roo, Mexico) are painted in the so-called International Style, which was used

in murals and codices in Postclassic Yucatán, Central Mexico, and Oaxaca, indicating a desire for multiple cultures to share artistic styles, perhaps for better communication between elites across regions.

Intermedial Transformations: Late Classic Painted Ceramic Vessels and Books

There are no surviving Maya books from the Classic period (300–900); they disintegrated in the tropical environment. Yet there is definitive evidence that the Maya made them, for archaeologists have discovered remnants of books in tombs.[29] Plus, books are depicted in Late Classic images, particularly on ceramic vessels painted in a style comparable to the extant Postclassic books—and most likely to Late Classic books, too. The Classic-period Maya word for "book" was the same as for "paper," *huun*. The portrayal of books covered with pelts of the powerful jaguar indicates that they were valued objects. On Late Classic Maya ceramic vessels, seated scribes are frequently shown painting or gesturing to books that are depicted as stacked pages covered with a jaguar pelt. Or they are depicted with strips of numbers, perhaps painted on bark paper and made for calculations. The scribes often hold tools of the trade. On one vessel at the Los Angeles County

Museum of Art (LACMA), one scribe has a book and quill or reed pen, and the other has a shell paint pot (fig. 9.4). Both wear abundant jade jewelry, including a royal jewel on the forehead. Artists, esteemed members of ancient Maya society, were called *its'aat* (wise person) or named by their practice. For example, *aj tz'ihb* (writer, painter) referred to those who painted with a brush or quill.

Some scribes are deities, such as the elderly God N; some are anthropomorphic rabbits or monkeys; and others appear human. But even when shown as human, they display characteristics such as mirror signs on their skin (see figs. 9.4a–b) or water lilies in their headdresses, suggesting a supernatural nature or connections with the supernatural. Likewise, a carved bone at Tikal features a painter's hand emerging from a solar centipede portal, indicating that the artist's hand comes from the otherworld, and suggesting that artistic inspiration is divine. The depiction of scribes—whether human, animal, or divine—who paint or point to books, communicate with other artists over a book, or stand near a ruler in a palace scene hints at the interactive and performative nature of Maya scribal work. Such images of two or more people using books together recall the 1596 blessing ceremony from Calotmul, Yucatán, in which multiple scribes gathered to consult and bless a hieroglyphic codex.

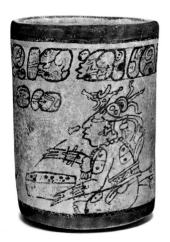
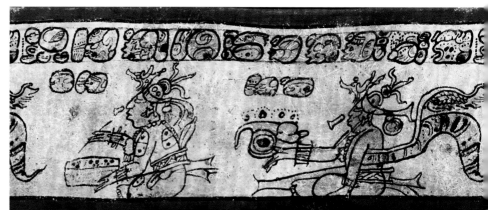

9.4a–b. Codex-style ceramic vessel with scribes, northern Peten (Guatemala) or southern Campeche (Mexico), 650–800. Los Angeles County Museum of Art, Anonymous Gift, M.2010.115.562

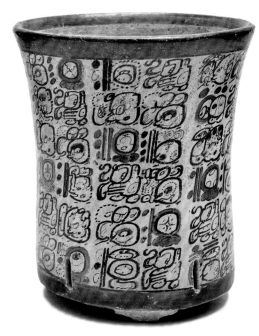

9.5. Codex-style ceramic vessel with Kaanul polity dynastic list, northern Peten (Guatemala) or southern Campeche (Mexico), 650–800. Los Angeles County Museum of Art, Anonymous Gift, M.2010.115.1

Certain Maya ceramic vessels have been called "codex-style" because these cylindrical vases share the color palette of Postclassic Maya codices, with white or cream backgrounds, red borders, and black lines used for images and texts; some red appears in the texts as well (figs. 9.4, 9.5, 9.7).[30] These vessels come from northern Peten and southern Campeche and were made during a specific period, 650 to 800.[31] A whole vessel was found in an offering in Structure II of Calakmul (Campeche, Mexico), and sherds have been found in multiple sites, including Calakmul, El Mirador, Nakbe, La Muerta, La Muralla, Porvenir, Guiro, Pacaya, and El Tintal in Guatemala.[32] Codex-style vessels appear to have been given as gifts or otherwise exchanged between elites, but the exchanges took place primarily in this region. The names of elite patrons or owners repeat on vessels made or found at multiple sites, although they may have been made at the same workshop or site.[33] Massive illicit looting in northern

Guatemala disrupted many contexts that could have provided additional evidence for exchange of vessels between the sites in this region.

Although codex-style vessels were not widely distributed, other types of ceramic vessels were exchanged across larger territories, and some are indices of intercultural exchange. For example, in the fourth and fifth centuries, the Maya area had strong contacts with Teotihuacan (State of Mexico, Mexico). During this time, ceramic vessels were carried to Maya cities from Teotihuacan, and Maya artists made vessels in the styles of the Teotihuacan vessels.[34] Indeed, one Teotihuacan-style vessel found at Tikal portrays emissaries (likely from Teotihuacan) carrying lidded vessels to a Maya city (fig. 9.6). Comparable to the book in later periods, the ceramic vessel was one of the primary forms of intercultural exchange in the fourth century.

Codex-style vessels depict some of the same imagery as the Postclassic books, including images of deities such as K'awiil (deity of lightning and rulership) and other supernatural entities acting in primordial time. Codex-style vessels also portray humans giving offerings or re-creating primordial events, and some bear dynastic lists of rulers from the Kaanul polity, listed in columns of black and red inscriptions that evoke pages from the Postclassic books (see fig. 9.5). Some scenes on codex-style vessels are cognates or partial cognates, with multiple vessels telling the same stories (fig. 9.7a–b). It is possible that some of these images or texts had cognates in contemporaneous books, but none survive.

The concentrated practice of making codex-style vessels undoubtedly related to contemporaneous book production, perhaps as a form of emulation or even skeuomorphism, with vessels made to look like books and requiring painters to stretch ceramic materials and techniques. Both books and vessels were painted on a substrate—bark paper for books and shaped clay for the vessels—and then covered with a white or cream substance—plaster for the books and calcium or potassium-rich clay slips for the vessels. For the black lines, book painters used carbon black, and vessel painters used manganese-rich slips, but painters of both media used

9.6. Rollout drawing (a) and detail (b) of a fourth-century Teotihuacan-style ceramic vessel from Tikal, Guatemala, showing emissaries (likely from Teotihuacan) carrying lidded cylinder vessels to a Maya city.

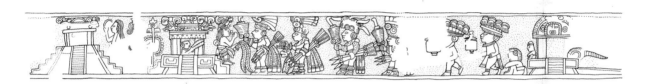

iron-bearing minerals (such as hematite) for the reds. The organic red pigment cochineal has also been identified in the CMM. Granted, the processes were different, since vessel painters had to plan for color changes caused by firing to produce the same palette. Yet at the same time, one can imagine that vessel painters used bark-paper strips to map out designs on cylindrical vessels to ensure that the design would fit properly, such that there may have been a more natural connection between the two media related to production. Moreover, most portrayals of scribes painting or pointing to books appear on codex-style vessels, possibly an explicit if not playful reference to the intermediality salient in the painted scenes.

The form, content, and painting process of the Vase of the 11 Gods further strengthens this relationship between Late Classic vessels and books (fig. 9.8). It is a square vessel that forms a four-sided palace structure. Ten deities with solar and avian attributes, seated in two registers, face the cigar-smoking God L (an underworld deity), who is seated on a throne inside a mountain or cave. The text states that the gods are *tz'ahkaj* (ordered) on 4 Ajaw 8 Kumku, the start of a new cycle of time, when the world was created or renewed. This square shape is rare among Maya vessels; our research at LACMA has determined it was square-coiled and shaped into this form.[35] Making the square vase was more difficult than creating a cylinder, but the potter (and painter) certainly wanted the square shape to create the four-sided palace and cosmos, and thus integrated the vessel's form and construction with its painted scene.

Yet the squared sides are also like pages of a Maya book. The Vase of the 11 Gods is 24 centimeters high and 16.5 centimeters wide, close to the height of the Postclassic books (20.4 to 22.5 centimeters high), and each side is rectangular and taller than wide, comparable to the books. The vessel's ratio of height to width is 3:2, differing from that of the books (about 2:1). But books create different measurement ratios depending on how many pages are open. Regardless, there may have been more diversity in book sizes in the Late Classic period, just as there is more diversity in the extant Central Mexican and Oaxacan codices. The compositions of the vessel's painted sides are also analogous to Postclassic books. Like the books, the panels on the Vase of the 11 Gods are divided into registers, and as in books, the number of registers of images and texts is flexible. On the vessel, however, the registers' dividing lines are parts of the image, appearing as if they are benches or other architectural elements on which the gods are seated.

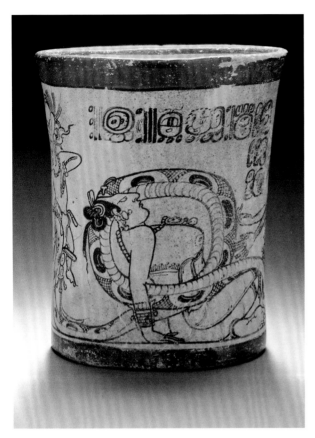

9.7a–b. Codex-style ceramic vessels with *Supernatural Birth Scene*, northern Peten (Guatemala) or southern Campeche (Mexico), 650–800. Los Angeles County Museum of Art, Anonymous Gifts, M.2010.115.3 and M.2010.115.4

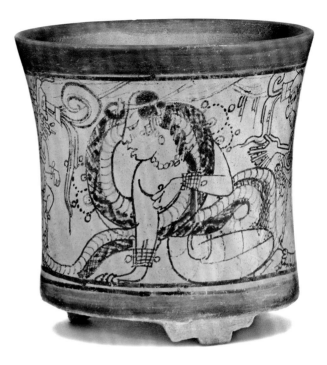

Other comparable features are in the content and color palette. The vessel portrays God L and various solar deities gathered in primordial time. The texts recount this past event, and the vessel's dedication statement refers to the present, naming the owner, a ruler from Naranjo. Maya books also mix temporalities. The color palettes are comparable, too, and the painting sequence is like that of codex-style painting and Post-classic books. Indeed, first applied was a cream slip layer, and then the artist painted black lines for the images and texts and added details in the images in red and black. The last layers of slip were the black and red backgrounds, which were applied around the already-painted images and texts. This application of the background as the last layer is also seen in the Dresden Codex (see fig. 9.3a).

This book-like vessel, then, was painted in a manner similar to the pages of a book, but they are book pages wrapped around a vessel, thereby creating an interesting and important dialogue between painted media. Even more than the

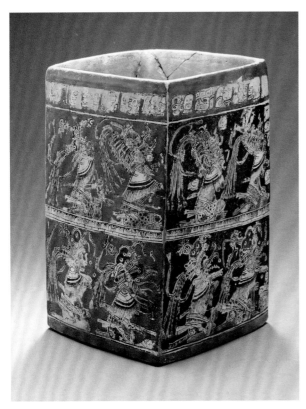

9.8. Vase of the 11 Gods, Naranjo, Guatemala, 755–800. Los Angeles County Museum of Art, Anonymous Gifts, M.2010.115.14

a more elaborate costume.[36] Painted over part of one wall are several layers of numbers and calculations with calendrical and astronomical content also seen in Postclassic codices such as the Dresden Codex. The archaeologists hypothesize that these transcriptions may have been made for—or at the same time as—contemporaneous codices, and that books were made in the same room as the murals. Moreover, because there are three layers of painting, Saturno and colleagues identify this as an "active workspace" for scribes.[37]

Additional evidence for painters working in both media is the discovery of two bark beaters (to make bark paper) and a stucco polisher, strongly indicating paper books were made there, too. Saturno et al. note that Maya production of books and murals would have involved the same materials and techniques: preparation and application of calcium carbonate plaster on a substrate (whether paper or a wall), preparation of mineral and organic colorants, and application of pigments onto the plaster.[38] One bark beater was found in clean floor fill, on the center line. The other was found in Burial 7; the defunct individual held a bark beater and stucco smoother, and Franco Rossi et al. suggest that the deceased was one of the painters who worked in this room and was portrayed in the mural.[39] Moreover, the Xultun example is another case of intermediality, in which books and murals were made and viewed in the same space and had similar content. Although there is no material evidence thus far that Maya painters worked in both book and vessel production, the fact that codex-style vessels emulate books creates an intermedial relationship that has analogies with the excavated workshops where artists worked in multiple media.

The paintings of scribes in the Xultun murals provide another example of the sociality and performativity of Maya artistic production. This joins other lines of evidence from this and other periods indicating that Maya books were produced by multiple individuals working together (seen in the multiple hands of the Postclassic codices) and evidence that multiple individuals consulted books together, for Late Classic images portray two or more individuals pointing to books, and at least one sixteenth-century story recounts multiple scribes or

cylindrical codex-style vessels, this squared vessel emulates not only the color palettes and content of books but also their form. The painter may have even been a manuscript painter, although this hypothesis may not be provable. The vessel's dedication statement clearly names it as a *yuk'ib* (his or her drinking vessel), but it is possible that the vessel images were copied from a book. Regardless, there is an explicit message of intermediality among this vessel and other codex-style vessels and contemporaneous and Postclassic books. The vessels are what survive and give us glimpses into what Late Classic books might have looked like.

William Saturno and colleagues have argued that Late Classic painters worked on both books and murals in the Los Sabios residential complex at Xultun, Guatemala. Painted on the walls of one room is a gathering of seated or kneeling scribes or scribal priests in identical costume, facing a ruler in

priests gathered to consult or bless Maya books. Maya books were thus sites of interactivity and performativity. Yet vessels appear to have been comparably interactive and performative. Indeed, vessels must be turned to reveal the whole image or text, and painted vessels may have been used in rites in which they were passed among gathered individuals, and used either for feasting or storytelling.

Pre-Hispanic books and related media were important tools for interaction and exchange between Maya elites within and between polities, with other cultures, and with the divine. In this way, they are analogous to what is seen in the Post-classic period and in sixteenth-century contexts. However, the Spanish dramatically changed the Maya scribes' relationships to their hieroglyphic books, severing them from their artistic continuity and transforming them into points of conflict as opposed to loci for exchange and understanding.

Attempts at Understanding

Three of the four pre-Hispanic Maya books became publicly known in Europe in the eighteenth and nineteenth centuries; their rediscovery and publication inspired study of them by people throughout the world. The Dresden Codex emerged in a private collection in Vienna in 1739 and was purchased by the Royal Library in Dresden, Germany, and the Paris Codex was found in the Bibliothèque nationale in Paris in the nineteenth century.[40] The Madrid Codex was published in Paris in the nineteenth century as two separate codices, the Troano and Cortesianus, and later identified as belonging to the same document, which Madrid's Museo Arqueológico Nacional purchased.[41] How these codices got to Europe remains a mystery. They may have been taken there in the sixteenth or early seventeenth century, either given as gifts or seized by Spanish friars, as Chuchiak hypothesizes for the Madrid Codex, which he argues was seized in a 1607 extirpation campaign and given to the Spanish Crown.[42] These movements thus also concern intercultural contact and exchange in both Mexico and Europe.

Within a century of their rediscoveries, people across the world used the codices to begin to categorize Maya supernatural entities, figure out numbering and calendrical systems,

and decipher Maya hieroglyphic writing, which enabled reading of the inscriptions in the Postclassic books and on Late Classic vessels, too. Key to the decipherment was the "alphabet" (actually a syllabary) produced by Gaspar Antonio Chi and Diego de Landa (see fig. 9.1), which Yuri Knorozov used together with a facsimile of the Dresden Codex to crack the Maya script.[43] That decipherment has led to renewed reading and writing in Maya hieroglyphs by Maya people in Mexico and Central America as well, such that the use of rescued books helped revive an extinguished writing system and return it to its original users' descendants. Surviving the systematic purge of Maya documents by Spanish clergy in the Yucatán, these dislocated books again have become central to ongoing cultural exchange, which has opened new avenues for understanding within and outside the Maya area, and between present and past.

— Megan E. O'Neil is an assistant professor of art history at Emory University and faculty curator of the art of the Americas at the Michael C. Carlos Museum. She was formerly associate curator of art of the ancient Americas at the Los Angeles County Museum of Art.

1 See Byron Ellsworth Hamann's essay in this volume.
2 Chuchiak 2010, 89–90.
3 Chuchiak 2004a, 165. This is only one of many examples in colonial Yucatán and elsewhere in New Spain. John Chuchiak (2004a, 166–69) discusses multiple cases in sixteenth- and seventeenth-century Yucatán, particularly in extirpation campaigns in which the Church was trying to destroy Maya practices the clergy deemed idolatrous. He also identifies cases of seized codices in the following towns and years: Tikuche and Tahmuy, 1589; Cozumel, 1590; Tixmukul, 1592–93; Peto and Calotmul, 1595; Tzucopo, 1603; Ppole, 1607; Conkal and Baca,
 1607; Chancenote region, 1608; Champoton, 1610; Campeche/Timucuy, 1609–10; Bacalar, 1618; Isla de Cozumel, 1625 (Chuchiak 2004a, 171–75).
4 Chuchiak 2004a, 167–69.
5 Tozzer 1941. Chi may have provided even more information to Landa, and what has been credited as Landa's *Relación de las Cosas de Yucatán* (Tozzer 1941) may have been a collection of manuscripts written not only by Landa but also by his collaborators, including Chi (Restall and Chuchiak 2002).
6 Coe 2012.
7 Vail and Aveni 2004, 13, citing Bricker and Miram 2002.

8 Chuchiak 2004a, 176; Chuchiak 2010, 106.

9 Chuchiak 2004a, 176; Chuchiak 2010, 91, 106.

10 The CMM was acquired by Josué Sáenz, a Mexican art collector (Coe and Kerr 1997, 175), and later donated to the library of the National Museum of Anthropology. It was renamed in 2018 (Piñon 2018).

11 Previous conjecture was that the CMM was from the thirteenth century, but new studies date it to the eleventh or twelfth century. Ruvalcaba et al. 2007; Coe et al. 2015, 118; Solis et al. 2018.

12 Love 1994, 10–11; Vail and Aveni 2004, 13; Vail 2006, 503–4, citing N. Grube 2001, 337; Coe et al. 2015, 118.

13 They include almanacs of cycles of 260 or 365 days or multiples thereof, *k'atuns* of twenty years, and cycles of the planets Venus and Mars, and they include tables to track eclipses and follow solar years, solstices, and equinoxes and celebrate New Year rites (J. E. S. Thompson 1972, 25; Coe and Kerr 1997, 175, 178; Love 1994; Vail 2006, 501). The Madrid Codex also has almanacs devoted to trades like beekeeping, hunting, carving, and painting (Coe and Kerr 1997, 181–82).

14 Coe and Kerr 1997, 178–79; Vail 2006, 503, citing Ciudad Ruiz 2000 and Lacadena 2000.

15 Chuchiak 2004a, 173.

16 Von Hagen 1944, 36–37; Xelhuantzi López et al. 2018. Descriptions of observed processes for preparing this paper, which includes the soaking of the tree branches in water, the removal of the inner bark from the branches, the beating of the bark with stone beaters, and the smoothing of the sheets, can be found in von Hagen 1944, 35–37. In contrast to the Maya bark-paper books, most of the extant pre-Hispanic Central Mexican and Oaxacan books are painted on animal hide.

17 The lengths range from 123.9 centimeters (CMM) to 670 centimeters (Madrid), although the Paris Codex and the CMM are fragments of longer originals. The heights range from 20 centimeters (CMM) to 22.5 centimeters (Madrid) (J. E. S. Thompson 1972, 3–5); Martinez del Campo Lanz 2018, 18.

18 J. E. S. Thompson 1972, 3–5; Coe et al. 2015, 121.

19 For the Dresden, Madrid, and Paris codices, artists used calcium carbonate stucco, but the CMM was covered with gypsum or calcium sulfate plaster, which was used in Central Mexican and Oaxacan codices (Ruvalcaba et al. 2007; Buti et al. 2015, 174–77; Coe et al. 2015, 123). All four codices are stuccoed on both sides, and analyses of the Madrid Codex by Buti et al. (2015, 174) show that the plaster layer was applied to both sides at the same time, before the other painting was begun. The Madrid, Dresden, and Paris codices have painted images and texts on both sides, but the CMM is painted on only one side (Stuart 1994, xvii; Coe and Kerr 1997, 175).

20 Coe and Kerr 1997, 146–49.

21 Buti et al. 2015, 175; Ruvalcaba et al. 2007; Coe et al. 2015, 128. Maya blue is made by mixing and heating indigo with particular clays such as palygorskite (Arnold 2005).

22 Buti et al. 2015, 174–77.

23 Vail and Aveni 2004, 13. The calcium carbonate plaster of the Madrid Codex does not contain magnesium, which is another piece of evidence suggesting a source in the Yucatán (and not the southern lowlands) (Buti et al. 2015, 167).

24 Aveni 2004, 152. Several Central Mexican and Oaxacan codices are partial or full cognates of each other as well, as Boone (2000) and others have observed.

25 Taube and Bade 1991, 13, citing Seler 1898 and Seler 1904; Aveni 2004; Coe et al. 2015, 119. Just (2004) also has observed almanacs in the Madrid Codex that have similarities to *in extenso* format almanacs in the Mixteca-Puebla codices.

26 Taube and Bade 1991, 14, citing Whittaker 1986; Taube and Bade 1991, 18.

27 Taube and Bade 1991, 50.

28 Chase and Chase 1986; Vail and Aveni 2004, 19, citing Milbrath and Peraza Lope 2003.

29 These were found at Uaxactun, San Agustin Aguacastlan, and Nebaj in Guatemala and Altun Ha in Belize (T. Lee 1985, 28, citing J. E. S. Thompson 1960, 23, and Pendergast 1979, 76, fig. 16), but the paper had disintegrated, and the plaster layers were stuck together. Robert Smith (1937, 216–17) noted remnants of a book in a Uaxactun tomb, but they were in terrible condition and could not be read. Carter and Dobereiner (2016) used multispectral imaging to attempt to recover aspects of the images painted on the stucco-painted bark paper codex remnants from Uaxactun, but little of this painting survives.

30 Coe 1978.

31 Hansen, Bishop, and Fahsen 1991; Reents-Budet et al. 2010, 2; Boucher and Palomo 2012.

32 Reents-Budet et al. 2010, 2–5; Garcia Barrios 2011.

33 Reents-Budet et al. 2010, 6–7.

34 Coggins 1975.

35 This research is part of the Maya Vase Research Project at LACMA. See Hirx and O'Neil forthcoming.

36 Saturno et al. 2015, 133; Rossi, Saturno, and Hirst 2015, 117, 133.

37 Saturno et al. 2012; Saturno et al. 2015, 131.

38 Saturno et al. 2015, 125–26, 133. Takeshi Inomata and colleagues uncovered an elite residence at Aguateca, Guatemala, with evidence of artists working in multiple artistic media (Rossi, Saturno, and Hirst 2015, 127, citing Inomata 2001). See also Buti et al. 2015, 177; Rossi, Saturno, and Hirst 2015, 125–26.

39 Rossi, Saturno, and Hirst 2015, 123, 125.

40 Coe and Kerr 1997, 175, 179.

41 Chuchiak 2004b, 57.

42 Chuchiak 2004b, 57, 72; Chuchiak 2006, 113–15.

43 Coe 2012.

Missionary Effects and Messianic Aspirations at the Court of Shah ʿAbbas I

SUSSAN BABAIE

The "renaming" of the famous Crusader Bible—also known as the Morgan Picture Bible or the Maciejowski Bible—to the Shah ʿAbbas Bible reflects the manuscript's pivotal place in representing the art historical turn toward the global, here anchored to the location in the world of the book and that of the world in the book.[1] An extraordinary case study, this medieval picture book is implicated in a network of transmissions and translations. Each of its "reinventions," from Paris (thirteenth century), to Naples (fourteenth century), to Kraków (sixteenth century), to Isfahan (seventeenth century), as we shall see, represents the ways the book was invested with meanings and functions that reached beyond its initial intentions as its audiences, their expectations, and their frames of reference changed.[2] It testifies to the complexity of the condition that is "the world in a book," acquiring other linguistic dimensions or visual, material, and thus cultural homes.

The history of the Shah ʿAbbas Bible is intertwined with missionary activities and diplomatic intrigues between the imperial realms in the Eastern Mediterranean and Western Asia—the Ottomans and the Safavids—and the emergent European empires. In its current fragmentary and dispersed existence in three collections, the book carries within its pages the somatic marks of a "world" experience of an object.[3] While meandering alongside the book on its journey, this essay focuses on two questions: How had the book become "the Shah ʿAbbas Bible," akin to a Persian manuscript, and not a picture book? What can we learn from its reception during its Persian sojourn about the host, the imperial *ketabkhana* (royal atelier-cum-library) and the taste in Safavid (1501–1722) Persia/Iran in pictorial arts? I am also interested in knowing how a magnificent gift such as this pictorial Bible was received. Was it seen as an object to be admired and emulated, and did it solicit interest among Safavid court artists to try their hand at a style of painting unfamiliar in their midst?

The Book, a Description, and a History

The Bible's association with the arts of the Crusader period stems from the fact that it is believed to have been commissioned by King Louis IX of France (r. 1226–70), patron of the Sainte-Chapelle in Paris, who led the disastrous Seventh Crusade in 1249 against the Muslims in Egypt, and who was eventually canonized in 1297—henceforth known as Saint Louis. The picture book, with forty-six of its original forty-eight leaves extant, consists of large parchment folios representing a selection of the Old Testament (Hebrew Bible) books of Genesis, Exodus, Joshua, Judges, and Ruth, and stories about Samuel, Saul, Jonathan, and mostly David (fig. 10.1). In depicting the lives of heroes and kings, villains and victors, the vivid and exquisite images offer examples of the lives of the Israelites and of models of kingship. In both the style—associated with the prevailing French Gothic painting in the middle of the thirteenth century—and in religio-cultural attitude—mainly of a Christian view of the Hebrew Bible—the book represents an extraordinarily rich example in an age marked by its unbounded relish of Christian-themed luxurious manuscripts.[4] The book depends entirely on its pictorial program to convey the Old Testament stories, hence it is an unusually text-free picture Bible.

The picture Bible found its way, possibly through gifting, into a fourteenth-century Italian scriptorium, probably in Naples, where Latin descriptions approximating the depicted scenes were added in gold letters to the wider top and bottom margins of the folios.[5] It bears an inscription in Latin on the verso of its folio 1, where the book's presence in Kraków in

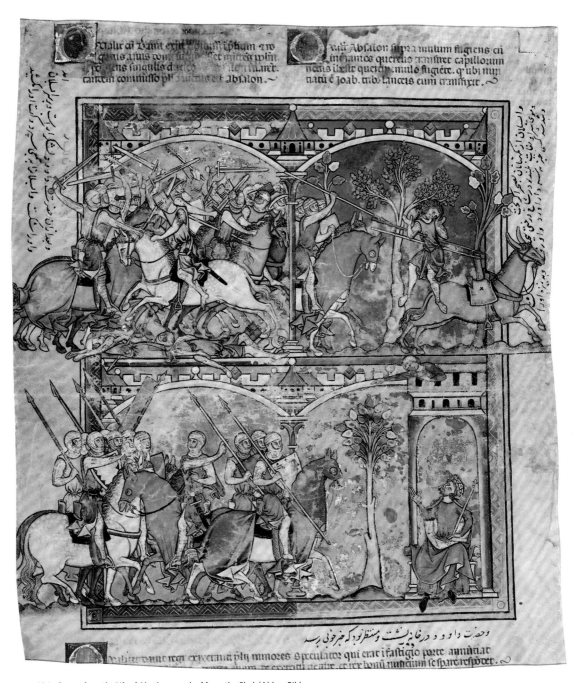

10.1. *Scenes from the Life of Absalom* on a leaf from the Shah ʿAbbas Bible, northern France (Paris), 1240s–1250. Los Angeles, The J. Paul Getty Museum, Ms. Ludwig I 6 (83.MA.55) verso

1604 is recorded. Subsequent Persian interventions appear in the narrower margins on the sides of the folios (Persian language in Arabic script as it was written in the post-Islamic period). These emendations, records indicate, were introduced into the book immediately after the arrival of the Bible in Isfahan and its reception at the court of Shah ʿAbbas the Great (1571–1629). Still later, text in Judeo-Persian (a dialect of the Jewish community of Iran that is recognizably Persian but written in Hebrew letters) was added, probably in or after 1722, according to Dr. Vera Moreen, around the time of the Afghan sack of Isfahan.[6] It next landed in the library of Sir Thomas Phillipps, Bt. (1792–1872), through its purchase at a Sotheby's auction in Paris in 1833, after which it entered late in the nineteenth century into the manuscript collection of Pierpont Morgan, becoming one of the most magnificent items in the Morgan Library in New York.[7]

Becoming the Shah ʿAbbas Bible

On January 3, 1608, Shah ʿAbbas granted an audience to the first missionaries of the Discalced Carmelite Order sent by Pope Clement VIII (r. 1592–1605) to Safavid Persia.[8] There is some uncertainty about where exactly the audience took place—at a pavilion in the royal district of the Daulatkhana (Royal Palace) of Naqsh-e Jahan in Isfahan, or at a suburban palace.[9] In any case, the group, consisting of Paulus Simon a Jesu Maria (vicar of the order in Naples), Joannes Thaddeus a S. Elisaeo (a Spaniard, afterward bishop of Isfahan), and Vincentius a S. Francisco, joined by a Spanish soldier and a lay brother, presented their impressive array of gifts, an event that was recorded in Carmelite sources with considerable interest, although tracing it in the Persian chronicles has proved rather difficult.[10] The Carmelites bore gifts that were neither from Pope Clement VIII, who blessed the initial mission in 1604, nor from his successor, Pope Paul V (r. 1605–21). Rather, they were collected, together with letters, from eminent persons the friars visited en route. Cinzio Aldobrandini (1551–1610), the cardinal of San Giorgio in Velabro and a relative of Clement VIII, sent them off with a book of the Gospels and a Euclid written in Arabic.[11] As we shall see further, it was the Polish

cardinal Maciejowski (1548–1608), the bishop of Kraków, who was the source for the picture Bible. Other gifts, including two pictorial tapestries, a rock crystal vase embellished with gold and emeralds, a cross of Bohemian rock crystal with emeralds supporting a relief statue of the crucified Christ in gold, and a keg of Russian vodka, remain anonymous but may have their source at the courts of no less than the emperor Rudolf II (r. 1576–1612), who received the friars in Prague, King Sigismund III of Poland (r. 1587–1632), who offered the mission substantial donations, or any of the dignitaries they met in Russia.[12]

The Shah ʿAbbas Bible holds great interest for medieval manuscript scholars. But an obvious and very compelling facet of this book's study is its location within the matrix of gifting, and the politics and economy of gift exchange, about which recent scholarship has made important contributions, including some especially important studies related to Ottoman, Safavid, and Mughal exchanges with Europe in the early modern period.[13] Earlier in 1605, Persian ambassador Mehdi Quli Beg (d. 1618) had attended the wedding ceremonies of King Sigismund III in Kraków, and his retinue must have carried gifts appropriate for the stately occasion.[14] And in 1608, the year the picture Bible arrived in Iran, the famous Englishman Sir Robert Shirley (ca. 1581–1628) was sent by Shah ʿAbbas as his envoy to negotiate potential alliances with King James I and other European courts against the common enemy, the Ottomans. Again, it would have been unimaginable to dispatch such an important embassy without considerable gifts. My focus here, however, remains on the way the book as a physical object may have exerted its charisma in that charged diplomatic context: How might that "effect" be teased out of the book itself and the records surrounding its arrival and presence?

The Polish cardinal's role, though widely recognized to be significant, has attracted little scholarly attention. This is perhaps understandable given the linguistic barriers, but a recent search through Polish-language publications and Polish archives in Kraków and Warsaw yielded much less than expected either in scholarly interest or in available archival

material.[15] Nevertheless, bits and pieces of evidence will assist here to draw up a picture of the centrality of Maciejowski to papal goals and indeed its echoes in Safavid Persia. An inscription in Latin on folio 1 recto bears the following: "Bernard Maciejowski, Cardinal Priest of the Holy Roman Church, Bishop of Kraków, Duke of Siewierz, and Senator of the Kingdom of Poland with sincere wishes offers this gift to the supreme King of the Persians at Kraków the mother city of the kingdom of Poland on the seventh of September 1604."[16]

The Carmelite reports relay that the shah, after having admired the pictures, charged a *mulla*—a religious scholar in Safavid time and not as banal a designation as it has become in contemporary Iran—"to write on each page of this book of miniatures in the Persian language what they represented: and, so that he might do it the more correctly, to refer to the Carmelites."[17] From the point of view of the shah and his court, the Old Testament stories would be recognizable to a Muslim audience because the images were legible through their Quranic knowledge about the same prophets. Such a basic understanding of the text-image would have mediated the book's reception in a place and time when an interest in Christianity had prompted translations of the Bible under Shah ʿAbbas.[18]

So how does the text-image discourse work in this case? At least two versions of the record of this mission have been preserved in Carmelite documents.[19] In both versions, the beautifully wrought crucified Christ on the cross is singled out to have pleased the shah greatly, a preference that may reflect the friars' own partial view more than the shah's admiration. The picture Bible is said to have fascinated the shah when, according to one version, he accidentally opened the book at the page "where the combat between the good angels and the bad angels is related." Although it is hard to believe that the book opened accidentally to its first page, it is reasonable to assume that the shah was looking at folio 1 recto and the image of the first day of Creation (the opening of the Book of Genesis) (fig. 10.2).

But as one reads on in the Carmelite reports, a different impression begins to emerge. The exchange continues: "When he saw the dragon vanquished and prostrate at the feet of St. Michael, who was brandishing his sword, threatening the Devil, the king inquired: 'Who is that vanquished at the feet of the angel?' Fr. Paul replied: 'This is the fallen angel, whom we call the Devil.' 'No,' said the Shah, laughing much, 'this is the Turk.'"[20] The Saint Michael reference may actually have been to another image altogether, because in the other version of the report, the shah, when shown the Gospels from Cardinal Cinzio, is said to have inquired: "I had asked from him a picture of Michael the Archangel treading a horrible monster underfoot." When this (presumably an image of Saint Michael) was shown to the shah, he pretended not to know who the "loathly beast" was, and when the Father informed him that it was the Devil, the shah said, "I quite thought it was the Turk!" The image of a saintly figure about to vanquish a demonic creature carried very specific associations for Shah ʿAbbas. The Italian traveler Pietro della Valle (1586–1652) reports a 1617 encounter during which Shah ʿAbbas explained to him the Safavid version of Shiʿa belief in which the imam ʿAli is equated with Saint George.[21] Such shared spiritual genealogies were particularly meaningful to a Shiʿa-Catholic discourse, with its millenarian expectations in the face of the common experience of the Ottoman threat. When Shah ʾIsmaʿil (r. 1501–24), the founder of the Safavid dynasty, rose to power in 1501, his *khoruj* (exit from spiritual hiding) was viewed by the Europeans as much as that of the messiah/*mahdi* by his followers. In the gloom of the later fifteenth century, the emergence of the promise of restoration was found not in Christendom but in Shiʿa Safavid Iran.

Ambassadorial exchanges between Safavid Iran and Venice, Rome, and other Italian city-states produced no tangible political results in forging an alliance against the Ottomans. But one facet of such exchanges was the impression given in Europe mainly by imposters and opportunists such as the trader Asad Beg (d. 1620 or 1631–32), who came to Venice in 1601 following the Englishman Anthony Shirley (1565–1635) (an ambassador of Shah ʿAbbas), who implied in his message to the bishop that Shah ʿAbbas was inclined toward Christianity.[22] Asad Beg, evidently, went as far as asking for letters from the pope to be addressed to the shah's Christian wife.

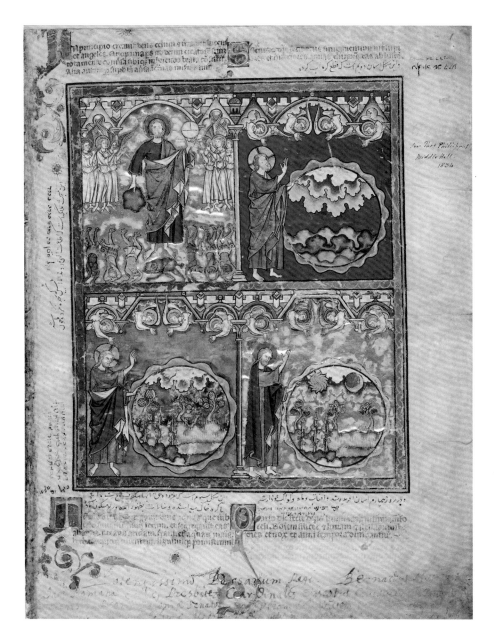

10.2. *The First Day; The Second Day; The Third Day; The Fourth Day* in the Shah ʿAbbas Bible: northern France (Paris), 1240s–1250. New York, The Morgan Library & Museum, Purchased by J. P. Morgan (1867–1943) in 1916, MS. M.638, fol. 1r

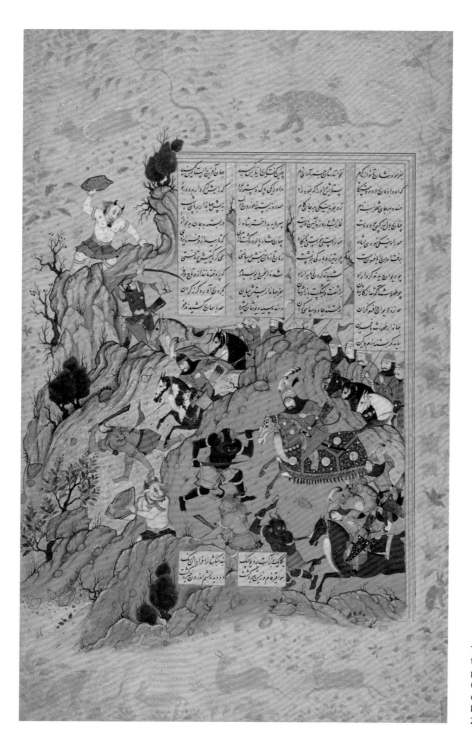

10.3. *Tahmuras Defeating the Divs* from a *Shahnama* (Book of Kings), probably for Shah ʿAbbas I, Iran (Safavid period), late sixteenth century CE / tenth century AH. Dublin, Chester Beatty Library, Per 277.17

Cinzio Aldobrandini, who had dispatched the book of Gospels and an Arabic Euclid with the Carmelites, was a nephew of Pope Clement VIII, the cardinal of San Giorgio in Velabro, and in charge of negotiations with Iran. Indeed, the missions from Italy sent to Safavid Iran during the period between 1600 and 1608 were energized by wishful potential for an anti-Ottoman alliance with the shah. As Safavid historian Rudolph Matthee has shown, however, the Safavid side was entirely driven by pragmatic calculations of what such an alliance would produce, or whether it was worth further complicating a precarious peace with the Ottomans.[23]

My recent research into the Polish side of the exchange, carried out with the help of Mateusz Kłagisz, shows that Maciejowski was deeply involved with the papal agendas and missionary activities dispatched from Rome.[24] There is evidence that the bishop of Kraków had commissioned specific objects for destinations as far east as Japan. That part of my research is still unfolding, but what appears to be a more likely scenario of intentions and of reception surrounding this gift is embedded in the religious significance of the Bible and not necessarily or primarily its pictorial interest.

The reception at the Safavid court of a book as magnificent as this picture Bible demands some probing. Marianna Shreve Simpson has already made a compelling argument for the fact that the book and its pictures would have been familiar to the shah and his court. Accordingly, the biblical pictures may be situated within a visual cultural environment where they would have been recognizable for their luxurious materials—namely the pigments, gold, and ink, but not the parchment, which was never used beyond an occasional example in books in greater Iran and had been out of use in nearly all of Islamicate lands since the tenth century. They would also have been attractive for their subject matter and details depicted in battle scenes, carnage, bedroom trysts, and so forth (fig. 10.3). And, indeed, they could have resonated with the Safavids by virtue of the presence of that same critical mass of European art and artists in seventeenth-century Isfahan. Paintings of biblical scenes such as the return from the flight into Egypt, Lamentation over the dead body of Christ,

and the Virgin and Child with Saint John the Baptist, among others, testify to this practice whereby many a European model was interpreted or translated by the court painters or else inspired the Europeanizing style of the works produced at the *ketabkhana*.[25]

European arts, ranging from single-sheet prints to printed books, tapestries, portraits, pictures on panels and canvas, sacred objects, and *objets de luxe* (luxury objects), including mirrors, clocks, and other curiosities, were generally sought after, pointedly ordered by the court and the urban elite, and were available in the marketplace of Isfahan.[26] An example of precisely that sort of fascination with European prints and their pictorial strategies of modeling and perspective, for instance, is found in the delicate tinted drawing of a kneeling youth, a single-sheet work that was intended for an album made often by sought-after artists for people outside the court circle or wealthy individuals who saw prestige in such personal collecting practices (fig. 10.4).[27] And it is well known that European artists, mostly of lesser talent than their kin back home, found employment at the Safavid court.

Other methods of transculturation through seeing, repeating, reinterpreting, and reinventing may be found in the transmission of a particularly popular image. The reclining Venus by Raphael (1483–1520), made popular through a printed version by Marcantonio Raimondi (1480–1534), reached Safavid Isfahan, where its presence at the court workshop is confirmed by the existence of multiple inventive Persian versions by or attributed to the great artist Ali Reza ʿAbbasi (1565–1635); these are datable from the 1590s to well into the second decade of the seventeenth century and are contemporary with the Bible's arrival.[28] Yet again, no traces of the French picture book are found in Persian pictorial arts, while a great many European prints inspired Armenian artists of New Julfa or artists at the Safavid court and in Isfahan to think afresh their own ways of picturing the world around them.[29]

The question then remains as to why there are no visual traces of the picture Bible's life—of more than one hundred years—in Isfahan and in Persian painting. And, as I shall suggest here, the absence of any such traces—at least as

10.4. *A Young Man Holding a Cup,* Persian drawing signed by Mu'in Musavvir (1638–1697), mounted on an album page, Iran, Isfahan, ca. 1650 / AH 1060. Toronto, The Aga Khan Museum, AKM 441

Simpson's and my research can attest thus far—must mean something. Scholarship too often assumes that such a great pictorial program and richly decorated book would have "naturally" solicited some reaction; after all, the book contains vivid evidence of some of the greatest medieval European painting styles and thus, we might assume, is so powerful as to be irresistible! As the argument presented above suggests, I remain convinced that this magnificent collection of images left absolutely no trace of its presence in the cosmopolitan seventeenth-century capital of the Safavids, when pictorial arts were indeed prolifically produced and when artists were familiar with and

increasingly appear to have harbored a fascination for Europe and European arts as well.[30]

Despite such routes of approach as digestibility or familiarity for acculturation of new subjects and styles, and indeed good evidence for artistic interest, the book appears to have spent much if not all of its time in Iran gathering dust on some shelf. Whether the shelf in question was in a Muslim environment or a Jewish one, it appears nearly certain that no visual trace is to be found in the arts in Iran. Alternatively, it may be argued that the visual anonymity of the Bible in Safavid Iran was due to its early dispatch to the Qal'a Tabarrok, the citadel

in Isfahan that served as a storage house for much of the royal treasures, including the most precious diplomatic gifts. On the other hand, books and works on paper, regardless of their place of origin, seem to have all ended up at the *ketabkhana* on the grounds of the Daulatkhana.

Although not all possible scenarios have yet been exhausted, the elimination of most barriers that would hinder a court painter's encounter with the Bible suggests another possible solution. The artistic rejection of the picture Bible was not a rejection of either the European style or its biblical theme. Rather, the reaction was, at best, a lukewarm reception of an old-fashioned style. The high esteem in which the book was received is attested to by the friars themselves and by the command that the Persian descriptions be added. But beyond that, the Bible must have been recognized for what it was: an old book.

Persian chronicles of the time seem to have been indifferent to the mission or its gifts, for reasons that may well be logical; the emissaries were perhaps taken to be low-level Christian monks. But one may reasonably argue that the reception of the picture Bible at the Safavid court was indeed enthusiastic, as can be gleaned from ample internal evidence on the book itself—not to mention what the Carmelites reported. Be that as it may, I am convinced that problematizing an absence is as valuable an analytical strategy as searching for the traces of visual impact, and given the disparity between enthusiasm shown at the time of the receipt of the gift, the addition of text emendations, and the survival of the book in Safavid Iran until the dynasty's demise, a different argument may be advanced that sees the book through the lens of political exigencies of the time and the particular meanings it may have acquired in light of the papal mission. My point here then is not about the expectation of positive effects in visual terms of the book's presence, but about how the book may have been redirected, not lost, in translation, to carry a different kind of weight.

The fourteenth-century Latin captions in Bolognese style added in the court of Naples, possibly made by a scribe trained in Bologna, had the effect of narrativizing the images, making it, from a Persian point of view, a "real" book. In other words, it became an illustrated manuscript and not just an assembly of images. There was of course a perfectly comparable medium, the album format, to make the picture book digestible, even without the text. As such, the picture Bible, containing texts and images of the Old Testament prophets, was a recognizable genre in Persian arts; for instance, the *Qisas-al-anbiya* (Stories of the Prophets) was a familiar text, existing in illustrated versions.[31] And again, the local Persian attitude toward the object as a book is discernible from the very fact of the emendations in Persian to the Latin texts.

To return to the pictorial once again, and to the "misidentification" of the painting on folio 1 recto, noted above. While clearly the image is not of Saint Michael (there is no other painting in this book that resembles such a theme, either), the likening of the Devil to the Turk was a meaningful interjection, striking an agreeable chord for the Carmelite friars while also being a Safavid expression of their bitter rivalry. It was furthermore timely in the context of that particular audience, for it is also reported that the shah turned his head when he uttered those words, looking mockingly at the two Turkish pashas present at the reception.[32] Beyond jest, however, the import of this cunning use of an image was that it provided the shah with a subtle means to relate his recently accomplished victories against the Ottomans—that is, his reconquest of a large portion of the Caucasus (Azerbaijan, Nakhjevan, Yerevan, Shirvan, and Georgia), of which victories the pope and other rulers were fully aware, and for which they had congratulated the shah in letters brought by this same mission.[33]

There is also the appropriateness of the image to be considered. In the Bible, it is the Lord Himself who stands on the crouched Devil. While the Turk may be equated with the Devil, the parallels between the Lord and the shah would not have been permissible. We may assume an image of the archangel among the gifts, or better yet one of Saint George, but given the fact that the book was opened to the page "where the combat between the good angels and the bad angels is related," it is more likely that the reference to Saint Michael was brought up additionally to provide a more appropriate

thematic comparison, for the sword-brandishing saint made a more suitable prototype for the victorious shah, especially if he understood Michael and George to be archetypal heroes like ʿAli.

While those hypothetical scenarios and discussions may remain just that, it is worth remembering that papal interest in Safavid Persia pursued a double wishful agenda: to convert the shah, and to forge a military alliance against the Turks. As in Marcel Mauss's classic theory of gift exchange, gifting ceremonies such as those at the royal audience in Isfahan played a foundational role in forging relationships between the court and the Church. The Church gifts served as a significant conduit for promoting that wished-for but never-materialized military alliance, but they also facilitated trade opportunities and cemented privileged protections for the performance of missionary agendas. The clustering of such agendas under the umbrella of the papacy at such a transregional level of coordination represents the urgency of the collective interest on the European side. On the Persian side, the mission and its implementation through gift exchange carried a different set of priorities. Despite important recent research on the subject of gifts, the qualitative difference between gifts from the center of Christendom and those from other Europeans has rarely been noted. The Persian court and its patronized religious elite, the *ulema*, were keenly aware of the differences in potential value between those sent from the papacy (*papan*) and those representing mercantile and royal interests: the Dutch East India Company or the Dukes of Holstein or Muscovy. This sort of qualitative difference can be gleaned from visual and textual Persian sources.

It is then central to this argument to note that the shah had repeatedly asked the Carmelite friars whether any of the gifts were from the pope, and he was told that they were not;[34] the report's very mention of this exchange seems to indicate a note of disappointment on the part of the shah. From the Safavid point of view, and even though the Bible was a gift from the bishop of Kraków, it was sent, as the shah wished it to have been, from the pope himself, and it would have instantiated a different kind of response. It is in searching for

the book as a book, and especially as a religious book, a story of the Prophets genre, that the gift mattered. As such, and not because of the European style of the images, the book could acquire cultural meaning. It seems to me also that the order to add Persian translations of the Latin text cast the book as a proper gift of a proper religious book from the center of Catholicism to the center of Shiʿa Islam, drawing parallels and highlighting familial links between the two faiths in contra-distinction to the Sunni-Caliphal model of Islam practiced by the Ottomans. In attempting to locate the Bible within a book culture at the Persian court, it may be possible to offer a different reading of the European images that reached Safavid Persia, one that may lift the burden of having to constantly isolate their "influence" in pictorial terms.

— Sussan Babaie is Andrew W. Mellon Reader in the Arts of Iran and Islam at the Courtauld Institute of Art.

This essay has gone through several iterations, but was never committed to print until now, and for that I am grateful to Bryan C. Keene and his colleagues at the Getty Museum for inviting me to join this venture. I also want to thank the Getty Research Institute for hosting me while I finished the final stages of my research during April 2016. The initiative for this research comes from Dr. Vera Basch Moreen, who invited me to contribute to the companion volume of the facsimile (D. Weiss 1999). To her I owe a debt of gratitude for introducing me to this magnificent object and for teaching me so much about the Jewish communities of medieval and early modern Isfahan and about the Judeo-Persian literary world. The fruits of that research, which was focused on the emendations in Persian and Judeo-Persian, were presented in a joint paper at the

conference of the Middle East Studies Association (MESA) in Washington, DC, on November 22, 1999; see Simpson 2002, 120–41. I have greatly benefited from discussions about this project with Dr. Marianna Shreve Simpson, to whom I wish to dedicate this article in thanks for her intellectual generosity and her unwavering support and friendship.

1 Cockerell 1969, 5–21; D. Weiss 1999. Note that I rely for the information about the book's making and life until Kraków on these publications. See also Taylor 1995, 25. The website of the Pierpont Morgan Library provides concise and accessible information on the book, its patronage, provenance, and conservation issues, as well as digital images and information on all forty-three folios in the collection: https://www.themorgan.org/collection/Crusader-Bible.

2 The provenance of the book is most easily accessed at https://www.themorgan.org/collection/crusader-bible/provenance.

3 The folios are distributed as follows: forty-three are in the Morgan Library (MS M.638); two (fols. 43 and 44) are in the Bibliothèque nationale de France, Paris (MS. Nouv. Acq. Lat. 2294); one (fol. 45) is in the J. Paul Getty Museum, Los Angeles (83.MA.55); and two are missing.

4 In a sea of scholarship on the subject, here two especially relevant books will suffice: Voelkle and L'Engle 1998; McKendrick and Doyle 2016.

5 Cockerell 1969, 6; D. Weiss 1999, 226, where he suggests that the Latin is in Bolognese style.

6 Moreen 1999, 149 (English version 353); also see diverse text additions in Latin (91–120, English version 299–326), Persian (121–48, English version 327–52), and Judeo-Persian (149–74, English version 353–76) in this companion volume. On the devastating sack of Isfahan, see Floor 1998; Babaie 2008, 267–73.

7 Rogers 2012, http://www.iranicaonline.org/articles/great-britain-xi; see also the Morgan website for provenance, https://www.themorgan.org/collection/Crusader-Bible.

8 Cockerell 1969, 11; see also Chick 2012. Persian historians did not always record exact details of ambassadorial arrivals, but, for instance, Mahmud Natanzi recorded one in 1604 (Natanzi Afushte 1366/1987, 555).

9 For the *Daulatkhana*, see Babaie 2008, 113–43. According to Cockerell (1927), whose study was the first important consideration of the book's journey, the shah was inspecting horses at the royal stables in one of the suburban palaces in Isfahan when he received the mission in audience; Chick 2012, 122–23. For the 1608 movements of Shah 'Abbas, see Babaie 1994, 237; Simpson 2002, 120–41.

10 Cockerell 1969, 9.

11 Cardinal of San Giorgio, elected 1592, died 1610; see Cockerell 1969, 9 and fn. 14.

12 Note the different versions of the items collected and presented as told in Isidorus a S. Joseph and Petro a S. Andrea 1668 and 1671; Chick 2012; del Niño Jesús 1929. For letters from these rulers and others as well as the list of gifts, see Cockerell 1969, 12; Chick 2012, 123–24. Also see Simpson 2011, 125–39; Simpson 2002, 120–41.

13 Simpson has dedicated three major studies to diplomatic gifts to Shah 'Abbas I: 2005, 141–50; 2011, 125–31; and 2017, 951–71. Also see Uluç 2011, 144–47.

14 Matthee 2013, 27.

15 I am grateful to Mateusz M. Kłagisz, a PhD candidate in the Department of Iranian Studies, Institute of Oriental Studies, Jagiellonian University, Kraków, who served as my research agent ("assistant" seems inadequate here) during several months in 2016.

16 D. Weiss 1999, 227.

17 Chick 2012, 124n2; del Niño Jesús 1929, 117.

18 For Persian translations of the Bible commissioned by Shah 'Abbas, see Thomas and Aghbar 2015. For the increasing interest in Christianity and the religious debate that ensued, see Jafarian 1370/1991, 301–13; Babaie 2009, 129–30.

19 Chick 2012, 124; Cockerell 1969, 13. But also note that with regard to the reaction to the Bible, the chronicle footnotes a passage that is different from the one in Cockerell, so there must be more than two versions. Chick 2012, 124n2, quoting del Niño Jesús 1929, 117.

20 Chick 2012, 124n2.

21 della Valle 1989, 165–66. And on Shi'a and messianic expectations, see Babayan 2003.

22 For the contacts, see Matthee 2013, 6–39.

23 Matthee 2017, 551.

24 On Maciejowski and his collection and patronage, see Obłąk 2008. On a tablet commissioned by the Bishop of Kraków in Rome to be sent to Japan, see Malicka 2010, 60–62.

25 *The Return from the Flight into Egypt*, signed by Muhammad Zaman, 1689, Iran, Harvard Art Museums, 1966.6, https://www.harvardartmuseums.org/art/216250; *Lamentation over the Dead Body of Christ* is by Ali Reza 'Abbasi after a Perugino, early seventeenth century, Iran, Freer Gallery of Art and Arthur M. Sackler Gallery, F1953.61, https://www.freersackler.si.edu/object/lamentation-over-the-dead-body-of-christ/. *The Virgin and Child with Saint John the Baptist* is also signed by Muhammad Zaman and dated 1682–83 and is in the Asian Civilizations Museum, Singapore.

26 Taylor 1995.

27 Farhad 1987; Farhad 2018, 114–38.

28 Babaie 2009, 105–36.

29 Judeo-Persian illustrated manuscripts of the period are also totally ignorant of the Bible; see Fathnama in the British Library (Or 13704) and *Ilana Tahan*, "A Judeo-Persian Epic, the Fath Nama (Book of Conquest)," September 27, 2017, http://blogs.bl.uk/asian-and-african/2017/09/a-judeo-persian-epic-the-fath-nama-book-of-conquest.html.

30 On European arts in Safavid Isfahan, see Canby 1996, 46–59; Landau 2007; Landau 2011, 101–31; Langer 2013.

31 For examples of *qisas*, see Milstein, Rührdanz, and Schmitz 1999.

32 Chick 2012, 124n2, quoting del Niño Jesús 1929, 117.

33 Cockerell 1969, 12; Chick 2012, 123–24.

34 Cockerell 1969, 13.

11

Reproducing the Resurrection: From European Prints to Armenian Manuscripts

SYLVIE L. MERIAN

The Resurrection of Jesus Christ on the third day after his Crucifixion is one of the central tenets of Christianity, reported in all four Gospels with slight variations. It is not surprising that artists should have desired to depict this amazing and miraculous event throughout the centuries, in media such as manuscript illuminations, wall paintings, and sculpture. This short study briefly summarizes the iconography of the Resurrection in Christian art, presents a major change that occurred in the depiction of this event by Armenian artists, and explains how this change came about.[1]

The most familiar Resurrection iconography, consisting of Christ emerging from or floating above his tomb in some fashion, first appeared in Western Europe in the eleventh century, and in the Christian East in the seventeenth century. Previously in both regions the Resurrection was represented indirectly, by depictions of the Holy Women at the Tomb, the Harrowing of Hell (also known as the Descent into Limbo), or both. These earlier versions probably resulted from the lack of a description in the Gospel texts, since Christ's emergence from the tomb was never actually witnessed.

All four Gospels relate some version of the story of the women who visit the tomb on the third day to anoint Christ's body with spices and oils. The number of women, angels, and/or guards who are present varies, as the Gospels differ in these and other details.[2] Upon their arrival, the women discover that the tomb has already been opened and one or two angels (depending on the Gospel followed) announce that he is gone: Christ has been raised. In Armenian manuscript illuminations, images of the Women at the Tomb are sometimes even labeled "Resurrection of Christ" or "Resurrection of the Lord," indicating that this symbolism was clearly the intent of the artist.[3] One of the earliest extant Armenian miniatures depicting the Holy Women at the Tomb is found in the mid-eleventh-century Gospels of King Gagik, where four women stand before the tomb, two holding long-necked vessels, as a seated angel points to the shroud in the empty tomb.[4] There

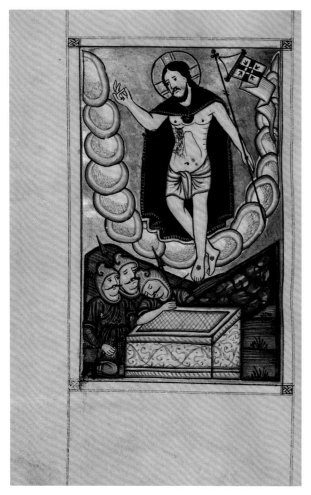

11.1. *The Resurrection* in an Armenian hymnal, Constantinople, 1678. Baltimore, The Walters Art Museum, MS W.547, fol. 118v

are innumerable examples in Armenian manuscripts produced up to the seventeenth century that may illustrate combinations of episodes from the accounts in the Gospels.[5] There is usually an angel pointing to the empty shroud; the number of women may vary; and there might or might not be depictions of the guards. Occasionally the illumination includes a figure of Christ, which may reference the Gospel of John, in which Christ appears at the tomb to Mary Magdalene, who initially does not recognize him (John 20:1–18).[6]

In the Greek tradition, Christ's Resurrection was symbolically represented by an image variously called the Harrowing of Hell, the Descent into Limbo, or the Anastasis ("Resurrection" in Greek).[7] This narrative does not appear in the Gospels and is only alluded to in other books of the New Testament, but it is described in the fourth- to fifth-century Apocryphal Gospel of Nicodemus.[8] It was believed that after his death but before he was raised, Christ descended into Hell (or Limbo, the "border" of Hell) to crush Satan and liberate the souls of the righteous,[9] and he is usually shown standing on the broken-down door of Hell, grabbing Adam by the wrist to set him free. This composition indirectly symbolized not only the raising of Christ but also the raising of Adam, and thereby all humankind through Christ's ultimate sacrifice. Quite often both the Harrowing of Hell and the Women at the Tomb are included in a single Armenian manuscript, frequently facing each other.[10]

Although the Descent into Limbo and the Women at the Tomb were also common in early Western European manuscripts, around the eleventh century another iconography developed. Western European artists began representing Christ's Resurrection by depicting him actually emerging from the tomb in some fashion, usually holding a cross and banner: he may be shown halfway out of the tomb, with only his torso visible, or more actively stepping out of the tomb, or, later on, floating above the tomb.[11] This third variation appeared in many fifteenth-century Italian paintings and frescoes, such as Fra Angelico's fresco of 1440 in the Convent of San Marco in Florence, in which Christ floats overhead within a mandorla and holds the banner of the Resurrection, while below an angel, Saint Dominic, and five women surround the tomb.[12] In Giovanni Bellini's *Resurrection* of 1475, Christ hovers over the tomb, clad in a billowing loincloth and holding a banner, as two guards sleep and two others look up in amazement.[13]

By contrast, in the Armenian tradition, at the beginning of the seventeenth century we observe a different iconography in manuscript illuminations of Christ's Resurrection (although the Women at the Tomb and the Harrowing of Hell are still found). At this time Armenian manuscript artists began to depict Christ standing on the tomb or floating above it, usually surrounded by a half-circle of clouds, along with angels and/or guards (fig. 11.1). By the second half of the seventeenth century, this iconography

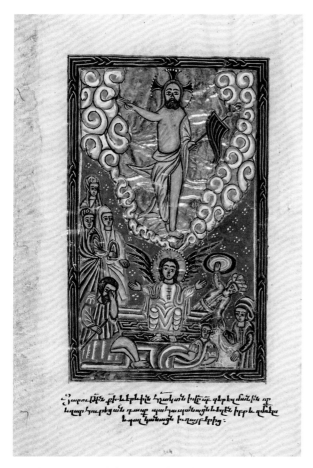

11.2. *The Resurrection with the Women at the Tomb* in a Gospel book, Mesrop of Khizan, New Julfa (Isfahan), Iran, 1609. Oxford, Bodleian Library, MS Arm. d. 13, fol. 17v

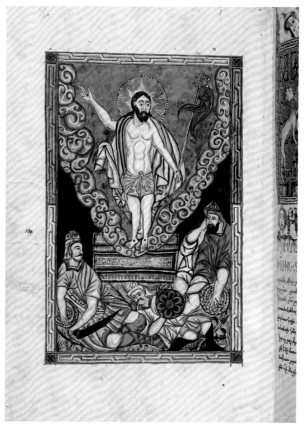

11.3. *The Resurrection* in a lectionary, Mrktich' varpet and his student Tēr Petros, New Julfa (Isfahan), Iran, 1631. Oxford, Bodleian Library, MS Arm. c. 1, fol. 151v

had become very popular among artists throughout Armenia and the Armenian diaspora, although the Women at the Tomb and the Descent into Limbo never completely disappear. So far, the two earliest Armenian manuscript examples I have found of this new expression date from 1609 and 1631; both were produced in New Julfa, Iran, a wealthy Armenian suburb of Isfahan, the capital of the Safavid Empire (figs. 11.2, 11.3).[14]

Why did the Armenian artistic tradition of expressing the Resurrection indirectly change to a more direct approach in the seventeenth century? Where did this iconography come from? It is highly unlikely that any seventeenth-century Armenian priests, scribes, or manuscript artists in the Near East would have had an opportunity to examine Italian frescoes or

panel paintings or German medieval manuscripts. How were they exposed to the new iconography?

The advent of printing in mid-fifteenth-century Europe provides the answer. Illustrations of Resurrections with Christ emerging from the tomb in some form abound in European printed books from the fifteenth century onward and were reproduced repeatedly as woodcuts, engravings, and etchings as well as in paintings, frescoes, and ceramics. Individual prints and illustrated printed books were portable and easily transportable, and they made their way all over Europe and also to the Near East through trade, diplomatic gifts, and Catholic missionaries. It is significant that the two earliest known Armenian manuscripts with Resurrection scenes were produced in New

Julfa. This town was founded as a result of policies Shah ʿAbbas I (1571–1629) instigated during the protracted wars with the Ottoman Empire. He forcibly deported Armenians from the various towns and villages in Nakhichevan that had been conquered by his empire, practicing a scorched-earth policy: destroying the towns to prevent their former inhabitants from returning and leaving nothing for the invading Ottomans. New Julfa, named after their former town (Julfa), was established after the deportations of 1604. Many Armenians from this region were extremely affluent merchants who had accumulated wealth through the silk trade with Europe, and this wealth became even more vast throughout the seventeenth century after their relocation. The community developed close ties with Europe through this trade, and their factors certainly brought all types of European goods back to Iran.

The connections become evident when one compares Western European prints (woodcuts, engravings, etchings) of Resurrection scenes with corresponding illuminations in Armenian manuscripts, although the sheer number of prints produced makes it difficult to identify which ones could have been the precise sources for the Armenians. The task is made even more complicated because European artists often copied one another. For example, it is well known that due to Albrecht Dürer's immense fame in Europe, his works were directly copied by other artists in many different media, including ceramic plates, enamels, and paintings.[15] These copies were also widely disseminated and inspired even more artists. The *Resurrection* from Dürer's *Small Passion* of 1509–10 was clearly the direct model for a French plaque of enamel and gold on copper produced about fifty years later by Pierre Veyrier II (active ca. 1528–58).[16] In the sixteenth century, Dürer's printed images were even copied into manuscripts that were still being produced in Europe during this period when manuscripts and printed books coexisted. The underdrawing of an unfinished *Resurrection* in a Morgan Library manuscript—a diurnal of the mid- to late sixteenth century from Pisa, Italy—was directly copied from Dürer's woodcut of the *Resurrection* in his *Great Passion* of 1510.[17] It is doubtful, however, that Armenians in the Near East had direct access to

any of Dürer's prints; more likely they were exposed to later European woodcuts or engravings which themselves had been Dürer-inspired, perhaps generations earlier.[18]

One typical Resurrection composition that inspired Armenian illuminators consists of Christ standing on the tomb, surrounded by a semicircle of clouds and holding the banner of the Resurrection,[19] closely similar to a printed *Resurrection* by the Dutch engraver and painter Lucas van Leyden (1494–1533), itself copied by many other European artists in the sixteenth and seventeenth centuries.[20] Another variation of the Resurrection, in which Christ floats over the tomb surrounded by clouds and with guards and/or angels below him (fig. 11.4), became a favorite of Armenians, and was also modeled after European compositions. The inscription in Armenian at the bottom of this illumination informs the viewer: "This is the Resurrection of our Lord Jesus Christ." A tiny Flemish engraving (1600, fig. 11.5) by Adriaen Collaert (ca. 1560–1618) is not the exact model for these Armenian manuscript paintings, but is an example of the type of printed composition the artists used for inspiration. The *Resurrection* in a late Armenian Missal manuscript dated 1750 (fig. 11.6) again exemplifies European sources, and was certainly inspired by a print similar to the engraving by Mario Cartaro (ca. 1540–1620) dated 1566.[21] What is particularly remarkable about this Armenian illumination/miniature is that the artist, Yovan Ēsibits'i (active mid-1700s), attempted to copy a Latin inscription (perhaps the name of the original engraver?) from the original print, seen at the lower right and below Christ's right foot on the tomb; the artist probably did not know the Latin alphabet because what he wrote is illegible. If the original model can be found someday, it might be possible to decipher what he tried to imitate in the painting.

Although we generally don't know the exact print source for an illumination or derived print, there are a few exceptions. The original late sixteenth-century engravings by numerous Flemish artists used in the book *Evangelicae historiae imagines . . .* (Illustrations of Gospel Stories; Antwerp, 1593) by Jesuit Jérôme Nadal (1507–1580) were widely disseminated by the Jesuits for didactic and proselytizing purposes,

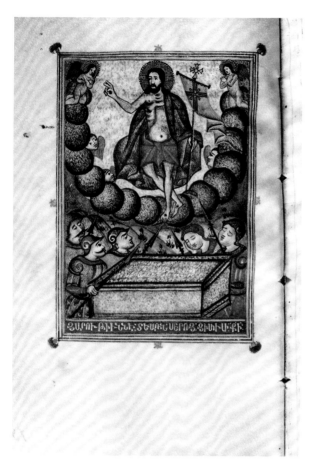

11.4. *The Resurrection* in a hymnal, Constantinople, 1652. Venice, Armenian Mekhitarist Congregation, Library of San Lazzaro Abbey, MS 400, fol. 139v

embellished his printed Bible with about 160 woodcuts by Christoffel van Sichem, including this *Resurrection*.[25] The Armenian Bible was sold in the Near East (where the largest number of clients would be found), and in this way these Dutch prints were widely circulated among Armenians. The Wierix *Resurrection* in Nadal's book, through Van Sichem's version, was recut at least twice into new woodblocks by Armenians, which were then used to create woodcuts for Armenian printed books produced in Constantinople in the eighteenth century.[26]

The Van Sichem compositions were also utilized in other media. These Dutch woodcuts found their way to a seventeenth-century Armenian silversmith's workshop in Kayseri, a town in Central Anatolia on an important trade route. We can have no doubt that Van Sichem's *Resurrection* print was used as the model for the Resurrection scene reproduced on a luxurious enameled, jeweled, and silver repoussé plaque dated 1691 on the back cover of a thirteenth-century Gospel book, now in the Metropolitan Museum of Art in New York.[27] Many of the silver pieces made in this workshop were inscribed with the dates and the names of the silversmiths who produced them.[28] These silversmiths specialized in liturgical objects, especially silver covers for religious books, and were inspired by many of Van Sichem's woodcuts for their plaques, including some that were in neither the 1666 Armenian Bible nor the 1646–57 Dutch Bible. This demonstrates that the silversmiths not only had access to a copy of the Armenian Bible (or perhaps the Dutch Bible) in their workshop but also were exposed to at least one other Dutch book illustrated with Van Sichem's woodcuts. Silver plaques on religious manuscripts or printed books with some form of Christ emerging from the tomb (usually on the back cover) became extremely common in the eighteenth and nineteenth centuries in many other Armenian silversmith workshops in the Ottoman Empire.[29]

In mid-seventeenth-century New Julfa, prosperous Armenian merchants were financing not only the production of luxurious manuscripts and the printing of the first Armenian-language Bible in Amsterdam but also the building

reaching as far as Ethiopia, Iran, and China.[22] Many engravings in Nadal's book, including the *Resurrection* by Hieronymus Wierix (1553–1619) on plate 134, were copied early on by the Dutch woodcut artist Christoffel van Sichem, whose works were published in many early seventeenth-century Dutch books, including a Dutch-language Bible printed in 1646–57.[23] After decades of use in many different Dutch books, the woodblocks were acquired by the Armenian printer Matt'ēos Tsarets'i (d. 1661) in Amsterdam. After his death, Oskan Erewants'i (1614–1674), an Armenian cleric from New Julfa, took over the printing house and printed the first Bible in the Armenian language in Amsterdam in 1666. Three Armenian merchants from New Julfa financed this project.[24] Oskan

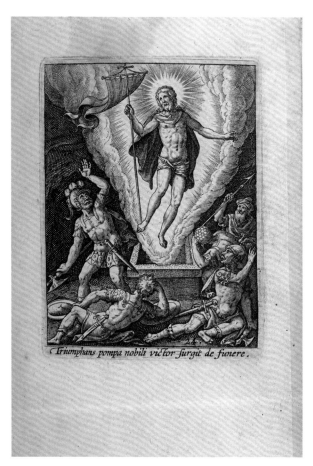

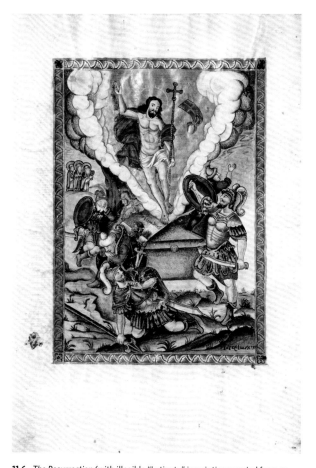

11.5. *The Resurrection* in *Passio et Resurrectio D.N. Iesu Christi* (The Passion and Resurrection of Our Lord Jesus Christ), Adriaen Collaert, Antwerp, Belgium, 1600. New York, The Morgan Library & Museum, Bequest of G. Clark Stillman, 1995, PML 126118, plate 24

11.6. *The Resurrection* (with illegible "Latinate" inscriptions copied from an engraving) in a Missal, Yovan Ēsibits'i, 1750. Antelias, Lebanon, Holy See of Cilica, MS 157, fol. 12v

of spectacular churches. And they were interested in decorating these churches in new, exotic, and impressive ways as a means of displaying their piety and their prestige. Holy Bethlehem Church, commissioned by the extremely wealthy merchant Petros Velijanian in 1628–29, was decorated from the 1630s to the 1650s with extraordinary wall paintings. Amy Landau of the Walters Art Museum in Baltimore has convincingly proved that a group of these wall paintings were inspired not by the Van Sichem woodcuts in the Armenian Bible (not printed until 1666) or other, earlier Dutch books with Van Sichem woodcuts but by the earlier engravings found in Jerome Nadal's work that Van Sichem used as models.[30]

The type of Resurrection scene showing Christ standing on or floating above the tomb became exceedingly popular with Armenian artists. The iconography was readily accepted for depicting the Resurrection in many Armenian religious works of art, including manuscripts, wall paintings, illustrated printed books, ceramic tiles, silverwork, and embroidered vestments, and is indeed still used today. This iconography, initially developed in Europe, was first brought to the attention of Armenians in the early seventeenth century through the vehicle of European illustrated printed books, or perhaps individual prints. The earliest Armenian examples discovered thus far were painted in manuscripts produced in New Julfa, a logical location for this initial exposure. Isfahan was a

cosmopolitan city with strong ties to Western Europe: as the Safavid capital, many travelers, diplomats, and missionaries visited it. New iconography and compositions (besides the Resurrection) had profound effects on artistic production in New Julfa; it is probably from there that the iconography spread to at least some other Armenian scriptoria, and eventually to many regions with large Armenian communities.

It should be noted that some of these books, such as Nadal's, might also have been brought to Iran through Jesuit or other Catholic orders for didactic purposes, and as a means to attempt to convert people to Catholicism. Catholic conversions did occur in New Julfa, and a few Armenian Catholic churches were constructed there. However, we should not construe the use of this new iconography as an indication of mass conversion—it was far too ubiquitous and accepted to support that concept. Rather, I believe that these images were initially considered modern and even somewhat exotic to Armenian viewers.

The global book trade from West to East was a vital factor for the introduction of new artistic themes such as the Resurrection iconography I have discussed. These pictorial representations had an important influence on Armenian religious manuscripts that continued to be actively produced in the Near East in the seventeenth and eighteenth centuries. For Armenians, this period was still one of transition from manuscript to printed book, in which both forms coexisted.[31] Furthermore, an interesting transition from *printed book* to *manuscript* was also occurring at this time, where Armenian artists were inspired by illustrations in printed books for their manuscript art. This also occurred in the early years of printing in Europe (as with Dürer's aforementioned *Resurrection*, which was copied into an Italian manuscript). The Resurrection image eventually became ubiquitous in Armenian religious art, ultimately forming part of the regular visual vocabulary for depicting this miraculous event.

— Sylvie L. Merian is a reader services librarian at the Morgan Library & Museum.

I would like to thank Susan L'Engle for her helpful comments on this article. Any errors are my own.

1 For the iconography in Christian art, see Réau 1955–59, vol. 2, part 2, 531–50; Schiller 1966; Kartsonis 1986.

2 Matthew 28:1–10 states that two women go to the tomb and see one angel, who tells them that Christ is raised from the dead (it is the only Gospel that mentions guards); Mark 16:1–8 mentions three women at the tomb, the stone has already been rolled away, and a young man in white robe tells them that he is not here, that he has been raised; Luke 24:1–12 states that more than four women go to the tomb, find it empty, and see two men in dazzling clothes who say that he is not here, and that he has risen; John 20:1–18 states that Mary Magdalene goes to the tomb, sees the stone removed, and runs back to tell the disciples, who rush to the tomb and see only linen wrappings. They leave, Mary stays and weeps, and looks inside the tomb and sees two angels in white. She sees Jesus but thinks he is the gardener, only later realizing his real identity. He says: "Do not hold onto me" (*Noli me tangere*).

3 For example, a Gospels in the Walters Art Museum, MS W.543, fol. 10v (by Khach'atur the priest, Khizan, 1455). Or a Gospels in the Bodleian Library, MS Arm. d. 22, f. 8r (by Sargis Mok'ats'i, Mok's [south of Lake Van], late sixteenth century). In the latter case, the illumination of the Women at the Tomb is captioned at the top: "Resurrection of our Lord Jesus Christ." See Van Lint and Meyer 2015, cat. 9, pp. 88–89. Note that the Library of Congress transliteration system is used in this article for transcribing Armenian words.

4 Jerusalem, Armenian Patriarchate [Library], MS 2556, the Gospels of King Gagik of Kars (1045–54), fol. 132v. For further discussion of the iconography of the Women at the Tomb in Armenian manuscript traditions and a reproduction of this illumination, see Mathews and Sanjian 1991, 115–17, and fig. 179a.

5 Note that Armenian manuscripts, both religious and secular, were still being produced in the seventeenth and eighteenth centuries, on both parchment and paper. For an example of *The Women at the Tomb*, see Azadian, Merian, and Ardash 2013, cat. 1.3 (MS L1988.259, p. 160, a hymnal from the Crimea produced in 1423 by K'ristosatur). For more examples ranging from the thirteenth to seventeenth century from many regions, see Der Nersessian and Mekhitarian 1986, 48, 101, 128, 132, 143, 161, 174.

6 See a Gospels in the Walters Art Museum MS W.543, fol. 10v (by Khach'atur the priest, Khizan, 1455).

7 Kartsonis 1986.

8 http://www.earlychristian writings.com/text /gospelnicodemus.html, accessed April 24, 2018. See Réau 1955–59, vol. 2, part 2, p. 531; Hall 1974, 100–101; Apostolos-Cappadona 1994, 104.

9 Such as unbaptized children, pre-Christian people, Adam and Eve, and the Old Testament saints and prophets.

10 For example, Bodleian Library MS Arm. d. 22 (by Sargis Mok'ats'i, Mok's, late sixteenth century) includes both *The Harrowing of Hell* and *The Women at the Tomb* on facing pages, fols. 7v–8r; see Van Lint and Meyer 2015, cat. 9, pp. 88–89.

11 The earliest examples show only Christ's torso coming into

view as he emerges from the tomb, as in the eleventh-century Reichenau Gospels of ca. 1000–1020, produced in the Benedictine Abbey of Reichenau (Bayerische Staatsbibliothek, Munich, MS Clm. 4454, fol. 86v). The image of Christ emerging from the tomb with only his torso visible is located in the arch above the portrait of Mark. The entire manuscript has been digitized: http://daten.digitale-sammlungen.de/~db/0000/bsb00004502/images/, accessed March 14, 2017. Other illustrations depict him in the act of stepping out of his tomb, or already out and standing before it. For example Morgan Library MS M.739, fol. 24r, a book of hours from Germany from 1204–19 with a combination scene: on the left Christ stands outside the tomb holding the banner of the Resurrection, and on the right Christ grasps Adam's wrist with one hand and holds the banner in the other (*The Harrowing of Hell*): http://corsair.themorgan.org/cgi-bin/Pwebrecon.cgi?BBID=258789, accessed April 21, 2018; and Morgan Library MS M.299, fol. 7v, a Gospel Lectionary from Germany of ca. 1220–30 in which Christ already has one leg outside of the tomb, with the sleeping guards visible: http://corsair.themorgan.org/cgi-bin/Pwebrecon.cgi?BBID=256176, accessed April 21, 2018. The women who come to anoint his body may also be included, sometimes with an angel, and the guards might also be depicted.

12 For an online reproduction of this fresco, see image 18 at http://www.museumsinflorence.com/musei/museum_of_san_marco.html, accessed April 24, 2018.

13 In the collection of the Gemäldegalerie der Staatlichen Museen, Berlin; see http://www.smb-digital.de/eMuseumPlus?service=ExternalInterface&module=collection&objectId=867398&viewType=detailView, accessed April 24, 2018. The motif of Christ hovering over the tomb probably developed first in miniature painting in the early fourteenth century, and was later adopted to monumental painting. See Cassee and Berserik 1984.

14 Interestingly, the 1609 illumination seems to be a combination of *The Woman at the Tomb* with *The Resurrection.* Van Lint and Meyer 2015, 55–56; cat. 2, 74–75; cat. 15, 102–3. A Gospel book at the Morgan Library & Museum (MS M.624) done in two stages (1588 and 1659) includes *The Ascension of Christ* (fol. 7v), in which Christ is shown almost completely surrounded by billowing red clouds. This may indicate some acquaintance with clouds from Western European Resurrection iconography. Mathews and Wieck 1994, cat. 63, pp. 192–93, pl. 34.

15 Much has been written about Dürer's influence on other artists, for example Bartrum 2002, esp. chapters 8, 9, and 10.

16 St. Louis Art Museum object number 91:1988. For an image of this Limoges plaque, see http://emuseum.slam.org/objects/16162, accessed April 24, 2017. Compare with *The Resurrection* from Dürer's *Small Passion* of 1510: https://en.wikipedia.org/wiki/List_of_woodcuts_by_D%C3%BCrer#/media/File:D%C3%BCrer_-_Small_Passion_29.jpg, accessed April 24, 2018.

17 Morgan Library & Museum, MS M.320, fol. 57v, Pisa, Italy, 1543–99. See http://corsair.themorgan.org/cgi-bin/Pwebrecon.cgi?BBID=333166, accessed April 21, 2018. Compare with *The Resurrection* from Dürer's *Great Passion.*

18 For this phenomenon, including a discussion on the indirect influence of Dürer on Armenian illumination of the Book of Revelation in seventeenth-century manuscripts, see Merian 2014.

19 For an example, see *The Resurrection* on fol. 167v of Freer/Sackler Gallery MS F1937.19, an Armenian hymnal dated 1651–52. Der Nersessian 1963, fig. 298 on plate 85.

20 For an online image of this Lucas van Leyden engraving, see https://commons.wikimedia.org/wiki/File:Lucas_van_Leyden_057.jpg, accessed April 24, 2018.

21 London, The British Museum, museum no. 1874,0613.652. See http://www.britishmuseum.org/research/collection_online/collection_object_details.aspx?objectId=1457558&partId=1&people=129933&peoA=129933-2-60&page=1, accessed April 22, 2018.

22 For Ethiopia, see Mercier 1999; Bosc-Tiessé 2004. For Iran, see Landau 2012. For China, see Bailey and O'Malley 2005.

23 There were probably four artists called Christoffel van Sichem, all of whom used the same monogram CvS. Some scholars think that Christoffel van Sichem II produced the woodcut under consideration. The Dutch Bible was printed by Pieter Jacopsz Paets in Antwerp, general title page dated 1657 and New Testament title page dated 1646. H. Evans 2018, cat. 139.

24 Baghdiantz McCabe 1998.

25 Oskanyan, Korkotyan, and Savalyan 1988, cat. 58, pp. 44–50; Kévorkian 1986, 51–60. For a reproduction of the Christoffel van Sichem Resurrection in the 1666 Armenian Bible, see Azadian, Merian, and Ardash 2013, 55, fig. 1.14b.

26 There are two examples in the collection of the Krikor and Clara Zohrab Information Center, Diocese of the Armenian Church, New York: *Zhamagirk'* (Book of Hours) printed in Constantinople in 1721 (no accession number), and a *Tagharan* (Songbook) printed in 1738 (accession no. 34).

27 Metropolitan Museum of Art, New York, accession no. 16.99. See Mathews and Wieck 1994, cat. 50, p. 183, and fig. 79; H. Evans 2018, cat. 112a, b.

28 Merian 2013.

29 Mathews and Wieck 1994, cats. 16, 57, 79; Azadian, Merian, and Ardash 2013, cats. 1.6, 1.17, 1.18, 1.19. For a related discussion on blind-tooled Armenian leather bindings in which the back covers include a rectangular design that may symbolize Christ's tomb, and by extension the Resurrection, see Kouymjian 2008.

30 Landau 2012. Her meticulous comparison of the wall paintings with the Van Sichem woodcuts and the engravings in Nadal's book uncovered details that only exist in the Nadal engravings and were included in the wall paintings.

31 Even though the first Armenian printed book was made in Venice in 1511 or 1512, the technology of the printing press was slow to take hold in the Near East for a variety of reasons. Armenians, Greeks, Jews, and Muslims were all still producing manuscripts up to the eighteenth century, and sometimes even the early nineteenth.

As this book was going to press, I discovered an illumination in an Armenian Synaxarion manuscript, produced in Lvov, Poland, in 1603 (Vienna Mechitarist Congregation Ms. 437). This will be the subject of future research.

III. Identity: Finding One's Place in the Medieval World

<div align="right">BRYAN C. KEENE</div>

Blurred Boundaries

The thirteenth-century Iraqi painter Yahya ibn Mahmud al-Wasiti's depiction of Indo-African sailors in *A Ship Sailing to Oman* (fig. III.1) from the *Maqāmāt al-Harīrī* (The Assemblies of al-Hariri) has been described as paradigmatic of Indian Ocean trade.[1] Indeed, throughout the manuscript, the artist conveys ethnic and cultural diversity through skin tones and dress.[2] Swahili coast merchants and emissaries certainly traded throughout the Indian and Pacific Oceans, as recorded, for example, in the *Kitab al-Sulwa* (Kilwa Chronicles), which preserve the genealogy of the sultanate who ruled the Swahili coast from the island of Kilwa Kisiwani off the coast of present-day Tanzania.[3] It is precisely the combination of texts and images that reveal the spatial, cultural, temporal, and in this instance racial dimensionality of a global Middle Ages. The essays in this section examine strategies for navigating racial, national, and confessional identities.

The Holy Roman emperor Otto III (r. 996–1002) leveraged the optics of imperial ambitions in a pair of illuminations from a Gospel book produced at the Benedictine monastery of Reichenau (Germany) (fig. III.2). At left are four kneeling personifications of Otto's territorial remit bringing offerings to the ruler: Sclavinia (Slavic territories of the East), Germania, Gallia (roughly France), and Roma. At right, Otto is flanked by deacons (one of whom places his hand on the throne) and generals (one of whom gestures toward the orb, representing the world). A few pages later, the artist depicted the Adoration of the Magi (fol. 29), effectively forming a visual parallel with the national tributes. As Roland Betancourt demonstrates in this section, racial and gender diversity in contemporaneous Byzantine illuminated manuscripts did not necessarily engender social tolerance, a theme that deserves further in-depth study across all fields addressed in this volume.

Following descriptions of the physical traits, habits, and moral lessons that can be learned from birds and animals, the compiler of a Franco-Flemish miscellany included a section on the "Wonders of the East" with a series of images and short captions about the so-called monstrous races, or peoples, living at the extremities of the world (fig. III.3).[4] The writer

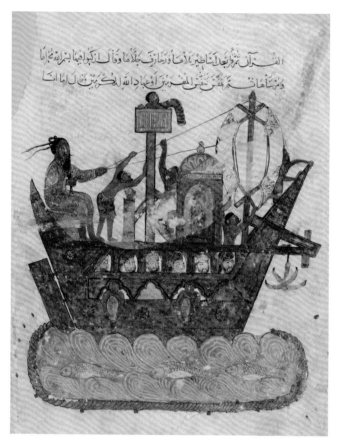

III.1. *A Ship Sailing to Oman* in *Maqāmāt al-Harīrī* (The Assemblies of al-Hariri) by Yahya ibn Mahmud al-Wasiti, Baghdad, Iraq, 1237 CE / AH 634. Paris, Bibliothèque nationale de France, MS Arabe 5847, fol. 119v

III.2. *The Provinces Bringing Tribute* and *Ruler Portrait of Otto III* in the Gospels of Otto III, Reichenau Abbey, Germany, late tenth or early eleventh century. Munich, Bayerische Staatsbibliothek, Clm.4453, fols. 23v–24

III.3. *A Hairy Woman of the Island of Gorgade*, *A Scorpion*, and *Men with Shields and Weapons* in a Bestiary, Thérouanne (Flanders), present-day France, 1277 or after. Los Angeles, The J. Paul Getty Museum, Ms. Ludwig XV 4 (83. MR.174), fols. 119v–120

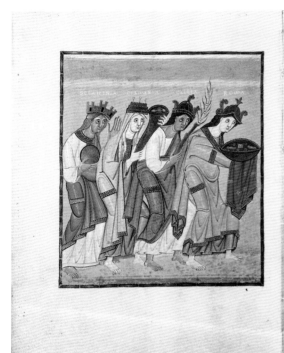

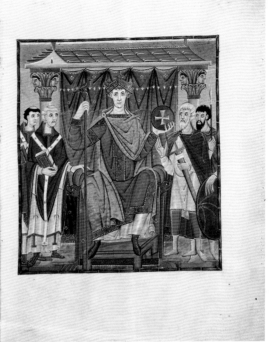

III.4. *William Burch, Lion, Eskimos, and Wild Horses* in the *Burch Album*, Canterbury, England, 1590. Canterbury, England, Canterbury Cathedral Archives, Lit. Ms. A 14, fol. 12

often distinguished between *gens* (tribe/people) and *hominum* (human/people), and a few notes were penned at the top of some pages to give additional geographic information (like the "Island of Meroe," that is, the Sudan), although the artist did not include landscape details in most images. The lack of clothing and exaggerated or misshapen physical features distinguishes these beings from other human figures in the manuscript, such as "the diverse types of humans" arranged to evoke a modified T-O map. The case study by Kristen Collins and myself addresses the ways in which these types of prejudicial and derogatory images serve as reminders of the power behind such rhetoric, which allowed reader-viewers in positions of privilege to imagine their world as intrinsically divided and hierarchical. Pamela A. Patton then provides a close reading of racial and religious identity in a thirteenth-century Navarro-Aragonese legal code, the *Fueros de Aragón* (Feudal Customs of Aragón), which provides a lens through which to view intercultural relations in periods of expulsion or eventual genocide.

The dearth of indigenous accounts from the period covered by this volume—the result of the inhumanity just mentioned—requires that one maintain a critical eye on what glimpses there are of marginalized groups, often preserved in luxury objects made for elites. In 1576–77, the English sea captain Martin Frobisher (ca. 1535/39–1594) explored the greater Hudson Bay area, known at the time as Meta Incognita and represented on maps between Europe, Greenland, North America, and Asia.[5] On Baffin Island, he encountered the Eskimo population, and he eventually took three individuals captive and brought them to England together with luxury items such as furs and bows. Representations of Kalicho, Arnaq, and a one-year-old boy, Nutaaq, as they were called, spread quickly throughout England and Northern Europe, including a drawing by seventeen- or eighteen-year-old William Burch (born ca. 1560) (whose alias was Vicar of the Kings-benche in Southwarke, London), likely based on prints (fig. III.4).[6] The Burch manuscript is a compendium of aphorisms, chiromancy charts, a short history of chemistry, drawings of animals and coins, and even a portrait of Queen Elizabeth I with a complete Tudor genealogy.[7] The precocious youth paired the "true picture," as he wrote, of "the Indian man and woman that Sr. Martin Frobysher brought into

England: 158 . . ."[8] (the date is incomplete) with passages from Virgil's *Georgics* and Peter Lombard's *Sentences*.[9] Burch rendered the patterns and textures of Kalicho's outfit in color, the only instance of color in this manuscript (aside from some yellow to indicate coins), thereby revealing the sartorial interests of European audiences. Amerindians like Kalicho, Arnaq, and Nutaaq were exhibited as specimens in what Coll Thrush has called the "urban origins of English colonialism" precisely at the moment when indigenous knowledge contributed to English (and broader European) understanding and ultimate exploitation of the Americas.[10]

The Global Impact of the Mongols, Marco Polo, and a Muslim Emirate

The Mongol military campaigns or conquests across Eurasia represent something of a paradigm: on the one hand, they devastated human life and the urban fabric of the lands they conquered, but on the other, as Linda Komaroff and Stefano Carboni have argued, "the practices of governance, patronage, conscription, and mercantile exchange adopted by the Mongols after their conquest produced a singular environment for artistic creation, and this in turn had a profound impact on the development of art and architecture throughout Eurasia and particularly in the Islamic lands of western Asia."[11] In this section, Kaiqi Hua presents a case study of cultural methods for depicting the Mongol military campaign in manuscripts produced across Eurasia, with a particular focus on war machines and battle strategy.

By the thirteenth century, there was already a tradition for producing large illuminated copies of the *Shahnama* (Book of Kings) of Abu 'l-Qasim Firdowsi (from about 1010). The *Great Mongol Shahnama*, which was dispersed in the early twentieth century (and survives as at least fifty-eight illustrations), is an impressive, if unfinished, copy of the text produced in the 1330s in Iran, probably in the cosmopolitan capital city of Tabriz. Global considerations in this manuscript include a decorative program consisting of Christian subjects and mendicant figures, painterly features and patterns from Chinese and Buddhist art, and the attention to narrative and the boldness

III.5. *Taynush before Iskandar* and *The Visit to the Brahmans* on a page of the *Great Mongol Shahnama* (Book of Kings), Tabriz, Azerbaijan, 1330s CE / 730s AH. Washington, DC, Freer Gallery of Art and Arthur M. Sackler Gallery, Purchase—Smithsonian Unrestricted Trust Funds, Smithsonian Collections Acquisitions Program, and Dr. Arthur M. Sackler, S.1986.105.1

of palette and pattern that characterizes painting of the Ilkhanids, the westernmost subordinate branch of the Mongol world (from about 1256 to 1353).[12] Two scenes from the life of Iskandar (Alexander the Great) (fourth century BCE) in the manuscript present the world ruler at the extremes of the medieval globe, as conceived by artists and writers in Afro-Eurasia at the time: at right, Iskandar meets with Taynush, the son of Qaydafa, the queen of Andalus, and at left, Iskandar is on his way to the land of India to meet with the Brahmans before heading to the ends of the world (fig. III.5).[13]

Situated at the crossroads of Europe and Asia, historic Armenia and the later kingdom of Cilicia had ties to the

III.6. Decorated incipit page in a Gospel book, Petros (scribe), K'ajberunik' Lake Van region, Armenian kingdom (present-day Turkey), 1386. Los Angeles, The J. Paul Getty Museum, Ms. Ludwig II 6 (83.MB.70), fol. 198

III.7. Qur'an case, Nasrid Emirate of Granada, Spain, 1450–1500 CE / 853–905 AH. New York, The Metropolitan Museum of Art, Rogers Fund, 1904, 04.3.458

Byzantine Empire and to Muslim caliphs and Mongol khans alike. In the thirteenth century, some of these territories were part of the western branch of the Mongol dynasty, referred to as the Ilkhanate. Artisans there quickly began incorporating motifs from Chinese art like dragons and phoenixes, generally found on Chinese pottery and textiles, into a range of objects, including illuminated manuscripts like the Lectionary of Het'um II of 1286. A fourteenth-century Gospel book from the Lake Van region blends local and global traditions. The pages are made of paper, invented in China during the Han dynasty (206 BCE–220 CE), which likely arrived in the area by way of trade networks with cities like Tabriz (Iran) or Baghdad

(Iraq). The isolation of monastic centers in the area led to the emergence of a regional style characterized by frenetic lines and simple washes of color. The polylobed arch of the incipit pages (fig. III.6) is characteristic of Abbasid (750–1258) and Seljuq (tenth century–1307) architecture, and the stylized dragons or sirens (or phoenixes) within the interlaced vines may derive from Chinese art. These examples from Cilicia and historic Armenia complement the material identities explored by Mark Cruse in his essay about the travels of Marco Polo (1254–1324). The Venetian merchant describes the silk fabrics woven in greater Armenia, as well as the silver mines there, in contrast to the spices and goods from the East that are traded

in lesser Armenia. These multiple identities for a region and culture characterize Polo's descriptive writing style.

Shifting our focus to another extreme of Eurasia, we find that portable objects allow us to discover pathways of regional and hemispheric encounters. One of the most remarkable surviving portable objects of the Nasrid dynasty, who ruled in Granada prior to the 1492 expulsion of Jews and Muslims from the Iberian Peninsula, is a small Qur'an case bearing the dynasty's motto, There is no victor but Allah.

The case may have once belonged to the last Muslim ruler of Granada, Muhammad XII (r. 1482–83, 1487–92) (fig. III.7). The Arabic motto was copied with great precision by Georges Trubert (active 1469–1508) in a book of hours made for a patron likely living within the courtly or cultural sphere of René of Anjou (1409–1480) (see fig. 17.1). Alexandra Kaczenski's case study in this section considers global interactions between courts separated by great distances and by doctrine through the lens of simulated devotional objects or dress and

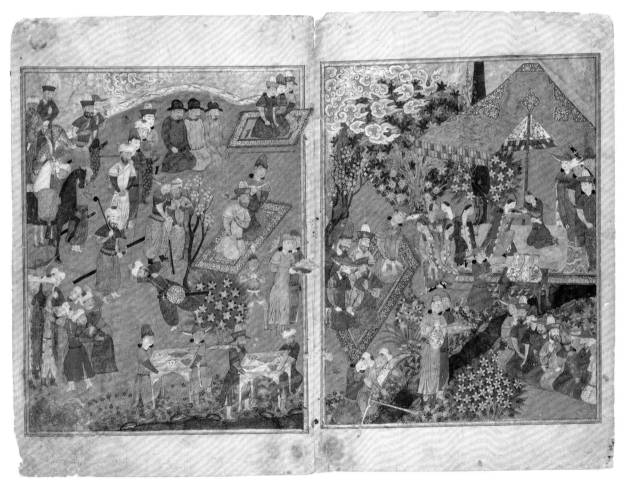

III.8. *A Princely Banquet in a Garden* from the *Shahnama* (Book of Kings) of Abu'l-Qasim Firdowsi, Shiraz, Iran, 1444 CE / 847–48 AH. Cleveland, Ohio, The Cleveland Museum of Art, Purchase from J. H. Wade Collection, 1945.169

the shifting geographic referents of the depicted material. Luxury items in porcelain, silk, and silver were often prized commodities for establishing diplomatic relationships. A page from a 1444 copy of the *Shahnama* produced in Shiraz, Iran, depicts a banquet in a garden, with a striking display of Chinese porcelain, perhaps a memory of the trade between China and the Timurids during the time of the voyages of Zheng He (1371–1444 or 1435) (fig. III.8). Here, the narrative and the decorative arts represent the commingling of foreign elements and peoples, similar to the pictorial embedding of trans-Mediterranean motifs in manuscripts made for the courtly sphere of René of Anjou.[14]

1 George 2011, 1–42; George 2012, 11–37.
2 See Hillenbrand 2017, 215–25.
3 Rollins 1983, 29; Geider 2002, 255–88; Pillsbury, Potts, and Richter 2017.
4 For bibliography on "race" and "racism" in the Middle Ages, see the introduction in this volume (note 4) and the case study by Kristen Collins and myself in part 3 (note 9), as well as G. Heng 2018.
5 Sturtevant and Quin 1987, 61–140.
6 Sturtevant and Quin (1987, 93–100) have identified several possible print sources for Burch's drawings, including works by Adrian Coenen in The Hague or Katharina Gerlachin and Johannes vom Berg in Nuremberg.
7 Malay 2010, 54–76.
8 Burch labels the individuals as "Collinsbough" and "Agnot."

9 From Virgil: *Optima quaeque dies miseris mortalibus aevi prima fugit / Subeunt morbi tristisque senectus* (In youth alone, unhappy mortals live; bliss is fugitive: discolored sickness and anxiety come). From Terence: *Oculi nostri tu(m) demum miserrimi sunt, ubi coguntur paupertatem nostram co(n)spicere* (Then finally our eyes are most miserable, when they are forced to see our poverty). I thank Calvin Kaleel for his poetic input on these translations.
10 Thrush 2013, 195–281.
11 Komaroff and Carboni 2002, 7.
12 Hillenbrand 2002, 134–67; Bertalan 2002, 226–37; Hillenbrand 2017.
13 Hillenbrand 1996, 203–30.
14 Levenson 1991, 206, entry by J. Michael Rogers.

12

Imperial Brutality: Racial Difference and the Intersectionality of the Ethiopian Eunuch

ROLAND BETANCOURT

Over the course of his rule, the emperor Basil II (r. 958–1025) was known for his many military triumphs and terrestrial conquests for the Byzantine Empire. Among his numerous victories were the campaigns he led that would eventually annex Bulgaria and much of the Balkans, making Serbia and Croatia dependencies of the empire; he also acquired Western Armenia and Georgia, and the islands of Crete and Cyprus. He fought against, and fostered a treaty with, the Fatimid caliph in Egypt, and would even plan campaigns against Sicily and Western Europe late in his life.[1] His brutal assaults on the Bulgarians would centuries later earn him the epithet Basil the Bulgar-Slayer.[2] In the history of art, Basil II is remembered primarily for an illuminated manuscript made for him around the year 1000, a synaxarion, or collection of brief summaries of the lives of saints, which are arranged according to their celebration over the course of the calendar year. In this case, the volume covers the feast days observed from September 1 to the end of February.

The manuscript, known today as the *Menologion of Basil II*, is striking for its gratuitous, graphically violent, and gruesome depictions of martyrdom (fig. 12.1).[3] Over the course of its folios, there is a disturbing fascination with the suffering of these early Christian saints. The artists of the work drew from an eclectic variety of medical knowledge in order to vividly contour the sufferings, for example echoing prescribed mastectomy practices to depict the excision of Saint Agatha's breasts, or paying close attention to the wounds of victims in order to distinguish between freshly spilled versus dried blood. Figures are shown being disemboweled, their intestines spilling out of their abdomens, or dismembered, with multitudes of body fragments lying on the ground so as to suggest that their fingers, palms, wrists, forearms, and so forth were hacked off piece by piece. In other words, the manuscript seeks to intensely capture the unusual cruelty of those responsible for the torture and deaths of these holy persons, and in doing so suggests a view of how the Byzantines saw their place in a multiracial globe.

ΤΗ ΑΥΤΗ ΗΜΕΡΑ. ΜΝΗΜΗ ΤΩΝ ΑΓΙ ΠΡΩΝ ΤΩΝ
ΕΝ ΤΗ ΡΑΪΘΩ ΣΦΑΓΕΝΤΩΝ ΥΠΟ ΒΛΕΜΜΥΩΝ ΤΩ
ΚΑΤΟΙΚΟΥΝΤΩΝ Ο ΠΟ ΓΙ ΙΝΑΙ Β ΤΗ ΓΑΪ ΤΑ Ο ΧΙ Ν ΔΡΑ
ΤΩΜ ΦΟΙΝΙΚΩΝ ☦

Β λέμμυες μυριάδες δύο σ ωτ ι αμ τ αρ χυρι ο μ δ αριο· και
π ßρασαμ τομ τ π λ λ ρο τ ιν ο αγ θι ο σιασ· και δ λ θομ
τομ εισ το πωρ ι ιαι δρ ον ταμ πλοιομ· και δ μι αμ των
εισ αυ το ιαι δι α π ßρασαμ τομ μ ε ισ τ ιω χωρ αμ τ ων
φαρ αμ ι τ ο μ. εξ λι δ θομ οι φαρ αμ ιτ αι εισ συμ αμ τ ν ο ιμ
αυτ ομ· ιαι ομ μι κ ι θ νσαμ τω σ του ρι χμυ ομ· και σφα
γι ι σαμ αμ δρ ασ εκ αιομ τασ σαρ αιομ τ ασ πασ· ιιδ ε ελ ε
ι ι ω σ ω φαρ αμ τ ω τασ γυ μ α ιασ και τα παιδ ι α τ ων
φαρ αμ ι τ ω μ. αι ω λι δ θομ εισ το κ ά θρο μ ω που ει χο μ τ ν
εκ κ λ ν σι αμ οι λοιπ οι πρ· ιαι ι ω φ άλισαμ τ ν θυ ραμ
ο ι α ι ο ι· και π ρο σ ε φυ γομ εισ τ ν ε κ κ λ ν σιαμ. εκ δ δ ρο μ
ρο ι τ ομ θ άνατομ· και ε λ θον τασ οι μ α ρ μ αρο ι· και χρνμ ατα
ζ ν τ ο υ ν τασ ιαι μ ν δ ρ ο ν τασ· παν τ ασ εφ ον δ υσαμ· ε λ αμ ο ν τ ασ
τ ν α ι χ μ α λ ω σι αμ. α π ν λ θ ομ προσ το π ßρασαμ. ιαι μ ν δ ρ ο ν τ ασ
τ ο πλοιομ· το γαρ π λ ο ιομ οι α γ ρα ρτ δ μ τ ασ ε ιω θι σαμ ε ξ ε φυ γομ
ο μ α μ ν σαμ. ιαι ε σ φα ζαμ τ ν α ι χ μ α λ ω σι αμ· ε σ φα μ ν σαμ δ ε ξα ιτοι

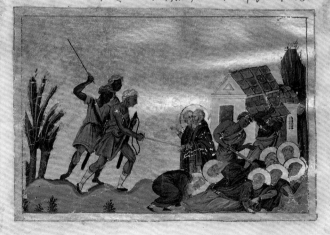

12.1. *The Martyrdom of Monks of Mount Sinai by Blemmyes* in the *Menologion* (Service Book) *of Basil II*, Constantinople, ca. 1000. Vatican City, Biblioteca Apostolica Vaticana, Vat. gr. 1613, fol. 317

his allies, for he is their friend. They throw down those lying at his feet."[6]

The general tone of the poem is militaristic, and the implied ambivalence between subjugation and veneration casts these figures as the subjects that compose Basil's ever-expanding empire. Perhaps they are conquered people, but they have come to recognize his magnanimity. Most interesting is the suggestion that the martyrs are his allies, which stages the contemporaneous *Menologion* as a sort of companion to the Psalter, manifesting in its pages all those martyred allies of the emperor. This association is alluded to as well in the opening poem of the *Menologion* itself that recounts: "In those whom he has portrayed in colors, may he find active helpers, sustainers of the State, allies in battles, deliverers from sufferings," and so on.[7] In other words, for Basil II, the *Menologion* served as a potent site of contemplation for his military deeds against foreign neighbors, and also as a validation of the imperial brutality that he undertook against these neighboring lands, which he eventually subjected to the empire's rule.

Thus the *Menologion* allows us to consider the manner in which the cosmopolitan Constantinopolitan center of Byzantine imperial power conceived and perceived of the broader global sphere in which it operated and with which it had extensive contact through trade, military expansion, and pilgrimage. The two questions I wish to consider in this chapter are: first, to what extent the depiction of racial difference worked to articulate a sense of otherness in the manuscript, and second, how the depiction of an early Christian person of color with a nonbinary gender identity in the Byzantine world acknowledged their intersectional identity.[8]

To answer these questions, I wish to focus on a single image in the *Menologion*: the figure of the Ethiopian eunuch (fig. 12.3). Here we are given a glimpse into two instances in the life of Philip the Evangelist, referred to as the Apostle, who is being commemorated in the scene. On the right we encounter the elderly Philip, who as the text above tells us would eventually become the bishop of Tralles in Asia Minor. On the left we find a key scene from the Acts of the Apostles 8:26–40, where Philip meets a powerful eunuch of Candace,

12.2. Frontispiece showing Basil II in the *Psalter of Basil II*, Constantinople, 1017–25. Venice, Biblioteca Marciana, Marciana gr. 17

In the frontispiece of a Psalter made for Basil II, roughly contemporaneous and closely associated in style to the *Menologion*, a portrait of the emperor sheds some light on the tenor and aims of the *Menologion* itself (fig. 12.2). Prostrated below Basil are a series of men who seem to encompass the span of the empire's lands. While Anthony Cutler has noted difficulty in ascribing specific identities to these figures,[4] they seem to represent those both liberated by and subjected to Byzantine rule through Basil's conquests.[5] The poem adjoining the image describes what we are seeing, musing on the emperor's depiction in a divinely sanctioned coronation with all his accoutrements of war. Icons of martyrs and military saints hang beside him, while subjects cower before him at his feet. The final lines of the poem tell us, "The martyrs are

12.3. *Philip and the Ethiopian Eunuch* in the *Menologion* (Service Book) *of Basil II,* Georgios (artist), Constantinople, ca. 1000. Vatican City, Biblioteca Apostolica Vaticana, Vat. gr. 1613, fol. 107

queen of the Ethiopians, who also served as her treasurer. The eunuch sits on a chariot reading the Prophet Isaiah, while on their way to a pilgrimage in Jerusalem. Hearing them read from Isaiah, Philip joins them and asks to be their tutor, showing them how the words of the prophet had become manifest in Christ, and together they continue on the road. Upon encountering a source of water, the eunuch asks Philip to baptize them. Philip agrees upon witnessing the eunuch's preparedness, and after doing so, Philip is swept away by the spirit of God and continues off on his own to Asia Minor.

One of the most striking details of the manuscript is the depiction of the eunuch as a black person. The artist, a man by the name of Georgios, as the inscription to the left of the image tells us, has chosen to depict the very instant when Philip seems to agree to baptize the eunuch. There is a startling intimacy between the two figures in this moment of tension. The eunuch stares intently into Philip's eyes. Philip looks back with a gaze that seems slightly awry, as if caught in thought about whether to undertake the baptism. In his right hand Philip carries a tied-up scroll that intimates his impending speech act, commanding the chariot to stop so that the eunuch may be baptized. Note the way the eunuch's own right hand rises from the reins and gestures toward the stream before them, while the other hand almost seems to pull at those reins, suggesting Philip's command to stop the chariot. The horses' front left legs are raised, while the front right ones are firmly planted on the ground and their back left legs seem to bend backward, all suggesting that the horses are abruptly stopping in their tracks. The gray horse closest to the viewer elegantly captures our attention, as he is the only figure staring directly out of the image, thereby effectively anchoring the center of the composition. Hence, rightly so, the heightened drama of the Ethiopian's conversion is stressed in an image dedicated to the life of Philip, for the eunuch's baptism manifests the success of the Apostle's evangelical mission and the Ethiopian people's conversion to Christendom.

It is in this context that the image of Philip and the Ethiopian eunuch most commonly appears in Byzantine art: notably appearing in conjunction with Psalm 68:31 (medieval numbering is 67:32), "Ethiopia shall soon stretch out her hands unto God," which was understood as foretelling the deeds of Philip in the Acts of the Apostles.[9] In such instances, we see a similar iconography of a youthful, boyish eunuch with a beardless face sitting in their chariot with Philip nearby. Subtle variations across the various manuscripts change the exact moment depicted. For example, in the late ninth-century Chludov Psalter (Moscow, State Historical Museum, Ms. gr. 129), we see standing in the chariot a long-haired youth with large rosy cheeks and wearing a simple blue tunic, while Philip greets them from beside the chariot (fol. 65). The depiction is almost identical in the contemporaneous Pantokrator Psalter (Mount Athos, Holy Pantokrator Monastery, Cod. 61, fol. 85v), also from the ninth century, as well as in the Theodore Psalter (London, The British Library, Add. Ms. 19352, fol. 85r) from 1066. However, in all these instances, the eunuch is invariably depicted as white. Despite the literal meaning of the term "Ethiopian" to denote a black person,[10] depictions of Ethiopians as white are by no means rare among Byzantine artists.

In the case of these white Ethiopian eunuchs, the youthfulness of their faces, the effeminate locks of hair, and those rosy cheeks all seem to stress their identity as court eunuchs.[11] Despite being Ethiopians, their identity as eunuchs won out, given the stereotypes of eunuchs' ghostly paleness, flushed cheeks, thin long hair, and feminine features. In other words, the *Menologion* is unique in its depiction of the Ethiopian eunuch as black. One of the only other appearances of the eunuch as black in Byzantine art is in another manuscript, a synaxarion from the Holy Monastery of Docheiariou on Mount Athos (Mount Athos, Holy Monastery of Docheiariou, Cod. 5, fol. 3v). In that image, the eunuch is brown skinned, wearing a turban and a short blue tunic that reveals their chest. The artists preserve the regal depiction of the eunuch, seated upon a throne, but stages them unequivocally as a foreigner through their attire. When we look closely at the image in the *Menologion*, an imperial commission of the highest quality, we observe that the facial features of the eunuch are comparable to those of the youthful Philip, and

his curling, undulating hair is not unlike other depictions in the manuscript. Unlike many ancient depictions of Ethiopians, which deploy grotesque stereotypes analogous to the infamous blackface of nineteenth- and twentieth-century minstrel shows, the eunuch here is depicted no differently than the rest of the saintly subjects—except of course that their face, hair, and hands are a grayish black.

Philip is depicted with a pink chiton under a cream-colored himation in the style of Late Antique figures, as the apostles are often depicted. However, the Ethiopian eunuch is dressed as an imperial subject, contemporaneous with Emperor Basil II and his commission, as Maria Parani has aptly noted.[12] Like Philip, they wear a pink tunic, but it is cuffed with gold bands and features a gold-ornamented epaulette over the shoulder. This sartorial depiction is in keeping with Byzantine imperial attire, inflected by the short military tunic and overgarment known as a chlamys (Vatican City, Biblioteca Apostolica Vaticana, Vat. gr. 747, fol. 15r). The eunuch's chlamys is fastened by a bedazzled fibula over their shoulder and is wholly in keeping with the garb of a Constantinopolitan court eunuch. Thus, despite their dark skin, these trappings do not encourage us to read them as other, foreign, or different. In fact, in this image it is the eunuch, not Philip, who looks like a contemporary Constantinopolitan subject. As they are riding on a chariot, we might even surmise that this imperial eunuch might have had some function as an envoy or military official. It was clearly not enough for the artist to simply depict the Ethiopian as another imperial eunuch; the skin color resolutely articulates them as an Ethiopian. Thus we are left with the image of an imperial Constantinopolitan eunuch who just so happens to be black. The artist has abandoned stereotypical associations of eunuchs' flesh with pale-white bodies to depict a certain form of racial identity.

The rich, dark-blue chlamys of the eunuch seems to pulsate, flickering between cloth and skin. Looking closely, one notices that its outline is contoured in a thick jet-black pigment, which gives body to its folds, just as it does to the eunuch's face. A muddy-gold highlighting glazes the chlamys, giving it an ethereal quality that alters its overall appearance

into what looks at a cursory glance like hues of gray. Hence the jet-black contouring lines, blacker than the Ethiopian's skin, make it appear as if the dark blue of the chlamys is almost the same shade as the ash gray of the eunuch's skin. That blue of the chlamys is not a brilliant color, as we might associate with similar imperial garments; instead this cloth can only be described as the blue of the night sky, tinged with silvery moonlight. It would seem, then, that our eunuch's appearance is somehow caught between that light and dark, between night and day.

In Byzantine art, personifications of night and day are featured in the context of the Genesis cycle, when God separates the light from the darkness in Genesis 1:3–4, and in instances where the artist endeavors to personify nighttime in order to locate the time of day in which the scene is unfolding, as in the Vatican Octateuch (Biblioteca Apostolica Vaticana, Ms. Grec. 747).[13] However, one of the more lavish representations of night and day that comes down to us is in the mid-tenth-century Paris Psalter: once in the miniature depicting the parting of the Red Sea, where the personified Night (Nyx) is depicted as a bust-length bluish-gray figure in the top left corner of the scene, and again in the scene depicting Isaiah's Prayer to the Lord from Isaiah 26:9–21 (fig. 12.4). In the latter depiction, Night is shown as a full-length female figure wearing a classicizing peplos with flowing folds, and draped in a half-moon billow above her is a cloth manifesting the starry night sky, just as is seen in the former bust-length depiction. Her left hand falls, and along with it her long and elegant torch with its brilliant blue flame, signaling the waning of night. Here, Night is depicted to the left of Isaiah, while a rosy-pink child jauntily springs into the scene from the right carrying a torch with a dark-red flame. Just as Night is labeled, this child is labeled Dawn (orthros). His right hand gestures up toward Isaiah, who himself raises both hands to the hand of God in the far top-right corner of the frame. The two figures, Night and Dawn, literally manifest the opening of Isaiah's prayer, "I look for you during the night, my spirit within me seeks you at dawn" (Isaiah 26:9). Dark grays, rich blues, and muted purples flesh out the body and garments of Night,

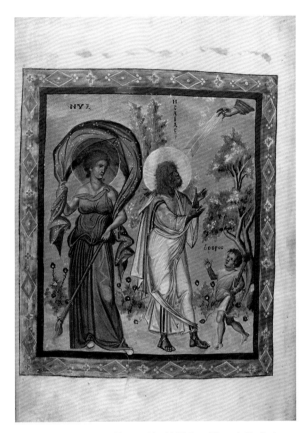

12.4. *The Prayer to the Lord from Isaiah with Night and Dawn* in the Paris Psalter, Constantinople, tenth century. Paris, Bibliothèque nationale de France, Par. gr. 139, fol. 435v

while a pungent red gives body to the fleshy baby, matching the hues of his torch, and his body is a rich pink. This is readily contrasted with Isaiah, whose flesh is reddened as if from years in the sun. Yet his garments are composed of a light-blue chiton and soft-pink himation, paralleling the tonalities of the palettes of the two personifications beside him. The pink garment that wraps around the blue almost seems to make manifest the overshadowing of night by day at the cusp of dawn. Isaiah, located as he is, thus comes to represent a figure on the edge of these two times of day.

This logic of handling the division between light and dark, day and night, seems to have been at work in Georgios's mind when he illuminated the miniature of Philip and the Ethiopian eunuch in the *Menologion*. As we gaze upon the eunuch's face, our eye is led down the outlining contour of the chlamys over their left shoulder and arm, making it seem as if their face and cloak are of the same tone. Fading into the richer blue with its dark shadowing, our eye is repeatedly deceived as to whether their skin as well might possibly be this same dark blue. And as the opposite of the figure of Isaiah, it is the blue chlamys that wraps over the pink tunic, the dark overshadowing the light. This contrast is made vividly by Philip's own garment, a pink chiton of the exact hue as that of the eunuch, whose shading and contours are handled quite the same, even though they are different types of garments. Philip's himation, on the other hand, contrasts starkly with the eunuch's chlamys. It is quite light, yet equally varied in the hues and color saturations; we note dull white highlights upon an olive-green color, while the contours of the fabric's folds and its outline over his left shoulder and arm are a tawny ocher. Turning to his face, we suddenly witness that the artist has deployed the same schema of colors to contour his visage: the same dull white marks are highlights on his face. The dull olive captures the shadowy right side of his face, the sides of his nose, the area around his eyes, and the shadows of the curves of his neck. And that ocher enlivens the lit left side of his face, particularly on his left temple, cheek, and neck. Thus, Georgios has deployed color with brilliant surgical precision across garb and skin to articulate the racial difference between the two figures. While their outward skins may differ, the two are the same in their Christian faith, manifested by the pink under-tunics that unite them.

Nevertheless, the eunuch's portrayal through a visual language articulated elsewhere for personifications of night and darkness is telling. More than a commentary on the Ethiopian's darkness as devoid of light, we can arguably understand Georgios's aim in depicting him as a figure betwixt day and night: mediating between the pale and boyish iconography of court eunuchs and the dark skin of their Ethiopian identity. That the unique depiction of Night and Dawn, in particular, from the Paris Psalter could have served as an inspiration for

the eunuch's depiction is quite feasible. The miniatures of the Paris Psalter, as Hugo Buchthal argued, are faithful copies of those commissioned by Constantine VII Porphyrogenitus (r. 912–59) in 952 for the fourteenth birthday of his son, the future emperor Romanus II (r. 938–63).[14] Romanus II would also become father of Basil II, for whom the *Menologion* was made around fifty years after the Psalter. The connection to the Prayer of Isaiah would have been particularly poignant here, given that the scene unfolds after Philip hears the eunuch reading from the book of Isaiah, and would go on to explicate to him the prophecy of Christ in Isaiah 53:7. Thus, in a sense, the image of Isaiah caught between Night and Dawn almost seems to foreshadow the story of the eunuch, who is also caught between the iconographic stereotypes of the dainty paleness of their castration and the Ethiopian darkness of their skin.

This form of representation is not how other people of color are depicted in the *Menologion*, for example, the figures of the dark-skinned Indians who martyr the apostle Thomas (fol. 93). The figure on the left has a striking profile, with pronounced nose and pointed chin. His flesh is dull, a blackish brown with hints of redness contoured with swaths of gray, notably down his sternum and rib cage, forearms, thighs, and shins. The figure on the right has darker pigmentations, but has similar facial features and a grayish, trimmed beard. His skin is just as dull, but blacker and with a similar mixing of pigments that give life to his arms and legs. Other depictions of persons of color throughout the manuscript are essentially treated with the same artistic technique as that used for the white figures, evidencing a great detail in contouring, which is achieved through a mixing of various color shades. This range of hues can be observed, for example, in the martyrdom of Theophilus the Younger by a Saracen (fol. 359) and of the monks of Mount Sinai by a tribe of Blemmyes and by Saracens (fols. 315–317; see fig. 12.1). And in all these instances, the depiction of the skin tones varies, indicating that a shared ethnic identity or grouping never suggested a homogeneous physical appearance in terms of skin tone. The two Indians differ in hue, and the Saracens and Blemmyes range from a

purplish brown to a grayish back with subtle variations. It must be noted that these various miniatures are made not by the same hand but by various of the manuscript's other artists, including Nestor, Pantoleon, and Michael of Blachernae. Nevertheless, the illuminations evidence a consistent handling of these figures of color, as is to be expected of the manuscript's renowned uniformity.

The eunuch's black skin, in comparison, evidences a striking regularity of color, which is what gives them that radiant, crisp, and refined appearance, seeming to glow off the parchment like an angel rather than a human being. Philip himself looks far more earthly, with his mottled contouring and pigmentation, in contrast to the pure radiance of the Ethiopian eunuch, who shares more with the gleaming personifications of Night than with the Indians, Blemmyes, or Saracens whom artists often clustered together with a vague geopolitical ideation of Ethiopia. Thus, I would argue that the eunuch's Ethiopian darkness is construed almost as some allegorical or personified image of darkness. Yet this darkness is not conceived as the absence of light, but rather as bearing its own luminosity, a figure that radiates darkness. The question that remains is why?

Looking across the depiction of Indians and other foreigners in the *Menologion* and the handling of the eunuch in the aforementioned Docheiariou synaxarion, we are confronted with the startling uniqueness of the Ethiopian eunuch in the *Menologion*. Unlike the treatment in the Docheiariou manuscript, which seeks to manifest the eunuch as belonging to another ethnos, the Constantinopolitan-like imperial eunuch in the *Menologion* proclaims their social and cultural interiority to the empire's center. That their complexion and overall body appear more like a personification of the Ethiopian's darkness than as an "ethnographic" sketch seemingly places them outside the militaristic economy of the *Menologion* and Basil's rule. Ethiopia is depicted as an ally, rather than a foreigner, and being at a loss as to how to depict the alleged epidermal alterity of that friend, the artist constructs it as a personification of darkness itself. "Ethiopian" becomes adjectival, modifying the hues of their identity as a court eunuch. Unlike

the other depictions of racial difference in the *Menologion*, the Ethiopian eunuch is therefore not othered, marginalized, but rather a subject and protagonist in the deeds of the empire. The Ethiopian is not one of the many neighboring foes of Basil II, but his servant and consort. He subverts our expectations, caught between the whiteness associated with their gender identity as a eunuch and the necessity for them to be dark as an Ethiopian. Hence, the artist produced an image that flickers between these possibilities, like night and day—a representation that ultimately articulates them not as a foreigner but as an imperial official.

In the *Menologion*, while the martyrs are usually wearing more classicizing Byzantine garments, the torturers often wear richly embroidered pants, shirts with pseudo-Arabic script, and other such details that articulate their distinction from the martyrs. This difference is not always contoured along the lines of skin color, and in the few instances where skin color is involved, it is clear that these enemies are treated neither as a monolithic racialized other nor as *only* racially different, as we have seen. Nevertheless, there is a murmur of racial tension in these images, and it is for this reason that I propose the artists resolved to have the Ethiopian eunuch depicted in a subtle, yet distinctly different manner than the non-Christian foreigners of color that seemed to strive toward some sense of ethnographic depiction in their facial features, garments, skin colors, and so on. Faced with the task of depicting an Ethiopian Christian eunuch in a manner that would not confuse the viewer into interpreting them as being somehow other to Philip, Georgios went to extensive pains to ensure that all these identities were favorably covered.

They are dressed in courtly attire with undertones of Byzantine military garb, articulating that they are on Basil II's side. Their facial features are youthful, dainty, refined, and feminine, ensuring that they properly read as a eunuch cultivated in the fineries of the imperial court. And when it came to conceiving of their Ethiopian identity, the artist chose not to simply render darker shades of skin color but to depict them as a personification of Night. Rather than dull and mottled, like most human figures (both friends and foes) in the manuscript,

the eunuch's skin radiates with darkness. Naturally, Georgios nevertheless had to ground the figure as a bodily, human form. And so he painted that pulsating night-sky chlamys, which captures the figure's origins as personification, while making them unquestionably earthly. In other words, the handling of the Ethiopian Christian eunuch's depiction is a visual metaphor for their intersectional identity, seeking to give representation to a subject whose identity lies at the intersection of several minority groups: eunuch, black, Christian. The fact that the eunuch cannot simply be a black Ethiopian, cannot simply be a pale eunuch, cannot simply be a (persecuted) early Christian, but must develop a new system of representation altogether, manifests the power of intersectionality as a methodology for the history of art—one that necessitates that we articulate new structures of representation to bring out the intersectional identities of medieval subjects.

The fact that such a rich and complex depiction of the Ethiopian eunuch occurs in a manuscript intensely focused on the martyrdom of Christian subjects at the hands of barbaric others nags us to rethink blackness in Byzantium. Elsewhere in Byzantine art, black peoples and other persons of color appear in the context of the Pentecost scene and in other depictions that similarly wish to stress the evangelization of the various peoples of the Earth.[15] Hence, the tenor of their depictions is usually positive, seemingly welcoming them into a broader Christian empire. The image of the Ethiopian eunuch demands that we confront the fact that while a long history of racial invective did indeed come down from antiquity, the Byzantines repeatedly turned racist stereotypes on their heads and had a radically different geopolitical placement in their identity as Mediterranean subjects with a range of skin colors and contacts with various persons of color.

One caveat is necessary regarding our outlook on epidermal difference in the Byzantine and neighboring worlds. Certainly the cosmopolitan conditions of a city such as Constantinople created a wider room for "Ethiopian"/black figures to maneuver favorably in art, literature, and daily life. Nevertheless, we should not accept this as suggesting that at that time there was no racism or prejudice based on skin

color. While it is necessary to pull the rug out from under the learned helplessness of modern racism as being a millennia-old phenomenon, beyond the possibility of radical and immediate change, we must also resist becoming apologists for racism by somehow normalizing the systematic oppression and brutality against racial minorities in history. If there is one lesson to be taken from this chapter, it is that blackness merits further study in Byzantium, but so do the other racialized minorities and ethnic groups who fell under imperial brutality. Blackness may not have been a focal point for marginalization and oppression in the medieval world, but that certainly does not mean that people of color were not severely marginalized and oppressed.

— Roland Betancourt is an associate professor of art history at the University of California, Irvine.

1 See Holmes 2005, 1–15.
2 See Stephenson 2003, 81–96.
3 On the *Menologion of Basil II* and its painters, see Ševčenko 1962, 245–76. See also Ševčenko 1972, 241–49.
4 Cutler 1977, 9–15.
5 See Stephenson 2003, 49–65. See also Cutler 1976, 9–19.
6 *Psalter of Basil II*, modified trans. Ševčenko 1962, 272.
7 *Menologion of Basil II*, trans. Ševčenko 1962, 273.
8 On intersectionality, see Crenshaw 1989, 139–67. See also Crenshaw 1991, 1241–99. On intersectionality and method, see Hancock 2016; Cho, Crenshaw, and McCall 2013, 785–810. On intersectionality in the medieval world, see Power and Whelan 2017. See also Betancourt 2018. Since, as Kathryn M. Ringrose (1994, 85–109, 507–18) has argued, eunuchs constituted a third gender in the Byzantine world, I have opted to use the singular they/their as the gender-neutral pronoun to describe all eunuchs and nonbinary figures in this chapter.
9 See Evangelatou 2009, 59–116.
10 Roth and Cousins 2002.
11 See Tougher 2008, 26–35. See also Ringrose 2003, 35–37.
12 Parani 2013, 433–63.
13 On Byzantine attire and terminology, see Ball 2005.
14 Buchthal 1974, 330–33. See also Buchthal 1938.
15 See A. Grabar 1968, 615–27. For a more generalist survey of this material, which is to be used with caution, see Devisse 2010a, 73–137.

Mobilizing the Collection: Teaching beyond the (Medieval) Canon with Museum Objects

KRISTEN COLLINS AND BRYAN C. KEENE

Museums with primarily European art collections *can* tell global narratives. As curators in the J. Paul Getty Museum's Department of Medieval and Renaissance Manuscripts, we have worked to consider the ways in which a collection that reifies the Western European canon can nevertheless serve as a fulcrum for discussions of premodern societies that were diverse, interconnected, and multicentered. Our holdings map trajectories from England to Ethiopia, Armenia to Tunisia. Despite this wide-ranging footprint, the balance of the collection nevertheless reinforces the long-held idea of Western Europe as the artistic center of the Middle Ages. The public accesses the collection primarily through the lens of small, single-gallery exhibitions, organized thematically to promote engagement with increasingly diverse and international audiences. Our brief as museum professionals is to teach an object-based global history. Our challenge: How do we move beyond the canon when we are working within it?

International loan exhibitions provide opportunities to expand art history beyond traditionally recognized centers and institutional parameters, but in this essay, we focus on strategies for mobilizing the permanent collection. Any object-based presentation in the galleries is necessarily constrained by issues such as budget, space, and the scope of the collection; when formulating exhibition narratives using only those objects at hand, curators are often forced to reconcile the ideal and the real. In the earliest medieval and Renaissance exhibitions at the Getty, manuscripts such as Martín de Murúa's *Historia General del Piru* (Ms. Ludwig XIII 16) or even Armenian Gospel books from the Lake Van region of historic Armenia (Ms. Ludwig II 6) and New Julfa (Ms. Ludwig II 7) were viewed as outliers to shows of French or Flemish illumination. The general evolution in the museum field away from "school" shows and toward thematic presentations incorporating various sociopolitical aspects of premodern societies

has helped to open a space for such objects. More recently we have applied the significant body of literature on a global Middle Ages to challenge the ways in which "the medieval" is mapped in the spaces of our galleries.

The 2016 exhibition *Traversing the Globe through Illuminated Manuscripts*, curated by Bryan C. Keene at the Getty, sought to effectively expand the geographic, artistic, and religious scope of "the medieval" by grouping Western European and Byzantine manuscripts from the collection with loans from local (Los Angeles) institutions of book arts from the Islamic world, South and Southeast Asia, Africa, and the Americas. The curator took an approach to the material that emphasized commonalities and linkages as he considered cultural contacts and the movement of peoples, ideas, and materials in the premodern world.[1] These were primarily positive stories.

We adopted a different strategy with the 2018 Getty exhibition *Outcasts: Prejudice and Persecution in the Medieval World*, focusing on some of the negative aspects of medieval European history and the difficult stories that are often avoided in art museums. The title *Outcasts* may signal a methodological framework that defines globality in terms of otherness, an approach that marked scholarship from decades past.[2] But the "other" was not the focus; rather, alterity provided a mechanism for making visible groups who were previously invisible in traditional presentations of our collection. An intersectional approach to this material provided an optic for examining images in which a powerful woman (later perceived as transgressive) was compared to Saracens, a re-gendered paramour and concubine was juxtaposed with sexually dominant Amazons, and devils and temptations were depicted as black Africans. Such examples demonstrate how the art of medieval Europe can reveal histories that both are true to the objects and resonate with contemporary audiences.

Medieval manuscripts from Europe preserve stories of romance, faith, and knowledge, but their luxurious illuminations can reveal more sinister narratives as well. Typically created for the privileged classes, such books nevertheless provide glimpses of the marginalized and the powerless, reflecting their tenuous social status. Attitudes toward Jews and Muslims, the poor, those perceived as sexual or gender deviants, and foreign peoples beyond European borders can be discerned through caricature and polemical imagery, as well as through marks of erasure and censorship. As repositories of history and memory, museums reveal much about our shared past, but all too often the stories told from luxury art objects focus on elites. Society in medieval Europe was far more diverse than is commonly understood, but diversity did not necessarily engender tolerance. Life presented significant obstacles for those who were not fully abled, white, wealthy, Christian, heterosexual, cisgender males. For today's viewer, the vivid images and pervasive narratives in illuminated manuscripts can serve as a stark reminder of the power of rhetoric and the danger of prejudice.[3] What follows addresses, briefly, those groups that were often considered strangers within European society, those perceived as enemies from beyond, and intersectional categories that include gender, sexuality, race, religion, and class.

Outcasts

From the perspective of museum collections of objects from medieval Europe, the presentation of diversity and global interactions necessarily involves histories of conflict, exclusion, and the formation of alien cultures in relation to the (often) acknowledged center. Our opening object label in *Outcasts* juxtaposed one of the dominant art historical narratives, that of style and period, with a close reading of the image's visual rhetoric. A masterpiece of Romanesque painting, the Stammheim Missal (1170s, fig. 13.1), with its gilded pages and geometric symmetry, celebrates Christian salvation history. At the same time, it reveals the institutionalized anti-Semitism that formed the basis of Christian rhetoric about the triumph of the Church.[4] Ecclesia, the personification of the Christian

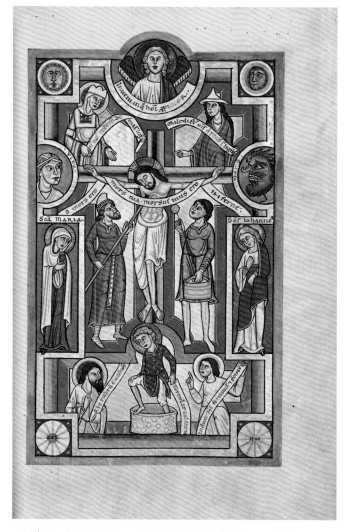

13.1. *The Crucifixion* in the Stammheim Missal, Hildesheim, Germany, 1170s. Los Angeles, The J. Paul Getty Museum, Ms. 64 (97.MG.21), fols. 85v–86

13.2. *Scenes from the Life of Saint Robert of Bury* in an illustrated *Vita Christi* (Life of Christ) with devotional supplements, East Anglia, England, 1490. Los Angeles, The J. Paul Getty Museum, Ms. 101 (2008.3), fol. 44

Church, is seen at Christ's right, while the Jewish Synagoga appears on his left. Often represented as a blindfolded figure, here Synagoga points at Christ, glaring. She holds a banderole (representing Old Testament law) that proclaims, "Cursed be he who hangs on the tree." Below, two additional personifications echo and amplify the antithetical positions of these two figures. In a roundel below Ecclesia, the fair-skinned figure of Life gazes calmly across the composition at Death, whose hook-nosed, swarthy features appear in caricatures of Jews in other twelfth-century images.

Blood libel was the false and incendiary claim that Jews killed Christian children for use in rituals that mocked the crucifixion. A twelfth-century illustrated *Vita Christi* (Life of Christ, fig. 13.2) with fifteenth-century devotional supplements provides the only remaining medieval images of Robert of Bury, an obscure child saint said to have been so murdered. The scenes at the upper left show a woman (possibly an accomplice) hiding the body in a well, and at right, an archer discovers the corpse. The establishment of Robert's cult appears to have been politically motivated. When two candidates vied for election to the seat of Abbot of Bury Saint Edmunds, the ultimate victor, Samson, accused his competitor of allowing the town's Jewish moneylenders inappropriate access to the abbey church. Under Abbot Samson, Robert's vita was written and a shrine erected for his veneration.[5]

Medieval manuscripts also reveal the ways in which writers and artists conflated or combined anti-Semitism and Islamophobia. The pages of the *Fueros de Aragón* (Feudal Customs of Aragon, fig. 13.3), discussed by Pamela A. Patton in part III of this volume, dictated where Jewish merchants were permitted to conduct business and legislated the movements of enslaved "Moors" (a medieval catchall and derogatory term for Muslims and black Africans) living in Christian lands. The law forbade Jews and Christians to return these slaves to their homelands. The manuscript avoids many of the negative caricatures often employed by medieval artists, perhaps reflecting the region's history of multiculturalism, but the text and images serve as a reminder of the strict constraints placed on out-groups living within Christian society.

13.3. Initial A: *Two Jews in Conversation*; initial Q: *Two Soldiers Leading Two Moors before a King* in the *Fueros de Aragón* (Feudal Customs of Aragón) or *Vidal Mayor*, Vidal de Canellas (translator), Huesca, northern Spain, 1290–1310. Los Angeles, The J. Paul Getty Museum, Ms. Ludwig XIV 6 (83. MQ.165), fols. 243v–244

The stringent realities of life in the Middle Ages, among them regular warfare and routine threats of violence, fanned the flames of xenophobia. Events from the past could be leveraged as powerful propaganda in the present. A page from the *Histoire de Charles Martel* (History of Charles Martel, 1467–72, fig. 13.4) no doubt reflected contemporary fifteenth-century concerns about the spread of Ottoman power with its narrative of Charles Martel (r. 718–41), the eighth-century French leader and grandfather of Charlemagne (r. 768–814) who prevented the advancement of Muslim armies from the Iberian Peninsula into Francia (France).[6] The text refers to the armies as Saracens, a pejorative term for North African Muslims (at

times used specifically to describe armies or warriors).[7] This manuscript was made after Constantinople, the capital of eastern Christendom, fell to the Ottomans in 1453. The book's patrons, Burgundian dukes Philip the Good (1396–1467) and his son Charles the Bold (1433–1477), commissioned a range of illuminated manuscripts with Crusading narratives during a time of heightened fear and aggression.

While the *Outcasts* exhibition contained examples highlighting histories of conflict, it also revealed how even positive portrayals of foreign peoples beyond the borders of Western Europe could signal a racialized worldview. The Queen of Sheba, one of the most powerful female protagonists of the Bible, offered gifts of precious metals and spices to King Solomon, who was famed for his wisdom.[8] The Gospels of Matthew and Luke report that she came from the "uttermost parts of the earth" to question the wise ruler. Medieval interpreters commonly identified her as African, usually an

13.4. *Roussillon Going to Martel's Aid* in *Histoire de Charles Martel* (History of Charles Martel), Loyset Liédet and Pol Fruit, Bruges, Belgium, 1467–72. Los Angeles, The J. Paul Getty Museum, Ms. Ludwig XIII 6 (83.MP.149), fol. 6

Ethiopian, but despite her purported origins she was typically "whitewashed" and represented as a European queen, as in a fifteenth-century Bible from Cologne (Los Angeles, The J. Paul Getty Museum, Ms. Ludwig I 13) or the Prayer Book of Cardinal Albrecht of Brandenburg (ca. 1525–30; see fig. 4.4).[9] When she was represented as a black woman, her blackness was not so much a recognition of diversity as an attempt to prove the universality of Christianity and its diffusion in lands beyond Europe.

When interpreting a collection that predominantly reflects a Western European worldview, globalities often serve as commentary on behaviors or characteristics that deviated from the perceived societal norm. When discussing art and literature from England between the thirteenth and the fifteenth centuries, Geraldine Heng demonstrates the ways that Jews and Saracens became tools for identity consolidation and the formation of an English nation.[10] Similar claims can be made of the German, French, Flemish, and Navarro-Aragonese works discussed above. Representations

of alien cultures also served to signal behaviors considered contrary to accepted social mores.

The Merovingian queen Brunhilde (ca. 543–613), dragged by a horse and then drawn and quartered, suffered a brutal death. Giovanni Boccaccio's fourteenth-century tales in *Des cas des nobles hommes et femmes* (The Fates of Illustrious Men and Women)—lurid stories with a moralizing twist—featured individuals such as she who had fallen from lofty positions of power.[11] Brunhilde, a historical figure who led armies and ruled over kingdoms, fell victim to the misogyny of later medieval authors, who cast her as the archetypal "nasty woman."[12] Variations of the story described her as ruthless and vengeful, characterizations also applied to Saracens. This parallel may explain the turbaned figures in the margins, which often served as a space for commentary on the larger picture. The "Saracen" in medieval art became a catchall category of people to be feared.

European manuscripts offer few images of Muslim women, with a notable exception offered in the *Roman de*

13.5. *King Haldin Accusing the Sultan's Daughter Gracienne of Dishonorable Behavior* in *Roman de Gillion de Trazegnies* (Romance of Gillion de Trazegnies), Lieven van Lathem (artist), Antwerp, Belgium, 1464. Los Angeles, The J. Paul Getty Museum, Ms. 111 (2013.46), fol. 150v

Gillion de Trazegnies (Romance of Gillion de Trazegnies, 1464, fig. 13.5) with the trope of the Christian convert.[13] In a palatial throne room meant to evoke Cairo in Egypt, a Muslim courtier maligns the chastity of the sultan's daughter, Gracienne; she kneels at left next to Gillion, a Christian knight who has fallen in love with her. Turbans and exotic headgear identify the figures of the sultan's court, who otherwise resemble inhabitants of the Burgundian Netherlands, where this manuscript was made. As in contemporary romance, Gracienne, though seemingly represented as a white European, sets herself apart from acceptable behaviors for women through her effusive demonstration of love for Gillion.[14] Gracienne's conversion to Christianity and Gillion's Mediterranean journey likely appealed to the manuscript's patron, a courtier to Duke Philip the Good. As mentioned above, Philip was committed to defending Christian lands in the Levant against the Ottoman Turks.

Medieval writers expressing moral judgment often framed such commentary on sexuality in terms of foreign peoples. The third-century BCE world ruler Alexander the Great, for example, had a range of lovers, including the young man Hephaistion and the eunuch Bagoas.[15] In Vasco da Lucena's fifteenth-century CE French translation of Quintus Curtius

Rufus's first-century CE Latin account of Alexander's life (Los Angeles, The J. Paul Getty Museum, Ms. Ludwig XV 8), Bagoas is recast as a beautiful woman, called Bagoe, in order to "avoid a bad example," according to the text. In the illumination, Bagoe wears luxurious, flowing garments that align her with the sexual mores of the fifteenth-century Burgundian court but also liken her to the spear-carrying Amazon women in the background. The Amazons were renowned for their military prowess and heightened sexual drive. The literary and artistic re-gendering of Bagoas/Bagoe reveals the predominant prejudice against same-sex attraction and, by comparison with the Amazons (who, like Bagoas/Bagoe, were described as sexual temptations), the wariness regarding powerful women that pervaded medieval society.

The field of academic publishing is quickly moving to enhance our ability to teach global art history by producing new textbooks with rich digital components. Museums, libraries, and archives are beginning to broaden their remit, collecting and displaying in a way that connects to an increasingly international and diverse audience. Expanded collecting parameters provide one means of charting a course away from canonicity; this can be a slow, laborious process, however. The 2018 acquisition of the Rothschild Pentateuch,

for example, was the product of a thirty-five-year search. This remarkable illuminated Hebrew manuscript allows the Getty for the first time to represent the artistic heritage of each of the Abrahamic faiths—that is, of the People of the Book (see figs. introduction.6 and IV.7). Teaching global art history in the museum today is as much about changing method as it is about changing content. With greater frequency, curators are called upon to adopt an "outside-in" approach that incorporates feedback from audiences in the gallery and online. Building upon questions from visitors to the *Outcasts* exhibition and website, we have organized a collections-based exhibition called *Balthazar: A Black African King in Medieval and Renaissance Art* to open at the Getty in 2019. The late fifteenth-century black African Magus, a Zoroastrian stargazer who brought gifts to the Christ Child, is a paradoxical figure (see figs. 4.4, IV.9). His presence reveals the racial diversity in Europe at a time when ecumenical church councils welcomed delegates from Ethiopia and the Coptic Church of Egypt to Florence and Rome. At the same time, Europeans began to engage in the brutal African slave trade. Collections change slowly, but as we have demonstrated through this case study, we can be more responsive to the changes in scholarship and the world by being more creative about the histories we present through our existing objects.

— Kristen Collins is curator of manuscripts at the J. Paul Getty Museum.

— Bryan C. Keene is associate curator of manuscripts at the J. Paul Getty Museum.

1 A concurrent exhibition at the Getty Research Institute, *Cave Temples of Dunhuang: Buddhist Art on China's Silk Road* (May 7–September 4, 2016), extended the history of book arts to East Asia.

2 Our aim was to title the exhibition in a way that would be immediately understandable to a large, non-specialist audience while also paying tribute to Ruth Mellinkoff's groundbreaking scholarship. *Outcasts: Signs of Otherness in Northern European Art of the Late Middle Ages* provided a lasting model for discussions of the many out-groups of medieval society. See Mellinkoff 1993.

3 The text of this essay is based on our exhibition *Outcasts: Prejudice and Persecution in the Medieval World* at the J. Paul Getty Museum, January 30–April 8, 2018 (http://getty.edu/outcasts). Over the course of 2017, the field of medieval studies responded to numerous charges of implicit bias and overt racism, both within the academy and at a societal level in the United States. Some examples of these instances and the field's response included, for instance, an all-white and male panel on medieval "others" at the International Medieval Congress annual conference at the University of Leeds (http://www.chronicle.com/article/Medievalists-Recoiling-From/240666), the treatment of Hawaiian culture at the International Society of Anglo-Saxonists (ISAS) meeting in Honolulu (http://www.inthemedievalmiddle.com/2017/07/decolonizing-anglo-saxon-studies.html), the important message and mission of Medievalists of Color (http://medievalistsofcolor.com/medievalists-of-color-/on-race-and-medieval-studies), and the Public Medievalists series of blogs on race and the Middle Ages (http://www.publicmedievalist.com/race-racism-middle-ages-toc/). Luke A. Fidler wrote a compelling piece for the Material Collective blog about teaching medieval art history in a time of white supremacy, in light of the appropriation of medieval history and culture by alt-right and neo-Nazi groups (http://thematerialcollective.org/teaching-medieval-art-history-time-white-supremacy/). The Medieval Academy and others responded to the appalling (and yet all too familiar) appropriation of medieval imagery by white supremacists following the call to remove a statue of Robert E. Lee at the University of Virginia in Charlottesville (http://www.themedievalacademyblog.org/medievalists-respond-to-charlottesville/). Such pivotal moments took place during the writing of this book and will continue to shape medieval studies.

4 See Lipton 2014, 120–25.

5 For more on Robert of Bury, see Bale 2006; K. Collins 2017; Rose 2015, 186–206. For a discussion of real and imagined Christian-Jewish relations in England, see G. Heng 2012, S54–S85.

6 For the history of the manuscript, see Kren, McKendrick, and Ainsworth 2003, 231–33, no. 55.

7 See Strickland 2003; Akbari 2009; Arjana 2015.

8 See Devisse and Mollat 2010, 83–152.

9 For discussions of the concept of race in the Middle Ages, see T. Hahn 2001, 1–37; Lomperis 2001, 147–64; G. Heng 2011a; G. Heng 2011b; G. Heng 2015, 358–66; Mittman 2015, 36–51; Whitaker 2015, 3–11; Whitaker 2016; D. Kim 2016; Lomuto 2016; "Race, Racism and the Middle Ages" series 2017.

10 See G. Heng 2005, 250.

11 See Hedeman 2008.

12 While utilizing a global approach, this exhibition was also heavily influenced by social justice issues. Just as Crusading narratives reflect the political culture of fifteenth-century Eurasia, this show (written in the early months of 2017) cannot help but interpret the medieval through the lens of contemporary politics. For a larger discussion, see note 3 above.

13 See Morrison 2015, 125.

14 De Weever (1998) discusses the whitening of Saracen princesses and their overt sexuality.

15 See McKendrick 1996.

Color, Culture, and the Making of Difference in the *Vidal Mayor*

PAMELA A. PATTON

The *Fueros de Aragón* (Feudal Customs of Aragón), also referred to as the *Vidal Mayor* (Los Angeles, The J. Paul Getty Museum, Ms. Ludwig XIV 6), hardly announces itself as a global manuscript.[1] Produced ca. 1300 in a northeastern Spanish center, probably Pamplona, it contains a unique Navarro-Aragonese translation of local laws (*fueros*) originally compiled in Latin by a local bishop, Vidal de Canellas of Huesca (active ca. 1236–52), for the Aragonese count-king Jaume I (r. 1213–76) in the mid-thirteenth century.[2] Although the code was never promulgated fully throughout historical Aragon, much less in the rest of the Crown formed by that kingdom's union with Catalunya in 1137,[3] a half century later it was translated into the local vernacular and recorded in the Getty codex by a certain Miguel López de Zandio (active ca. 1297–1305). Surnamed for a village thirteen kilometers to the north of Pamplona, López is known to have worked as a notary in the latter city between 1297 and 1305. The colophon names him as having written the manuscript ("iste liber scripsit Michael Lupi de Çandiu"; fol. 277).[4]

The work's patron is unrecorded, but its costly decoration, which includes 156 miniatures, gold leaf applied so lavishly that it even extends to pilcrows (paragraph marks), and two instances of the Aragonese coat of arms, suggests a royal commission, perhaps by Jaume II (1291–1327), with whose reign its production likely coincided.[5] It hews to local convention in combining French-derived stylistic elements with Aragonese costume details: an open-armed *pellote* (a sideless surcoat or overgown), a distinctively pointed Jew's hat, and a towering feminine headdress memorably compared by C. M. Kauffmann to an inverted breadbasket.[6] Despite its material luxury, these homely details, combined with the vernacular text and parochial subject matter, lend the manuscript such a provincial air as to inspire one legal commentator to pronounce it "about as cosmopolitan as the manual of Supreme Court trial practice of Wisconsin."[7]

Yet *Vidal Mayor* possesses international dimensions. As a systematic law code regulating nearly all aspects of Aragonese society, it shares features with legal manuscripts produced throughout the later medieval West. Its division into nine books was modeled on the Justinianic Code and Digest of the *Corpus Iuris Civilis*, the legal compilation that became the basis for European canon law after its eleventh-century revival at the University of Bologna, the center where Vidal de Canellas himself would study.[8] Its decorative program, featuring large illuminated initials opening each book and smaller ones introducing each *fuero*, is typical of Western juridical illustration from the mid-thirteenth century onward.[9]

These illustrations also engage with the transformed world into which the *Vidal Mayor* emerged some fifty years after the creation of its Latin model. In 1238, the Crown of Aragon had expanded southward, capturing Muslim-held lands in Valencia and parts of Murcia before halting at the borders of Castile and Granada. Reorienting its political appetites toward the Mediterranean, the Crown initiated a shrewd combination of conquest and alliance to create a far-flung empire, which by ca. 1300 included the Balearic Islands, Sicily, parts of Greece, and tributary zones in North Africa and West Asia. This dynamic outward turn, intensified by the development of the Catalan merchant marine, facilitated the formation of commercial networks that reliably linked the Crown to trade centers across the Western and Eastern Mediterranean.[10] In medieval terms, the Crown of Aragón had become a global player.

This characterization draws on Janet Abu-Lughod's description of a late medieval "world system" in which interconnected zones of commercial exchange formed a global network that by ca. 1300 linked Asia, Northern Africa, and Europe.[11] Abu-Lughod's model minimizes the participation of the Iberian Peninsula, but the direct engagement of the Aragonese Crown in at least three of the schema's subsystems justifies its inclusion.[12] Moreover, although scholarship on medieval globalism tends to privilege instances of interaction and exchange where such subsystems overlap, I would argue that these instances also occur in their centers and hinterlands, including those of Aragon.

It is this internal global impact—perhaps best envisioned as a cultural ripple washing back from the margins of the Aragonese empire at the turn of the fourteenth century— that the present essay investigates. It examines several initials in the *Vidal Mayor* that reveal this impact clearly: those introducing *fueros* regulating Jews and Muslims, the Crown's two official religious minorities. The two groups' status as religiously and socially other automatically placed them at the conceptual margins of Aragonese society, while their membership in faith communities that were recognized as global linked them implicitly with cultural and geographic spaces that lay beyond those borders. As will be shown, the *Vidal Mayor* illuminator demonstrated this not merely in choosing to articulate Jewish and Muslim difference visually but in drawing on internationally known stereotypes that emphasized the two groups' perceived potential to disrupt the local social order and conveyed the aspirations and anxieties of an increasingly global Aragonese society.

Jews and Money

Aragonese Jews were an internalized other, having lived among both Christians and Muslims there since the early Middle Ages.[13] Although they had been, and to some extent still were, much freer in their choice of occupation than were Jews in many other parts of Europe, during the thirteenth century many Jews in the Crown of Aragon had gravitated toward moneylending, encouraged by restrictions on lending between Christians, the obstruction of Jews from overseas trade, a booming national economy, and the support of the king, who reaped a percentage of Jewish interest.[14] Jewish lending benefited the growing economy but, especially toward the end of the thirteenth century, also raised anxieties among the nobles, clerics, and merchants whose growing dependence on it led to repeated disputation of the terms, honesty, and even validity of such loans.[15] This is reflected in the four *Vidal Mayor* initials depicting Jews, which despite introducing *fueros* concerning diverse aspects of Jewish life, including inheritance rules and livestock management as well as commercial activity, focus unwaveringly on tropes of Jewish financial control, cupidity, and dishonesty.

14.1. Initial *E: A Jewish Notary Recording a Loan between Jews and Christians* in the *Fueros de Aragón* (Feudal Customs of Aragón), or *Vidal Mayor*, Vidal de Canellas (translator), Huesca, northern Spain, 1290–1310. Los Angeles, The J. Paul Getty Museum, Ms. Ludwig XIV 6 (83.MQ.165), fol. 114

14.2. Initial *A: A Jew and a Christian Making a Loan* in the *Fueros de Aragón* (Feudal Customs of Aragón) or *Vidal Mayor*, Vidal de Canellas (translator), Huesca, northern Spain, 1290–1310. Los Angeles, The J. Paul Getty Museum, Ms. Ludwig XIV 6 (83.MQ.165), fol. 180

The first such initial, an *E* on folio 114r (fig. 14.1), prefaces a *fuero* with the rubric "De fide instrumentorum, es a saber, de la creyença de los instrumentos" (On faith in instruments).[16] It requires that contracts and loans between parties of different faith communities be recorded by a notary of the same group as the obligated party, reflecting the reality that Iberian Christians, Muslims, and Jews, all prohibited by their own laws from lending at interest within their communities, continued to lend across faith lines.[17] The miniature hews to conventions of juridical illustration in its straightforward visualization of the passage: it depicts two Jewish lenders, identifiable by their pointed hats, counting out money to two Christians, one possibly wearing a monk's habit. The Christians proffer

a chalice as collateral for the loan, while a third Jew records the transaction.

Since the *fuero* text successively addresses all possible combinations of interfaith exchange, including those in which Christians and Muslims serve as lenders, the illuminator's choice to depict Jews as lenders here is notable. It dovetails well with the stereotype of the duplicitous Jewish moneylender, a topos already well known in Northern Europe.[18] Disseminated in miracle tales and preaching *exempla* that cast Jews as predatory deceivers eager to ensnare innocent Christians through unfair or misleading transactions, the moneylender stereotype had slipped into Aragon over the course of the thirteenth century, coinciding with the growth of Jewish economic activity there. The artist's adoption of it here implies an active response to this.[19]

A similar choice appears in an oft-represented initial *N* on fol. 175v, which prefaces a *fuero* with the rubric, "De usuris, es a saber: de logro" (On usury).[20] The *fuero* states simply that no man may demand usury from another. It makes no reference to Jews, nor to cross-cultural lending, yet the disputed loan brought before the king in the initial's left half clearly was made by a Jew to a Christian, whose transaction is illustrated at right. The decision to preface this generic passage with a depiction of Jewish usury is reinforced by the *fuero*'s next section, which adds specific restrictions on loans made by Jewish moneylenders, whose "avarice and cupidity" it decries.[21]

The deceptiveness imputed to Jews constitutes the theme of an *exemplum* on fol. 180r, which is introduced by the rubric "De dolo, es a saber, De engaynno" (On trickery).[22] One of several short didactic tales interspersed among the *fueros*, it recounts how a Jewish borrower tried and failed to deceive a Christian moneylender by offering a fake silver chalice as collateral. Alert to the scheme, the Christian hid his inventory and pretended to have been robbed. The Jew repaid the loan immediately, expecting the lost chalice to be replaced by one of good silver, but to his shock, he received the same false goods. The tale admonishes, "There is no law against deceiving the deceiver."[23]

In the left half of the initial *E* that opens the *exemplum* (see fig. 14.2), the Jew is shown receiving a bag of money as he hands his chalice to the Christian lender; at right he gestures in surprise as the Christian returns his collateral and gathers up the repayment. While this illustration too could be described as literal, its interreligious tensions are amplified by marginalia on the same page. Beside the left text column, a bearded half figure wearing a Jew's hood points reproachfully at the words, "era de falsa plata" (it was made of fake silver), while in the upper margin a crowned hybrid battles a gryllus whose full-bearded profile may be meant to represent a Jew.

The characterization of Jews in an initial on fol. 243v, transcribed by some as an *E* but clearly an *A*, represents a variation on the theme of Jewish greed (see fig. 13.3).[24] The *fuero*'s rubric is generic—"De iudeis et sarracenis, es a saber:

De los judios y de los moros" (On Jews and Muslims)—and its four sections address a variety of issues related to both faith groups, including fines for assault, regulations for the sale of property, and rules for managing livestock.[25] The scene chosen for the initial, however, again focuses on Jews, depicting a pair of Jewish merchants seated within small, arched structures: one holds up a garment as additional clothing hangs behind him, and the other hammers at a chalice. They may relate to the *fuero*'s first section, which warns Jewish merchants not to sell goods in the street (presumably to evade royal taxes) but to rent a store in the king's market. Beyond its promotion of a financial scheme beneficial to the royal coffers, the passage suggests both fear of Jewish trickery and awareness of Jewish economic potential.

The *Vidal Mayor*'s emphasis on abstract "Jewish" features such as deceptiveness and greed is the more striking for its lack of the physiognomic caricature—typically an enlarged nose, staring eyes, and wild beard and hair—often assigned to Jews in Northern European art at this time.[26] Apart from their pointed headgear and slightly longer beards, Jews in the *Vidal Mayor* so closely resemble their Christian counterparts that it is their financial activity, not their appearance, that identifies them. This reversal of common practice underscores the intensity of Aragonese concern about the economic role of Jews in the newly internationalized Crown, in which Jewish moneylending and commerce predominated in ways perhaps not envisioned by Vidal de Canellas when he wrote his law code fifty years earlier.

Muslims, Sin, and Slavery

If the *Vidal Mayor* signals Jewish difference through stereotyped behavior, it presents Muslim alterity through stereotyped faces and bodies, a contrast distinctively reflective of the Muslim position in thirteenth-century Aragon. Unlike the Jews, whose incorporation into the Crown was long-standing and firmly if anxiously controlled, Muslims represented inveterate outsiders. Whether military antagonists doggedly holding on in Granada or uncertainly repressed subalterns living within the Crown, Muslims remained foreigners set apart

14.3. Initial S: *The Baptism of a Moor (Muslim)* in the *Fueros de Aragón* (Feudal Customs of Aragón), or *Vidal Mayor*, Vidal de Canellas (translator), Huesca, northern Spain, 1290–1310. Los Angeles, The J. Paul Getty Museum, Ms. Ludwig XIV 6 (83.MQ.165), fol. 242

by language, religious practice, and cultural ties to far-flung lands.[27] Their portrayal in the *Vidal Mayor* reflects this vividly.

The first of two initials to depict Muslim figures is an *S* on fol. 242v (fig. 14.3), opening a *fuero* with the rubric "De judeis et sarracenis baptizandis, es saber: de los judios y de los moros que vienen a baptismo" (On baptized Jews and Saracens, that is, on Jews and Muslims who come to baptism).[28] This mandates the protection of rights and property for Jews and Muslims who are baptized as Christians, and also stipulates that both faith groups must comply peacefully when summoned by Christian clerics to hear conversionary preaching. The initial portrays a nude male figure with deep brown skin and curly hair, flanked by a pale-skinned priest and two white godparents as he awaits baptism in the font. The

figure's rich skin color, derived from a blend of red, black, and yellow pigments, is unique to Muslim figures in the manuscript. Heightened by tiny dabs of white for teeth, eyes, and nails, a delicate stroke of red for the lip, and snail-like curls, the stereotype draws clearly on classical depictions of sub-Saharan Africans.[29]

The distinctiveness of these features alone might explain the artist's decision to employ them in the baptism initial, where a light-skinned Muslim or Jew, unclothed, might have been unidentifiable. Yet the choice raises a second question: Why make a Muslim look like a black African at all? Most Muslims in Iberia at the end of the thirteenth century were of Arab or North African, not sub-Saharan, descent and thus light or medium complexioned, a fact reflected in the

diversity of skin colors assigned to Muslim figures in other Iberian works of the era, such as the frescoes of the Palau d'Aguilar in Barcelona or the manuscript commissions of Alfonso X of Castile.[30] The dark-skinned figure here draws on a more generalized stereotype known in medieval terms as an "Ethiopian." Originating in the ancient Mediterranean world, where it had served as a semi-geographic referent for the peoples inhabiting Ethiopia proper but also Western and Central Africa, the Ethiopian gradually lost its specificity over

14.4. *Black and White Wrestlers*, painting from the Cappella Palatina, Palermo, Italy, ca. 1143. Grube and Johns 2005, plate VII

the course of the Middle Ages, hardening into an abstract stereotype whose black, brown, or occasionally blue skin and formulaic physiognomic features could represent all manner of foreign peoples, real or imagined, from sub-Saharan Africa, Egypt, or India.[31]

As Debra Strickland and others have shown, the Ethiopian's distant origins and perceived extremes of color, shape, and habits facilitated its association with multiple moral deficiencies, from lethargy and cowardice to barbarity, violence, and sinfulness.[32] These correlated easily with perceptions of Muslims in late thirteenth-century Aragon, whose Christian inhabitants were well aware of the Muslim-led forces that waited beyond their frontiers, as well as of the thousands of *mudejars*, or unconverted Muslim subjects, who lived throughout the Crown. In recently conquered zones such as Valencia, Mallorca, and Sicily, Muslim populations far outnumbered their Christian counterparts and were scarcely integrated into their new setting. The phantasm of the barbaric black African embodied the foreignness and violent potential ascribed to these subgroups by nervous Christian overlords and neighbors, a potential also found in thirteenth-century literary narratives ascribing black skin and uncanny features to Muslim characters.[33] Like such texts, the black figure in the *Vidal Mayor* feeds the fantasy of Christian social control over a perceived aggressor by presenting the baptizand as a dangerous black man subordinated, stripped, and surrounded by authoritative white Christians.

The Ethiopian stereotype also offered a shorthand for low social status, as illustrated by the Q on fol. 244r (see fig. 13.3), introducing a *fuero* with the rubric "De sarracenis fugitivis, es saber, de los moros fuidiços" (On fugitive Muslims).[34] The *fuero* forbids Jews or Christians from secretly employing or transporting Muslim slaves and threatens to confiscate the goods of anyone hiring a "moro" or taking him to the "tierra de los moros" (land of the Muslims) without the owner's knowledge. The initial depicts two figures with the same brown skin, curly hair, and distinctive physiognomy as the Muslim of folio 242v (see fig. 14.3). Clad in simple white robes, they are presented to the king by two white-skinned soldiers.

The Ethiopianized appearance of these figures had minimal basis in the social realities of thirteenth-century Aragon, where slaves of sub-Saharan African descent were substantially outnumbered by locally enslaved war captives.[35] Instead, their dark skin drew on long-standing stereotypes of slaves and servants as black. Building on Roman visual traditions, the stereotype of the black retainer was revived in Europe in the twelfth and thirteenth centuries, especially in Mediterranean zones.[36] In Iberia from the late twelfth century onward, black figures served as slaves, servants, and soldiers in a wide variety of media and contexts.[37] This practice might have been strengthened by an awareness of painting traditions in western Islamic lands, in which slaves and servants often were shown with dark skin. The painted *muqarnas* ceiling of the Cappella Palatina in Palermo, produced circa 1143, preserves two such figures: one, apparently a servant, wears a simple waist wrap and gold ornaments on his upper arms, and the other, a nude wrestler, struggles with his white opponent (fig. 14.4).[38]

The participation of the *Vidal Mayor* in this visual equation of blackness and servitude offers a curiously syllogistic extension of the *fuero* itself, in which the word *moro*, already suggestive of blackness, also serves as the functional equivalent for "slave." To be Muslim, in this context, was to be both enslaved and black. While this logical circularity hardly reflected the range of ethnicities or social roles characteristic of actual *mudejars* in thirteenth-century Aragon, it roots the social inferiority of the *Vidal Mayor* figures within an international cultural tradition.

The depiction of Jews and Muslims in the *Vidal Mayor* offers subtle but telling evidence of the changes wrought by globalism in the Crown of Aragon—a globalism more complex, and with far greater artistic ramifications, than this brief essay can address. The manuscript's deployment of internationally meaningful stereotypes reveals a heightened perception of both groups' foreignness to Aragon's dominant culture, while their adaptation to local concerns addresses the preoccupations of a population freshly awakened to the social and economic changes that accompanied Mediterranean expansion. The images also highlight the iconographic pliancy of such figures, attesting that, to adapt once more Claude Lévi-Strauss's oft-adapted dictum, Aragon's Christians found Muslim and Jewish stereotypes "good to think with," offering flexible visual-conceptual targets for the anxieties and appetites sparked by their changing world.[39]

The broad purview of these images opens space for the *Vidal Mayor* in a volume examining medieval manuscripts within a global context. The stolid, vernacular, quaintly dressed figures (the legalese notwithstanding) in the book's fine-tuned portrayals of Muslims and Jews show that the mid-thirteenth-century world for which Vidal de Canellas had composed his text was now considerably wider. When a patron of substantial means—perhaps indeed the imperially oriented King Jaume II, whose fluctuating relationships with religious minorities at the turn of the fourteenth century merit closer consideration—commissioned that text's preservation in a new luxury manuscript, these miniatures helped adapt the law code to a changing world. In preserving the past while embracing newly broadened horizons, the *Vidal Mayor* miniatures demonstrate that even the most local medieval artist might surprise us by thinking globally.

— Pamela A. Patton is director of the Index of Medieval Art at Princeton University.

1 "Fuero de Aragon," Getty Ms. Ludwig XIV 6. Critical editions: Tilander 1956; Cabanes Pecour, Blasco Martínez, and Pueyo Colemino 1996. See also Kauffmann 1963–64, 299–325; García-Granero Fernández 1980, 243–64; Ubierto Arteta 1989; Lacarra Ducay 2012, 7–44; Fatás Cabeza 2014.

2 Cabanes Pecour, Blasco Martínez, and Pueyo Colemino 1996, 9–16.

3 Bisson 2000, 31.

4 "Laus tibi sit, Christe, quoniam liber explicit iste. Iste liber scripsit Michael Lupi de Çandiu"; see García-Granero Fernández 1980, 248–54.

5 The royal arms appear on fols. 84 and 232v. Lacarra Ducay (2012, 27–34) associates the manuscript with either Pere III (r. 1276–85) or Alfonso III (r. 1285–91), based mainly on questionably dated stylistic comparanda. This study adheres to the date range suggested by the scribe's recorded activity.

6 Kauffmann 1963–64, 323; on the Jew's hood, see Patton 2012, 25–27.

7 Weiner 2013.

8 Gout Grautoff 2000, 67–79, at 70. On Canellas in Bologna, see Delgado Echevarría 2009.

9 Gout Grautoff 2000, 67–71.

10 Bisson 2000, 86–103; Hillgarth 1975.

11 Abu-Lughod 1989, esp. 3–20, 32–40; see also A. Walker 2012, 183–96.

12 Subsystems I, II, and V; Abu-Lughod 1989, 34.

13 Assis 1997a.

14 Assis 1997b, 15–27.

15 Assis 1997b, 49–63.

16 Book III, 39. Cabanes Pecour, Blasco Martínez, and Pueyo Colemino 1996, 125.

17 ". . . si el cristiano vende al judío or al moro, o da o aloga o empriesta o se premete de fazer o de dar, el escrivano cristiano deve ser" (. . . if the Christian sells to the Jew or the Muslim, or gives or rents or lends or promises to do or to give [to one], the Scribe must be Christian). Cabanes Pecour, Blasco Martínez, and Pueyo Colemino 1996, 126. On interfaith lending in the Crown, see Milton 2006, 301–18.

18 Strickland 2003, 140–43; Lipton 1999, 300–322.

19 Patton 2012, 54–62.

20 Book V, 17. Cabanes Pecour, Blasco Martínez, and Pueyo Colemino 1996, 188. For the initial, see Patton 2012, 58, fig. 32.

21 Cabanes Pecour, Blasco Martínez, and Pueyo Colemino 1996, 188–89; Patton 2012, 58–59.

22 Book V, 21. Cabanes Pecour, Blasco Martínez, and Pueyo Colemino 1996, 192.

23 "Ninguna ley no vieda de engaynnar al qui engaynna, et así el art est engaynnado por art" (There is no law against deceiving the deceiver, and as such the art of deception is itself an art). Cabanes Pecour, Blasco Martínez, and Pueyo Colemino 1996, 192.

24 Transcribed as an E by Tilander (1956, 474) and Pecour et al. (1996, 188), but its form is consistent with A initials in the manuscript. The resulting "al" would then identify "el judio" (the Jew) as the object of "será constreynnido de responder" (will be constrained to respond).

25 Book VIII, 12. Cabanes Pecour, Blasco Martínez, and Pueyo Colemino 1996, 254.

26 See for example Strickland 2003, 105–7; Lipton 2014, 171–99. For Iberia, see Patton 2012, 67–96.

27 Tolan 2002, esp. 174–80.

28 Book VIII, 11. Cabanes Pecour, Blasco Martínez, and Pueyo Colemino 1996, 253.

29 I thank Getty manuscripts conservator Nancy Turner for information about the pigments. On classical depictions of Africans, see esp. Tanner 2010, 1–39; Verkerk 2001, 57–77.

30 For Palau d'Aguilar, see Patton 2012, fig. 28. On Muslims in the Cantigas de Santa María, see esp. García-Arenal 1985, 133–51; Klein 2008, 67–86.

31 See Block Friedman 1981, 8, 54–55, and 64–65; Strickland 2003, 79–93; Devisse 2010b, 31–72, esp. 46–55.

32 Strickland 2003, 79–83; Devisse 2010b, 46–55; Byron 2002, 55–76.

33 Patton 2012, 114–17.

34 Book VIII, 16. Cabanes Pecour, Blasco Martínez, and Pueyo Colemino 1996, 255.

35 W. Phillips 2013, 10–27, 57–61; Constable 1996, 264–84.

36 Verkerk 2001, 60–61; Devisse 2010b, 64–72; Kaplan 1987, 29–36.

37 See Monteira Arias 2012, 479–88; García-Arenal 1985, 137–38; Constable 2007, 341–42, fig. 20.

38 Grube and Johns 2005, pl. VII; Brenk and Settis 2010, 560–62 (cat. 510), 571–72 (cat. 550), and IV: figs. 406–7, 435.

39 Lévi-Strauss 1963, 89.

Horses, Arrows, and Trebuchets: Picturing the Mongol Military Campaign in Eurasia

KAIQI HUA

The conquests of the Mongol army (thirteenth century) filled the pages of manuscripts—illuminated and textual alike—across Eurasia.[1] This dramatic political and humanitarian crisis of the thirteenth century impacted more than a dozen states and countless peoples across a vast geography, from present-day Hungary to Japan. The turmoil inflicted by the Mongol armies loomed large and lasted long in the memories of generations affected by the events, which artists and writers throughout these regions depicted in a range of manuscripts. Some of these individuals were survivors of the Mongol raids, having either witnessed firsthand or overheard accounts of brutal military campaigns. Mongol warfare and attack strategies were visualized as devastatingly catastrophic in the eyes of the defenders, regardless of the cultural or manuscript tradition.[2] Moreover, these images also show a similar pattern of military encounters when Eurasian states faced the Mongol army and were ultimately left fragmented. The most common motifs of these battlefield illustrations include horses, arrows, and catapults, which the Mongols used in hot pursuit, long-range attack, and in the sacking of cities, respectively.

From the hagiography of a royal saint in Silesia (southwest Poland) to a world history written in Ilkhanid Persia (the westernmost territory of Mongol-occupied Asia), manuscript illuminations showing Mongol warfare were produced based on both shared disaster memories and constant fear of violence from foreign invaders throughout the thirteenth and fourteenth centuries. Thus, these battle depictions have similar patterns, such as weaponry use and horse pursuit scenes, although the artists did not always depict the Mongol weaponry with great accuracy. The artists in general were interested in visualizing the brutality of warfare, which demonstrates their xenophobia due to the collective memory of violence. The Mongol armies comprised international forces, including different Mongol tribes and states, and captives and mercenaries from other ethnic groups. Only a few illustrations include different types of individuals in the Mongol armies, such as the *Chingiznama* (History of Genghis Khan, fig. 15.1) painted by Tulsi (active 1575–96) and Madhu (active 1575–ca. 1604) under the reign of Emperor Akbar (r. 1556–1605). It shows, in great detail, Chingis Khan's marching group made up of different ethnicities, holding various weapons and objects, wearing varied dress, and even riding distinct breeds of horses.

A common theme of the Mongol conquest is the siege of cities, including the surrounding of the city and the final attack, as shown in the painted manuscripts in Europe and Persia. The early Mongol campaigns to Europe in the thirteenth century caused mass destruction in local societies and distorted regional political order. In Eastern Europe, the Mongols conducted three raids, and some of the battle scenes, such as the war in Silesia, were recorded in illustrations on medieval manuscripts.[3] In the initial stage of capturing the city, the Mongol army took oaths and threatened their enemies with extreme means, such as using dead bodies to instill fear and spread plague. At the Battle of Liegnitz (Legnica, Poland) in 1241, the Mongol troops decapitated King Henry II the Pious of Silesia (Heinrich II, 1196–1241) and presented the head on a pike outside the city wall (fig. 15.2). This image strongly suggests the psychological stress presented by the Mongols when they demanded surrender in front of the targeted city. King Henry II's troops suffered a complete defeat, which led to the triumph of the Mongol main force over the Kingdom of Hungary in the battle of Mohi two days later. The manuscript under consideration was produced nearly one hundred years after this conquest, when the Black Death was sweeping across Europe (not to mention the always-looming threat that the Mongols would return).

15.1. *Toda Mongke and His Mongol Horde* in a *Chingiznama* (History of Genghis Khan), Tulsi and Madhu (painters), Lahore, present-day Pakistan, 1596 CE / AH 1004. Los Angeles County Museum of Art, From the Nasli and Alice Heeramaneck Collection, Museum Associates Purchase, M.78.9.8

15.2. *The Battle of Liegnitz; The Beheading of Heinrich and His Soul Carried by Angels to Heaven; The Tartars Carrying the Head of Heinrich before Castle Liegnitz; Saint Hedwig Seeing in a Dream Her Son's Soul Carried to Heaven* in *Vitae beatae Hedwigis* (The Life of the Blessed Hedwig), Silesia (Poland), 1353. Los Angeles, The J. Paul Getty Museum, Ms. Ludwig XI 7 (83.MN.126), fols. 11v–12

Despite the Mongols' nomadic nature, they were the masters of conquering large, fortified cities. Some of the most lavishly painted depictions of Mongol battles are in Persian miniatures, such as Rashid al-Din's *Jami' al-tawarikh* (Compendium of Chronicles, fig. 15.3). The peak of the Mongol conquest in Asia was the takeover of Baghdad, the Abbasid Caliphate's capital, in 1258. In that year, Hulagu (1218–1265) sacked the city with much bloodshed. In the preparation for the siege of Baghdad, Hulagu's army first broke dikes and destroyed the irrigation system, causing a flood in the Tigris and Euphrates Rivers. The flood raised the water level of the city's moats, which assisted the siege by cutting off the city's resource supply completely; the army then made floating bridges of connected boats in order to cross the flooded moats. The sieges of both Baghdad and Mosul benefited from this "Musta'simid flood," named after the last caliph, Al-Musta'sim (r. 1242–58), who was captured and killed by the Mongols after the fall of Baghdad.

Besides the floating bridge for infantry and navy, Mongol warfare applied military tactics for cavalry such as an encircling, chisel attack, and feigned retreat, which cannot be fully displayed in static illustrations or in the small image block of manuscripts.[4] However, the manuscript illustrations vividly show the Mongol war weapons and military techniques. The Mongol archers used a variety of arrows, depending on the conditions of the attack.[5] The available illustrations do not depict different arrow types, which reveals artists' lack of familiarity with the details of the Mongol army. But in many illustrations of battles in both Liegnitz and Baghdad, we see the exchange of arrows and infantry archery units carrying Mongolian bows acting as the frontline force in siege warfare.

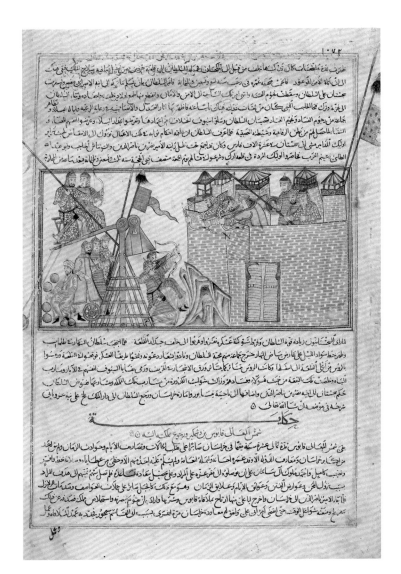

15.3. *A City under Seige* in *Jami' al-tawarikh* (Compendium of Chronicles) by Rashid al-Din, Herat, Afghanistan, 1314 CE / AH 713. Edinburgh University Library, Or.MS.20

The Mongol cavalry also heavily relied on shooting arrows in pursuit of enemies. Besides flying arrows and arched bows, we encounter such military accessories as rally drums and signal flags, as well as other popular weapons employed by the Mongol forces such as swords, spears and pikes, and explosive gunpowder weapons. In siege warfare, the Mongols learned from Central Asian engineers to create and use catapults, which threw heavy rock balls, fire balls, and bombs; in one scene, we see a Muslim engineer with a white turban behind a trebuchet preparing rock balls. It was usually used along with arrow volley, right before the Mongol army launched ladders to climb the city walls. Such catapult techniques were recorded in an illustration of the Mongol conquest of Baghdad.

In addition to siege warfare, another common theme of Mongol military campaigns in illustration is cavalry pursuit. It took place in various battlefield landscapes, including on the plains and other flat terrain. Illustrations show the Mongol army moving quickly, the soldiers in motion on horseback. The mounted archers, with well-stocked quivers, could launch a speedy pursuit thanks to their lightly loaded horses, shooting arrows constantly while racing along after the enemy. The

image is symbolically vivid as representing the Mongol army's rampant military storm across Eurasia. Usually, in illustrations, the enemy troops under attack are fleeing the scene while the Mongols advance. Sometimes illustrations show arrows only traveling in one direction, from the Mongol archers toward their enemies. When their horses got closer to their targets, the Mongol archers would switch to swords and shields to attack the fleeing enemy from behind.

Medieval manuscript artists who included vivid war imagery featuring Mongols offered visual astonishment to readers and delivered information regarding weaponry and fighting technology that purely textual narratives could not. Mongol military tactics depicted in dynamic form dominated the imaginations of artists in conquered regions across Eurasia. Collective memories of Mongol brutality and postwar trauma haunted the regions affected, and influenced the production of historical books with images. The Hedwig manuscript was written one hundred years after the initial conquest, but fears in the fourteenth century were very much alive in light of plague and other Mongol invasions (for instance, into the Lake Van region of Cilicia, Armenia). In a sense, the Mongols never left—neither from memory nor from the parchment and paper pages of manuscripts.

— Kaiqi Hua is a lecturer in Asian studies at the University of British Columbia.

1 See G. Heng 2018.
2 The iconography of the Mongol soldiers can be divided into two types. Either their appearance and armor were generally depicted as similar to the soldiers of the conquering state, whose home culture produced the illustrated manuscript, such as Rashid al-Din's *Jami' al-tawarikh*; or, as is the case with European illustrated manuscripts, the Mongols were depicted as wearing typical conical Tartar helmets, and were not differentiated from other unfamiliar oriental nomadic groups in terms of appearance and armor.
3 The three raids of Poland and Hungary were in 1240–41, 1259–60, and 1285–88. The Mongol major forces were from the Golden Horde.
4 The encircling was developed from the hunting culture of the Mongols—the hunting circle called *nerge* or *jerge*. May 2013, 191.
5 For an example of Mongol archery, see "The Mongol cavalry in pursuit," *Saray Album*. Inv. Diez A fol. 71. May 2007, 114.

Novelty and Diversity in Illustrations of Marco Polo's *Description of the World*

MARK CRUSE

No text better exemplifies medieval Europe's global engagement than the *Devisement du monde* (Description of the World) by Marco Polo (1254–1324). Composed in 1298, Polo's text is noteworthy for several reasons: it was the first extensive European travel and encyclopedic account to be written in the vernacular by a layman; it names and describes many cities, regions, and realms that had never before been mentioned in European writing; it describes an unprecedentedly long and intimate encounter with foreign lands and peoples; it largely eschews, or outright refutes, traditional accounts of marvels; it was read by a broad swath of society, from merchants to monarchs; and it influenced European cartographers and explorers for centuries. Polo's text altered Europe's understanding of the globe in unique and consequential ways.[1]

Polo's work survives in 141 manuscripts and fragments written in Latin and various European vernaculars.[2] Among these, the eighteen complete or fragmentary copies of the French text stand out for their exceptional content and history. These copies are closely related to the one in Paris at the Bibliothèque nationale de France (fr. 1116, ca. 1310–20), which is widely considered the oldest surviving copy of Polo's text and is also the longest version extant.[3] Eight manuscripts of the *Devisement* corpus possess illustrations, while almost no manuscripts of any other recension (revised edition of a text) contain images.[4] The *Devisement* manuscripts represent the largest group of illustrated Polo texts and reflect these manuscripts' origins in the orbit of the French royal family. The earliest known patron of Polo's text was Charles of Valois (r. 1284–1325), son of King Philip III of France (r. 1270–85), brother of King Philip IV (r. 1285–1314), and father of King Philip VI (r. 1328–50). Early in its history, the *Devisement* became the patrimony of the French royal family and of Francophone elites, who helped make it famous and for whom it was copied over a period of more than two centuries.

This essay examines the illustrations in two copies of the *Devisement du monde*: one that is also in Paris at the

Bibliothèque nationale de France (fr. 2810, ca. 1410–12), and one in Oxford at the Bodleian Library (MS Bodley 264, ca. 1410).[5] Both are among the most famous illuminated manuscripts of the Middle Ages and have attracted a great deal of scholarly attention. They merit reappraisal in light of current scholarship, including that found in the present volume, on the ways in which contact with foreign cultures and habitats influenced Europeans' understandings of themselves, their history, and their place in the world. The effect of this contact is visible not only in travel texts such as Polo's but also in the novel subjects and compositions devised by artists to illustrate them. Medieval European art relied largely on traditional motifs and formulas; it was a codified visual language passed from generation to generation. Artistic innovation is therefore a striking and important phenomenon in the Middle Ages, as it may indicate new sources and inspirations, a shift in the conceptual landscape, or both. Fr. 2810 and Bodley 264 are products of an era in which Northern European artists employed innovative visual interpretations in manuscript art, which led to unprecedented images of the world beyond Europe's borders.[6] This is not to say that their illustrations were accurate depictions of the East, but rather that a work such as Polo's could alter artistic practice by exposing artists to scenarios to which their visual codes did not correspond. As textual interpretations, manuscript images offer insight into the responses—conservative or creative, dismissive or receptive—of late medieval readers to the novelty and diversity that they encountered in Polo's text. They are a measurable indication of how, and to what extent, Polo's global vision was assimilated (and assimilable) into European consciousness.

Produced in Paris, fr. 2810—the *Livre des merveilles du monde* (Book of the Marvels of the World)[7]—is an illustrated compilation of texts in French related to commercial, missionary, and diplomatic contact between Europe and Asia. Marco Polo's *Devisement* opens the volume and is followed by texts by Odoric of Pordenone (1286–1331) and William of Boldensele (ca. 1285–1338/39), a letter from the khan Uzbeg (r. 1313–41) to Pope Benedict XII (r. 1334–42), a letter from

the Alans of Cambalec (Beijing) to Benedict XII, a note on the dating of these two letters, Benedict XII's reply to the Alans, as well as the texts *De l'estat et de la gouvernance du grant kaan de Cathay* (On the Estate and Government of the Great Khan of Cathay), *Voyages de Jean de Mandeville* (Voyages of Jean de Mandeville), *Les fleurs des estoires d'Orient* (Flowers of the Histories of the East) by Het'um of Corycus (ca. 1240–ca. 1310–20), and the *Liber peregrinationis* (Book of the Sojourn Abroad) by Riccoldo da Montecroce (ca. 1243–1320) (translated by Jean le Long [ca. 1315–1383] as *Le Itineraire de la peregrinacion*), all in French. The manuscript comprises 297 folios adorned with 265 miniatures painted by the workshops of the Boucicaut Master (active ca. 1390–1430) and the Bedford Master (active first half of the fifteenth century). It was commissioned by John the Fearless, Duke of Burgundy (1371–1419), and given to his uncle John (1340–1416), Duke of Berry, as a New Year's gift in 1413.

As many scholars have noted, this manuscript preserves a visual catalogue of traditional motifs related to the East: marvelous creatures such as unicorns and dragons; monstrous peoples such as sciapods, blemmyes, and cynocephali; idols and idol worship; orientalized costume; and figures with dark complexions or other racialized features.[8] With the exception of the cynocephali of the island of Angamanam (folio 76v), the marvelous creatures and peoples in the illustrations do not correspond to Polo's descriptions. They are interpolations that reflect either the artists' visual repertory of Eastern subjects and anticipation that readers would expect such images, or the desire of the patron. Such images would seem to indicate the reactionary tendency of tradition in the face of novel information—ancient notions of the oriental fantastic and centuries-old artistic practice insert themselves, often inappropriately, into Polo's rational and largely favorable account of the East.

However, this iconographic conservatism is only one aspect of the Polo illustrations in fr. 2810, as the miniature on folio 12r (fig. 16.1) demonstrates. This image illustrates Polo's account of his visit to a castle in which the three Magi are magnificently buried, in the Persian city of Saba.[9] According

to the story Polo learns there, the Magi were Persian kings who, at the Adoration, decided first to visit Christ individually. Christ appeared differently to each Magus but as an infant to all three together, a sign of his divinity. They gave him their gifts and upon their departure Christ gave them a box, which they opened on their way home to find a stone inside. Not understanding its significance, they threw the stone into a well that was immediately struck by fire from the sky, upon which the Magi understood that the stone was a gift from God. They gathered the fire, took it back to the castle, and shared it with the locals, who became fire worshippers. This story is interesting, as it both demonstrates the ancient ties between the Magi and Zoroastrianism, and shows Polo's willingness to record stories contrary to Catholic tradition. The common belief in late medieval Europe was that the Magi were buried in Cologne. In fact, the rubric on folio 11v in fr. 2810 reads, "On the city of Saba where are buried the three of Cologne"— another example of traditional belief clashing with Polo's account.

The illustration on 12r is significant because it is very likely the only image in medieval European art of the Magi worshipping fire. From the placement of this image and the visual detail, there is no doubt that it depicts the three kings. Here the artists respond to the text in a manner completely at odds with what tradition dictates. By way of comparison, in Bodley 264 the passage on the Magi is illustrated with a typical Adoration scene (223v) in which all of the Magi have pale skin; the only potentially orientalizing detail is the headgear of one of their attendants. No Adoration image appears in fr. 2810, and the only other image of the Magi in the Polo text shows them riding out of a city toward the star (11v). In effect, the artists have embraced Polo's alternative, Persian history of the Magi and substituted it for a traditional image of the Adoration. The Virgin and Child have been displaced by fire on an altar.

The miniature on 12r is noteworthy not only as a unicum but also for what it suggests about the potential influence of Polo's text upon its readers. While we cannot know exactly what motivated the iconographic choice on 12r, it is

16.1. *The Magi Worshiping Fire* in *Le Livre des merveilles du monde* (The Book of the Marvels of the World) by Marco Polo, Paris, 1410. Paris, Bibliothèque nationale de France, Ms. fr. 2810, fol. 12

reasonable to assume a combination of factors. On one level is a careful reading of the text and the desire to depict telling details, a hallmark of Parisian illumination in this period. Beyond that is a willingness to adopt the text's perspective and to make the familiar strange. As many scholars have observed, estrangement is an important feature of medieval European travel and ethnographic writing. European writers could imagine the gaze of others upon themselves, and so momentarily perceive their own beliefs and customs as bizarre or marginal.[10] Polo's account demonstrates that the Magi are not the sole property of Europeans or Catholics, but rather are potentially global patrimony whose story acquires different forms in different lands. Just as Polo includes this Persian lore in his account, so do the artists make space for it in the book. It could be argued that their choice on 12r expresses the same orientalism as do the images of marvelous creatures and monstrous peoples mentioned above, in that the miniature represents one more device for othering or distancing the East. The difference, however, is that on 12r the image adheres to the text, and what is displaced is not Eastern belief but the traditional Western motif of the Adoration.

Fr. 2810 is possibly the largest textual and visual compendium devoted to the contemporary (or near-contemporary) East in medieval European culture. There is likely no other manuscript that possesses this many images of Asia based on accounts produced within only a few generations of the book's production. The number of images of Asia in fr. 2810 may even surpass that of the most lavishly illustrated manuscripts of the *Alexander Romance*, with whose visual tradition fr. 2810 shares many features.[11] This scope may offer another explanation for the iconographic novelty in this manuscript: the artists realized that they were contributing to a unique, encyclopedic volume that required an expansive visual approach. Marie-Thérèse Gousset has even suggested that the visual program was overseen by the patron John the Fearless himself.[12] He had led the crusade that ended in defeat at the Battle of Nicopolis in 1396, and this experience, combined with his political ambition, may explain his interest in this manuscript. He had gained intimate knowledge of foreign ways on his

16.2. *The Khan's Money Exchange* in Le Livre des merveilles du monde (The Book of the Marvels of the World) by Marco Polo, Paris, 1410. Paris, Bibliothèque nationale de France, Ms. fr. 2810, fol. 45

campaign and in captivity, and the book's luxury and scope were equal to the great royal commissions of his forebears and of his uncle the Duke of Berry. Even if he did not select specific images, he may have inspired the artists to break with tradition as they envisioned these texts.

The illustration of the khan's money exchange (45r; fig. 16.2) is another demonstration of these artists' attentive reading and iconographic innovation. The accompanying text famously describes how the khan has paper money made for use throughout his empire, and how merchants from "India and other lands" go to him willingly to trade their merchandise for these bills.[13] The miniature depicts the enthroned khan on the left watching as two of his officials present boxes containing rectangular white strips to a merchant, who hands over a bag of wares, while two other men look on. The three men on the right are all carefully differentiated: they are spaced so that each is almost entirely visible, they are of varying height and posture, and their facial features and costume differ noticeably. They would seem to illustrate the diversity of the merchants mentioned in the text. The middle merchant is notable for his Asiatic features; a similar visage appears on 54r. Gousset notes that these traits could have been inspired from life, as the archbishop of Soltaniyeh made an embassy to Paris on the part of Tamerlane (Timur; r. 1370–1405) in 1403, or from figurines or other Asian art.[14] Perhaps the likeliest possibility, however, is that these faces, like much else in the styles of the Boucicaut and Bedford Masters, were influenced by Italian art. Such "Eastern types" were new in the context of Parisian illumination, but they originated in Italian painting and predated fr. 2810 by many decades in the work of artists such as Ambrogio Lorenzetti (ca. 1290–1348) and Andrea da Firenze (1346–1379).[15] Another way to understand fr. 2810 is as one of the most impressive examples of the Italian absorption and diffusion of global art ranging from Islamic textiles to Chinese costume. As the Polo, Pordenone, and Montecroce texts remind us, the novelty and diversity of fr. 2810's illuminations ultimately depend in large part on Italian enterprise, one of the main engines of medieval globalism.[16]

One could point to numerous other examples of creative iconographic responses to the Polo text in fr. 2810: lively porcupines (18r); the harvesting of rubies (18v); tax collectors seated at a cloth-covered *banco* that is clearly inspired by Italian painting (69r); the cynocephali of Angamanam dressed in robes and engaged in commerce (76v); the crowned and scantily clad king of Maabar wearing his lavish jewel necklace (78r); the "nuns" of Maabar performing a chain dance before an idol (80r); dark-skinned, nearly naked Brahmans (83r); the picking of peppers (84r). Some of these images are striking for their naturalism, and confirm Millard Meiss's observation that the texts in fr. 2810 "stimulated the painters to more intensive observation not of exotic but of familiar things."[17] Others combine the exotic and the familiar in striking ways, much like the image of the fire-worshipping Magi. Still others show a desire to strictly respect the text, or at least to capture its most salient details, however they may differ from traditional iconographic formulas. In these images, the illuminators of fr. 2810 reveal a sympathy to the Polo text's perspective that leads them to envision the world in novel ways.

Bodley 264 offers an instructive comparison to fr. 2810 because of its very different history but equally elite origin. The first part of this manuscript preserves a sumptuously illuminated copy of the Old French verse *Roman d'Alexandre* (Romance of Alexander the Great) that was completed in Tournai (present-day Belgium) in 1344.[18] This book made its way to England, where in the first decade of the fifteenth century two more texts were added to it: an illustrated copy of the Middle English *Alexander and Dindimus*, and Polo's *Devisement*, here titled *Livre du Grant Kaam* (Book of the Great Khan), adorned with thirty-six miniatures. These additions were likely produced in London for a member of the royal family.[19] While fr. 2810 is a near-contemporary portrait of the East, Bodley 264's compilation is a diptych suggesting continuity and resemblance between Alexander the Great and Marco Polo and, more to the point, between Alexander and Kublai Khan (r. 1260–94). Indeed, whereas fr. 2810's compilation is very much about sustained European efforts to convert the East, Bodley 264, by ending rather than beginning with Polo,

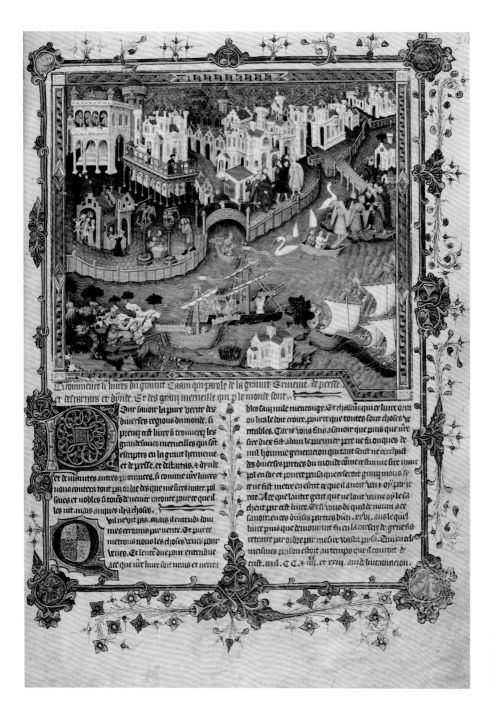

16.3. *Venice* in *Livre du Grant Kaam* (Book of the Great Khan) by Marco Polo, Johannes?, London, ca. 1400–1410. Oxford, Bodleian Library, Bodley 264, fol. 218

suggests a reverse *translatio* through which Alexander has been replaced by the khan.

As in fr. 2810, the Polo text inspires unprecedented iconography in Bodley 264. The text opens with a bird's-eye view of Venice that is one of the most famous city scenes in medieval European art (fig. 16.3).[20] There is nothing comparable in Northern European painting of this period. Although most scholars have argued that the scene is imaginary (although realistic), there is reason to agree with Philippe Ménard that the artist knew Venice firsthand.[21] The Doge's Palace, San Marco, and the columns of Saint Theodore and Saint Mark are rendered with great detail, even if they are not completely accurate. As Elfriede Knauer notes, the bottom left of the image seems to show a cormorant perch, which suggests intimate knowledge of the city.[22] Henry IV, to whose family Bodley 264 belonged, made a pilgrimage to the Holy Land that took him through Venice in 1392, and he later commissioned a set of choir books made in Venice between ca. 1401 and 1404 for the Franciscans of Bethlehem.[23] These contacts open the intriguing possibility of an artist in Henry's entourage either accompanying him to the Holy Land or receiving a detailed rendering of the city from a Venetian artist.

However we imagine the genesis of this image, it confirms the potential of Polo's text to inspire an innovative and detailed envisioning of distant places. As the numerous multicolored buildings and the boats in the lagoon make clear, the illumination emphasizes Venice's role as a node in a global commercial network from which the city profited enormously. It is significant that the Polo text in Bodley 264 opens with this miniature that is simultaneously an author portrait (Polo, his father, and his uncle appear three times) and, much more emphatically, a depiction of Polo's city. Bodley 264's portrait of Venice suggests that it is the city's wealth and global reach that guarantee the authority, veracity, and utility of Polo's account. The painted scene announces too the text's focus on commercial activities in cities; Polo's is very much an urban world. At the same time, this miniature figures Venice as a portal not only to the East but into the book itself. With its extraordinary perspective and detail that invite the eye to

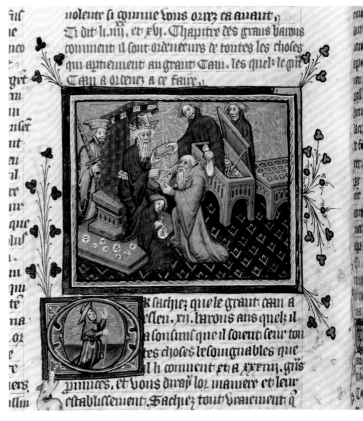

16.4. *The Khan's Money Exchange* in *Livre du Grant Kaam* (Book of the Great Khan) by Marco Polo, Johannes?, London, ca. 1400–1410. Oxford, Bodleian Library, Bodley 264, fol. 242v

wander, this image materializes the roving narratorial gaze that the reader will encounter in the text. It is a kind of *invitation au voyage* that prepares the reader for the displacement to come and that figures the book space itself as a mirror, or material extension, of the world Polo's text describes.

Another example of creative illustration in Bodley 264 is the miniature depicting the khan's money exchange (242v; fig. 16.4). As in fr. 2810, we see the enthroned khan on the left seated under a canopy, but with this the similarities end. A single merchant kneels before the khan and hands him a box full of what appear to be pearls and rubies, while the khan hands a gold bar to an attendant standing next to

a treasure-filled coffer. Seated on the khan's dais is a scribe writing characters on round white objects that are clearly meant to illustrate the paper bills described in the text. The nonsense figures on these paper coins are an orientalizing detail that both corresponds to the textual reference to the khan's seal and echoes the foreign "alphabets" copied into *Mandeville* and other late medieval works.[24] This image and that in fr. 2810 are especially noteworthy because they are likely the only two depictions of paper money in medieval art. The one in Bodley 264 is an example of the familiar and the strange combined—for this artist, money is round and therefore so must be the khan's bills. In fr. 2810 (see fig. 16.2), on the other hand, the artist has carefully indicated thin rectangular strips with no markings. This shape is indeed closer to that of the historical yuan banknote, although it would seem that the artist is illustrating the word *chartrete* (little letter or document) rather than a real artifact.

The fact that the vast majority of Polo manuscripts are not illustrated suggests a largely non-elite readership and, more tellingly, reading modes that did not require pictures. This makes the illustrations of the text, for which no picture cycle ever developed, all the more important, because the readers behind the images' designs—artists, planners, or patrons—were left entirely to their own devices. Marco Polo's *Devisement du monde* is a place-making—or world-making—text that displaces the European reader's perception to realms beyond traditional geography and historiography.[25] Fr. 2810 and Bodley 264 are historically significant testaments to this place-making potential because they show medieval artists incorporating foreign territories into European art in innovative and creative ways that often break with traditional iconographic canons. It is not the documentary accuracy of the images but the fact and manner of their production that indicate the Polo text's capacity to inspire new ways of envisioning the world. After all, despite our technologies, the Western image of Asia remains a thoroughly mediated construct determined by the pervasive power of capitalism, nationalism, and orientalism, to name only the most obvious perception-shaping forces. We know of smog in Beijing, but how many images do we see of grocery stores or elementary schools? For all their orientalist iconography, fr. 2810 and Bodley 264 also respect Polo's uniquely dispassionate and often sympathetic view of Asia. These manuscripts are thus reminders of the contrasts but also of the profound continuities between the Middle Ages and our own global era.

— Mark Cruse is an associate professor of French at Arizona State University.

1 The relevant bibliography is far too long to cite in toto. See Kinoshita 2016; Gaunt 2013a; Larner 1999.

2 Gadrat-Ouerfelli 2015; Dutschke 1993.

3 Benedetto 1928. See also Ménard et al. 2001–9. It is from the Paris copy, fr. 1116, that the work derives the title *Devisement du monde*; it is given other titles in other manuscripts.

4 Four other Polo manuscripts contain author portraits: Escorial, Z. I. 2; Florence, Biblioteca Nazionale, Conventi soppressi, C 7. 1170; Glasgow, University Library, Hunter 458; and Wolfenbüttel, Gud., lat. 3. See Ménard 2006, 993–1021.

5 Both manuscripts have been digitized. Fr. 2810: http://gallica.bnf.fr/ark:/12148/btv1b52000858n; Bodley 264: http://image.ox.ac.uk/show?collection=bodleian&manuscript=msbodl264.

6 I will refer throughout to "artists" with the understanding that workshop directors or even patrons (see below) may have been responsible for the images under discussion. On the styles in fr. 2810 and innovation in early fifteenth-century French illumination, see Meiss 1968, 38–59.

7 This title was inscribed on the flyleaf by the Duke of Berry's secretary.

8 Strickland 2005, 493–529; Harf-Lancner 2003, 39–52; Gousset 1996, 353–64; Bousquet-Labouérie 1994; Wittkower 1987, 76–92; Ménard 1986, 17–31; Chiappori 1981, 281–90; Meiss 1968, 43–46.

9 "Saba" in fr. 2810; "Sava" in other copies.

10 Khanmohamadi 2014; K. Phillips 2014; Kinoshita 2006; Akbari 2001, 19–34.

11 Wittkower 1987, 91–92.

12 Gousset 1996, 363.

13 The text states, erroneously, that the bills are made from the bark of mulberry trees on which silkworms feed.

14 Gousset 1996, 362.

15 Chiappori 1981, 281–90.

16 A comprehensive account is Mack (2002).

17 Meiss 1968, 46.

18 Tournai is in present-day Belgium. On Bodley 264, see Cruse 2011.

19 See the overview of the evidence in Cruse 2014, 149–53.

20 Knauer 2009, 47–59.

21 Ménard 2006.

22 Nonetheless Knauer (2009, 49) too believes that the image is an "imaginary reconstruction."

23 James Black 1983, 18–26.

24 See Kupfer 2008, 58–111, and bibliography therein.

25 On "world-making," see Higgins 1997, 1–6.

Visualizing Byzantine and Islamic Objects in Two Fifteenth-Century Francophone Manuscripts

ALEXANDRA KACZENSKI

In the second half of the fifteenth century, three well-known bibliophile-rulers—the displaced René of Anjou (1409–1480), king of Naples, and dukes Philip the Good (1396–1476) and Charles the Bold (1433–1477) of the Valois-Burgundian dynasty—understood the power of manuscripts for self-promotion and identity formation. Decorated handmade books were performative status symbols, actors in diplomatic and political relationships, and objects with devotional potency. Two illuminated manuscripts from the Getty collection—a petite book of hours (Ms. 48) and a set of leaves from the *Histoire de Charles Martel* (History of Charles Martel) (Ms. Ludwig XIII 6)—are related to these French and Burgundian patrons. Produced in France and the Burgundian Netherlands in the wake of the Ottoman conquest of Constantinople in 1453 and the lingering plans of the pope for a renewed crusade, the manuscripts' illuminations visually transmute Byzantine and Muslim identities, promoting Christianity's Eastern origins and unity among Christian communities.[1] In other words, these objects become a gateway for things Byzantine (the Eastern Roman Empire recently fallen to the Ottoman Turks, in 1453) and more generally "Eastern," at times conflated with or embedded visually with references to neighboring kingdoms in Muslim Iberia or Egypt (the Nasrid and Mamluk, respectively). Although considerable research exists on the individual manuscripts, they have yet to be considered in relation to one another. Together they represent a tension between the materialization of Islamicizing motifs and the anti-Ottoman sentiment and crusading ideals prevalent in the Mediterranean in the decades following the 1453 fall of Constantinople.

Beginning with the book of hours just mentioned, the prayer *O Intemerata* (Oh Untouchable One) opens with a miniature of a *Portable Altarpiece with the Weeping Madonna* containing a trompe l'oeil frame (fol. 159, fig. 17.1). It was painted by Georges Trubert, an artist active at the court of King René of Anjou between 1467 and 1480.[2] This book is one of three related manuscripts, along with Ms. M.1020 at the Morgan Library and Ms. Lat. 17332 in the Bibliothèque nationale de France, each of which includes a miniature of the *Sorrowful Virgin with a Wart*. Scholarly consensus over the source of the distinctive Madonna remains divided, with some suggesting a Northern European diptych inspired by a Byzantine icon or a portable Italo-Byzantine diptych.[3] Others propose that the model is a Byzantine icon itself, as René's inventories attest to his penchant for imported exotica, which may be expected given his position as titular king of Jerusalem.[4] In 1477 he purchased a frame for *Our Lady of Egypt*, and it has been suggested that the illumination mentioned above replicates the shrine encasing René's personal icon.[5] The altarpiece reframes the painted Virgin as a relic and opens a window toward the Holy Land. Mary is enshrined by a range of designs—a six-pointed star, pseudo-Kufic and Arabic script, and symbols of Nasrid and Mamluk powers.

As Maryan Ainsworth points out, only one inscription on the top right is legible Arabic—There is no victor but Allah—the motto for the Nasrid Emirate of Granada, who controlled Al-Andalus (the Muslim kingdom of the southern Iberian Peninsula) until 1492 (see fig. III.7 for a Qur'an case embroidered with the same phrase).[6] It is unclear if Trubert or his patron was aware of the phrase's legibility or meaning. Hebrew and Arabic were sometimes interchanged as signifiers of Mary's Jewish and Eastern roots, and often incorporated into the borders of textiles evoking *tiraz* (embroidered) fabrics.[7] Nasrid proximity to European Christendom and its impact on Italian majolica may justify this stylistic conflation.

17.1. *Portable Altarpiece with the Weeping Madonna* in a book of hours, Georges Trubert (artist), Provence, France, 1480–90. Los Angeles, The J. Paul Getty Museum, Ms. 48 (93.ML.6.159), fol. 159

Apart from the Nasrid motto, Ainsworth demonstrated that the Virgin's reliquary appropriates the lion and heraldic pen box (representing the sultan's *dawādār*, or executive secretary), emblems of the Mamluk sultanate.[8] From 1250 to 1517, the Mamluks controlled a swath of territory extending over Egypt, the Levant, Hejaz (a region in present-day Saudi Arabia), and Cyprus (a tributary state). The dominion of Mamluk sultan Qa'it Bay (r. 1468–96) included Christian pilgrimage sites such as Mount Sinai and Jerusalem, to which he pledged protections and respected devotees.[9] Furthermore, the sultanate clashed with the expanding Ottoman Empire and in response increased diplomatic relations with European powers outside of anterior trade relationships.[10] Therefore, integration of Mamluk emblems into the Virgin's frame may specifically reference pilgrimage or Muslim-controlled Jerusalem.

Historians have turned a somewhat critical eye toward René, comparing his artistic and military ambitions to those of the Burgundian duke Philip the Good.[11] Related through the French royal line, both were great patrons who set themselves up as benevolent leaders interested in lands to the East. Despite an adversarial relationship—Philip held René prisoner during the 1430s—René's establishment in 1448 of the Order of the Crescent may be inspired by Philip's Order of the Golden Fleece (established 1429–30). Each included a code of chivalric behavior for Christian knights, such as protecting the realm and reclaiming Jerusalem.[12] They also utilized public displays of splendor to express political intent, as with René's *Tournament of the Shepherdess* (1449) or Philip's *Feast of the Pheasant* (1454).[13]

The *Histoire de Charles Martel*, divided between the Bibliothèque royale de Belgique (MS 6-9) and the Getty Museum (Ms. Ludwig XIII 6), is a four-volume text commissioned by Philip the Good, with illuminations by Loyset Liédet (1420– after 1479 or after 1484), completed at the request of Charles the Bold.[14] The French vernacular *histoire* and its miniatures are marked by cycles of battles, the coronations of Charles Martel and his son Pepin, marriages, births, and deaths.[15] More than a display of courtly luxury, the propagandistic

manuscript presents a microcosm of Burgundian ideology.[16] Like René of Anjou, Philip never traveled to the Holy Land, but he was interested in *outremere* (overseas) politics. Among his many Mediterranean activities, Philip initiated the diplomatic mission that saw Guillebert de Lannoy (1386–1462) travel to the Levant and Eastern Europe in 1421, and sent a Burgundian fleet to aid the Knights Hospitallers of Rhodes and provide support to the Byzantines against Ottoman forces.[17] Furthermore, he actively called upon other European courts to participate in a new crusade (although his sincerity is still debated) as part of their Christian chivalric duty. The choice of Charles Martel as a main subject supports Philip's crusading tendencies. Martel is credited for both consolidating territory that formed the Carolingian Empire and for successfully defeating the forces of the Umayyads (a Muslim dynasty, in Spain from 756 to 1031) at the Battle of Tours (732).[18] Within the *histoire*, visual and textual representations of Saracens reflect what Kristen Collins and Bryan C. Keene have referred to as the stereotype of the militant Muslim.[19]

In contrast to these representations of violence, the Byzantine Empire is depicted in Western European fashion. When the empire was threatened by Ottoman forces, European powers rallied to assist, despite the Great Schism between the Orthodox and Latin Churches and failed attempts at unification during the ecumenical Councils of Basel-Ferrara-Florence (1431–39).[20] This political situation elucidates the rendering of the miniature on leaf 2 of Ms. Ludwig XIII 6, which presents the arrival of Martel and Roussillon at Constantinople (bringing aid against the Saracen foe) and their subsequent meeting with the emperor (fig. 17.2). Despite knowledge of Byzantine costume, which existed in Europe through the presence of Byzantine emperor John Palaeologus VIII (1392-1448) at the ecumenical councils and from the circulation of his image on medals following designs by Pisanello (1395-1455), this Byzantine ruler is rendered as a typical Burgundian royal, leaving a Western European–style palace led by processing monks who are tonsured and robed.[21] The golden patriarchal cross stands out as a marker of Byzantine identity, although it is capped with a fleur-de-lis. A lack of differentiation between

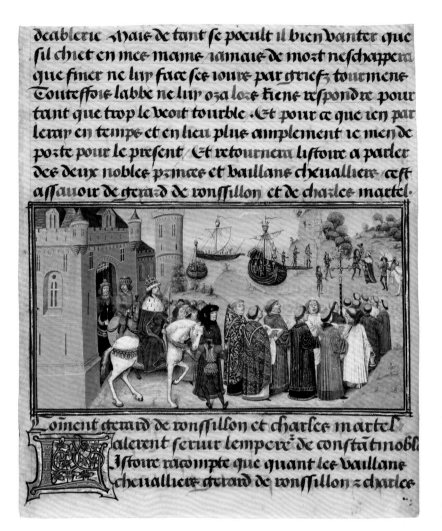

17.2. *The Byzantine Emperor Welcoming Roussillon and Martel* in *Histoire de Charles Martel* (History of Charles Martel), Loyset Liédet and Pol Fruit (artists), written in Brussels and illuminated in Bruges, Belgium, 1467–72. Los Angeles, The J. Paul Getty Museum, Ms. Ludwig XIII 6 (83.MP.149), leaf 2

the Orthodox and Latin knights may reflect the Burgundians' support for the restoration of Christian control over the former Byzantine capital, as Burgundian artistic commissions used costume and textiles to display sociopolitical agendas.[22] Imitations of elaborate brocades, cut velvets, and patterned silks feature in Burgundian devotional manuscripts, such as the Getty's Prayer Book of Charles the Bold,[23] while Charles was infamous for his lavish cloth-of-gold garments. These luxury fabrics were vessels for aesthetic transmissions and evidence of global trade: on fol. 10 of Getty Ms. 37, Margaret Goehring identifies what she considers a Yuan dynasty motif that was adapted by Mamluk and Byzantine weavers, a design that eventually appeared in Lucca (Tuscany, Italy) (fig. 17.3).[24]

Marco Polo famously lauded cloth-of-gold production in Tabriz, Iran, during his trans-Asian journey.[25]

Together, the multivalent iconographies in each manuscript discussed above display the fluidity with which European Christians delineated Byzantine, Muslim, or Holy Land identities. The scope of these narratives is trans-geographic and diachronic—they reach out across time to earlier histories and places, to the ancestors of the books' patrons, to the origins of Christianity, and then forward to us.

— Alexandra Kaczenski is a doctoral candidate at Case Western University and was formerly a curatorial assistant in the Manuscripts Department at the J. Paul Getty Museum.

17.3. *The Virgin and Child with Angels* in the Prayer Book of Charles the Bold, Lieven van Lathem, Ghent, Belgium, 1469. Los Angeles, The J. Paul Getty Museum, Ms. 37 (89.ML.35), fol. 10

1 Housley 2012, 10–11.
2 Gautier and Avril 2009, 145.
3 Ainsworth 2004, 567; Léonelli 2009, 260–61.
4 M. Reynolds 1993, 127.
5 Léonelli 2009, 260–61.
6 Ainsworth 2004, 568. See also Fondo Aga Khan de Cultura 1991, 35, 36.
7 Mackie 2015, 85, 113.
8 Ainsworth 2004, 568. See also Sadeq 2014, 138–43; Ettinghausen 1972, 216.
9 Newhall 1987, 44–48, 59.
10 Newhall 1987, 28, 32–33, 36–37.
11 M. Reynolds 1993; Nievergelt 2011, 137–68. For more recent interpretations, see Bouchet 2011 and Margolis 2016.
12 Chipps Smith 1982, 114–15, 164; M. Reynolds 1993, 128, 134; Boulton 2006, 27; Wrisley 2006, 150; Marti, Borchert, and Keck 2009, 186–89; Housley 2012, 10–15; Paviot 2012, 70, 72, 74.
13 Gertz 2010, 163.
14 van den Gheyn 1910, 5–6, 14; Doutrepont 1939, 41; Doutrepont 1970, 30–37; J. Paul Getty Museum 1984, 301; Kren, McKendrick, and Ainsworth 2003, 231; Naudet 2005, 8–9.
15 Doutrepont 1939, 42; Doutrepont 1970, 30; Cockshaw, Lemaire, and Rouzet 1977, 82; Kren, McKendrick, and Ainsworth 2003, 231, cat. no. 55.
16 Murrell 1926, 4–53; Coleman 1996, 119; Nash 2008, 80; Housley 2012, 1, 15, 216; Kren, McKendrick, and Ainsworth 2003, 231; Moodey 2012, 14–15; Donovan et al. 2013, 1–5.
17 de Lannoy 1849, 33; Vaughan and Small 1970, 270–72; Chipps Smith 1982, 114–15; Housley 2012, 74; Paviot 2012, 70, 72.
18 Chipps Smith 1982, 114–16, 129–49; Moodey 2012, 149–51.
19 For a discussion of the appropriate use of "Saracen," see the case study in this section by Kristen Collins and Bryan C. Keene. See also Cartellieri and Letts 1929, 147; Kubiski 2001, 163; Saurma-Jeltsch 2010, 55.
20 Housley 2012, 71.
21 Lavin 1993, 70.
22 Goehring 2006, 23.
23 Getty Museum, Ms. 37, fols. 1v, 10 and 24v.
24 Goehring 2007, 141.
25 Blair 2014, 321.

IV. Itineraries from the Atlantic to the Pacific: Travel, Circulation, and Exchange

BRYAN C. KEENE

The themes of travel and spiritual journeys are fundamental to many world religions: the Buddha traversed considerable distances to spread his teachings; Jewish communities annually commemorate the Israelites' exodus from Egypt and the eventual establishment of a kingdom in the Promised Land; among Christ's last words to his followers was the commission to go into all the world and make disciples; and the Prophet Muhammad's *hajj* (pilgrimage) to Mecca is emulated by Muslims from around the world each year. Buddhism, Christianity, and Islam, in particular, became global faiths in the premodern world. Their followers adapted practices from one cultural or geographic area to another, giving rise to local expressions, interpretations, and variations. Interactions between religious communities or empires occurred in many ways—as peaceful, if at times wary, encounters, or as violent or destructive clashes. Among the themes presented by the essays in this section is the potential risk involved, or possible intellectual-artistic flowering that might occur, in commercial exchanges across religious, geographic, and political boundaries.

The global exchange of manuscripts as gifts occurred across Afro-Eurasia. In 1461, a fourteenth-century deluxe copy in Greek of *The Romance of Alexander the Great*, perhaps produced for Emperor Alexios III Komnenos (r. 1349–90), was presented to Ottoman sultan Mehmed II (r. 1444–46; 1451–81).[1] At that point, Turkish captions and marginal notes were added (fig. IV.1).[2] The second half of the fifteenth century witnessed the increased production of illuminated manuscripts with Alexander stories, from a copy by Vaso da Lucena (d. 1512) for a member of the court of Charles the Bold (r. 1467–77) in the Burgundian Netherlands (Los Angeles, The J. Paul Getty Museum, Ms. Ludwig XV 8) to a text by Ahmadi (active in the mid-fifteenth century) made for Mehmed II (fig. IV.2) and a now dispersed edition of the *Iskandarnama* (Book of Alexander) by Nizami (1141–1209) from Shiraz, Iran (Los Angeles County Museum of Art, M.73.5.462). The cultural currency of book arts and of portable objects—such as manuscripts, ceramics, textiles, glassworks, and small-scale sculptures—is another theme addressed in this section.

IV.1. *The Marriage of Alexander the Great and Roxane* in *The Romance of Alexander the Great*, Trebizond, Turkey, 1300s. Venice, Manuscript Collection of the Hellenic Institute of Byzantine and Post-Byzantine Studies

Manuscripts and portable objects have borne witness to the territorial ambitions and global connections of countless civilizations. In her essay in this section, Jill Caskey explores the process of transculturation and transplanting through an analysis of two seemingly disparate objects: a French liturgical book in Southern Italy and the ceramic finds from the Belitung shipwreck. During the Middle Ages, roadways and waterways brought people and objects together.

The northern climes of Scandinavia offer similar points of departure when considering itinerant objects. An inscription in the eighth-century Codex Aureus in Stockholm (fig. IV.3), for example, declares that Ealdorman Alfred and his wife, Wæburh, ransomed the Gospel book from "the heathen army"

IV.2. *Iskandarnama* (Book of Alexander) *of Ahmadi*, Timurid-Turkoman artists, Edirne Palace, Ottoman Turkey, 1440–50 CE / 843–853 AH. Venice, Biblioteca Marciana, Cod. Or. Xc. (= 50), fol. 12

IV.3. *Saint Matthew* in the Stockholm Codex Aureus, Southumbria, Canterbury, England, eighth century. Stockholm, National Library of Sweden, MS A. 135, fols. 10v–11

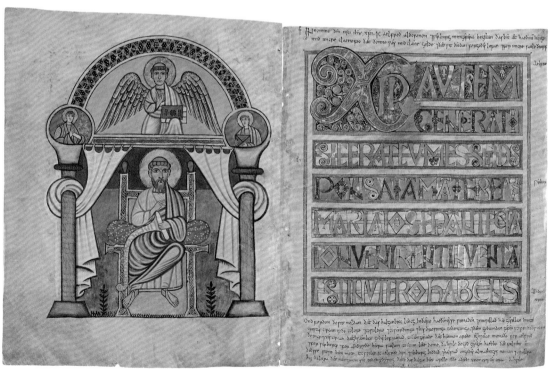

and donated it to Christ Church, Canterbury. The illumination campaign consists of Evangelist portraits with Anglo-Saxon and Italo-Byzantine features, as well as text pages stained purple, emulating royal book decoration from ancient Rome.[3] On the Island of Helgo, Sweden, the content of a hoard (of about the eleventh century) extends the Norse or greater Scandinavian transcultural encounters to Asia through a seated Buddha likely from Indian Kashmir made around the sixth century, and to Africa with a bronze ladle perhaps from a Coptic community in Egypt (a bishop's crozier from Ireland, probably eighth century, was also found there).[4] Other nearby hoards have revealed significant quantities of Central Asian dirhams (currency) of the Sasanian, Umayyad, and Abbasid periods (224–651 CE, 651–750 CE, and 750–1258 CE, respectively), such as those found at Sundveda[5] and Sigsarve on Gotland Island in present-day Sweden.[6] In Norway, silks from Byzantium, Persia, and perhaps Northern India have been found in several graves, such as the Osberg ship burial.[7] A ring found in a ninth-century grave of a woman on Björkö Island and a textile fragment from Birka provide cautionary tales to a global Middle Ages, as some scholars once claimed that the Arabic word for God, "Allah," could be read on both objects, whereas Islamicists have demonstrated that pseudo-Arabic

was more common and pervasive in the European context of the time.[8] As we saw in the introduction, textiles and decorative patterns—like the çintamani—traveled great distances, and in the Scandinavian contexts, one encounters animals set within roundels like those in Byzantium or variations of the swastika pattern (a design from India that was ubiquitous in the Mediterranean).

At the Crossroads of Cultures: Trans-Saharan Africa and Northeastern India

A Qur'an probably from Tunisia, produced within about one hundred and fifty to two hundred years of the Prophet's death (632), preserves an early example of chrysography (gold writing) (fig. IV.4). Gold reached Tunisia by way of trans-Saharan caravan routes, usually from Sijilmasa in Morocco. The blue pigment is likely indigo, a precious dyestuff traded from towns in Ethiopia to Baghdad and throughout India. Michelle H. Craig's case study in this section considers linguistic and material journeys of Quranic culture in trans-Saharan Africa. The implications of her essay—that local and global often merge on the pages of manuscripts from multiethnic and religiously pluralistic cities or communities in contact with worlds beyond—can be explored further through the

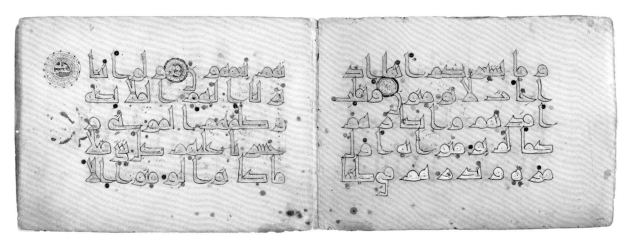

IV.4. Text pages from a Qur'an (Surah 6, verses: 109–11), North Africa (Tunisia?), ninth century CE / third century AH. Los Angeles, The J. Paul Getty Museum, Ms. Ludwig X 1 (83.MM.118), fols. 5v–6

IV.5. Text page in Ge'ez, Syriac, Coptic, Arabic, and Armenian from a Pentaglot Psalter, Nile Delta, Egypt, fourteenth century. Vatican City, Biblioteca Apostolica Vaticana, Barb.Or. 2, fol. 3

beautifully preserved pages of a fourteenth-century Pentaglot Psalter, written in Coptic, Syriac, Ge'ez, Arabic, and Armenian (fig. IV.5). Produced in Cairo, the manuscript later found its way into the Vatican Library, joining a rich collection of codices from Orthodox Christian communities of the Mediterranean Basin and North Africa that began during the Councils of Ferrara-Florence in 1438–39.

The Kathmandu Valley of Nepal nurtured a rich heritage of Hindu, Buddhist, and Jain religious communities. The sacred narrative on a painted cotton scroll, divided into registers and quadrants like the pages of painted books, weaves a tale of the elephant-headed god Ganesh, who manifests himself to local, indigenous Newar people as Manavinayaka (fig. IV.6). At top, as punishment for jinxing a game of dice, the goddess Parvati (whose attributes are fertility and love) curses a mortal devotee to the god Shiva (the destroyer-transformer) by having the man tormented by monstrous sea creatures

IV.6. Narrative scroll extolling Manavinayaka, Nepal, ca. 1575. Pasadena, California, The Norton Simon Foundation, Gift of Mr. Norton Simon, F.1983.27.P

(center), until he is saved by Manavinayaka (below).[9] As with the Buddhist examples that Tushara Bindu Gude discusses in this section, Hindu book-painting practices informed the Nepalese scroll's format and arrangement, as did the visual traditions of Jainism and Buddhism. The religious, linguistic, and cultural or ethnic contacts among Afro-Eurasian peoples do not constitute monolithic categories, but rather fluid and at times hybrid exchanges, each of which contributed to the development of a cosmopolitan world.

Worlds Embedded, Embroidered, and Buried

The year 1492 saw the expulsion of Jews and Muslims from the Iberian Peninsula, and a significant number of deaths in the name of Inquisition, headed by Father Tomas de Torquemada (1420–1498). At some point in the fifteenth century, the Rothschild Pentateuch of 1296, perhaps produced in France or Germany, arrived in Italy (see fig. introduction.6). There, Joel ben Simeon (active second half of the fifteenth century) added an illumination of Moses addressing the Israelites (fig. IV.7), a scene that may have had particular relevance for a family or community that had been transplanted from their home and homeland. This theme of imagined journeys through the process of reading and visualizing the events across the pages of manuscripts is addressed by Melanie Holcomb and Elizabeth Eisenberg in their essay. A poignant reminder that works of art live on while human life

is short emerges from a Hebrew Bible (New York, Hispanic Society of America, MS. B241) written in Spain around 1450 that was among the possessions of a refugee family who must have fled to Portugal, where the text and illumination campaign were finished (fig. IV.8). In 1618, the manuscript apparently belonged to the Rossilho family in Fez, Morocco, before it was sold in that same century to a certain Jacob Curiel in Pisa, Italy.

In the Hours of Engelbert II of Nassau (1470s–80s; fig. IV.9; Oxford, Bodleian Library, Ms. Douce 219–220), a range of blue-and-white vessels appear displayed on shelves or compartments. This arrangement complements the theme of "Eastern-ness" or extreme geographic distance implied by the illuminations of *The Adoration of the Magi*.[10] Blue-and-white wares in a Mediterranean context raise several questions about appropriation, emulation, alteration, and identification. For example, in the context of Burgundian manuscripts, including the Hours of Engelbert of Nassau, although the blue-and-white vessels may, on the one hand, evoke the ambiguous "East" or foreign lands, they may on the other also serve an indexical function that refers to any number of production sites on a map (majolica from Valencia or Majorca, Caffaggiolo wares from Italy, Iznik earthenware objects from Turkey, and so forth). The taxonomies of porcelain wares from the Burgundian Netherlands to sub-Saharan Africa reveal the impact of trade and collecting on visual arts and textual objects. Chronicles and other text manuscripts provide further evidence of the interconnected material world of Africa and the lands beyond its shores. The early sixteenth-century *Kitab al-Sulwa* (Kilwa Chronicles), for example,

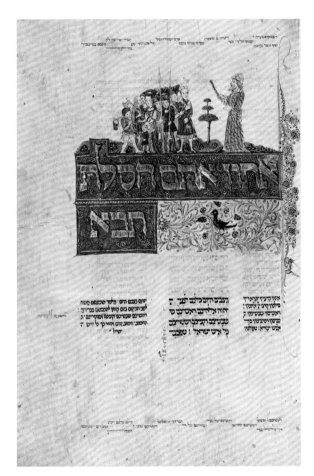

IV.7. *Moses Addressing the Israelites* in the Rothschild Pentateuch, Joel ben Simeon, Italy, fifteenth century. Los Angeles, The J. Paul Getty Museum, Ms. 116 (2018.48), fol. 478

IV.8. Hebrew Bible, Spain, text: 1450; illumination: Portugal, 1490–96; taken to North Africa, 1496. New York, Hispanic Society of America, MS. B241, fol. 581

IV.9. *The Adoration of the Magi* in the Hours of Engelbert II of Nassau, Master of Mary of Burgundy, Ghent, Belgium, 1470s–80s. Oxford, Bodleian Library, Ms. Douce 219, fols. 145v–146

IV.10. Pottery sherds, Zhejiang, Longquan area, China; found in Kilwa, Tanzania, tenth–fourteenth century. London, The British Museum, OA+.916

describes the tenth-century Persian origins of the Kilwa state and documents the successive reigns of sultans, as well as provides descriptions about trade in gold and other precious materials along the Swahili coast and with Yemen and India.[11] Archaeological finds on the island of Kilwa include sherds of celadon (from China), glazed earthenware pottery (from Iran or Oman), and terracotta vessels (of local production), providing exciting testimony to the truly globalized nature of the premodern world (fig. IV.10). Additionally, Chinese ceramics from the Longquan area of Zhejiang, dating from the tenth through the fourteenth century, have been found at Great Zimbabwe, and Ife sources in Nigeria testify to knowledge of Chinese systems of divination at the time.[12]

Elsewhere in the Hours of Engelbert of Nassau, simulated pilgrim badges appear to have been sewn in, following the actual practice of embedding such tokens of travel or memory into the pages of books. This range of potential associations conflates local and global on a material level, which is the subject of Rheagan Eric Martin's case study in this section.

As mentioned in the introduction to this volume and as demonstrated by each essay herein, the peoples of Afro-Eurasia traveled with great frequency during the long Middle Ages. We can begin to glimpse a global Middle Ages through the lens of itineraries of people, objects, and ideas. Beyond hemispheric Afro-Eurasia, there is much potential for comparative studies with the Americas, or for deeper examination of the ways in which climate, language, and trade in foodstuffs or other raw materials connect the worlds of the Pacific Ocean. In sum, we are working toward a global Middle Ages that is not confined to any geographic center and that dismantles colonial structures—historic, academic, and museological.

1 Kastritsis 2011, 103–31.
2 As a result of uncertain circumstances, the manuscript ended up in Venice, perhaps as the property of a refugee. See Drandake, Papanikola-Mpakitze, and Turta 2013, 197–98, n. 95, entry by Chryssa Maltezou.
3 Alexander 1975, 56–57.
4 Lundstrom 1978, 24–31; Androshchuck 2007, 153–63.
5 Evanni 2009, 1–32.
6 Kovalev 2013, 67–102.
7 Vedeler 2014. See also Stephennie Mulder, "The Rise and Fall of the Viking 'Allah' Textile," Hyperallergic, October 27, 2017, https://hyperallergic.com/407746/refuting-viking-allah-textiles-meaning/.
8 Hedenstierna-Jodon 2012, 29–46.
9 Pal 2004.
10 The Phocaean bowl and amphorae from Turkey and glass vessels from Spain that have appeared at Tintagel Castle (Cornwall, England) highlight one moment in the long history of this exchange. The Intan shipwreck provides additional evidence of long-range trade in ceramics, this time in the Java Sea, and the Los dhow expands the nautical archaeological evidence to the Indian Ocean off Belitung Island, Indonesia. See Flecker 2002; Cronin 2009; Worrall 2014.
11 British Library, Or. 2666. Strong 1895, 385–430; Chittick 1974; Samson 2012.
12 Zhao 2015.

Transplants and Transformations in a Global Middle Ages

JILL CASKEY

The studies collected here stem from a simple yet potent idea: books travel. Medieval books traveled as gifts, booty, tribute, and personal possessions intended for devotion, study, diversion, and display. Like all objects, they carried meanings and possessed agency that derived from their changing owners, uses, and settings. This essay offers a brief sketch of a traveling book and the changes it prompted as a transplant far from home. It also considers ceramics recovered from a shipwreck in the Java Sea and evaluates their implications for how we understand and study the medieval world. The book and the shipwreck illuminate how different types of networks help conceptualize the premodern world as global. They also signal some of the methodological problems posed by the global, including the artificiality of any boundary or category and the difficulties of cross-cultural research.

I use the word "transplant" for a number of reasons. It more readily applies to both people and things, unlike such related terms as "export," "expatriate," "foreigner," "immigrant," "refugee," or "diaspora." The word's implicit biological and botanical associations evoke the fragile or vulnerable state of the object, as well as the overwhelming otherness of its new environment. The word also helps draw attention to the specific conditions that allow a transplant to "take" and thrive, or cause it to fail. Furthermore, the word suggests the idea that by thriving, the transplant may transform its new environment. Whether transplants are people or the objects that they make, move, give, sell, buy, use, or view, they may instigate cultural encounters across visual, material, and other fields. Consequently, they challenge the cultural, political, religious, geographic, and chronological taxonomies that have shaped how we envision the medieval world and its art.

My traveling book is a breviary that was produced in Paris in the 1270s.[1] The book is thought to have arrived on the southeast coast of Italy in 1296, when the king of Sicily, Charles II (r. 1285–1309) of Anjou, gave it to the pilgrimage church of San Nicola in Bari. The breviary was likely one of

twenty service books in the king's initial gift that redefined the treasury of San Nicola.[2] Described in the donation as *ad usum Parisiensem*, or conforming to the liturgical Use of Paris, the books were transplants, works made in Paris for Parisian liturgical celebrations. Charles II's foundation and related decrees helped the books "take," particularly after 1304, when the king mandated Use of Paris for San Nicola.

Endowed with some miniatures, including a cycle of scenes from the life of the biblical king David in the Psalter, the Bari breviary was the go-to book for the performance of daily offices in this south Italian environment reshaped by the king. Parisian saints and sites reverberate throughout the book's calendar, Psalter, daily readings, litanies, and antiphons. The dedication of the Cathedral of Notre Dame in Paris appears in its calendar, and the figure of Saint Denis looms large in its calendar, litany, and readings. Many entries correspond to the saints revered in new or recently reconstructed churches in Paris, including Saint-Symphorien, Sainte-Geneviève, Saint-Sulpice, and Saint-Séverin.[3] Through the agency of the king and breviary, then, such local feasts celebrated in Paris became official in Bari. Thus, the manuscript reset the pulse of daily life in Bari and circulated Parisian religious practices to and through this pilgrimage hub.

As an active agent of change, the book also was subjected to change to help it "take." The clerics of San Nicola added to it in a piecemeal process of recontextualization. In the early fourteenth century, the *inventio* (Latin for "discovery") of Saint Michael was added to the May calendar, thereby returning southern Italy's most venerable pilgrimage site at Monte Gargano to Bari's commemorations (fig. 18.1). The *inventio* of Saint Sabinus, the early Christian bishop of Canosa (southern Italy) whose remains were venerated at the Cathedral of Bari, was added as well. Furthermore, a table calculating the dates of Easter for the years 1339 to 1416 was inscribed on a blank verso at the end of the Temporale. Such changes testify to the breviary's status and key role in planning and performing the liturgy at San Nicola.

This characterization of the Bari breviary as an agent of change has implications that extend beyond the book's impact

18.1. Calendar page in a breviary, Paris, 1270s (transferred to Italy in 1296). Bari, Italy, Archivio della Basilica di San Nicola, MS 1.7, fol. 3r (photo: Jill Caskey)

on southern Italy. Created in Paris and featuring northern French illuminations, script, and text, the Gothic book was transplanted to an environment shaped by centuries of cross-cultural encounters. A litany of conquerors, including the Byzantines, Aghlabids (847–71), and Normans (1071–1194), helped shape Bari's cultural landscape. Emblematic of the city's Mediterranean character is Saint Nicholas himself. An early Christian bishop in Asia Minor, he performed a range of miracles that were highly valued by medieval Christians, from calming stormy seas to freeing the unjustly imprisoned. Barese sailors broke into his shrine in Myra (present-day Turkey) in 1087 and brought his remains to Bari, where a new Romanesque basilica was constructed for the saint.

Two centuries later, Charles II and the Parisian book transformed this Mediterranean environment. The breviary helped pull Nicholas's pilgrimage center into Northern European political, devotional, liturgical, and visual networks. The book thereby challenges Mediterranean models of interpretation. It helps point out that recent conceptualizations of the Mediterranean as connective must take into account networks that move far beyond the sea's coastlines and hinterlands, whether they move into Northern Europe, sub-Saharan Africa, Central Asia, or the Indian Ocean. Yet medieval connectivity undermines the geographic boundaries that have shaped centuries of historical research. Any fence we build around our field of study—no matter how carefully conceived, designed, constructed, and maintained—may fail to contain the vital evidence we cultivate.

Books, Bowls, and Buildings: Materials and a Global Middle Ages
From the various networks established in Europe by a traveling book, I now turn to commercial networks in Asia and the commodity of ceramics, which were described and depicted in Eurasian manuscripts (see fig. IV.9; Keene's introductory essay to this section discusses porcelain in the Kilwa Chronicles). When fishermen diving for sea cucumbers discovered the remains of a medieval cargo ship near Belitung Island in Indonesia in 1998, they could not have imagined the excitement and controversy that the find would generate around the

18.2a–b. (a) Bowl found in the Belitung Shipwreck, Gongxian, Henan province, China (Tang dynasty), 825–50. Singapore, Asian Civilisations Museum, Inv. 2005.1.00474; (b) Clay bowl, Iraq (probably Basra), ninth century CE / third century AH. New York, The Metropolitan Museum of Art, Harris Brisbane Dick Fund, 63.159.4

globe.[4] The dhow and its well-preserved contents have materialized vividly a ninth-century maritime network that spanned Asia—that is, a seaborne Indian Ocean Silk "Road" that linked Abbasid Iraq and Tang China. Of the sixty thousand objects salvaged from the wreck, the vast majority are ceramics, although gold vessels, copper mirrors, and other pieces of metalwork were part of the heavy cargo as well.[5] Most of the ceramics have been linked to the massive Changsha kilns in Hunan province (China), which produced industrial quantities of glazed bowls and ewers (pitchers) with highly varied abstract and figurative motifs, both painted and incised. One of them bears a date corresponding to 826, thereby providing the wreck with an apparent anchor in time.[6] Among the more exceptional pieces found on the ship are three white stone-paste dishes featuring blue underglaze designs, works that stand out because they are the earliest intact Chinese examples of what are tersely called blue-and-white (fig. 18.2a).[7]

Narratives of blue-and-white tend to focus on the dissemination of porcelain from China to Western Asia and Europe, beginning generally in the thirteenth century during the Yuan dynasty and continuing through the heyday of *chinoiserie* (imitation of Chinese motifs or techniques) in the 1700s (see fig. III.8, which imagines a banquet in a garden, featuring Chinese Ming porcelain vessels, in a *Shahnama* [Book of Kings] of 1444 from Timurid Shiraz, Iran).[8] The Belitung finds shift this discourse in significant ways. First, they provide new material confirmation of the export of blue-and-white wares centuries before Mongol rule. They also confirm that artistic exchange at that early date was dyadic (two-way) and iterative, for the Belitung finds are not the first instance of cross-cultural interaction with blue-and-white, but the third.[9] The first chapter in this long story sees the export of Chinese porcelains to Abbasid Baghdad and Samarra in present-day Iraq, a process registered in archaeological and textual records alike.[10] The second chapter outlines the reception and appropriation of such works in Basra, Iraq, where ceramists developed white pottery with the raw materials they had at hand: a yellowish clay that was highly worked and fired with a lead-and-tin glaze, thereby achieving a look—but not feel—comparable

to white Chinese stone-paste.[11] These wares have been described as imitations or copies of delicate Chinese exemplars from prestigious kilns in Xing and Ding.[12] However, this characterization glosses over the fact that the Basran ceramists did not develop these new techniques merely to reproduce white vessels; they added bold underglaze designs, some of which were painted with cobalt pigment mined in Iran. Many of them feature Arabic inscriptions, suggesting that the development and use of white glazes was in part a means of highlighting calligraphy (fig. 18.2b). In other words, in the second chapter of this story of artistic cross-pollination across Asia, the blue emphasized and prioritized the local and Islamic identity of the objects; the objects were not just trying to "look Chinese." Indeed, the blue script on white is striking, reminiscent of the Blue Qur'an from Kairouan, Tunisia, albeit with reversed grounds and less pristine letters (see fig. introduction.9).

The third chapter of this story features the Belitung blue-and-whites and the Chinese reception and appropriation of Islamic art from Western Asia. Interest in the key visual innovation of the Abbasid works, namely the cobalt underglaze designs, prompted the importation to China of the blue pigment from mines in Iran.[13] The three Belitung blue-and-whites feature designs that closely resemble the linear compositions and effects of the Islamic works. The arching blue sprigs that fan out from central lozenges on two of the dishes seem to emulate Abbasid designs; the trefoils that divide the sides of the plates into neat quadrants closely resemble Islamic wares in collections in New York, London, Berlin, and Munich. Thus the Belitung blue-and-whites seem to have been produced with Abbasid models and markets in mind. They may well have been "commercial samples" intended to kick-start a new venture, as Simon Worrall has posited;[14] but, critically, the samples were made to "look Islamic," and that Islamic look must have been understood as key to securing the Abbasid market and commercial success in Western Asia. However, these would-be transplants would not have "taken" even if they had not sunk in the Java Sea. With the collapse of the Tang dynasty in 906, the persecution of foreign merchants in

southern China, and interruption of long-distance trade, this new blue-and-white venture was doomed to fail.

The significance of the Belitung wreck extends beyond the stories it tells about interactions between Islamic and Chinese art in the ninth century. As portable objects manufactured from imported materials in one place and intended to be sold, used, and appreciated on the other side of Asia, the blue-and-white wares discovered in the Java Sea help conceptualize a more complex model of cultural interaction than the dyadic one sketched out above. The segmented nature of long-distance trade, be it overland or maritime, means that stops along the way shaped and reshaped crew and cargo alike. Our jet age may normalize travel as a binary, a leap from here to there, but medieval maritime travel entailed myriad stops necessitated by trade winds, hunger, and disease as well as markets and mammon. Quotidian objects found on the Belitung dhow suggest that its crew was from Southeast Asia, China, Indonesia, and Western Asia.[15] Its voyage likely began in Canton (modern Guangzhou) in southern China, where its cargo had been assembled from multiple workshops and kilns located across inland China. It then sailed along the coast of Vietnam to Indonesia, where it sank near the mouth of the Straits of Malacca. The early tenth-century Arabic compilation known as the *Akhbār al-Ṣīn wa'l-Hind* (Account of China and India) describes the reverse voyage, from Siraf on the Persian Gulf to Kanfu (Canton/Guangzhou), with stops in the Maldives, Quilon (in Kerala, India), Kedah (on the northeastern coast of Malaysia), and Champa (the eastern coast of Vietnam) before sailing up the Pearl River to Guangzhou, "a haven for the boats and market-place of Arab and Chinese commerce . . . the meeting place of merchants."[16]

For art historians, such an itinerary renders our tidy areas of specialization rather limited and limiting. Each of the locales named between the Persian Gulf and the Pearl River Delta brings unique problems of interpretation. Each possesses particular historiographic traditions that require analysis in order to reveal their limitations and move beyond them.[17] Each had distinct visual and material cultures composed of portable and monumental works—some extant,

some excavated from land or sea, some lost—and textual sources relating to them.[18] The multiplication of localities also creates untold linguistic challenges. Some of us may read Latin, Greek, Arabic, Hindi, or Mandarin, but how many of us have mastered all of them? And what about Malay and its medieval antecedents? Whether examining books, bowls, or buildings, scholarship on such global networks necessitates collaboration. By working with one another, we are better able to assess the evidence arising from long-distance trade with care, attention to detail, and deep contextualization, so that we may grasp the complexities created by connectivity and the myriad contingencies of cultural exchange.

— Jill Caskey is an associate professor in the Department of Art at the University of Toronto.

Many thanks to Bryan C. Keene for his invitation to participate in the symposium "Manuscripts in a Global Context" at the J. Paul Getty Museum in 2016. I am grateful for the Getty Foundation's generous support of Global and Postglobal Perspectives on Medieval Art and Art History, a Connecting Art Histories project in which I participated. This essay is dedicated to the students and colleagues in Guangzhou and Toronto from whom I have learned so much.

1 MS 1.7 in the Archivio della Basilica di San Nicola, Bari. This brief discussion of the breviary derives from my current research on pilgrimage, patronage, and the cult of saints in southern Italy. I am grateful for the assistance of Fr. Gerardo Cioffari, Francesco Innamorato, and Antonella di Marzo in Bari, and for the support of the Social Science and Humanities Research Council of Canada. Previous work on the manuscript includes Cioffari (2008, 118).

2 This donation established a new *capella regis* at San Nicola. Overview in Caskey 2011, 108–29; also Cioffari 1986, 21–23.

3 The Parisian building boom is discussed in Meredith Cohen (2015, 35–65).

4 Fierce debates about the ethics of the commercial salvage of the site and sale of its contents led the Smithsonian to cancel the *Shipwrecked* exhibition in 2010. Since then, the finds, now housed in the Asian Civilisations Museum in Singapore, have been exhibited in North America at the Aga Khan Museum in Toronto in 2014 (the new museum's first exhibition) and at the Asia Society in New York in 2017. Both museums tackled the wreck's ethical issues in exhibition materials and accompanying symposia. Criticisms of the excavation and Smithsonian exhibition appear in J. Green (2011, 449–52) and Bartman (2011, 6).

5 Krahl et al. 2010; Worrall 2014. A summary of the scientific evidence for the origins of the ship is in Burger et al. (2010, 383–86).

6 Still, the wreck is dated from 826 to ca. 840 to allow time for the inscribed ware to reach the port; await ship, crew, and favorable winds; and then sail. Also, the inscription was not necessarily made in the year it mentions. J. Green 2011, 451.

7 The works are attributed to the Gongxing kilns in Henan province. Hallett 2010, 75–81; Krahl et al. 2010, cats. 279 and 280, pp. 261–62; Worrall 2014, 42–43. Now Asian Civilisations Museum, Singapore, nos. 2005.1.00474 and 2005.1.00475.

8 Recent studies include Finlay 2010; George 2015, 579–624; Krahl 2010, 209–11; Pierson 2012, 9–39.

9 "Dyadic" model in Chaffee 2006, 395–420. Also Krahl 2010.

10 Textual references to large quantities of Chinese porcelain sent to the caliph Harun al-Rashid (r. 789–809) discussed in Hallett 2010; Blair and Bloom 1997, 107–8.

11 Because the Munich inscription is a generic blessing to the owner, it presumably was made for the open market. Dolezalek 2014, 67–68; also George 2015, 604–5.

12 For instance Hallett 2010, 79.

13 Debates in Krahl 2010. Also Du and Su 2008, 249–59; Matin and Pollard 2016, 1–16.

14 Worrall 2014, 42.

15 Chong and Murphy 2017.

16 Ahmad 1989, 37. Analysis of an earlier Chinese account of the route, penned by the geographer and Tang statesman Jia Din around 800, is in Park (2012, 30–34).

17 For an example of historiographical analysis, see Giang 2016, 59–82. Analogous Mediterranean models are developed in D. Smith (2016).

18 For instance D. Heng 2009.

Manuscripts, Faith, and Trade across the Medieval Sahara MICHELLE H. CRAIG

Overland commerce in and across the Sahara Desert developed from the first centuries of the Common Era, peaked during the seventh through the sixteenth century, and coincided with much of the area's Islamization. The desert served as a conduit, a place of profound exchange and innovation. By the late Middle Ages, connectivity between North African, Saharan, and Sahelo-Sudanic (between the southern Sahara and the savanna) peoples transcended ethnic divisions. Diverse communities benefited from a sustained interest in Islamic scholarship and a shared Islamic faith with adherence to the Maliki school of jurisprudence—a major branch of sharia, or Islamic law, that relies on the Qur'an and hadiths, or wisdom attributed to the Prophet Muhammad (about 560–632). Functional literacy was more widespread in Africa than in Europe by the early modern period, allowing ethnic groups to communicate in Arabic, share information, and conduct commerce.[1] Paper, books, and manuscripts became some of the most lucrative goods exchanged across the desert, and analysis of these desirable commodities allows us to gain greater depth of understanding of trans-Saharan markets, the societies that supported them, and their educational initiatives.

Few early manuscripts are extant, but diplomatic exchanges and tombstone inscriptions assert that Arabic writing appeared at an early date among polyglot African communities.[2] The absence of early manuscripts indicates the preciousness and rarity of paper at a time when pedagogy did not require it.[3] Early Islamic education for both boys and girls took place at home, and once the Qur'an was memorized, students would enter a course of study with Islamic scholars in nomadic or fixed locations.[4] Throughout the Sahara and Sahelo-Sudan, Qur'anic learning privileged oral presentation, and written exercises were ephemeral, with a wooden slate used for continuous study. Passages were written and then washed off (similar to the tablet with Coptic inscriptions from Egypt, see fig. II.4), and paper was rarely used.[5] Moreover, learned populations soon acquired books and established local institutions to serve a variety of educational needs. Such educational institutions arose before centralized Islamic governments endowed them. And if a topic was not taught locally, a scholar would travel to a school that offered the desired subject. Book markets in North Africa, where paper and manuscript production thrived by the eleventh century, matched educational demands from the south. Saharan scholars organized special caravan trips to Morocco to attend the book market held every Friday at Jami' al-Qarawiyyin (the mosque, university, and library) in Fez, and the one on Thursdays next to Jami' al-Kutubiyya (the mosque so named for its book market) in Marrakech.[6]

Demand for religious texts, scholarly works, legal rulings, and text-based amulets supported complex business operations and encouraged book collecting as a sign of education, social status, and wealth. Brisk manuscript trade across the Sahara ensured that Muslim-majority societies could instill proper religious practice grounded in the Qur'an and canonical texts on the way of life of the Prophet Muhammad.[7] Two manuscripts in West African collections articulate the level of Islamic knowledge present in medieval Africa via importation and local production. Written by a twelfth-century Maliki scholar, *Al-shifa bi ta'arif huquq al-Mustafa* (The Rights of the Prophet, fig. 19.1) describes the life of the Prophet Muhammad, including his morals and genealogy. This beautiful copy was produced in Morocco and carried over the Sahara to Timbuktu, Mali, where rumor has it that it was purchased for the equivalent of twenty-four grams of gold.[8] Muslims adhering to the Maliki law school dominated late medieval trade routes, and Maliki authors were popular from the Maghrib (Northwest Africa) through the Sudan.[9] The volume's calligraphy

19.1. Moroccan commissioned copy of *Al-shifa bi ta'arif huquq al-Mustafa* (The Rights of the Prophet) by Qāḍī ʿIyāḍ ibn Mūsā, Morocco, 1149 CE / AH 544. Timbuktu, Mali, Ahmed Baba Institute, Manuscript 165

19.2. Shetima Kawo Qur'an, Nigeria, sixteenth century CE / tenth century AH. Jos Museum, Jos, Nigeria

and ornamentation are emblematic of the educational and commercial excellence of Moroccan cities, the importance of trans-Saharan trade, and the bibliophile culture of Timbuktu. The sixteenth-century Shetima Kawo Qur'an (fig. 19.2) introduces viewers to a different intellectual center of the Sahelo-Sudanic belt. Trade routes, as well as southern and northern termini, changed according to the rise and fall of a number of political states and empires. Various routes influenced the development of Arabic calligraphy, manuscript production, and book culture, linking different political states, fostering education, and supporting local social structures.

The scholarly city of Timbuktu was well positioned at a commercial crossroads transitioning from the Sahara to the Niger Delta. Literacy and books meant more than the capacity to learn; they indicated wealth, power, and blessing.[10] Both the literate and the illiterate owned books, as manuscripts were one of the few acceptable ways of displaying wealth. Timbuktu's intellectual reputation was strengthened by the Almoravid invasion from Morocco of 1054–55, when Abdallah Ibn Yasin (d. 1059) united the groups in the western Sahara and created a centralized, Islamic government from Spain to West Africa.[11] Between one hundred and fifty and one hundred and eighty Qur'anic *maktabs* (schools) served four thousand to five thousand students by the sixteenth century, firmly placing Timbuktu in a constellation of African institutions of higher learning. While libraries in North Africa were accessible to the public, this was not often the case in the Sahara or Sudan.[12] Private libraries in the Saharo-Sahelian belt concatenated collection, wealth, and status. Class divisions included the literate *zwaya* (scholarly or clerical class), who worked as farmers, cattle breeders, merchants, teachers, religious leaders, and judges; warriors, who sold protective services to *zwaya*; vassal social groups; *m'allmin* (craftsmen) and praise singers; and finally freed slaves and slaves. While open to all in principle, in practice, only the *zwaya* attended *maktabs* in order to maintain strict class distinction.[13]

Arabic scripts epitomized the desire to learn and glorify the divine. *Maghribi* script distinguishes the *Al-shifa bi ta'arif huquq al-Mustafa* manuscript. This popular style

of calligraphy originated in eleventh-century Maghrib or al-Andalus (Muslim-controlled territories on the Iberian Peninsula) and featured swooping tails regularly descending below the flat baseline of text.[14] Red ink alerts readers to praises of the Prophet, and polychrome geometric designs provide visual delight and separate passages. The manuscript includes commentary added at a later date, showing engagement with the document over time. Saharan and Sahelo-Sudanic scribes and scholars copied and produced works in *maghribi*, and also developed a number of other variations for both religious and secular works to suit the needs of local patrons.[15] Scripts were not ethnically distinct; rather, peoples across the Maghrib, Sahara, and Sahelo-Sudanic zone shared script styles regionally, with certain scripts centered in specific areas. By owning a copy of *Al-shifa bi ta'arif huquq al-Mustafa*, a Timbuktu patron sought to increase a reputation built on piety and allegiance to the Maliki school of law. The place of origin, contents, script, and ornamentation reflected the owner's cosmopolitanism.

If *Al-shifa bi ta'arif huquq al-Mustafa* demonstrates the flow of goods and information from Morocco to Mali, the Shetima Kawo Qur'an illuminates Kanem-Borno-specific educational practices. The bold and squat *barnawi*, or central Sudanic script, was developed in the late medieval period and responded to devotional and educational needs in Kanem-Borno, the trading empire around Lake Chad (present-day Cameroon, Chad, Niger, and Nigeria) from the ninth to the nineteenth century, its rulers having adopted Islam in the eleventh century.[16] The state thrived on north-south trade routes through the Fezzan (now Libya) to Fatimid (909–1171) and Hafsid (1229–1574) states in present-day Tunisia. It also connected westward to Almoravid (1040–1147) and Almohad (1121–1269) capitals in Morocco via Songhay-held Gao and Timbuktu. The Borno capital of Gazargamu would become known not only for its scholars but also for fine calligraphy and Qur'ans.[17]

One of four royal Borno Qur'ans, the sixteenth-century Shetima Kawo Qur'an contains *barnawi* script and elements that emphasize linguistic excellence and class distinction. The *barnawi* script common in Borno developed due to local needs in conjunction with calligraphic trends in North Africa and the Middle East.[18] The unbound volume is typical of Saharan and Sudano-Sahelian production. Pages were unnumbered and kept together in a special case, and such a composition underscores the importance of individual knowledge as well as an aesthetic of movement—here the haptic quality of turning pages and reciting the text, which corresponded to the privileging of mobile elements in textiles, garments, personal adornments, and horse trappings to indicate wealth and status. West African materials covered both local and imported manuscripts.[19] The margins include interlinear translations from Qur'anic Arabic into precise and technical Kanembu, the archaic language of Kanem from the ninth to the thirteenth century, evidence of one of the advanced stages of Qur'anic learning.[20] Kanembu was not used for independent composition, nor was it the spoken language of the sixteenth century. The archaic language would have had a limited audience of scholars, and yet would have assisted these intellectuals in making Qur'anic meaning understandable for the wider Kanuri-speaking community in Borno. As in Timbuktu, books were present in private libraries but were largely absent in the public spheres of the Niger Delta, northern Nigeria, and Lake Chad.[21] Literacy was available to a controlled population who built reputations on their Islamic knowledge and access to valuable books.

The differences in script and composition of these two manuscripts assert the diversity of Islam in Africa in the Middle Ages. Arabic calligraphy developed differently in the Islamic West than in the East. Both *maghribi* and *barnawi* grew out of archaic Kufic from the Middle East, but these scripts responded to divergent transregional encounters. *Maghribi* evolved in the wake of changing politics in North Africa, where Almoravid leaders controlled parts of al-Andalus, the Sahara, and Sudan. *Barnawi* did not originally contain elements traceable to al-Andalus and has its roots prior to the establishment of the *maghribi* script in North Africa.[22] The diverse scripts used in religious and secular manuscripts throughout Islamicate Africa suggest regional rather than ethnic divisions

and demonstrate how bonds of trade and faith connected as well as distinguished different communities.[23]

These two manuscripts illuminate the complexity of polyglot Saharan communities and the commerce thriving among them. Arabic scripts arose from the need to express, in the most noble and beautiful way, the divine word of the religion undergirding many communities. Manuscript materials originated in the Sudan, the Maghrib, and even al-Andalus or Christian European states, and traveled across routes following changing political alliances. As possessions, these sacred volumes helped to demonstrate piety and wealth, build reputations, and maintain social order. The conservative appearance of both texts was appropriate for local readers and emphasized the religious rigor present on the margins of the Islamic world but at the very centers of book culture in medieval Africa.

— Michelle H. Craig is a professor of art history at Cuesta College.

My sincere thanks to Bryan C. Keene for inviting me to contribute to this volume. I gratefully acknowledge the Getty Research Institute and the National Endowment for the Humanities for supporting the research for this case study. Any views, findings, conclusions, or recommendations expressed in this contribution do not necessarily reflect those of the National Endowment for the Humanities.

1 Lydon 2011, 38.
2 Brigaglia and Nobili 2013, 201.
3 See El Hamel 1999, 62–87.
4 Islamic universities at major mosques were founded at the Qarawiyyin mosque in Fez, Morocco, in 859 CE; the Zaytuna mosque in Tunis, Tunisia, in 864 CE; and the Azhar mosque in Cairo, Egypt, in 972 CE. Universities were associated with mosques in Timbuktu in the fifteenth century (Sankore and Sidi Yahya), but many institutions were founded independently. The Arabic terms for these institutions vary. Some are called *maktab* (place of reading), *madrasa* (place of study), or *mahadra* (place of lecture). In the western Sahara, they may also be called *zawiya* (assembly), without affiliation with a Sufi order. For a discussion of nomadic schools in the western Sahara, see El Hamel 1999. For female patronage of mosques and universities, see Glacier 2012. For a history of Qur'an teaching and memorization in West Africa, see Ware 2014.
5 Brigaglia and Nobili 2013, 202.
6 Krätli and Lydon 2011, 268.
7 Al-Ḥasan Al-Wazzānī (Leo Africanus) recorded that books and manuscripts from Morocco were sold for more money than any other merchandise. See Africanus 1956, ii, 468–69.
8 *Timbuktu: Script and Scholarship* 2008, 50.
9 Krätli and Lydon 2011, 1–34.
10 Singleton 2004, 3.
11 El Hamel 1999, 68.
12 Singleton 2004, 9.
13 See Lydon 2011, 39.
14 For a discussion of *maghribi*'s evolution and different typologies, see Ennahid 2011, 266–72.
15 There is no standard definition for *maghribi*, or western script. Saharan and sub-Saharan variations—*sahrawi*, *sudani*, *suqi*—similarly lack clear definitions. Blair (2008) reinscribes the ill-defined variations, positing African scripts as marginal and primitive. Recent scholarship seeks greater nuance and clarity. For synchronic analysis, see Hamès 2013, 232–52; Nobili 2011, 105–33.
16 See Brigaglia and Nobili 2013; Bondarev 2006, 142–53; Bondarev 2007; Bondarev 2013, 56–83; Brigaglia 2011, 51–85.
17 The first known writer in Arabic of sub-Saharan origin, Abu Ishaq Ibn Ya'qub al-Kanemi, received education in Kanem before traveling to Marrakech some time before 1198–99, when he was received by the Almohad sultan. He wrote in an archaic Kairouani script and helped to popularize Almoravid and Almohad writings. Bondarev 2006, 143.
18 Brigaglia and Nobili 2013, 198.
19 Tanned leather from the central Sudan was exported to the Maghrib and sold to European merchants by the twelfth century, when Islamic Cordoba became a recognized center for European bookbinding. The West African leather there was dubbed Morocco leather due to its Moroccan ports of trade. Lydon 2011, 62.
20 Bondarev 2006, 144.
21 Krätli and Lydon 2011, 175–211.
22 Brigaglia and Nobili 2013, 220.
23 Nobili 2011, 130.

20

Narrative Shifts: The Life of the Buddha in Palm-Leaf Manuscripts

TUSHARA BINDU GUDE

Although the earliest surviving Buddhist manuscripts, written on birch-bark scrolls, date from the first century CE, Buddhist texts do not appear to have borne illustrations until nearly one thousand years later (the earliest surviving examples date from the eleventh century).[1] Even then, the manner in which images came to adorn palm leaf and, later, paper manuscripts was not "illustrative" of the texts in the usual sense of this term. Rather, such illustrations—often bearing little or no relation to the text—were intended to empower and enliven the book, and link it with broader patterns of Buddhist doctrine and religiosity. A consideration of the many ways in which images operated in these manuscripts has considerable bearing on how we come to understand such objects in relation to immovable and other arts and, indeed, on the many different ways in which one might consider the nature of the manuscript or book.

A pair of wooden Buddhist manuscript covers from Eastern India (possibly Bihar), dating from about 1075 to 1100, provide an ideal starting point (fig. 20.1). They originally would have enclosed a palm-leaf text, its individual folios stacked between them. The inner side of each is painted. The top cover contains eight scenes from the Buddha's life, and an image of the Buddha receiving homage at the far right. The bottom cover likely depicts the seven Buddhas of the ages, flanked by images of Maitreya (the future Buddha of this world) as a Buddha, at left, and as a bodhisattva (a compassionate savior), at right. Judging by its immense popularity in this particular time period, the text associated with the covers was probably the *Aṣṭasāhasrikā Prajñāpāramitā Sūtra* (The Perfection of Wisdom) in eight thousand verses, which was recorded in the first or second century CE and became one of the foundational texts of Mahayana Buddhism (one of the main branches of Buddhism, concerned with bodhisattvas and other foci of veneration, which is also at the core of Zen,

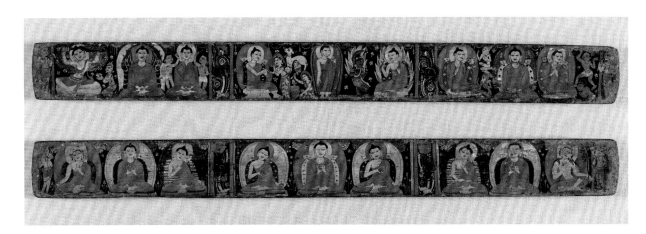

20.1. Pair of Buddhist manuscript covers with *Buddhas with a Bodhisattva* and *Scenes from the Buddha's Life*, Bihar, India, 1075–1100. Los Angeles County Museum of Art, From the Nasli and Alice Heeramaneck Collection, Museum Associates Purchase, M.72.1.20d–c

20.2. *Pancharaksha* (The Five Protective Charms) manuscript, Chakrabahal, Nepal, 1770. Los Angeles County Museum of Art, Gift of A. Peter Burleigh, M.88.132

Pure Land, and Tibetan practices, among others). The larger body of *Prajñāpāramitā* literature, which consists of various summaries or elaborations of the *Aṣṭasāhasrikā* text, expounds upon various themes, including the doctrine of *shunyata* (emptiness), referring to the illusory and insubstantial nature of all phenomena. It also articulates the concept of the goddess Prajñāpāramitā as a personification of the transcendent wisdom contained in the text. Another very important innovation of the text was its pronouncement that it should be a focus of *puja*, or ritual worship. Because Prajñāpāramitā is the source of all Buddhas—in the sense that she is the wisdom that makes their Buddhahood possible—her worship is, in fact, more meritorious than the worship of a Buddha's bodily relics.[2] Indeed, manuscripts of the *Prajñāpāramitā Sūtra*

are still venerated, as at the Golden Temple (Kwa Baha) in Patan, Nepal, where a lavish thirteenth-century copy of the *Aṣṭasāhasrikā Prajñāpāramitā Sūtra* receives regular worship throughout the year. Of particular interest is the fact that the *puja* parallels devotional rituals directed to images. Following ritual purification and installation, the goddess is invoked to enter and reside in the manuscript, which is then recited in its entirety.[3] That other types of Buddhist texts were also accorded such worship is indicated by a *Pancharaksha Sūtra* manuscript from Nepal, dated 1770, that bears heavy traces of ritual use (fig. 20.2). The Pancharaksha are five protective goddesses invoked and worshipped primarily through such books, in which their presence is thought to reside.[4]

The manuscript covers introduced above can be viewed in a number of ways. They are certainly representative of one of the many manuscript traditions that flourished around the globe between the late first and early second millennia, each having its own stylistic trajectory, cultural ambit, patterns of use, and networks of circulation. Indian Buddhist manuscripts of the eleventh and twelfth centuries stand at the beginning of an extraordinary efflorescence of manuscript illustration in Eastern Indian monastic institutions. They survive largely because of their portability and ultimate preservation in Himalayan monasteries. They contributed to the conscious adaptation of Eastern Indian visual styles into Nepalese and Tibetan visual traditions due to the fact that these manuscripts, and other artworks from Eastern India, were considered authoritative prototypes.

As intraregional networks of circulation and exchange increasingly come to the fore in examinations of the early globalized world, it is now more than ever possible to consider the circulation of such manuscripts, their cognates (sculptures, paintings, and so forth), and the visual traditions espoused therein within a broader geographic arena. Eastern Indian manuscripts are conceivably among the sources for some of the unique iconographies encountered in Southeast Asia, for instance. In the late eleventh-century manuscript covers discussed above, two of the life scenes on the top cover—the fifth and sixth from the left—address the Buddha's taming of the serpent in the fire temple at Uruvilva, which was associated with a Hindu rival teacher named Kasyapa (see fig. 20.1, sixth scene). In the first scene, the Buddha encounters the fire snake. The second scene depicts the outcome of their battle, which lasted an entire night, ending with the Buddha subduing the serpent and setting him into an alms bowl. This instance is a rare depiction of the narrative in a late Indian Buddhist context; the standardized life scenes traditionally used at this time to illustrate the Buddha's biography do not include this episode. The story appears in the 50 BCE–50 CE narrative imagery at the Great Stupa at Sanchi, and in Gandharan narrative reliefs of the early centuries CE, but individual icons of the Buddha holding the snake in an

alms bowl are unknown from India.[5] Such images are known from Southeast Asia, however, where examples as early as the ninth century have been found in Java and Borneo.[6] The relationship between Indonesia and Eastern India is well attested by several extant Eastern Indian–style Buddhist bronzes produced in Java between the eighth and the twelfth centuries.[7] Of course, the intra-Asian circulation of Indian Buddhist texts and imagery began in a much earlier period—in the first centuries CE—as Indian, Chinese, and Central Asian monks traversed tortuous overland trade routes, propagating the faith or seeking its authentic teachings. Maritime routes to and from India brought early Buddhist travelers through Sri Lanka and Indonesia, such that the wide dispersal of Indian books and manuscripts gave rise to unique local idioms.

Apart from their value in documenting visual and material exchanges between Buddhist regions of Southern Asia, Eastern Indian manuscripts are valuable for what they tell us about the nature and use of narrative in a late Buddhist context. Narrative drives a good deal of manuscript production in the Hindu, Jain, and Islamic traditions of South Asia, but plays a very limited, though intriguing, role in illustrated Buddhist manuscripts. This limited use of narrative stands in sharp contrast to architectural and sculptural evidence from the earliest Buddhist monuments in India, where scenes from the life of the Buddha and from the *jatakas*, the Buddha's previous birth stories, adorn various parts of Buddhist stupas and shrines. Some of the most extensive early narrative reliefs appear on the architraves of the gateways to the Great Stupa at Sanchi. Wrapping around the front and back sides of the lower register of the north gate, for example, is the *Vessantara Jātaka*, which tells the story of the Buddha's last life before his birth as Shakyamuni (the historical Buddha, who lived in the sixth–fifth century BCE) (fig. 20.3). One of the most popular of the birth stories in India and elsewhere, the *Vessantara Jātaka* is essentially a tale of selfless giving. Prince Vessantara was banished from his kingdom for giving away an auspicious elephant, associated with rainmaking. During his exile, he successively gave up his horses, chariot, and children. Lastly, he gave his wife to a mendicant—actually the god Indra

included his birth, enlightenment, first sermon, and death.[9] Sculptural emphasis shifted to iconic imagery of the historical Buddha, often in association with the abbreviated life scenes, and of bodhisattvas, goddesses, transcendental Buddhas, and an expanding group of esoteric deities. This shift is reflected in both the content and the illustration of Buddhist manuscripts, including the *Prajñāpāramitā* literature.

Four folios are among the earliest surviving fragments from an Eastern Indian *Prajñāpāramitā Sūtra* manuscript, in which the Buddha's biography is pushed to the margins of the text (fig. 20.4). The central images in the surviving folios depict Prajñāpāramitā and the bodhisattva Manjushri, the female and male personifications of wisdom, respectively, which are essential to enlightenment. The extant life scenes (from top to bottom, left to right) include the Buddha's birth, enlightenment, first sermon, miracles at Shravasti, taming of the elephant at Nalagiri, descent from Trayastrimsha, and death (*parinirvana*). The missing left portion of the fourth folio likely depicted the monkey's gift of honey at Rajagriha. The eight life scenes of the Buddha came to collectively signify the Buddha's enlightenment. Their inclusion in the manuscript, though peripheral to the central images, is intended to reinforce the association between the enlightenment of the historical Buddha and the *Prajñāpāramitā* text as the root of all enlightenment.[10]

The *Vessantara Jātaka*, which is not encountered in sculpture of this period, does however find a place in *Prajñāpāramitā* manuscripts. In a late twelfth-century manuscript now in the Bharat Kala Bhavan in Varanasi (India), for instance, the story of Vessantara appears in the interstitial spaces of four extant folios, the larger illustrations reserved for the eight expected life scenes and four images of bodhisattvas.[11] In these spaces—comprising eight in all, two per folio—the Vessantara narrative is reduced to the figures of the prince and a mendicant flanking the central image. One cover of the manuscript depicts Prajñāpāramitā flanked by the seven Buddhas of the past and the future Buddha Maitreya. The second cover depicts five transcendental Buddhas and four bodhisattvas. Embedded within this nexus of imagery, the

20.3. North Gateway of the Great Stupa, Sanchi, Madhya Pradesh, India, 50 BCE–50 CE

in disguise. Having thus witnessed firsthand Vessantara's extraordinary generosity, Indra revealed himself and restored to the prince his family, possessions, and kingdom.

By the sixth century, the previous lives of the Buddha had ceased to be major avenues for artistic exploration in stone.[8] Around the same time, the life of Shakyamuni started to become encapsulated in abbreviated scenes which, by the eighth century, were codified as eight key narrative moments—associated with places of pilgrimage—that

20.4. *Prajñāpāramitā and Scenes from the Life of the Buddha; Manjushri and Scenes from Buddha's Life; Scenes from Buddha's Life;* and *The Death of Buddha,* folios from a *Prajñāpāramitā* (The Perfection of Wisdom), Bihar, India, 1025. Los Angeles County Museum of Art, E. Manheim and Dr. and Mrs. Pratapaditya Pal, M.86.185a–d

much-abbreviated *Vessantara Jātaka* imagery functions in such a way as to add additional layers of meaning and import to the manuscript. The *Vessantara Jātaka* is concerned with acts of giving, as noted above, and giving is extolled in this text as one of the six perfections, or *paramitas*. The *Prajñāpāramitā Sūtra* and the wisdom it contained was embodied as a goddess representing the knowledge necessary for enlightenment. In combining the *Prajñāpāramitā*'s teachings with a geospatial mapping of sacred sites and with images of Vessantara, the historical Buddha, past Buddhas, transcendent ones, and the future one, such texts—cult objects of focused devotion—reveal themselves as complex objects that defy easy

categorization as books or manuscripts, not unlike much of the other material discussed in this volume.

Further examinations of a global Middle Ages for India, South Asia, and the Himalayas hold great promise, especially considering the diversity of religions, peoples, cultures, and visual traditions that existed across this vast area, and which were transformed in various ways as they connected with one another and with worlds beyond. Art museums are ideally suited to showcasing such complexity and diversity, and many recent exhibitions, such as the Getty's *Traversing the Globe through Illuminated Manuscripts* (2016) and *Pathways to Paradise: Medieval India and Europe* (2018), have taken on the responsibility and challenges of interrogating and decentering history and presenting multiple points of view. Many museums are, additionally, supporting a broader goal of sharing art and exhibitions—and thus also knowledge, ideas, insights—across borders. *The Arts of Buddhism*, for instance,

an exhibition organized by the Los Angeles County Museum of Art, is showing at the Museo Nacional de Antropología in Mexico City in 2018 under the title *Tras las huellas de Buda* (Treading the Buddha's Path). The show presents an international survey of Buddhism and Buddhist art through 171 works from LACMA's permanent collection, following the spread of the faith from India to mainland and island Southeast Asia (Myanmar [Burma], Thailand, Cambodia, Vietnam, and Indonesia), the Himalayas (Kashmir, Nepal, and Tibet), and East Asia (China, Korea, and Japan). Varied sculptures, paintings, manuscripts, scrolls, and ritual objects trace key Buddhist concepts and teachings as they emerged, developed, and were translated across time and remote geographies. More than one hundred works (nearly two-thirds of the show) were produced in the "Middle Ages" and reveal an extraordinarily refined and cosmopolitan Buddhist world, in which book arts played a fundamental role.

— Tushara Bindu Gude is associate curator of South and Southeast Asian art at the Los Angeles County Museum of Art.

1 On what appears to be the earliest surviving corpus of Buddhist texts, see Salomon 1999. Another cache of early manuscripts, some dating from as early as the seventh century, was discovered in Gilgit, Pakistan, in 1931. While they do not contain illustrations, three pairs of manuscript covers that were later recovered from the same site were adorned with figures of the Buddha, bodhisattvas, and donors. The most recent discussion of these covers is in Linrothe (2014, 39–54).

2 For a good introduction to this goddess, see Shaw 2006, 166–87.

3 For a description of these procedures, see J. Kim 2013, 271–85. See also Gellner 1987.

4 J. Kim 2010, 259–329.

5 For Gandharan version of the narrative, see Pal 2003, cat. no. 27, p. 59.

6 Robert L. Brown was the first scholar to identify the subject (in Pal 1984, cat. no. 58, p. 116). Another curious parallel between this manuscript and the narrative sculpture of Gandhara is the manuscript's inclusion of an image of the emaciated Buddha (top cover, third scene from left). Such depictions appear with some frequency in Gandhara, but are rare in other South Asian Buddhist contexts.

7 Huntington and Huntington 1990, 208–12.

8 R. Brown (2014) convincingly argues that the decline in Buddhist visual narratives coincided with the rise of bronze production of icons.

9 The four additional life scenes typically included the miracles at Shravasti, the descent from Trayastrimsha, the taming of the elephant at Nalagiri, and the monkey's gift of honey at Rajagriha.

10 For a study of such manuscripts and their image programs, see J. Kim 2013.

11 This manuscript and other examples are discussed at length in J. Kim (2009, 261–72).

MELANIE HOLCOMB
AND ELIZABETH A.
EISENBERG

21

Traveling off the Page: Bringing the Voyage to Life in Hebrew Poetry and Paintings

One of the best known of all medieval Jewish travelers is Benjamin of Tudela (1130–1173), who left his homeland in Spain around 1165 for a journey lasting some six years. His *Sefer ha-Masa'ot* (ספר המסעות; Book of Travels) takes us from Saragossa (Spain) to Rome, and onward to Constantinople, Jerusalem, Baghdad, and Cairo.[1] Adventurous, observant, and curious, Benjamin represents something of an ideal European traveler, yet as a raconteur, as a conjurer of the *experience* of travel, he quite frankly disappoints. There is something dry and oddly arduous about his prose. He answers the basic questions: How many Jews live there? What are the names of their leaders? And he conveys basic facts: here are the curious customs of this place; here are the principal trades. And always, the next town lies ahead, its distance dutifully conveyed in days and/or parasangs (variable itinerant distances). We are left to wonder, though, how he got from place to place. What did travel involve for him, practically, physically, emotionally? We are never privy to the difficulty or drama that his wide-ranging travels and the experience of incessant voyaging surely stirred.

To be fair, Benjamin's account falls into the widespread and long-standing tradition of the itinerary, the aim of which is to move reliably and efficiently from place to place, to mark ground. By those standards, his text might well be considered fulsome.[2] Yet there is a concurrent medieval tradition, both written and visual, that lingers on the journey, that relishes in and draws inspiration from the magic and marvel of not being in a place but between places. It is that tradition, within a Jewish context, that we seek to explore in this essay.

The uptick in travel literature and broadening of artistic expression prompted by the increased sense of mobility in the Middle Ages has been documented and explored to great advantage by scholars in recent years.[3] Medieval Jews participated in this global migratory trend, and the well-mined body of Jewish travel literature has been exploited to consider questions of medieval Jewish identity, cosmopolitanism, and

attitudes toward ethnic and religious others.[4] But the focus in these studies has largely been on the destination—what travelers encountered upon arrival, and how they interpreted what they found—rather than the voyage itself. The medieval journey, with its dangers, constraints, and unpredictability, as well as its often noble motivations, made for both a memorable experience and a powerful metaphor. This "dwelling in travel,"[5] while certainly found within broader literary and artistic practices of the era, had particular salience within a medieval Jewish context. Their foundational texts, liturgies, and political circumstances regularly intoned a call to travel, both real and imagined, whether in the form of pilgrimage, emigration, or religious ritual. Our interest is in how Jewish writers and artists in the Middle Ages explored the distinctive experience of being in transit. To what extent did it serve as a potent rhetorical or visual device?

We focus here on two especially creative moments for medieval Jews, each of which engendered a body of texts or images that explicitly evoke, explore, capitalize upon, and even reenact the experience of the voyage. The first is twelfth- and thirteenth-century Spain, a golden age of Hebrew poetry. Two poets, Yehudah Halevi (ca. 1075–1141) and Yehudah Alharizi (1165–1225), well-known travelers both, gave focused consideration to the topic, the former in a small subset of poems perhaps written on shipboard, and the latter in a poem from a collection of picaresque prose poems. The second is fifteenth-century Italy, which saw the elaboration of Exodus imagery in a group of prayer books produced or inspired by the itinerant scribe and illuminator Joel ben Simeon (active 1400s). Our contention is that these writers and artists aligned the experience of moving from place to place with that of reading and looking. Each of them exploited their respective mediums to allow their audience to journey with them off the page, traversing time and space.

One of the most beloved of all medieval Jewish poets, Yehudah Halevi, left the comfort of home and family in 1140 to travel to Jerusalem, where he wished to live out his remaining days.[6] He documented this trip in both poetry and letters, from the longing and preparation that preceded it through his

arrival and sojourn in Egypt and subsequent departure for the Holy Land. Some nine poems chronicle his two-month ship voyage.[7] To read them is to plunge deeply into the subjective experience of the poet, whose insistent "I" anchors each of the poems. This is a journey that barely registers the presence of anyone other than God, to whom every poem is addressed. It is a profound spiritual exercise for one man, his own penitential work that leads to grateful acknowledgment of and complete submission to God's almighty power.

The poems locate the poet *in medias res*, or rather *in medias nihil*: "I peer in all directions at nothing but water, sky, and ark," he states in one poem, which describes a world "washed . . . to waste."[8] The "mid seafare" traveler, like the penitential soul, is peculiarly vulnerable, adrift with no home, no property, no family, no friends, and no skills deemed valuable aboard ship. His emigration wrests him not only from the privileges and comforts he enjoyed as a successful Andalusian doctor and poet but also from the very ties that made him human: "I've even abandoned my daughter, my kindred spirit and only child, and it pains me to think I could forget her son."[9] He is subjected to daunting forces, whether caught between rival winds or "dangling between sea and sky."[10] His most haunting analogy for this acute state of liminality is "that of a woman in labor, whose strength is spent and cannot push her firstborn out."[11]

The poet's immersion into this profoundly abject state is best conveyed in a poem devoted to a storm at sea.[12] The five strophes allow him to trace the long arc of the storm and the emotions it stirs. The first sets the stage with a declaration of the omnipotence of God. The second launches into the storm with palpable force:

> Waves whirl, are whipping
> Tops, Louring clouds
> scud over the sea.
> Sky dims, water
> Spumes, the deep over-
> brims and spills
> its tide

as the cauldron
hisses unappeased.

<div dir="rtl">

ברוץ גלגלים	המו גלים
על פני הים	ועבים וקלים
ויחמרו מימיו	קדרו שמיו
ונשאו דכים	ועלו תהומיו
וקול יצריח	וסיר ירתיח

</div>

The poem as a whole maintains a forceful metrical and visual rhythm: a sustained pattern of quadrisected verses permit concentrated units of rhyme and repetition.[13] From the outset, we experience the ship's insistent rocking, the intensity of which increases with every strophe. Choppy waters evolve into aggressively churning seas that in turn metamorphose into a briny maelstrom of terrifying violence:

Easterly winds rough up the sea,
blast the cedar beams;
gusts scatter
foam and flotsam. Crew
cower, helmsman
blanches, yardarm
strains to spread
shroud.

<div dir="rtl">

וקדים יפוצץ	וים מתרוצץ
רוח קצפיו	ארזים, ויפץ
ונבהל סרנם	שחה קרנם
לפרש כנפיו	ונלאה תרנם

</div>

When "Gales are swept / away," in the final stanza, we are consoled by the "Lord's glory," yet the vestigial sobs of the passengers are a reminder of the price of that solace. The poet meanwhile retains a certain stoicism throughout. Though fearful, he humbly resigns himself to his fate, for "there is no shelter, / nor any- / where to flee." The storm, from buildup to aftermath, is an exercise in abnegation, a pious erasure of self.

For Yehudah Halevi, the voyage is a necessary course of denial and suffering, a grateful giving over of one's self to God. It is also fiercely teleological. A journey to Zion of course carries messianic implications for a redeemed Jewish people. But for Halevi, an old man aware of his own mortality, it is also preparation for his eventual death, with the space of the ship an inadequate stage for its rehearsal. There, the poet is "boxed in / alive in a bottomless wooden casket / without four cubits of soil, or less."[14] To be in transit is to acknowledge and enact one's own transience.

If the voyage for Halevi is the path to redemption, for Yehudah Alharizi it is a poet's playground, the ideal setting for literary mischief, competitive sport, hijinks, and bravado.[15] Born in Spain and a longtime resident of Provence (southern France), Alharizi set out for the East around 1215, stopping in Alexandria, Damascus, and Baghdad, among other cities (he would die in Aleppo). The *Book of Tahkemoni*, the work for which he is best known, captures his travels through some fifty prose poems, or "gates."

The *Book of Tahkemoni* takes its cues from the *maqāmat* (an Arabic word meaning "assemblies," but also a literary genre; *maqāmah* in the singular).[16] With a roguish rhymester at its center, this Arabic genre laces together all manner of literary enterprise, from fable to satire, riddles to romance, with proverbs and occasional prayers thrown in.[17] Though Alharizi compares his own work to a garden or a string of pearls, it is the notion of the voyage that drives and structures the work. The very term *maqāmah* denotes a place where one stands.[18] As we move from story to story, we move from place to place. These adventures on the road fuel the whole literary endeavor, providing fresh inspiration and a steady replenishment of listeners to be impressed—and likely fleeced—by his derring-do. The result is a merry romp through poetic genres, propelled less by the conventions of narrative than by our curiosity to learn what's in store. "Unhappy here?" we practically hear our poet/tour guide say. "No worries, tomorrow we'll be in Mosul."

Given the itinerant character of the *Book of Tahkemoni* as a whole, it should hardly surprise that one of the gates confronts the topic of travel head-on. The tale, largely told in rhymed prose, opens as usual with a narrator setting the

scene—a group of young men in the town square engaged in literary sport—before an unknown older man emerges, who will trump them all with his verbal acrobatics.[19] "What is worse than travel . . . ?" he declares, and with a dazzling litany of rhyming woes, he proves his point: "He who puts home and 'heritance behind shall . . . naught find but fear and dread. He shall not lift his head before the Sun smite him, the Wind bite him, Heat blight him, Dark fright him, and Snow white him."[20] If weather were not enough, the dangers of robbers and rain take their toll, not to mention the peculiar burdens of sea travel that leave the voyager retching and wrecked. Alharizi's white-bearded character conjures a sea journey no less miserable than Halevi's penitent poet, but redemption eludes him. Nay, he does not even seek it. In the rhymed verse that caps the poet's performance, he simply seeks relief from the frustration and distress that are the traveler's sure companions: "Inhabiting torment, he cries, God send / me a herald proclaiming salvation!"[21]

Within the confined narrative of this gate, the poem is not a prayer but a dare, the goad that prompts the audience to demand a rebuttal, the cue for the second act. Can the poet top his own creation? Forgetting the physical woes of travel, the old man makes a case for the itinerant life: "If travel be injurious, its woes furious, its blessings spurious, is it not curious, in life's harsh tourney, the laurel is won only through journey."[22] His pithy counterargument rests almost exclusively on the frustrations of the stay-at-home life and the rewards of fame and fortune that ensue from wandering. "He who stands fast, stands last; but he who roves wins troves."[23] Travel both quickens the blood and fattens the purse. Again he concludes his performance with rhymed verse. Its last line intentionally recalls those of the anti-traveling poem he had recited only moments before. "The adventurer, spurning the gifts of repose, wins Wandering's high consummation; . . . Winning home he is hailed by expectant throngs / as a herald proclaiming salvation."[24] If we seek a "herald," the peripatetic poet is the answer to our prayers.

The gate concludes as they generally do, with a grand reveal. The old man is none other than Heber the Kenite, the antihero of the whole *maqāmat*, whose genius lies in both wordplay and the shakedown. As he boasts of his prodigious skills, his listeners shower him with prodigious gifts. What a contrast to the traveling poet in Yehudah Halevi's poems: hungry, dejected, and at the mercy of hooligans, his skills and wisdom unappreciated.[25] Alharizi's silver-tongued huckster exemplifies the wanderer triumphant.

Both Halevi and Alharizi are masters at scrutinizing the experience of travel and exploiting that experience to bring their audience along with them. Whether in the rhymes and rhythms of individual poems, as we see in Halevi's sea writings, or in the very structure of the compilation, as in the *Book of Tahkemoni*, the text immerses the listeners and readers in a voyage, inviting them—indeed, requiring them—to become fellow travelers as they take in the words. The illuminations created and inspired by the renowned fifteenth-century scribe-illuminator Joel ben Simeon (active 1400s) demonstrate that images are just as powerful a cicerone (or guide), enveloping the viewer in the journey alongside the painted figures. Indeed, his innovative illuminations of the Exodus so fully bring to life the experience of travel that they enrich the ritualized context in which they are set.

Born in Cologne, Joel was a traveler himself, working in both Germany and northern Italy. He seems to have specialized in *haggadot*, the service books used for the Passover Seder, the ritual feast celebrating the Ancient Israelites' divine deliverance from slavery in Egypt as recounted in the Hebrew Scriptures.[26] The liberated Israelites are archetypal travelers, and the Seder ritual requires a retelling of the events that will launch their historic journey through the desert to the land promised them by God.

Of all the Jewish commemorative holidays, Passover alone is not simply a commemoration of ancient history nor a contemporary reenactment of that history but a sort of active memory, a reawakening to the knowledge that the Seder participant, whenever that person might be living, took part in the Exodus from Egypt themselves. The Haggadic text instructs the reader:

In each and every generation, a person is obligated to see himself as if he left Egypt, as it is stated (Exodus 13:8); For the sake of this, did the Lord do [this] for me in my going out of Egypt. Not only our ancestors did the Holy One, blessed be He, redeem, but rather also us [together] with them did He redeem, as it is stated (Deuteronomy 6:23); And He took us out from there, in order to bring us in, to give us the land which He swore unto our fathers.[27]

In reviewing the Exodus, the reader is neither simply commemorating a past event nor re-creating it, but actually reliving it. The text of the Haggadah and any accompanying illuminations therefore serve not only to outline and illustrate the evening's liturgy but also to envelop the reader in that past experience—a kind of early virtual reality system that traverses both space and time.

Joel pushed the possibilities presented by this framework to such compelling result that his evocative arrangement of the Exodus became the model for subsequent depictions created both in his workshop and by unaffiliated artists

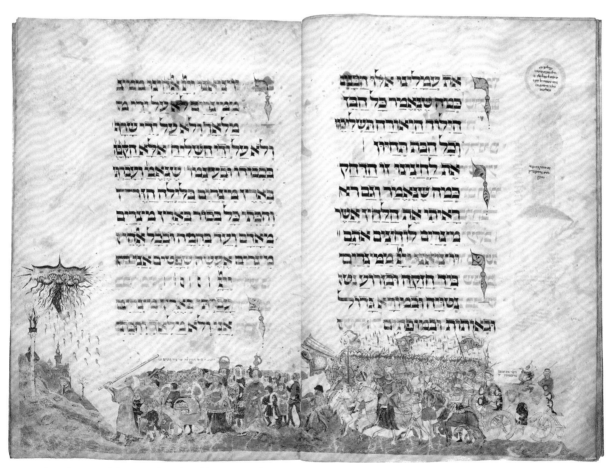

21.1. *Exodus and Crossing of the Red Sea* from the Ashkenazi Haggadah, Joel ben Simeon Feibush (artist), Meir Jaffe (scribe), Germany (Ulm), 1460. London, The British Library, Ms. Add. 14762, fols. 14v–15r

impressed by his creative mastery.[28] The largest and most lav-
ish of Joel's manuscripts, the Ashkenazi Haggadah (fig. 21.1),[29]
produced in Ulm but executed in Joel's Italian style, presents
what is arguably the most accomplished interpretation of the
most dramatic moment of the Passover story.[30]

Unfurling across the bottom of the double-page opening
is the triumphant departure of the Israelites from Egypt and
the miraculous parting of the Red Sea. Led by Moses, the Isra-
elites march forward on the left. They are guided by the pillar
of fire that illuminated their path at night, while the pillar of
cloud that was their diurnal guide has shifted to the rear of the
camp, shielding them from the oncoming arrows of the Egyp-
tian army.[31] The Egyptians charge forward on the right, with
the crowned Pharaoh leading "all of [his] horses, his chariots,
and his horsemen."[32] At the fore of all of these figures and
ultimately directing their fates, the hand of God appears to
Moses from the cloud of glory, instructing him to extend his
staff over the Red Sea and thereby cause its fish-filled waters
to part.[33] The power of this illustration lies in Joel's implemen-
tation of an ingenious compositional arrangement. Instead
of sitting docilely behind isolating frames, the two scenes
merge and expand into one panoramic image spanning the
full double-page opening. The artist ingeniously utilizes each
page's distinct field to perfectly house each of the two camps,
while simultaneously melding them into one unified scene.[34]
The action parallels the right-to-left orientation of the Hebrew
text, both literally and figuratively following the march of
the Haggadah's narrative from captivity to freedom, and the
rolling scene physically unfolds as the reader turns the page
to reveal it.

Strangely, the cities of Egypt that both the Israelites and
the Egyptians have just vacated appear not behind them as
one would presume, but before them, rendered at some-
what of a distance through the sensitive use of atmospheric
perspective.[35] This puzzling placement is clearly intentional
in comparison to, for example, the Rothschild-Weill Mahzor
(fig. 21.2),[36] a holiday prayer book created in Joel's Italian
workshop, in which the ramparts of Egypt are firmly installed
on the right, where one would expect to find them.[37] The

Ashkenazi Haggadah's arrangement indicates a circuitous
route that—while at first baffling—is in fact in agreement with
the biblical text, in which God directs the Israelites to circle
back toward Egypt in a feint designed to entice pursuit.[38]
More invigorating than Joel's scrupulous adherence to the
text, however, is what his spatial distinction accomplishes
conceptually, carving a third axis into the two-dimensional
page. "Fore" and "aft" of the chase are not just the left and the
right, as in a horizontal register of an Egyptian tomb painting,
but the front and the very far back. Joel has decompressed
the page, deepening it extensively by forcing the viewer's
awareness of the three-dimensional circular path the figures
have just traversed. Joel has captured travel itself—not its
effects nor its rewards and travails, not a point of departure or
a destination, but the movement in between.

The three-dimensionality of Joel's image renders it inhab-
itable for the viewer, and the scene is all the more accessible
for the absence of obstructing frames. Frames hedge an
image in, contain it, limit it to its illustrative function. By doing
away with the frame and bringing the image to the edge of
the page, Joel presents us not simply with an illustration to
look at, but an experience to engage in. The unframed figures
traverse not only the fictive landscape but also the pages of
the book, merging their sphere with ours, and we are drawn
in alongside them because our ground line—the bottom edge
of the page—is theirs as well, with both viewers and viewed
navigating the same animated space.[39]

Joel often employed individual pen-drawn figures on the
blank page,[40] but here he deliberately creates as dense a
ground as possible, anchoring the figures rather than allowing
them to float freely and using them as much to reinforce the
ground as to traverse it. The mass of Pharaoh's army is con-
veyed through the knot of horses' legs, each positioned to fill
the negative space left by the ones before it, and by the row
upon row of helmeted heads packed into the distance. The
two green trees on the right page serve no actual purpose,
and the one behind Pharaoh's horse in particular could only
impede the progress of the mounted officers behind him.
Similarly, in the Rothschild-Weill Mahzor, the dog cavorting

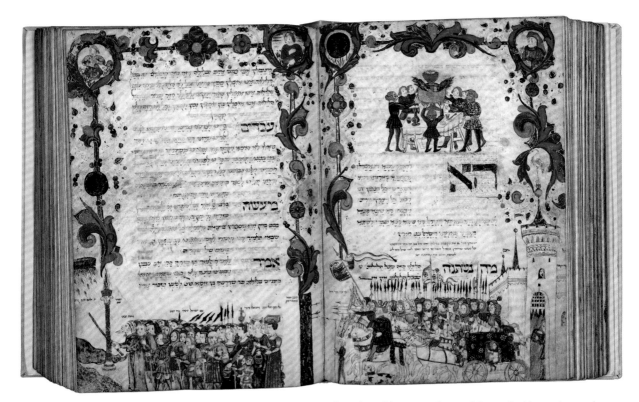

21.2. *Exodus and Crossing of the Red Sea* in the Rothschild-Weill Mahzor, workshop of Joel ben Simeon Feibush (artist), Italy, 1450. Jerusalem, National Library of Israel, Ms. Heb. 8° 4450, fols. 115v–116r

between the legs of Pharaoh's horse serves no narrative function. The one objective of these irrelevant insertions is to saturate the scene, filling any notable negative space in order to create a block of mass. This congestion re-creates the urgency of the Israelites' entrapment between a rock and a hard place,[41] but more importantly, it visually solidifies the ground line. The density of the foreground makes it appear almost weight bearing, allowing the viewer to step inside the scene. By flooding our entire visual field with the image, creating an awareness of traversable depth within the page, eliminating the frame, and furnishing the page with a concrete ground that extends into our space, Joel presents the viewer not only with an illustration of the Exodus story

but also with an experience of it, one that he or she can lean over into.

Joel exults in the nobility of the depicted voyage, rather than its potential hardships. These are no refugees fleeing before the pursuing Egyptians nor shrinking from the water's edge, but rather, "the children of Israel were marching triumphantly."[42] Heads held high, they gaze (for the most part) not fearfully toward the sea but awestruck toward the Divine Presence and their tireless leader, Moses.[43] They wear rich fabrics and carry golden vessels, reparations made by the Egyptians in their haste to usher the Israelites out. The caption above the Israelites' heads reinforces the exultant nature of their journey: "On that day the Lord saved Israel from the hand[s] of the Egyptians, etc."[44] The Rothschild-Weill Mahzor highlights this atmosphere even more explicitly. The Israelites here bear arms, a completely tangential note to the current narrative but included by the artist to emphasize the triumph of their Exodus.[45]

That projection of divine victory is precisely what renders the image more than a simple textual illustration tethered to the words it portrays. While each iteration of this scene created in Joel's workshop and beyond largely hews to his visual language and composition, nearly each one appears in a different place within the prayer book that contains it.[46] The fact that the image is appropriate in whichever part of the liturgy it inhabits indicates its larger role as an emblem of the holiday as a whole. In the Ashkenazi Haggadah, Joel chose the route of lyric literalism, including the illumination on an opening that declares, "And God took us out of Egypt with a strong hand and an outstretched arm, with great awe, and with signs and wonders. . . . And the Lord our God took us out from Egypt not by the hand of an angel and not by the hand of a seraph, and not by the hand of a messenger but Blessed Be He by His own honor and by Himself."[47] This sense of majestic victory and divine triumph is captured in Joel's illustrations of the outstretched arm of God, His golden divinity showering down upon the Israelites, and the resulting confidence with which they undertake their journey. The Rothschild-Weill Mahzor by contrast uses this imagery—its only large-scale illumination apportioned to the Passover liturgy—to headline the holiday. The scene introduces the Seder narrative and appears alongside text that recalls the bread of affliction, the

21.3. *Exodus* in the Leipzig Mahzor, Worms, Germany, ca. 1310. Universitats-bibliothek Leipzig, Germany, MS V 1002/1, fols. 72v–73r

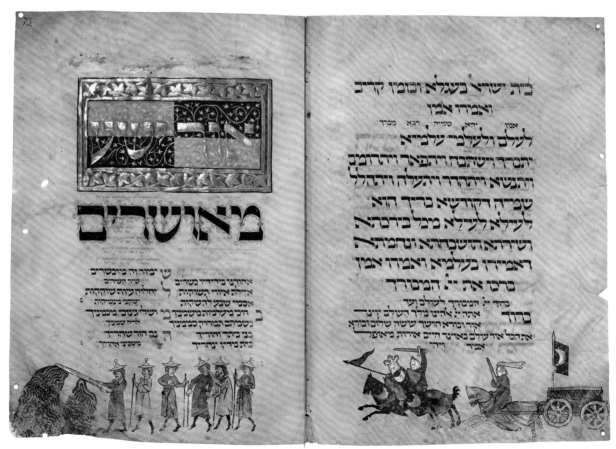

Israelites' slavery in Egypt, and one's obligation to recount the story of God's deliverance from that land. The power of this image allows it to serve in almost any part of the liturgical text as a triumphant emblem or icon of Passover.

Joel's illustrations create for the viewer a triumphant journey through space, but the Passover ritual also demands that its participants traverse time. Joel nods to the mandate of seeing oneself as a participant in the Exodus by dressing his figures in contemporary costume, but he does not insist upon it. The Leipzig Mahzor (fig. 21.3)[48] from one hundred and fifty years earlier offers an instructive counterpoint. It too makes use of the double-page spread to show the Exodus from Egypt. Rather than filling the opening to create the impression of a navigable threshold, however, it provides a sparer but equally immediate image whose power lies in its ability to draw the viewer through time rather than space. Here the figures are very specifically dressed, wearing neither generic robes evoking biblical antiquity nor contemporary finery symbolizing triumphant autonomy. Instead, the Israelites wear the *Judenhut*, the identifying "Jewish hat" mandated by contemporary anti-Jewish sumptuary laws, while the advancing Egyptian army wears contemporary European armor, including conical helmets and small triangular shields.[49] The rear horseman has doffed his surcoat, affording a clear view of his European hauberk (coat of mail covering the neck and shoulders) with self-mittens for the hands and mail chausses that protect his legs. The crescent that is so identifiable with Islam today featured on many Crusader seals and coins in the Middle Ages, and the dual identity of these menacing figures as ancient Egyptians and contemporary Crusaders is explicit.

The participants in the First Crusade carved a bloody detour through the German Rhineland on their way to Jerusalem. They murdered thousands of Jews in the towns of Speyer, Worms, and Mainz, with hundreds more killed in the subsequent campaigns. To describe the devastation of the Crusades, medieval Jews invoked the anguish of enslaved Egypt. Rhineland Jews beseeched God for a miraculous rescue like that from Egypt;[50] the Crusaders' slaughter of Jewish infants in Jerusalem was paralleled with Pharaoh's mandated drowning of all male Jewish newborns in the Nile;[51] and the prayer *Shfoch Chamatcha* (Pour Out Your Wrath) was canonized in the official Haggadic text during this era, calling for divine justice upon those who "devoured Jacob and laid waste to his habitation."[52] The Leipzig Mahzor illumination peoples the ancient Exodus with the players of contemporary conflict, visualizing the time travel necessary to "see [oneself] as if he left Egypt."

In fact, each one of the prayer books mentioned manifests a journey through time. The Haggadic text does not celebrate a rescue mission in isolation—an exodus alone—but rather its completion and redemption through travel to an ultimate destination—an eisodus. "And He took us out from there *in order to bring us, to give us the land which He swore to our fathers*."[53] The anguish of Egypt, the Exodus, and the desert journey depicted all culminate in the inhabiting of the land of Israel. In parallel, the Haggadah reader, having just commemorated slavery's bitterness, divine deliverance, and the journey out of Egypt, completes the Seder with the cry, "Next Year in Jerusalem!"[54] One is not only reliving the past and celebrating in the present but also looking toward the messianic future, when a return to the promised land will allow one to have truly lived out the eisodus cycle of the ancient Exodus.[55]

This journey through time is undertaken not only via the text but also and emphatically through the illuminations, which merge the spheres of their ancient and medieval coreligionists. The Rothschild-Weill Mahzor exemplifies this coalescence, situating the participants of the biblical Exodus and the contemporary Seder in the same habitable space and on the same opening page of the Haggadah. Above, the celebrants' gaze upon the lifted Seder basket,[56] initiating an evening that will progress with their immersion in the memories of the Exodus unfurled below, patiently pauses until the diners lower their gaze and minds to the scene, innervating it by inhabiting it.

The great rabbi and scholar Nachmanides (1194–1270) emigrated from Catalonia (northeastern Spain) to Jerusalem in 1267, where he proceeded to rebuild the Jewish community decimated by the Crusaders. There he penned his *Prayer at the*

Ruins of Jerusalem—an anthem, elegy, and appeal for the Holy City all at once. The prayer opens with Nachmanides surveying the Temple Mount. He documents what he sees:

> There is "the Ark of the Covenant / of the Lord of all the earth" (Joshua 3:11), / and therein are the Tablets, / "written with the finger of God" (Ex. 31:18). . . . There is the sacred Sanctuary. . . . There is the Table and upon it the Showbread. . . . There is "the pure Candelabrum" (Ex. 31:8), / it sheds light before itself unto the Sages of Israel. . . . There is the outer court and the altar hearth. . . . There is the chosen place, / the chamber of Hewn Stones.[57]

Of course, none of the items he describes are visible because they were destroyed centuries before.

Nachmanides is not dreaming. His eyes are open and he can in fact see the living city of Jerusalem filled with medieval monuments spread out before him. Yet here he deliberately describes in the present tense, as if he can see them, all the structures that are not currently there but once were and, in accordance with his own prayer, will be again—what he so strongly felt *should* be there. Nachmanides calls two temporally distinct realities into being at once. His poem begs the question, Are you here, or are you *then*? As in the poems of Yehudah Halevi and Yehudah Alharizi and the illuminations of Joel ben Simeon, travel for Nachmanides can take place standing still.

— Melanie Holcomb is curator of medieval art at the Metropolitan Museum of Art, New York.

— Elizabeth A. Eisenberg is a doctoral candidate at New York University and formerly a research associate at the Metropolitan Museum of Art, New York.

1 Originally written in Hebrew, the text has remained in continuous circulation since the Middle Ages, with printed editions in Latin as early as the sixteenth century and in English, German, French, and Dutch in the seventeenth. The standard English translation remains that of Nathan Adler, published in 1907. It can be found with a new introduction in Signer (1983).

2 On itineraries, see Prawer 1988, 169–250; Reiner 2002, 9–19.

3 The literature is vast. Some recent studies include Legassie 2017; Classen 2013; Allen 2004, 88–106; Weber 2005.

4 In addition to Prawer cited above, see Jacobs 2014; Botticini and Eckstein 2012, 153–200; Gitlitz and Davidson 2006; Weber 2004, 35–52.

5 The locution is from Clifford (1997, 1–13).

6 Brody 1894–1930 is still considered the standard Hebrew text, though Joseph Yahalom is preparing a new critical edition. For English translations of selected poems, see Halkin 2011 and Salaman 1924, both of which are bilingual editions. For his biography in English, see Halkin 2010; Yahalom 2009; Scheindlin 2008 (which incorporates translations of many of his poems); Goitein 1959, 41–56. On Halevi as a chronicler of his travels, see also the helpful remarks in Jacobs 2014, 59–61.

7 The sea poems are discussed in depth with both Hebrew and English translations embedded in the commentary in Scheindlin (2008, 216–48). Eight of the sea poems (9–16) are presented in the Salaman translation (1924, 20–31). See also the chapter devoted to the sea voyage in Yahalom 2009, 107–18. For this essay, we make use of Levin's translation (1995, 87–90), both for its convenient presentation of all the poems in a single place and for its deftness in capturing the prosodic virtues crucial to our argument. On maritime travel as a theme in medieval literature, see Sobecki 2007 as well as the essays collected in Sobecki 2011.

8 Poem 2 in Levin 1995, 87.

9 Poem 3 in Levin 1995, 88.

10 For the wind, see especially Levin 1995, 89, poem 7: "though he plead / for the west wind, east rings / in the shrouds." "Dangling between sea and sky" is found in poem 4, p. 88.

11 Poem 3 in Levin 1995, 88.

12 Poem 7 in Levin 1995, 88–90.

13 Translator Gabriel Levin attempts to capture the same effect through his bountiful use of alliteration and assonance within a consistent quadratic structure of terse, stepped lines.

14 Poem 8 in Levin 1995, 90.

15 For the most recent edition in Hebrew, see Yahalom and Katsumata 2010. For English, see Al-Harizi 1965. For this essay, we prefer the lively translation of Simha (Al-Harizi and Segal 2001), which well conveys the spunk and literary bravado of the original.

16 It is explicitly modeled after the *Maqamat* of al-Harīrī (1054–1122), which Alharizi had translated from Arabic into Hebrew. Alharizi reveled in his facility with Arabic, Hebrew, and Judeo-Arabic, which allowed him to translate, among other works, Maimonides's *Guide for the Perplexed*, originally composed in Judeo-Arabic.

17 Hämeen-Anttila 2002. See also Stewart 2006, 145–58.

18 On the evolution of the meaning of this term, see Brockelmann and Pellat 2012.

19 Segal 2001, 228–32.

20 Segal 2001, 228–29.

21 Segal 2001, 230.

22 Segal 2001, 230–31.

23 Segal 2001, 231.

24 Segal 2001, 231.

25 Poem 8 in Levin 1995, 90.

26 Nine of Joel's fifteen securely attributed manuscripts are *haggadot*. For a brief biography and a chronological list of his manuscripts, see Narkiss 1991, 27–102, specifically 30–42.

27 For Pesach Haggadah, Magid, Rabbi Gamliel's Three Things, see https://www.sefaria.org /Pesach_Haggadah,_Magid, _Rabban_Gamliel's_Three _Things.7?lang=bi.

28 Manuscripts created in Joel's own workshop bearing this composition are the Murphy Haggadah, ca. 1455, National Library of Israel, MS Heb. 4°6130, fols. 22v–23r; the Ashkenazi Haggadah discussed here; and the Rothschild-Weill Mahzor discussed presently. The influence of Joel's design is undeniable in the Joab Emmanuel Mahzor attributed to an artist in the workshop of Duke Borso d'Este, probably Giorgio d'Alemagna, 1466, British Library, Harley 5686, fols. 60v–61, and in what was formerly known as the Baroness Adelaide de Rothschild Haggadah (the Hindman Haggadah), Jerusalem, The National Library of Israel, MS Heb. 4°6130, created in northern Italy in the early sixteenth century, fols. 19v–20r.

29 Ashkenazi Haggadah, ca. 1460, British Library, Ms. Add. 14762, fols. 14v–15r.

30 Joel illuminated the Haggadah on a return trip to Germany, but in the Italian style in which he was already practiced. For intricate analyses regarding the Ashkenazi Haggadah's scribe, patron, and second illuminator, see Edmunds 1980, 25–34; Glatzer 1991, 137–69; Fraiman 2001, 103–18; Goldstein 1985; E. Cohen 2000, 59–71.

31 Exodus 14:19.

32 Exodus 14:22.

33 Joel has employed a kind of continuous narrative at either end of the image to capture as much of the action as possible. Moses is depicted in the moment before action, receiving God's instructions and preparing to extend his staff, but the waters are already parting to expose a dry path between the two receding walls of water. Similarly, the wheels of the Egyptians' chariot are shattering as narrated in the biblical caption above it, yet the army has not yet reached the seabed where that destruction is supposed to take place.

34 Hamburger (2008, 51–133) examines how framed images interact with each other across the opening but does not address instances in which the artist has created a single unconstrained and panoramic stage on which the viewer is invited to step. One can suggest that this is because, prior to the moment explored here, such images were not being produced. Hamburger's one image that truly spans the opening (his fig. 43) does so out of a need for more room, rather than a conscious decision to explore what playing with the page can accomplish.

35 These cities' identification as Egypt is confirmed through the simple fact of their inclusion in the scene, as well as the placement of the plague-blighted tree before them (compare it to the thriving trees on the opposite page) and not, as stated by previous scholars, by the "fire and brimstone" raining down on them from the heavens. The perceived projectiles are actually the rays of God's majesty emanating from the cloud of glory, a constant symbol of divinity employed in every example of this composition even when nothing but empty desert is depicted below.

36 Rothschild-Weill Mahzor, vol. I, National Library of Israel, Ms. Heb. 8°4450, ca. 1470, fols. 115v–116r.

37 This arrangement is also found in the Joab Emmanuel Mahzor (see note 28 above), where the identifying label that is cut off in the Rothschild-Weill Mahzor conclusively identifies these ramparts as "Egypt."

38 Exodus 14:2–3: "Speak to the children of Israel, and let them turn back and encamp . . . and Pharaoh will say about the children of Israel, 'They are trapped in the land. The desert has closed in upon them.'"

39 The success of this device is best felt in contrast to, for example, the Joab Emmanuel Mahzor (see note 28 above), where rather than the action unfolding across the open stage of the page, the same visual language has been employed but framed—boxed in—in the middle of the page, affording a view of an image rather than an experience for the viewer to join.

40 Narkiss 1991, 47, 50.

41 Exodus 14:3: "And Pharaoh will say about the children of Israel, 'They are trapped in the land. The desert has closed in upon them.'"

42 Exodus 14:8.

43 One particularly wide-eyed worrier in the middle of the group may be the victim of the manuscript's condition—it appears his lower eyelids have suffered damage.

44 Exodus 14:30.

45 Exodus 13:18. The medieval commentator Rashi explains that the Bible only mentions that they are armed here so that in later wars, the reader will not wonder where the weapons came from. A. Davis 1993, 156.

46 See note 28 above. The Murphy and Hindman Haggadot are the only manuscripts to repeat the placement of this image, with both including it at the beginning of Hallel, the songs of divine praise.

47 Deut. 26:8.

48 Leipzig Mahzor, ca. 1310, Leipzig, Ubib., MS. Voller 1002/I, fols. 72v–73r.

49 The enforcement of segregating dress for Jews was instituted after the Fourth Lateran Council of 1215.

50 "Where are all your wonders which our forefathers related to us, saying: 'Did You not bring us up from Egypt and from Babylonia and rescue us on numerous occasions?'" From Eidelberg 1977, 23–24.

51 Grossman 1996, 305.

52 Sacks 2006, 68–69.

53 Emphasis added.

54 These three remembrances, symbolized by the bitter herbs, shank bone, and matzah on the Seder plate, are the essential obligations of the holiday. "Rabban Gamliel was accustomed to say, Anyone who has not said these three things on Pesach has not fulfilled his obligation, and these are them: the Pesach sacrifice, matsa and *marror*." Pesach Haggadah, Magid, Rabbi Gamliel's Three Things, Sefaria, see https://www .sefaria.org/Pesach _Haggadah,_Magid,_Rabban _Gamliel's_Three_Things .7?lang=bi.

55 This hopeful cry clearly relates to messianic Jerusalem, as even those currently living in Jerusalem utter the refrain.

56 The Italian equivalent of the more widely known Seder plate.

57 Chavel 1978, 2:703–6.

Peregrinations of Parchment and Pewter: Manuscripts and Mental Pilgrimage

RHEAGAN ERIC MARTIN

The book of hours has been called the "medieval bestseller," as these prayer books were widely owned and their contents could be personalized to reflect the owner's spiritual needs and desires. Within a book of hours now housed at the J. Paul Getty Museum (Ms. 5), two sewing holes and slight cockling of the parchment at the beginning of a prayer cycle dedicated to the Virgin Mary (known as the Hours of the Virgin) suggest that a round pilgrim badge was once inserted there.[1] This case study challenges the traditionally accepted notion that the badge, a touch relic (more on this to follow) from the Holy Land, spiritually enhances a neutral manuscript. Instead, I argue for a reciprocal relationship in which pewter and parchment are mutually enriched in the eyes of the medieval Christian: the badge activates a virtual pilgrimage route through the campaign of illuminations, while the text functions as a framing device to protect—both physically and metaphysically—the badge within.

The manuscript under consideration was illuminated by the so-called Master of Sir John Fastolf, an artist named for a manuscript containing the *Livre des quatre vertus* (Book of the Four Virtues) and the *Epître d'Othéa* (Epistle of Othea) owned by Sir John Fastolf (d. 1459).[2] The personal devotional manuscript measures just 11.8 centimeters high, 9.5 centimeters wide, and 5.2 centimeters deep after a seventeenth-century rebinding. Rather than codicological curiosities, these statistics suggest that the insertion of a large pilgrim badge would have forced the text block slightly ajar, resulting in a physical negotiation and accommodation between the two objects.

Illuminated evidence in the manuscript demonstrates that it highlighted pilgrimage networks and the global ambition of medieval Christianity even before the insertion of a pewter token. The order of texts follows the Use of Sarum—that is, the pre-Reformation liturgical use in the diocese of Salisbury, England, which suggests that the book was likely created for

an English owner. Stylistically, the prayer book was created between 1430 and 1440, while the Master of Sir John Fastolf was still working in English-occupied France.[3] In addition to this relatively small geographic span, the saints illuminated in the suffrages (prayers said in memory of specific saints) established a broader hagiographic landscape.[4] Beginning in the extreme West, the inclusion of Saint Thomas Becket creates a node at the English pilgrimage site of Canterbury. Saint Leonard links the manuscript to the Abbey of Noblac in the Frankish lands and evokes that saint's protection for crusaders to the Holy Land. The illumination of Saint Francis of Assisi recalls his pilgrimage to Rome and farther, to Egypt, in his attempt to convert the Ayyūbid sultan al-Malik al-Kāmil (r. 1218–38).[5] Two more saints push the locus of this litany into the East: Saint Anthony Abbot, a hermit in the Egyptian wilderness, and Saint Catherine of Alexandria, whose monastery was established on the Sinai Peninsula.

The evidence of the now lost pilgrim badge is located at the beginning of the Hours of the Virgin (fol. 64), in which a series of full-page miniatures on versos is paired on rectos with a parallel series of historiated initials (those containing painted narratives) (fig. 22.1). At first, the organization of these illuminations appears haphazard. For example, a verso miniature of the flagellation of Christ (fol. 92v) is paired with a recto initial *D* with the Annunciation to the Shepherds (fol. 93r), ignoring the chronological narrative of the life of Christ established in the Gospels.

These pairings may be untangled by the concept of virtual pilgrimage: for those who were unable to journey to the Holy Land, mental pilgrimages guided by texts or images allowed the reader to travel via devotion.[6] The Virgin Mary was considered the first pilgrim, retracing the footsteps of Christ from Mount Zion along the *via dolorosa* and onward to the Mount of Olives each day after the crucifixion until

22.1. Initial *D*: *The Virgin Weaving* in a book of hours, Master of Sir John Fastolf, France or England, 1430–40. Los Angeles, The J. Paul Getty Museum, Ms. 5 (84.ML.723.64), fol. 64

her assumption.[7] The pairing of illuminations throughout the Hours of the Virgin can now be read as an intentional reference to the Virgin's pilgrimage, as each scene of the passion is paired with a moment in the life of Mary. While these pairs are not organized chronologically, they serve to overlay Mary's pilgrimage route with the Passion of Christ. As Kathryn Rudy explains, the prayers that compose the Hours of the Virgin—intended to be recited at canonical hours—synchronize the reader's day with the activities of the Virgin on Good Friday.[8]

Thus, the badge at the beginning of the Hours of the Virgin marked a mental pilgrimage through Jerusalem aligned with the canonical hours.[9]

For most of the fourteenth and fifteenth centuries, Western Christians were largely excluded from participation at holy sites in Jerusalem and were not allowed to enter the city without Muslim guides.[10] The annual number of Western pilgrims in these centuries was only around three hundred to five hundred, with the total from England perhaps around one

hundred and fifty.[11] Considering this low number, it has been suggested that rather than pilgrims returning from the Holy Land with badges, the "souvenirs" may have been imported by traders for Western Christians who had not undertaken the journey themselves.[12] Badges obtained by purchase or inheritance may not have embodied the same evocations for a viewer who had never completed a pilgrimage. Instead, it is the *visualization* of pilgrimage provided by the *manuscript* that would have activated the badge in the viewer's mind.

The popularity of badges was derived from the knowledge that they had been pressed against saintly relics, shrines, or holy sites and were thought to have absorbed the shrine's "virtue" (ability to effect worldly change by spiritual means).[13] Given this virtue, scholarship on badges in manuscripts has suggested a book in need of apotropaic protection.[14] Yet one must consider the full nature of miraculous objects in the premodern world before assigning weighted power dynamics. The repeated unveiling of miraculous objects by random individuals was thought to decrease their spiritual efficacy.[15] The evidence of this badge inserted deep within the text, however, suggests that the physical structure of the manuscript—its leather covers, wooden boards, and parchment text block—acted as a framing device to protect the thin metal badge and preserve its spiritual virtue. Sylvie Merian has demonstrated the talismanic nature ascribed to manuscripts (and printed texts) in an Armenian context and suggests that votive offerings of repoussé objects, precious stones, and/or coins both protected and were protected by the codices to which they were attached.[16] One may find further parallels of this reciprocal relationship between talismanic text and protective object in the early printed *dhāranī* (talismans) contained in three-tiered wooden pagodas of eighth-century Nara, Japan.[17]

To close with the Fastolf book of hours and the pilgrim badge it contained, the mutually enriching relationship may be exemplified by the impression of the badge's imagery on the parchment folios, which yielded to its shape as they protected its spiritual virtue. For medieval viewers who understood vision to be haptic as well as optic, the sight of the manuscript's illumination, sewn-in pilgrim badge, and

parchment impression would have sustained one another in a spiritually complementary fashion that enhanced their mental pilgrimages.[18]

— Rheagan Eric Martin is a doctoral candidate at the University of Michigan, Ann Arbor, and was formerly a curatorial assistant in the Manuscripts Department at the J. Paul Getty Museum.

1 I am indebted to Getty conservator Nancy Turner for spotting these minute details.
2 Bodleian Library MS. Laud. Misc. 570.
3 For more on the Master of Sir John Fastolf (Fastolf Master), see C. Reynolds 1996, 664.
4 I thank Bryan C. Keene for his suggestion to map the suffrages.
5 Tolan 2009, 4.
6 Rudy 2011, 35.
7 Rudy 2011, 35.
8 At Matins, Mary was informed that Jesus was arrested; Mary follows Jesus to Pilate's house at Prime; the raising of the cross occurs at Sext; the Virgin witnesses Christ's death at None; and at Vespers, readers contemplate the pietà. From HKB 132 G 38, fol. 133v, as cited in Rudy 2011, 243.
9 This theory is further strengthened by the fact that the folio on which the badge was sewn contains a historiated initial *D* with the Virgin weaving, a metaphor for the motherly matrix of her womb weaving the body of Christ into earthly existence. See Constas 2003, 349.

10 Peters 1985, 421.
11 Peters 1985, 421.
12 Peters 1985, 108.
13 As early as the sixth century, luxury objects such as silver or terra-cotta ampullae containing holy water were designed for European pilgrims to the Holy Land to return with souvenirs known as *eulogiae*. By the later part of the twelfth century, these objects were transformed into mass-produced badges cast in molds borrowing from the technology of seal engravers and goldsmiths. See Spencer 1998, 16. For more on *eulogiae*, see C. Hahn 2012, 18.
14 Foster-Campbell 2011, 233.
15 Trexler 1973, 131–32.
16 Merian 2013, 56.
17 For more on the *Muku jōkō darani kyō* (Sutra of the Dharani Prayers of Pure Unsullied Light) held in the Richard C. Rudolph East Asian Library, UCLA (SALF H000 013 013 8), see Burlingham and Whiteman 2001, 107–9, no. 43.
18 Biernoff 2002, 97.

Epilogue: Global History and the Art Museum

JAMES CUNO

Sometime around or just after the year 800, the owner of a Psalter living in or traveling through County Tipperary, Ireland, dropped the manuscript. The book rested in a peat bog for centuries until being rediscovered in 2006. The Faddan More Psalter, as it is known, constitutes a significant manuscript find, not only because of its early date and because its surviving parts have been meticulously pieced together to reveal a masterpiece of Insular art (of the British Isles and Ireland) but also because its binding—which is lined with papyrus—confirms long-distance contacts with Egypt.[1]

Two centuries later, a scribe from the Fayum region of Middle Egypt recorded the life of Samuel of Kalamoun (597–695), the most important saint of the Byzantine Egyptian church. The frontispiece of this now dispersed manuscript is preserved in the Getty Museum, and it is from one of the earliest decorated Coptic codices (fig. epilogue.1). The imaginative hare at the bottom of the page and the complex interlace pattern at the top are both found on a range of objects from Northwest Africa, including ceramics, mosaics, and talismanic objects from Roman Alexandria to the Byzantine commonwealth in the Mediterranean Basin, and later still to Fatimid and Persian communities in the region (as seen on a bowl for domestic or mosque use, fig. epilogue.2). From Ireland to Egypt, raw materials and ideas circulated as people moved from place to place. The pages of these two manuscripts allow us to glimpse a global (Mediterranean) Middle Ages.

In light of these examples, and with the rise of populist ethnonationalism across so much of the Western world, I reread Patrick Geary's *The Myth of Nations: The Medieval Origins of Europe* (2002) and Sebastian Conrad's *What Is Global History?* (2016). The first explores the complex history of European identity and the role historians have played in laying its intellectual foundations. It begins with a string of challenging statements:

Epilogue.1. Decorated text page, leaf from the *Life of Samuel of Kalamoun*, Fayum (possibly), Egypt, tenth century. Los Angeles, The J. Paul Getty Museum, Ms. 12 (85.MS.119), recto

Epilogue.2. Bowl depicting a running hare, Egypt, first quarter of the eleventh century. New York, The Metropolitan Museum of Art, Purchase, Joseph Pulitzer Bequest, 1964, 64.261

Modern history was born in the thirteenth century, conceived and developed as an instrument of European nationalism. As a tool of nationalist ideology, the history of Europe's nations was a great success, but it has turned our understanding of the past into a toxic waste dump, filled with the poison of ethnic nationalism, and the poison has seeped deep into popular consciousness. Cleaning up this waste is the most daunting challenge facing historians today.[2]

It then traces the development of modern European nationalism from the study of language, culture, and history of a subject people by a small group of "awakened" individuals, to the transmission of their ideas by a group of "patriots" and the mass embrace of a modern national movement. In the example of Germany, it cites the philosopher Johann Gottlieb Fichte

(1762–1814), who in his *Fourth Address to the German Nation* (1808) declared that Germans alone among "neo-Europeans" remained in the original dwelling place of "their ancestral stock," and unlike other national peoples retained their original language deriving entirely from Germanic elements.[3] The following year, Freiherr Karl vom Stein (1757–1831), the Prussian minister of state, founded the Gesellschaft für ältere deutsche Geschichtskunde (Society for Older German Historical Knowledge), dedicated to the publication of the *Monumenta Germaniae Historica*, a compendium of texts laying the foundation of German identity.[4] And seventy-five years later, Gustaf Kossinna (1858–1931), a professor of German archaeology at the University of Berlin, added to this the theory of what today we would call ethnoarchaeology, the "scientific" exploration and identification of culturally specific *things* that could then be connected to linguistic groups. The implications of Kossinna's theories encouraged modern states like Germany to claim regions of neighboring countries on the basis that they were the original homelands of the nation's peoples.[5]

Geary's book is an argument against the misuse of history for ethnonationalist purposes and a warning to his professional peers: "We historians are necessarily to blame for the creation of enduring myths about peoples, myths that are both tenacious and dangerous. By constructing a continuous, linear story of the peoples of Europe, we validate the attempts of military commanders and political leaders to claims that they did indeed incorporate ancient traditions of peoples."[6]

Sebastian Conrad picks up where Geary leaves off:

The genesis of the social sciences and humanities was tied to the nation-state. In their themes and questions, and even in their societal function, fields like history, sociology, and philology remained tied to a country's own society. Beyond that, the "methodological nationalism" of the academic disciplines meant that, theoretically, the nation-state was presupposed as the fundamental unit of investigation, a territorial entity that served as a "container" for a society. The commitment to territorially bounded containers was more pronounced in the field of history

than in some of its neighboring disciplines. Knowledge of the world was thereby discursively and institutionally pre-structured in such a way as to obscure the role of exchange relationships. History, in most quarters, was limited to national history.[7]

Conrad then identifies three varieties of global history. *The history of everything*: "From such an omnivorous per-spective, everything that ever happened on the earth is a legitimate ingredient of global history." *The focus on exchange and connections*: "The common thread connecting these kinds of studies is the general insight that no society, nation, or civilization exists in isolation." And *a comparative consideration of individual nations in the context of domestic changes and global transformations*, a comparative study of nations or institutions facing similar political, economic, or cultural challenges.[8] In Conrad's terms, global history is concerned with mobility and exchange, and with processes that transcend borders and boundaries as a way to overcome fragmentation and "to arrive at a more comprehensive understanding of the interactions and connections that have made the modern world."[9] It offers a counterargument to nationalist historical projects and is in keeping with the world as we currently experience it—one of entanglements and networks, of the sharing and overlapping of economic, political, and cultural developments.

I have argued for the importance of a global perspective in the work of art museums. In *Museums Matter* (2013), I argued that by presenting representative examples of the world's artistic legacy, art museums encourage an understanding of difference in the world and a shared sense of human history. In *Who Owns Antiquity?* (2008), I argued that encyclopedic museums offer a counternarrative to those of modern nation-states claiming an ethnonationalist link to the remains of cultures found within their sovereign borders.[10]

For example, an ivory casket in the Art Institute of Chi-cago's collection, likely made in Sicily in the twelfth century, is covered with thin plaques made of African ivory, perhaps acquired through encounters with Muslim traders from North Africa, or along the Swahili coast, perhaps for silk or cotton obtained in trade across the Indian Ocean. In Sicily, the plaques were cut and decorated with Arab-inspired arabesques, gazelles, and peacocks, and made into a box to hold jewelry or other domestic valuables and later used as a reliquary for a Christian owner.[11] In another example, a fourteenth-century German monstrance, once part of an ecclesiastical treasury, is made of gilt silver in the shape of a medieval church building surmounted by a delicate crucifix. At its center is a translucent rock-crystal bottle, within which is said to be a tooth of Saint John the Baptist (identified by an inscription on a piece of paper in the relic's linen wrapping). The bottle itself was originally made in Fatimid Egypt. Late in the eleventh century, the palace of the Fatimid ruler, the caliph al-Mustansir Billah (r. 1036–94), was looted and much of its treasury—tens of thousands of objects incorporating gold, silver, precious stone, and rock crystal—was either removed or melted down. Many things made their way to the Byzan-tine court in Constantinople, and then on to Europe when the Byzantine court was sacked in the Fourth Crusade in 1204.[12] By a simple examination of just these two objects, much of the global history of the Mediterranean can be told—a history of trade, exchange, hybridity of form and iconography, use and reuse, conflicting beliefs, political power. This is the fact of museums. Their collections comprise aesthetic objects imprinted with the historical circumstances of their making.

It is also true of special exhibitions. Consider just three, two organized by the Metropolitan Museum of Art—*The Year One: Art of the Ancient World East and West* (2000) and *Lost Kingdoms: Hindu-Buddhist Sculpture of Early Southeast Asia* (2014)—and a third, *India and the World* (2017–18), a collab-oration between the British Museum in London, Chhatrapati Shivaji Maharaj Vastu Sangrahalaya (CSMVS) in Mumbai, and the National Museum in Delhi.[13] *The Year One* brought together 141 works of art made by people living along routes of contact from the Atlantic Ocean across the Mediterranean Sea and Asia to the Pacific. These included busts of a man and a woman made in the second century CE in or near the ancient oasis settlement of Palmyra on the trade routes across the northern Syrian desert connecting the Roman Empire

with the Parthian territory east of the Euphrates and on to India, the head of the Persian Gulf, and the Silk Road to China. The figurative style of these sculptures reflects both Greco-Roman and Parthian (ancient Iranian) elements: the pose of the hand emerging from deep drapery folds recalls similar elements of Greek sculpture, while the frontal posture and spiraling pattern of their hair suggest an Eastern influence.[14] Other examples are two first-century BCE weights depicting Herakles and various marine deities from ancient Gandhara (now Pakistan) and betraying the influence of ancient Greek sculptural forms and Indian iconography, Gandhara having been ruled by the Mauryas (India), Alexander the Great, and a combination of Scythians and Parthians, from the fourth through the first century BCE.[15]

Lost Kingdoms comprised 170 works of art documenting the dissemination of artistic styles and iconographies in the first millennium CE along land and seafaring routes through the Hindu and Buddhist kingdoms, from Pyu in modern Myanmar to Śrīvijaya in western Indonesia, Malaysia, and southern Thailand. This is often called the "Indianization" of Southeast Asia, or the adoption and adaptation of Indic ideas "providing a conceptual and linguistic framework for new ideals of kingship, state, and religious order."[16] One sees this in an impression of a clay seal depicting a ship at sea, dated to the fourth or fifth century CE, made in India and found in central Thailand. The ship is an oceangoing vessel, and similar ships are found on sculptural reliefs in India on a stupa from the Mauryan period (first century BCE) from Bharhut, Madhya Pradesh, and on coins that circulated along the Coromandel Coast of Andhra Pradesh in the first century CE. That the clay impression was found in central Thailand is evidence of the maritime trade across the Indian Ocean in the early centuries of the first millennium CE. But perhaps the most compelling evidence of this trade and the dissemination of religious ideas and iconography throughout the region is the comparison between a fifth-century CE sculpture of the Buddha Shakyamuni from Sarnath, India, and a seventh-century CE sculpture of the Buddha preaching from southern Cambodia, and the many formal similarities between Buddhist and Hindu figures

found throughout Southeast Asia and deriving from earlier Indian examples.

The third exhibition, *India and the World*, was organized by three museums (two Indian and one British), with loans from those museums and more than twenty other collections across India. The purpose of the presentation was to tell the story of India and its vast and rich artistic invention, from a lower Paleolithic hand ax from Tamil Nadu made more than a million years ago to a contemporary sculpture, *Unicode*, made in 2011 by the Kundapur-born, Indian- and British-educated, Indian and Korean resident artist L. N. Tallur, in which a ball of concrete and money is set within a traditional *prabha*, or flaming halo, as if to suggest that concrete and money are the new, Shiva-like Indian gods of time and destruction. Sabyasachi Mukherjee, director general of CSMVS, the organizing Indian museum, described the exhibition as an experiment, an attempt "to provide a model for museums to share their collections with people across the world," and one that "gives an opportunity to people from diverse countries and cultures to become partners in the world narrative, and motivates them to reclaim and reposition their own unique regional, national and global identities in the changing cultural landscape of the world."[17] In this case, three art museums collaborated on the conception and presentation of exhibitions of objects borrowed from multiple collections and shown in venues where such a range of objects are not likely ever to have been seen, but which can provoke curiosity about connections between people and cultures over time.

Take just one example. The exhibition opened with a group of hand axes, including one estimated to be four hundred thousand to eight hundred thousand years old, found in Olduvai Gorge, Tanzania, and now in the British Museum, and an even older Lower Paleolithic hand ax, dating back as many as a million years, excavated in India at Attirampakkam in northwest Chennai, and now in the collection of the Sharma Centre for Heritage Education, Chennai. These two objects remind us not only that humans lived a very long time ago but also that despite being separated by more than 5,400 kilometers, they quite similarly cut and chipped stones to make them more

effective and efficient as a means of butchering animals, digging for root plants and water, chopping wood, and removing tree bark, constantly refining them to be sharper and stronger, to be held more easily and firmly in the hand, and to glint in the sunlight and enhance the play of colors across their surfaces.

The impulse to improve the human condition is a defining feature of our species and was evident throughout all three exhibitions, however distant the peoples or cultures represented may have been from one another. But of course it's not only exhibitions that make these points. Sometimes it's just one object, as with the Faddan More Psalter, or the page from the *Life of Samuel of Kalamoun* discussed above.

The stories of these exhibitions, as with *all* exhibitions, are told through the objects they present. And those objects, like all objects, include evidence of the circumstances of their history—the history of their form and materials, imagery and iconography, discovery and subsequent ownership. It is fashionable to be critical of encyclopedic museums as colonial or imperial institutions with collections resulting from an imbalance of power. Objects bear the imprint of their histories. Many of those in the British Museum are imprinted with the evidence of empire—not only the British Empire but also the empires of Assyria, New Kingdom Egypt, China, Rome, and the Mauryan and Mughal Empires of India, too. Political power is an aspect of their history that must be acknowledged. But empire is no simple thing.

It is a truth about empire that despite its violence, it has and does contribute to the overlapping of territories and intertwined histories. As Edward Said reminds us in his 1994 book *Culture and Imperialism*:

> Far from being unitary or monolithic or autonomous things, cultures actually assume more "foreign" elements, alterities, differences, than they consciously exclude. Who in India or Algeria today can confidently separate out the British or French component of the past from present actualities, and who in Britain or France can draw a clear circle around British London or French Paris that would exclude the impact of India and Algeria upon those two imperial cities?[18]

Cultures are humanly made structures of, in Said's words, "both authority and participation, benevolent in what they include, incorporate, and validate, less benevolent in what they exclude."[19] Or, as Sanjay Subrahmanyam, the Indian-born scholar who has lived and worked in Paris, Oxford, Los Angeles, and New York, has written, "A national culture that does not have the confidence to declare that, like all other national cultures, it too is a hybrid, a crossroads, a mixture of elements derived from chance encounters and unforeseen consequences, can only take the path to xenophobia and cultural paranoia."[20]

This is the lesson and importance of encyclopedic art museums: they are the repositories of material evidence from which so much of the global history of the world can be written. Protecting, documenting, and sharing that history is the responsibility of such museums. They remind us that the history of the world is inevitably a history of entanglements and networks, of the sharing and overlapping of economic, political, and cultural developments, and that a nation's history is ineluctably intertwined with global history.

— James Cuno is president and CEO of the J. Paul Getty Trust.

1 Kelly 2006b, S4–S7; Kelly 2006a.
2 Geary 2002, 15.
3 Geary 2002, 25.
4 Geary 2002, 26.
5 Geary 2002, 35.
6 Geary 2002, 156–57.
7 Conrad 2016, 3.
8 Conrad 2016, 9–10.
9 Conrad 2016, 15–16.
10 Cuno 2013; Cuno 2008.
11 Cuno 2008, xxvii–xviii. See also Guérin 2013.
12 Cuno 2008, xxix–xxxi.
13 Milleker 2000; Guy 2014; Ahuja and Hill 2017.
14 Milleker 2000, 115. Also see fig. 93, p. 120, an image of a standing man from ancient Iran.
15 Milleker 2000, figs. 102–4, pp. 142–45.
16 Guy 2014, 3.
17 Ahuja and Hill 2017, ix.
18 Said 1994, 15.
19 Said 1994, 15.
20 Subrahmanyam 2001; see also https://www.outlookindia.com/magazine/story/golden-age-hallucinations/212957.

Bibliography

Abulafia, David. 2008. *The Discovery of Mankind: Atlantic Encounters in the Age of Columbus*. New Haven, CT: Yale University Press.
———. 2013. *The Great Sea: A Human History of the Mediterranean*. Oxford: Oxford University Press.
———. 2016. *The Mediterranean in History*. London: Thames and Hudson.
Abulafia, David, and Maria Bormpoudaki. 2017. *Crossroads: Traveling through the Middle Ages, AD 300–1000*. Amsterdam: Allard Pierson Museum. Exhibition catalogue.
Abu-Lughod, Janet. 1989. *Before European Hegemony: The World System A.D. 1250–1350*. New York: Oxford University Press.
Adamjee, Qamar. 2017. "Persian-Language Literature in India." In *Epic Tales from Ancient India*, edited by Marika Sardar, 124–41. San Diego, CA: San Diego Museum of Art; New Haven, CT: Yale University Press.
Adorno, Rolena. 2008. "Censorship and Approbation in Murúa's Historia General del Piru." In *The Getty Murúa: Essays on the Making of Martín de Murúa's "Historia General del Piru,"* edited by Thomas B. F. Cummins and Barbara Anderson, 95–124. Los Angeles: The J. Paul Getty Museum.
Africanus, Leo. 1956. *Description de l'Afrique*. Translated by A. Epaulard et al. Paris: Adrien-Maisonneuve.
Afrique bleue: Les routes de l'indigo. 2000. Aix-en-Provence, France: Édisud.
Agnew, Neville, Marcia Reed, and Tevvy Ball, eds. 2016. *Cave Temples of Dunhuang: Buddhist Art on China's Silk Road*. Los Angeles: The Getty Conservation Institute.
Ahmad, S. Maqbul, trans. and commentary. 1989. *Arabic Classical Accounts of India and China*. Shimla: Indian Institute of Advanced Study.
Ahuja, Naman P. 2017. "Time Unbound." In *India and the World: A History in Nine Stories*, edited by Naman P. Ahuja and Jeremy David Hill, 209–18. Delhi: National Museum of India; Mumbai: Chhatrapati Shivaji Maharaj Vastu Sangrahalaya; London: British Museum; Haryana, India: Penguin Random House India. Exhibition catalogue.
Ahuja, Naman P., and Jeremy David Hill. 2017. *India and the World: A History in Nine Stories*. Delhi: National Museum of India; Mumbai: Chhatrapati Shivaji Maharaj Vastu Sangrahalaya; London: British Museum; Haryana, India: Penguin Random House India. Exhibition catalogue.
Ainsworth, Maryan W. 2004. "'À la façon de grèce': The Encounter of Northern Renaissance Artists with Byzantine Icons." In *Byzantium: Faith and Power (1261–1557)*, edited by Helen C. Evans, 545–93. New York: Metropolitan Museum of Art.
Akbari, Suzanne Conklin. 2001. "From Due East to True North: Orientalism and Orientation." In *The Postcolonial Middle Ages*, edited by Jeffrey Jerome Cohen, 19–34. New York: Palgrave.
———. 2009. *Idols in the East: European Representations of Islam and the Orient, 1100–1450*. Ithaca, NY: Cornell University Press.
———. 2017. "Modeling Medieval World Literature." *Middle Eastern Literatures* 20 (1): 2–17.
Akbari, Suzanne Conklin, Tamar Herzog, Daniel Jütte, Carl Nightingale, William Rankin, and Keren Weitzberg. 2017. "AHR Conversation: Walls, Borders, and Boundaries in World History." *American Historical Review* 122 (5): 1501–53.
Akbari, Suzanne Conklin, and Amilcare Iannucci, eds. 2008. *Marco Polo and the Encounter of East and West*. Toronto: University of Toronto Press.
Akyürek, Engin, et al., eds. 2013. *The Byzantine Court: Source of Power and Culture: Papers from the Second International Sevgi Gönül Byzantine Studies Symposium, Istanbul, 21–23 June 2010*. Istanbul: Koç University Press.
Alcock, Susan E., Mariana Egri, and James F. D. Frakes, eds. 2016. *Beyond Boundaries: Connecting Visual Cultures in the Provinces of Ancient Rome*. Los Angeles: Getty Publications.
Alexander, J. J. G. 1975. *Insular Manuscripts, 6th–9th Century*. London: Miller.
Alfonso, Esperanza, and Johnathan P. Decter. 2015. *Patronage, Production, and Transmission of Texts in Medieval and Early Modern Jewish Cultures*. Turnhout, Belgium: Brepols.
Al-Harizi, Judah. 1965. *The Tahkemoni of Judah Al-Harizi*. 2 vols. Translated by Victor Emanuel Reichert. Jerusalem: R. H. Cohen's Press.
Al-Harizi, Judah, and David Simha Segal. 2001. *The Book of Taḥkemoni: Jewish Tales from Medieval Spain*. Oxford: Littman Library of Jewish Civilization.
Ali, Daud. 2014. "The Idea of the Medieval in the Writing of South Asian History: Contexts, Methods, and Politics." *Social History* 39 (3): 382–407. Special issue on South Asia edited by Vinayak Chaturvedi.
Ali, Daud, and Emma J. Flatt. 2011. *Garden and Landscape Practices in Precolonial India: Histories from the Deccan*. London: Taylor and Francis.
Allan, James. 2013. "Inlaid Metalwork in Iran in the Twelfth to Early Thirteenth Centuries." Paper delivered at the symposium "The Idea of Iran: From Saljuq Collapse to Mongol Conquest," February 9, 2013, School of Oriental and African Studies, London. https://www.soas.ac.uk/lmei-cis/events /idea-of-iran/file81627.pdf/.
Allen, Rosamund, ed. 2004. *Eastward Bound: Travel and Travelers, 1050–1550*. Manchester and New York: Manchester University Press.
Al-Nuwqyri, Shihāb al-Dīn, trans. Elias Muhanna. 2016. *The Ultimate Ambition in the Arts of Erudition: A Compendium of Knowledge from the Classical Islamic World*. New York: Penguin.
Alpers, Edward A. 2014. *The Indian Ocean in World History*. Oxford: Oxford University Press.
Al-Saleh, Yasmine. 2000–. "Amulets and Talismans from the Islamic World" (November 2010). In *Heilbrunn Timeline of Art History*. New York: Metropolitan Museum of Art. http://www.metmuseum.org/toah/hd/tali /hd_tali.htm/.
Alt, Susan, and Timothy R. Pauketat. 2015. *Medieval Mississippians: The Cahokian World*. Santa Fe, NM: School for Advanced Research Press.
Andaya, Leonard. 1993. *World of Maluku*. Honolulu: University of Hawaii Press.
Anderson, Benjamin. 2017. *Cosmos and Community in Early Medieval Art*. New Haven, CT: Yale University Press.
Anderson, Jeffrey C. 2013. *The Christian Topography of Kosmas Indikopleustes: The Map of the Universe Redrawn in the Sixth Century*. Rome: Edizioni di Storia e Letteratura.
Androshchuck, Fedir. 2007. "Rural Vikings and Viking Helgo." In *Cultural Interactions between East and West: Archaeology, Artefacts and Human Contacts in Northern Europe*, edited by Ulf Fransson et al., 153–63. Stockholm Studies, Archaeology 44. Stockholm: Stockholm University.
Annequin, Guy, and Charles Marty. 1992. *Le roi Salomon et les maîtres du regard: Art et médecine en Éthiopie*. Paris: Édition de la réunion des musées nationaux.
Apostolos-Cappadona, Diane. 1994. *Dictionary of Christian Art*. New York: Continuum.
Arjana, Sophia Rose. 2015. *Muslims in the Western Imagination*. Oxford: Oxford University Press.
Arnold, Dean E. 2005. "Maya Blue and Palygorskite: A Second Possible Pre-Columbian Source." *Ancient Mesoamerica* 16 (1): 51–62.
Assis, Yom Tov. 1997a. *The Golden Age of Aragonese Jewry: Community and Society in the Crown of Aragon, 1213–1327*. Portland, OR: Vallentine Mitchell.
———. 1997b. *Jewish Economy in the Medieval Crown of Aragon, 1213–1327*. Leiden, the Netherlands: Brill.
Asutay-Effenberger, Neslihan, and Ulrich Rehm. 2009. *Sultan Mehmet II: Eroberer Konstantinopels—Patron der Künste*. Cologne: Böhlau.
Atiyeh, George N. 1995. *The Book in the Islamic World: The Written Word and Communication in the Middle East*. New York: SUNY Press.
Austen, Ralph A. 2010. *Trans-Saharan Africa in World History*. Oxford: Oxford University Press.
Aveni, Anthony F. 2004. "Intervallic Structure and Cognate Almanacs in the

Madrid and Dresden Codices." In *The Madrid Codex: New Approaches to Understanding an Ancient Maya Manuscript*, edited by Gabrielle Vail and Anthony F. Aveni, 147–70. Boulder: University of Colorado Press.

Azadian, Edmond Y., Sylvie L. Merian, and Lucy Ardash. 2013. *A Legacy of Armenian Treasures: Testimony to a People*. Southfield, MI: Alex and Marie Manoogian Museum.

Babaie, Sussan. 1994. "Safavid Palaces in Isfahan: Continuity and Change (1599–1666)." PhD diss., New York University.

———. 2008. *Isfahan and Its Palaces: Statecraft, Shi'ism and the Architecture of Conviviality in Early Modern Iran*. Edinburgh: Edinburgh University Press.

———. 2009. "Visual Vestiges of Travel: Persian Windows on European Weaknesses." *Journal of Early Modern History* 13 (2/3): 105–36.

Babayan, Kathryn. 2003. *Mystics, Monarchs and Messiahs: Cultural Landscapes of Early Modern Iran*. Cambridge, MA: Harvard University Press.

Baghdiantz McCabe, Ina. 1998. "Merchant Capital and Knowledge: The Financing of Early Printing Presses by the Eurasian Silk Trade of New Julfa." In *Treasures in Heaven: Armenian Art, Religion, and Society: Papers Delivered at the Pierpont Morgan Library at a Symposium Organized by Thomas F. Mathews and Roger S. Wieck, 21–22 May 1994*, 59–71. New York: Pierpont Morgan Library.

———. 1999. *The Shah's Silk for Europe's Silver: The Eurasian Trade of the Julfa Armenians in Safavid Iran and India (1530–1750)*. Atlanta: Scholars Press.

Bagnoli, Martina, and Kathryn Gerry, eds. 2011. *The Medieval World: The Walters Art Museum*. Baltimore: Walters Art Museum.

Bailey, Gauvin, and John O'Malley. 2005. *The Jesuits and the Arts, 1540–1773*. Philadelphia: Saint Joseph's University Press.

Baker, Colin F. 2007. *Qur'an Manuscripts: Calligraphy, Illumination, Design*. London: British Library.

Bale, Anthony. 2006. *The Jew in the Medieval Book: English Antisemitisms, 1350–1500*. Cambridge, England: Cambridge University Press.

Balfour-Paul, Jenny. 2010. *Indigo: A Color That Links the World*. Peterborough, England: Cobblestone.

Ball, Jennifer L. 2005. *Byzantine Dress: Representations of Secular Dress in Eighth- to Twelfth-Century Painting*. New York: Palgrave Macmillan.

Bangha, Imre. 2014. "Early Hindi Epic Poetry in Gwalior." In *After Timur Left*, edited by Francesca Orsini and Samira Sheikh, 365–402. Oxford: Oxford University Press.

Barnes, Ruth, and Mary Hunt Kahlenberg, eds. 2010. *Five Centuries of Indonesian Textiles*. Munich: Prestel.

Bartlett, Robert. 1993. *The Making of Europe: Conquest, Colonization, and Cultural Change, 950–1350*. Princeton, NJ: Princeton University Press.

Bartman, Elizabeth. 2011. "From the President: The Belitung Shipwreck." *Archaeology* 64 (5): 6.

Bartrum, Giulia. 2002. *Albrecht Dürer and His Legacy: The Graphic Work of a Renaissance Artist*. London: British Museum.

Beardsley, John, ed. 2016. *Cultural Landscape Heritage in Sub-Saharan Africa*. Washington, DC: Dumbarton Oaks.

Beecroft, Alexander. 2016. "Eurafrasiachronologies between the Eurocentric and the Planetary." *Journal of World Literature* 1 (1): 17–28.

Beihammer, Alexander Daniel, et al., eds. 2008. *Diplomatics in the Eastern Mediterranean, 1000–1500: Aspects of Cross-Cultural Communication*. Leiden, the Netherlands: Brill.

Belcher, Wendy Laura. 2009. "African Rewritings of the Jewish and Islamic Solomonic Tradition: The Triumph of the Queen of Sheba in the Ethiopian Fourteenth-Century Text *Kebra Nagast*." In *Sacred Tropes: Tanakh, New Testament, and Qur'an as Literature and Culture*, edited by Roberta Sterman Sabbath, 441–59. Leiden, the Netherlands: Brill.

———. 2010. "From Sheba They Come: Medieval Ethiopian Myth, U.S. Newspapers, and a Modern American Narrative." *Callaloo* 33 (1): 239–57.

Belich, James. 2016. "Black Death and the Spread of Europe." In *The Prospect of Global History*, edited by James Belich et al., 93–107. Oxford: Oxford University Press.

Belich, James, John Darwin, Margret Frenz, and Chris Wickham. 2016. *The Prospect of Global History*. Oxford: Oxford University Press.

Bell, Julian. 2010. *Mirror of the World: A New History of Art*. London: Thames and Hudson.

Ben Amos, Paula G., and Arnold Rubin, eds. 1983. *The Art of Power / The Power of Art: Essays in Benin Iconography*. Los Angeles: University of California Press.

Benedetto, Luigi Foscolo, ed. 1928. *Marco Polo: Il milione*. Florence, Italy: Olschki.

Benson, Larry, Kenneth Petersen, and John Stein. 2007. "Anasazi (Pre-Columbian Native American) Migrations during the Middle-12th and Late-13th Centuries: Were They Drought Induced?" *Climatic Change* 83:187–213.

Bentley, Jerry H. 2007. "Early Modern Europe and the Early Modern World." In *Between the Middle Ages and Modernity: Individual and Community in the Early Modern World*, edited by Charles H. Parker and Jerry H. Bentley, 13–31. Lanham, MD: Rowman and Littlefield.

Berlekamp, Persis. 2011. *Wonder, Image, and Cosmos in Medieval Islam*. New Haven, CT: Yale University Press.

Berlo, Janet Catherine, and Ruth B. Phillips. 2015. *Native North American Art*. New York: Oxford University Press.

Bertalan, Sarah. 2002. "Close Examination of Leaves from the Great Mongol *Shahnama*." In *The Legacy of Genghis Khan: Courtly Art and Culture in Western Asia, 1256–1353*, edited by Linda Komaroff and Stefano Carboni, 226–37. New Haven, CT: Yale University Press.

Berzock, Kathleen Bickford, and Christa Clarke, eds. 2011. *Representing Africa in American Art Museums: A Century of Collecting and Display*. Seattle: University of Washington Press.

Besom, Thomas. 2009. *Of Summits and Sacrifice: An Ethnohistoric Study of Inka Religious Practices*. Austin: University of Texas Press.

Betancourt, Roland. 2018. *Premodern Intersectionality: Marginal Identities in Early Cultures* symposium. Center for Early Cultures, University of California, Irvine. March 6, 2018.

Biddick, Kathleen. 1998. *The Shock of Medievalism*. Durham, NC: Duke University Press.

Biernoff, Suzannah. 2002. *Sight and Embodiment in the Middle Ages*. New York: Palgrave Macmillan.

Bisaha, Nancy. 2004. *Creating East and West: Renaissance Humanists and the Ottoman Turks*. Philadelphia: University of Pennsylvania Press.

Bisson, Thomas N. 2000. *The Medieval Crown of Aragon: A Short History*. Oxford: Clarendon.

Black, Crofton, ed. 2006. *Transformation of Knowledge: Early Manuscripts from the Collection of Lawrence J. Schoenberg*. London: Paul Holberton.

Black, James. 1983. "Henry IV's Pilgrimage." *Shakespeare Quarterly* 34 (1): 18–26.

Black, Jeremy. 1997. *Maps and Politics*. Chicago: University of Chicago Press.

Blair, Sheila. 2008. *Islamic Calligraphy*. Edinburgh: Edinburgh University Press.

———. 2014. "Tabriz: International Entrepôt under the Mongols." In *Politics, Patronage and the Transmission of Knowledge in 13th–15th Century Tabriz*, edited by Judith Pfeiffer, 321–56. Leiden, the Netherlands: Brill.

Blair, Sheila, and Jonathan Bloom. 1996. *The Art and Architecture of Islam, 1250–1800*. New Haven, CT: Yale University Press.

———. 1997. *Islamic Arts*. London: Phaidon.

———. 2013. *God Is Beautiful and Loves Beauty: The Object in Islamic Art and Culture*. New Haven, CT: Yale University Press.

Blick, Sarah, ed. 2007. *Beyond Pilgrim Souvenirs and Secular Badges: Essays in Honour of Brian Spencer*. Oxford: Oxbow Books.

Blier, Suzanne Preston. 2008. "Africa, Art, and History: An Introduction." In *A History of Art in Africa*, edited by Monica Blackmun Visoná, Robin Poynor, and Herbert M. Cole, 14–19. Upper Saddle River, NJ: Prentice Hall.

———. 2012a. "Cosmic References in Ancient Life." In *African Cosmos: Stellar Arts*, edited by Christine Mullen Kreamer, Erin L. Haney, Katharine Monsted, and Karen Nell, 204–15. Washington, DC: National Museum of African Art, Smithsonian Institution. Exhibition catalogue.

———. 2012b. *Royal Arts of Africa: The Majesty of Form*. London: Lawrence King.

——. 2015. *Art and Risk in Ancient Yoruba: Ife History, Power, and Identity, c. 1300*. Cambridge, England: Cambridge University Press.

Block Friedman, John. 1981. *The Monstrous Races in Medieval Art and Thought*. Cambridge, MA: Harvard University Press.

Blöndal, Sigfús. 1978. *The Varangians of Byzantium*. Translated by Benedict Benedikz. Cambridge, England: Cambridge University Press.

Blondeau, Etienne. 2014. *Les routes bleues: Périples d'une couleur de la Chine à la Méditerranée*. Limoges, France: Les Ardents.

Bloom, Jonathan M. 2005. "Silk Road or Paper Road?" *Silkroad* 3 (2): 21–25.

——. 2015. "The Blue Koran Revisited." *Journal of Islamic Manuscripts* 6 (2/3): 196–218.

Bloom, Jonathan, and Sheila Blair. 2015. *God Is the Light of the Heavens and the Earth: Light in Islamic Art and Culture*. New Haven, CT: Yale University Press.

Boardman, John. 2006. *The World of Ancient Art*. New York: Thames and Hudson.

——. 2015. *The Greeks in Asia*. New York: Thames and Hudson.

Boeck, Elena N. 2015. *Imagining the Byzantine Past: The Perception of History in the Illustrated Manuscripts of Skylitzes and Manasses*. Cambridge, England: Cambridge University Press.

Boehm, Barbara Drake, and Melanie Holcomb. 2016. *Jerusalem, 1000–1400. Every People under Heaven*. New Haven, CT: Yale University Press.

Bondarev, Dmitry. 2006. "An Archaic Form of Kanuri/Kanembu: A Translation Tool for Qur'anic Studies." *Journal of Qur'anic Studies* 8 (1): 142–53.

——. 2007. "Early Nigerian Qur'anic Manuscripts: Palaeography." SOAS University of London. http://www.soas.ac.uk/africa/research/kanuri/subjectareas/palaeography/.

——. 2013. "Qur'anic Exegesis in Old Kanembu: Linguistic Precision for Better Interpretation." *Journal of Qur'anic Studies* 15 (3): 56–83. Special issue on "Qur'anic Exegesis in African Languages," edited by Tal Tamari and Dmitry Bondarev.

Bonnet-Bidaud, Jean-Marc, Françoise Praderie, and Susan Whitfield. 2009. "The Dunhuang Chinese Sky: A Comprehensive Study of the Oldest Known Star Atlas." International Dunhuang Project. http://idp.bl.uk/4DCGI/education/astronomy_researchers/index.a4d/.

Boone, Elizabeth Hill. 1994. "Introduction: Writing and Recording Knowledge." In *Writing without Words: Alternative Literacies in Mesoamerica and the Andes*, edited by Elizabeth Hill Boone and Walter D. Mignolo, 3–26. Durham, NC, and London: Duke University Press.

——. 2000. *Stories in Red and Black: Pictorial Histories of the Aztecs and Mixtecs*. Austin: University of Texas Press.

——. 2005. *Painted Books and Indigenous Knowledge in Mesoamerica: Manuscript Studies in Honor of Mary Elizabeth Smith*. New Orleans: Middle American Research Institute.

——. 2007. *Cycles of Time and Meaning in the Mexican Books of Fate*. Austin: University of Texas Press.

Boone, Elizabeth Hill, and Walter D. Mignolo, eds. 1994. *Writing without Words: Alternative Literacies in Mesoamerica and the Andes*. Durham, NC, and London: Duke University Press.

Borgolte, Michael. 2014. *Mittelalter in der größeren Welt: Essays zur Geschichtsschreibung und Beiträge zur Forschung (Europa im Mittelalter, Band 24)*. Berlin: De Gruyter Auflage.

Born, Robert, et al. 2015a. *The Ottoman Orient in Renaissance Culture: Papers from the International Conference at the National Museum in Krakow, June 26–27, 2015*. Krakow: Muzeum Narodowe.

——. 2015b. *The Sultan's World: The Ottoman Orient in Renaissance Art*. Ostfildern, Germany: Hatje Cantz Verlag.

Bosc-Tiessé, Claire. 2004. "The Use of Occidental Engravings in Ethiopian Painting in the 17th and 18th Centuries." In *The Indigenous and the Foreign in Christian Ethiopian Art: On Portuguese-Ethiopian Contacts in the 16th–17th Centuries: Papers from the Fifth International Conference on the History of Ethiopian Art, Arrábida, 26–30 November 1999*, edited by Manuel João Ramos with Isabel Boavida, 83–102. Aldershot, England: Ashgate.

Botticini, Maristella, and Zvi Eckstein. 2012. "Educated Wandering Jews, 800–1250." In *The Chosen Few: How Education Shaped Jewish History, 70–1492*, edited by Maristella Botticini and Zvi Eckstein, 153–200. Princeton, NJ, and Oxford: Princeton University Press.

Boucher, Sylviane, and Yoly Palomo. 2012. "Visual Discrimination as a Style and Typological Classification Determiner for 'Codex' Ceramics in Calakmul, Campeche." *Estudios de Cultura Maya* 39:99–132.

Boucheron, Patrick. 2009. *Histoire du monde au XVe siècle*. Paris: Fayard.

Bouchet, Florence. 2011. *René d'Anjou, écrivain et mécène (1409–1480)*. Turnhout, Belgium: Brepols.

Boulton, D'Arcy J. D. 2006. "The Order of the Golden Fleece and the Creation of Burgundian National Identity." In *The Ideology of Burgundy: The Promotion of National Consciousness, 1364–1565*, edited by D'Arcy J. D. Boulton and Jan R. Veenstra, 21–97. Leiden, the Netherlands: Brill.

Bousquet-Labouérie, Christine. 1994. "Les Voyageurs et l'Orient. Etude des rapports entre les textes et les images dans quelques récits manuscrits sur l'Asie aux XIVe et XVe siècles." PhD diss., Université François Rabelais.

Bowditch, Charles P., ed. 1904. *Mexican and Central American Antiquities, Calendar Systems, and History*. Washington, DC: Government Printing Office.

Brac de la Perrière, Eloïse. 2008. *L'art du livre dans l'Inde des sultanats*. Paris: Presses de l'Université Paris-Sorbonne.

——. 2009. "Du Caire à Mandu: La transmission des modèles dans l'Inde des sultanats (XIIIe–XVIe)." In *Ecrit et culture en Asie centrale et dans le monde turco-iranien, Xe–XIXe siècles*, edited by Francis Richard and Maria Szuppe, 333–58. Studia Iranica 40. Paris: Association pour l'Avancement des Études Iraniennes.

Braudel, Fernand. 1949. *The Mediterranean and the Mediterranean World in the Age of Philip II*. Berkeley: University of California Press.

——. 1978. *Expansion and Reaction: Essays on European Expansion and Reaction in Asia and Africa*. Leiden, the Netherlands: Leiden University Press.

Brenk, Beat, and Salvatore Settis, eds. 2010. *La Cappella Palatina à Palermo*. 4 vols. Modena, Italy: Atlante.

Brentjes, Sonja. 2008. "Revisiting Catalan Portolan Charts: Do They Contain Elements of Asian Provenance?" In *The Journey of Maps and Images on the Silk Roads*, edited by Philippe Forêt and Andreas Kaplony, 181–201. Leiden, the Netherlands: Brill.

——. 2012. "Medieval Portolan Charts as Documents of Shared Cultural Spaces." In *Acteur des transferts culturels en Méditerranée médiévale*, edited by R. Abdellatif et al., 134–46. Munich: Oldenbourg Verlag.

Brewer, Keagan. 2018. "Prester John and European Orientalism: The Mentality behind the Most Enduring and Malleable of Medieval European Legends (Twelfth to Eighteenth Centuries)." The Global Middle Ages in Sydney Faculty Research Group Semester 2 Seminar Series. University of Sydney. https://wordvine.sydney.edu.au/files/1944/21578/.

Bricker, Victoria R., and Harvey M. Bricker. 1986. "The Mars Table in the Dresden Codex." In *Research and Reflections in Archaeology and History: Essays in Honor of Doris Stone*, edited by E. Wyllys Andrews V, 51–80. New Orleans: Tulane University Press.

——. 1992. "A Method for Cross-Dating Almanacs with Tables in the Dresden Codex." In *The Sky in Mayan Literature*, edited by Anthony F. Aveni, 43–86. Oxford: Oxford University Press.

Bricker, Victoria R., and Helga-Maria Miram. 2002. *An Encounter of Two Worlds: The Book of Chilam Balam of Kaua*. New Orleans: Tulane University Middle American Research Institute.

Brigaglia, Andrea. 2011. "Central Sudanic Arabic Scripts (Part 1): The Popularization of the Kanawī Script." *Islamic Africa* 2 (2): 51–85.

Brigaglia, Andrea, and Mauro Nobili. 2013. "Central Sudanic Arabic Scripts (Part 2): Barnawi." *Islamic Africa* 4 (2): 195–223.

Bright, Michael. 1984. *Cities Built to Music: Aesthetic Theories of Victorian Gothic Revival*. Columbus: Ohio State University Press.

Brockelmann, C., and C. Pellat. 2012. "Maḳāma." In *Encyclopaedia of Islam*, 2nd ed., edited by P. Bearman, Th. Bianquis, C. E. Bosworth, E. van Donzel,

and W. P. Heinrichs. Leiden, the Netherlands: Brill. http://referenceworks
.brillonline.com/entries/encyclopaedia-of-islam-2/makama-COM_0634?s
.num=0&s.f.s2_parent=s.f.book.encyclopaedia-of-islam-2&s.q=Ma%E1
%B8%B3%C4%81ma/.

Brody, Heinrich, ed. 1894–1930. *Dîwan des Abû-l-Hasân Jehuda ha-Levi*. 4 vols.
Berlin: Druck von H. Itzkowaki.

Bromilow, Poille. 2013. *Authority in European Book Culture, 1400–1600*. Farn-
ham, England: Ashgate.

Brooks, Timothy. 2008. *Vermeer's Hat: The Seventeenth Century and the Dawn
of the Global World*. Toronto: Penguin Canada.

Brotton, Jerry. 1997. *Trading Territories: Mapping the Early Modern World*.
London: Reaktion.

———. 2012. *A History of the World in 12 Maps*. London: Penguin.

Brotton, Jerry, and Lisa Jardine. 2000. *Global Interests: Renaissance Art between
East and West*. Ithaca, NY: Cornell University Press.

Brotton, Jerry, and Nick Millea. 2019. "Exhibition Proposal: Talking Maps."
Oxford: Bodleian Library.

Brown, Kate. 2018. "Benin's Looted Bronzes Are All Over the Western World.
Here Are 7 Museums that Hold Over 2,000 of the Famed Sculptures."
Artnet News, July 27, 2018. https://news.artnet.com/art-world/benin
-bronzes-restitution-1322807/.

Brown, Robert L. 2014. *Carrying Buddhism: The Role of Metal Icons in the Spread
and Development of Buddhism*. Amsterdam: J. Gonda Fund Foundation of
the KNAW.

Buchthal, Hugo. 1938. *The Miniatures of the Paris Psalter: A Study in Middle
Byzantine Painting*. Studies of the Warburg Institute 2. London: Warburg
Institute.

———. 1974. "The Exaltation of David." *Journal of the Warburg and Courtauld
Institutes*, no. 37, 330–33.

———. 1983. *Art of the Mediterranean World: 100 to 1400 AD*. Washington, DC:
Decatur House.

Buckley Ebrey, Patricia. 2008. *Accumulating Culture: The Collections of Emperor
Huizong*. Seattle: University of Washington Press.

Budge, E. A. 1929. *The Bandlet of Righteousness: An Ethiopian Book of the Dead*.
London: Luzac.

———. 1935. *Book of the Mysteries of the Heavens and the Earth: And Other
Works of Bakhayla Mika'El (Zosimas)*. Oxford: Oxford University Press.

Burger, Pauline, Armelle Charrié-Duhaut, Jacques Connan, Pierre Albrecht,
and Michael Flecker. 2010. "The 9th-Century-AD Belitung Wreck, Indone-
sia: Analysis of a Resin Lump." *International Journal of Nautical Archaeology*
39 (2): 383–86.

Burgersdijk, Diederik, et al., eds. 2015. *Sicily and the Sea*. Zwolle, the Nether-
lands: WBooks.

Burke, Peter. 2016. *Hybrid Renaissance: Culture, Language, Architecture*. Buda-
pest: Central European University Press.

Burkhart, Louise. 1989. *The Slippery Earth: Nahua-Christian Moral Dialogue in
Sixteenth-Century Mexico*. Tucson: University of Arizona Press.

Burlingham, Cynthia, and Bruce Whiteman, eds. 2001. *The World from Here:
Treasures of the Great Libraries of Los Angeles*. Los Angeles: UCLA Grunwald
Center for the Graphic Arts and the Armand Hammer Museum of Art and
Cultural Center.

Burns, J. Patout, Jr., Robin M. Jensen, and Graeme W. Clarke, eds. 2014. *Chris-
tianity in Roman Africa: The Development of Its Practices and Beliefs*. Grand
Rapids, MI: Eerdmans.

Burtea, Bogdan. 2007. "Magic Literature." In vol. 3 of *Encyclopaedia Aethiopica*,
edited by Siegbert Uhlig and Baye Yimam, 638–40. Wiesbaden, Germany:
Harrassowitz.

Buti, David, Davide Domenici, Costanza Milani, Concepción García Sáiz,
Teresa Gómez Espinoza, Félix Jímenez Villalba, Ana Verde Casanova,
and et al. 2015. "Non-Invasive Investigation of a Pre-Hispanic Maya
Screenfold Book: The Madrid Codex." *Journal of Archaeological Science*
42:166–78.

Byland, Bruce, and John M. D. Pohl. 1994. *In the Realm of Eight Deer: The
Archaeology of the Mixtec Codices*. Norman: University of Oklahoma Press.

Byron, Gay L. 2002. *Symbolic Blackness and Ethnic Difference in Early Christian
Literature*. London: Routledge.

Cabanes Pecour, María de los Desamparados, Asunción Blasco Martínez, and
Pilar Pueyo Colomino. 1996. *Vidal Mayor: Edición, introducción, y notas al
manuscrito*. Zaragoza, Spain: Libros Certeza.

Calkins, Robert G. 1978. "Stages of Execution: Procedures of Illumination as
Revealed in an Unfinished Book of Hours." *Gesta* 17 (1): 61–70.

Camille, Michael. 1989. *The Gothic Idol: Ideology and Image-Making in Medieval
Art*. Cambridge, England: Cambridge University Press.

Canby, Sheila R. 1993a. "Depictions of Budda Sakyamuni in the Jami' al-
Tavarikh and the Majma' al-Tavarikh." *Muqarnas* 10:299–310.

———. 1993b. *Persian Painting*. London: Trustees of the British Museum.

———. 1996. "Farangi Saz: The Impact of Europe on Safavid Painting." In *Silk
and Stone: The Art of Asia*, edited by Jill Tilden, 46–59. London: HALI.

———. 2016. *Court and Cosmos: The Great Age of the Seljuqs*. New York: Metro-
politan Museum of Art.

Canepa, Matthew P. 2010. "Theorizing Cross-Cultural Interaction among
Ancient and Early Medieval Visual Cultures." *Ars Orientalis* 38:7–29.

Cannuyer, Christian. 1992. *Flavors of Paradise: The Spice Routes*. Brussels: Van
Driessche.

Caraci, G. 1937. "A Little Known Atlas of Vesconte Maggiolo." *Imago Mundi*
2:37–54.

Carboni, Stefano. 1997. *Following the Stars: Images of the Zodiac in Islamic Art*.
New York: Metropolitan Museum of Art.

Carlson, John B. 2012–13. "The Twenty Masks of Venus: A Brief Report of
Study and Commentary on the Thirteenth-Century Maya Grollier Codex,
a Fragment of a 104-Year Hybrid-Style Maya Divinatory Venus Almanac."
Archaeoastronomy 25:1–29.

Carrier, David. 2008. *A World Art History and Its Objects*. University Park:
Pennsylvania State University Press.

Carruthers, Leo, Raeleen Chai-Elsholz, and Tatjana Silec, eds. 2011. *Palimpsests
and the Literary Imagination of Medieval England: Collected Essays*. New York:
Palgrave Macmillan.

Cartellieri, Otto, and Malcolm Letts. 1929. *The Court of Burgundy: Studies in the
History of Civilization*. London: K. Paul, Trench, Trubner.

Carter, John. 1992. *ABC for Book Collectors*. New Castle, DE: Oak Knoll.

Carter, Nicholas P., and Jeffrey Dobereiner. 2016. "Multispectral Imaging of a
Classic Maya Codex Fragment from Uaxactun, Guatemala." *Antiquity* 90
(351): 711–25.

Casagrande-Kim, Roberta, Samuel Thrope, and Raquel Ukeles. 2018. *Romance
and Reason: Islamic Transformations of the Classical Past*. Princeton, NJ:
Princeton University Press.

Casid, Jill H., and Aruna D'Souza. 2014. *Art History in the Wake of the Global
Turn*. Williamstown, MA: Sterling and Francine Clark Art Institute.

Caskey, Jill. 2011. "The Look of Liturgy: Identity and *Ars Sacra* in Southern
Italy." In *Ritual and Space in Medieval Europe*, Proceedings of the 2009
Harlaxton Symposium, edited by Frances Andrews, 108–29. Donington,
England: Shaun Tyas.

Caskey, Jill, Adam S. Cohen, and Linda Safran. 2011. *Confronting the Borders of
Medieval Art*. Leiden, the Netherlands: Brill.

Cassee, Elly, and Kees Berserik. 1984. "The Iconography of the Resurrection:
A Re-examination of the Risen Christ Hovering above the Tomb." *Burlington
Magazine* 126 (970): 20–24.

Cassidy-Welch, Megan. 2018. "The Crusades in Africa: Imaginings and
Encounters." The Global Middle Ages in Sydney Faculty Research Group
Semester 2 Seminar Series. University of Sydney. https://wordvine.sydney
.edu.au/files/1944/21578/.

Centeno, Silvia A., and Nellie Stavisky. 2013. "The *Prato Haggadah*: An Inves-
tigation into the Materials and Techniques of a Hebrew Manuscript from
Spain in Relation to Medieval Treatises." In *Craft Treatises and Handbooks:*

The Dissemination of Technical Knowledge in the Middle Ages, edited by Ricardo Córdoba de la Llave, 161–84. Turnhout, Belgium: Brepols.

Chaffee, John. 2006. "Diasporic Identities in the Historical Development of the Maritime Muslim Communities of Song-Yuan China." *Journal of the Economic and Social History of the Orient* 49 (4): 395–420.

Chakrabarty, Dipesh. 2000. *Provincializing Europe: Postcolonial Thought and Historical Difference*. Princeton, NJ: Princeton University Press.

Chakravarti, Ranabir. 2001. "Monarchs, Merchants and a Matha in Northern Konkan (c. AD 900–1053)." In *Trade in Early India*, edited by Ranabir Chakravarti, 257–81. New Delhi: Oxford University Press.

———. 2008. *Trade and Traders in Early Indian Society*. New Delhi: Manohar.

Chase, Diane Z., and Arlen F. Chase. 1986. *Offerings to the Gods: Maya Archaeology at Santa Rita Corozal*. Orlando: University of Central Florida.

———. 2005. "The Early Classic Period at Santa Rita Corozal: Issues of Hierarchy, Heterarchy, and Stratification in Northern Belize." *Research Reports in Belizean Archaeology* 2:111–29.

Chaturvedi, Vinayak. 2014. "Introduction: Writing History in the Borderlands." *Social History* 39 (3): 307–22. Special issue on South Asia edited by Vinayak Chaturvedi.

Chavel, Charles B., trans. 1978. *Writings and Discourses by Nahmanides*. 2 vols. New York: Shilo.

Chelkowski, Peter J. 1975. *Mirror of the Invisible World: Tales from the "Khamseh" of Nizami*. New York: Metropolitan Museum of Art.

Chiappori, Maria Grazia. 1981. "Riflessi figurativi des contatti Oriente-Occidente e dell'opera poliana nell'arte medievale italiana." In *Marco Polo: Venezia e l'Oriente*, edited by Alvise Zorzi, 281–90. Milan, Italy: Electa.

Chick, H. 2012. *A Chronicle of the Carmelites in Persia: The Safavids and the Papal Mission of the 17th and 18th Centuries*. London: I. B. Tauris.

Chipps Smith, Jeffrey. 1982. *The Artistic Patronage of Philip the Good, Duke of Burgundy (1419–1467)*. New York: Columbia University Press.

Chittick, Neville. 1974. *Kilwa: An Islamic Trading City on the East African Coast*. 2 vols. Nairobi, Kenya: British Institute in Eastern Africa.

Cho, Sumi, Kimberlé Williams Crenshaw, and Leslie McCall. 2013. "Toward a Field of Intersectionality Studies: Theory, Applications, and Praxis." *Signs* 38 (4): 785–810.

Chong, Alan, and Stephen A. Murphy, eds. 2017. *The Tang Shipwreck: Art and Exchange in the 9th Century*. Singapore: Asian Civilisations Museum.

Chuchiak, John F. 2004a. "The Images Speak: The Survival and Production of Hieroglyphic Codices and Their Use in Post-Conquest Maya Religion, 1580–1720." In *Continuity and Change: Maya Religious Practices in Temporal Perspective*, edited by Daniel Graña Behrens, 165–83. Markt Schwaben, Germany: A. Saurwein.

———. 2004b. "Papal Bulls, Extirpators and the Madrid Codex: The Content and Probable Provenance of the Madrid 56 Patch." In *The Madrid Codex: New Approaches to Understanding an Ancient Maya Manuscript*, edited by Gabrielle Vail and Anthony F. Aveni, 57–88. Boulder: University Press of Colorado.

———. 2006. "De Extirpatio Codicis Yucatanensis: The 1607 Colonial Confiscation of a Maya Sacred Book—New Interpretations on the Origins and Provenience of the Madrid Codex." In *Sacred Books, Sacred Languages: Two Thousand Years of Ritual and Religious Maya Literature*, edited by Rogelio Valencia Rivera and Geneviève Le Fort, 113–40. Acta Mesoamericana 18. Möckmühl, Germany: Verlag Von Flemming.

———. 2010. "Writing as Resistance: Maya Graphic Pluralism and Indigenous Elite Strategies for Survival in Colonial Yucatan, 1550–1750." *Ethnohistory* 57 (1): 87–116.

Cioffari, Gerardo. 1986. "La riforma di Carlo II d'Angiò e i codici liturgici di S. Nicola." In *I codici liturgici in Puglia*, edited by Gerardo Cioffari, 21–23. Bari, Italy: Edizioni Levante.

———. 2008. "Storia dell'archivio di S. Nicola." *Nicolaus, Studi Storici* 19, parts 1-2: 9–156.

Ciudad Ruiz, Andrés. 2000. "The Tro-Cortesian Codex of the Museum of America of Madrid." *Revista Española de Antropología Americana* 30:9–25.

Claman, Henry M. 2000. *Jewish Images in the Christian Church: Art as the Mirror of the Jewish-Christian Conflict, 200–1250 CE*. Macon, GA: Mercer University Press.

Clanchy, M. T. 1980/81. "'Tenacious Letters.' Archives and Memory in the Middle Ages." *Archivaria* 11 (Winter): 115–25.

Classen, Albrecht, ed. 2013. *East Meets West in the Middle Ages and Early Modern Times: Transcultural Experiences in the Premodern World*. Berlin and Boston: De Gruyter.

Cleveland Museum of Art. 1980. *Eight Dynasties of Chinese Painting: The Collections of the Nelson Gallery-Atkins Museum, Kansas City, and the Cleveland Museum of Art*. Cleveland, OH: Cleveland Museum of Art. Exhibition catalogue.

Clifford, James. 1997. "Prologue: In Medias Res." In *Routes: Travel and Translation in the Late Twentieth Century*, edited by James Clifford, 1–13. Cambridge, MA: Harvard University Press.

Cockerell, Sydney C. 1927. *A Book of the Old Testament Illustrations of the Middle of the Thirteenth Century, Sent by Cardinal Bernard Maciejowski to Shah Abbas the Great, King of Persia, Now in the Pierpont Morgan Library at New York: [Morgan Ms. 638]*. Cambridge, England: Cambridge University Press.

———. 1969. "The Book and Its History." In *Old Testament Miniatures: A Medieval Picture Book with 283 Paintings from the Creation to the Story of David*, edited by Sydney C. Cockerell and John Plummer, 5–21. London: Phaidon.

Cockshaw, P., Claudine Lemaire, and Anne Rouzet. 1977. *Charles le Téméraire: Exposition organisée à l'occasion du cinquième centenaire de sa mort: Catalogue*. Brussels [Bd de l'Empereur, 4]: Bibliothèque royale Albert 1er.

Coe, Michael D. 1978. *La Victoria: An Early Site on the Pacific Coast of Guatemala*. Millwood, NY: Kraus Reprint.

———. 2012. *Breaking the Maya Code*. London: Thames and Hudson.

Coe, Michael D., and Justin Kerr. 1997. *The Art of the Maya Scribe*. London: Thames and Hudson.

Coe, Michael D., and Stephen D. Houston. 2015. *The Maya: Ancient Peoples and Places*. 9th ed. London: Thames and Hudson.

Coe, Michael D., et al. 2015. "The Fourth Maya Codex." In *Maya Archaeology 3*, 117-67. San Francisco: Precolumbia Mesoweb.

Coggins, Clemency Chase. 1975. "Painting and Drawing Styles at Tikal: An Historical and Iconographic Approach." PhD diss., Harvard University.

Cohen, Evelyn M. 2000. "Joel ben Simeon Revisited: Reflections of the Scribe's Artistic Repertoire in a Cinquecento Haggadah." In *A Crown for a King; Studies in Jewish Art, History and Archaeology in Memory of Stephen S. Kayser*, edited by Shalom Sabar, Steven Fine, and William M. Kramer, 59–71. Jerusalem: Gefen.

Cohen, J. 2000. *The Postcolonial Middle Ages*. Basingstoke, England: Palgrave Macmillan.

Cohen, Matthew, and Jeffrey Glover, eds. 2014. *Colonial Mediascapes: Sensory Worlds of the Early Americas*. Lincoln: University of Nebraska Press.

Cohen, Meredith. 2015. *The Sainte-Chapelle and the Construction of Sacral Monarchy: Royal Architecture in Thirteenth-Century Paris*. Cambridge, England: Cambridge University Press.

Colburn, Cynthia. 2016. "Whose Global Art (History)? Ancient Art as Global Art." *Journal of Art Historiography* 14:1-11.

Coleman, Joyce. 1996. *Public Reading and the Reading Public in Late Medieval England and France*. New York: Cambridge University Press.

Colin, G. 2008. *La version éthiopienne de Barlaam et Josaphat (Baralam Wayewasef)*. Leuven, Belgium: Peeters.

Collins, Kristen. 2017. "Resonance and Reuse: The Reinvention of a Late-Romanesque Vita Christi (Getty Ms. 101)." *British Art Studies*, no. 6 (June 29, 2017). http://britishartstudies.ac.uk/issues/issue-index/issue-6/vita-christi/.

Collins, Minta. 2000. *Medieval Herbals: The Illustrative Tradition*. London: British Library.

Connell, Raewyn. 2007. *Southern Theory*. Ann Arbor: University of Michigan Press.

Conrad, Sebastian. 2016. *What Is Global History?* Princeton, NJ: Princeton University Press.

Constable, Olivia Remie. 1996. "Muslim Spain and Mediterranean Slavery: The Medieval Slave Trade as an Aspect of Muslim-Christian Relations." In *Christendom and Its Discontents: Exclusion, Persecution, and Rebellion, 1000–1500*, edited by Scott L. Waugh and Peter D. Diehl, 264–84. New York: Cambridge University Press.

———. 2007. "Chess and Courtly Culture in Medieval Castile: The Libro de Ajedrez of Alfonso X, el Sabio." *Speculum* 82:341–42.

Constas, Nicholas, ed. 2003. *Proclus of Constantinople and the Cult of the Virgin in Late Antiquity: Homilies 1–5, Texts and Translations*. Leiden, the Netherlands: Brill.

Contadini, Anna. 2010. *Arab Painting: Text and Image in Illustrated Arabic Manuscripts*. Leiden, the Netherlands: Brill.

Contadini, Anna, and Claire Norton. 2013. *The Renaissance and the Ottoman World*. Surrey, England: Ashgate.

Content, Derek J. 2016. *Ruby, Sapphire, and Spinel: An Archaeological, Textual, and Cultural Study*. Turnhout, Belgium: Brepols.

Copp, Paul. 2014. *The Body Incantatory: Spells and the Ritual Imagination in Medieval Chinese Buddhism*. New York: Columbia University Press.

Coquery-Vidrovitch, Catherine, and Georges Balandier, eds. 2017. *L'Afrique des routes: Histoire de la circulation des hommes, des richesses et des idées à travers le continent africain*. Paris: Musée du quai Branly-Jacques Chirac.

Cosgrove, Denis. 2001. *Apollo's Eye: A Cartographic Genealogy of the Earth in the Western Imagination*. Baltimore: Johns Hopkins University Press.

Crenshaw, Kimberlé W. 1989. "Demarginalizing the Intersection of Race and Sex: A Black Feminist Critique of Antidiscrimination Doctrine, Feminist Theory, and Antiracist Politics." *University of Chicago Legal Forum* 1 (8): 139–67.

———. 1991. "Mapping the Margins: Intersectionality, Identity Politics, and Violence against Women of Color." *Stanford Law Review* 43 (6): 1241–99.

Cronin, Jennifer Lauren. 2009. "Unfolding the Landscape of Dark Age Cornwall: Tintagel and Its Hinterland." MA thesis, University of Winchester.

Cropper, Elizabeth. 2009. *Dialogues in Art History, from Mesopotamia to Modern: Readings for a New Century*. New Haven, CT: Yale University Press.

Cruse, Mark. 2011. *Illuminating the "Roman d'Alexandre" (Oxford, Bodleian Library, MS Bodley 264): The Manuscript as Monument*. Cambridge, England: D. S. Brewer.

———. 2014. "Un Monumento in Pergama." In *Il Manoscritto Bodley 264. Il Romanzo di Alessandro. I Viaggi di Marco Polo. Saggi e Commenti*, 149–53. Rome: Treccani.

Cummins, Thomas B. F., and Barbara Anderson. 2008. *The Getty Murúa: Essays on the Making of Martín de Murúa's "Historia General del Piru."* Los Angeles: The J. Paul Getty Museum.

Cuno, James. 2008. *Who Owns Antiquity? Museums and the Battle over Our Ancient Heritage*. Princeton, NJ: Princeton University Press.

———. 2013. *Museums Matter: In Praise of the Encyclopedic Museum*. Chicago: University of Chicago Press.

Cutler, Anthony. 1976. "A Psalter of Basil II (Part I)." *Arte Veneta* 30:9–19.

———. 1977. "A Psalter of Basil II (Part II)." *Arte Veneta* 31:9–15.

Dackerman, Susan, ed. 2011. *Prints and the Pursuit of Knowledge in Early Modern Europe*. Boston: Harvard Art Museums.

DaCosta Kaufmann, Thomas, Catherine Dossin, and Béatrice Joyeux-Prunel, eds. 2015. *Circulations in the Global History of Art*. London: Ashgate.

DaCosta Kaufmann, Thomas, and Elizabeth Pilliod, eds. 2005. *Time and Place: The Geohistory of Art*. London: Ashgate.

Dalton, Heather. 2018. "Parrots, People, Pearls and Slugs: Micro Markers of Medieval Crossroads between the Local and Global." The Global Middle Ages in Sydney Faculty Research Group Semester 2 Seminar Series. University of Sydney. https://wordvine.sydney.edu.au/files/1944/21578/.

Dalton, Heather, Jukka Salo, Pekka Niemalä, and Simo Örmä. 2018. "Frederick II of Hohenstaufen's Australasian Cockatoo: A Symbol of Detente between East and West and Evidence of the Ayyubid Sultanate's Global Reach." *Parergon* 35 (1): 35–60.

Davies, Penelope J. E., et al. 2011. *Janson's History of Art: The Western Tradition*. 8th ed. Upper Saddle River, NJ: Prentice Hall.

Davis, Avrohom. 1993. *Chumash/Rashi: A New Linear Translation, Shmos*. Translated by Avrohom Kleinkaufman. Hoboken, NJ: Metsudah.

Davis, Caroline, and David Johnson, eds. 2015. *The Book in Africa: Critical Debates*. Houndmills, England: Palgrave Macmillan.

Davis, Kathleen, and Nadia Altschul. 2009. "The Idea of 'The Middle Ages' outside Europe." In *Medievalisms in the Postcolonial World*, edited by Kathleen Davis and Nadia Altschul, 1–24. Baltimore: Johns Hopkins University Press.

de Borhegyi, Stephen F. 1951. "Further Notes on Three-Pronged Incense Burners and Rim-Head Vessels in Guatemala." *Notes on Middle American Archaeology and Ethnology* 4 (105): 162–76.

De Landa, Manuel. 1997. *A Thousand Years of Nonlinear History*. New York: Zone Books.

de Lannoy, Guillebert. 1849. *Voyages et Ambassades de Messire Guillebert de Lannoy, 1399–1450*. Mons, Belgium: Typographie d'Em. Hoyois, Libraire.

Delgado Echevarria, Jesús. 2009. "El 'Vidal Mayor,' Don Vidal de Canellas y los Fueros de Aragón." *REVISTA de Derecho Civil Aragonés* 15:11–21.

Dell'Aqua, Francesca, et al., eds. 2016. *The Salerno Ivories: Objects, Histories, Contexts*. Berlin: Gebr. Mann Verlag.

della Valle, Pietro. 1989. *The Pilgrim: The Journeys of Pietro della Valle*. Edited by George Bull. London: Folio Society.

del Niño Jesús, Florencio. 1929. *A Persia: (1604–1609): Peripecias de una embajada pontificia que fue a Persia a principios del Siglo XVII*. Pamplona, Spain: Ramón Bengaray.

del Paso y Troncoso, Francisco. 1905. Vol. 4 of *Papeles de la Nueva España*. Madrid: Sucesores de Rivadeneyra.

———. 1979. *Relaciones geográficas de la Diócesis de México*. Mexico City: Editorial Cosmos.

Department of Asian Art. 2000–. "Northern Song Dynasty (960–1127)." In *Heilbrunn Timeline of Art History*. New York: Metropolitan Museum of Art. http://www.metmuseum.org/toah/hd/nsong/hd_nsong.htm.

Der Nersessian, Sirarpie. 1933. "The Date of the Initial Miniatures of the Etchmiadzin Gospel." *Art Bulletin* 15 (4): 327–60.

———. 1963. *Armenian Manuscripts in the Freer Gallery of Art*. Washington, DC: Freer Gallery of Art.

Der Nersessian, Sirarpie, and Arpag Mekhitarian. 1986. *Armenian Miniatures from Isfahan*. Brussels: Editeurs d'Art Associés.

de Varthema, Ludovico, et al. 1928. *The Itinerary of Ludovico di Varthema of Bologna from 1502–1508, as Translated from the Original Italian Edition of 1510, by John Winter Jones, F.S.A., in 1863 for the Hakluyt Society, with a Discourse on Varthema and His Travels in Southern Asia, by Sir Richard Carnac Temple*. London: Argonaut.

Devisse, Jean. 1979. Vol. 2, part 1, of *The Image of the Black in Western Art*. New York: Morrow.

———. 2010a. "The Black and His Color: From Symbols to Realities." In vol. 2, part 1, of *The Image of the Black in Western Art*, edited by David Bindman and Henry Louis Gates Jr., 73–137. Cambridge, MA: Belknap.

———. 2010b. "Christians and Black." In vol. 2, part 1, of *The Image of the Black in Western Art*, edited by David Bindman and Henry Louis Gates Jr., 31–72. Cambridge, MA: Belknap.

Devisse, Jean, and Michel Mollat. 1979. Vol. 2, part 2, of *The Image of the Black in Western Art*. New York: Morrow.

———. 2010. "The Appeal to the Ethiopian." In vol. 2, part 2, of *The Image of the Black in Western Art*, edited by David Bindman and Henry Louis Gates Jr., 83–152. Cambridge, MA: Belknap.

de Weever, Jacqueline. 1998. *Sheba's Daughters: Whitening and Demonizing the Saracen Woman in Medieval French Epic*. New York: Garland.

Dhavalikar, M. K., and Shreenand L. Bapat. 2011. *An Illustrated Prakit*

Manuscript of Paryusana-kalpasutra. Pune, India: Bhandarkar Research Institute.

Dolezalek, Isabelle. 2014. "Trendy Trade with Blue-and-White Dishes: Early Networks of Ceramic Exchange between East and West." In *Early Capitals of Islamic Culture: The Artistic Legacy of Umayyad Damascus and Abbasid Baghdad (650–950)*, 67–68. Berlin: Hirmer. Exhibition catalogue.

Donkin, Lucy, and Hanna Vorholt, eds. 2012. *Imagining Jerusalem in the Medieval West*. Proceedings of the British Academy 175. Oxford: Oxford University Press.

Donkin, R. A. 1999. *Dragon's Brain Perfume: A Historical Geography of Camphor*. Boston: Brill.

Donovan, Claire. 1993. *The Winchester Bible*. London: British Library; Winchester, England: Winchester Cathedral.

Donovan, Erin, Anne D. Hedeman, Elizabeth Morrison, Areli Marina, and Karen L. Fresco. 2013. *Imagined Crusaders: The "livre D'eracles" in Fifteenth-Century Burgundian Collections*. Urbana: University of Illinois at Urbana-Champaign.

Doutrepont, Georges. 1939. *Les mises en prose des épopées et des Romans chevaleresques du XIVe au XVIe siècle*. Brussels: Palais des académies.

———. 1970. *La littérature française à la cour des ducs de Bourgogne: Philippe le Hardi, Jean Sans Peur, Philippe le Bon, Charles le Téméraire*. Geneva: Slatkine Reprints.

Drakard, Jane. 1990. *A Malay Frontier: Unity and Duality in a Sumatran Kingdom*. Ithaca, NY: Southeast Asian Program, Cornell University.

Drandake, Anastasia, Demetra Papanikola-Mpakitze, and Anastasia Turta, eds. 2013. *Heaven and Earth: Art of Byzantium from Greek Collections*. Athens: Hellenic Republic, Ministry of Culture and Sports.

Drewal, Henry John, John Pemberton III, and Rowland Abiodun. 1989. "The Yoruba World." In *Yoruba: Nine Centuries of African Art and Thought*, 13–46. New York: Center for African Art. Exhibition catalogue.

Driscoll, Matthew James, and Ragnheiður Mósesdóttir, eds. 2009, 2011, 2012, 2014, 2016, 2018. Vols. 11–16 of *Care and Conservation of Manuscripts*. Copenhagen, Denmark: København Royal Library.

Du, Feng, and BaoRu Su. 2008. "Further Study of the Sources of the Imported Cobalt-Blue Pigment Used on Jingdezhen Porcelain from Late 13 to Early 15 Centuries." *Science in China*, ser. E, 51 (3): 249–59.

Dunlop, Anne. 2016. "Ornament and Vice: The Foreign, the Modile, and the Cocharelli Fragments." In *Histories of Ornament: From Global to Local*, edited by Güluru Necipoğlu and Alina Payne, 228–391. Princeton, NJ: Princeton University Press.

Durand, Jannic, Ionna Rapti, and Dorota Giovannoni. 2007. *Armenia Sacra: Mémoire Chrétienne des Arméniens (IVe–XVIIIe siècle)*. Paris: Musée du Louvre. Exhibition catalogue.

Dusenbury, Mary M. 2015. *Color in Ancient and Medieval East Asia*. New Haven, CT: Yale University Press.

Dutschke, Consuelo W. 1993. "Francesco Pipino and the Manuscripts of Marco Polo's *Travels*." PhD diss., University of California, Los Angeles.

Eck, Diana L. 1998. *Darśan: Seeing the Divine Image in India*. New York: Columbia University Press.

Eckher, Heather. 2004. *Caliphs and Kings: The Art and Influence of Islamic Spain*. Washington, DC: Arthur M. Sackler Gallery, Smithsonian Institution.

Edmunds, Sheila. 1980. "The Place of the London Haggadah in the Work of Joel ben Simeon." *Journal of Jewish Art* 7:25–34.

Edson, Evelyn. 1999. *Mapping Time and Space: How Medieval Mapmakers Viewed Their World*. London: British Library.

Effros, Bonnie, and Goulong Lai. 2018. *Unmasking Ideology in Imperial and Colonial Archaeology: Vocabulary, Symbols, and Legacy*. Los Angeles: Cotsen Institute of Archaeology Press.

Eidelberg, Shlomo. 1977. *The Jews and the Crusaders: The Hebrew Chronicles of the First and Second Crusades*. Madison: University of Wisconsin Press.

Eisenbeiss, Anja, and Lieselotte E. Saurma-Jeltsch, eds. 2012. *Images of Otherness in Medieval and Early Modern Times: Exclusion, Inclusion, Assimilation*. Berlin: Deutscher Kunstverlag.

El Hamel, Chouki. 1999. "The Transmission of Islamic Knowledge in Moorish Society from the Rise of the Almoravids to the 19th Century." *Journal of Religion in Africa* 29 (1): 62–87.

El Hamel, Chouki, Muhammad ibn Abi Bakr al-Sidiq, and Bartalli al-Walati. 2002. *La vie intellectuelle islamique dans le Sahel ouest-Africain, XVI–XIX siècles: Une étude sociale de l'enseignement islamique en Mauritanie et au nord du Mali (XVI–XIX siècles) et traduction annotée de Fath ash-shakur d'al-Bartili al-Walati (more en 1805)*. Paris: L'Harmattan.

Eliot, Simon, and Jonathan Rose, eds. 2007. *A Companion to the History of the Book*. Oxford: Wiley-Blackwell.

Elkins, James. 2002. *Stories of Art*. New York: Routledge.

Ellen, Roy. 2003. *On the Edge of the Banda Zone*. Honolulu: University of Hawaii Press.

Eltis, David, and David Richardson. 2015. *Atlas of the Transatlantic Slave Trade*. New Haven, CT: Yale University Press.

Elverskog, Johan. 2010. *Buddhism and Islam on the Silk Road*. Philadelphia: University of Pennsylvania Press.

Eman, Carla Zanotti. 1993. "The Harag of the Manuscripts of Gunda Gundi." In *Aspects of Ethiopian Art from Ancient Axum to the Twentieth Century*, edited by Paul B. Henze, 68–72. London: Jed.

Ennahid, Said. 2011. "Information and Communication Technologies for the Preservation and Valorization of Manuscript Collections in Morocco." In *The Trans-Saharan Book Trade: Manuscripts Culture, Arabic Literacy and Intellectual History in Muslim Africa*, edited by Graziano Krätli and Ghislaine Lydon, 265–89. Boston: Brill.

Enterline, James Robert. 2004. *Erikson, Eskimos, and Columbus: Medieval European Knowledge of America*. Baltimore: Johns Hopkins University Press.

Epstein, Marc Michael, and Hartley Lachter. 2015. *Skies of Parchment, Seas of Ink: Jewish Illuminated Manuscripts*. Princeton, NJ: Princeton University Press.

Ettinghausen, Richard. 1972. *Islamic Art in the Metropolitan Museum of Art*. New York: Metropolitan Museum of Art.

Ettinghausen, Richard, Oleg Grabar, and Sheila Blair. 1987. *The Art and Architecture of Islam, 650–1250*. New York: Penguin.

Euben, Roxanne. 2006. *Journeys to the Other Shore: Muslim and Western Travelers in Search of Knowledge*. Princeton, NJ: Princeton University Press.

Evangelatou, Maria. 2009. "Liturgy and the Illustration of the Ninth-Century Marginal Psalters." *Dumbarton Oaks Papers* 63:59–116.

Evanni, Louise. 2009. "Sundvedaskatten: En grav med oväntat innehåll." *Riksantikvarieämbetet Avdelningen för arkeologiska undersökningar* 5 (123): 1–32.

Evans, Helen C. 2018. *Armenia: Art, Religion, and Trade in the Middle Ages*. New York: Metropolitan Museum of Art. Exhibition catalogue.

Evans, Helen C., and Brandie Ratliff, eds. 2012. *Byzantium and Islam: Age of Transition, Seventh–Ninth Century*. New York: Metropolitan Museum of Art. Exhibition catalogue.

Evans, Robert John Weston, and Alexander Marr. 2006. *Curiosity and Wonder from the Renaissance to Enlightenment*. Burlington, VT: Ashgate.

Falchetta, Piero. 2006. *Fra Mauro's World Map*. Turnhout, Belgium: Brepols.

Farago, Claire, ed. 1995. *Reframing the Renaissance: Visual Culture in Europe and Latin America, 1450–1650*. New Haven, CT: Yale University Press.

Farhad, Massumeh. 1987. "Safavid Single Page Painting, 1629–1666." PhD diss., Harvard University.

———. 2018. "Military Slaves in the Provinces: Collecting and Shaping the Arts." In *Slaves of the Shah: New Elites of Safavid Iran*, edited by Sussan Babaie, Kathryn Babayan, and Ina Baghdiantz McCabe, 114–38. London: I. B. Tauris.

Farhad, Massumeh, and Simon Rettig, eds. 2016. *The Art of the Qur'an: Treasures from the Museum of Turkish and Islamic Arts*. Washington, DC: Smithsonian Books.

Fasolt, Constantin. 2012. "Saving Renaissance and Reformation: History, Grammar, and Disagreements with the Dead." *Religions* 3:662–80.

Fatás Cabeza, Guillermo. 2014. *Fueros de Aragón miniados: Las imágenes del Vidal Mayor*. Zaragoza, Spain: Fundación Caja Inmaculada.

Fauvelle, François-Xavier. 2014. *Le Rhinocéros d'Or: Histoires du Moyen Âge Africain*. Paris: Gallimard.

Feest, Christian. 2014. "The People of Calicut: Objects, Texts, and Images in the Age of Proto-Ethnography." *Boletim do Museu Paraense Emílio Goeldi. Ciências Humanas* 9 (2): 287–303.

Fellows-Jensen, Gillian, and Peter Springborg, eds. 1995, 1996, 1997, 1999, 2000, 2002, 2003, 2005, 2006, 2008, 2009, 2011, 2012. Vols. 1–13 of *Care and Conservation of Manuscripts*. Copenhagen: København Royal Library.

Fernández-Armesto, Felipe. 1987. *Before Columbus: Exploration and Colonization from the Mediterranean to the Atlantic*. Philadelphia: University of Pennsylvania Press.

Fiaccadori, Gianfranco, ed. 1994. *Bessarione e l'Umanesimo: Catalogo della mostra*. Naples, Italy: Vivarium.

Findley, Carter Vaughn. 2005. *The Turks in World History*. Oxford: Oxford University Press.

Finlay, Robert. 2010. *The Pilgrim Art: Cultures of Porcelain in World History*. Berkeley: University of California Press.

Fitzgerald, Devin. 2017. "How to Know What You Don't Know." Books and the Early Modern World: The Research of Devin Fitzgerald, October 17, 2017. http://devinfitz.com/how-to-know-what-you-dont-know/.

Flecker, Michael. 2002. *The Archaeological Excavation of the 10th Century Intan Shipwreck*. Oxford: Archaeopress.

Flood, Finbarr B. 2009. *Objects of Translation: Material Culture and Medieval "Hindu-Muslim" Encounter*. Princeton, NJ: Princeton University Press.

Floor, Willem. 1998. *The Afghan Occupation of Safavid Persia, 1721–1729*. Paris: Association pour l'avancement des etudes iraniennes.

Folda, Jaroslav. 2007. "Crusader Artistic Interactions with the Mongols in the Thirteenth Century: Figural Imagery, Weapons, and the Çintamani Design." In *Interactions, Artistic Interchange between the Eastern and Western Worlds in the Medieval Period*, edited by Colum Hourihane, 147–66. University Park: Pennsylvania State University Press.

———. 2010. *Crusader Art in the Holy Land: From the Third Crusade to the Fall of Acre, 1187–1291*. Cambridge, England: Cambridge University Press.

———. 2016. "An Icon of the Crucifixion and the Nativity at Sinai: Investigating the Pictorial Language of Its Ornamental Vocabulary: Chrysography, Pearl-Dot Haloes, and Çintemani." In *In Laudem Hierosolymitani: Studies in Crusades and Medieval Culture in Honour of Benjamin Z. Kedar*, edited by Iris Shagrir, Roni Ellenblum, and Jonathan Riley-Smith, 163–79. New York: Routledge.

Fondo Aga Khan de Cultura. 1991. *La Casa Nazarí De Zafra, Granada: The Nasrid House of Zafra, Granada*. Granada, Spain: Ayuntamiento de Granada.

Ford, A. J. 2016. *Marvel and Artefact: The "Wonders of the East" in Its Manuscript Contexts*. Leiden, the Netherlands: Brill.

Forêt, Philippe, and Andreas Kaplony. 2008. *The Journey of Maps and Images on the Silk Road*. Leiden, the Netherlands: Brill.

Foster-Campbell, Megan H. 2011. "Pilgrimage through the Pages: Pilgrim's Badges in Late Medieval Devotional Manuscripts." In *Push Me, Pull You: Imaginative, Emotional, Physical, and Spatial Interaction in Late Medieval and Renaissance Art*, edited by Sarah Blick and Laura D. Gelfand, 227–74. Leiden, the Netherlands: Brill.

Fraiman, Susan Nashman. 2001. "The Marginal Images of a Marginal People." In *The Metamorphosis of Marginal Images; from Antiquity to Present Time*, edited by Nurith Kenaan-Kedar and Asher Ovadiah, 103–18. Tel Aviv, Israel: Tel Aviv University.

Frank, André Gunder. 1998. *ReOrient: Global Economy in the Asian Age*. Los Angeles: University of California Press.

Franklin, Arnold E. 2014. *Jews, Christians and Muslims in Medieval and Early Modern Times: A Festschrift in Honor of Mark R. Cohen*. Leiden, the Netherlands: Brill.

Frankopan, Peter. 2015. *The Silk Roads: A New History of the World*. London: Bloomsbury.

Fries, K. 1893. "The Ethiopian Legend of Socinius and Ursula." In *Actes du Huitième Congrés International des Orientalistes I*, 55–70. Leiden, the Netherlands: Brill.

Fry, Roger. 1918. "American Archaeology." *Burlington Magazine for Connoisseurs* 33 (188): 154–57.

Fuess, Albrecht. 2008. "Sultans with Horns: The Political Significance of Headgear in the Mamluk Empire." *Mamluk Studies Review* 12 (2): 71–94.

Fulghum, Mary Margaret. 2001–2. "Under Wraps: Byzantine Textiles as Major and Minor Arts." *Studies in the Decorative Arts* 9 (1): 13–33.

Gadrat-Ouerfelli, Christine. 2015. *Lire Marco Polo au Moyen Age. Traduction, diffusion et réception du Divisement du monde*. Turnhout, Belgium: Brepols.

Galavaris, George. 2007. *Athos, la Sainte Montagne: Tradition et renouveau dans l'art*. Athens: Ethniko Hidryma Ereunon, Institouto Vyzantinon Ereunon.

Gallop, Annabel T. 1994. *The Legacy of the Malay Letter*. London: British Library.

García-Arenal, Mercedes. 1985. "Los moros en las Cantigas de Alfonso X." *Al-Qantara* 6: 133–51.

García Barrios, Ana. 2011. "Análisis Iconográfico Preliminar de Fragmentos de Las Vasijas Estilo Códice Procedentes de Calakmul." *Estudios de Cultura Maya* 37: 65–97.

García-Granero Fernández, Juan. 1980. "'Vidal Mayor': Versión romanceada navarra de la 'Maior Compilatio' de Vidal de Canellas." *Anuario de Historia del Derecho Español* 50:243–64.

Gaunt, Simon. 2013a. "Coming Communities in Medieval Francophone Writing about the Orient." In *Violence and the Writing of History in the Medieval Francophone World*, edited by Noah D. Guynn and Zrinka Stahuljak, 187–201. Cambridge, England: D. S. Brewer.

———. 2013b. *Marco Polo's "Le devisement du monde": Narrative Voice, Language and Diversity*. Cambridge, England: D. S. Brewer.

Gautier, Marc-Edouard, and François Avril, eds. 2009. *Splendeur de l'enluminure: Le roi René et les livres*. Angers, France: Ville d'Angers.

Geanakoplos, Deno John. 1966. *Byzantine East and Latin West: Two Worlds of Christendom in Middle Ages and Renaissance: Studies in Ecclesiastical and Cultural History*. New York: Barnes and Noble.

Geary, Patrick. 2002. *The Myth of Nations: Medieval Origins of Europe*. Princeton, NJ: Princeton University Press.

Geider, Thomas. 2002. "The Paper Memory of East Africa: Ethnographies and Biographies Written in Swahili." In *A Place in the World: New Local Historiographies from Africa and South Asia*, edited by Axel Harneit-Sievers, 255–88. Leiden, the Netherlands: Brill.

Gellner, David N. 1987. *The Perfect Wisdom: A Text and Its Uses in Kwa Baha Lalitpur*. Oxford: Oxford University Press.

Gelpke, J. H. F. Solewijn. 1994. "The Report of Miguel de Brito of His Voyage in 1581–1582 to the Raja Ampat, the MacCluer Gulf and Seram." *Bijdragen tot de taal-, land- en volkenkunde* 150 (1): 123–45.

George, Alain F. 2011. "The Illustrations of the Maqamat and the Shadow Play." *Muqarnas: An Annual on the Visual Culture of the Islamic World* 28:1–42.

———. 2012. "Orality, Writing, and the Image in the Maqamat: Arabic Illustrated Books in Context." *Art History* 35 (1): 10–37.

———. 2015. "Direct Sea Trade between Early Islamic Iraq and Tang China: From the Exchange of Goods to the Transmission of Ideas." *Journal of the Royal Asiatic Society*, series 3, 25 (4): 579–624.

Gernet, Jean. 1982. *A History of Chinese Civilization*. Cambridge, England: Cambridge University Press.

Gertz, Sunhee K. 2010. *Visual Power and Fame in René D'anjou, Geoffrey Chaucer, and the Black Prince*. New York: Palgrave Macmillan.

Ghose, Madhuvanti, ed. 2016. *Vanishing Beauty: Asian Jewelry and Ritual Objects from the Barbara and David Kipper Collection*. Chicago: Art Institute of Chicago.

Giang, Do Truong. 2016. "Diplomacy, Trade and Networks: Champa in the Asian Commercial Context (7th-10th Centuries)." *Moussons* 27:59–82.

Gillis, John. 2009. "Book in a Bog." In *Care and Conservation of Manuscripts 11*, edited by Matthew James Driscoll and Ragnheiður Mósesdóttir, 43–47. Copenhagen, Denmark: København Royal Library.

Ginsburg, Carlo. 1989. *The Cheese and the Worms: The Cosmos of a Sixteenth-Century Miller*. Baltimore: Johns Hopkins University Press.

Gitlitz, David M., and Linda Kay Davidson. 2006. *Pilgrimage and the Jews*. Westport, CT: Praeger.

Glacier, Osire. 2012. "Fatima al-Fihri." In *Dictionary of African Biography*, edited by Emmanuel K. Akyeampong and Henry Louis Gates Jr., 357–59. Oxford: Oxford University Press.

Glatzer, Mordechai. 1991. "The Ashkenazic and Italian Haggadah and the Haggadot of Joel ben Simeon." In *The Washington Haggadah: A Facsimile Edition of an Illuminated Fifteenth-Century Hebrew Manuscript at the Library of Congress Signed by Joel ben Simeon*, edited by M. M. Weinstein, 137–69. Washington, DC: Library of Congress.

Gludovatz, Karin, Juliane Noth, and Joachim Rees. 2015. *The Itineraries of Art: Topographies of Artistic Mobility in Europe and Asia*. Paderborn, Germany: Wilhelm Fink.

Goehring, Margaret. 2006. "Taking Borders Seriously: The Significance of Cloth-of-Gold Textile Borders in Burgundian and Post Burgundian Manuscript Illumination in the Low Countries." *Oud-holland* 119 (1): 22–40.

———. 2007. "The Representation and Meaning of Luxurious Textiles in Franco-Flemish Manuscript Illumination." In *Weaving, Veiling, and Dressing: Textiles and Their Metaphors in the Late Middle Ages*, edited by Kathryn M. Rudy and Barbara Baert, 121–55. Turnhout, Belgium: Brepols.

Goitein, Shelomo Dov. 1959. "The Biography of Rabbi Judah Ha-Levi in the Light of the Cairo Geniza Documents." *Proceedings of the American Academy for Jewish Research* 28:41–56.

Goldberg, Jessica. 2012. *Trade and Institutions in the Medieval Mediterranean: The Geniza Merchants and their Business World*. Cambridge, England: Cambridge University Press.

Golden, Peter B. 2011. *Central Asia in World History*. Oxford: Oxford University Press.

Goldstein, David, ed. and trans. 1985. *The Ashkenazi Haggadah: A Hebrew Manuscript of the Mid-15th Century from the Collections of the British Library*. London: British Library.

Goldstone, Jack A. 1998. "The Problem of the 'Early Modern' World." *Journal of the Economic and Social History of the Orient* 41 (3): 249–84.

Goody, Jack. 2010. *Renaissances: The One or the Many?* Cambridge, England: Cambridge University Press.

Gordon, Stewart. 2007. *When Asia Was the World: Traveling Merchants, Scholars, and Monks Who Created the "Riches of the East."* Boston: Da Capo.

Goss, Vladimir Peter, ed. 1986. *The Meeting of Two Worlds: Cultural Exchange between East and West during the Period of the Crusades*. Kalamazoo, MI: Medieval Institute Publications, Western Michigan University.

Goswamy, B. N. 1983. "A Pre-Mughal Shahnama from Jaunpur." In *An Age of Splendor: Islamic Art in India*, edited by Karl Khandalavala, 122–27. Mumbai: Marg.

Gottschalk, Peter. 2013. *Religion, Science, and Empire: Classifying Hinduism and Islam in British India*. Oxford and New York: Oxford University Press.

Gousset, Marie-Thérèse. 1996. "Un programme iconographique conçu par Jean sans Peur?" In *Marco Polo: Le Livre des merveilles / Marco Polo: Das Buch der Wunder*, 353–64. Lucerne, Switzerland: Facsimile Verlag.

Gout Grautoff, Gwendolyn. 2000. "Vidal Mayor: A Visualisation of the Juridical Miniature." *Medieval History Journal* 3 (1): 67–79.

Grabar, André. 1968. "Le schéma iconographique de la Pentecôte." In vol. 1 of *L'Art de la fin de l'Antiquité et du Moyen âge*, edited by André Grabar, 615–27. Paris: Collège de France.

Grabar, Oleg. 2009. *Masterpieces of Islamic Art: The Decorated Page from the Eighth to the Seventeenth Century*. Munich: Prestel.

"Graduate Centre for Mediaeval Studies: University of Toronto." 1963. *Speculum* 38 (4): 678–81.

Green, Jeremy. 2011. "Shipwrecked: Tang Treasures and Monsoon Winds." *International Journal of Nautical Archaeology* 40 (2): 449–52.

Green, Monica H., ed. 2014. *Pandemic Disease in the Medieval World: Rethinking the Black Death*. The Medieval Globe 1. Kalamazoo, MI: Arc Medieval Press, 2014.

Green, Monica H. 2015. "The Black Death and Ebola: On the Value of Comparison." In *Pandemic Disease in the Medieval World: Rethinking the Black Death*, edited by Monica H. Green, ix–xx. Kalamazoo, MI: Arc Medieval.

———. 2017. "History in a Hemispheric Mode: Redrawing the Medieval Map." Medieval Academy of America 2017 Fellows Plenary Lecture, MAA Annual Meeting. Toronto, April 8, 2017. https://www.academia.edu /31278821/Green_History_in_a_Hemispheric_Mode-_Redrawing_the _Medieval_Map_-_MAA_Plenary_2017/.

Greenblatt, Stephen. 1991. *Marvelous Possessions: The Wonder of the New World*. Chicago: University of Chicago Press.

Greene, Candace S., and Russell Thornton. 2007. *The Year the Stars Fell: Lakota Winter Counts at the Smithsonian*. Washington, DC: Smithsonian National Museum of Natural History and Smithsonian National Museum of the American Indian; Lincoln: University of Nebraska Press.

Grosjean, Georges, ed. 1979. *Vesconte Maggiolo: Atlante nautico del 1512*. Zurich: Urs Graf Verlag.

Grossman, Avraham. 1996. "Jerusalem in Jewish Apocalyptic Literature." In *The History of Jerusalem: The Early Muslim Period (638–1099)*, edited by Joshua Prawer and Haggai ben Shammai, 295–310. New York: Yad Izhak Ben-Zvi and New York University Press.

Grube, Ernst J., and Jeremy Johns. 2005. *The Painted Ceilings of the Cappella Palatina*. New York: East-West Foundation.

Grube, Nikolai K. 2001. "Dresden Codex." In *The Oxford Encyclopedia of Mesoamerican Cultures*, edited by David Carrasco, 337–39. Oxford: Oxford University Press.

Guéret-Laferté, Michèle. 2004. *De l'Inde. Les voyages en Asie de Niccolo de' Conti: De varietate fortunae, livre IV*. Turnhout, Belgium: Brepols.

Guérin, Sarah M. 2013. "Forgotten Routes: Italy, Ifriqiya, and the Trans-Saharan Ivory Trade." *Al-Masaq: Islam and the Medieval Mediterranean* 25 (1): 70–91.

Guesdon, Marie-Geneviève, and Oleg Grabar. 2008. *Kitâb al-Diryâq: (Thériaque de Paris)*. Sansepolcro, Italy: Aboca Museum Edizioni.

Guha, Ranajit. 2002. *History at the Limits of the World*. New York: Columbia University Press.

Gunn, Geoffrey C. 2003. "Mapping Eurasia." In *First Globalization: The Eurasian Exchange, 1500–1800*, edited by Geoffrey C. Gunn, 113–43. Lanham, MD: Rowman and Littlefield.

Gunsch, Kathryn Wysocki. 2018. *The Benin Plaques: A 16th Century Imperial Monument*. London: Routledge, Taylor and Francis.

Guy, John, et al. 2014. *Lost Kingdoms: Hindu-Buddhist Sculpture of Early Southeast Asia*. New York: Metropolitan Museum of Art. Exhibition catalogue.

Habibi, Negar. 2012. "Farang and Farangi in Persian Painting: Pictorial History of 'European' Presence in Persian Painting from 14th to 17th Century Iran." Paper presented at "From Influence to Translation: Art of the Global Middle Ages," University of Edinburgh, May 16–18, 2012.

Hahn, Cynthia. 2012. *Strange Beauty: Issues in the Making and Meaning of Reliquaries: 400–circa 1204*. University Park: Pennsylvania State University Press.

Hahn, Thomas. 2001. "The Difference the Middle Ages Makes: Color and Race before the Modern World." *Journal of Medieval and Early Modern Studies* 31:1–37.

Haile, Getachew. 1978. *A Catalogue of Ethiopian Manuscripts Microfilmed for the Ethiopian Manuscript Library, Addis Ababa, and for the Hill Monastic Manuscript Microfilm Library, Collegeville*. Collegeville, MN: Hill Monastic Manuscript Library.

———. 1993. *A Catalogue of Ethiopian Manuscripts Microfilmed for the Ethiopian Manuscript Microfilm Library, Addis Ababa, and for the Monastic Manuscript Library, Collegeville*. Collegeville, MN: Hill Monastic Manuscript Library, St. John's University.

Hakubutsukan, Tokyo Kukuritsu. 1957. *Japanese Arts of the Medieval Periods: Late Twelfth to Mid-Sixteenth Centuries*. Tokyo: National Museum.

Hakubutsukan, Nara Kokuritsu. 2010. *Dai Kentōshi-ten: Heijō sento 1300-nen kinen* 1300 (Imperial Envoys to Tang China: Early Japanese Encounters with Continental Culture). Nara, Japan: Nara Kokuritsu Hakubutsukan. Exhibition catalogue.

Haldon, John, ed. 2009. *A Social History of Byzantium*. Chichester, England: Wiley-Blackwell.

Halkin, Hillel. 2010. *Yehuda Halevi*. New York and Toronto: Schocken.

———, trans. 2011. *The Selected Poems of Yehuda Halevi*. New York: Nextbook.

Halkiu, Emmanuel, ed. 2017. *L'Afrique des routes: Histoire de la circulations des hommes, des richesses et des idées à travers le continent africain*. Paris: Musée du quai Branly.

Hall, James. 1974. *Dictionary of Subjects and Symbols in Art*. New York: Harper and Row.

Hallett, Jessica. 2010. "Pearl Cups Like the Moon: The Abbasid Reception of Chinese Ceramics." In *Shipwrecked: Tang Treasures and Monsoon Winds*, edited by Regina Krahl et al., 75–81. Washington, DC: Smithsonian Institution. Exhibition catalogue.

Hamann, Byron Ellsworth. 2004. "'In the Eyes of the Mixtecs / To View Several Pages Simultaneously': Seeing and the Mixtec Screenfolds." *Visible Language* 38 (1): 68–123.

———. 2013. "Object, Image, Cleverness: The *Lienzo de Tlaxcala*." *Art History* 36 (3): 519–45.

———. 2016a. "Anarchist Calendrics." *Cabinet* 61: 72–79.

———. 2016b. "How to Chronologize with a Hammer, or, The Myth of Homogeneous, Empty Time." *HAU: Journal of Ethnographic Theory* 6 (1): 69–101.

———. 2017. "*Las Relaciones Mediterratlánticas*: Comparative Antiquarianism and Everyday Archaeologies in Castile and Spanish America (1575–1586)." In *Antiquarianisms: Contact, Conflict, and Comparison*, edited by Benjamin Anderson and Felipe Rojas, 49–71. Oxford: Oxbow Books.

———. 2019. "Introduction." In *Bad Christians, New Spains: Muslims, Catholics, and Native Americans in a Mediterratlantic World*. Abingdon, England: Routledge.

Hamburger, Jeffrey. 2008. "Openings." In *Imagination, Books and Community in Medieval Europe: Papers of a Conference Held at the State Library of Victoria Melbourne, Australia, 29–31 May 2008 in Conjunction with an Exhibition "The Medieval Imagination" 28 March–15 June 2008*, edited by Gregory Kratzman, 51–133. Melbourne, Australia: State Library of Victoria.

Hämeen-Anttila, Jaakko. 2002. *Maqama: A History of the Genre*. Wiesbaden, Germany: Harrassowitz Verlag.

Hamès, Constant. 2013. "Sura Headings and Subdivisions in Qur'an Manuscripts from Sub-Saharan Africa: Variations and Historical Implications." *Journal of Qur'anic Studies* 15 (3): 232–52.

Hancock, Ange-Marie. 2016. *Intersectionality: An Intellectual History*. Oxford: Oxford University Press.

Hansen, Richard D., Ronald L. Bishop, and Federico Fahsen. 1991. "Notes on Maya Codex-Style Ceramics from Nakbe, Peten, Guatemala." *Ancient Mesoamerica* 2 (2): 225–43.

Hansen, Valerie. 2012. *The Silk Road: A New History*. Oxford: Oxford University Press.

Haour, Anne. 2007. *Rulers, Warriors, Traders, and Clerics: The Central Sahel and the North Sea*. Oxford: Oxford University Press.

Harari, Yuval. 2005. "Moses, the Sword, and the Sword of Moses: Between Rabbinical and Magical Traditions." *Jewish Studies Quarterly* 12:293–329.

Harf-Lancner, Laurence. 2003. "Divergences du texte et de l'image: L'illustration du *Devisement du monde* de Marco Polo." *Ateliers* 30:39–52.

Harvey, P. D. A. 2006. *The Hereford World Map: Medieval World Maps and Their Context*. London: British Library.

Hasan, Perween. 2007. *Sultans and Mosques: The Early Muslim Architecture of Bangladesh*. London: I. B. Tauris.

Haskins, Charles Homer. 1927. *The Renaissance of the Twelfth Century*. Cambridge, MA: Harvard University Press.

Haug, Walter. 1997. *Vernacular Literary Theory in the Middle Ages: The German Tradition, 800–1300, in Its European Context*. Cambridge, England: Cambridge University Press.

Hayot, Eric, et al. 2008. *Sinographies: Writing China*. Minneapolis: University of Minnesota Press.

Hedeman, Anne D. 1991. *The Royal Image: Illustrations of the Grandes Chroniques de France*. Berkeley: University of California Press.

———. 2008. *Translating the Past: Laurent de Premierfait and Boccaccio's De casibus*. Los Angeles: Getty Publications.

Hedenstierna-Jodon, Charlotte. 2012. "Traces of Contacts: Magyar Material Culture in the Swedish Viking Age Context of Birka." In *Die Archäologie der Frühen Ungarn: Chronologie, Technologie und Methodik: Internationaler Workshop des Archäologischen Institutes der Ungarischen Akademie der Wissenschaften und des Römisch-Germanischen Zentralmuseums Mainz in Budapest*, edited by Tobias Bendeguz, 29–46. Mainz, Germany: Verlag des Römisch-Germanischen Zentralmuseums.

Hegewald, Julia A. B. 2015. *Jaina Painting and Manuscript Culture: In Memory of Paolo Pianarosa*. Berlin: EB Verlag.

Heilbrunn Timeline of Art History. 2000–ongoing. Metropolitan Museum of Art, funded by the Heilbrunn Foundation, New Tamarind Foundation, and Zodiac Fund. https://www.metmuseum.org/toah/.

Heller, Ena Giurescu, and Patricia Pongracz, eds. 2010. *Perspectives on Medieval Art: Learning through Looking*. London: Giles.

Helman-Wazny, Agnieszka. 2014. *The Archaeology of Tibetan Books*. Leiden, the Netherlands: Brill.

Heng, Derek. 2009. *Sino-Malay Trade and Diplomacy from the Tenth through the Fourteenth Century*. Ohio University Research in International Studies, Southeast Asia Series 121. Athens: Ohio University Press.

Heng, Geraldine. 2005. "Jews, Saracens, 'Black Men,' Tartars: England in a World of Racial Difference, 13th–15th Centuries." In *A Companion to Medieval English Literature, c. 1350–c. 1500*, edited by Peter Brown, 247–69. Hoboken, NJ: Blackwell.

———. 2011a. "The Invention of Race in the European Middle Ages I: Race Studies, Modernity, and the Middle Ages." *Literature Compass* 8 (5): 258–74.

———. 2011b. "The Invention of Race in the European Middle Ages II: Race Studies, Modernity, and the Middle Ages." *Literature Compass* 8 (5): 275–93.

———. 2012. "England's Dead Boys: Telling Tales of Christian-Jewish Relations before and after the First European Expulsion of the Jews." In *Modern Language Notes* 127 Supplement: S54–S85.

———. 2013. "A Global Middle Ages." In *A Handbook of Middle English Studies*, edited by Marion Turner, 413–29. Hoboken, NJ: John Wiley.

———. 2014. "Early Globalities, and Its Questions, Objectives, and Methods: An Inquiry into the State of Theory and Critique." *Exempla: Medieval, Early Modern, Theory* 26 (2/3): 234–53.

———. 2015. "Reinventing Race, Colonization, and Globalisms across Deep Time: Lessons from the *Longue Durée*." *Modern Language Association of America* 130 (2): 358–66.

———. 2018. *The Invention of Race in the European Middle Ages*. Cambridge, England: Cambridge University Press.

Heng, Geraldine, and Lynn Ramey. 2014. "Early Globalities, Global Literatures: Introducing a Special Issue on the Global Middle Ages." *Literature Compass* 11 (7): 389–94.

Hermes, Nizar F. 2009. "The Byzantines in Medieval Arabic Poetry: Abu Firas' Al-Rumiyyat and the Poetic Responses of Al-Qaffal and Ibn Hazm to Nicephorus Phocas' Al-Qasida Al-Arminiyya Al-Mal'una (The Armenian Cursed Ode)." *Byzantina Symmeikta* 19:35–61.

———. 2013. "The Orient's Medieval 'Orient(alism)': The Rihla of Sulaymán al-Tájir." In *Orientalism Revisited: Art, Land, and Voyage*, edited by Ian Richard Netton, 207–22. London: Routledge.

———. 2014. "The Moor's First Sight: An Arab Poet in a Ninth-Century Viking Court." In *Historic Engagements with Occidental Cultures, Religions, Powers,*

edited by Anne R. Richards and Iraj Omidvar, 57–69. New York: Palgrave Macmillan.

Hernández, Christine, and Gabrielle Vail. 2010. "A Case for Scribal Interaction: Evidence from the Madrid and Borgia Group Codices." In *Astronomers, Scribes, and Priests: Intellectual Exchange between the Northern Maya Lowlands and Highland Mexico in the Late Postclassic Period*, edited by Gabrielle Vail and Christine Hernández, 333–67. Washington, DC: Dumbarton Oaks.

Hess, Catherine, Linda Komaroff, and George Saliba. 2004. *The Arts of Fire: Islamic Influences on Glass and Ceramics of the Italian Renaissance*. Los Angeles: The J. Paul Getty Museum.

Heuberger, Rachel. 1996. *Bibliothek des Judentums: Die Hebraica- und Judaica-Sammlung der Stadt- und Universitätsbibliothek Frankfurt am Main: Entstehung, Geschichte und heutige Aufgabe*. Frankfurt, Germany: Vittorio Klostermann.

Hidalgo Ogáyar, Juana. 1991. "La imagen de Santiago 'Matamoros' en los manuscritos iluminados." *Cuadernos de arte e iconografía* 4 (7): 340–45, plates clxii–clxv.

Higgins, Iain Macleod. 1997. *Writing East: The "Travels" of Sir John Mandeville*. Philadelphia: University of Pennsylvania Press.

Hillenbrand, Robert. 1996. "The Iskandar Cycle in the Great Mongol Shahnama." In *The Problematics of Power: Eastern and Western Representations of Alexander the Great*, edited by M. Bridges and J. Bürgel, 20–30. Bern, Switzerland: P. Lang.

———. 1999. *Islamic Art and Architecture*. London: Thames and Hudson.

———. 2002. "The Arts of the Book in Ilkhanid Iran." In *The Legacy of Genghis Khan: Courtly Art and Culture in Western Asia, 1256–1353*, edited by Linda Komaroff and Stefano Carboni, 134–67. New Haven, CT: Yale University Press.

———. 2005. *Image and Meaning in Islamic Art*. London: Altajir Trust.

———. 2017. *Shahnama: The Visual Language of the Persian Book of Kings*. London: Routledge.

Hillgarth, J. N. 1975. *The Problem of a Catalan Mediterranean Empire, 1229–1327*. London: Longman.

Hilsdale, Cecily J. 2017. "Worldliness in Byzantium and Beyond: Reassessing the Visual Networks of Barlaam and Ioasaph." *Medieval Globe* 3 (2): 57–96.

Hirx, John W., and Megan E. O'Neil. Forthcoming. "The World of the Ancient Artist: Encounters through Technical and Scientific Analyses. Part A: Building the Ceramic Vessel." In *Revealing Creation: The Science and Art of Ancient Maya Ceramics*, edited by Diana Magaloni Kerpel and Megan E. O'Neil. New York: Delmonico-Prestel.

Hoffman, Eva. 2007. *Late Antique and Medieval Art of the Mediterranean World*. Oxford: Blackwell.

Hohensee, Naraelle. 2018. "Heilbrunn Timeline of Art History." CAA Reviews, March 22, 2018. http://caareviews.org/reviews/3222/.

Holmes, Catherine. 2005. *Basil II and the Governance of Empire (976–1025)*. Oxford: Oxford University Press.

Holmes, Catherine, and Naomi Standen. 2015. "Defining the Global Middle Ages." *Medieval Worlds* 1:106–17.

Holmes, Catherine, and Naomi Standen. 2018. "Introduction: Towards a Global Middle Ages." *Past & Present* 238 (13): 1–44.

Holsinger, Bruce. 1998. "The Color of Salvation: Desire, Death, and the Second Crusade in Bernard of Clairvaux's *Sermons on the Song of Songs*." In *The Tongue of the Fathers: Gender and Ideology in Twelfth-Century Latin*, edited by David Townsend and Andrew Taylor, 156–85. Philadelphia: University of Pennsylvania Press.

———. 2002. "Medieval Studies. Postcolonial Studies, and the Genealogies of Critique." *Speculum* 77:1195–227.

Hôtel Drouot. 1997. *Exceptionnel astrolabe ayant appartenu à Amir Dowlat Amasia, physician de la cour de Mehmed II le Conquérant*. Paris: Hôtel Drouot.

Hourihane, Colum, ed. 2005. *Between the Picture and the Word*. Princeton, NJ: Index of Christian Art Publications.

———. 2007. *Interactions: Artistic Interchange between the Eastern and Western Worlds in the Medieval Period*. University Park: Pennsylvania State University Press for the Index of Christian Art, Department of Art and Archaeology, Princeton University.

Housley, Norman. 2012. *Crusading and the Ottoman Threat, 1453–1505*. Oxford: Oxford University Press.

Howard, Michael C. 2012. *Transnationalism in Ancient and Medieval Societies: The Role of Cross-Border Trade and Travel*. London: McFarland.

Huang, Shih-shan Susan. 2011. "Early Buddhist Illustrated Prints in Hangzhou." In *Knowledge and Text Production in an Age of Print: China, 900–1400*, edited by Lucille Chia and Hilde De Weerdt, 147–63. Leiden, the Netherlands: Brill.

Huntington, Susan L., and John C. Huntington. 1990. *Leaves from the Bodhi Tree: The Art of Pala India (8th–12th Centuries) and Its International Legacy*. Dayton, OH: Dayton Art Institute.

Hunwick, John O., and Alida Jay Boye. 2008. *The Hidden Treasures of Timbuktu: Historic City of Islamic Africa*. London: Thames and Hudson.

Iguchi, Masatoshi. 2017. *Java Essay: The History and Culture of a Southern County*. Leicester, England: Troubador.

Inden, Ronald. 2000. "Introduction: From Philological to Dialogical Texts." In *Querying the Medieval: Texts and the History of Practices in South Asia*, edited by Ronald Inden, Jonathan Walters, and Daud Ali, 3–28. Oxford: Oxford University Press.

Inomata, Takeshi. 2001. "The Power and Ideology of Artistic Creation: Elite Craft Specialists in Classic Maya Society." *Current Anthropology* 42 (3): 321–49.

Institut du Monde Arabe. 2008. *Qantara: Mediterranean Heritage*. Paris: Hazan. http://www.qantara-med.org/.

International Congress on Medieval Studies. 2018. "Whiteness in Medieval Studies 2.0." Conference session held at Western Michigan University, Kalamazoo.

Isaacs, Jennifer. 2009. *Australian Dreaming: 40,000 Years of Aboriginal History*. Sydney: New Holland.

Isidorus a S. Joseph and Petro a S. Andrea. 1668 and 1671. *Historia generalis fratrum discalceatorum ord. B.M.V. de Monte Carmelo*. 2 vols. Rome: Philip M. Macinus.

Jacobs, Martin. 2014. *Reorienting the East: Jewish Travelers to the Medieval Muslim World*. Philadelphia: University of Pennsylvania Press.

Jacoby, David. 2004. "Silk Economics and Cross-Cultural Artistic Interaction: Byzantium, the Muslim World, and the Christian West." *Dumbarton Oaks Papers* 58:197–240.

Jafarian, Rasul. 1370/1991. "Din va siyasat dar daure-ye Safavi" [Religion and Politics in the Safavid Period]. *Qom* 48:301–13.

James, Diana. 2015. "Tjukurpa Time." In *Long History, Deep Time: Deepening Histories of Place*, edited by Ann McGrath and Mary Anne Jebb, 33–45. Canberra: Australian National University Press.

James, Liz. 2010. *A Companion to Byzantium*. Malden, MA: Wiley-Blackwell.

Jansen, Maarten, and Gabina Aurora Pérez Jiménez. 2005. *Codex Bodley: A Painted Chronicle from the Mixtec Highlands, Mexico*. Oxford: Bodleian Library.

Jardine, Lisa, and Jerry Brotton. 2005. *Global Interests: Renaissance Art between East and West*. London: Reaktion.

Jeppie, Shamil. 2014. "Writing, Books, and Africa." *History and Theory* 53:94–104.

Jirousek, Charlotte. 1995. "More Than Oriental Splendor: European and Ottoman Headgear, 1380–1580." *Dress* 22:22–33.

Johns, Christopher M. S. 2016. *China and the Church: Chinoiserie in Global Context*. Oakland: University of California Press.

Johnson, Nicholas. 2015. "What Is a Lienzo?" In *The Lienzo of Tapiltepec: A Painted History from the Northern Mixteca*, edited by Arni Brownstone, 1–35. Toronto: Royal Ontario Museum; Norman: University of Oklahoma Press.

Johnston, Michael, and Michael Van Dussen, eds. 2015. *The Medieval Manuscript Book: Cultural Approaches*. Cambridge Studies in Literature 94. Cambridge, England: Cambridge University Press.

Jones, Amelia, and Erin Silver, eds. 2015. *Otherwise: Imagining Queer Feminist Art Histories.* Manchester, England: Manchester University Press.

Jordan, R. Furneaux. 1960. *The Medieval Vision of William Morris: A Lecture Given by R. Furneaux Jordan on November 14, 1957, at the Victoria and Albert Museum, South Kensington.* London: William Morris Society.

J. Paul Getty Museum, The. 1984. "Manuscript Acquisitions: The Ludwig Collection." *J. Paul Getty Museum Journal* 12:281–306.

Just, Bryan R. 2004. "*In Extenso* Almanacs in the Madrid Codex." In *The Madrid Codex: New Approaches to Understanding an Ancient Maya Manuscript,* edited by Gabrielle Vail and Anthony F. Aveni, 255–76. Boulder: University Press of Colorado.

Kabir, Ananya Jahanara, and Deanne Williams, eds. 2005. *Postcolonial Approaches to the European Middle Ages: Translating Cultures.* Cambridge, England: Cambridge University Press.

Kaplan, Paul. 1985. *The Rise of the Black Magus in Western Art.* Ann Arbor, MI: UMI Research Press.

———. 1987. "Black Africans in Hohenstaufen Iconography." *Gesta* 26 (1): 29–36.

Kartsonis, Anna D. 1986. *Anastasis: The Making of an Image.* Princeton, NJ: Princeton University Press.

Kastritsis, Dimitris. 2011. "The Trebizond Alexander Romance (Venice Hellenic Institute Codex Gr. 5): The Ottoman Fate of a Fourteenth-Century Illustrated Byzantine Manuscript." *Journal of Turkish Studies* 36:103–31.

Kauffmann, C. M. 1963–64. "Vidal Mayor: Un código español del siglo XIII, hoy de propiedad particular en Aquisgrán." *Anuario de Derecho Aragonés* 12:299–325.

Kebede, Gidena Mesfin. 2016. "Ethiopian Abǝnnät Manuscripts: Organizational Structure, Language Use, and Orality." PhD diss., Universität Hamburg.

Keene, Bryan C. 2012. "No. 58, Lorenzo di Niccolò (Possibly the Master of the Lazzaroni Madonna), Childbirth Tray (*desco da parto*) with *Diana and Acteon* (recto) and *Justice* (verso)." In *Florence at the Dawn of the Renaissance: Painting and Illumination, 1300–1350,* edited by Christine Sciacca, 382–85. Los Angeles: Getty Publications.

———. 2016. "Il medioevo globale: visioni del mondo al Getty Museum." *Alumina: Pagine miniate,* no. 52 (January–March): 46–51.

Keene, Bryan C., and Morgan Conger. 2018. "Sestieri al paradiso: percorsi spirituali tra Europa e India." *Alumina: Pagine miniate,* no. 60, 50–57.

Kelemen, Pál. 1969. *Medieval American Art: Masterpieces of the New World before Columbus.* 2 vols. New York: Dover. Originally published in 1943.

Kelley, Daneene. 2016. "Did the Plague Impact Sub-Saharan Africa before 1899?" College of William and Mary, Williamsburg, April 22–23, 2016. https://www.wm.edu/as/history/news/did-the-plague-impact-sub -saharan-africa-before-1899.php.

Kelly, Eamonn P. 2006a. *The Faddan More Psalter: A Medieval Manuscript Discovered in County Tipperary, Ireland, 20 July 2006.* Dublin: Wordwell.

———. 2006b. "The Manuscript Discovered." *Archaeology Ireland* 20 (3): S4–S7.

Kelly, Stephen, and John J. Thompson. 2005. *Imagining the Book.* Turnhout, Belgium: Brepols.

Kerner, Jaclynne. 2010. "Art in the Name of Science: The *Kitâb al-Diryâq* in Text and Image." In *Arab Painting: Text and Image in Illustrated Arabic Manuscripts,* edited by Anna Contadini, 25–40. Leiden, the Netherlands: Brill.

Kévorkian, Raymond. 1986. *Catalogue des "Incunables" arméniens (1511–1695) ou Chronique de l'imprimerie arménienne.* Geneva: P. Cramer.

Keyes, Roger. 2006. *Ehon.* New York: New York Public Library.

Khair, Tabish. 2006. *Other Routes: 1500 Years of African and Asian Travel Writing.* Oxford: Signal.

Khandalavala, Karl, and Moti Chandra. 1969. *New Documents of Indian Painting: A Reappraisal.* Mumbai: Prince of Wales Museum.

Khanmohamadi, Shirin A. 2014. *In Light of Another's Word: European Ethnography in the Middle Ages.* Philadelphia: University of Pennsylvania Press.

Kidder, Alfred V. 1946. "Introduction." In *Excavations at Kaminaljuyu,*

Guatemala, edited by Alfred V. Kidder, Jesse D. Jennings, and Edwin M. Shook, 1–9. Washington, DC: Carnegie Institution of Washington.

Kim, Dorothy. 2016. "The Unbearable Whiteness of Medieval Studies." *In the Middle* (blog), November 10, 2016. http://www.inthemedievalmiddle.com /2016/11/the-unbearable-whiteness-of-medieval.html/.

Kim, Jinah. 2009. "Illustrating the Perfection of Wisdom: The Use of the Vessantara Jataka in a Manuscript of the Astasahasrika Prajnaparamita Sutra." In vol. 2 of *Prajnadhara: Essays on Asian Art History, Epigraphy, and Culture in Honour of Gouriswar Bhattacharya,* edited by Gerd J. R. Mevissen and Arundhati Banerji, 261–72. New Delhi: Kaveri.

———. 2010. "A Book of Buddhist Goddesses: Illustrated Manuscripts of the Pancaraksa Sutra and Their Ritual Use." *Artibus Asiae* 70 (2): 259–329.

———. 2013. *Receptacle of the Sacred: Illustrated Manuscripts and the Buddhist Book Cult in South Asia.* Berkeley: University of California Press.

Kinoshita, Sharon. 2004. "Almería Silk and the French Feudal Imaginary: Toward a 'Material' History of the Medieval Mediterranean." In *Medieval Fabrications: Dress, Textiles, Clothwork, and Other Cultural Imaginings,* edited by E. Jane Burns, 165–76. London: Palgrave Macmillan.

———. 2006. *Medieval Boundaries: Rethinking Difference in Old French Literature.* Philadelphia: University of Pennsylvania Press.

———. 2007. "Deprovincializing the Middle Ages." In *The Worlding Project: Doing Cultural Studies in the Era of Globalization,* edited by Rob Wilson and Christopher Leigh Connery, 61–75. Berkeley: North Atlantic Books

———. 2008. "Translation, Empire, and the Worlding of Medieval Literature: The Travels of *Kalila wa Dimna.*" *Postcolonial Studies* 11 (4): 371–85.

———. 2009. "Locating the Medieval Mediterranean." In *Locating the Middle Ages: The Spaces and Places of Medieval Culture,* edited by Julian Weiss and Sarah Salih, 39–52. London: Centre for Late Antique and Medieval Studies.

———, trans. 2016. *Marco Polo: The Description of the World.* Indianapolis: Hackett.

———. 2017. "Traveling Texts: De-orientalizing Marco Polo's *Le Devisement du monde.*" In *Travel, Agency, and the Circulation of Knowledge,* edited by Gesa Mackenthun, Andrea Nicolas, and Stephanie Wodianka, 223–46. Münster, Germany: Waxmann.

Kirch, Patrick Vinton. 1989. *The Evolution of the Polynesian Chiefdoms.* Cambridge, England: Cambridge University Press.

———. 2017. *On the Road of the Winds: An Archeological History of the Pacific Islands before European Contact.* 2nd ed. Berkeley: University of California Press.

Kirchhoff, Paul. 1943. "Mesoamérica: Sus límites geográficos, composición étnica y caracteres culturales." *Acta Americana* 1 (1): 92–107.

———. 1952. "Mesoamerica: Its Geographic Limits, Ethnic Composition, and Cultural Characteristics." In *Heritage of Conquest,* edited by Sol Tax, 17–30. Glencoe, IL: Free Press.

Klein, Peter. 2008. "Der Ausdrück unterschiedlicher Konflikte in der Darstellungen der Juden und Mauren in den 'Cantigas' Alfons des Weisen von Kastilien und León." In *Bereit zum Konflikt; Strategien und Medien der Konflikterzeugung und Konfliktbewältigung im europäischen Mittelalter,* edited by Oliver Auge et al., 67–86. Ostfildern, Germany: Jan Thorbecke.

Knauer, Elfriede R. 2009. "A Venetian Vignette One Hundred Years after Marco Polo." *Metropolitan Museum Journal* 44:47–59.

Knothe, Florian. 2017. *Illustrious Illuminations II: Armenian Christian Manuscripts from the Gothic to the Age of Enlightenment.* Hong Kong: University of Hong Kong.

Kogman-Appel, Katrin, et al. 2009. *Between Judaism and Christianity: Art Historical Essays in Honor of Elisheva (Elisabeth) Revel-Neher.* Leiden, the Netherlands: Brill.

———. 2011. "Jewish Art and Cultural Exchange: Theoretical Perspectives." In *Confronting the Borders of Medieval Art,* edited by Jill Caskey, Adam S. Cohen, and Linda Safran, 1–26. Leiden, the Netherlands: Brill.

Kohara, Hironobu. 1991. "Narrative Illustration in Handscroll Format." In *Words and Images: Chinese Poetry, Calligraphy and Painting,* edited by Alfreda Murck and Wen C. Fong, 247–66. Princeton, NJ: Princeton University Press.

Komaroff, Linda. 2005. *Islamic Art at the Los Angeles County Museum of Art*. Los Angeles: Los Angeles County Museum of Art.

———. 2012. "Two Folios from a Qur'an." In *Byzantium and Islam: Age of Transition, 7th–9th Century*, edited by Helen C. Evans and Brandie Ratliff, cat. no. 192A.B., 275–76. New York: Metropolitan Museum of Art. Exhibition catalogue.

Komaroff, Linda, and Stefano Carboni, eds. 2002. *The Legacy of Genghis Khan: Courtly Art and Culture in Western Asia, 1256–1353*. New Haven, CT: Yale University Press.

König, Viola. 1993. *Die Schlacht bei Sieben Blume: Konquistadores, Kaziken und Konflikte auf alten Landkarten der Indianer Südmexikos*. Bremen, Germany: Temmen.

Kotar, Peter Christos. 2011. "The Ethiopic Alexander Romance." In *A Companion to Alexander Literature in the Middle Ages*, edited by David Zuwiyya, 157–76. Leiden, the Netherlands: Brill.

Kouymjian, Dickran. 2008. "The Decoration of Medieval Armenian Manuscript Bindings." *La reliure médievale: Pour une description normalisée*, edited by Guy Lanoe and Geneviève Grand, 209–18. Turnhout, Belgium: Brepols.

Kovalev, Roman. 2013. "Were There Direct Contacts between Volga Bulgaria and Sweden in the Second Half of the Tenth Century? The Numismatic Evidence." *Archivum Eurasias Medii Aevi* 20:67–102.

Kozok, Uli. 2016. *A 14th Century Malay Code of Laws*. Singapore: Institute of Southeast Asian Studies.

Krahl, Regina. 2010. "Tang Blue-and-White." In *Shipwrecked: Tang Treasures and Monsoon Winds*, edited by Regina Krahl et al., 209–11. Washington, DC: Smithsonian Institution. Exhibition catalogue.

Krahl, Regina, John Guy, J. Keith Wilson, and Julian Raby, eds. 2010. *Shipwrecked: Tang Treasures and Monsoon Winds*. Washington, DC: Smithsonian Institution. Exhibition catalogue.

Krätli, Graziano, and Ghislaine Lydon, eds. 2011. *The Trans-Saharan Book Trade: Manuscript Culture, Arabic Literacy and Intellectual History in Muslim Africa*. Leiden, the Netherlands: Brill.

Kren, Thomas, Scot McKendrick, and Maryan Ainsworth, et al. 2003. *Illuminating the Renaissance: The Triumph of Flemish Manuscript Painting in Europe*. Los Angeles: Getty Publications.

Krupp, Edwin. 2015. "Crab Supernova Rock Art: A Comprehensive, Critical, and Definitive Review," *Journal of Skyscape Archaeology* 1 (2): 167–97.

Kubiski, Joyce. 2001. "Orientalizing Costume in Early Fifteenth-Century French Manuscript Painting (cité Des Dames Master, Limbourg Brothers, Boucicaut Master, and Bedford Master)." *Gesta* 40 (2): 161–80.

Kubler, George. 1966. "Indianismo y mestisaje como tradiciones clásicas y medievales americanas." *Revista de Occidente* 38:158–67.

———. 1969. *Studies in Classic Maya Iconography*. New Haven: Connecticut Academy of Arts and Sciences.

———. 1977. "Renascence and Disjunction in the Art of Mesoamerican Antiquity." *Via* 3:31–41.

Kumar, Ann. 1996. *Illuminations: The Writing Traditions of Indonesia*. Boston: Weatherhill.

Kumar, Sunil. 2007. *The Emergence of the Delhi Sultanate*. New Delhi: Permanent Black.

Kunamoto Kenritsu Bijutskan. 2001. *Mōko shūrai ekotoba ten: kaikan nijūgoshūnen kinen* (Exhibition of the Illustrated Account of the Mongol Invasion: The 25th Anniversary of the Museum). Kumamoto, Japan: Kumamoto Kenritsu Bijutsukan.

Kupfer, Marcia. 2008. "'. . . Lectres . . . plus vrayes': Hebrew Script and Jewish Witness in the 'Mandeville' Manuscript of Charles V." *Speculum* 83 (1): 58–111.

Kusimba, Chapurukha, and Carla Klehm. 2013. "Museums and Public Archeology in Africa." In *The Oxford Handbook of African Archaeology*, edited by Peter Mitchell and Paul Lane, 227–37. Oxford: Oxford University Press.

Lacadena, Alfonso. 2000. "The Scribes of the Codice de Madrid: Paleographic Methodology." *Revista Española de Antropología Americana* 30:27–85.

———. 2010. "Highland Mexican and Maya Intellectual Exchange in the Late Postclassic: Some Thoughts on the Origin of Shared Elements of Interaction." In *Astronomers, Scribes, and Priests: Intellectual Exchange between the Northern Maya Lowlands and Highland Mexico in the Late Postclassic Period*, edited by Gabrielle Vail and Christine Hernández, 383–406. Washington, DC: Dumbarton Oaks.

Lacarra Ducay, María del Carmen. 2012. "El manuscrito del Vidal Mayor. Estudio histórico-artístico de sus miniaturas." In *La miniatura y el grabado de la Baja Edad Media en los archivos españoles*, edited by María del Carmen Lacarra Ducay, 7–44. Zaragoza, Spain: Institución Fernando El Católico.

Lach, Donald Frederick. 1994. *A Century of Wonder*. Vol. 2 of *Asia in the Making of Europe*. Chicago: University of Chicago Press.

Ladis, Andrew. 2008. *Victims and Villains in Vasari's 'Lives'*. Chapel Hill: University of North Carolina Press.

Ladner, Gerhart B. 1995. *God, Cosmos, and Humankind: The World of Early Christian Symbolism*. Translated by Thomas Dunlap. Los Angeles: University of California Press.

Lambah, Abha Narain, and Alka Patel, eds. 2006. *The Architecture of the Indian Sultanates*. Mumbai: Marg.

Lampart-Weissig, Lisa. 2010. *Medieval Literature and Postcolonial Studies*. Edinburgh: Edinburgh University Press.

Landau, Amy S. 2007. "Farangi-Saziat Isfahan: The Court Painter Muhammad Zaman, the Armenians of New Julfa and Shah Sulayman (1666–1694)." PhD diss., University of Oxford.

———. 2011. "From Poet to Painter: Allegory and Metaphor in a Seventeenth-Century Persian Painting by Muhammad Zaman, Master of Farangi-Sazi." *Muqarnas* 28:101–31.

———. 2012. "European Religious Iconography in Safavid Iran: Decoration and Patronage of Meydani Bet'ghehem." In *Iran and the World in the Safavid Age*, edited by Willem Floor and Edmund Herzig, 425–46. New York: I. B. Tauris.

Langer, Axel, ed. 2013. *The Fascination of Persia: The Persian-European Dialogue in Seventeenth-Century Art and Contemporary Art from Tehran*. Zurich: Museum Rietberg; Scheidegger & Spiess.

la Orden Miracle, Ernesto, ed. 1971. *Santiago en España, Europa y América*. Madrid: Editorial Nacional.

Lapatin, Kenneth. 2015. *Luxus: The Sumptuous Arts of Greece and Rome*. Los Angeles: Getty Publications.

Lapina, Elizabeth, et al. 2015. *The Crusades and Visual Culture*. New York: Routledge.

Larner, John. 1999. *Marco Polo and the Discovery of the World*. New Haven, CT: Yale University Press.

Last, Murray. 2011. "The Book and the Nature of Knowledge in Muslim Northern Nigeria." In *The Trans-Saharan Book Trade: Manuscripts Culture, Arabic Literacy and Intellectual History in Muslim Africa*, edited by Graziano Krätli and Ghislaine Lydon, 175–211. Boston: Brill.

Lavin, Irving. 1993. "Pisanello and the Invention of the Renaissance Medal." In *Italienische Frührenaissance und Nordeuropäisches Spätmittelalter / Hrsg. Von Joachim Poeschke. Mit Beiträgen Von F. Ames-Lewis*, 67–78. Munich: Hirmer.

Lawal, Babatunde. 2012. "Ayél'ojà, Òrunn'ilé: Imaging and Performing Yoruba Cosmology." In *African Cosmos: Stellar Arts*, edited by Christine Mullen Kreamer, Erin L. Haney, Katharina Monsted, and Karen Nell, 216–43. Washington, DC: National Museum of African Art, Smithsonian Institution. Exhibition catalogue.

Ledyard, Gari. 1994. "Cartography in Korea." In *Cartography in the Traditional East and Southeast Asian Societies*, 235–345. Vol. 2, book 2, of *The History of Cartography*, edited by J. B. Harley and David Woodward. Chicago: University of Chicago Press.

Lee, Soyoung, and Denise Patry Leidy. 2013. *Silla: Korea's Golden Kingdom*. New York: Metropolitan Museum of Art.

Lee, Thomas A. 1985. *Los Códices Mayas*. Tuxtla Gutierrez, Mexico: Universidad Autónoma de Chiapas.

Legassie, Shayne Aaron. 2017. *The Medieval Invention of Travel.* Chicago: University of Chicago.

Le Goff, Jacques. 2017. *Must We Divide History into Periods?* Translated by Malcolm DeBevoise. New York: Columbia University Press.

Legrand, Catherine. 2012. *Indigo: The Colour That Changed the World.* London: Thames and Hudson.

Leibsohn, Dana. 1995. "Colony and Cartography: Shifting Signs on Indigenous Maps of New Spain." In *Reframing the Renaissance: Visual Culture in Europe and Latin America, 1450–1650*, edited by Claire Farago, 265–81. New Haven, CT: Yale University Press.

———. 1996. "Mapping Metaphors: Figuring the Ground in Sixteenth-Century New Spain." *Journal of Medieval and Early Modern Studies* 26 (3): 497–523.

Léonelli, Marie-Claude. 2009. "Les Heures de Rene d'Anjou." In *Splendeur de l'enluminure: Le roi René et les livres*, edited by Marc-Edouard Gautier and François Avril, 260–62. Angers, France: Ville d'Angers.

Levenson, Jay A., ed. 1991. *Circa 1492: Art in the Age of Exploration.* New Haven, CT, and London: Yale University Press.

Levin, Gabriel. 1995. "On the Sea—A Sequence of Poems by Yehuda Halevi (c. 1075–1141)." *European Judaism* 28 (1): 87–90.

Lévi-Strauss, Claude. 1963. *Totemism.* Translated by Rodeny Needham. Boston: Beacon.

Levkoff, Mary. 2008. *Hearst, the Collector.* New York: Abrams; Los Angeles: Los Angeles County Museum of Art.

Lewis, Malcolm G. 1998. "Maps, Mapmaking, and Map Use by Native North Americans." In *Cartography in the Traditional African, American, Arctic, Australian, and Pacific Societies*, 51–182. Vol. 2, book 3, of *The History of Cartography*, edited by David Woodward and G. Malcolm Lewis. Chicago: University of Chicago Press.

Lifchitz, Deborah, and Sylvain Grébaut. 1940. *Textes éthiopiens magico-religieux.* Paris: Institut d'ethnologie.

Lindsay, Wallace Martin, and Isidore of Seville. 1989. *Etymologiarum Sive Originum. 1, Libros I–X Continens.* Oxford: Clarendon.

Linehan, Peter, and Janet L. Nelson, eds. 2001. *The Medieval World.* London: Routledge.

Lings, Martin, and Yasin Hamid Safadi. 1976. *The Qur'an: Catalogue of an Exhibition of Qur'an Manuscripts at the British Library, 3 April–15 August 1976.* London: World of Islam.

Linrothe, Rob. 2014. *Collecting Paradise: Buddhist Art of Kashmir and Its Legacies.* New York: Rubin Museum of Art; Evanston, IL: Block Museum of Art. Exhibition catalogue.

Lintz, Yannick, et al., eds. 2014. *Le Maroc médiéval: Un empire de l'Afrique à l'Espagne.* Paris: Hazan.

Lipton, Sara. 1999. "The Root of All Evil: Jews, Money, and Metaphor in Images of Intolerance: The Representation of Jews and Judaism in the Bible moralisée." *Medieval Encounters* 1 (3): 301–22. Berkeley: University of California Press.

———. 2008. "Where Are the Gothic Jewish Women? On the Non-Iconography of the Jewess in the Cantigas de Santa Maria." *Jewish History* 22 (1–2): 139–77.

———. 2014. *Dark Mirror: The Medieval Origins of Anti-Jewish Iconography.* New York: Macmillan.

Little, Stephen, and Shawn Eichman, et al. 2000. *Taoism and the Arts of China.* Chicago: Art Institute of Chicago.

Littmann, Enno. 1904. "Arde'et: The Magic Book of the Disciples." *Journal of the American Oriental Society* 25:119–23.

Liu, Xinru. 2010. *The Silk Road in World History.* Oxford: Oxford University Press.

Lockard, Craig A. 2009. *Southeast Asia in World History.* Oxford: Oxford University Press.

Lomperis, Linda. 2001. "Medieval Travel Writing and the Question of Race." *Journal of Medieval and Early Modern Studies* 31 (1): 147–64.

Lomuto, Sierra. 2016. "White Nationalism and the Ethics of Medieval Studies." *In the Middle* (blog), December 5, 2016. http://www.inthemedievalmiddle.com/2016/12/white-nationalism-and-ethics-of.html/.

Longyear, John M., III. 1952. *Copan Ceramics: A Study of Southeastern Maya Pottery.* Washington, DC: Carnegie Institution of Washington.

Lopez, Donald S., and Peggy McCracken. 2014. *In Search of the Christian Buddha: How an Asian Sage Became a Medieval Saint.* New York: Norton.

Lopez, Robert S., and Irving W. Raymond. 1990. *Medieval Trade in the Mediterranean World: Illustrative Documents.* New York. Columbia University Press.

Losty, Jeremiah. 1982. *The Art of the Book in India.* London: British Library.

Love, Bruce. 1994. *The Paris Codex: Handbook for a Maya Priest.* Austin: University of Texas Press.

Lowden, John. 1992. "Concerning the Cotton Genesis and Other Illustrated Manuscripts of Genesis." *Gesta* 31 (1): 40–53.

Lowe, David J., and Adrian Pittari. 2014. "An Ashy Septingentenarian: The Kaharoa Tephra Turns 700 (with Notes on Its Volcanological, Archaeological, and Historical Importance)." *Geoscience Society of New Zealand Newsletter* 13:25–46.

Lucas, Gavin. 2005. *The Archaeology of Time.* New York: Routledge.

Lundstrom, Agneta. 1978. "Helgo: A Pre-Viking Trading Centre." *Archaeology* 31 (4): 24–31.

Luttikhuizen, Henry, and Dorothy Verkerk. 2006. *Snyder's Medieval Art.* 2nd ed. Upper Saddle River, NJ: Prentice Hall.

Lydon, Ghislaine. 2011. "A Thirst for Knowledge: Arabic Literacy, Writing Paper and Saharan Bibliophiles in the Southwestern Sahara." In *The Trans-Saharan Book Trade: Manuscripts Culture, Arabic Literacy and Intellectual History in Muslim Africa*, edited by Graziano Krätli and Ghislaine Lydon, 35–72. Boston: Brill.

Lydon, Ghislaine, and Graziano Krätli, eds. 2011. *The Trans-Saharan Book Trade: Manuscripts Culture, Arabic Literacy and Intellectual History in Muslim Africa.* Boston: Brill.

Lymberopoulou, Angeliki, and Rembrandt Duits. 2016. *Byzantine Art and Renaissance Europe.* London: Routledge.

MacEachern, Scott. 2016. "Globalization: Contact between West Africa, North Africa and Europe during the European Medieval Period." In *The Routledge Handbook of Archaeology and Globalization*, edited by Tamar Hodos, 90–103. New York: Taylor and Francis.

Mack, Rosamond E. 2002. *Bazaar to Piazza: Islamic Trade and Italian Art, 1300–1600.* Berkeley: University of California Press.

MacKay, Angus. 1988. "Andalucía y la guerra del fin del mundo." In *Andalucía entre oriente y occidente (1236–1492)*, edited by Emilio Cabrera, 329–42. Cordoba, Spain: Excma. Diputación Provincial de Cordoba, Area de Cultura.

Mackie, Louise W. 2015. *Symbols of Power: Luxury Textiles from Islamic Lands, 7th–21st century.* New Haven, CT: Yale University Press.

Maïga, Hassimi Oumarou. 2010. *Balancing Written History with Oral Tradition: The Legacy of the Songhoy People.* New York: Routledge.

Malay, Jessica. 2010. *Prophecy and Sibylline Imagery in the Renaissance: Shakespeare's Sibyls.* New York: Routledge.

Malicka, Ewa. 2010. "Historia srebrnej tabliczki." *Alma Mater / Miesięcznik Uniwersytetu Jagiellońskiego* 128:60–62.

Mancall, Peter C. 2006. *Travel Narratives from the Age of Discovery: An Anthology.* Oxford: Oxford University Press.

Mango, Cyril, Marila Mango, and Earleen Brunner, eds. 2011. *St Catherine's Monastery at Mount Sinai: Its Manuscripts and their Conservation: Papers Given in Memory of Professor Ihor Ševčenko.* London: Saint Catherine Foundation.

"Manuscript Illumination." 2008. *Qantara.* http://www.qantara-med.org.

Marer-Banasik, Elizabeth. 1995. "The Creator with the Cosmos and a Compass: The Frontispieces of the Thirteenth-Century Moralizing Bibles." *Rutgers Art Review* 15:26.

Margolis, Oren J. 2016. *The Politics of Culture in Quattrocento Europe: René of Anjou in Italy.* Oxford: Oxford University Press.

Marks, Robert. 2015. *Origins of the Modern World: A Global and Environmental Narrative*. London: Rowman and Littlefield.

Marti, Susan, Till Borchert, and Gabriele Keck. 2009. *Splendour of the Burgundian Court: Charles the Bold (1433–1477)*. Brussels: Mercatorfonds.

Martínez del Campo Lanz, Sofía, ed. 2018. *El Códice Maya de México, antes Grolier*. México, D.F.: Secretaría de Cultura, Instituto Nacional de Antropología e Historia.

Massing, Jean Michel. 2007. "Stone Carving and Ivory Sculpture in Sierra Leone." In *Encompassing the Globe: Portugal and the World in the 16th and 17th Centuries: Essays*, edited by Jay Levenson, 64–75. Washington, DC: Arthur M. Sackler Gallery, Smithsonian Institution.

Mathews, Thomas F., and Avedis K. Sanjian. 1991. *Armenian Gospel Iconography: The Tradition of the Glajor Gospel*. Washington, DC: Dumbarton Oaks Research Library and Collection.

Mathews, Thomas F., and Roger S. Wieck. 1994. *Treasures in Heaven: Armenian Illuminated Manuscripts*. New York: Pierpont Morgan Library. Exhibition catalogue.

Matin, M., and A. M. Pollard. 2016. "From Ore to Pigment: A Description of the Minerals and an Experimental Study of Cobalt Ore Processing from the Kashan Mine, Iran." *Archaeometry* 59 (4): 1–16.

Matisoo-Smith, Elizabeth. 2017. "Ancient DNA in Zooarchaeology: New Methods, New Questions and Settling Old Debates in Pacific Commensal Studies." In *Zooarchaeology in Practice: Case Studies in Methodology and Interpretation in Archaeofaunal Analysis*, edited by Christina M. Giovas and Michelle J. LeFebvre, 209–25. New York: Springer.

Matthee, Rudolph. 2013. "Iran's Relations with Europe in the Safavid Period: Diplomats, Missionaries, Merchants and Travel." In *The Fascination of Persia: The Persian-European Dialogue in Seventeenth-Century Art and Contemporary Art from Tehran*, edited by Axel Langer, 6–39. Zurich: Scheidegger und Spiess.

———. 2017. "'Abbās I, Shah of Persia." In *Christian-Muslim Relations: A Bibliographical History: Volume 10, Ottoman and Safavid Empires (1600–1700)*, edited by David Thomas and John Chesworth, 549–61. Leiden, the Netherlands: Brill.

Mattos, Claudia. 2014. "Wither Art History? Geography, Art Theory, and New Perspectives for an Inclusive Art History." *Art Bulletin* 96 (3): 259–64.

May, Timothy. 2007. *The Mongol Art of War*. Yardley, PA: Westholme.

———. 2013. "The Mongol at War." In *Genghis Khan and the Mongol Empire*, edited by William W. Fitzhugh, Morris Rossabi, and William Honeychurch, 191–99. Hong Kong: Odyssey Books and Maps.

McCleary, Timothy P. 2016. *Crow Indian Rock Art: Indigenous Perspectives and Interpretations*. New York: Routledge.

McClure, Julia. 2015. "A New Politics of the Middle Ages: A Global Middle Ages for a Global Modernity." *History Compass* 13 (11): 610–19.

McCracken, Peggy. 2014. *Barlaam and Josaphat: A Christian Tale of the Buddha*. Original text by Guy de Cambrai. New York: Penguin.

McHugh, James. 2011a. "The Incense Trees of the Land of Emeralds: The Exotic Material Culture of Kamasastra." *Journal of Indian Philosophy* 39 (1): 63–100.

———. 2011b. "Seeing Scents: Methodological Reflections on the Perception of Aromatics in South Asian Religions." *History of Religions* 51 (2): 156–77.

———. 2012a. "Gemstones." In *Encyclopedia of Hinduism*, edited by Knut A. Jacobsen, Helene Basu, Angelika Malinar, and Vasudha Narayana, 59–64. Leiden, the Netherlands: Brill.

———. 2012b. *Sandalwood and Carrion: Smell in South Asian Religion and Culture*. Edited by Cynthia Read. New York: Oxford University Press.

———. 2013. "Blattes de Byzance in India: Mollusk Opercula and the History of Perfumery." *Journal of the Royal Asiatic Society* 23 (1): 53–67.

———. 2014. "From Precious to Polluting: Tracing the History of Camphor in Hinduism." *Material Religion* 10 (1): 30–53.

McIntosh, Gregory C. 2015. *The Vesconte Maggiolo World Map of 1504 in Fano Italy*. 2nd ed. Long Beach, CA: Plus Ultra.

McKendrick, Scot. 1996. *The History of Alexander the Great*. Malibu, CA: The J. Paul Getty Museum.

McKendrick, Scot, and Kathleen Doyle. 2016. *The Art of the Bible: Illuminated Manuscripts from the Medieval World*. London: Thames and Hudson.

McKenzie, Judith S., and Francis Watson. 2016. *The Garima Gospels: Early Illuminated Gospel Books from Ethiopia*. Oxford: Manar al-Athar.

McLaughlin, M. L. 1988. "Humanist Concepts of Renaissance and Middle Ages in the Tre- and Quattrocento." *Renaissance Studies* 2 (2): 131–42.

Medrano, Manuel, and Gary Urton. 2017. "Toward the Decipherment of a Set of Mid-Colonial Khipus from the Santa Valley, Coastal Peru." *Ethnohistory* 65 (1): 1–23.

Meier, Prita S., and Allyson Purpura. 2018. *World on the Horizon: Swahili Arts across the Indian Ocean*. Champaign, IL: Krannert Art Museum and Kinkead Pavilion.

Meiss, Millard. 1968. *French Painting in the Time of the Duke of Berry: The Boucicaut Master*. London: Phaidon.

Mellinkoff, Ruth. 1993. *Outcasts: Signs of Otherness in Northern European Art of the Late Middle Ages*. Berkeley: University of California Press.

Melville, C. P., and Barbara Brend. 2011. *Epic of the Persian Kings: The Art of Ferdowsi's Shahnameh*. London: I. B. Tauris.

Ménard, Philippe. 1986. "L'illustration du *Devisement du Monde* de Marco Polo. Etude d'iconographie compare." In *Métamorphoses du récit de voyage: Actes du colloque de la Sorbonne et du Sénat (2 mars 1985)*, edited by François Moureau, 17–31. Geneva: Slatkine.

———. 2006. "Marco Polo en images: Les représentations du voyageur au moyen âge." In vol. 2 of *Studi di filologia romanza offerti a Valeria Bertolucci Pizzorusso*, edited by Piero G. Beltrami et al., 993–1021. Pisa, Italy: Pacini.

Ménard, Philippe, et al., eds. 2001–9. *Marco Polo: Le Devisement du monde*. 6 vols. Geneva: Droz.

Mercier, Jacques. 1979. *Ethiopian Magic Scrolls*. New York: G. Braziller.

———. 1997. *Art That Heals: The Image as Medicine in Ethiopia*. Munich: Prestel; New York: Museum for African Art.

———. 1999. "Les sources iconographiques occidentales du cycle de la vie du Christ dans la peinture éthiopienne du dix-huitième siècle." *Journal Asiatique* 287 (2): 375–94.

Merian, Sylvie L. 2013. "The Armenian Silversmiths of Kesaria/Kayseri in the Seventeenth and Eighteenth Centuries." In *Armenian Kesaria/Kayseri and Cappadocia*, edited by Richard G. Hovannisian, 117–85. UCLA Armenian History and Culture Series, Historic Armenian Cities and Provinces 12. Costa Mesa, CA: Mazda.

———. 2014. "Illuminating the Apocalypse in Seventeenth-Century Armenian Manuscripts: The Transition from Printed Book to Manuscript." In *The Armenian Apocalyptic Tradition: A Comparative Perspective*, edited by Kevork B. Bardakjian and Sergio La Porta, 603–39. Leiden, the Netherlands: Brill.

Merklinger, Elizabeth Schotten. 2005. *Sultanate Architecture of Pre-Mughal India*. New Delhi: Munshiram Manoharlal.

Metz, Peter. 1957. *The Golden Gospels of Echternach: Codex aureus Epternacensis*. London: Thames and Hudson.

Meyer, Joachim, and Peter Wandel. 2016. *Shahnama: The Colorful Epic about Iran's Past*. Copenhagen: David Collection.

Milbrath, Susan, and Carlos Peraza Lope. 2003. "Revisiting Mayapan: Mexico's Last Maya Capital." *Ancient Mesoamerica* 14 (1): 1–46.

Milleker, Elizabeth Johnston. 2000. *The Year One: Art of the Ancient World East and West*. New York: Metropolitan Museum of Art. Exhibition catalogue.

Miller, Arthur G. 1973. *The Mural Painting of Teotihuacan*. Washington, DC: Dumbarton Oaks.

Miller, William. 1955a. "Two Possible Astronomical Pictographs Found in Northern Arizona." *Pleateau* 27 (4): 6–13.

———. 1955b. "Two Prehistoric Drawings of Possible Astronomical Significance." *Astronomical Society of the Pacific Leaflet*, no. 314, 1–8.

Millet-Gallant, Ann, and Elizabeth Howie. 2016. *Disability and Art History*. London: Routledge.

Milstein, Rachel, Karin Rührdanz, and Barbara Schmitz. 1999. *Stories of the Prophets: Illustrated Manuscripts of Qiṣaṣ Al-Anbiyā'*. Costa Mesa, CA: Mazda.

Milton, Gregory B. 2006. "Christian and Jewish Lenders: Religious Identity and the Extension of Credit." *Viator* 37:301–18.

Mittman, Asa Simon. 2015. "Are the 'Monstrous Races' Races?" *postmedieval: a journal of medieval cultural studies* 6:36–51.

Mittman, Asa Simon, and Marcus Hensel. 2018. "Introduction: A Marvel of Monsters." In *Demonstrare*, ix–xv. Vol. 1 of *Classic Readings on Monster Theory*, edited by Asa Simon Mittman and Marcus Hensel. Kalamazoo, MI: Medieval Institute Press, WMU/Arc-Humanities Press.

Monfasani, John. 2011. *Bessarion Scholasticus: A Study of Cardinal Bessarion's Latin Library*. Leiden, the Netherlands: Brepols.

Monnas, Lisa. 2008. *Merchants, Princes, and Painters: Silk Fabrics in Italian and Northern Paintings, 1300–1500*. New Haven, CT: Yale University Press.

Monteira Arias, Inés. 2012. *El enemigo imaginado: La escultura románica hispana y la lucha contra el Islam*. Toulouse, France: CNRS.

Moodey, Elizabeth J. 2012. *Illuminated Crusader Histories for Philip the Good of Burgundy*. Turnhout, Belgium: Brepols.

Moore, Robert I. 2016. "A Global Middle Ages?" In *The Prospect of Global History*, edited by James Belich et al., 80–92. Oxford: Oxford University Press.

Moreen, Vera Basch. 1999. "Übersetzung der judeo-persischen Texte." In *Die Kreuzritterbibel: Kommentar*, edited by Daniel Weiss. Lucerne, Switzerland: Faksimile Verlag.

Morencos, Pilar García. 1977. *Libro de ajedrez, dados y tablas de Alfonso X el Sabio: Estudio*. Madrid: Patrimonio Nacional.

Morgan, Nigel. 2006. *The Douce Apocalypse: Picturing the End of the World in the Middle Ages*. Oxford: Bodleian Library.

Morley, Sylvanus Griswold. 1913. "Archaeological Research at the Ruins of Chichen Itza." In *Reports upon the Present Condition and Future Needs of the Science of Anthropology*, presented by W. H. R. Rivers, A. E. Jenks, and S. G. Morley, 61–91, plates 1–14. Washington, DC: Gibson Brothers.

———. 1917. "The Hotun as the Principal Chronological Unit of the Old Empire." In *Proceedings from the International Congress of Americanists 19th Session*, 195–201. Washington, DC: Carnegie Institution of Washington.

———. 1930. *The Inscriptions at Copan*. Washington, DC: Carnegie Institution of Washington.

———. 1946. *The Ancient Maya*. Stanford, CA: Stanford University Press.

———. 1956. *The Ancient Maya*. Revised by George W. Brainerd. 3rd ed. Stanford, CA: Stanford University Press.

Morris, James, and Suzanne Preston Blier, eds. 2004. *Butabu: Adobe Architecture of West Africa*. Princeton, NJ: Princeton Architectural Press.

Morrison, Elizabeth. 2015. *The Adventures of Gillion de Trazegnies: Chivalry and Romance in the Medieval East*. Los Angeles: The J. Paul Getty Museum.

Mote, Frederick W., and Hung-lam Chu. 1989. *Calligraphy and the East Asian Book*. Boston: Shambala.

Moxey, Keith. 2013. *Visual Time: The Image in History*. Durham, NC: Duke University Press.

Mukherji, Parul Dave. 2014. "Whither Art History in a Globalizing World." *Art Bulletin* 96 (2): 151–55.

Mukhia, Harbans. 1976. *Historians and Historiography during the Reign of Akbar*. New Delhi: Vikas.

Mulder, Stephennie. 2017. "The Rise and Fall of the Viking 'Allah' Textile." *Hyperallergic*, October 27, 2017. https://hyperallergic.com/407746/refuting-viking-allah-textiles-meaning/.

Mullin, Glenn H., and Heather Stoddard. 2007. *Buddha in Paradise: A Celebration in Himalayan Art*. New York: Rubin Museum of Art.

Mundy, Barbara E. 1996. *The Mapping of New Spain: Indigenous Cartography and the Maps of the Relaciones Geográficas*. Chicago: University of Chicago Press.

———. 1998. "Mesoamerican Cartography." In *Cartography in the Traditional African, American, Arctic, Australian, and Pacific Societies*, 183–256. Vol. 2, book 3, of *The History of Cartography*, edited by David Woodward and G. Malcolm Lewis. Chicago: University of Chicago Press.

———. 2008. "Relaciones Geográficas." In vol. 1 of *Guide to Documentary Sources for Andean Studies, 1530–1900*, edited by Joanne Pillsbury, 144–59. Norman: University of Oklahoma Press.

Murray, Alexander. 2004. "Should the Middle Ages Be Abolished?" *Essays in Medieval Studies* 21:1–22.

Murray, Julia. 1994. "The Evolution of Buddhist Narrative Illustration in China after 850." In *Latter Days of the Law: Images of Chinese Buddhism, 850–1850*, edited by Marsha Weidner, 125–50. Lawrence, KS: Spencer Museum of Art.

Murrell, Eric S. 1926. *"Girart De Roussillon" and the "Tristan" Poems*. Chesterfield, England: Bales and Wilde.

Myers, Susan E., and Steven J. McMichael. 2004. *Friars and Jews in the Middle Ages and Renaissance*. Leiden, the Netherlands: Brill.

Namekong, Donald, and Bernard Roussel. 2006. "Botanique: Ces plantes vertes dont on fit le bleu...Approche botanique des sources d'indigo." In *Indigo: Les routes de l'Afrique bleue*, edited by Karen Petrossian and Bernard Roussel, 15–24. Aix-en-Provence, France: Edisud.

Narkiss, Bezalel. 1991. "The Art of the Washington Haggadah." In *The Washington Haggadah: A Facsimile Edition of an Illuminated 15th Century Hebrew Manuscript at the Library of Congress Signed by Joel ben Simeon*, edited by M. Weinstein, 27–102. Washington, DC: Library of Congress.

Nash, Susie. 2008. *Northern Renaissance Art*. New York: Oxford University Press.

Natanzi Afushte, Mahmud b. Hedayat-Allah. 1366/1987. *Ehsan Eshraqi*. 2 vols. Edited by Noqavatal-Asar fi zekr al-akhyar. Tehran, Iran: Bongah-e tarjome va nashr-e ketab.

National Library of Australia. 2013. *Mapping Our World: Terra Incognita to Australia*. Canberra: National Library of Australia.

National Library of China. 2008. *Diyi pi guojia zhengui guji minglu tulu*. Beijing: Guojia tushuguan chubanshe.

Naudet, Valérie. 2005. *Guerin le Loherain*. Aix-en-Provence, France: Publications de l'Université de Provence.

Navarrete, Federico. 2006. "La Malinche, la Virgen y la montaña: El juego de la identidad en los códices tlaxcaltecas." *História* (São Paulo) 26 (2): 288–310.

———. 2008. "Beheadings and Massacres: Andean and Mesoamerican Representations of the Spanish Conquest." *Res: Anthropology and Aesthetics* 53/54:59–78.

Necipoglu, Gülru, and Alina Payne, eds. 2016. *Histories of Ornament from Global to Local*. Princeton, NJ: Princeton University Press.

Nelson, Robert S. 1996. "Living on the Byzantine Borders of Western Art." *Gesta* 35 (1): 3–11.

Nelson, Robert S., and Kristen Collins. 2006. *Holy Image, Hallowed Ground: Icons from Sinai*. Los Angeles: Getty Publications.

Newhall, Amy W. 1987. *The Patronage of the Mamluk Sultan Qa'it Bay, 872–901/1468–1496*. Boston: Harvard University Press.

Niane, D. T. 2006. *Sundiata: An Epic of Old Mali*. London: Pearson.

Nievergelt, M. 2011. "The Quest for Chivalry in the Waning Middle Ages: The Wanderings of Rene d'Anjou and Olivier de la Marche." *Fifteenth-Century Studies* 36:137–68.

Nobili, Mauro. 2011. "Arabic Scripts in West African Manuscripts: A Tentative Classification from the de Gironcourt Collections." *Islamic Africa* 2 (1): 105–33.

Noble, Thomas F. X., and Julia H. Smith. 2008. *Early Medieval Christianities, c. 600–c. 1100*. Cambridge History of Christianity 3. Cambridge, England: Cambridge University Press.

Noever, Peter, and Bert G. Fragner. 2009. *GLOBAL: LAB: Kunst als Botschaft: Asien und Europa 1500–1700*. Ostfildern, Germany: Hatje Cantz.

Normore, Christina, ed. 2017. "Editor's Introduction: A World Within Worlds? Reassessing the Global Turn in Medieval Art History." *Medieval Globe* 3 (2): 1–10.

Norris, R. P., and D. W. Hamacher. 2015. "Australian Aboriginal Astronomy: An Overview." In *Handbook of Archaeoastronomy and Ethnoastronomy*, edited by C. Ruggles, 2215–22. New York: Springer.

Nortrup, David. 2005. "Globalization and the Great Convergence: Rethinking World History in the Long Term." *Journal of World History* 16 (3): 249–67.

Obłąk, Jan. 2008. "Kardynał Bernard Maciejowski jako biskup krakowski." PhD diss., Jagiellonian University, Poland.

Ödekan, Ayla, Nevra Necipoğlu, and Engin Akyürek, eds. 2013. "The Byzantine Court: Source of Power and Culture." Papers from the Second International Sevgi Gönül Byzantine Studies Symposium. Istanbul: Koç University Press.

Oktel, Ertugrul Zekai, ed. 1988. *Piri Reis: Kitab-i bahriye*. Istanbul: Istanbul Research Center.

Oleg, Grabar. 2006. *Islamic Art and Beyond*. Aldershot, England: Ashgate.

O'Neil, Megan E. 2012. *Engaging Ancient Maya Sculpture at Piedras Negras, Guatemala*. Norman: University of Oklahoma Press.

Oskanyan, Ninel A., K'narik A. Korkotyan, and Ant'aṛam M Savalyan. 1988. *Hay Girkě 1512–1800 T'vakannerin: Hay hnatip grk'i matenagitowt'un* [The Armenian Book in 1512–1800: Bibliography of Old Printed Armenian Books]. Erevan, Armenia: Al. Myasnikyani Anvan Zhoghovurdneri Bareka-mut'yan Shk'anshanakīr, HSSH Petakan Gradaran.

Otaño Gracia, Nahir I. 2018. "Lost in Our Field: Racism and the International Congress on Medieval Studies." *Medievalists of Color*, July 24, 2018. http://medievalistsofcolor.com/uncategorized/lost-in-our-field-racism-and-the-international-congress-on-medieval-studies/.

Özdemir, Kemal. 1992. *Ottoman Nautical Charts and the Atlas of Ali Macar Reis*. Istanbul: Marmara Bank.

Pak, Young-sook. 1987. "Illuminated Buddhist Manuscripts in Korea." *Oriental Art* 33 (4): 357–74.

Pal, Pratapaditya. 1981. *Elephants and Ivories in South Asia*. Los Angeles: Los Angeles County Museum of Art.

——, ed. 1984. *Light of Asia: Buddha Sakyamuni in Asian Art*. Los Angeles: Los Angeles County Museum of Art.

——. 1985. *Art of Nepal: A Catalogue of the Los Angeles County Museum of Art Collection*. Los Angeles: Los Angeles County Museum of Art.

——. 1986. *Indian Sculpture: A Catalogue of the Los Angeles County Museum of Art Collection*. Los Angeles: Los Angeles County Museum of Art.

——. 1993. *Indian Painting: A Catalogue of the Los Angeles County Museum of Art Collection*. Los Angeles: Los Angeles Museum of Art.

——. 2003. *Art from the Indian Subcontinent*. Vol. 1 of *Asian Art at the Norton Simon Museum*. New Haven, CT: Yale University Press.

——. 2004. *Art from the Himalayas and China*. Vol. 2 of *Asian Art at the Norton Simon Museum*. New Haven, CT: Yale University Press.

Pal, Pratapaditya, and Julia Meech-Pekarik. 1988. *Buddhist Book Illuminations*. New York: Ravi Kumar.

Palladino, Pia. 2005. *Treasures of a Lost Art: Italian Manuscript Painting of the Middle Ages and Renaissance*. New Haven, CT: Yale University Press.

Panayotova, Stella, and Paola Ricciardi, eds. 2017. *Manuscripts in the Making: Art and Science*. Vol 1. London and Turnhout, Belgium: Harvey Miller.

——. 2018. *Manuscripts in the Making: Art and Science*. Vol 2. London and Turnhout, Belgium: Harvey Miller.

Panofsky, Erwin. 1960. *Renaissance and Renascences in Western Art*. Stockholm: Almqvist and Wiksell.

"Panorama: adjugé en images." 2016. *La Gazette Drouot* 3:130.

Parani, Maria G. 2003. *Reconstructing the Reality of Images: Byzantine Material Culture and Religious Iconography, Eleventh–Fifteenth Centuries*. Leiden, the Netherlands: Brill.

——. 2013. "Look Like an Angel: The Attire of Eunuchs and Its Significance within the Context of Middle Byzantine Court Ceremonial." In *Court Ceremonies and Rituals of Power in Byzantium and the Medieval Mediterranean*, edited by Alexander Beihammer, Stavroula Constantinou, and Maria G. Parani, 433–63. Leiden, the Netherlands: Brill.

Park, Hyunhee. 2012. *Mapping the Chinese and Islamic Worlds: Cross-Cultural Exchange in Pre-modern Asia*. Cambridge, England: Cambridge University Press.

Patel, Alka. 2004. *Building Communities in Gujarat: Architecture and Society during the 12th through 14th Centuries*. Leiden, the Netherlands: Brill.

——. 2006. "Revisiting the Term 'Sultanate.'" In *The Architecture of the Indian Sultanates*, edited by Abha Narain Lambah and Alka Patel, 8–12. Mumbai: Marg.

——. 2008. "The Mosque in South Asia: Beginnings." In *Piety and Politics in the Early Indian Mosque*, edited by Finbarr Barry Flood, 3–28. Debates in Indian History. New Delhi: Oxford University Press.

——. 2010. "Hind wa Sind: Textual and Material Evidence of Muslim Communities in 7th- and 8th-Century South Asia." Paper presented at the Association for Asian Studies Annual Conference, Philadelphia.

——. 2016. "Puja and Piety." *Burlington Magazine* 158 (1361): 680–82.

——. 2017. "The *Shahnama* in India." In *Epic Tales from Ancient India*, edited by Marika Sardar, 142–53. San Diego, CA: San Diego Museum of Art; New Haven, CT: Yale University Press.

Patel, Jashu, and Krishan Kumar. 2001. *Libraries and Librarianship in India*. London: Greenwood.

Patrinelis, Christos. 1988. *Stavronikita Monastery: History, Icons, Embroideries*. New Rochelle, NY: Aristide D. Caratzas.

Patton, Pamela A. 2012. *Art of Estrangement: Redefining Jews in Reconquest Spain*. University Park: Pennsylvania State University Press.

Paviot, Jacques. 2012. "Burgundy and the Crusade." In Norman Housley, *Crusading and the Ottoman Threat, 1453–1505*. Oxford: Oxford University Press.

Peers, Glen. 2004. *Sacred Shock: Framing Visual Experience in Byzantium*. University Park: Pennsylvania State University Press.

——. 2010. "Utopia and Heterotopia: Byzantine Modernisms in America." In *Defining Neomedievalism(s)*, edited by Karl Fugelso, 77–113. Studies in Medievalism 19. Cambridge, England: Cambridge University Press.

Pelekanidis, S. M. 1975. *The Treasure of Mount Athos. The Protatonn and the Monasteries of Dionysiou, Koutloumousiou, Xeropotamou and Gregoriou: Illuminated Manuscripts, Miniatures, Headpieces, Initial Letters*. Athens: Ekdotike Athenon S.A.; Thessaloniki, Greece: Patriarchal Institute for Patristic Studies.

Pendergast, David M. 1979. *Excavations at Altun Ha, Belize 1964–1970*. Toronto: Royal Ontario Museum.

Peters, F. E. 1985. *Jerusalem: The Holy City in the Eyes of Chroniclers, Visitors, Pilgrims, and Prophets from the Days of Abraham to the Beginnings of Modern Times*. Princeton, NJ: Princeton University Press.

Petrossian, Karen, and Bernard Roussel, eds. 2006. *Indigo: Les routes de l'Afrique bleue*. Aix-en-Provence, France: Édisud.

Philips, C. H., ed. 1961. *Historians of India, Pakistan, and Ceylon*. London: School of Oriental and African Studies and Oxford University Press.

Phillips, Kim M. 2014. *Before Orientalism: Asian Peoples and Cultures in European Travel Writing, 1245–1510*. Philadelphia: University of Pennsylvania Press.

Phillips, William D., Jr. 2013. *Slavery in Medieval and Early Modern Iberia*. Philadelphia: University of Pennsylvania Press.

Piera, Monserrat, ed. 2018. *Remapping Travel Narratives, 1000–1700: To the East and Back Again*. Leeds, England: ARC Humanities Press.

Pierson, Stacey. 2012. "The Movement of Chinese Ceramics: Appropriation in Global History." *Journal of World History* 23 (1): 9–39.

Pigeaud, Theodore. 1960. *Java in the 14th Century: A Study in Cultural History*. The Hague, the Netherlands: M. Nijhoff.

Pillsbury, Joanne. 2017. "Imperial Radiance: Luxury Arts of the Incas and Their Predecessors." In *Golden Kingdoms: Luxury Arts in the Ancient Americas*, 33–43. Los Angeles: The J. Paul Getty Museum and Getty Research Institute.

Pillsbury, Joanne, Timothy Potts, and Kim Richter. 2017. *Golden Kingdoms: Luxury Arts in the Ancient Americas*. Los Angeles: The J. Paul Getty Museum and Getty Research Institute.

Piñon, Alida. 2018. "El INAH confirma: Códice Maya es auténtico." *El Universal* (Mexico City), August 31, 2018, E10.

Pinto, Karen C. 2016. *Medieval Islamic Maps: An Exploration*. Chicago: University of Chicago Press.

Piqué, Francesca, and Leslie H. Rainer. 1999. *Palace Sculptures of Abomey: History Told on Walls*. Los Angeles: Getty Publications.

Plankensteiner, Barbara. 2010. *Benin (Visions of Africa)*. Milan: 5 Continents.

Pollock, Griselda. 2014. "Wither Art History?" *Art Bulletin* 96 (1): 9–23.

Pomeranz, Kenneth. 2012. "Areas, Networks, and the Search for 'Early Modern' in East Asia." In *Comparative Early Modernities, 1100–1800*, edited by David Porter, 245–69. New York: Palgrave Macmillan.

Porter, David. 2012. *Comparative Early Modernities, 1100–1800*. New York: Palgrave Macmillan.

Pouwels, Randall. 2002. *Horn and Crescent: Cultural Change and Traditional Islam on the East African Coast, 800–1900*. Cambridge, England: Cambridge University Press.

Power, Amanda, and Robin Whelan. 2017. *Medieval Intersectionality Conference, Taylor Institute, St. Giles, Oxford, UK, March 15, 2017*. http://torch.ox.ac.uk/medieval-intersectionality.

Prawer, Joshua. 1988. "The Hebrew Itineraries of the Crusader Period." In *The History of the Jews in the Latin Kingdom of Jerusalem*, edited by Joshua Prawer, 169–250. Oxford: Oxford University Press.

Preiser-Kapeller, Johannes. 2015. "Calculating the Middle Ages? The Project 'Complexities and Networks in the Medieval Mediterranean and the Near East.'" *Medieval Worlds* 2:100–127.

———. 2019. "Migration." In *A Companion to the Global Early Middle Ages, 600–900 CE*, edited by Erik Hermans. Leeds, England: ARC Humanities Press.

Preiser-Kapeller, Johannes, and Ekaterini Mitsiou, eds. 2011. "Byzanz und der Rest der Welt, 800–1204: Von Karl dem Grossen bis zu den Kreuzzügen." *Historicum: Zeitschrift für Geschichte*, 3–82.

Prezbindowski, Lauren. 2012. "The Ilkhanid Mongols, the Christian Armenians, and the Islamic Mamluks: A Study of their Relations, 1220–1335." PhD diss., University of Louisville.

Pritchett, Francis W. 2012. "Hamza-Nama II. In the Subcontinent." *Encyclopaedia Iranica, Online Edition*. http://www.iranicaonline.org/articles/hamza-nama-ii.

Proskouriakoff, Tatiana. 1968. "Olmec and Maya Art: Problems of Their Stylistic Relation." In *Dumbarton Oaks Conference on the Olmec*, edited by Elizabeth P. Benson, 119–34. Washington, DC: Dumbarton Oaks.

Pryor, John. 2013. "The Mediterranean Breaks Up: 500–1000." In *The Mediterranean in History*, edited by David Abulafia, 151–81. London: Thames and Hudson.

Quinn, Rebecca C. 2011. "Santiago as Matamoros: Race, Class, and *Limpieza de Sangre* in a Sixteenth-Century Spanish Manuscript." The Larrie and Bobbi Weil Undergraduate Research Award Documents 1. Dallas: Southern Methodist University. http://digitalrepository.smu.edu/weil_ura/1/.

Raby, Julian. 1987. "East and West in Mehmed the Conqueror's Library." *Bulletin du Bibliophile* 3:296–318.

"Race, Racism and the Middle Ages" series. 2017. *The Public Medievalist*. http://www.publicmedievalist.com/race-racism-middle-ages-toc/.

Rapoport, Yossef, and Emilie Savage-Smith, eds. and trans. 2014. *An Eleventh-Century Egyptian Guide to the Universe: The Book of Curiosities*. Leiden, the Netherlands: Brill.

Réau, Louis. 1955–59. *Iconographie de l'art chrétien*, 3 vols. in 6. Paris: Presses universitaires de France.

Reed, Marcia. 2011. *China on Paper: European and Chinese Works from the Late Sixteenth to the Early Nineteenth Century*. Los Angeles: Getty Research Institute.

Reents-Budet, Dorie, Sylviane Boucher le Landais, Ronald L. Bishop, and M. James Blackman. 2010. "Codex-Style Ceramics: New Data Concerning Patterns of Production and Distribution." Paper presented at the XXIV Simposio de Investigaciones Arqueológicas en Guatemala, National Museum of Archaeology and Ethnology, Guatemala City, July 19–24, 2010.

Reese, Scott, ed. 2004. *The Transmission of Learning in Islamic Africa*. Leiden, the Netherlands: Brill.

Reimer, Stephen R. 2015. "Punctuation." *Manuscript Studies Medieval and Early Modern*. http://www.ualberta.ca/~sreimer/ms-course/course/punc.htm.

Reiner, Elchanan. 2002. "Traditions of Holy Places in Medieval Palestine—Oral versus Written." In *Offerings from Jerusalem: Portrayals of Holy Places by Jewish Artists*, edited by Rachel Sarfati, 9–19. Jerusalem: Israel Museum.

Reingold, Edward M., and Nachum Dershowitz. 2017. *Calendrical Calculations: The Ultimate Edition*. 4th ed. Cambridge, England: Cambridge University Press.

Réschillerau, Louis. 1955–59. *Iconography of Christian Art* 2. Paris: University Presses of France.

Restall, Matthew, and J. F. Chuchiak. 2002. "A Re-evaluation of the Authenticity of Fr. Diego de Landa's *Relación de las Cosas de Yucatán*." *Ethnohistory: Journal of the American Society for Ethnohistory* 49 (3): 651–69.

Reynolds, Catherine. 1996. "Fastolf Master." In vol. 20 of *Dictionary of Art*, edited by Jane Turner, 664. New York: Grove.

Reynolds, Michael T. 1993. "René of Anjou, King of Sicily, and the Order of the Croissant." *Journal of Medieval History* 19 (1): 125–61.

Reynolds Brown, Katharine. 2000. *From Attila to Charlemagne: Arts of the Early Medieval Period in the Metropolitan Museum of Art*. New York: Metropolitan Museum of Art.

Rich, Michelle, Matthew H. Robb, Varinia Matute, David Freidel, and F. Kent Reilly. 2012. "Una figurilla de estilo olmeca del Entierro 39, el Perú-Waká, Petén, Guatemala." In *XXV Simposio de Investigaciones Arqueológicas en Guatemala, 2011*, edited by Bárbara Arroyo, Lorena Paiz, and Héctor Mejía, 1146–84. Guatemala City: Ministerio de Cultura y Deportes, Instituto de Antropología e Historia y Asociación Tikal.

Richards, Anne R., and Iraj Omidvar. 2014. *Historic Engagements with Occidental Cultures, Religions, Powers*. New York: Palgrave Macmillan.

Richter, Kim. 2017. "Bright Kingdoms: Trade Networks, Indigenous Aesthetics, and Royal Courts in Postclassic Mesoamerica." In *Golden Kingdoms: Luxury Arts in the Ancient Americas*, edited by Joanne Pillsbury, Timothy Potts, and Kim Richter, 99–109. Los Angeles: The J. Paul Getty Museum and Getty Research Institute.

Ridpath, Ian. 1988 (2018). "Charting the Chinese Sky: The Dunhuang Star Chart." http://www.ianridpath.com/startales/chinese2.htm/.

Riello, Giorgio, and Anne Gerritsen. 2016. *The Global Lives of Things: The Material Culture of Connections in the Early Modern World*. London: Routledge.

Riello, Giorgio, and Tirthankar Roy. 2013. *How India Clothed the World: The World of South Asian Textiles, 1500–1850*. Leiden, the Netherlands: Brill.

Ringrose, Kathryn M. 1994. "Living in the Shadows: Eunuchs and Gender in Byzantium." In *Third Sex, Third Gender: Beyond Sexual Dimorphism in Culture and History*, edited by G. Herdt, 85–109, 507–18. New York: Zone Books.

———. 2003. *The Perfect Servant: Eunuchs and the Social Construction of Gender in Byzantium*. Chicago: University of Chicago Press.

Robson, Stuart. 1995. *Deśawarnana*. Leiden, the Netherlands: KITLV Press.

Rogers, J. Michael. 2002. "Great Britain xi. Persian Art Collections in Britain." In *Encyclopædia Iranica*. Iranica Online. http://www.iranicaonline.org/articles/great-britain-xi.

———. 2010. "Text and Illustration: Dioscorides and the Illustrated Herbal in the Arab Tradition." In *Arab Painting: Text and Image in Illustrated Arabic Manuscripts*, edited by Anna Contadini, 41–48. Leiden, the Netherlands: Brill.

Rollins, Jack. 1983. *From the Earliest Times to the End of the Nineteenth Century*. Part 1 of *A History of Swahili Prose*. Leiden, the Netherlands: Brill.

Rose, Emily. 2015. *The Murder of William of Norwich: The Origins of the Blood Libel in Medieval Europe*. Oxford: Oxford University Press.

Rosen, Mark. 2015. *The Mapping of Power in Renaissance Italy: Painted Cartographic Cycles in Social and Intellectual Context*. Cambridge, England: Cambridge University Press.

Rosenfield, John M., and Shūjirō Shimada. 1970. *Traditions of Japanese Art: Selections from the Kimiko and John Powers Collection*. Cambridge, MA: Fogg Art Museum.

Rosenfield, John M., et al. 1973. *The Courtly Tradition in Japanese Art and Literature*. Cambridge, MA: Fogg Art Museum.

Ross, Doran H. 1992. *Elephant: The Animal and Its Ivory in African Culture.* Los Angeles: Fowler Museum of Cultural History, University of California at Los Angeles.

———. 1994. *Visions of Africa: The Jerome L. Joss Collection of African Art at UCLA.* Los Angeles: Fowler Museum of Cultural History, University of California at Los Angeles.

Ross, Elizabeth. 2014. *Picturing Experience in the Early Printed Book: Breydenbach's Peregrinatio from Venice to Jerusalem*. University Park: Pennsylvania State University Press.

Ross, Eric S. 1994. "Africa in Islam: What the Afrocentric Perspective Can Contribute to the Study of Islam." *International Journal of Islamic and Arabic Studies* 11 (2): 1–36.

———. 2011. "A Historical Geography of the Trans-Saharan Trade." In *The Trans-Saharan Book Trade: Manuscript Culture, Arabic Literacy and Intellectual History in Muslim Africa*, edited by Graziano Krätli and Ghislaine Lydon, 1–34. Boston: Brill.

Rossi, Franco D., William A. Saturno, and Heather Hurst. 2015. "Maya Codex Book Production and the Politics of Expertise: Archaeology of a Classic Period Household at Xultun, Guatemala." *American Anthropologist* 117 (1): 116–32.

Roth, Catharine, and James Cousins, eds. and trans. 2002. *Suda Lexicon*, alphaiota 129 and alphaiota 138. "*Aithiops*" and "*Aithops*." Suda online, edited by David Whitehead, http://www.stoa.org/sol-entries/alphaiota/129 and www.stoa.org/sol-entries/alphaiota/138.

Roullier, Caroline, Laurie Benoit, Doyle B. McKey, and Vincent Lebot. 2013. "Historical Collections Reveal Patterns of Diffusion of Sweet Potato in Oceania Obscured by Modern Plant Movements and Recombination." In *Proceedings of the National Academy of Sciences of the United States of America* 110 (6): 2205–10. St. Louis, MO: Washington University.

Royal Asiatic Society. 1989. *Proceedings of the First International Conference on the History of Ethiopian Art. Sponsored by the Royal Asiatic Society.* Held at the Warburg Institute of the University of London, October 21 and 22, 1986. London: Pindar.

Rubiés, Joan-Pau. 2002. *Travel and Ethnology in the Renaissance: South India through European Eyes, 1250–1625.* Cambridge, England: Cambridge University Press.

———. 2009. *Medieval Ethnographies: European Perceptions of the World Beyond*. London: Routledge.

Rubin, Miri, and Walter Simons. 2009. *Christianity in Western Europe, c. 1100–c. 1500.* Cambridge, England: Cambridge University Press.

Rudy, Kathryn. 2011. *Virtual Pilgrimages in the Convent: Imagining Jerusalem in the Late Middle Ages.* Turnhout, Belgium: Brepols.

Ruiz, Teofilo. 2006. "Medieval Europe and the World: Why Medievalists Should Also Be World Historians." *History Compass* 4/6:1073–88.

Rujivacharakul, Vimalin, et al., eds. 2014. *Architecturalized Asia: Mapping a Continent through History (Spatial Habitus: Making and Meaning in Asia's Architecture).* Honolulu: Center for Korean Studies.

Ruvalcaba, Jose Luis, Sandra Zetina, Helena Calvo del Castillo, Elsa Arroyo, and Eumelia Hernandez. 2007. "The Grolier Codex: A Non Destructive Study of a Possible Maya Document Using Imaging and Ion Beam Techniques." In *MRS Proceedings 1047.* Cambridge, England: Cambridge University Press.

Ryder, Edmund C. 2000–. "Popular Religion: Magical Uses of Imagery in Byzantine Art." In *Heilbrunn Timeline of Art History.* New York: Metropolitan Museum of Art. http://www.metmuseum.org/toah/hd/popu/hd_popu.htm/.

Sacks, Jonathan. 2006. *Rabbi Jonathan Sacks's Haggadah: Hebrew and English Text with New Essays and Commentary*. New York: Continuum.

Sadeq, Moain. 2014. "Mamluk Cartouches and Blazons Displayed in the Museum of Islamic Arts, Doha: An Art Historic Study." *International Journal of Business, Humanities and Technology* 4 (2): 138–43.

Said, Edward. 1994. *Culture and Imperialism*. London: Vintage.

Salaman, Nina, trans. 1924. *Selected Poems of Jehuda Halevi*. Philadelphia: Jewish Publication Society of America.

Salomon, Frank, and Renata Peters. 2009. "Governance and Conservation of the Rapaz *Khipu* Patrimony." In *Intangible Heritage Embodied*, edited by D. Fairchild Ruggles and Helaine Silverman, 101–26. Berlin: Springer Science and Business Media.

Salomon, Richard. 1999. *Ancient Buddhist Scrolls from Gandhara: The British Library Kharosthi Fragments.* Seattle: University of Washington Press.

Samson, Ridder. 2012. "Swahili Manuscripts: Looking in East African Collections for Swahili Manuscripts in Arabic Script." Presented at "50 Years of Kiswahili as a Language of African Liberation, Unification and Renaissance," October 4–6, 2012, University of Dar es Salaam, Tanzania. Published online at https://www.academia.edu/26313364/SWAHILI_MANUSCRIPTS_Looking_in_East_African_Collections_for_Swahili_Manuscripts_in_Arabic_Script_1/.

Sarnow, Emil. 1920. *Handschriften, Einbände, Formschnitte und Kupferstiche des 15. Jahrhunderts, Druckwerke und Einblattdrucke des 15. Bis 20. Jahrhunderts (Katalog der Ständigen Ausstellung der Stadtbibliothek).* Frankfurt, Germany: Stadt- und Universitätsbibliothek.

Sassen, Saskia. 2006. *Territory, Authority, Rights: From Medieval to Global Assemblages.* Princeton, NJ: Princeton University Press.

Saturno, William, Heather Hurst, Franco Rossi, and David Stuart. 2015. "To Set before the King: Residential Mural Painting at Xultun, Guatemala." *Antiquity* 89 (343): 122–36.

Saturno, William, David Stuart, Anthony Aveni, and Franco Rossi. 2012. "Ancient Maya Astronomical Tables from Xultun, Guatemala." *Science* 336 (6082): 714–17.

Saurma-Jeltsch, L. E. 2010. "Saracens: Opponents to the Body of Christianity." *Medieval History Journal* 13 (1): 55–95.

Schaefer, Karl R. 2006. *Enigmatic Charms: Medieval Arabic Block Printed Amulets in American and European Libraries and Museums.* Leiden, the Netherlands: Brill.

Schaeken, Jos. 2012. *Stemmen op berkenbast.* Leiden, the Netherlands: Leiden University Press.

Scheindlin, Raymond P. 2008. *The Song of the Distant Dove: Judah Halevi's Pilgrimage.* Oxford: Oxford University Press.

Schele, Linda, and Mary Ellen Miller. 1986. *The Blood of Kings: Dynasty and Ritual in Maya Art.* Fort Worth, TX: Kimbell Art Museum.

Schiller, Gertrud. 1966–91. *Ikonographie der Christlichen Kunst.* Gütersloh, Germany: G. Mohn.

Schleif, Corine, and Volker Schier. 2016. *Manuscripts Changing Hands.* Wiesbaden, Germany: Harrassowitz Verlag.

Schorta, Regula. 2006. *Central Asian Textiles and Their Contexts in the Early Middle Ages.* Riggisberger Berichte 9. Riggisberg, Switzerland: Abegg-Stiftung.

Schüppel, Katharina Christa. 2014. "Negotiating the Global and the Local in Medieval Lives of St. Thomas: Florence, Biblioteca Riccardiana 1538, and Turin, Biblioteca Nazionale Universitaria, I.II.17." *Rivista di storia della miniature* 18:48–63.

Schwede, Rudolph. 1912. *Ueber das Papier der Maya Codices: U. einiger altmexikanischer Bilderhandschriften.* Dresden, Germany: Verlag von Richard Bertling.

Scott, Margaret. 2006. "The Role of Dress in the Image of Charles the Bold, Duke of Burgundy." In *Flemish Manuscript Painting in Context*, edited by Thomas Kren and Elizabeth Morrison, 43–56. Los Angeles: The J. Paul Getty Museum. Exhibition catalogue.

Seetah, Krish. 2018. *Connecting Continents: Archaeology and History in the Indian Ocean World.* Athens: Ohio University Press.

Segal, David Simha, trans. 2001. *The Book of Tahkemoni: Jewish Tales from Medieval Spain by Judah Harizi.* Portland: Littman Library of Jewish Civilization.

Selassie, Yohannes Gebre. 2011. "Plague as a Possible Factor for the Decline and Collapse of the Aksumite Empire: A New Interpretation." *Ityopis* 1:36–61.

Seler, Eduard G. 1898. "Die Venusperiode in den Bilderschriften der Codex-Borgia-Gruppe." *Zeitschrift fur Ethnologie* 30:346–83.

———. 1904. "The Venus Period in the Borgian Codex Group." In *Mexican and Central American Antiquities, Calendar Systems, and History*, edited by Charles P. Bowditch, 353–91. Washington, DC: Smithsonian Institution.

Sen, Tansen. 2014. Vol. 1 of *Buddhism across Asia: Networks of Material, Intellectual, and Cultural Exchange*. Singapore: ISEAS.

Seppou, Nadege. 2017. "The UnAfrican-ness of Africa's Fabric." *Huffington Post*, April 29, 2017. https://www.huffingtonpost.com/nadege-seppou /the-unafricanness-of-afri_b_9801874.html/.

Ševčenko, Ihor. 1962. "The Illuminators of the Menologium of Basil II." *Dumbarton Oaks Papers* 16:245–76.

———. 1972. "On Pantoleon the Painter." *Jahrbuch der Österreichischen Byzantinistik* 21:241–49.

Shatzmiller, Joseph. 2017. *Cultural Exchange: Jews, Christians, and Art in the Medieval Marketplace*. Princeton, NJ: Princeton University Press.

Shaw, Miranda. 2006. *Buddhist Goddesses of India*. Princeton, NJ: Princeton University Press.

Shinn, David Hamilton, and Thomas P. Ofcansky. 2013. *Historical Dictionary of Ethiopia*. Lanham, MD: Scarecrow.

Shook, Edwin M. 1947. "Guatemala Highlands." *Carnegie Institution of Washington Yearbook* 46:179–84.

———. 1948. "Guatemala Highlands." *Carnegie Institution of Washington Yearbook* 47:214–18.

Shryock, Andrew, and Daniel Lord Smail. 2011. *Deep History*. Berkeley: University of California Press.

Signer, M. A. 1983. "Introduction." In *The Itinerary of Benjamin of Tudela: Travels in the Middle Ages*. Translated by Nathan Adler and A. Asher. Malibu, CA: Joseph Simon.

Simeon, Joel Ben. 2011. *The Washington Haggadah*. Boston: Harvard University Press.

Simpson, Marianna Shreve. 2002. "Shah ʿAbbas and His Picture Bible." In *The Book of Kings: Art, War and the Morgan Library's Medieval Picture Bible*, edited by William Noel Louis and Daniel H. Weiss, 120–41. Baltimore: Walters Art Museum.

———. 2005. "The Morgan Bible and the Giving of Religious Gifts between Iran and Europe / Europe and Iran during the Reign of Shah ʿAbbas I." In *Between the Picture and the Word*, edited by Colum P. Hourihane. Princeton, NJ: Index of Christian Art Publications.

———. 2011. "Gifts for the Shah: An Episode in Hapsburg-Safavid Relations during the Reigns of Philip III and Abbas I." In *Gifts of the Sultan: The Arts of Giving at the Islamic Courts*, edited by Linda Komaroff and Sheila Blair, 125–31. Los Angeles: Los Angeles County Museum of Art.

———. 2017. "The Arts of Gifting between Safavids and Habsburgs." In *A Companion to Islamic Art and Architecture II: From the Mongols to Modernism*, edited by Finbarr Barry Flood and Gülru Necipoğlu, 951–71. London and Hoboken, NJ: John Wiley and Sons.

Sindbæk, Søren Michael. 2007. "The Small World of the Vikings: Networks in Early Medieval Communication and Exchange." *Norwegian Archaeological Review* 40 (1): 59–74.

Singh, Upinder, and Parul Pandya Dhar. 2014. *Asian Encounters: Exploring Connected Histories*. Oxford: Oxford University Press.

Singleton, Brent D. 2004. "African Bibliophiles: Books and Libraries in Medieval Timbuktu." *Libraries and Culture* 39 (1): 1–12.

Skelton, Robert. 1962. "The Cartography of the Voyages." In James Alexander Williamson, *The Cabot Voyages and Bristol Discovery under Henry VIII*, 308–11. London: Hakluyt Society.

———. 1978. "The *Iskandar Nama* of Nusrat Shah." In *Indian Painting: Mughal and Rajput and a Sultanate Manuscript*, 133–52. London: P. & D. Colnaghi.

Smith, A. L. 1947. "Guatemala Highlands." *Carnegie Institution of Washington Yearbook* 46:184–87.

Smith, Catherine Delano. 1987. "Cartography in the Prehistoric Period in the Old World: Europe, the Middle East, and North Africa." In *Cartography in Prehistoric, Ancient, and Medieval Europe and the Mediterranean*, 54–101. Vol. 1 of *The History of Cartography*, edited by J. B. Harley and David Woodward. Chicago: University of Chicago Press.

Smith, D. Romney. 2016. "Across an Open Sea: Mediterranean Networks and Italian Trade in an Era of Calamity." PhD diss., Centre for Medieval Studies, University of Toronto.

Smith, Judith G., ed. 1998. *Arts of Korea*. New York: Metropolitan Museum of Art.

Smith, Mary Elizabeth. 1973. *Picture Writing from Ancient Southern Mexico: Mixtec Place Signs and Maps*. Norman: University of Oklahoma Press.

———. 1994. "Why the Second Codex Selden Was Painted." In *The Caciques and Their People: A Volume in Honor of Ronald Spores*, edited by Joyce Marcus and Judith Francis Zeitlin, 111–41. Ann Arbor: Museum of Anthropology, University of Michigan.

Smith, Phillippa Mein. 2009. "Mapping Australasia." *History Compass* 7 (4): 1–24.

Smith, Robert E. 1937. "A Study of Structure A-I Complex at Uaxactun, Peten, Guatemala." *Contributions to American Archaeology* 3 (19): 189–231. Washington, DC: Carnegie Institution of Washington.

Smythe, Dion. 2016. *Strangers to Themselves: The Byzantine Outsider: Papers from the Thirty-Second Spring Symposium of Byzantine Studies, University of Sussex, Brighton, March 1998*. Abingdon, England: Routledge.

Snijders, Ludo, Tim Zaman, and David Howell. 2016. "Using Hyperspectral Imaging to Reveal a Hidden Prehispanic Codex." *Journal of Archaeological Science: Reports* 9:143–49.

Sobecki, Sebastian I. 2007. *The Sea and Medieval English Literature*. Cambridge, England: D. S. Brewer.

———. 2011. *The Sea and Englishness in the Middle Ages: Maritime Narratives, Identity and Culture*. Cambridge, England: D. S. Brewer.

Sorimachi, Shigeo. 1978. *Catalogue of Japanese Illustrated Books and Manuscripts in the Spencer Collection of the New York Public Library*. Tokyo: Kōbunsō.

Southgate, Minoo S. 1978. *Iskandarnamah: A Persian Medieval Alexander-Romance*. New York: Columbia University Press.

Spencer, Brian. 1998. *Pilgrim Souvenirs and Secular Badges*. London: Museum of London.

Spinden, Herbert. 1913. *A Study of Maya Art: Its Subject Matter and Historical Development*. Cambridge, MA: Peabody Museum.

Spink, Michael, et al. 2013. *The Art of Adornment: Jewellery of the Islamic Lands*. London: Nour Foundation.

Stahuljak, Zrinka. 2010. "Minor Empires: Translation, Conflict, and Postcolonial Critique." *The Translator* 16 (2): 255–74.

———. 2013. "The Sexuality of History: The Demise of Hugh Despenser, Roger Mortimer, and Richard II in Jean le Bel, Jean Froissart, and Jean d'Outremeuse." In *Violence and the Writing of History in the Medieval Francophone World*, edited by Noah D. Guynn and Zrinka Stahuljak, 133–47. Cambridge, England: D. S. Brewer.

Staikos, Konstantinos, Sp. 2004. *From Minos to Cleopatra*. Translated by Timothy Cullen. Vol. 1 of *The History of the Library in Western Civilization*. New Castle, DE: Oak Knoll.

Starr, S. Frederick. 2013. *Lost Enlightenment: Central Asia's Golden Age, from the Arab Conquest to Tamerlane*. Princeton, NJ: Princeton University Press.

Stchoukine, Ivan, et al. 1971. *Illuminierte islamische Handschriften*. Wiesbaden, Germany: Franz Steiner.

Stephenson, Paul. 2003. *The Legend of Basil the Bulgar-Slayer*. Cambridge, England: Cambridge University Press.

Stern, David. 2017. *The Jewish Bible: A Material History*. Seattle and London: University of Washington Press.

Stevenson, Edward Luther. 2012. *Terrestrial and Celestial Globes: Their History and Construction, Including a Consideration of Their Value as Aids in the Study of Geography and Astronomy.* Project Gutenberg, 26–33. https://www.gutenberg.org/files/39866/39866-h/39866-h.htm.

Stewart, Devin. 2006. "The *Maqama.*" In *The Cambridge History of Arabic Literature in the Post-Classical Period,* edited by Roger Allen and D. S. Richards, 145–58. Cambridge, England: Cambridge University Press.

Stokstad, Marilyn. 2004. *Medieval Art.* 2nd ed. Boulder, CO: Westview.

Strauch, Ingo, ed. 2012. *Foreign Sailors on Socotra: The Inscriptions and Drawings form the Cave Hoq.* Vergleichende Studien zu Antike und Orient 3. Bremen, Germany: Hempen Verlag.

Strelcyn, Stefan. 1955. *Prières magiques éthiopiennes pour délier les charmes (maftḥe šǝrāy).* Warsaw, Poland: Pánstwowe Wydawnicto Naukowe.

Strickland, Debra Higgs. 2003. *Saracens, Demons, and Jews: Making Monsters in Medieval Art.* Princeton, NJ: Princeton University Press.

———. 2005. "Artists, Audience, and Ambivalence in Marco Polo's *Divisament dou Monde.*" *Viator* 36:493–529.

Strong, S. Arthur. 1895. "The History of Kilwa." *Journal of the Royal Asiatic Society* 272:385–430.

Stuart, George E. 1994. "Introduction." In *The Paris Codex: A Handbook for a Maya Priest,* edited by Bruce Love, xvii. Austin: University of Texas Press.

Sturtevant, Paul B. 2017. "Leaving 'Medieval' Charlottesville." *Public Medievalist* "Race, Racism and the Middle Ages" series. August 17, 2017. https://www.publicmedievalist.com/leaving-medieval-charlottesville/.

Sturtevant, William C., and David Beers Quin. 1987. "This New Prey: Eskimos in Europe in 1567, 1576, and 1577." In *Indians and Europeans: An Interdisciplinary Collection of Essays,* edited by Christian F. Feest, 61–140. Lincoln: University of Nebraska Press.

Suarez, Michael F., and H. R. Woudhuysen. 2010. *The Oxford Companion to the Book.* Oxford: Oxford University Press.

Suarez, Michael F., et al., eds. 2014. *The Book: A Global History.* Oxford: Oxford University Press.

Subrahmanyam, Sanjay. 1997. "Connected Histories: Notes towards a Reconfiguration of Early Modern Eurasia." *Modern Asian Studies* 31 (3): 735–62.

———. 2001. "Golden Age Hallucinations." *Outlook India Magazine,* August 20, 2001. https://www.outlookindia.com/magazine/story/golden-age-hallucinations/212957.

Sullivan, Bruce M., ed. 2015. *Sacred Objects in Secular Spaces: Exhibiting Asian Religions in Museums.* London: Bloomsbury Academic.

Sullivan, Michael. 1967. *The Arts of China.* 5th ed. Berkeley: University of California Press.

Summers, David. 2003. *Real Spaces: World Art History and the Rise of Western Modernism.* New York: Phaidon.

Suzhou Museum. 2006. *Huqiu Yunyansi ta, Ruiguangsi ta wenwu* [The Cultural Relics of the Pagoda of Yunyan Temple and the Pagoda of Ruiguan Temple at Tiger Hill, Suzhou], 159–64. Beijing: Wenwu chubanshe.

Swadling, Pamela. 1997. *Plumes from Paradise: Trade Cycles in Outer Southeast Asia and Their Impact on New Guinea and Nearby Islands until 1920.* Boroko: Papua New Guinea National Museum.

Swanson, R. N. 2015. *The Routledge History of Medieval Christianity, 1050–1500.* London: Routledge.

Swarenski, Georg, and Rosy Schilling. 1929. *Die illuminierten Handschriften und Einzelminiaturen des Mittelalters und der Renaissance in Frankfurter Besitz.* Frankfurter Bibliophilen-Gesellschaft, 69–73, no. 67. Frankfurt, Germany: Baer.

Tahan, Illana. 2017. "A Judeo-Persian Epic, the Fath Nama (Book of Conquest)." British Library blog, September 27, 2017. http://blogs.bl.uk/asian-and-african/2017/09/a-judeo-persian-epic-the-fath-nama-book-of-conquest.html.

Tambiah, Stanley Jeyaraja. 1990. *Magic, Science, Religion, and the Scope of Rationality.* Cambridge, England: Cambridge University Press.

Tanabe, Willa J. 1988. *Paintings of the Lotus Sutra.* New York: John Weatherhill.

Tanner, Jeremy. 2010. "Introduction to the New Edition: Race and Representation in Ancient Art: *Black Athena* and After." In *From the Pharaohs to the Fall of the Roman Empire,* 1–39. Vol. 1 of *The Image of the Black in Western Art,* edited by David Bindman and Henry Louis Gates Jr. Cambridge, MA: Belknap.

Taube, Karl L., and Bonnie L. Bade. 1991. *An Appearance of Xiuhtecuhtli in the Dresden Venus Pages.* Washington, DC: Mesoweb Center for Maya Research.

Taylor, Alice. 1995. *Book Arts of Isfahan: Diversity and Identity in Seventeenth-Century Persia.* Malibu, CA: The J. Paul Getty Museum.

"Thème universel." 2017. *La Gazette Drouot* 3:129.

Thomas, Kenneth J., and Ali Asghar Aghbar. 2015. *A Restless Search: A History of Persian Translations of the Bible.* Philadelphia: Nida Institute for Biblical Scholarship, American Bible Society.

Thompson, John Eric Sidney. 1960. *Maya Hieroglyphic Writing: Introduction.* Norman: University of Oklahoma Press.

———. 1972. *A Commentary on the Dresden Codex: A Maya Hieroglyphic Book.* Philadelphia: American Philosophical Society.

Thompson, Jon, and Sheila R. Canby. 2003. *Hunt for Paradise: Court Arts of Safavid Iran 1501–1576.* Milan, Italy: Skira Editore.

Thrush, Coll. 2013. "Meere Strangers: Indigenous and Urban Performances in Algonquian London, 1580–1630." In *Urban Identity and the Atlantic World,* edited by E. Fay and L. von Morze, 195–281. New York: Palgrave Macmillan.

Tignor, Robert, et al. 2013. *Worlds Together, Worlds Apart.* 4th ed. New York: W. W. Norton.

Tilander, Gunnar. 1956. *Vidal Mayor. Traducción aragonesa de la obra "In excelsis Dei thesauris" de Vidal de Canellas.* 3 vols. Lund, Sweden: Ohlsson.

Timbuktu: Script and Scholarship. 2008. Prepared by the Tombouctou Manuscripts Project and Iziko Social History Collections Department. Cape Town, South Africa: Tombouctou Manuscripts Project.

Titley, Norah M. 1964. "An Illustrated Persian Glossary of the Sixteenth Century." *British Museum Quarterly* 29 (1/2): 15–19.

———. 2005. *The Ni'matnama Manuscript of the Sultans of Mandu: The Sultan's Book of Delights.* London: Routledge.

Tobriner, Stephen. 1972. "The Fertile Mountain: An Investigation of Cerro Gordo's Importance to the Town Plan and Iconography of Teotihuacán." In *Teotihuacán XI Mesa Redonda,* edited by Alberto Ruz, 103–15. Mexico City: Sociedad Mexicana de Antropología.

Tolan, John. 2002. *Saracens: Islam in the Medieval European Imagination.* New York: Columbia University Press.

———. 2009. *Saint Francis and the Sultan: The Curious History of a Christian-Muslim Encounter.* Oxford: Oxford University Press.

Tolan, John, et al. 2013. *Europe and the Islamic World: A History.* Translated by Jane Marie Todd. Princeton, NJ: Princeton University Press.

Touati, Houari. 2010. *Islam and Travel in the Middle Ages.* Chicago: University of Chicago Press.

Tougher, Sean. 2008. *The Eunuch in Byzantine History and Society.* London: Routledge.

Touwaide, Alain. 2016. "Agents and Agencies? The Many Facets of Translation in Byzantine Medicine." In *Medieval Textual Cultures: Agents of Transmission, Translation and Transformation,* edited by Faith Wallis and Robert Wisnovsky, 13–38. Berlin: De Gruyter.

Townshend, Dale. 2014. *Terror and Wonder: The Gothic Imagination.* London: British Library.

Tozzer, Alfred M. 1941. *Landa's Relación de las cosas de Yucatán: A Translation.* Cambridge, MA: Peabody Museum of Archeology and Ethnology.

Trau, Adam M. 2012. "The Glocalisation of World Heritage at Chief Roi Mata's Domain, Vanuatu." *Historic Environment* 24 (3): 4–11.

Trexler, Richard C. 1973. "Ritual Behavior in Renaissance Florence: The Setting." In vol. 4 of *Medievalia et Humanistica: Studies in Medieval and Renaissance Culture,* edited by Paul Maurice Clogan, 131–32. Denton: North Texas State University.

Trivellato, Francesca, Leor Halevi, and Catia Antunes, eds. 2014. *Religion and Trade: Cross-Cultural Exchanges in World History, 1000–1900*. Oxford: Oxford University Press.

Troyer, Pamela. 2017. "Canterbury Trails: Walking with Immigrants, Refugees, and the Man of Law." The Once and Future Classroom: Resources for Teaching the Middle Ages. https://once-and-future-classroom.org /canterbury-trails-walking-with-immigrants-refugees-and-the-man -of-law/.

Tsien, T. H. 1985. *Paper and Printing*. Vol 5.1 of *Science and Civilisation in China*. Cambridge, England: Cambridge University Press.

Turner, Nancy. 1998. "The Recipe Collection of Johannes Alcherius and the Painting Materials used in Manuscript Illumination in France and Northern Italy, c. 1380–1420." In *Painting Techniques: History, Materials, and Studio Practice. Contributions to the Dublin Congress, 7–11 September 1998*, edited by Ashok Roy and Perry Smith, 45–50. London: International Institute for Conservation.

——. 2009. "Cases in Reconstructing the Fragment: The Conservation Treatment of Single Leaves and Cuttings." In *Care and Conservation of Manuscripts 11*, edited by Matthew James Driscoll and Ragnheiður Mósesdóttir, 215–42. Copenhagen, Denmark: København Royal Library.

——. 2018. "Reflecting a Heavenly Light: Gold and Other Metals in Medieval and Renaissance Manuscript Illumination." In vol. 1 of *Manuscripts in the Making: Art and Science*, edited by Stella Panayotova and Paola Ricciardi, 77–92. London and Turnhout, Belgium: Harvey Miller.

Turner, Nancy, Elena Phipps, and Karen Trentleman. 2008. "Colors, Textiles and Artistic Production in Martín de Murúa, *Historia General del Piru*, J. Paul Getty Museum." In *The Getty Murúa: Essays on the Making of the "Historia General del Piru,"* edited by Thomas B. F. Cummins and Barbara Anderson, 125–46. Los Angeles: Getty Research Institute.

Turner, Nancy, and Catherine Schmidt Patterson. 2017. "New Discoveries in the Painting Materials in the Medieval Mediterranean: Connections between Manuscript Illumination and Glass Technology during the Byzantine Era, c. 1100–1300." In vol. 1 of *Manuscripts in the Making: Art and Science*, edited by Stella Panayotova and Paola Ricciardi, 186–97. London and Turnhout, Belgium: Harvey Miller.

Turner, Nancy, David Scott, Narayan Khandekar, Michael Schilling, Yoko Taniguchi, and Herant Khanjian. 2001. "Technical Examination of a 15th Century German Illuminated Manuscript on Paper: A Case Study in the Identification of Materials." *Studies in Conservation* 46 (2): 93–108.

Turner, Nancy, and Karen Trentleman. 2009. "Investigation of the Painting Materials and Techniques of the Late 15th Century Manuscript Illuminator Jean Bourdichon." *Journal of Raman Spectroscopy* 40 (5): 577–84.

Ubieto Arteta, Antonio, et al. 1989. *Vidal Mayor. Estudios*. 2 vols. Huesca, Spain: Excma. Diputación Provincial.

Uluç, Lale. 2011. "Gifted Manuscripts from the Safavids to the Ottomans." In *Gifts of the Sultan: The Arts of Giving at the Islamic Courts*, edited by Linda Komaroff, 144–45, 263. Los Angeles: Los Angeles County Museum of Art.

Umberger, Emily. 1987. "Antiques, Revivals, and References to the Past in Aztec Art." *Res: Anthropology and Aesthetics* 13:62–105.

——. 2016. "Aztec Art in Provincial Places: Water Concerns, Monumental Sculptures, and Imperial Expansion." In *Altera Roma: Art and Empire from Mérida to Mexico*, edited by John M. D. Pohl and Claire L. Lyons, 109–46. Los Angeles: Cotsen Institute of Archaeology.

United States Department of Energy, Brookhaven National Library. 2013. *Dating the Vinland Map*. Washington, DC: United States Department of Energy.

Urton, Gary. 2007. "A Multi-Year Tukapa Calendar." In *Skywatching in the Ancient World: New Perspectives in Cultural Astronomy, Studies in Honor of Anthony F. Aveni*, edited by Clive Ruggles and Gary Urton, 245–68. Boulder: University Press of Colorado.

——. 2017. "Writing the History of an Ancient Civilization without Writing: Reading the Inka Khipus as Primary Sources." *Journal of Anthropological Research* 73 (1): 1–20.

Utz, Richard J., and Jesse G. Swan. 2004. *Postmodern Medievalisms*. Cambridge, England: Brewer.

Vail, Gabrielle. 2006. "The Maya Codices." *Annual Review of Anthropology* 35. Palo Alto, CA: Annual Reviews.

Vail, Gabrielle, and Anthony F. Aveni, eds. 2004. *The Madrid Codex: New Approaches to Understanding an Ancient Maya Manuscript*. Boulder: University Press of Colorado.

Vallet, Eric, Sandra Aube, and Thierry Kouamé. 2013. *Lumières de la Sagesse: Écoles Médiévales d'Orient et d'Occident*. Paris: Publications de la Sorbonne and Institut du Monde Arabe.

van den Gheyn, J. 1910. *Histoire De Charles Martel: Reproduction Des 102 Miniatures De Loyset Liédet (1470)*. Brussels: Vromant.

van den Hoonard, Will C. 2013. *Map Worlds: A History of Women in Cartography*. Waterloo, Canada: Wilfrid Laurier University Press.

Van der Meij, Th. C. 2017. *Indonesian Manuscripts from the Islands of Java, Madura, Bali, and Lombok*. Leiden, the Netherlands: Brill.

van Doesburg, Sebastián, and Javier Urcid. 2017. "Two Fragments of an Ancient Mantic Manuscript from San Bartolo Yautepec, Oaxaca." *Ancient Mesoamerica* 28 (2): 403–21.

van Duzer, Chet. 2016. *Apocalyptic Cartography: Thematic Maps and the End of the World in a Fifteenth-Century Manuscript*. Leiden, the Netherlands: Brill.

Van Lint, Theo Maarten, and Robin Meyer. 2015. *Armenia: Masterpieces from an Enduring Culture*. Oxford: Bodleian Library and University of Oxford.

Vaughan, Richard, and Graeme Small. 1970. *Philip the Good: The Apogee of Burgundy*. London: Longmans, Green.

Vedeler, Marianne. 2014. *Silk for the Vikings*. Oxford: Oxbow Books.

Velásquez García, Erik. 2009. "Reflections on the Codex Style and the Princeton Vessel." *PARI Journal* 10 (1): 1–16.

Verkerk, Dorothy Hoogland. 2001. "Black Servant, Black Demon: Color Ideology in the Ashburnham Pentateuch." *Journal of Medieval and Early Modern Studies* 31 (1): 57–77.

——. 2004. *Early Medieval Bible Illumination and the Ashburnham Pentateuch*. Cambridge, England: Cambridge University Press.

Vernay-Nouri, Annie, and Annie Berthier. 2011. *Enluminures en terre d'Islam: Entre abstraction et figuration*. Paris: Le Grand livre du mois.

Visonà, Monica Blackmun, Robin Poynor, and Herbert M. Cole, eds. 2007. *A History of Art in Africa*. London: Pearson.

Voelkle, William. 2005. "Provenance and Place: The Morgan Picture Bible." In *Between the Picture and the Word*, edited by Colum P. Hourihane, 12–23. Princeton, NJ: Index of Christian Art.

Voelkle, William M., and Susan L'Engle. 1998. *Illuminated Manuscripts: Treasures of the Pierpont Morgan Library*. New York: Abbeville.

Vogel, Susan. 1991. "Always True to the Object, in Our Fashion." In *Exhibiting Cultures: The Poetics and Politics of Museum Display*, edited by Ivan Karp and Steven Lavine, 191–204. Washington, DC: Smithsonian Books.

——. 2004. "Always True to the Object, in Our Fashion." In *Grasping the World: The Idea of the Museum*, edited by Donald Preziosi and Claire Farago, 653–85. Burlington, VT: Ashgate.

von den Brincken, Anna-Dorothee. 1973. *Die "Nationes Christianorum Orientalium" im Verständnis der lateinischen Historiographie*. Cologne: Böhlau.

Von Fircks, Juliane, and Regula Schorta, eds. 2016. *Oriental Silks in Medieval Europe*. Vol. 21 of *Riggisberger Berichte*. Riggisberg, Switzerland: Abegg-Stiftung.

Von Folsach, Kjeld. 2008. *For the Privileged Few: Islamic Miniature Painting from the David Collection*. Humlebaek, Denmark: Louisiana Museum of Modern Art.

von Hagen, Victor Wolfgang. 1944. *The Aztec and Maya Papermakers*. New York: J. J. Augustin.

Vyner, Tim. 2014. *An Experience of Life on Mount Athos*. Thessaloniki, Greece: Hagioreitike Hestia.

Waddell, Eric, Vijay Naidu, and Epeli Hau'ofa. 1993. *A New Oceania: Rediscovering Our Sea of Islands*. Suva, Fiji: School of Social and Economic Development, University of the South Pacific in association with Beake House.

Wagner, Stephen M. 2004. "Silken Parchments: Design, Context, Patronage and Function of Textile-Inspired Pages in Ottonian and Salian Manuscripts." PhD diss., University of Delaware.

Walker, Alicia. 2008. "Meaningful Mingling: Classicizing Imagery and Islamicizing Script in a Byzantine Bowl." *Art Bulletin* 90 (1): 32–53.

———. 2012. "Globalism." *Medieval Art History Today: Critical Terms* 33:183–96.

Walker, David. 1971. "The Organization of Material in Medieval Cartularies." In *The Study of Medieval Records: Essays in Honour of Kathleen Major*, edited by Donald A. Bullough, R. L. Storey, and Kathleen Major, 132–50. Oxford: Clarendon.

Walker, Joel. 2012. "Armenian Perspectives on the Mongol Conquest of the Middle East." Preliminary notes for a collection of primary sources on the Mongol Empire. Washington, DC.

Wallis, Faith, and Robert Wisnovsky. 2016. *Medieval Textual Cultures: Agents of Transmission, Translation, and Transformation*. Boston: De Gruyter.

Ware, Rudolph T. 2014. *The Walking Qur'an: Islamic Education, Embodied Knowledge, and History in West Africa*. Chapel Hill: University of North Carolina Press.

Warren, Michelle R. 2014. "*The Song of Roland*: How the Middle Ages Aren't Old." *Cambridge Journal of Postcolonial Literary Inquiry* 1 (2): 281–91.

Watt, James C. Y., and Denise Patry Leidy. 2005. *Defining Yongle: Imperial Art in Early Fifteenth-Century China*. New York: Metropolitan Museum of Art. Exhibition catalogue.

Watts, James. 2012. *Iconic Books and Texts*. Sheffield, England: Equinox.

Weber, Elka. 2004. "Sharing the Sites: Medieval Jewish Travellers to the Land of Israel." In *Eastward Bound: Travel and Travelers, 1050–1550*, edited by Rosamund Allen, 35–52. Manchester and New York: Manchester University Press.

———. 2005. *Traveling through Text: Message and Method in Late Medieval Pilgrimage Accounts*. Abingdon, England: Routledge.

Weckmann, Luis. 1984. *La herencia medieval de México*. 2 vols. Mexico City: El Colegio de México.

Weiner, Mark S. 2013. "The Internationalism of Particularism." *Worlds of Law*, August 17, 2013. https://worldsoflaw.wordpress.com/2013/08/17/the-internationalism-of-particularism/.

Weiss, Daniel H. 1999. *Die Kreuzritterbibel: Kommentar*. Lucerne, Switzerland: Faksimile Verlag.

Weiss, Julian, and Sarah Salih, eds. 2009. *Locating the Middle Ages: The Spaces and Places of Medieval Culture*. London: Centre for Late Antique and Medieval Studies.

Weitz, Ankeney. 2015. "Privately Published Books on Art from the Song Dynasty." In *Imprimer sans Profit? Le livre non commercial dans la Chine impériale*, 46–69. Geneva: Librairie Droz.

Weitzmann, Kurt. 1971. "Greek Sources of Islamic Scientific Illustrations." In *Studies in Classical and Byzantine Manuscript Illumination*, 20–44. Chicago: University of Chicago Press.

Wenzel, Marian. 1993. *Ornament and Amulet: Rings of the Islamic Lands*. London: Nour Foundation in association with Azmimuth and Oxford University Press.

Wenzhou Museum, ed. 2010. *Baixiang Huiguang: Wenzhou Baixiang ta, Huiguang ta diancang daquan*. Beijing: Wenwu chubanshe.

West, Alexander. 2017. "The Medieval Tropics." Medium.com, August 21, 2017. https://medium.com/@siwaratrikalpa/the-medieval-tropics-7faeb33a355f.

Whitaker, Cord. 2015. "Race-ing the Dragon: The Middle Ages, Race, and Trippin' into the Future." *postmedieval: a journal of medieval cultural studies* 6:3–11.

———. 2016. "Pale Like Me: Resistance, Assimilation, and 'Pale Faces' Sixteen Years On." *In the Middle* (blog), July 20, 2016. http://www.inthemedievalmiddle.com/2016/07/pale-like-me-resistance-assimilation.html.

White, T. H. 1954. *The Book of Beasts: Being a Translation from a Latin Bestiary of the Twelfth Century*. New York: G. P. Putnam's Sons.

Whittaker, Gordon. 1986. "The Mexican Names of Three Venus Gods in the Dresden Codex." *Mexicon* 8 (3): 56–60.

Williamson, Beth. 2009. *The Madonna of Humility: Development, Dissemination, and Reception, c. 1340–1400*. Woodbridge, England: Boydell and Brewer.

Willis, Michael D. 1985. "An Eighth Century Mihrab in Gwalior." *Artibus Asiae* 46 (3): 227–46.

Windmuller-Luna, Kristen. 2000–. "Ethiopian Healing Scrolls." In *Heilbrunn Timeline of Art History*. New York: Metropolitan Museum of Art. http://www.metmuseum.org/toah/hd/heal/hd_heal.htm.

Winks, Robin W., and Teofilo F. Ruiz. 2005. *Medieval Europe and the World: From Late Antiquity to Modernity, 400–1500*. Oxford: Oxford University Press.

Winslow, Sean M. 2015. "Ethiopic Manuscript Production: Practices and Contexts." PhD diss., University of Toronto.

Wittkower, Rudolf. 1987. "Marco Polo and the Pictorial Tradition of the Marvels of the East." In *Allegory and the Migration of Symbols*, 76–92. London: Thames and Hudson.

Wolfgang von Hagen, Victor. 1944. *The Aztec and Maya Papermakers*. London: Forgotten Books.

Wolters, O. W. 1970. *The Fall of Śrīvijaya in Malay History: East Asian Historical Monographs*. London: Oxford University Press.

Wood, Denis. 2010. *Rethinking the Power of Maps*. New York: Guilford.

Wood, Frances, and Mark Barnard. 2010. *The Diamond Sutra*. London: British Library.

Wood, Paul. 2013. *Western Art and the Wider World*. Chichester, England: Wiley-Blackwell.

Woodward, David, and G. Malcolm Lewis, eds. 1998. *Cartography in the Traditional African, American, Arctic, Australian, and Pacific Societies*. Vol. 2, book 3, of *The History of Cartography*, edited by J. B. Harley and David Woodward. Chicago: University of Chicago Press.

Worrall, Simon. 2014. *The Lost Dhow. A Discovery from the Maritime Silk Route*. Toronto: Aga Khan Museum. Exhibition catalogue.

Wright, Julia Elaine. 2009. *Islam: Faith, Art, Culture: Manuscripts of the Chester Beatty Library*. London: Scala.

Wrisley, D. J. 2006. "Burgundian Ideologies and Jehan Wauquelin's Prose Translations." In *The Ideology of Burgundy: The Promotion of National Consciousness, 1364–1565*, edited by D'Arcy J. D. Boulton and Jan R. Veenstra, 131–50. Leiden, the Netherlands: Brill.

Wynne-Jones, Stephanie, and Jeffrey Fleisher, eds. 2015. *Theory in Africa, Africa in Theory: Locating Meaning in Archaeology*. London: Routledge.

Xyngopoulos, Andreas, and Photis Zachariou. 1956. *Manual Panselinos. Text by Andrew Xyngopoulos. Copies, Drawings, and Ornamental Designs by Photis Zachariou*. Athens: Athens Editions.

Yahalom, Joseph. 2009. *Yehuda Ha-Levi: Poetry and Pilgrimage*. Translated by Gabriel Levin. Jerusalem: Hebrew University Magnes Press.

Yahalom, Joseph, and Naoya Katsumata. 2010. *Tahkemoni, or the Tales of Heman the Ezrahite*. Jerusalem: Ben Zvi Institute.

Zhao, Bing. 2015. "Chinese-Style Ceramics in East Africa from the 9th to the 16th Century: A Case of Changing Value and Symbols in the Multi-Partner Global Trade." *Afriques* 6:1–50.

Zijlmans, Kitty, and Wilfried van Damme. 2008. *World Art Studies: Exploring Concepts and Approaches*. Amsterdam: Vailz.

Zwalf, W., ed. 1985. *Buddhism: Art and Faith*. London: British Museum.

Illustration Credits

Cover; p. i; fig. 1.1: HM 427. The Huntington Library, San Marino, California

Cover; figs. Introduction.19a–c, Introduction.21, 9.4a, II.8: Digital Image © 2019 Museum Associates / LACMA. Licensed by Art Resource, NY

Cover; p. 45, fig. 12.3: © 2018 Biblioteca Apostolica Vaticana. Vat. gr. 1613, fol. 107 by permission of Biblioteca Apostolica Vaticana, with all rights reserved.

Cover; figs. Introduction.11, 7.3; pp. 102–3: Image copyright © The Metropolitan Museum of Art. Image source: Art Resource, NY

Back cover; p. 45; fig. 21.2: The National Library of Israel, Jerusalem, Ms. Heb. 4450=8

Back cover; p. 45; fig. Introduction.14: Ben Curtis / AP / Shutterstock

P. ii; fig. 4.2a: Herzog August Bibliothek Wolfenbüttel: Ms. Cod. Guelf. 1 Gud. Lat. Fol. 69v

P. ii; fig. 1.3: The Bodleian Library, University of Oxford, MS Arab c.90

P. ii; fig. 1.4: FLHC 90 / Alamy Stock Photo

Pp. ii, iv; fig. 1.2: Topkapi Palace Museum

Pp. vi; figs. Prologue.4, Introduction.17, Introduction.22, Introduction.29, II.4, III.7, 4.1, 7.5, 18.2, Epilogue.2: www.metmuseum.org, CC0 1.0

P. 44; fig. Introduction.28: Photo: Kenneth D. and Rosemarie Ann Keene

P. 44; fig. 9.3a: Los Angeles, Getty Research Institute (2645-271)

P. 45; fig. 10.3: © The Trustees of the Chester Beatty Library, Dublin

P. 45; fig. 2.4: © Photography: Rainer Wolfsberger, Museum Rietberg, Zürich

P. 45; fig. 5.1: Photo: Dr. Uli Kozok

P. 45; figs. 7.1a–b, III.8 © The Cleveland Museum of Art

Pp. 46–47; fig. 3.1: Los Angeles, Getty Research Institute (2645-271)

Fig. Prologue.2: Photographed from Pelekanidis 1975

Figs. Prologue.3, Introduction.9, 9.5, 9.7a–b, 9.8, 15.1, 20.1, 20.2, 20.4, II.2: http://www.lacma.org/

Fig. Introduction.1: © Calouste Gulbenkian Foundation, Lisbon. Calouste Gulbenkian Museum - Founder's Collection. Photo: Catarina Gomes Ferreira

Fig. Introduction.2: Courtesy of The Ethiopian Heritage Fund

Fig. Introduction.3: Firenze, Biblioteca Medicea Laurenziana, Ms. Plut. 1.56, f. 14r. Su concessione del MiBACE' vietata ogni ulteriore riproduzione con qualsiasi mezzo

Fig. Introduction.4: The Pierpont Morgan Library, New York

Fig. Introduction.7: Photo: Robert S. Nelson

Fig. Introduction.10: imageBROKER / Alamy Stock Photo

Figs. Introduction.12, I.1, II.1, III.1, 12.4, 16.1, 16.2: BnF

Fig. Introduction.13: Library of Congress, G93. Q3185 1553

Fig. Introduction.15: National Library of Russia, Hebr./Evr./Yevr. I 19 a.

Fig. Introduction.18: Fowler Museum at UCLA, Photograph by Don Cole

Fig. Introduction.23: © RMN-Grand Palais / Art Resource, NY / Repro-photo: Thierry Ollivier

Fig. Introduction.24: Courtesy of the East Asian Library and the Gest Collection, Princeton University Library

Fig. Introduction.25: Art Collection 4 / Alamy Stock Photo

Fig. Introduction.26: The Bodleian Library, University of Oxford, MS Arch. Selden A. 1, fol. 46

Fig. Introduction.27: Royal Danish Library, GKS 2232 4°, p. 647 [661]; drawing 258

Fig. Introduction.30; p. 45: Museum of New Zealand Te Papa Tongarewa

Fig. 2.1a–b: N.C. Mehta Collection, Gujarat Museum Society, Lalbhai Dalpatbhai Museum, Ahmedabad

Fig. 2.2: Courtesy of the Trustees of the Chhatrapati Shivaji Maharaj Vastu Sangrahalaya. Not to be reproduced without prior permission of the Trustees

Figs. 2.3, 2.5: bpk Bildagentur / Staatsbibliothek Preussischer Kulturbesitz, Orientabteilung / Art Resource, NY

Fig. 2.7: Spencer Collection, The New York Public Library

Fig. 3.2: Los Angeles, Getty Research Institute (93-B3709)

Fig. 3.3: Ministerio de Cultura y Deporte. Archivo General de Indias. MP-Mexico, 17

Fig. 3.4: Reconstruction courtesy of www.mesolore.org

Fig. 4.2b: Herzog August Bibliothek Wolfenbüttel: Ms. Cod. Guelf. 1 Gud. Lat. Fol. 70

Figs. 4.3a–b, 10.2, 11.5: The Morgan Library & Museum, New York

Fig. 6.2: By Permission of the President and Fellows of St John's College Oxford. MS 17, f. 6r

Figs. II.3, 2.6, 2.8, 6.1, 8.1a–b, 8.2, 9.1, 21.1a–b; p. 107: British Library, London, UK © British Library Board. All Rights Reserved / Bridgeman Images

Figs. II.5, 11.1: The Walters Art Museum, Baltimore

Fig. II.6: V&A Images, London / Art Resource, NY

Fig. II.9: Los Angeles, Getty Research Institute (2013.M.24)

Fig. 7.2: Collection of the National Palace Museum

Fig. 7.4: Photo: Bruce M. White / Princeton University Art Museum / Art Resource, NY

Fig. 9.2: Los Angeles, Getty Research Institute (2645-271)

Fig. 9.4h: Rollout Photograph Justin Kerr

Fig. 9.6a: Courtesy of Penn Museum, image # 64-5-30

Fig. 9.6b: Drawing by Linda Schele © David Schele. Photo courtesy Ancient Americas at LACMA (ancientamericas.org)

Fig. 10.4: © The Aga Khan Museum, AKM441

Fig. 11.2: The Bodleian Library, University of Oxford, MS Arm.d.13, fol. 17v

Fig. 11.3: The Bodleian Library, University of Oxford, MS Arm.c.1, fol. 151v

Fig. 11.4: Courtesy of the Mekhitarist Congregation Library of San Laazaro Abbey, Venice, Italy. MS 400, fol. 139v. Photograph by Hrair Hawk Khatcherian

Fig. 11.6: Courtesy of the Armenian Catholicosate of the Great House of Cilicia, Antelias, Lebanon (MS 157, fol. 12v). Photograph by Hrair Hawk Khatcherian

Fig. III.2: Bayerische Staatsbibliothek München, Clm 4453, fol. 23v-24r

Fig. III.4: Reproduced courtesy of the Dean and Chapter of Canterbury, Lit. Ms. A 14, fol. 12

Fig. 12.1: © 2018 Biblioteca Apostolica Vaticana. Vat. gr. 1613, fol. 317 by permission of Biblioteca Apostolica Vaticana, with all rights reserved

Fig. 12.2, IV.2: Su concessione del Ministero per i Beni e le Attività Culturali - Biblioteca Nazionale Marciana. Divieto di ripodizione

Fig. 14.4: University of Oxford, Khalili Research Centre Image Archive, slide no. ISL15203 (© The Barakat Trust and The University of Edinburgh)

Fig. 15.3: Or.Ms.20, f. 124v, Special Collections, University of Edinburgh, Main Library

Fig. 16.3; pp. 156–57: The Bodleian Library, University of Oxford, Bodley 264, folio 218r

Fig. 16.4: The Bodleian Library, University of Oxford, Bodley 264, folio 242v

Fig. IV.1: The Picture Art Collection / Alamy Stock Photo

Figs. IV. 3a–b: National Library of Sweden, MS A 135

Figs. IV. 5a–b: © 2018 Biblioteca Apostolica Vaticana. Barb.Or. 2, fol. 3 by permission of Biblioteca Apostolica Vaticana, with all rights reserved

Fig. IV.8: Courtesy of The Hispanic Society of America, New York

Fig. IV.9a: The Bodleian Library, University of Oxford, MS Douce 219, fol. 145v

Fig. IV.9b: The Bodleian Library, University of Oxford, MS Douce 219, fol. 146

Fig. IV.10: bpk Bildagentur / British Museum, London, Great Britain / Art Resource, NY

Fig. 18.2a: Asian Civilisations Museum, Singapore. Tang Shipwreck Collection

Fig. 19.1: Photo: Ariadne Van Zandbergen

Fig. 19.2: SOAS University of London

Fig. 20.3: ephotocorp / Alamy Stock Photo

Fig. 21.3a: Leipzig University Library, Vollers 1102-I, fol. 72v

Fig. 21.3b: Leipzig University Library, Vollers 1102-I, fol. 73r

Index

practices, 73; and Indian historiography, 61–62; Jews expelled from, 11; Korean cartographic knowledge of, 58; Marco Polo travel book, 196, 197, 199–202, *200*, *201*; pilgrimages, 246, 247–48; Safavid negotiations with, 139; Saracen depictions, 179; Stockholm Codex Aureus, 37, 210, *211*; Tintagel Castle finds, 217n10; T-O maps, 38, *100*; *Vita Christi*, 41, 177, *177*

Ēsibits'i, Yovan, 43, 151, *153*

Eskimo peoples, 160–61

Etchmiadzin Gospels (Armenia), 9, 21

Ethiopia: amulet scrolls, 121–24; *Awdä Nägäst* (Cycle of Kings), 43, 123–24, *123*; biblical associations of, 83, 86–89, 167–73, 178–79; British campaign against, 91; and Buddha-Josaphat connections, 1; and Church councils, 181; eunuch from, 167–73, *168*; Garima Gospels, 9, *9*, 19, 37, 91; Gospel book from Amhara region, 40, 83, *83*; Gospel book from Gunda Gundé Monastery, 19–21, *19*, 33n72, 41; indigo trade, 212; magic recipe book, 43, 121–22, *122*; map depictions of, 83–86; "medieval" as a temporal classification for, 82–83, 89–92; stereotype of the "Ethiopian," 169, 187

Etymologies by Isidore of Seville, 38, 83–85, 99, *100*

Euthymius of Athos, 1

Faddan More Psalter, 249, 254

Fastolf, Sir John, 246

Fatimids, 14, 19, 55, 165, 227, 249, 252

Fez, 15, 214, 224, 228n4

Florence, Biblioteca Medicea Laurenziana: Cod. Plut. I, 56 (Rabbula Gospels), 9, *9*

Frederick II, Holy Roman Emperor, 31

Frobisher, Martin, 160

Fueros de Aragón (Feudal Customs of Aragon), or *Vidal Mayor*, 39, 160, 177, *178*, 182–89, *184*, *186*

Gama, Vasco da, 53

Gandhara (India/Pakistan), 231, 234n6, 253

Garima Gospels (Ethiopia), 9, *9*, 14, 19, 37, 91

Ge'ez language, 1, 93n11, 93n18, 121–22, 213

Georgios (artist), *168*, 169–73

gender: medieval concepts of, 5, 12, 15, 21, 27, 59n1, 175–81; Ethiopian eunuch, 19, 86, 89, 163–73, 178–79

Gessner, Abraham, 105, *106*

Ghent (Belgium), 41, *207*, *216*

Ghurids, 14, 61, 70n6

globe cup, silver (Zurich), 42, 105, *106*

Golden Horde, 26, 194n3

gold in manuscripts, 112–19, 143, 182, 212

Gonzalez, Juan, *28*

Gospel books: Armenian Etchmiadzin Gospels, 9, 21; Armenian, from Lake Van region, 40, 162, *162*; Armenian, by Mesrop of Khizan, 42, 150,

150; Ethiopian, from Amhara region, 40, 83, *83*; Ethiopian, from Gunda Gundé Monastery, 19–21, *19*, 33n72, 41; Ethiopian Garima Gospels, 9, *9*, 19, 37, 91; from Helmarshausen (Germany), 10, *10*, 38; Lindau Gospels, 10, *10*, 37; from Nicaea or Nicomedia, 12, *13*, 39; of Otto III (Germany), 38, 158, *159*; Rabbula Gospels (Syria), 9, *9*, 37; Resurrection iconography in, 148–54, *150*, 154nn3–11, 155n14; silk doublures for, 10, *10*, 37, 43, 109–11, *111*; Stockholm Codex Aureus (Canterbury), 37, 210, *211*

Gothic, 11, 51, 137, 220

Granada (Spain), 41, 80, *162*, 163, 183, 185, 203

Great Zimbabwe, 21, 217

Gualpuyogualcal, Francisco, *28*

Guaman Poma de Ayala, Felipe, 27, *28*

Gui de Cambrai, 1

Gujarat (India): *Devasano Pado Kalpasutra* manuscript, 41, 66, *66*; *Iskandarnama* manuscript possibly from, 40, 63–65, *64*; Jain *Kalpasūtra* manuscripts, 23, *23*, 40, 41, 63–66, *65*, *66*; Southeast Asian trade, 94

Hafiz-i Abru, 1, *2*, 40

Hagenau (Alsace, France), x, 1, 27, 41

haggadot (Seder service books), 41, 75, 238–43, *239*, 245nn26–30

Hainaut (France/Flanders), 38, *84*

Halevi, Yehudah, 236–37, 238

Hamzanama (Adventures of Hamza), 40, 65–66, *65*, 70n21

handscrolls, 3, 24, *24*, 26, *26*, 213–14, *214*

Han dynasty, 162

Han Gan, 24, *24*, 37

al-Harīrī, 39, 158, *158*, 244n16

Hebrew manuscripts: Alharizi's *Book of Tahkemoni*, 237–38, 244n16; Ashburnham Pentateuch, 37, 48, *48*; Ashkenazi Haggadah (Germany), 41, *239*, 240, 242, 245nn28–30; Benjamin of Tudela's *Book of Travels*, 235, 244n1; Codex Leningradensis (Hebrew Bible; Egypt), *18*, 19, 38; Halevi's poetry, 236–37; Hebrew Bible (Spain/Portugal), 41, 214, *215*; Joel ben Simeon's Exodus illuminations, 11, 214, *215*, 238–43, *239*, *241*; Leipzig Mahzor (Germany), 39, *242*, 243, 245n48; Nachmanides's poetry, 243–44; Rothschild Pentateuch (France/Germany, Italy), 11, *11*, 39, 40, 180–81, 214, *215*; Rothschild-Weill Mahzor (Italy), 40, 240–43, *241*, 245n28, 245nn36–37

Helgo hoard (Sweden), 49, 212

Helmarshausen (Germany), 10, *10*, 38

Henry II the Pious of Silesia, 190, *192*

Henry IV, King of England, 201

Herat (Afghanistan), *2*, 39, 40, 67, *193*

Hildesheim (Germany), 39, *176*

Hindu manuscripts, 22, 23–24, *23*, 42, 213–14, 231, 253

Histoire de Charles Martel (History of Charles Martel), 41

Historia general del Piru (General History of Peru) by Martín de Murúa, 27, 42, 108, *109*, 175

Historia septem sapientum (The Seven Wise Masters), 27

Holy Roman Empire, 9, 90

Hulagu Khan, 192

Hui yaofang (Prescriptions of the Hui), 31

Hu Sihui, 31

hymnals, 43, *149*, *152*, 155n19

Ibn Battuta, 17, 18

al-Idrisi, Muhammad, 15–17, *16*, 33n54, 39

Ilkhanids, 26, 161–62, 190

Inca peoples, 26, 27, 35, 108, *109*, 111

India: bibliographic history of, 22–24; Buddhist manuscripts and manuscript covers, 38, 229, *230*, 231–33, *233*; Byzantine depiction of Indians, 172; cartographic knowledge of, 53, 54, 85; global networks, 23, 94, 212, 231, 253; Great Stupa at Sanchi, 37, 231–32, *232*; Hindu manuscripts, 23–24, *23*, 42; Jain manuscripts, 23–24, *23*, 40, 41, 63–69, *65*, *66*, 213–14, 231; "medieval" as a temporal classification for, 60–62, 69; palm-leaf manuscripts, 3, 24, 94, 113, 229; Persianate manuscripts, 40, 41, 63–69, *64–68*, 70n21, 70n23; talismanic shirt, 40, 106, *108*, 121

indigo, 14–15, 105, 112–19, 120n26, 136n21, 212

Injuids, 63

Ireland, 23, 212, 249

Isfahan (Iran), 42–43, 109, *111*, 137–46, 150–54, *150*

Isidore of Seville, 31, 38, 83–85, 99, *100*

Iskandarnama (Book of Alexander), 40, 63–65, *64*, 69, 210, *211*

Islam: apotropaic objects, 106, *108*, 121, 123; calendar system, 36; ceramics, *220*, 221; and Christian access to Jerusalem, 247; and Christian Aksumite kingdom, 91; Christian-Muslim clashes, 54–55, 80, 178, 183 (*see also* Crusades); Christian travelers posing as Muslims, 97, 98n19; educational practices, 224–28, 228n4; European depictions of Muslims, 172, 177–80, *178*, *180*, 185–88, *186*, 205; geographical scope of, 12; Iberian expulsion of Muslims, 163, 214; and Indian history, 22, 24, 61–62; maps reflecting the worldview of, 56; Persian court's familiarity with biblical subjects, 140, 143, 145–46, 147n25, 147n29; pilgrimages to Mecca, 210; and pseudo-Arabic inscriptions, 212; Qur'an case, 41, *162*, 163; Qur'an stand, monumental, *14*, 15, 40; women's role in, 15

Published by the J. Paul Getty Museum, Los Angeles

Getty Publications
1200 Getty Center Drive, Suite 500
Los Angeles, CA 90049-1682
www.getty.edu/publications

Ruth Evans Lane, *Project Editor*
Lindsey Westbrook, *Manuscript Editor*
Kurt Hauser, *Designer*
Amita Molloy, *Production*
Nina Damavandi, *Image Rights and Acquisition*

Distributed in the United States and Canada by the
University of Chicago Press

Distributed outside the United States and Canada by
Yale University Press, London

Printed in China

Library of Congress Cataloging-in-Publication Data
Names: Keene, Bryan C., editor.
Title: Toward a global Middle Ages : encountering the world through
 illuminated manuscripts / edited by Bryan C. Keene ; with contributions by
 Suzanne Conklin Akbari, Sussan Babaie, Roland Betancourt, Jerry Brotton,
 Jill Caskey, Kristen Collins, Morgan Conger, Michelle H. Craig, Mark
 Cruse, James Cuno, Eyob Derillo, J. Soren Edgren, Elizabeth A. Eisenberg,
 Tushara Bindu Gude, Byron Ellsworth Hamann, Melanie Holcomb, Kaiqi Hua,
 Alexandra Kaczenski, Rheagan Eric Martin, Sylvie L. Merian, Asa Simon
 Mittman, Megan E. O'Neil, Alka Patel, Pamela A. Patton, Alex J. West.
Description: Los Angeles : The J. Paul Getty Museum, [2019] | Includes
 bibliographical references and index.
Identifiers: LCCN 2018052225 | ISBN 9781606065983 (pbk.)
Subjects: LCSH: Illumination of books and manuscripts—History. |
 Illumination of books and manuscripts, Medieval. | Manuscripts, Medieval.
 | Middle Ages.
Classification: LCC ND2900 .T69 2019 | DDC 745.6/7—dc23 LC record
available at https://lccn.loc.gov/2018052225